D1684034

Population Dynamics
in Prehistory and Early History

Topoi
Berlin Studies of the Ancient World

Edited by
Excellence Cluster Topoi

Volume 5

De Gruyter

Population Dynamics in Prehistory and Early History

New Approaches Using
Stable Isotopes and Genetics

Edited by
Elke Kaiser
Joachim Burger
Wolfram Schier

De Gruyter

ISBN 978-3-11-026629-0
e-ISBN 978-3-11-026630-6
ISSN 2191-5806

Library of Congress Cataloging-in-Publication Data

A CIP catalog record for this book has been applied for at the Library of Congress

Bibliographic information published by the Deutsche Nationalbibliothek

The Deutsche Nationalbibliothek lists this publication in the Deutsche Nationalbibliografie; detailed bibliographic data are available in the Internet at http://dnb.dnb.de.

© 2012 Walter de Gruyter GmbH & Co. KG, Berlin/Boston

Typesetting: Dörlemann Satz GmbH & Co. KG, Lemförde
Printing and binding: AZ Druck und Datentechnik GmbH, Berlin
∞ Printed on acid-free paper

Printed in Germany

www.degruyter.com

Contents

Preface . IX

Genetics

MATHIAS CURRAT
Consequences of population expansions on European genetic diversity 3

PASCALE GERBAULT, MICHELA LEONARDI, ADAM POWELL, CHRISTINE WEBER,
NORBERT BENECKE, JOACHIM BURGER, MARK G. THOMAS
Domestication and migrations: Using mitochondrial DNA to infer domestication
processes of goats and horses 17

GREGER LARSON
Using pigs as a proxy to reconstruct patterns of human migration 31

INGRID WIECHMANN
Poor DNA preservation in bovine remains excavated at Pre-Pottery Neolithic Göbekli
Tepe (Southeast Turkey): Brief communication 41

AMELIE SCHEU, CHRISTINA GEÖRG, ANNA SCHULZ, JOACHIM BURGER,
NORBERT BENECKE
The arrival of domesticated animals in South-Eastern Europe as seen from
ancient DNA . 45

LARS FEHREN-SCHMITZ
Population dynamics, cultural evolution and climate change in pre-Columbian
western South America . 55

Stable isotopes and genetics

MALCOLM C. LILLIE, INNA POTEKHINA, CHELSEA BUDD, ALEXEY G. NIKITIN
Prehistoric populations of Ukraine: Migration at the later Mesolithic to Neolithic
transition . 77

VYACHESLAV I. MOLODIN, ALEXANDER S. PILIPENKO, AIDA G. ROMASCHENKO,
ANTON A. ZHURAVLEV, ROSTISLAV O. TRAPEZOV, TATIANA A. CHIKISHEVA,
DMITRIY V. POZDNYAKOV
Human migrations in the southern region of the West Siberian Plain during the
Bronze Age: Archaeological, palaeogenetic and anthropological data 93

Christina Sofeso, Marina Vohberger, Annika Wisnowsky, Bernd Päffgen, Michaela Harbeck
Verifying archaeological hypotheses: Investigations on origin and genealogical lineages of a privileged society in Upper Bavaria from Imperial Roman times
(Erding, Kletthamer Feld) . 113

Stable isotopes

Marek Zvelebil, Malcolm C. Lillie, Janet Montgomery, Alena Lukes, Paul Pettitt, Mike P. Richards
The emergence of the LBK: Migration, memory and meaning at the transition to agriculture . 133

Rouven Turck, B. Kober, J. Kontny, F. Haack, Andrea Zeeb-Lanz
"Widely travelled people" in Herxheim? Sr-isotopes as indicators of mobility 149

Claudia Gerling, Volker Heyd, Alistair Pike, Eszter Bánffy, János Dani, Kitti Köhler, Gabriella Kulcsár, Elke Kaiser, Wolfram Schier
Identifying kurgan graves in Eastern Hungary: A burial mound in the light of strontium and oxygen isotope analysis 165

Natalia Shishlina, Vyacheslav Sevastyanov, Robert E.M. Hedges
Isotope ratio study of Bronze Age samples from the Eurasian Caspian Steppes . . . 177

Johanna Irrgeher, Maria Teschler-Nicola, Katrin Leutgeb, Christopher Weiss, Daniela Kern, Thomas Prohaska
Migration and mobility in the latest Neolithic of the Traisen Valley, Lower Austria: Sr isotope analysis . 199

Daniela Kern
Migration and mobility in the latest Neolithic of the Traisen Valley, Lower Austria: Archaeology . 213

Julia K. Koch, Katharina Kupke
Life-course reconstruction for mobile individuals in an Early Bronze Age society in Central Europe: Concept of the project and first results for the cemetery of Singen (Germany) . 225

Argyro Nafplioti
Late Minoan IB destructions and cultural upheaval on Crete: A bioarchaeological perspective . 241

Elisabeth Stephan, Corina Knipper, Kristine Schatz, T. Douglas Price, Ernst Hegner
Strontium isotopes in faunal remains: Evidence of the strategies for land use at the Iron Age site Eberdingen-Hochdorf (Baden-Württemberg, Germany) 265

Corina Knipper, Anne-France Maurer, Daniel Peters, Christian Meyer, Michael Brauns, Stephen G. Galer, Uta von Freeden, Bernd Schöne, Harald Meller, Kurt W. Alt
Mobility in Thuringia or mobile Thuringians: A strontium isotope study from early medieval Central Germany . 287

T. Douglas Price, Karin Margarita Frei, Vera Tiesler, Hildur Gestsdóttir
Isotopes and mobility: Case studies with large samples 311

Gisela Grupe, Sabine Eickhoff, Anja Grothe, Bettina Jungklaus, Alexander Lutz
Missing in action during the Thirty Years' War: Provenance of soldiers from the Wittstock battlefield, October 4, 1636. An investigation of stable strontium and oxygen isotopes . 323

Jason E. Laffoon, Menno L. P. Hoogland
Migration and mobility in the circum-Caribbean: Integrating archaeology and isotopic analysis . 337

Preface

In March 2010, Berlin's Freie Universität hosted an international conference on the topic "Migration in Prehistory and Early History: Stable Isotopes and Population Genetics – New Answers to Old Questions?".

Until well into the nineties, migration was not considered in the fields of ancient studies in Central and Western Europe to be a topic worthy of research. In contrast, in other countries migration began, even before the war, to be almost a standard model for explaining cultural change. In past decades, conventional methods have permitted scholars to achieve only a limited degree of progress in the question of how archaeological cultures and innovations spread over large areas. Even now, models of diffusion and migration are juxtaposed as opposites, though more recently convergence phenomena have also been discussed.

Recent decades have seen the application of methods of analysis involving archaeometry and molecular genetics. Most prominent are approaches using stable isotopes and palaeogenetics, but also computer simulation, all of which are providing new impulses within the discussion of (pre)historical population dynamics. As a result, the state of migration research has undergone rapid change. Thus, we decided to invite to Berlin groups whose research is focussed on migration in prehistoric and early historic times, to create an opportunity to exchange experiences and insights about methodological approaches, research results and prospects for future research. No chronological or geographical restrictions were placed on the invitation, which made it possible to have scholars from widely diverse scientific disciplines comparatively present their approaches, findings and interpretations to an audience far broader than the circles of the individual disciplines.

A total of 32 papers and 6 posters were presented, addressing specific historical questions concerning population dynamics and migration in the light of cutting edge bio-archaeological research. The conference programme was divided into three larger thematic sections: 1) isotope analysis, 2) population genetics and 3) modelling and computer simulation. The same structure has been adopted for this volume.

Over the course of the conference, one aspect that emerged clearly was that archaeologists, modellers, population geneticists and analysts share a common interest in history, and above all the history of the human population (and their domesticated animals). The participants also learned, though, that despite all that they have in common in terms of ideas, by and large the limits of the capacity for mutual understanding have been reached. The high degree of specialization in the separate disciplines and the complexity of modern archaeological research have demolished the utopia of an untroubled transdisciplinary approach – so much for the lessons from this conference. However, the farther the disciplines grow apart from one another in their quest for new insights, the more essential it becomes that rigorous and regular dialogues take place among them – this too was something upon which everyone at the conference could agree. The aim of this volume is to conduct that dialogue at a high level for the purpose of a reconstruction of (pre)historic population history.

The large audience and the extraordinary quality both of the papers presented and of the subsequent discussion bore witness to the great interest in the field of (pre)historical migration research that currently exists. This ultimately led to the decision to publish in printed form as many of the papers presented as possible. In deciding upon the title of this volume, **Population Dynamics in Prehistory and Early History. New Approaches Using Stable Isotopes and Genetics,** the editors have attempted to do justice to the broad spectrum of research on mobility and migration presented within it.

The monograph series of the Excellence Cluster TOPOI permits this volume to be released in book format and, at the same time, in an electronic edition. The manuscripts included were subjected to a peer-review process. The authors of the more than 20 papers generously took on the chore of preparing the manuscripts themselves, thereby making this important publication possible. We owe great thanks to Gisela Grupe and T. Douglas Price for content-related support in the preparation of these conference proceedings. The conference itself was generously supported by the Excellence Initiative 264 TOPOI and organized by the research group A II of the excellence cluster. That group, under the title "*Spatial effects of technological innovations and changing ways of life*", examines large-scale movements and migrations of populations in the North Pontic and Central Asian region in prehistoric times. At the focus in their activities is the parallel application of stable isotope analysis and population genetic analyses on human skeletal material.

Alison Borrowman proof read the English-language texts for linguistic errors. To her as well, we owe our thanks.

Editorial work was performed by Elke Kaiser with assistance from Josephine Schoeneberg and Solveig Semjank.

The editors
Elke Kaiser, Joachim Burger, Wolfram Schier

Genetics

*Mathias Currat**

Consequences of population expansions on European genetic diversity

* Laboratory of Anthropology, Genetics and Peopling History (AGP), Anthropology unit of the department of Genetics and Evolution, University of Geneva, Switzerland: mathias.currat@unige.ch

Abstract

Population movements over space and time played a crucial role in generating the genetic patterns that are observed in the present day. Numerous factors, such as climate changes or cultural innovations, have the potential to induce large-scale movements, such as population expansions (i.e. increases both in density and range) or contractions to refugee areas. It is thus very important to take the spatial dynamic of populations into account when trying to reconstruct their history from genetic data. Computer simulation constitutes a very powerful tool for the study of the combined impacts of biological and demographic factors on the genetic structure of populations. The rapid increase of computer power opens many new possibilities for research in that specific area. A series of recent studies have focused on the consequences of population expansions on their genetic diversity. These studies extensively described one potentially important genetic process which may occur during a range expansion: the "mutation surfing" phenomenon. In this paper, we describe in detail this process and its potential implications for the establishment of the current genetic diversity in Europe. We also discuss the limitations and perspectives of such computer simulation studies in the field, and possible future improvements to them.

Keywords

Europe, population genetics, computer simulation, modern humans, Neolithics, surfing mutation

Population movements and computer simulations

Prehistoric migrations were numerous from the time of the emergence of our own species, *homo sapiens* and there is no doubt that those migrations constitute one of the main factors that shaped the current human diversity (e.g. Lahr and Foley, 1994). According to the out-of-Africa scenario, modern humans left Africa to colonize the rest of the Old World and subsequently the Americas (Ramachandran et al., 2005, Excoffier, 2002). But migrations of individuals did not stop once the entire world was colonized; populations continued to exchange migrants. Moreover, climate variation involving changes in sea-level and vegetation and the displacement of ice sheets during glacial eras contributed to large-scale population movements during specific periods (e.g. Foley, 1989). Short-scale migrations, generation after generation, may result in larger-scale processes, such as the settlement of a new area over time, a process that will be called "population expansion" here. Population expansion means both that a small population increases in terms of numbers of individuals and that it expands its geographic range over the course of generations.

When individuals move from one place to another, so do their genes. Population expansions may thus have important evolutionary consequences that are associated with the spread of colonists' genes over large areas. Consequently the spatial dynamics of populations must be taken into account when studying their genetic structure. Unfortunately it is very difficult to consider the spatial dynamics of individuals (and populations) using simple mathematical models, due to the high number of parameters involved. When complex models are used, it becomes difficult, or even impossible, to get analytical derivations for certain statistics. Fortunately, the rapid increase of computer power during the last three decades has led to the development of computer simulations, which offer a powerful tool for the study of complex evolutionary scenarios.

At the population level, the genetic diversity observed in contemporary populations is due partly to biological factors such as mutation and recombination, and to the effect of natural selection. This diver-

Fig. 1 | Basic principles of the model-based computer simulations approach

sity has also been strongly influenced by the past demography of the population. Indeed, migration of individuals and the variations of density through time contribute to shaping the current genetic diversity of populations, notably through genetic drift. It is thus very important to consider both kinds of parameters (biological and demographic) when analyzing the genetic structure of populations. One powerful approach consists in developing various plausible evolutionary models in order to estimate the genetic diversity theoretically expected under those models (Fig. 1). A comparison between the genetic diversity expected under various alternative scenarios and the observed diversity, allows the evaluation of the relative probability of the different models. Computer simulations may be used to generate the expected diversity for complex scenarios that involve many molecular and demographic parameters as well as environmental influences. In particular, computer simulations have proven to be very efficient in studying the impact of the movements of populations over space and time under realistic hypotheses and especially in studying the genetic consequences of population expansion. In this paper, I am going to present how those results apply to the evolution of Europe.

Population expansion and mutation surfing

In order to simulate a population expansion, Edmonds et al. (2004) and the authors of subsequent articles (Hallatschek and Nelson, 2008; Klopfstein et al., 2006; Travis et al., 2007) used an original simulation framework (Fig. 2). Briefly, this approach consists of simulating, generation after generation, the evolution of individuals (and their genes) within an array of "demes", the whole array representing a subdivided population. Each deme represents a population subunit (or subpopulation) that exchanges migrants with its neighbors. The simulation is spatially-explicit in the sense that the array of demes represents a geographic area with known dimensions. At each generation, two steps occur in every deme. First, a demographic regulation step: the local density increases following a logistic equation at a speed dependant on the growth rate (parameter r) until reaching a maximum (parameter K). The carrying capacity K corresponds to the maximum number of individuals that may coexist in one deme given the

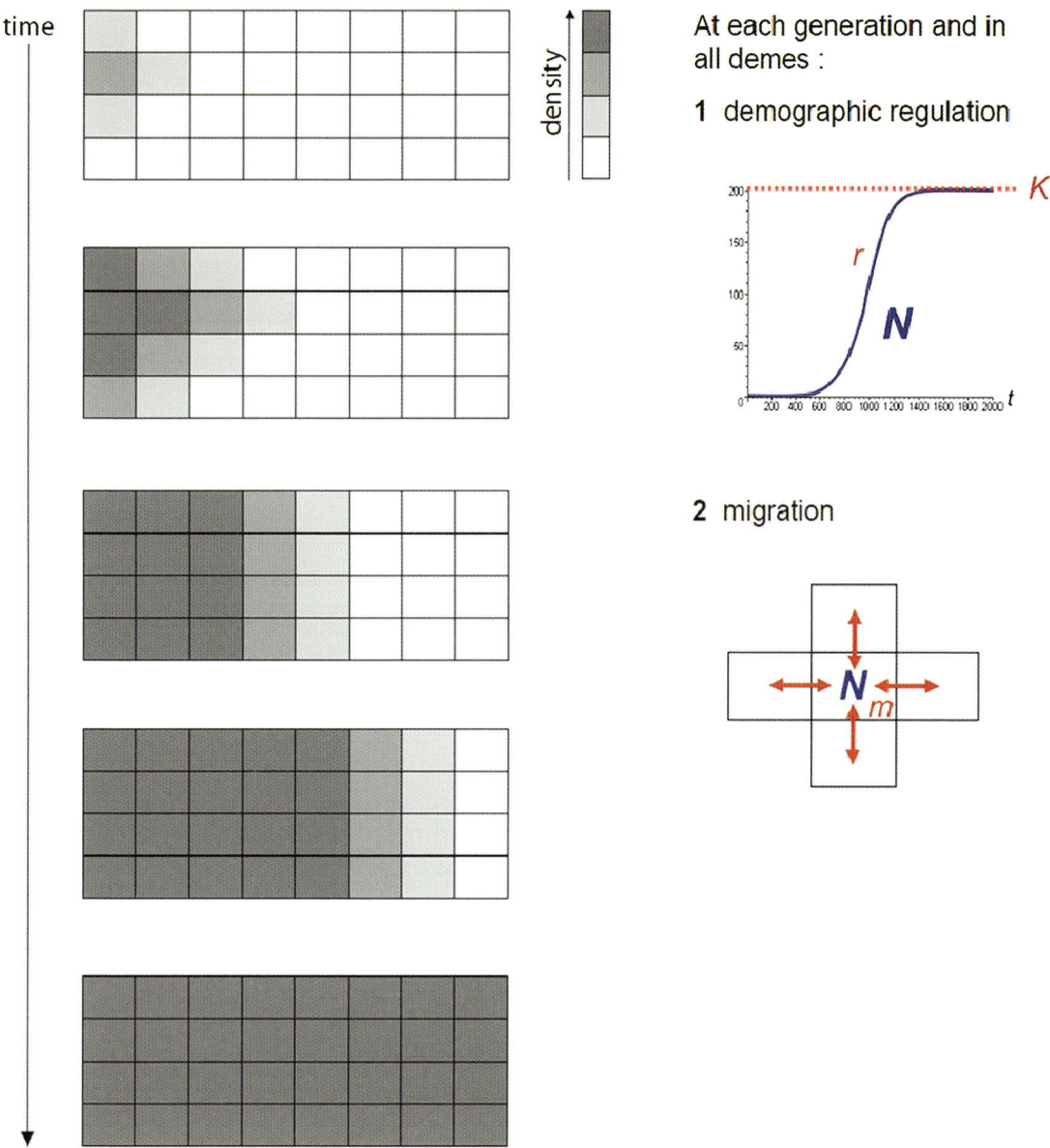

Fig. 2 | Framework designed for the simulation of a simple demographic and range (population) expansion

available resources. Second, a migration step: a proportion of individuals belonging to each deme emigrates to any of the four neighboring demes. This proportion is equal to the migration rate (parameter m). By putting a few individuals in one deme located at one extremity of an empty array and letting the process go on, it is possible to simulate the colonization of a geographic area by a demographically increasing population, and to simulate the genetic diversity of this population throughout the process.

Such frameworks have been used to study the genetic consequences of population range expansions. One important genetic phenomenon resulting from a population expansion is the "mutation surfing" process, which describes a mutation surfing at the wave front of an expanding population. This process has been extensively investigated using computer simulations (Edmonds et al., 2004; Klopf-

Fig. 3 | Schematic representation of an allele surfing in an expanding population (modified from Excoffier and Ray, 2008). Red and blue alleles are present at equal frequencies in the initial population, before the expansion. The frequency of the blue allele increases at the front of the expansion wave due to surfing. This allele then becomes the commonest allele in the whole population

stein et al., 2006) and it describes a mutation (defining a genetic variant or allele) that takes advantage of a population expansion to increase dramatically in frequency, due to the combined effects of genetic drift and demographic growth (Fig. 3). If the allele is neutral (i.e. not the target of natural selection) and if it belongs to the pioneers of a demographic and spatial expansion, it may then surf on this expansion wave. If surfing occurs, the frequency of this mutation drastically increases at the expansion front and, consequently, in the whole population. The final frequency pattern of this neutral allele thus mimics the effect of positive selection. Evaluating the current distribution of a surfing allele may thus lead to the erroneous conclusion that the distribution in question is the result of this allele being the target of positive selection, while it actually results from demographic processes. Klopfstein et al. (2006) demonstrated theoretically that new mutations can reach very high frequencies by surfing, with various final spatial and frequency distributions depending on demographic factors such as population size, growth and migration rates. More importantly, the probability of the survival of a new mutation depends to a large extent on its proximity to the front of the wave. The closer to the front of the expansion wave a mutation is, the higher is the probability that it will surf. This result underlines the very important role played by the pioneers of a population expansion in spreading their genes in the population. When surfing occurs, the centre of the spatial distribution of the mutation is often found far away from its origin, at odds with the common view that the place of origin of an allele is located where its frequency is the highest (Edmonds et al., 2004). It is worth mentioning that surfing is not limited to the mutations that appear during the expansion but affects any standing variants (alleles) carried by the pioneers.

The surfing phenomenon can be explained by three elements associated with the wave front of an expanding population. First, population density at the edge of the expansion is low because the number of individuals colonizing a new area is usually small (Fig. 3A). This promotes genetic drift, i.e. rapid

shifts in allele frequency. Second, population density increases after the initial colonization phase, tending to "stabilize" the new allele frequency (Fig. 3B). Third, pioneers in the colonization of the next area are recruited at the wave front and consequently have a higher probability of transmitting their genes farther away (Fig. 3C). The repetition over space and time of these three events can explain why the frequency of some neutral alleles in a population increases during an expansion. Despite the fact that only a small proportion of alleles do actually surf, mutation surfing can have drastic consequences on the evolution of an expanding species (Excoffier and Ray, 2008; Excoffier et al., 2009; Currat and Excoffier, 2004; Currat et al., 2008; Hallatschek et al., 2007). A range expansion can create very complex patterns at neutral loci, mimicking adaptative processes and resembling postglacial segregation of clades from distinct refuge areas. Below, I am going to present the potential implications of mutation surfing with respect to European prehistory.

Southwest–northeast genetic clines over Europe

One genetic pattern commonly observed for Europe is the presence on the continent of clines of allele frequencies oriented from the southeast to the northwest (SE–NW AFC). Evidence of the presence of such clines was uncovered as early as in 1978 (Menozzi et al.). Those authors created synthetic maps summarizing allelic variation at 38 independent genetic loci, using principal component analyses. Because the first principal component map (PC1) was found to be very similar to the spread of the Neolithic, based on archaeological dates, the authors interpreted those gradients as having been generated by the migration of early farmers from the Near East ~10,000 years ago, and by the subsequent replacement of resident hunter-gatherer populations with little or no interbreeding. Although some aspects of this theory have been criticized (Zvelebil, 1989; Zvelebil, 1986; Sokal et al., 1999a; Sokal et al. 1999b; Rendine et al., 1999; Novembre and Stephens, 2008), this interpretation of SE–NW genetic clines, under the name of the Demic Diffusion model (DDM), has been and is still highly influential in research about the genetic impact of the Neolithic transition. In addition to principal component analyses, other studies have reported the existence of clines of variation across Europe (Sokal and Menozzi, 1982, Sokal et al., 1989, Barbujani and Pilastro, 1993; Chikhi et al., 1998; Chikhi et al., 2002; Rosser et al., 2000; Dupanloup et al., 2004; Bauchet et al., 2007; Heath et al., 2008; Lao et al., 2008; Novembre et al., 2008; Tian et al., 2008; Price et al., 2009; Sabatti et al., 2009). However, those studies investigated different aspects of the genetic variation using various tools, and the precise direction of the reported cline is sometime a matter of debate. Nevertheless, the observation of SE–NW AFC in Europe is still widely considered as the main evidence supporting the Neolithic DDM. My colleagues and I decided to investigate this aspect using a spatially explicit computer simulation approach, more elaborated than those taken in previous attempts.

Following two earlier studies (Rendine et al., 1986; Barbujani et al., 1995), we took advantage of computer simulation to investigate the genetic patterns expected under various scenarios for the Neolithic transition (Currat and Excoffier, 2005). We performed a series of simulations of two population expansions that may have affected the genetic structure of Europeans on the continental scale: the arrival of anatomically modern humans who colonized the continent from east to west around 40,000 years ago (Mellars, 2006); and the European Neolithic transition, which started some 10,000 years ago in the Middle East and spread over the continent toward its northern and western periphery (Pinhasi et al., 2005). Of course the reality was not as simple as two consecutive uniform expansions, and archaeological research suggests that distinct demographic, cultural and economic processes occurred in the vari-

Fig. 4 | Simulation of two successive expansions in Europe. The first one starts 1600 generations before the present (~40,000 years ago) and represents the arrival of anatomically modern humans (orange). The second one starts 400 generations before the present (~10,000 years ago) and represents the Neolithic transition (light green). The zone in black represents the area of cohabitation between hunter-gatherers and farmers and the dark green zone is empty prior to the first expansion

ous regions of Europe (e.g. Zvelebil, 2000). However, the modeling of real processes requires many simplifications and abstractions, and one has to keep in mind that the goal of simulations is not to reproduce reality exactly, which would of course be impossible, but to obtain expectations for simple alternative scenarios in order to evaluate which scenario better fits the observed data and, hopefully, be able to discard certain hypotheses. Our own simulations were designed to generate patterns of genetic diversity for basic scenarios of European evolution in order to obtain an interpretative framework on which observed genetic data could be compared. Those scenarios can be seen as basic hypotheses. We tried to capture the possible influence of population expansions in Europe by considering the dynamics of individuals and their genes over space and time. Because the uncertainty associated with many of the parameters to be used is large (e.g. migration and growth rates, carrying capacity, etc.), we performed multiple simulations with different values of input for those parameters in order to explore as well as possible the parameter space. I redirect the reader to the original publication for details on the methodology (Currat and Excoffier, 2005).

We simulated two successive population expansions in two superimposed arrays of demes representing Europe (Fig. 4). The two expansions spread over Europe from east to west, the first one representing the Paleolithic expansion of the first modern humans around 40,000 BP and the second one representing the Neolithic transition around 10,000 BP. At the end of the first (Paleolithic) expansion, the entire continent is occupied by hunter-gatherers. Then the second (Neolithic) expansion starts from the Middle East in the second layer of demes (farmers) superimposed on the first (hunter-gatherers), and is simulated as a uniform wave of advance over Europe. Gene flow (parameter γ) may occur between hunter-ga-

therers and farmers belonging to the same geographic area. Here, gene flow represents acculturation, i.e. hunter-gatherer assimilation in the Neolithic population due to the acquisition of Neolithic components. We varied the amount of hunter-gatherer acculturation, in order to simulate either a pure demic (DDM, $\gamma=0$), or alternatively a pure cultural diffusion (CDM, $\gamma=1$) over the entire continent. The genetic consequences of both alternative models are fundamentally different, because DDM implies a large genetic replacement of local populations by incoming exogenous farmers while CDM implies no such replacement and hence suggests that current European gene pool contains a large genetic contribution from European (Upper Palaeolithic/Mesolithic) hunter-gatherers. We also simulated intermediate scenarios in terms of amount of hunter-gatherer assimilation ($0.0 < \gamma < 1.0$). A competition model between hunter-gatherers and farmers was implemented in order to simulate the disappearance of hunter-gatherers after a period of cohabitation with farmers (whose duration depends on the combination of all parameters).

Allele frequency clines (AFC) can be generated by any expansion

At the end of each demographic simulation, data on genetic diversity are generated for a series of virtual samples distributed along a Southeast–Northwest transect. We performed tens of thousands of simulations for various combinations of parameters and measured the proportion of alleles whose frequency increases gradually along the transect. This proportion of allele frequency clines (AFC) is computed for various levels of gene flow (γ) between hunter-gatherers and Neolithic farmers (see Table 1).

Only a very small proportion (max. 4%) of all new mutations shows a cline between the Near East and the northwestern periphery of Europe in every case. This corresponds to the proportion of mutations that have surfed. Indeed, surfing on a wave of expansion tends to increase the frequency of a mutation from the starting point of the expansion toward its end (Klopfstein et al., 2006). More interestingly, the proportion of AFC after a pure Neolithic demic diffusion (3%, DDM) is very similar to the proportion of AFC after a pure cultural diffusion process (2%, CDM). Finally, if we look only at alleles that are very frequent over Europe at the end of the simulation (more than 5% over the entire continent), the proportion of AFC is much higher (between 48% and 71%). This last result confirms that surfing alleles are responsible for the clines, because they also tend to reach high frequencies in the final population precisely because of the surfing phenomenon (see Fig. 3).

Table 1 | Proportion of allele frequency clines (AFC) reported among 10,000 simulations for various amounts of gene flow between hunter-gatherers and farmers during the Neolithic transition

	Hunter-gatherers assimilation rate γ	Alleles showing AFC	Frequent alleles (>5%) showing AFC
Pure demic diffusion (DDM)	0.00	3%	57%
	0.05	3%	48%
	0.10	3%	50%
	0.15	4%	51%
	0.25	3%	66%
	0.50	2%	71%
	0.75	2%	70%
Pure cultural diffusion (CDM)	1.00	2%	68%

Altogether, those results show that allele frequency clines (AFC) could have been generated either by the Paleolithic or by the Neolithic expansions (or by both). The observation of AFC is thus not indicative of the level of resident hunter-gatherer genetic contribution (during the Neolithic transition) to the actual European gene pool. More importantly, it means that the observation of SE–NW AFC cannot on its own be viewed as evidence for the Neolithic Demic diffusion model (DDM).

SE–NW PC1 gradient does not fit a simple expansion from the Near East

In a subsequent study (Francois et al., 2010), we again simulated a large set of scenarios for the Paleolithic and Neolithic expansions, but this time we generated many virtual genetic samples distributed all over Europe (and not only along a SE–NW transect). Instead of looking at allele frequency clines, we performed principal component analyses in order to check which scenario (combination of parameters) fits the PC1 showing a Southeast–Northwest cline, as described by Menozzi et al. (1978). Our study directly follows the one by Novembre and Stephens (2008), which demonstrated that PC clines similar to those reported by Menozzi et al. (1978) could be recreated by a "null" model of isolation by distance, without any demographic expansion. Our study revealed an unexpected result: in a majority of cases (78 %–100 %) the PC1 cline is perpendicular to the expansion instead of being parallel to it, at odds with what is commonly thought (Fig. 5). A PC1 parallel to the expansion was almost never obtained. Among the many observations drawn from those simulations, we showed that a single expansion from the Middle East results in PC1 cline oriented from the Iberian Peninsula to Russia, which does not fit at all the SE–NW PC1 cline observed in Europe.

However, this surprising result can be explained by the mutation surfing phenomenon. Indeed, if we look at the frequency pattern in one dimension, along the axis of a population expansion, surfing alleles display an increasing cline of frequency (AFC). But looking at the two dimensions level, different mutations appeared at different places of the wave front, creating sectors along the axis perpendicular to the expansion (Fig. 6). Those sectors correspond to areas where different alleles are fixed or predominant and their presence leads to a very high genetic differentiation along this axis perpendicular to the expansion. In a few words, surfing promotes genetic differentiation along the axis of expansion of a population by increasing the frequency of some alleles, but if the area is broad enough, it also promotes an even larger differentiation pattern that is parallel to the axis of expansion. The formation of such sectors is a generic phenomenon driven by random fluctuations that originate in a thin band of pioneers at the expanding front and has been confirmed *in vitro* in bacteria (*E. Coli*) and yeast populations (Hallatschek et al., 2007).

Fig. 5 | First principal component map (PC1) obtained by simulating a range expansion of Neolithic farmers in Europe from the Near-East 10,000 years ago. In this particular simulation, there is no hunter-gatherers assimilation (100 % of genetic replacement during the Neolithic). Taken from Francois et al. (2010)

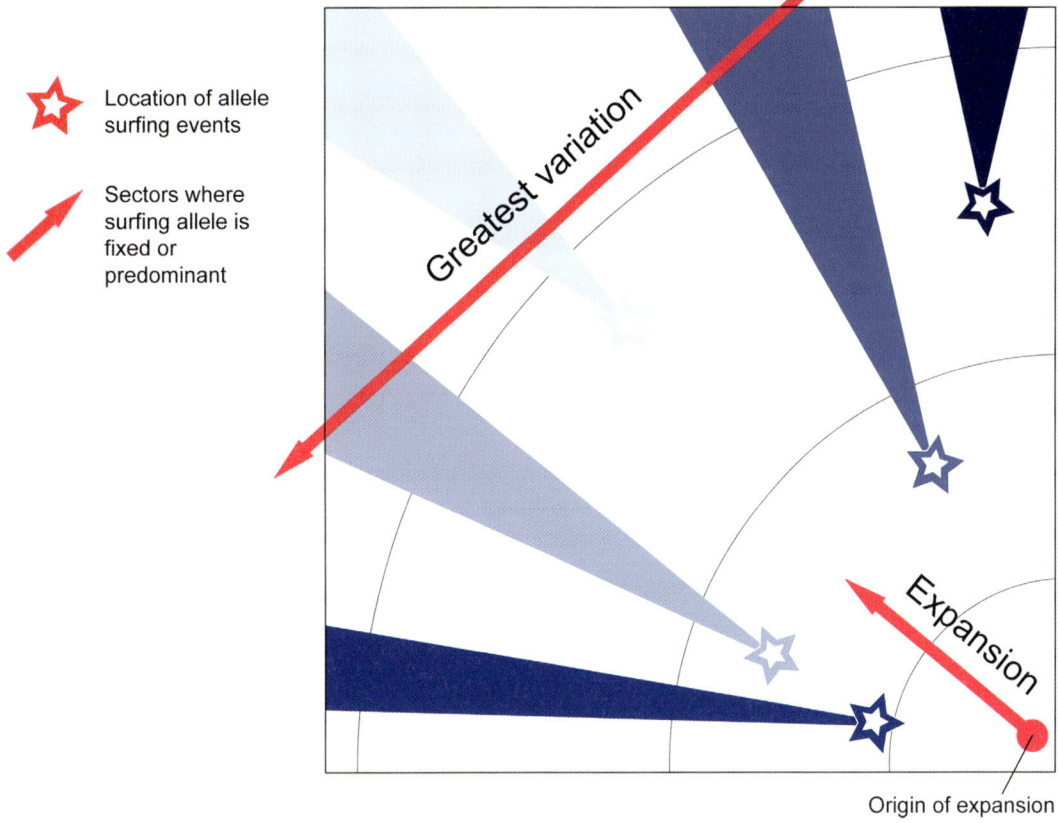

Fig. 6 | Schematic representation of sectors of fixed (or predominant) alleles due to the surfing phenomenon during a population expansion. Slightly modified from Francois et al. (2010)

The consequence of the existence of sectors is that genetic differentiation perpendicular to the axis of an expansion is greater than genetic differentiation along the axis. As the first principal component (PC1) reveals the axis of largest differentiation, in this case the PC1 is a cline perpendicular to the expansion.

Using our simulation framework, a SE–NW PC1 gradient was consistently obtained only when an expansion from the Southwest (Iberic peninsula) was simulated at the onset of the last glacial maximum (20,000 years ago), followed by the Neolithic expansion with a very high genetic contribution of local hunter-gatherers (> 80 %). This result deserves more investigation, particularly in conjunction with issues of environmental heterogeneity, but it underlines the need to consider potential retreat to southern refugee areas and postglacial routes in future simulations aiming at reconstructing the evolution of modern humans in Europe.

Conclusion and Perspectives

In this paper, I hope to have demonstrated the usefulness of computer simulations in establishing a theoretical framework to assist in the interpretation of the current genetic structure of population and to help us to understand the evolution of our species. Computer simulation is a very powerful tool for the evaluation of complex evolutionary scenarios involving population demography and molecular evolution, and especially the spatial dynamics of populations through time. In particular, I have presented

here some results regarding the genetic consequences of past demographic expansions and what they tell us about the history of Europeans.

We have shown that spatial patterns of genetic variation, such as clines, can arise under a broad range of expansion scenarios. Consequently, the interpretation of current patterns of genetic diversity in terms of past demography is not a straightforward task. Thus a more precise theoretical framework is needed. Simulations have also revealed that the observation of southeast/northwest genetic clines on the continent is not indicative of the amount of hunter-gatherer genetic contribution during the Neolithic transition. Those clines may have resulted from alleles that surfed during the arrival of anatomically modern humans in Europe or during the Neolithic transition or during both events. Moreover, simulations have also shown that SE–NW PC1 genetic clines, such as the ones observed among contemporary Europeans, are not compatible with a simple expansion from the Near East and that more complex scenarios must be envisaged in order to explain their presence.

The simulated models that were presented here may be seen as null hypotheses on which more refined scenarios could be developed and tested in the future. Indeed, despite being more realistic than former models, in that we take the spatial dynamics of populations into consideration, our simulations still lack a number of key components that could significantly affect the results. Specifically, glaciations periods (e.g. during the last glacial maximum, LGM, around 20,000 years ago) should be considered in the models, as our recent results suggest that they may have had an impact on the current genetic structure. Other additional factors could be included in the models, such as more detailed archaeological information (e.g. areas of presumed acculturation or demic dispersal) or environmental factors acting either as physical barriers or as corridors promoting migration (e.g. mountains, rivers, vegetation, sea-level changes). However, as there are many potential parameters and a lot of uncertainty regarding the values assigned to many of them, we believe that it is necessary to proceed in a step by step manner when adding new parameters and in the careful investigation of their impact on the results. Only then can we increase our understanding of the processes under study and all of their implications.

In addition to model refinements, the incorporation of ancient DNA data within the coalescent framework is very promising with respect to shedding light on past demographic events. Indeed, their incorporation opens exceptional and exciting opportunities for obtaining direct molecular evidence from the past and has been shown to increase the possibilities for uncovering more complex demographic histories than could be revealed using modern genetic data alone (e.g. Drummond et al., 2003). Although ancient DNA studies have, so far, mainly considered species other than humans (e.g. Ramakrishnan and Hadly, 2009) due to technical difficulties and to the limited availability of large samples from relevant archaeological sites, recent work has begun to focus on human populations (e.g. Bramanti et al., 2009; Burger et al., 2007; Haak et al., 2005). If combined with the inferential power of spatially explicit simulations, such as those presented in that paper, aDNA data could be used to address a wide range of questions pertaining to the evolutionary history of past and present populations and their genealogical relationships.

Acknowledgements

I would like to thank the organizers of the conference 'Migrations in Prehistory and Early History: Stable Isotopes and Population Genetics – New Answers to Old Questions?' and especially E. Kaiser, W. Schier and J. Burger. I also warmly thank all of my colleagues who were involved in different aspects of the studies presented in that paper, and especially L. Excoffier, S. Klopfstein, O. François and J. Novembre. I am also grateful to E. S. Poloni for her precious comments on a previous version of the manuscript, to A. Sanchez-Mazas for discussing certain aspects of the work presented and to E. Gutscher for technical support with the figures. I am financially supported by Swiss National Foundation Grant No. 31003A–127465.

References

Barbujani, G., Pilastro, A., 1993. Genetic evidence on origin and dispersal of human populations speaking languages of the Nostratic macrofamily. Proceedings of the National Academy of Science USA 90, 4670–4673.

Barbujani, G., Sokal, R.R., Oden, N.L., 1995. Indo-European origins: a computer-simulation test of five hypotheses. American Journal of Physical Anthropology 96, 109–132.

Bauchet, M., McEvoy, B., Pearson, L.N., Quillen, E.E., Sarkisian, T., Hovhannesyan, K., Deka, R., Bradley, D.G., Shriver, M.D., 2007. Measuring European population stratification with microarray genotype data. American Journal of Human Genetics 80, 948–956.

Bramanti, B., Thomas, M.G., Haak, W., Unterlaender, M., Jores, P., Tambets, K., Antanaitis-Jacobs, I., Haidle, M.N., Jankauskas, R., Kind, C.J., Lueth, F., Terberger, T., Hiller, J., Matsumura, S., Forster, P., Burger, J., 2009. Genetic Discontinuity Between Local Hunter-Gatherers and Central Europe's First Farmers. Science 326 (5949), 137–140.

Burger, J., Kirchner, M., Bramanti, B., Haak, W., Thomas, M.G., 2007. Absence of the lactase-persistence-associated allele in early Neolithic Europeans. Proceedings of the National Academy of Science USA 104, 3736–3741.

Haak, W., Forster, P., Bramanti, B., Matsumura, S., Brandt, G., Tanzer, M., Villems, R., Renfrew, C., Gronenborn, D., Alt, K.W., Burger, J., 2005. Ancient DNA from the first European farmers in 7500-year-old Neolithic sites. Science 310, 1016–1018.

Chikhi, L., Destro-Bisol, G., Bertorelle, G., Pascali, V., Barbujani, G., 1998. Clines of nuclear DNA markers suggest a largely neolithic ancestry of the European gene pool. Proceedings of the National Academy of Science USA 95, 9053–9058.

Chikhi, L., Nichols, R.A., Barbujani, G., Beaumont, M.A., 2002. Y genetic data support the Neolithic demic diffusion model. Proceedings of the National Academy of Science USA 99, 11008–11013.

Currat, M., Excoffier, L., 2004. Modern humans did not admix with Neanderthals during their range expansion into Europe. PLoS Biology 2, e421.

Currat, M., Excoffier, L., 2005. The effect of the Neolithic expansion on European molecular diversity. Proceedings of the Royal Society London B: Biological Sciences 272, 679–688.

Currat, M., Ruedi, M., Petit, R.J., Excoffier, L., 2008. The hidden side of invasions: Massive introgression by local genes. Evolution 62, 1908–1920.

Drummond, A.J., Pybus, O.G., Rambaut, A., Forsberg, R., Rodrigo, A., 2003. Measurably evolving populations. Trends in Ecology and Evolution vol 18 (9), 481–488.

Dupanloup, I., Bertorelle, G., Chikhi, L., Barbujani, G., 2004. Estimating the impact of prehistoric admixture on the genome of europeans. Molecular Biology and Evolution 21, 1361–1372.

Edmonds, C.A., Lillie, A.S., Cavalli-Sforza, L.L., 2004. Mutations arising in the wave front of an expanding population. Proceedings of the National Academy of Science USA 101, 975–979.

Excoffier, L., 2002. Human demographic history: refining the recent African origin model. Current Opinion in Genetics and Development 12, 675–682.

Excoffier, L., Ray, N., 2008. Surfing during population expansions promotes genetic revolutions and structuration. Trends in Ecology and Evolution 23, 347–351.

Excoffier, L., Foll, M., Petit, R.J., 2009. Genetic consequences of Range Expansions. Annual Review of Ecology, Evolution, and Systematics 40, 481–501.

Foley, R.A., 1989. The Ecological Conditions of Speciation: a Comparative Approach to the Origins of Anatomically-Modern Humans, in: Mellars, P., Stringer, C. (Eds.), The Human Revolution: Biological perspectives in the Origins of Modern Humans, Princeton University Press, Princeton, pp. 299–318.

Francois, O., Currat, M., Ray, N., Han, E., Excoffier, L., Novembre, J., 2010. Principal Component Analysis under Population Genetic Models of Range Expansion and Admixture. Molecular Biology and Evolution 27 (6), 1257–1268.

Hallatschek, O., Hersen, P., Ramanathan, S., Nelson, D.R., 2007. Genetic drift at expanding frontiers promotes gene segregation. Proceedings of the National Academy of Science USA 104, 19926–19930.

Hallatschek, O., Nelson, D.R., 2008. Gene surfing in expanding populations. Theoretical Population Biology 73, 158–170.

Heath, S.C., Gut, I.G., Brennan, P., McKay, J.D., Bencko, V., Fabianova, E., Foretova, L., Georges, M., Janout, V., Kabesch, M., Krokan, H.E., Elvestad, M.B., Lissowska, J., Mates, D., Rudnai, P., Skorpen, F., Schreiber, S., Soria, J.M., Syvanen, A.C., Meneton, P., Hercberg, S., Galan, P., Szeszenia-Dabrowska, N., Zaridze, D., Genin, E., Cardon, L.R., Lathrop, M., 2008. Investigation of the fine structure of European populations with applications to disease association studies. European Journal of Human Genetics 16, 1413–1429.

Klopfstein, S., Currat, M., Excoffier, L., 2006. The Fate of Mutations Surfing on the Wave of a Range Expansion. Molecular Biology and Evolution 23 (3), 482–490.

Lahr, M.M., Foley, R., 1994. Multiple Dispersals and Modern Human Origins. Evolutionary Anthropology: Issues, News, and Reviews 3, 48–60.

Lao, O., Lu, T.T., Nothnagel, M., Junge, O., Freitag-Wolf, S., Caliebe, A., Balascakova, M., Bertranpetit, J., Bindoff, L.A., Comas, D., Holmlund, G., Kouvatsi, A., Macek, M., Mollet, I., Parson, W., Palo, J., Ploski, R., Sajantila, A., Tagliabracci, A., Gether, U., Werge, T., Rivadeneira, F., Hofman, A., Uitterlinden, A.G., Gieger, C., Wichmann, H.E., Ruther, A., Schreiber, S., Becker, C., Nurnberg, P., Nelson, M.R., Krawczak, M., Kayser, M., 2008. Correlation between genetic and geographic structure in Europe. Current Biology 18, 1241–1248.

Mellars, P., 2006. Archeology and the Dispersal of Modern Humans in Europe: Deconstructing the "Aurigniacian". Evolutionary Anthropology, 167–182.

Menozzi, P., Piazza, A., Cavalli-Sforza, L., 1978. Synthetic maps of human gene frequencies in Europeans. Science 201, 786–792.

Novembre, J., Johnson, T., Bryc, K., Kutalik, Z., Boyko, A.R., Auton, A., Indap, A., King, K.S., Bergmann, S., Nelson, M.R., Stephens, M., Bustamante, C.D., 2008. Genes mirror geography within Europe. Nature 456, 98–101.

Novembre, J., Stephens, M., 2008. Interpreting principal component analyses of spatial population genetic variation. Nature Genetics 40, 646–649.

Pinhasi, R., Fort, J., Ammerman, A.J., 2005. Tracing the origin and spread of agriculture in Europe. PLoS Biology 3, e410.

Price, A.L., Helgason, A., Palsson, S., Stefansson, H., St Clair, D., Andreassen, O.A., Reich, D., Kong, A., Stefansson, K., 2009. The impact of divergence time on the nature of population structure: an example from Iceland. PLoS Genetics 5, e1000505.

Ramachandran, S., Deshpande, O., Roseman, C.C., Rosenberg, N.A., Feldman, M.W., Cavalli-Sforza, L.L., 2005. Support from the relationship of genetic and geographic distance in human populations for a serial founder effect originating in Africa. Proceedings of the National Academy of Science USA 102, 15942–15947.

Rosser, Z.H., Zerjal, T., Hurles, M.E., Adojaan, M., Alavantic, D., Amorim, A., Amos, W., Armenteros, M., Arroyo, E., Barbujani, G., Beckman, G., Beckman, L., Bertranpetit, J., Bosch, E., Bradley, D.G., Brede, G., Cooper, G., Corte-Real, H.B., de Knijff, P., Decorte, R., Dubrova, Y.E., Evgrafov, O., Gilissen, A., Glisic, S., Golge, M., Hill, E.W., Jeziorowska, A., Kalaydjieva, L., Kayser, M., Kivisild, T., Kravchenko, S.A., Krumina, A., Kucinskas, V., Lavinha, J., Livshits, L.A., Malaspina, P., Maria, S., McElreavey, K., Meitinger, T.A., Mikelsaar, A.V., Mitchell, R.J., Nafa, K., Nicholson, J., Norby, S., Pandya, A., Parik, J., Patsalis, P.C., Pereira, L., Peterlin, B., Pielberg, G., Prata, M.J., Previdere, C., Roewer, L., Rootsi, S., Rubinsztein, D.C., Saillard, J., Santos, F.R., Stefanescu, G., Sykes, B.C., Tolun, A., Villems, R., Tyler-Smith, C., Jobling, M.A., 2000. Y-chromosomal diversity in Europe is clinal and influenced primarily by geography, rather than by language. American Journal of Human Genetics 67, 1526–1543.

Rendine, S., Piazza, A., Cavalli-Sforza, L., 1986. Simulation and separation by principal components of multiple demic expansions in Europe. American Naturalist 128, 681–706.

Ramakrishnan, U., Hadly, E.A., 2009. Using phylochronology to reveal cryptic population histories: review and synthesis of 29 ancient DNA studies. Molecular Ecology 18, 1310–1330.

Rendine, S., Piazza, A., Menozzi, P., Cavalli-Sforza, L., 1999. A Problem with Synthetic Maps: Reply to Sokal et al. Human Biology 71, 15–25.

Sabatti, C., Service, S.K., Hartikainen, A.L., Pouta, A., Ripatti, S., Brodsky, J., Jones, C.G., Zaitlen, N.A., Varilo, T., Kaakinen, M., Sovio, U., Ruokonen, A., Laitinen, J., Jakkula, E., Coin, L., Hoggart, C., Collins, A., Turunen, H., Gabriel, S., Elliot, P., McCarthy, M.I., Daly, M.J., Jarvelin, M.R., Freimer, N.B., Peltonen, L., 2009. Genome-wide association analysis of metabolic traits in a

birth cohort from a founder population. Nature Genetics 41, 35–46.

Sokal, R.R., Menozzi, P., 1982. Spatial Autocorrelations of HLA Frequencies in Europe Support Demic Diffusion of Early Farmers. American Naturalist 119, 1–17.

Sokal, R.R., Harding, R.M., Oden, N.L., 1989. Spatial patterns of human gene frequencies in Europe. American Journal of Physical Anthropology 80, 267–294.

Sokal, R.R., Oden, N.L., Thomson, B.A., 1999a. A problem with synthetic maps. Human Biology 71, 1–13; discussion 15–25.

Sokal, R.R., Oden, N.L., Thomson, B.A., 1999b. Problems with Synthetic Maps Remain: Reply to Rendine et al. Human Biology 71, 447–453.

Tian, C., Plenge, R.M., Ransom, M., Lee, A., Villoslada, P., Selmi, C., Klareskog, L., Pulver, A.E., Qi, L., Gregersen, P.K., Seldin, M.F., 2008. Analysis and application of European genetic substructure using 300 K SNP information. PLoS Genetics 4, e4.

Travis, J.M., Munkemuller, T., Burton, O.J., Best, A., Dytham, C., Johst, K., 2007. Deleterious mutations can surf to high densities on the wave front of an expanding population. Molecular Biology and Evolution 24, 2334–2343.

Zvelebil, K.V., 1989. On the transition to farming in Europe, or what was spreading with the Neolithic: a reply to Ammerman. Antiquity 63, 379–382.

Zvelebil, M., 1986. Review of Ammerman & Cavalli-Sforza (1984). Journal of Archaeological Science 13, 93–95.

Zvelebil, M., 2000. The social context of the Agricultural transition in Europe, in: Renfrew, C., Boyle, K. (Eds.), Archaeogenetics: DNA and the population prehistory of Europe, McDonald Institute for Archaeological Research, University of Cambridge, Cambridge, pp. 57–79.

Pascale Gerbault[a,*], *Michela Leonardi*[b,*], *Adam Powell*[a,c], *Christine Weber*[b],
Norbert Benecke[d], *Joachim Burger*[b], *Mark G. Thomas*[a,e]

Domestication and migrations: Using mitochondrial DNA to infer domestication processes of goats and horses

[*] Corresponding Authors: p.gerbault@ud.ac.uk; leonardm @uni-mainz.de (ML and PG have contributed equally to this work, ML for horses, and PG for goats)
[a] Research Department of Genetics, Evolution and Environment, University College London, United Kingdom
[b] Palaeogenetics Group, Institute of Anthropology, Johannes Gutenberg-University Mainz, Germany
[c] AHRC Centre for the Evolution of Cultural Diversity, Institute of Archaeology, University College London, United Kingdom;
[d] German Archaeological Institute, Scientific Department, Berlin, Germany
[e] Department of Evolutionary Biology, Evolutionary Biology Centre, Uppsala University, Sweden

Abstract

The complex process of animal domestication will have lead to important biological changes, including a reshaping of patterns of genetic diversity. Studying those patterns permits inferences to be made on the demographic and trait-selection components of the domestication process, and different models arising from archaeological and archaeozoological data to be compared. In order to contribute to current understanding of the domestication process, we analysed both modern and ancient mtDNA-sequence data in two domestic species, goats and horses, to compare different models of their demographic histories. The first archaeological evidence for goat domestication, on the southern slopes of the Zagros and Taurus mountains, dates back to between 10,000 and 11,500 BP, while the first evidence for horse domestication seems to date to around 7,000 BP, in modern day Ukraine and Kazakhstan. We examine two sets of increasingly complex demographic models, five for goats and three for horses, based on prior knowledge from archaeological and genetic data, and use coalescent simulation and observed genetic-diversity patterns to compare these models. We discuss the implications of the results and propose further domestication-process hypotheses that could be considered for each species.

Keywords
Domestication, goat, horse, coalescent, mitochondrial DNA, ancient DNA

Introduction

Domestication and archaeology

The southern slopes of the Zagros and Taurus mountains host the earliest archaeological evidence, dating back to between 10,000 and 11,500 BP, for the domestication of sheep, goats, cattle and pigs. It seems that animals were initially managed in these centres and only later develop features of the domesticated forms we see today (Zeder, 2008). Reconstructing the demographic histories of these species is a challenging task and, to date, most of our knowledge comes from archaeozoological investigation of skeletal remains. In this article we show that the additional inferences that can be made on the basis of genetic and palaeogenetic data provide complementary information about the demographic history of human and domesticate populations.

In order to contribute to current understanding of domestication processes, we focus on two of these species, namely goats and horses. The natural distribution of *Capra aegagrus*, the closest wild ancestor of domestic goat (*Capra hircus*) is restricted to Anatolia, the Near and the Middle East, a region that encompasses the Zagros and Taurus mountains, where the earliest evidence for animal domestication is found. As *Capra hircus* is now widely distributed throughout Eurasia and Africa, goat domestication must have first occurred in these regions; and domesticated stock must have spread from there.

Horse domestication differs in at least two important ways from that of goat, sheep, cattle and pigs. First, it seems to have occurred at least 3,000 years later (Anthony and Brown, 2003), and second, archaeological evidence suggests the existence of distinct domestication centres, located mainly in modern day Ukraine and Kazakhstan; some distance from domestication centres for other species. Indeed, isotopic and osteological analyses provide direct evidence of horse milking and riding in a site from the Botai Culture, Nothern Kazakhstan, dated to the mid-sixth millennium BP (Outram et al., 2009).

Goat and horse genetic diversity

As domesticates are numerous worldwide, it is expected that the range expansions and migrations from local wild populations would have left some signatures on patterns of genetic diversity in these animals. Mitochondrial DNA (mtDNA) has some features that are well suited to address such questions. First, its uniparental (i.e., maternal) inheritance means all copies in a population are related through a single-gene genealogy that is relatively easy to infer. Second, its mutation rate is high enough (particularly in hypervariable regions I and II) to allow distinct types (haplotypes) to evolve over relatively short time spans. Third, because it is present in many copies per cell, it is considerably easier to obtain from archaeological samples, where DNA degradation can be considerable.

One of the first studies on goat genetic diversity (Luikart et al., 2001) defined 4 highly divergent mtDNA haplogroups in *C. hircus* populations. Two alternative hypotheses were proposed to explain the presence of such high divergence in those domesticates: either (i) they represented four distinct maternal origins (and therefore, four distinct domestication events); or (ii) such diversity already existed in the ancestral population. The latter hypothesis was discarded because the estimated effective-population size necessary to maintain such diversity (between 38,000 and 82,000 effective females) would have been, *a priori*, too high. However, an ancient DNA study has shown that two of these haplogroups, A and C, were already present within an ancient sample from south-eastern France dated to 7,000 years BP (Fernandez et al., 2006). Furthermore, the genetic diversity of domestic goats (Naderi et al., 2007) appears to be a subset of the diversity observed in wild goats (Naderi et al., 2008), at least in terms of presence/absence of mtDNA haplogroups. The principal differences between wild and domestic, and within domestic, populations remain at the level of haplogroup frequencies, with haplogroup A being the more frequent in domestic goats. Therefore, if these highly divergent haplogroups are represented in wild populations, and the genetic diversity observed in domestic goats can be considered a subset of *C. aegagrus* diversity, then the "one haplogroup equals one domestication event" approach to inferring population histories should be reconsidered. Indeed, it is now clear that equating haplogroups – which are arbitrarily designated – with ancestral populations or demographic episodes, such as domestication events, is highly problematic (Barbujani et al., 1998; Belle et al., 2006; Burger and Thomas, 2011; Goldstein and Chikhi, 2002; Nielsen and Beaumont, 2009).

For horses, the only wild species still alive is Przewalski's horse (*Equus przewalskii*). However, it is genetically very different from domestic horse and cannot be considered as a proxy for the ancestral horse population(s) from which domestication occurred. One attempt to investigate horse domestication on the basis of genetic diversity was made by Vilà and colleagues (2001). They analysed a portion of the mtDNA control regions in 191 modern horses from 10 different breeds. They also sequenced ancient DNA from 8 Pleistocene Alaskan horses and 8 northern European archaeological samples dated between 1,000 and 2,000 years ago. They found high diversity and deep coalescence time in mtDNA.

Unsurprisingly, analysis of autosomal microsatellites revealed a higher divergence than for mtDNA. These data indicate that domestic horse mtDNA lineages have an ancient origin that is anterior to the beginning of domestication, and further suggest either multiple domestication events, or domestication from a genetically diverse population, or introgression from many different wild lineages subsequent to domestication. The wild ancient Alaskan group shows low levels of genetic diversity, and even though haplotype diversity differs significantly between modern breeds, each shows usually high genetic diversity. Moreover, there is little evidence of strong mtDNA phylogeographic or breed structuring. In contrast, individuals from the same breed did tend to cluster together in a tree based on 15 hypervariable autosomal microsatellites. These observations led Vilà and colleagues to favour post-domestication introgression of wild horses from a large number of distinct populations and predominantly maternal gene flow in breeding practices (Vila et al., 2001).

This hypothesis was supported by another study that considered a wider set of sequences (Jansen et al., 2002). In their article, 652 mtDNA sequences from domestic and Przewalski horses were interpreted from a median-joining network representation of the data. The diversity pattern did not show any notable phylogeographic structuring. By eliminating the proportion of mtDNA types that are likely to have arisen in their sample – by the fastest conceivable mutation rate – between the earliest likely date for horse domestication and the present, they estimated that a minimum of 77 wild mares contributed to domestic horse populations. They finally addressed the possibility that these females were domesticated from a single wild horse population. To do so, they used the contemporaneous geographical distribution of mtDNA haplotypes and compared their frequency and diversity with those of wild Przewalski and Alaskan horses. Jansen and colleagues concluded that the most likely scenario is that more than one wild horse population was recruited for domestication. Finally, recent work from Lira and colleagues (2010) suggested a certain degree of continuity between wild Neolithic and modern domesticated Iberian horses.

The coalescent and inference of population demographic histories

The coalescent is a retrospective and probabilistic model of how lineages coalesce, or join, to form the genealogy of a sample of genes under a particular demographic history. When combined with a mutation model, it can be used to make predictions about patterns of genetic variation. In simplified terms, coalescent theory considers the ancestral relationships among gene copies for a sample of genes. Rather than considering the genetic history of a whole population going forward in time, the coalescent looks backwards in time, building gene genealogies only for the samples under consideration. At each step going back one generation in time, two samples "pick" a parent randomly in the population, and whenever they both "pick" the same parent, they coalesce into a single lineage (Rosenberg and Nordborg, 2002). All the lineages eventually coalesce into one single common ancestor, the most recent common ancestor (MRCA) of all the gene copies in a sample. Because selectively neutral mutations do not affect reproduction, they can be superimposed, or 'sprinkled' at random, onto the branches of a simulated genealogy afterwards. (Note that an important assumption here is that the mitochondrial variation is selectively neutral.) When the MRCA is found, mutations are added through a Poisson process forwards along the branches of the generated gene genealogy to produce simulated genetic data. Crucially, because one need only consider the ancestors of the sampled gene copies, there is no need to simulate the entire population. This feature makes coalescent simulation computationally very efficient and so an appropriate and powerful tool for investigating domestication processes.

Coalescent simulation does not lead a researcher directly from empirical data to an inference about population-demographic history. Rather, it allows a researcher to examine a range of different demographic history hypotheses. This can be performed by simulating genetic datasets under a range of demographic scenarios and then identifying those scenarios (hypotheses) for which the simulated data are most similar to the observed data (see Nielsen and Beaumont (2009) for a review of some of the methods utilized). This is in sharp contrast to phylogeographic approaches, which assume that population histories can be directly deduced from estimated genealogies (as represented by phylogenetic trees or networks). The coalescent approach has a number of advantages, including the ability to examine a wide range of different hypotheses and accommodation of the fact that genealogies sampled from distinct individuals are random realizations of a stochastic, population-level process. But perhaps most importantly, the coalescent simulation approach, in combination with statistical methods such as Approximate Bayesian Computation (ABC) (Fagundes et al., 2007; Ray et al., 2009), allows different hypotheses to be compared in a robust statistical framework.

In this paper we use coalescent simulation and observed genetic diversity patterns to compare a number of models, of different complexity, for the domestication of goats and horses. The models we consider here are necessarily simplifications of the true domestication processes and are only a small subset of all plausible models. They are, however, informed by archaeological data and allow us to address the following questions concerning these domestication processes: (1) Can the mtDNA diversity pattern observed in wild and domestic goat populations be explained by those populations having originated from a single metapopulation (without significant structuring between them), or are more complex (multi-population) models required? (2) Assuming continuity between wild and domestic horse populations, are patterns of modern and ancient horse mtDNA diversity best explained by domestication of a small proportion of wild horses, or by domestication of most wild horses present at the time?

Material and Methods

Samples

Goats: We used published sequences of domestic (Naderi et al., 2007) and wild goats (Naderi et al., 2008) from Europe and the Middle East, as well as published sequences of ancient domestic goats (Fernandez et al., 2006). When using the term "Middle East" for both *C. hircus* and *C. aegagrus* samples, we refer to samples coming from five countries, namely Azerbaijan, Dagestan, Iran, Pakistan or Turkey. We restricted our Middle-Eastern *C. hircus* samples to the same geographic region as *C. aegagrus* samples for simplicity of comparison. We used the following sequences: 1046 mtDNA sequences of *C. hircus* from all over Europe and an ancestral sample of 19 sequences, 368 mtDNA sequences of *C. hircus* from the Middle-East and 471 sequences of *C. aegagrus* (Fig. 1). We considered 130 base pairs of the mtDNA HVR region, the maximum length available for the 19 published ancient samples (Fernandez et al., 2006).

Horses: We analysed 246 base pairs (bp) from the mtDNA HVR in ancient and modern horses. We obtained sequences for 10 ancient wild samples from Central Europe, dated to the Late Glacial period (17,000–11,600 BP) (Weber, 2005). We then compared those to 1096 published modern horse sequences from different regions and breeds throughout the world (Lira et al., 2010).

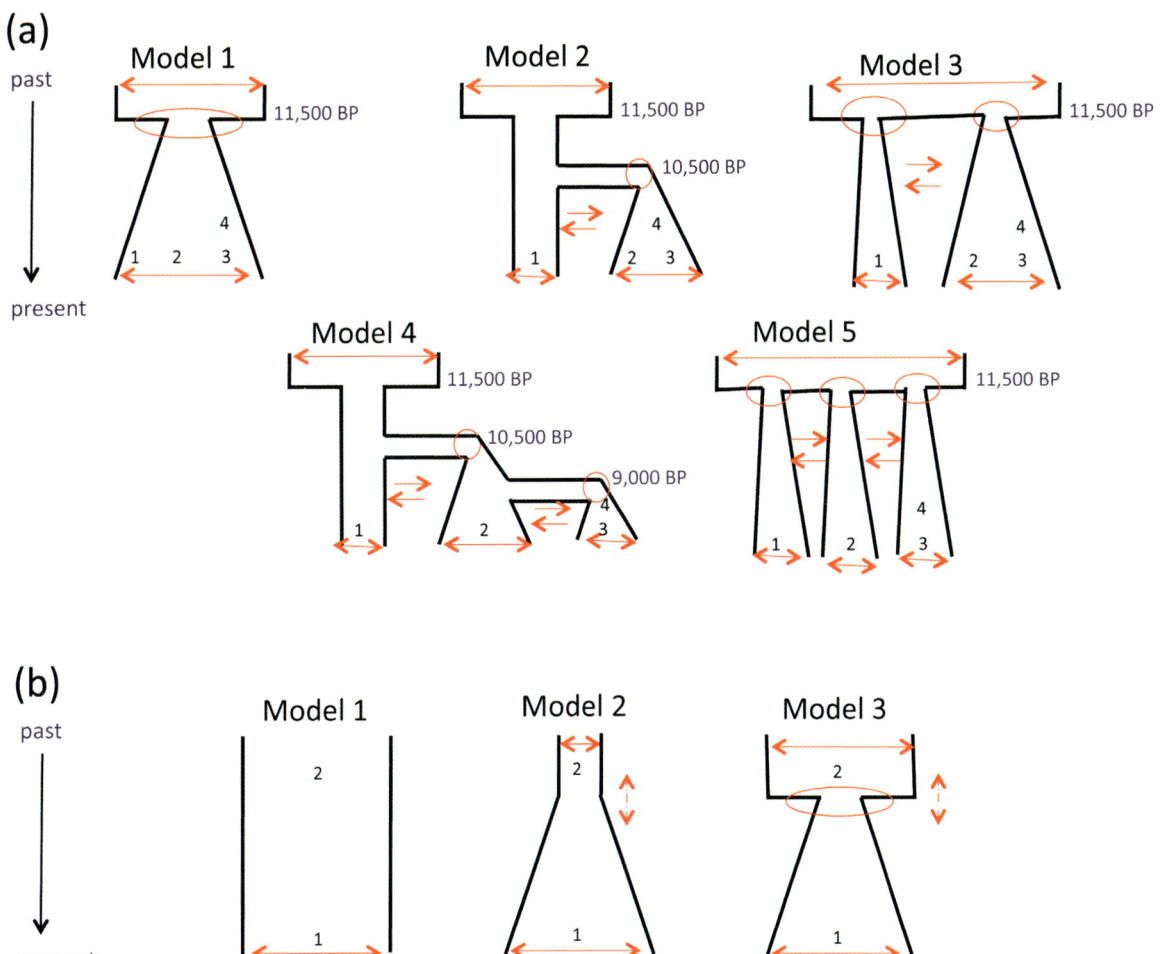

Fig. 1 | Schematic representation of the demography simulated under the coalescent to infer goat (a) and horse (b) domestication processes using mtDNA diversity. Note that time goes backward (arrows on the left) as these models have been simulated under the coalescent. Parallel lines means the population size remains constant through time, while non-parallel lines are used for expanding populations. Arrows and circles highlight the unknown parameters for which ranges of possible values were used. (a) Regarding the five models simulated for the goat samples, in each model three modern populations were sampled: 1: a sample of *C. aegagrus* population, 2: a sample of Near East *C. hircus* population, and 3: a sample of Europe *C. hircus* population. Additionally, sample 4, corresponding to the ancient DNA sample from Southern France, was sampled from the coalescent process at 7,000 years BP. Depending on the model considered, unknown parameters estimated at the end of the simulations are the ancestral population size (parameter range of [100–50,000] in all models), the modern population size(s) (parameter ranges of [10,000–1,000,000] in Model 1, [1,000–10,000] for the wild and [10,000–1,000,000] for the domestic populations in Model 2 to 5), the bottleneck sizes (parameter range of [10–10,000] in all models) that founded the respective populations simulated, and migration rates (parameter range of [0–0.001] in Model 2 to 5) when several populations were considered. Note that for model 1, the modern effective female population size estimated would represent the entire goat population, both wild and domestic; while in model 2 and 3, two modern population sizes are estimated, one for the wild population, and another one estimated for the domestic population of both Near Eastern and European goats. Finally in model 4 and 5, three modern effective population sizes are considered as distinct from one another, with an estimation of the wild effective population size, another of the Near-Eastern domesticate population and the last one of the European domesticate populations. (b) Regarding the three models simulated for the horse samples, two different genetic groups were sampled, indicated by the following numbers: 1: Late Glacial (17,000–11,600 BP); 2: modern horses. Depending on the model, unknown parameters that are estimated at the end of the simulations are the ancestral population size (parameter range of range [100–10,000] in Model 3), the modern population size (parameter range of [1,000–500,000] in all models), the bottleneck size (parameter range of [10–10,000] in Model 2), and the time of domestication (parameter range of [700–1,700] in Model 2 and 3)

Summary statistics

Distinct indices can be calculated from a set of DNA sequence samples to describe various aspects of their genetic diversity. These measures are called "summary statistics" and can be obtained for any sample of DNA sequences. They contain indirect information on the demographic parameters – ancestral population size(s), bottleneck size(s) and population structures – that have shaped the observed data in those samples. The software ARLEQUIN v. 3.1 (Excoffier et al., 2005) was used to calculate a number of summary statistics describing the genetic diversity within and among the samples used. Five summary statistics (number of haplotypes, number of segregating sites, haplotype diversity, Tajima's D and average number of pairwise differences) were calculated for each sample individually, and four summary statistics (number of private haplotypes to one sample, number of private haplotypes to the other sample, average number of pairwise differences and pairwise Fst) were calculated for pairwise comparisons of samples (e.g. between ancient and modern samples, or between modern samples from different regions). In total, 44 summary statistics were used to describe and compare the genetic diversity within and between the four goat populations samples (Fernandez et al., 2006; Naderi et al., 2008; Naderi et al., 2007). Likewise, a total of 14 summary statistics were calculated to describe the relationships within and between the two horse populations samples.

Coalescent simulations

The coalescent approach allows both the evaluation of competing demographic models and the estimation of the model parameters. First, genealogies are simulated for a given demographic model, with its associated parameter values. Once the genealogies have been created, simulated genetic data are generated through the genealogy. Finally, summary statistics describing the genetic diversity of the simulated data under that model are calculated. These simulations were performed with the software Bayesian Serial Simcoal (Anderson et al., 2005), as it allows the incorporation of both modern and ancient DNA samples. The software is based on a two-step modelling process. If n_1 and n_2 are the sample sizes for the modern and ancient sample, respectively, and t_1 is the age (in generations) of the ancient sample, coalescence of n_1 sequences is modelled backwards in time from the present, with n_2 sequences added to the genealogy after t_1 generations.

Genetic data are generated for each simulated genealogy, and those data are used to calculate summary statistics (i.e., the simulated summary statistics). The model(s) that generate the statistics the 'closest' to those observed (i.e., the 'best-fitting') are retained. For this purpose, a group of techniques called approximate Bayesian computation (ABC) have been widely used in population genetic studies (Beaumont et al., 2002; Fagundes et al., 2007; Nielsen and Beaumont, 2009; Wegmann et al., 2009). These techniques require a very large number of simulations to be performed. The basic idea underlying the use of ABC is that the probability of obtaining the observed summary statistics is proportional to the number of simulated data sets producing summary statistics that are a small distance from the observed summary statistics. Euclidean distances between the observed and simulated summary statistics allow us to determine which of the simulated model(s) best explain the observed patterns of genetic diversity. These Euclidean distances are standardized by common mean and standard deviation of the simulated summary statistics, calculated over all the simulations, regardless the model they belong to (Ray et al., 2009). Note that there are some issues about how small these Euclidean distances should be

and about the number of statistics to be used. These issues are discussed in detail elsewhere (Joyce and Marjoram, 2008; Wegmann et al., 2009). Once the best fitting models have been determined, inferences of some unknown parameters drawn from prior distributions (e.g. ancestral effective-population sizes, modern effective-population sizes, bottleneck or founder event sizes, or time of events) can be made.

Models of goat domestication

Five demographic models were examined to assess how the domestication process has shaped goat genetic diversity (Fig. 1a). The first model considers that all goat samples (the wild, and both modern domestic samples) come from a single population that underwent exponential growth following a bottleneck that occurred some 11,500 years ago. This bottleneck corresponds to a founder event, when animal management in the wild began to affect genetic diversity of the ancestral goat population. This is a simplistic way of seeing the domestication process, but our aim is to examine the simplest possible scenarios first, before adding further complexity. Our reasoning here is that if patterns genetic variation can be explained better by simple models than more complex ones, then – in the absence of clear evidence for specific components of additional complexity – invoking more complex models cannot be justified. This model tests the hypothesis that contemporaneous domestic and wild goat populations behave as a single, random-mating metapopulation. It is equivalent to a neutral model of population expansion without any population structuring. As we cannot be certain what the real ancestral effective population size may have been, we parameterized this component of the model so that it can take any value between 100 and 50,000 effective females. We also parameterized the bottleneck size, allowing it to take any value between 1,000 and 10,000 effective females, while the modern effective female population size could take any value between 10,000 and 1,000,000. We used the same ranges for both ancestral effective-population and bottleneck sizes in subsequent models.

The second model considers that both modern wild and modern domestic populations were derived from an initially 'managed' wild population that originated from an ancestral wild population via a bottleneck 11,500 years ago. This population was assumed to stay constant in size to give rise to modern wild goats. Some 1,000 years later, a founder event from this 'managed' wild population occurred, forming what would become the contemporaneous *C. hircus* population. The modern wild and domesticate effective population sizes take, independently, any values between 1,000 and 10,000, and between 10,000 and 1,000,000, respectively. These ranges were also used for the third model, which assumes that *C. hircus* samples both from Europe and the Middle East on the one hand, and the *C. aegagrus* sample, on the other hand, are drawn from a single ancestral population via two distinct founder events some 11,500 years ago. Both populations undergo exponential growth following those founding events. Both Models 2 and 3 assume that domestic populations, whether they come from Europe or the Middle East, represent a single large metapopulation without significant structuring. Note that Models 2 and 3 both allow migrations between domestic and wild goat populations, and migration rates can take any value between 0 and 0.001 females per generation.

The fourth model is similar to the second model except that Middle Eastern and European domestic goats were modelled as separate populations, with the latter assumed to be derived from the former. In this model, as in Model 2, the ancestral wild population underwent a founder event some 11,500 years ago and stayed constant thereafter. The Middle Eastern *C. hircus* population was then formed by a

founder event 10,500 years ago from the wild population which remained constant in size, and 1,500 years later the European *C. hircus* population was formed from the Middle Eastern domesticate population by a third founding event. In the fifth model, each of the three modern populations – European domestic, Middle Eastern domestic, and wild – were assumed to have been formed from the ancestral wild population by distinct founder events, each of which occurred 11,500 generations ago. All three populations were allowed to undergo exponential growth from that time on. In both Models 4 and 5, each modern domesticate and wild effective population size could take any value in the intervals [10,000–1,000,000] and [1,000–10,000], respectively. In both models, migrations between European *C. hircus* and *C. aegagrus* are prohibited. However, bidirectional migration is permitted (in the range [0–0.001]) between European and Middle Eastern *C. hircus*, and between Middle Eastern *C. hircus* and *C. aegagrus*. Both models address the role of continental-scale geographic structuring of goat populations, and whether more population structuring is required to account for the differences between the two domestic samples and the wild sample.

Models of horse domestication

As outlined above, the findings of several studies on horse mtDNA have been interpreted as indicating multiple domestications. However, patterns of genetic diversity in modern horses do not indicate any strong phylogeographic structuring (Jansen et al., 2002; Lira et al., 2010; Vilà et al., 2001). This could be explained by extensive gene flow between regions – presumably due to breeding practices and intensive trade – during the centuries since domestication. Nonetheless, we should first consider simple models of horse domestication; one of a single domestication event that founded a single and effectively panmictic worldwide population of domestic horses. We therefore simulated three different demographic models in order to test this single domestication hypothesis (Fig. 1b). The explored ranges for population sizes and domestication times were kept wider than might be considered realistic, in order to accommodate extreme parameter values.

Model 1 can be considered as our "null hypothesis". We simulated a single population constant in size over time. Effective-population sizes between 1,000 and 500,000 individuals were considered. While such a model might be considered unrealistic, it is important to included it to see if the genetic data available contain sufficient information to justify favouring more complex and realistic models.

Model 2 simulates a wild population whose size remained constant until domestication occurred and then underwent a period of exponential growth lasting until the modern day. The interval of values for the ancestral wild population size was between 10 and 10,000 effective females. We set the time of domestication within a range between 4,200 and 10,200 years BP. The modern day effective female population size could assume any value between 1,000 and 500,000 females, as in Model 1.

In Model 3, the ancestral wild population remains constant, at a size taking any value between 100 to 10,000 individuals, until domestication occurs, within the same time range used in Model 2. At that time, a bottleneck occurs – corresponding to the founder event – of between 10 and 10,000 effective domesticated females, from which the domesticated population grows exponentially until modern times. The range of possible values of modern effective female size is the same as in Models 1 and 2 (between 1,000 and 500,000 females).

Model comparisons

In order to compare the models tested, we used an extension of the Bayes Factor (Kass and Raftery, 1995) for more than two models. We performed 500,000 simulations under each model, providing a total of 2,500,000 and 1,500,000 simulations for goats and horses, respectively. For each species, we standardized the Euclidean distances (d) with common mean ($mean_i$) and standard deviation (std_i) over the total number of simulations using all the summary statistics as follow:

$$d = \sqrt{\sum_i \left(\frac{stat_i - mean_i}{std_i} - \frac{obs_i - mean_i}{std_i} \right)^2},$$

with i varying from 1 to 44, or 1 to 14 summary statistics for goats or horses, respectively. We then ranked those standardized Euclidean distances from the smaller ones (i.e., the ones where the summary statistics of the simulated data were most similar to those of the observed data). Finally, we obtained a ratio of the models that gave the smallest Euclidean distances over all the 2,500,000 and 1,500,000 simulations performed for goats and horses, respectively. This approach provides a relative marginal posterior probability of each model over all those tested. It enables comparisons of different models because it eliminates dependencies on the number of parameters used in each model while integrating overall parameter values of these models. It also includes an automatic penalty for model complexity as models with more parameters have larger parameter spaces to search and so require more simulations in order to identify those generating a good fit between the simulated and the observed statistics. Therefore, for a given number of simulations, additional parameters that fail to improve the fit to the data would produce proportionally fewer simulations that are closer to the empirical data, and the corresponding models receive less marginal support. Figure 2 presents the results of this approximate Bayes Factor analysis for the best 10,000 simulations for both goats (Fig. 2a) and horses (Fig. 2b).

Results

Goats

The simple model (Model 1), under which samples come from a single large expanding population, yielded a poorer overall fit to the data than did any of the other models except Model 5. This implies that demographic structure is required to explain the observed patterns of genetic diversity. The highest posterior probabilities were obtained for Models 2 and 4, which have 5 and 8 parameters, respectively. Both models assumed that the size of the *C. aegagrus* population remained constant size starting at 11,500 years BP, and that *C. hircus* population(s) come from an already 'managed' wild population of constant size. From an archaeological and geographic point of view, Model 4 makes the most sense, and despite being relatively complex, receives the best support.

Fig. 2 | Representation of the posterior probabilities of each model tested for goat (a) and horse (b), in function of the number of the smaller Euclidean distances considered. This Bayes factor analogous analysis is based on 500,000 simulations of each model, with a comparison based on the ranking of the closer simulated summary statistics to the observed ones. These representations show the result of this analysis based on the 10,000 smaller Euclidean distances for both goat (a) and horse (b), but note that as there are 5 and 3 models for goat and horse, the total number of simulations taken into account is not the same, i.e. 2,500,000 and 1,500,000 simulations, respectively

Horses

Among the three models proposed for horse domestication, the one that best fit the data is Model 2, which assumes a constant ancestral population size that starts to expand at the time of domestication, without any bottleneck. This result supports the hypothesis that most lineages from the ancestral wild population were incorporated into the domestic one.

Discussion

The Neolithic transition is a cultural process defining the move from a semi-nomadic life-style with an economy based on hunting and gathering to a sedentary culture, in which agriculture and animal exploitation become the dominant subsistence strategies. It is likely to have been a long and complex process involving the acquisition of social behaviours associated with sedentary settlements, the development of new economic strategies (such as animal and plant domestication) and the retention of new skills and technical innovations (e.g. pottery, polished stone tools). This transition entailed diverse changes that shaped cultures (structured societies), environments (farming-like landscapes) and genetic diversity (of both domesticate species and human populations). As such past evolutionary processes

shape the gene pool of modern populations, genetic data can be used to make inferences on those processes of domestication during the Neolithic transition.

Analyses of genetic diversity have attempted to address the relative role of founder events, geographic structure, local admixture with wild progenitors, and migrations, on their genetic diversity. In this context, phylogeographic studies have attempted to identify founding female (using mtDNA) or male (using Y chromosomes) lineages. However, the arrival of a population into a geographical region does not necessarily equate to the age of particular genealogical lineages observed in that region (Barbujani et al., 1998; Barbujani and Goldstein, 2004).

As exemplified above in the case of goat and horse domestication, the coalescent simulation approach enables different evolutionary models to be evaluated for consistency with observed data. The results of this analysis for the goat samples show that serial founder effects from previously managed populations (Model 2 and, in particular, Model 4) appear more likely than distinct founder events for each population (Models 3 and 5). Furthermore, as Model 1 receives little support, it seems that a certain level of population structure between wild and domestic populations is needed to explain the observed mtDNA diversity. Furthermore, as Models 3 and 5 have been shown not to explain the observed summary statistics very well, it seems that any structure is more likely to have arisen after 11,500 BP, probably by way of sequential founding events with subsequent gene flow. In summary, multiple independent domestications do not seem necessary to explain the highly divergent lineages found in today's day goat populations. Further models can be envisaged, such as models that parameterize the times of the founder events to infer when the domesticated goat populations started to diverge genetically from the wild population, and assess how this time correlates with archaeological estimates.

In comparison, the results of our analyses show that of the three models considered, horse mtDNA pattern of diversity are best explained by one of an expanding domesticated population issued from a smaller single wild ancestral population. This seems in accord with previous studies that suggested either multiple domestications, or strong introgression of wild mares in the domestic population (Jansen et al., 2002; Vila et al., 2001). However, we would need to explicitly test further scenarios either by including more ancient samples from different regions (Europe, Central Asia) or by considering more than one ancient wild population as ancestral to modern domestic horses. Indeed, it would be useful to simulate two horse populations ancestral to two domestic horse populations, (e.g. one in Central Asia and one in Europe, with or without gene-flow between them). Horse domestication could also be seen as a bottleneck (or founder event) from both populations and either a subsequent strong gene flow between the two groups, or the convergence in a unique modern population, could occur, as discussed above. However, the fact that no strong phylogeographic structure is found in modern horses suggests that geographically structured models are only likely to receive support with the addition of considerably more ancient DNA data than is considered here.

The best model among a set tested does not necessarily equate to the one reflecting what actually occurred. No model that we could test could capture the true complexity of a population's history. This is exemplified when studying structured populations (Beaumont, 1999; Nielsen and Beaumont, 2009; Wakeley, 1999; Wilson et al., 2003). Furthermore, we must emphasize that it is possible for multiple models to be consistent with both archaeological and genetic data; thus efficient statistical tools must be used to compare alternative evolutionary models. In that context, Approximate Bayesian Computation (ABC) provides a very promising means of comparing models of complex demographic histories of diverse populations (Beaumont et al., 2002; Ray et al., 2009). These methods make use of simplified models as a baseline to compare more complex models against. The reason why an ABC approach was

not used here to estimate unknown parameters is that the number of simulations performed in this study was not sufficient to provide reliable estimates. More simulations need to be run in order to be more conclusive. But the results presented here do provide us with information that can be used to refine models and to sharpen intuitions on goat and horse domestication processes. The coalescent approach is not an end in itself (Currat, this volume; Currat and Excoffier, 2005; Excoffier et al., 2009; Francois et al., 2010; Hofer et al., 2009), but it can provide an initial understanding of the ancestral relationship between contemporaneous and ancient populations (Bramanti et al., 2009; Malmström et al., 2009).

References

Anderson, C.N., Ramakrishnan, U., Chan, Y.L., Hadly, E.A., 2005. Serial SimCoal: A population genetics model for data from multiple populations and points in time. Bioinformatics 21, 1733–1734.

Anthony, D.W., Brown, D.R., 2003. Eneolithic horse rituals and riding in the steppes: new evidence, in: Levine, M., Renfrew, C., Boyle, K. (Eds.), Prehistoric Steppe Adaptation and the Horse. McDonald Institute for Archaeological Research, Cambridge, pp. 55–68.

Barbujani, G., Bertorelle, G., Chikhi, L., 1998. Evidence for Paleolithic and Neolithic gene flow in Europe. American Journal of Human Genetics 62, 488–492.

Barbujani, G., Goldstein, D.B., 2004. Africans and Asians abroad: Genetic diversity in Europe. Annual Review of Genomics and Human Genetics 5, 119–150.

Beaumont, M.A., 1999. Detecting population expansion and decline using microsatellites. Genetics 153, 2013–2029.

Beaumont, M.A., Zhang, W., Balding, D.J., 2002. Approximate Bayesian computation in population genetics. Genetics 162, 2025–2035.

Belle, E.M., Landry, P.A., Barbujani, G., 2006. Origins and evolution of the Europeans' genome: evidence from multiple microsatellite loci. Proceedings of the Royal Society London B: Biological Sciences 273, 1595–1602.

Bramanti, B., Thomas, M.G., Haak, W., Unterlaender, M., Jores, P., Tambets, K., Antanaitis-Jacobs, I., Haidle, M.N., Jankauskas, R., Kind, C.J., Lueth, F., Terberger, T., Hiller, J., Matsumura, S., Forster, P., Burger, J., 2009. Genetic discontinuity between local hunter-gatherers and Central Europe's first farmers, Science 326, 138–140.

Burger, J., Thomas, M.G., 2011. The palaeopopulation-genetics of humans, cattle and dairying in Neolithic Europe, in: Pinhasi, R., Stock, J. (Eds.), The Bioarchaeology of the Transition to Agriculture. Wiley Blackwell, Chichester, UK, pp. 371–384.

Currat, M., Excoffier, L., 2005. The effect of the Neolithic expansion on European molecular diversity. Proceedings of the Royal Society London B: Biological Sciences 272, 679–688.

Excoffier, L., Foll, M., Petit, R.J., 2009. Genetic consequences of range expansions. Annual Review of Ecology, Evolution, and Systematics 40, 481–501.

Excoffier, L., Laval, G., Schneider, S., 2005. Arlequin (version 3.0): an integrated software package for population genetics data analysis. Evolutionary bioinformatics Online 1, 47–50.

Fagundes, N.J., Ray, N., Beaumont, M., Neuenschwander, S., Salzano, F.M., Bonatto, S.L., Excoffier, L., 2007. Statistical evaluation of alternative models of human evolution. Proceedings of the National Academy of Science USA 104, 17614–17619.

Fernandez, H., Hughes, S., Vigne, J.D., Helmer, D., Hodgins, G., Miquel, C., Hanni, C., Luikart, G., Taberlet, P., 2006. Divergent mtDNA lineages of goats in an Early Neolithic site, far from the initial domestication areas. Proceedings of the National Academy of Science USA 103, 15375–15379.

Francois, O., Currat, M., Ray, N., Han, E., Excoffier, L., Novembre, J., 2010. Principal component analysis under population genetic models of range expansion and admixture. Molecular Biology and Evolution 27, 1257–1268.

Goldstein, D.B., Chikhi, L., 2002. Human migrations and population structure: what we know and why it matters. Annual Review of Genomics and Human Genetics 3, 129–152.

Hofer, T., Ray, N., Wegmann, D., Excoffier, L., 2009. Large allele frequency differences between human continental groups are more likely to have occurred by drift during range expansions than by selection. Annals of Human Genetics 73, 95–108.

Jansen, T., Forster, P., Levine, M.A., Oelke, H., Hurles, M., Renfrew, C., Weber, J., Olek, K., 2002. Mitochondrial DNA and the origins of the domestic horse. Proceedings of the National Academy of Science USA 99, 10905–10910.

Joyce, P., Marjoram, P., 2008. Approximately sufficient statistics and Bayesian computation. Statistical Applications in Genetics and Molecular Biology 1, Article 26.

Kass, R.E., Raftery, A.E., 1995. Bayes Factor. Journal of the American Statistical Association 90, 773–795.

Lira, J., Linderholm, A., Olaria, C., Brandstrom Durling, M., Gilbert, M.T., Ellegren, H., Willerslev, E., Liden, K., Arsuaga, J.L., Gotherstrom, A., 2010. Ancient DNA reveals traces of Iberian Neolithic and Bronze Age lineages in modern Iberian horses. Molecular Ecology 19, 64–78.

Luikart, G., Gielly, L., Excoffier, L., Vigne, J.D., Bouvet, J., Taberlet, P., 2001. Multiple maternal origins and weak phylogeographic structure in domestic goats. Proceedings of the National Academy of Science USA 98, 5927–5932.

Malmström, H., Gilbert, M.T., Thomas, M.G., Brandstrom, M., Stora, J., Molnar, P., Andersen, P.K., Bendixen, C., Holmlund, G., Gotherstrom, A., Willerslev, E., 2009. Ancient DNA reveals lack of continuity between neolithic hunter-gatherers and contemporary Scandinavians. Current Biology 19, 1758–1762.

Naderi, S., Rezaei, H.R., Pompanon, F., Blum, M.G., Negrini, R., Naghash, H.R., Balkiz, O., Mashkour, M., Gaggiotti, O.E., Ajmone-Marsan, P., Kence, A., Vigne, J.D., Taberlet, P., 2008. The goat domestication process inferred from large-scale mitochondrial DNA analysis of wild and domestic individuals. Proceedings of the National Academy of Science USA 105, 17659–17664.

Naderi, S., Rezaei, H.R., Taberlet, P., Zundel, S., Rafat, S.A., Naghash, H.R., el-Barody, M.A., Ertugrul, O., Pompanon, F., 2007. Large-scale mitochondrial DNA analysis of the domestic goat reveals six haplogroups with high diversity. PLoS One 2, e1012.

Nielsen, R., Beaumont, M.A., 2009. Statistical inferences in phylogeography. Molecular Ecology 18, 1034–1047.

Outram, A.K., Stear, N.A., Bendrey, R., Olsen, S., Kasparov, A., Zaibert, V., Thorpe, N., Evershed, R.P., 2009. The earliest horse harnessing and milking. Science 323, 1332–1335.

Ray, N., Wegmann, D., Fagundes, N.J., Wang, S., Ruiz-Linares, A., Excoffier, L., 2009. A statistical evaluation of models for the initial settlement of the American continent emphasizes the importance of gene flow with Asia. Molecular Biology and Evolution 27, 337–345.

Rosenberg, N.A., Nordborg, M., 2002. Genealogical trees, coalescent theory and the analysis of genetic polymorphisms. Nature Reviews Genetics 3, 380–390.

Vila, C., Leonard, J.A., Gotherstrom, A., Marklund, S., Sandberg, K., Liden, K., Wayne, R.K., Ellegren, H., 2001. Widespread origins of domestic horse lineages. Science 291, 474–477.

Wakeley, J., 1999. Nonequilibrium migration in human history. Genetics 153, 1863–1871.

Weber, C., 2005. Molecular genotyping of a Skythian horse population. Master thesis, Institute of Anthropology, Johannes Gutenberg University, Mainz.

Wegmann, D., Leuenberger, C., Excoffier, L., 2009. Efficient approximate Bayesian computation coupled with Markov chain Monte Carlo without likelihood. Genetics 182, 1207–1218.

Wilson, I.J., Weale, M.E., Balding, D.J., 2003. Inferences from DNA data: population histories, evolutionary processes and forensic match probabilities. Journal of the Royal Statistical Society, Series A (Statistics in Society) 166, 155–201.

Zeder, M.A., 2008. Domestication and early agriculture in the Mediterranean Basin: Origins, diffusion, and impact. Proceedings of the National Academy of Science USA 105, 11597–11604.

Greger Larson*

Using pigs as a proxy to reconstruct patterns of human migration

* Department of Archaeology, Durham University, Durham, United Kingdom: greger.larson@durham.ac.uk

Abstract

Human beings have been migrating since the dawn of our species. For the vast majority of that time, populations moved across the continents without the aid of domestic animals. In fact, by the time the first animals were fully domesticated, migrating hunter-gatherers had already spread to every continent except Antarctica. Tracing the timing and trajectories of these migratory routes has been a significant anthropological endeavour, and to piece together the palimpsest of human migrations scientists have employed a range of proxies including modern human genetic signatures, linguistics, and numerous material culture elements. This paper discusses the insights that have been gained by using domestic pigs as a proxy for human movement (post domestication) across western Eurasia and into the Pacific. Pigs have not only informed specific trajectories and timings of migration routes, they have also led to a new general perspective on studies of human migration writ large and have even begun to raise heretofore unexplored questions about the ramifications of human movement for both people and their domestic partners.

Keywords

domestication, Neolithic, mtDNA, phylogeography

Introduction

By the beginning of the Neolithic in the Near East, humans occupied all of the continental landmasses, including Africa, Eurasia, the Americas and Australia. The only continent humans had not yet reached was Antarctica. And humans reached all these places without the advantage of domestic animals, or at least, without the benefit of the full compliment of domestic animals associated with the early Eurasian Neolithic. This record of migration demonstrates that for most regions of the world, people did not need domestic animals in order to travel. Following the domestication of pigs, sheep, goats, and cows, however, farmers travelled extensively with these walking larders and were able to move into areas already occupied by indigenous hunter-gatherers, and onto remote islands inaccessible to people who did not possess domestic animals.

Because farmers often travelled with their livestock, the archaeological remains and genetic signatures of both ancient and modern domestic and commensal animals can be used as a direct proxy for the timing and routes of ancient migration. This has been demonstrated for rats (Matisoo-Smith and Robins, 2004), sheep (Chessa et al., 2009), goats (Fernandez et al., 2006), cows (Edwards et al., 2007) and, of course, pigs (Larson et al., 2007a; Larson et al., 2007b). This paper will focus on the use of pigs as a proxy for human migration first in western Eurasia, and then in the Pacific region, where pigs travelled with people as far east as Hawai'i.

Tracking the migration of farmers into Europe

There is no question that wild boar had been domesticated independently in both the Near East (Ervynck et al., 2001) and in East Asia (Cucchi et al., 2010) by 9,000 cal BP. The degree to which European wild boar were locally domesticated, either independently or as a consequence of the earlier introduction of domestic pigs from the Near East, remains uncertain (Albarella et al., 2006b; Larson et al., 2007a). This uncertainty is the result of the success of *Sus scrofa*'s natural ability to migrate. The natural range of the

wild boar covers most of Eurasia. In this they are unlike sheep and goats, whose wild ancestors are (and likely were) confined to a relatively small geographic region in the Near East. Therefore, any sheep or goat remains found associated with archaeological contexts in Europe are easily identified as domestic specimens (Clutton-Brock, 1999), and thus these two species (along with associated material culture) provide an unambiguous marker of the presence of people whose ancestors migrated from the Near East. By contrast, the ubiquity of wild boar and the significant degree of size variability within wild populations across Eurasia (Albarella et al., 2009) have prevented archaeologists from confidently assigning a wild or domestic status to recovered *Sus* remains, and thus the presence of pig remains on their own cannot be associated with Near Eastern farmers.

In the past, archaeologists lacked the ability to unambiguously ascertain differences between geographically differentiated wild boar populations. Modern genetic studies of pigs have taken advantage of a greater degree of resolution and have confidently identified numerous geographically isolated populations of wild boar that possess distinct genetic signatures. This strong phylogeographic structure has revealed nearly 20 unique genetic groupings of wild boar, even if the relationships between those groupings remain ambiguous (Giuffra et al., 2000; Larson et al., 2005; Larson et al., 2010).

A surprising finding of these publications was the lack of a shared genetic affinity between European domestic pigs and Near Eastern wild boar. The phylogeographic patterning suggested that wild boar from continental Europe differed significantly from those in the Anatolian peninsula and the Near East, and the archaeozoological evidence suggested that though pigs were first domesticated in the Near East, they were later introduced into Europe during the Neolithic. Assuming that the biogeographic boundary between European and Near Eastern wild boar, centred near the Bosporus, was established well before the origins of domestication, it was reasonable to conclude that the first pigs brought into Europe did not share a genetic affinity with the indigenous wild boar. Because modern European domestic breeds clustered with European wild boar, this result implied that the first pigs introduced by Neolithic farmers had at some point been replaced by European pigs descended, at least maternally, from European wild boar.

This narrative rests on the assumption that the natural geographic ranges of wild boar possessing Near Eastern and European signatures have remained static since at least the beginning of the Holocene. If the European genetic motif was naturally present within wild boar populations in the Near East, then Near Eastern farmers could have domesticated this type and a secondary domestication in Europe would no longer be necessary to explain the modern pattern.

At least three different studies (Giuffra et al., 2000; Larson et al., 2005; Ramírez et al., 2009) have independently found what are thought to be European haplotypes in Near Eastern wild boar, though they are present at low frequencies. This pattern has led some authors to suggest that the phylogeographic structure is not as dichotomous as Larson and colleagues (2007a) initially proposed. Ramírez and colleagues (2009), for example, suggested that the occasional inconsistency within the general phylogeographic pattern could be due to the natural admixture of wild boar populations, and need not be a consequence of human-mediated translocation of domestic pigs that subsequently became feral, as has been suggested by Larson and colleagues (2005, 2007a,). Ramírez and colleagues (2009) supported their argument with a nuclear microsatellite analysis, the results of which demonstrated that European, Near and Middle Eastern, and North African wild boar populations cluster into a single group, despite the fact that the mitochondrial haplotype frequencies within these samples differ markedly. They argued that since mitochondrial DNA is more prone to extinction on shorter time scales (due to genetic drift), the observed haplotypes frequencies in modern populations could be due to recent demographic events.

Because domestic pigs have been known to become feral (Albarella et al., 2006a), ancient introgression, as suggested by Larson and colleagues (2007a), cannot be ruled out as the cause of the observed discrepancies within the phylogeographic pattern.

A perspective that incorporated only modern DNA would never be able to resolve this issue. The analysis of DNA extracted from ancient remains, however, has become a powerful tool in domestication and migration studies. Though modern DNA analyses allow for a greater resolution than is typically possible through traditional archaeological approaches, they lack any temporal perspective, thus limiting the ability of modern studies to extrapolate their results into the past. Given the complex history of pig domestication, and the inability of modern DNA studies to differentiate between competing historical explanations, ancient DNA studies of archaeological material are the best means with which to resolve the questions discussed above.

As previously mentioned, a great deal of the modern genetic understanding of Near Eastern and European pig domestication rests on the assumption of temporally consistent phylogeographic patterns. By extracting DNA from archaeological material from the Near East to Western Europe, dated from 10,000 years ago to the present, Larson and colleagues (2007a) were able to directly test pig domestication hypotheses and reveal the temporal and geographic pattern of pig haplotypes.

Like the organisms from which it is derived, DNA degrades through time. The rate of that degradation is determined by numerous factors but tends to be faster in hotter climates and in lower latitudes (Binladen et al., 2006). The authors maximized the number of successful samples by identifying a short (~80bp) fragment that contained sufficient changes to enable the sample to be assigned to a Near Eastern or European heritage. Despite this effort, the relatively hotter climates of the Near East had significantly diminished the number of archaeological bones that retained amplifiable DNA fragments even of this size, thus limiting the ability of ancient DNA researchers to compare the DNA of the earliest domestic pigs with those of their European counterparts. Despite this frustration, the preservation of bones from Mesolithic, Neolithic, and later contexts throughout Europe was sufficient to retrieve a continental picture of the shifting patterns of haplotypes from wild and domestic pigs (Larson et al., 2007a).

The evidence firstly demonstrated that no wild boar in Europe dated to a time before the arrival of the Neolithic possessed Near Eastern haplotypes. In fact, the only Mesolithic pigs that did possess a Near Eastern affinity were from the Crimea, suggesting that the biogeographic boundary located near the Bosporus straits was intact at the beginning of the Holocene. This geographic split between the genetic signatures of wild boar on each side of the boundary then allowed Larson and colleagues (2007a) to directly test whether the first domestic pigs in Europe were brought in from the Near East, or were domesticated from wild boar indigenous to Europe. In several sites in Romanian near the Black Sea coast, and the site of Eilsleben in Germany, every pig identified as domestic using morphometric criteria possessed Near Eastern haplotypes, and every wild boar possessed a European genetic signature. The same was true at the Neolithic site of Bercy in France (dated to ~4000 cal BC), except for a single domestic pig that possessed a European haplotype.

From this point to the present, however, all the domestic pigs sampled across Europe possessed European mitochondrial signatures, demonstrating that at least on the continent, the domestic pigs originally introduced from the Near East had been replaced by those who were maternally descended from European wild boar. Some individual medieval and modern pigs from the island of Corsica, however, still retain a Near Eastern maternal genetic affinity, suggesting that they are the sole European pigs to retain the inheritance of the first pigs introduced to the island during the Neolithic. Even more intrigu-

ingly, domestic pigs in the Near East hung onto their Near Eastern ancestry until at least 700 cal BC, after which, they too were replaced by pigs derived from European wild boar. The presence of different haplotypes along the purported northern and southern Neolithic routes into Europe also seemed to suggest that different lineages of pigs were transported along these two routes, but the number of samples was too small to conclusively demonstrate this potential correlation (Larson et al., 2007a).

What is not in dispute is the complexity of pig domestication and subsequent human migration across western Eurasia. That being said, technological advancements enabling the generation of ever-longer DNA sequences from archaeological material will continue to reveal variability among pig populations in time and space. This increased degree of resolution will only add to our ability to tease apart the complexity, and I suspect that within the next decade the domestic animal proxy model for human migration into Europe will substantially add to our understanding of when and where incoming farmers interacted with indigenous hunter-gatherers and what the ramifications were for the humans and for their domestic animal partners.

Tracking human migrations into the Pacific

The movement of people into Oceania was one of the most extensive human dispersals (Diamond, 2000) and is enormously significant because although hunter-gatherers had travelled over water to reach, for example, Australia, it appears that people were unable to colonise the remote islands of the Pacific without the aid of domestic animals. Though of course the ancestors of the Pacific settlers must have originated in East Asia, uncertainties remain regarding the precise geographic origins of modern populations in Melanesia, Micronesia and Polynesia. A wide variety of scenarios have been suggested, based upon the associated material culture, language, and human genetic signatures, to explain the movement of Neolithic cultures into Near and Remote Oceania (Anderson, 2005; Bellwood, 1998; Bellwood and Diamond, 2005; Green, 2000; Hurles et al., 2003; Kirch, 2000; Oppenheimer, 2004; Terrell et al., 2001). The degree to which the cultural and biological elements used to trace the routes reflect the actual human dispersal has been questioned, as has the extent to which these various components were dispersed as a single unit (Hurles et al., 2003). For example, models of the origins of Lapita (the immediate ancestors of the Polynesians and many other Oceanic cultures) that focus on the entire Lapita cultural and ecological package moving from Taiwan to the Pacific with little interaction differ significantly from those that identify broader regions and possibly multiple origins of the various cultural components (Donohue and Denham, 2010).

Like the European example above, analyses of genetic variation in the domestic and commensal animals which were intimately linked with Neolithic cultures, and which were significant components of human dispersal and exchange networks, can shed light on the origins and routes of the migrating cultures. Pigs, chickens, dogs and rats were introduced to the various islands of Near and Remote Oceania by early human settlers, and studies of Pacific rats (Matisoo-Smith and Robins, 2004) and pigs (Allen et al., 2001; Larson et al., 2005) have demonstrated the potential of these taxa to act as reliable proxies for reconstructing patterns of human dispersal into Oceania. Interestingly, a previous genetic study of pigs in the region (Larson et al., 2005) revealed a unique genetic population of pigs which the authors termed the "Pacific Clade". Pigs that possessed this signature were found only in Halmahera (in the Moluccas), New Guinea, and several Pacific islands, including Hawaii and Vanuatu, places that have never had an indigenous population of wild boar (Bellwood and White, 2005). The absence of Pacific

Clade haplotypes in any wild or domestic pigs from mainland Asia, or ISEA west of the Wallace Line (Larson et al., 2005), however, meant the geographic origin of the clade could not be identified.

Larson and colleagues (2007b) later investigated the geographic origin of the Pacific Clade and its distribution within ISEA and Near and Remote Oceania by typing mitochondrial control region sequences from more than 200 wild, feral, and domestic pigs from across the region and mainland Southeast Asia, using both museum specimens and archaeological pig remains from several islands. The resulting phylogenetic tree revealed that all of the pigs in ISEA found west of the Wallace Line represented the most basal portion of the tree, suggesting that the genus *Sus* originated in this area. The Pacific Clade pigs, however, clustered with several other clades in East Asia, strongly suggesting that though they are now primarily present east of the Wallace Line, their ancestors did not evolve until wild boar had naturally crossed the Kra Isthmus in modern day Thailand and travelled into peninsular East Asia.

Large scale genetic typing of pigs in peninsular East Asia and throughout South Asia, China, the Koreas, and Mongolia, has recently revealed at least five individual wild boar samples whose genetic signatures match those of the Pacific Clade (Larson et al., 2010). These specimens, found in Vietnam, Laos, and Yunnan province, China, suggest that the Pacific Clade likely evolved in peninsular Southeast Asia. In addition to the peninsular East Asian specimens, museum samples possessing Pacific Clade haplotypes were also identified in Sumatra and Java and eight islands east of the Wallace Line in the Moluccas and Lesser Sunda chains, including New Guinea. Despite a reasonable sampling effort, however, no Pacific Clade pigs have yet been found either in Taiwan or on the Philippine Islands, despite the fact that archaeological evidence strongly implies that people travelled with pigs from Taiwan to at least Luzon, the northernmost Philippine island in the archipelago (Piper et al., 2009). None of the islands in Wallacea (with the exception of Sulawesi) possessed endemic populations of S. scrofa (Morwood et al., 2004). In fact, archaeological investigations on Flores (Morwood et al., 2004), Timor (Glover, 1986) and the northern Mollucas (Bellwood and White, 2005) have demonstrated that the first appearance of pigs only occurs in Holocene deposits associated with the arrival of the Neolithic "cultural package." The total of the archaeological evidence, then, seems to suggest that a separate population of pigs, unrelated to the Pacific Clade, were brought south from Taiwan to the Philippines, and because the modern Pacific Clade pigs in Wallacea and New Guinea match those in peninsular Southeast Asia, that perhaps it was in this region that pigs were domesticated before being transported though ISEA.

This narrative works nicely, except when one considers the archaeological record in peninsular Southeast Asia, where there is currently no indication that domestic pigs were present before the end 5th millennium BP, when they appear alongside the first evidence of sedentary agriculture (Higham, 1975; Higham, 2002). This suggests that these domestic pigs were not the result of a process involving local wild boar and that they should not have Pacific Clade haplotypes, though this has not yet been tested. In addition, no modern domestic pigs possessing Pacific Clade haplotypes have yet been found in mainland Asia.

These two facts seem to contradict a narrative that starts in peninsular Southeast Asia and ends in the Pacific. It may be possible, however, that earlier evidence for local domestication of Pacific Clade pigs in this understudied region may yet be uncovered. The lack of modern Pacific Clade pigs could be a consequence of a replacement of native domestics by pigs later introduced from Central China during several possible demographic expansions of agricultural populations into the region, including Austronesian speakers through ISEA and parts of the mainland coastal regions (Pawley, 2003), post-Neolithic expansions of Sino-Tibetan speakers (Pawley, 2003; Van Driem, 1998), and Austro-Tai or Miao-Yao groups from Southern China (Blench, 2005). This possibility is analogous to the temporal replacement

of several domestic animals including chickens in the Pacific (Gongora et al., 2008) and Near Eastern pigs during later prehistory (Larson et al., 2007a).

Intriguingly, there is substantial genetic and morphological evidence that people were transporting another suid species (*Sus celebensis*) within ISEA many thousands of years before the Pacific migrations. A single modern specimen and seven archaeological Liang Bua Cave specimens possessed a unique haplotype that clusters with *Sus celebensis* specimens from Sulawesi. ISEA and Island Melanesia possess a long history of animal translocation (Flannery and White, 1991; Heinsohn, 2003; Spriggs, 1997), and since *Sus celebensis* is endemic only to Sulawesi, its presence on Flores as early as 7,000 BP (based upon the stratigraphic association of the earliest pig specimen and associated ^{14}C dates of charcoal) suggests an early translocation of this species by humans. Independent verification of the distinctiveness (and also probable domesticated origin) of pigs with the Pacific mtDNA signature is shown by morphometric analysis of the lower third molar from the modern New Guinea and Flores pigs, as well as archaeological pigs from the site of Liang Bua on Flores.

Though the density of sampling in the region needs to be improved, the data thus far support human-mediated dispersals of *Sus* species not only from Asia into the Pacific, but also within Wallacea. The archaeological evidence in the northern Philippines (Piper et al., 2009) as well as the genetic evidence from the Lanyu island off the coast of Taiwan (Luetkemeier et al., 2010; Wu et al., 2007) suggests that people may well have been migrating with yet another genetically and regionally distinct domestic pig, even if that subpopulation was not subsequently carried into the Pacific. What is clear is that the different components of the Neolithic cultural complex may therefore have different origins and trajectories to Near Oceania, where they finally came together and are identified archeologically as Lapita. Knowing that the pigs may have had a different route than the people, or at least did not have the identical route helps researchers to unravel a complicated migration pattern (Donohue and Denham, 2010; Wollstein et al., 2010).

All of these narratives, both in the Pacific and in Europe, demonstrate the complexities of human movement and the dangers of layering an overly simple explanation over large spatial and temporal distances. People were likely involved in different degrees of pig domestication across the Old World and when they migrated, these different populations of people and pigs could easily have mated, creating hybrid populations with hybrid genomes. The extent to which domestic pigs introgressed with wild boar of the same or different species as a consequence of human migration remains unknown, and it is unlikely that we will able to find out using modern DNA alone. Ancient DNA, derived from the bones of archaeological pig remains, however, could provide the necessary temporal framework to reveal not only the genetic affinities of individual populations of domestic pigs, but also whether or not the processes of domestication across the Old World were truly independent or facilitated by human migration and the introduction of foreign domestic pigs.

References

Albarella, U., Manconi, F., Rowley-Conwy, P., Vigne, J.-D., 2006a. Pigs of Corsica and Sardinia: A biometrical re-evaluation of their status and history, in: Tecchiati, U., Sala, B. (Eds.), Archaeozoological Studies in Honour of Alfredo Riedel, Bolzano, pp. 285–302.

Albarella, U., Tagliacozzo, A., Dobney, K., Rowley-Conwy, P., 2006b. Pig hunting and husbandry in prehistoric Italy: a contribution to the domestication debate. Proceedings of the Prehistoric Society 72, 193–227.

Albarella, U., Dobney, K., Rowley-Conwy, P., 2009. Size and shape of the Eurasian wild boar (Sus scrofa), with a view to the reconstruction of its Holocene history. Environmental Archaeology 14, 103–136.

Allen, M.S., Matisoo-Smith, E., Horsburgh, A., 2001. Pacific 'Babes': Issues in the origins and dispersal of Pacific pigs and the potential of mitochondrial DNA analysis. International Journal of Osteoarchaeology 11, 4–13.

Anderson, A.J., 2005. Crossing the Luzon Strait: Archaeological chronology in the Batanes Islands, Philippines and the regional sequence of Neolithic dispersal. Journal of Austronesian Studies 1, 27–48.

Bellwood, P., 1998. The archaeology of Papuan and Austronesian prehistory in the Northern Moluccas, Eastern Indonesia, in: Blench, R., Spriggs, M. (Eds.), Archaeology and Language II: Archaeological Data and Linguistic Hypotheses. Routledge, London, pp. 128–140.

Bellwood, P., Diamond, J., 2005. On explicit 'replacement' in Island Southeast Asia: a reply to Stephen Oppenheimer. World Archaeology 37, 503–506.

Bellwood, P., White, P., 2005. Domesticated pigs in eastern Indonesia. Science 309, 381; author reply 381.

Binladen, J., Wiuf, C., Thomas, M., Gilbert, P., Bunce, M., Barnett, R., Larson, G., Greenwood, A.D., Haile, J., Ho, S.Y.W., Hansen, A.J., Willerslev, E., 2006. Assessing the fidelity of ancient DNA sequences amplified from nuclear genes. Genetics 172, 733–741.

Blench, R.M., 2005. From the moutains to the valleys: Understanding ethnoliguistic geography in Southeast Asia, in: Blench, R.M., Sagart, L., Sanchez-Mazas, A. (Eds.), Perspectives on the Phylogeny of East Asian Languages. Curzon Press, London, pp. 31–50.

Chessa, B., Pereira, F., Arnaud, F., Amorim, A., Goyache, F., Mainland, I., Kao, R.R., Pemberton, J.M., Beraldi, D., Stear, M.J., Alberti, A., Pittau, M., Iannuzzi, L., Banabazi, M.H., Kazwala, R.R., Zhang, Y.P., Arranz, J.J., Ali, B.A., Wang, Z., Uzun, M., Dione, M.M., Olsaker, I., Holm, L.E., Saarma, U., Ahmad, S., Marzanov, N., Eythorsdottir, E., Holland, M.J., Ajmone-Marsan, P., Bruford, M.W., Kantanen, J., Spencer, T.E., Palmarini, M., 2009. Revealing the history of sheep domestication using retrovirus integrations. Science 324, 532–536.

Clutton-Brock, J., 1999. A Natural History of Domesticated Mammals, 2nd ed. Cambridge University Press, Cambridge.

Cucchi, T., Hulme-Beaman, A., Yuan, J., Dobney, K., 2010. Early Neolithic pig domestication at Jiahu, Henan Province, China: Clues from molar shape analyses using geometric morphometric approaches. Journal of Archaeological Science 38, 11–22

Diamond, J.M., 2000. Taiwan's gift to the world. Nature 403, 709–710.

Donohue, M., Denham, T., 2010. Farming and language in island Southeast Asia. Current Anthropology 51, 223–256.

Edwards, C.J., Bollongino, R., Scheu, A., Chamberlain, A., Tresset, A., Vigne, J.-D., Baird, J.F., Larson, G., Ho, S.Y.W., Heupink, T.H., Shapiro, B., Freeman, A.R., Thomas, M.G., Arbogast, R.-M., Arndt, B., Bartosiewicz, L., Benecke, N., Budja, M., Chaix, L., Choyke, A.M., Coqueugniot, E., Döhle, H.-J., Göldner, H., Hartz, S., Helmer, D., Herzig, B., Hongo, H., Mashkour, M., Özdogan, M., Pucher, E., Roth, G., Schade-Lindig, S., Schmölcke, U., Schulting, R.J., Stephan, E., Uerpmann, H.-P., Vörös, I., Voytek, B., Bradley, D.G., Burger, J., 2007. Mitochondrial DNA analysis shows a Near Eastern Neolithic origin for domestic cattle and no indication of domestication of European aurochs. Proceedings of the Royal Society B: Biological Sciences 274, 1377–1385.

Ervynck, A., Dobney, K., Hongo, H., Meadow, R., 2001. Born free? New evidence for the status of Sus scrofa at Neolithic Cayönü Tepesi (southeastern Anatolia, Turkey). Paléorient 27, 47–73.

Fernandez, H., Hughes, S., Vigne, J.-D., Helmer, D., Hodgins, G., Miquel, C., Hänni, C., Luikart, G., Taberlet, P., 2006. Divergent mtDNA lineages of goats in an Early Neolithic site, far from the initial domestication areas. Proceedings of the National Academy of Sciences of the USA. 103, 15375–15379.

Flannery, T.F., White, L., 1991. Animal translocations, National Geographic Research and Exploration 7, 96–113.

Giuffra, E., Kijas, J.M., Amarger, V., Carlborg, O., Jeon, J.T., Andersson, L., 2000. The origin of the domestic pig: independent domestication and subsequent introgression. Genetics 154, 1785–1791.

Glover, I., 1986. Archaeology in Eastern Timor 1966–1967. ANU, Canberra.

Gongora, J., Rawlence, N.J., Mobegi, V.A., Jianlin, H., Alcalde, J.A., Matus, J.T., Hanotte, O., Moran, Ch., Austin, J.J., Ulm, S., Anderson, J.A., Larson, G., Cooper, A., 2008. Indo-European and Asian origins for Chilean and Pacific chickens revealed by mtDNA. Proceedings of the National Academy of Sciences of the USA 105, 10308–10313.

Green, R.C., 2000. Lapita and the cultural model for intrusion, integration and innovation, in: Anderson, A., Murray, T. (Eds.), Australian Archaeologist – Collected papers in honour of Jim Allen. Coombs Academic Publishing, Canberra, pp. 372–392.

Heinsohn, T., 2003. Animal translocation: long-term human influences on the vertebrate zoogeography of Australasia (natural dispersal versus ethnophoresy). Zoologist 32, 351–376.

Higham, C.F.W., 1975. Aspects of economy and ritual in Prehistoric Northeast Thailand. Journal of Archaeological Science 2, 245–288.

Higham, C.F.W., 2002. Early Culture of Mainland Southeast Asia. River Books, Bangkok.

Hurles, M., Matisoo-Smith, E., Gray, R.D., Penny, D., 2003. Untangling Oceanic settlement: the edge of the knowable. Trends in Ecology and Evolution 18, 531–540.

Kirch, P.V., 2000. On the Road of the Winds: An Archaeological History of the Pacific Islands before European Contact. University of California Press, Berkeley

Larson, G., Dobney, K., Albarella, U., Fang, M.Y., Matisoo-Smith, E., Robins, J., Lowden, S., Finlayson, H., Brand, T., Willerslev, E., Rowley-Conwy, P., Andersson, L., Cooper, A., 2005. Worldwide phylogeography of wild boar reveals multiple centers of pig domestication, Science 307, 1618–1621.

Larson, G., Albarella, U., Dobney, K., Rowley-Conwy, P., Schibler, J., Tresset, A., Vigne, J.D., Edwards, C.J., Schlumbaum, A., Dinu, A., Balacsescu, A., Dolman, G., Tagliacozzo, A., Manseryan, N., Miracle, P., van Wijngaarden-Bakker, L., Masseti, M., Bradley, D.G., Cooper, A., 2007a. Ancient DNA, pig domestication, and the spread of the Neolithic into Europe. Proceedings of the National Academy of Sciences of the USA 104, 15276–15281.

Larson, G., Cucchi, T., Fujita, M., Matisoo-Smith, E., Robins, J., Anderson, A., Rolett, B., Spriggs, M., Dolman, G., Kim, T.H., Thuy, N.T.D., Randi, E., Doherty, M., Due, R.A., Bollt, R., Djubiantono, T., Griffin, B., Intoh, M., Keane, E., Kirch, P., Li, K.T., Morwood, M., Pedrina, L.M., Piper, P.J., Rabett, R.J., Shooter, P., van den Bergh, G., West, E., Wickler, S., Yuan, J., Cooper, A., Dobney, K., 2007b. Phylogeny and ancient DNA of Sus provides insights into neolithic expansion in island southeast Asia and Oceania. Proceedings of the National Academy of Sciences of the USA 104, 4834–4839.

Larson, G., Liu, R.R., Zhao, X.B., Yuan, J., Fuller, D., Barton, L., Dobney, K., Fan, Q.P., Gu, Z.L., Liu, X.H., Luo, Y.B., Su, P., Andersson, L., Li, N., 2010. Patterns of East Asian pig domestication, migration, and turnover revealed by modern and ancient DNA. Proceedings of the National Academy of Sciences of the USA 107, 7686–7691.

Luetkemeier, E., Sodhi, M., Schook, L.B., Malhi, R.S., 2010. Multiple Asian pig origins revealed through genomic analyses. Molecular Phylogenetics and Evolution 54, 680–686.

Matisoo-Smith, E., Robins, J.H., 2004. Origins and dispersals of Pacific peoples: Evidence from mtDNA phylogenies of the Pacific rat. Proceedings of the National Academy of Sciences of the USA 101, 9167–9172.

Morwood, M.J., Soejono, R. P., Roberts, R. G., Sutikna, T., Turney, C.S.M., Westaway, K.E., Rink, W.J., Zhao, J.-x., van den Bergh, G. D., Rokus Awe Due, Hobbs, D.R., Moore, M.W., Bird, M. I., Fifield, L.K., 2004. Archaeology and age of a new hominin from Flores in eastern Indonesia. Nature 431, 1087–1091.

Oppenheimer, S., 2004. The 'Express Train from Taiwan to Polynesia': on the congruence of proxy lines of evidence. World Archaeology 36, 591–600.

Pawley, A., 2003. The Austronesian Dispersal: Languages, Technologies and People, in: Renfrew, C., Bellwood, P. (Eds.), Examining the Farming / Language Dispersal Hypothesis. McDonald Institute for Archaeological Research, Cambridge, pp. 251–273.

Piper, P.J., Hung, H.-c., Campos, F.Z., Bellwood, P., Santiago, R., 2009. A 4000 year-old introduction of domestic pigs into the Philippine Archipelago: implications for understanding routes of human migration through Island Southeast Asia and Wallacea. Antiquity 83, 687–695.

Ramírez, O., Ojeda, A., Tomàs, A., Gallardo, D., Huang, L.S., Folch, J.M., Clop, A., Sánchez, A., Badaoui, B., Hanotte, O., Galman-Omitogun, O., Makuza, S.M., Soto, H., Cadillo, J., Kelly, L., Cho, I.C., Yeghoyan, S., Pérez-Enciso, M., Amills, M., 2009. Integrating Y-chromosome, mitochondrial, and autosomal data to analyze the origin of pig breeds. Molecular Biology and Evolution 26, 2061.

Spriggs, M.J.T., 1997. The Island Melanesians. Blackwell, Cambridge, MA.

Terrell, J.E., Kelly, K.M., Rainbird, P., 2001. Foregone conclusions? In search of "Papuans" and "Austronesians". Current Anthropology 42, 97–124.

Van Driem, G., 1998. Neolithic correlates of ancient Tibeto-Burman migrations, in Blench, R., Spriggs, M. (Eds.), Archaeology and Language II: Archaeological Data and Linguistic Hypotheses. Routledge, London, pp. 67–102.

Wollstein, A., Lao, O., Becker, Ch., Brauer, S., Trent, R.J., Nürnberg, P., Stoneking, M., Kayser, M., 2010. Demographic history of Oceania inferred from genome-wide data. Current Biology 20, 1983–1992.

Wu, C.Y., Jiang, Y.N., Chu, H.P., Li, S.H., Wang, Y., Li, Y.H., Chang, Y., Ju, Y.T., 2007. The type I Lanyu pig has a maternal genetic lineage distinct from Asian and European pigs. Animal Genetics 38, 499–505.

*Ingrid Wiechmann**

Poor DNA preservation in bovine remains excavated at Pre-Pottery Neolithic Göbekli Tepe (Southeast Turkey): Brief communication

* Ludwig Maximilian University of Munich, Department of Veterinary Sciences, Institute of Palaeoanatomy, Domestication Research and the History of Veterinary Medicine: I.Wiechmann@lrz.uni-muenchen.de

Abstract

With regard to the domestication history of cattle the molecular genetic investigation of bovid remains excavated at Neolithic sites in the Near East may help to characterize the original mtDNA haplotypes. The preliminary results obtained for bovine remains excavated at the Early Neolithic site Göbekli Tepe, however, indicate a poor DNA preservation.

Keywords

Göbekli Tepe, domestication, *Bos*, ancient DNA, mtDNA

Introduction

Recent studies indicate that members of the extinct Near Eastern aurochs (*Bos primigenius*) were the progenitors of European domesticated cattle (e.g. Troy et al., 2001; Bollongino et al., 2006; Edwards et al., 2007; Achilli et al., 2009).

In this context, the molecular genetic investigation of bovine remains excavated at Neolithic sites in the Near East may help to characterize the original Near Eastern mtDNA haplotypes. Our molecular genetic analyses were applied to bovine remains excavated at the Early Neolithic site Göbekli Tepe, which is located about 15 km northeast of the town Şanlıurfa (often known simply as Urfa) in Southeastern Turkey. The site is situated on the highest point of a mountain ridge and consists of a number of megalithic structures which date to the period between 9,300 BC and 8,000 BC. The earlier levels contain many pillars decorated with animal depictions. Illustrations include wild boar, snakes, red fox, crane, wild cattle, ducks and vultures (Peters and Schmidt, 2004; Schmidt, 2007).

Material and methods

A first set of bovine tooth and bone samples excavated at Göbekli Tepe were washed on location, dried in the sun and subsequently stored conventionally. A second set of additional *Bos* remains were freshly excavated (excavation campaign in April 2009) and continuously cooled. Sample preparation, DNA extraction and PCR set-up were carried out in laboratories dedicated to ancient DNA analysis. Amplification and the analysis of amplification products were performed in separate laboratories.

After removal of the bone and tooth surface, the samples were UV-irradiated on all sides (254 nm, 30 min) and subsequently ground. DNA extraction was performed following the silica-based extraction protocol C developed by Yang and colleagues (1998). Each extraction series consisted of five samples and was accompanied by an extraction control. With regard to the highly variable region of the bovine mtDNA control region, four sets of overlapping primers were designed with the aid of the software component *Primer3* (Rozen and Skaletsky, 2000). The lengths of the amplification products vary between 102 bp and 152 bp and the overall framed mtDNA HVRI region contains 281 bp (nucleotide positions

16031 to 16311, GenBank accession number V00654.1, [Anderson et al., 1982]). Each PCR analysis consisted of five *Bos* samples and was accompanied by the associated extraction control and a PCR control (no template controls). In order to avoid contamination of the ancient samples, no positive control (modern cattle DNA) was processed with the samples. The amplification products obtained were purified and then directly sequenced on an Applied Biosystems 3730 DNA analyzer.

In addition to the molecular genetic investigation, collagen was extracted from 27 bovine remains. The collagen yield was calculated as the percentage of whole bone.

Preliminary results

All extraction and PCR controls processed with the samples remained free of amplification products, except primer dimers. Unfortunately, most of the 40 *Bos* samples under study remained free of amplification products, too. Amplification products were obtained for five conventionally treated *Bos* specimens (washed on site and sun-dried) only. The DNA sequences showed a high similarity with the reference sequence (GenBank accession number V00654.1) which is classified as haplotype T3. However, in almost all cases, sequences obtained in a single PCR attempt were not reproducible in a second one. The amount of collagen measured for 17 conventionally stored *Bos* specimens excavated at Göbekli Tepe was very low. Nine samples revealed 0.0 % collagen and seven samples yielded a collagen content below 0.4 %. One *Bos* specimen contained 0.91 % collagen, but also failed to show any PCR products on a silver-stained polyacrylamide gel.

The collection of freshly excavated and continuously cooled *Bos* remains gave rise to great expectations. But, no amplicons have as yet been obtained using this sample material. The amount of collagen measured for 10 freshly excavated *Bos* specimens was very low, too. Six samples revealed a collagen content below 0.2 % and four samples had a collagen content of below 0.4 %.

Discussion

Our preliminary results indicate that DNA preservation in the bovine remains from this important excavation site is poor, and the few mtDNA results that were obtained showed a low reproducibility. Reproducibility (from the same extract and separate extractions), however, is the most important criterion for the authenticity of ancient DNA results (Edwards et al., 2004).

Poor DNA preservation in skeletal remains from Neolithic sites in the Near East has already been demonstrated in other studies (Edwards et al., 2004; Edwards et al., 2007; Bollongino and Vigne, 2008; Bollongino et al., 2008). This poor biomolecular preservation is due to the climatic conditions in the Near East, which can be adequately summarized as hot and dry summers and humid and rainy winters. In this context, the climate feature of the Şanlıurfa Province is characterized by extremely hot, dry summers and cool, moist winters (semi-arid). According to Smith and colleagues (2003), the thermal history of a fossil is a key parameter for the survival of biomolecules. In general, fossils from cold environments will have better biomolecular preservation rates than those from hot climates (Smith et al., 2003). High temperatures promote DNA degradation, especially DNA depurination. Conventional excavation techniques (i.e. water cleaning and sun drying) subject the samples to additional thermal stress (Bollongino and Vigne, 2008).

With regard to the specimens under study, another biomolecule, collagen, was detectable only in small quantities. This is a further indication of poor sample preservation at this excavation site. Several studies have shown at least a weak correlation between DNA amplification and protein content (Colson et al., 1997; Poinar and Stankiewicz, 1999). Götherström and colleagues (2002) showed that the presence of DNA is strongly related to the crystallinity in the hydroxyapatite and to the amount of collagen. They suggested that DNA is adsorbed to and stabilized by hydroxyapatite, and that collagen is part of the complex system that preserves DNA in bone tissue (Götherström et al., 2002).

With regard to the Early Neolithic site Göbekli Tepe, the investigation of animal remains originating from deeper levels might produce better results, since these finds may have been better protected against adverse conditions of fluctuating levels of humidity and other abiotic factors. As suggested by Pruvost et al. (2007) and Bollongino and Vigne (2008), the freshly excavated bones should not be washed, but continuously cooled.

Acknowledgement

I would like to thank Prof. Dr. K. Schmidt (DAI Berlin) for the opportunity to analyze the bovid remains discussed in this study. This work was financially supported by the Deutsche Forschungsgemeinschaft (DFG project PE 424/9-1: Ungulate domestication and early animal husbandry in the Upper Euphrates basin [Prof. J. Peters, Prof. G. Grupe, Prof. H.-J. Uerpmann]).

References

Achilli, A., Bonfiglio, S., Olivieri, A., Malusà, A, Pala, M., Kashani, B.H., Perego, U.A., Ajmone-Marsan, P., Liotta, L., Semino, O., Bandelt, H.-J., Ferretti, L., Torroni, A., 2009. The multifaceted origin of taurine cattle reflected by the mitochondrial genome. PLoS ONE 4, e5753.

Anderson, S., de Bruijn, M.H.L., Coulson, A.R., Eperon, I.C., Sanger, F., Young, I.G., 1982. Complete sequence of bovine mitochondrial DNA. Conserved features of the mammalian mitochondrial genome. Journal of Molecular Biology 156, 683–717.

Bollongino, R., Edwards, C.J., Alt, K.W., Burger, J., Bradley, D.G., 2006. Early history of European domestic cattle as revealed by ancient DNA. Biology Letters 2, 155–159.

Bollongino, R., Tresset, A., Vigne, J.-D., 2008. Environment and excavation: pre-lab impacts on ancient DNA analyses. Comptes Rendus Palevolution 7, 91–98.

Bollongino, R., Vigne, J.-D., 2008. Temperature monitoring in archaeological animal bone samples in the Near East arid area, before, during and after excavation. Journal of Archaeological Science 35, 873–881.

Colson, I.B., Bailey, J.F., Vercauteren, M., Sykes, B.C., Hedges, R.E.M., 1997. The preservation of ancient DNA and bone diagenesis. Ancient Biomolecules 1, 109–117.

Edwards, C.J., MacHugh, D.E., Dobney, K.M., Martin, L., Russell, N., Horwitz, L.K., McIntosh, S.K., MacDonald, K.C., Helmer, D., Tresset, A., Vigne, J.-D., Bradley, D.G., 2004. Ancient DNA analysis of 101 cattle remains: limits and prospects. Journal of Archaeological Science 31, 695–710.

Edwards, C.J., Bollongino, R., Scheu, A., Chamberlain, A., Tresset, A., Vigne, J.-D., Baird, J.F., Larson, G., Ho, S.Y.W., Heupink, T.H., Shapiro, B., Freeman, A.R., Thomas, M.G., Arbogast, R.-M., Arndt, B., Bartosiewicz, L., Benecke, N., Budja, M., Chaix, L., Choyke, A.M., Coqueugniot, E., Döhle, H.-J., Göldner, H., Hartz, S., Helmer, D., Herzig, B., Hongo, H., Mashkour, M., Özdogan, M., Pucher, E., Roth, G., Schade-Lindig, S., Schmölcke, U., Schulting, R.J., Stephan, E., Uerpmann, H.-P., Vörös, I., Voytek, B., Bradley, D.G., Burger, J., 2007. Mitochondrial DNA analysis shows a Near Eastern Neolithic origin for domestic cattle and no indication of domestication of European aurochs. Proceedings of the Royal Society B 274, 1377–1385.

Götherström, A., Collins, M.J., Angerbjörn, A., Lidén, K., 2002. Bone preservation and DNA amplification. Archaeometry 44, 395–404.

Peters, J., Schmidt, K., 2004. Animals in the symbolic world of Pre-Pottery Neolithic Göbekli Tepe, southeastern Turkey: a preliminary assessment. Anthropozoologica 39 (1), 179–218.

Poinar, H.N., Stankiewicz, B.A., 1999. Protein preservation and DNA retrieval from ancient tissues. Proceedings of the National Academy of Sciences of the USA. 96, 8426–8431.

Pruvost, M., Schwarz, R., Correia, V.B., Champlot, S., Braguier, S., Morel, N., Fernandez-Jalvo, Y., Grange, T., Geigl, E.-M., 2007. Freshly excavated fossil bones are best for DNA amplification of ancient DNA. Proceedings of the National Academy of Sciences of the USA.104, 739–744.

Rozen, S., Skaletsky, H., 2000. Primer3 on the WWW for general users and for biologist programmers, in: Krawetz, S., Misener S. (Eds.), Bioinformatics Methods and Protocols: Methods in Molecular Biology. Humana Press, Totowa, NJ, pp. 365–386.

Schmidt, K., 2007. Sie bauten die ersten Tempel. Das rätselhafte Heiligtum der Steinzeitjäger. Die archäologische Sensation am Göbekli Tepe. 3., erweiterte und aktualisierte Auflage. Verlag C.H. Beck, München.

Smith, C.I., Chamberlain, A.T., Riley, M.S., Stringer, C., Collins, M.J., 2003. The thermal history of human fossils and the likelihood of successful DNA amplification. Journal of Human Evolution 45, 203–217.

Troy, C.S., MacHugh, D.E., Bailey, J.F., Magee, D.A., Loftus, R.T., Cunningham, P., Chamberlain, A.T., Sykes, B.C., Bradley, D.G., 2001. Genetic evidence for Near-Eastern origins of European cattle. Nature 410, 1088–1091.

Yang, D.Y., Eng, B., Waye, J.S., Dudar, J.C., Saunders, S.R., 1998. Technical note: Improved DNA extraction from ancient bones using silica-based spin columns. American Journal of Physical Anthropology 105, 539–543.

Amelie Scheu[a, b, *], *Christina Geörg*[a, b, *], *Anna Schulz*[a], *Joachim Burger*[a, *], *Norbert Benecke*[b]

The arrival of domesticated animals in South-Eastern Europe as seen from ancient DNA

[*] Corresponding authors: amscheu@uni-mainz.de; geoerg@uni-mainz.de (AS and CG contributed equally to this work); jburger@uni-mainz.de
[a] Palaeogenetics Group, Institute of Anthropology, Johannes Gutenberg-University Mainz, Germany
[b] German Archaeological Institute, Scientific Department, Berlin, Germany

Abstract

Owing to numerous archaeological, archaeozoological and molecular genetic studies, the origin of the first domestic animals – pigs, cattle, sheep and goats – has been traced back to the Near East and South-Eastern Anatolia more than 10,000 years ago. This finding has been supported by several ancient DNA studies on animal remains that stem mainly from Western, Central and Northern Europe. However, the region between Western Anatolia and the southeast of Europe is a key transitional area in the process of Neolithization and was essential to the further developments that took place in Europe. Here, we present the results of 271 successfully analysed bone samples from the first domestic animals that reached and crossed this frontier zone between Asia and Europe. Using noncoding mitochondrial DNA sequences from bone remains of the four genera *Bos*, *Sus*, *Capra* and *Ovis*, we have been able to shed light on phylogenetic and demographic patterns at the very beginning of their spread from the domestication origin towards Europe.

Keywords

ancient DNA, population genetics, Balkan, domestication, Neolithic

Introduction

Recent archaeozoological and archaeological research indicates that domestication of the first four livestock animals (goat, sheep, pig, and cattle) began in South-Western Asia about 11,000–10,000 years ago, with the small ruminants coming first in the series (Zeder, 2008). These domesticates arrived in Western Anatolia around 7,000 BC with the westward spread of the Neolithic, reached the area north of the Bosporus around 6,200 BC, and then spread along at least two different routes towards Central Europe (Boyadzhiev, 2006; Lüning, 2000; Özdoğan, 2007). Aside from the Mediterranean and the trans-Danubian routes of expansion, other routes are also conceivable; one possible route passes through the area of the Caucasus that has yielded early Neolithic sites as old as 6,000 BC (Hansen et al., 2007).

There has been longstanding debate concerning the theoretical possibility of multiple autochthonous domestication or hybridisation events of both cattle and swine in Europe, as both species lived in areas that were also populated by their wild counterparts (e.g. Bökönyi, 1974; Nobis, 1975; Rowley-Conwy, 2003). However, studies on modern and ancient mitochondrial DNA have shown no or only very limited impact of aurochs on the gene pool of Central and Northern European domesticated cattle (Edwards et al., 2007; Scheu et al., 2008). In the case of pigs, Larson et al. (2007) suggested on the basis of their study of ancient DNA that European wild boars were locally domesticated as a consequence of the introduction of Near Eastern domesticated swine and subsequently completely replaced the original Near Eastern domesticates during the Neolithic.

Unlike pigs and cattle, sheep and goats did not have wild precursors in Holocene Europe. The import of their domestic descendents during the Neolithic is therefore undisputed and hybridization events in Europe can be ruled out (Benecke, 1994; Zeder, 2008). However, a complex domestication pro-

Fig. 1 | The geographical location of the archaeological sites. 1 Abri Šan-Koba, 2 Ulucak Höyük, 3 Menteşe, 4 Kovačevo, 5 Koprivec, 6 Čavdar, 7 Samovodene, 8 Ovčarovo-Gorata, 9 Aruchlo, 10 Sofia-Slatina, 11 Aşağı Pınar and Kanlıgeçit, 12 Drama-Gerena and Drama-Merdžumekja, 13 Uivar, 14 Okolište, 15 Malkayası-Cave, 16 Pietrele, 17 Tachti Perda (Image ownership: "Ancient World Mapping Center © 2011 (www.unc.edu/awmc)" [with modification])

cess including repeated hybridizations through time remains theoretically possible in the whole ancient distribution area of wild caprines in the Near East and Anatolia (Benecke, 1994; Uerpmann, 2007).

In the following we present a summary of our ancient DNA study on all four early livestock species, addressing the essential archaeozoological questions of local domestication, inbreeding and backcrossing of wild animals, demographic processes possibly linked to human cultural developments and migrations, and differences among the four different species with respect to livestock management. We successfully analysed ancient mitochondrial DNA of 271 bone samples belonging to the genera *Bos*, *Sus*, *Capra* and *Ovis* from 19 different archaeological sites in South-Eastern Europe, Western Anatolia, Crimea and the Caucasus (see Fig. 1). The dates determined for the sites cover the time span between the earliest Neolithic and the Iron Age and are given in Table 1, together with the absolute number of samples and species per site.

Results and discussion

The domestication history of *Bos taurus*

A large number of molecular genetic studies on modern and ancient domesticated cattle (*Bos taurus*) have been carried out within the last several years. On the basis of this research, we now know that present-day European taurine cattle can be traced back to a single common origin in the Fertile Crescent. Modern mitochondrial control region sequences show a drastic decline in variability following the geographical spread of the Neolithic from areas around the putative origin of domestication towards Central Europe (Troy et al., 2001). Additionally, the low genetic mitochondrial diversity of modern Central and Western European cattle has proven not to be an artefact of recent demographic events or modern breed-

Table 1 | Dates determined for samples and the number of individuals per site and species

Archaeological site	Dating* (cal BC)	Bos taurus	Capra hircus	Sus domesticated	wild	Ovis aries
Abri Šan-Koba	7500–5300	–	–	–	5	–
Ulucak Höyük	6400–5900	7	–	6	–	1
Menteşe	around 6000	–	–	2	–	–
Kovačevo	6200–5600	15	4	3	2	7
Koprivec	6200–5800	7	–	–	2	3
Čavdar	6000–5500	4	1	3	3	1
Samovodene	5800–5300	9	–	–	4	1
Ovčarovo-Gorata	5700–5500	3	1	1	–	4
Aruchlo	5600–5300	5	–	7	–	10
Sofia-Slatina	5750–5600	–	–	3	–	–
Aşağı Pınar	5500–5000	3	13	9	1	3
Drama-Gerena	5500–5200	8	–	3	1	1
Drama-Merdžumekja	4800–4400	4	1	3	1	1
Uivar	5250–4500	9	1	1	2	3
Okolište	5100–5000	3	–	5	–	1
Malkayası-Cave	5000–4500	1	1	–	2	3
Pietrele	4450–4250	1	1	4	4	6
Kanlıgeçit	2700–2200	3	7	6	4	6
Tachti Perda	1400–700	6	6	8	–	–
Total per species **Total**	 271	88	36	64	31	52

* Dating is based on Benecke (2006), Çilingiroğlu (2009), Görsdorf and Bojadžiev (1996), Hansen et al. (2008), Hansen et al. (2009), Hofmann et al. (2007), Krauß (2008), Schier and Draşovean (2004), and personal communication with C. Çilingiroğlu, R. Gleser, R. Hofmann, R. Krauß, M. Lichardus-Itten, I. Motzenbäcker, N. Müller-Scheeßel, R. Pinhasi and W. Schier

ing strategies, as ancient domesticated bovines of the same area present a similar picture (Bollongino et al., 2006). However, exactly where, when, and how the decline in variability occurred remains unknown due to the lack of DNA sequences of ancient domesticated cattle from areas within or closer to the domestication origin. Only three sequences from South-Eastern Europe and the Caucasus have been reported so far, two from the site of Asagı Pinar in Turkish Thrace and one from Didi Gora in Georgia (Bollongino et al., 2006). Thus, to allow the comparison of the genetic variability of cattle from different geographical regions, we sequenced the mitochondrial hypervariable region I (HVR I) of 80 Neolithic to Iron Age domesticated cattle from the areas around the Black Sea. Subsequently, we grouped all novel and previously published sequences into three geographical regions: namely Central and Western Europe (33 sequences from Germany and France), South-Eastern Europe (71 sequences from Turkish Thrace, Bulgaria, Romania, Bosnia-Herzegovina) and the Caucasus (12 sequences from Georgia).

Using a 399 base pair fragment of the HVR I, we estimated standard diversity indices within and among these three geographical groups. For all three indices, a decline of diversity from the Caucasus to South-Eastern Europe (SE Europe) to Central/Western Europe (CW Europe) can be observed (exact values are given in Table 2). The large degree of difference between SE Europe and CW Europe is re-

Table 2 | Bovine haplotype diversity, nucleotide diversity, mean number of pairwise differences and F_{st}-values. Values were calculated using the ARLEQUIN v. 3 program (Excoffier et al., 2005)

Geographical areas	Haplotype diversity	Nucleotide diversity	Pairwise differences
Central/Western Europe	0.4735 ± 0.1066	0.003842 ± 0.002717	1.344697 ± 0.855112
South-Eastern Europe	0.7119 ± 0.0371	0.004232 ± 0.002810	1.616499 ± 0.968221
Caucasus	0.8333 ± 0.1002	0.007797 ± 0.005025	2.666667 ± 1.526511
	F_{st}-values (F_{st} p-values)		
Geographical areas	Central/Western Europe	South-Eastern Europe	Caucasus
Central/Western Europe	0.00000		
South-Eastern Europe	0.14914 (0.00000 ± 0.0000)	0.00000	
Caucasus	0.16177 (0.00391 ± 0.0019)	0.08136 (0.04883 ± 0.0061)	0.00000

markable, especially in the case of haplotype diversity (0.83 compared to 0.47). A calculation of the F_{ST} values among the three groups shows a genetic distance between the Caucasus and the SE European smaller than that between the SE European and the CW European samples (0.081 compared to 0.149).

Such a loss of genetic variability can be explained by population migration and expansion, i.e. demographic events that accompanied the process of Neolithization. The gradient of variability seen among the ancient samples is in general agreement with the scenario of a single domestication process in the Near East followed by the export of the domesticated cattle to the surrounding areas during the westward spread of the Neolithization process. However, the fact that the relationship between the SE European samples and the samples from the Caucasus is closer than that between the former and the CW European samples demonstrates that the genetic homogeneity in CW Europe must be due to enormous impacts from demographic events that occurred after the domesticated cattle crossed the Balkans during their movement along the trans-Danubian route of Neolithization. A link between the sudden and rapid spread of the Linear Pottery Culture (LBK) that arose north of the Balkans and the migration of cattle towards Central Europe could serve as an adequate explanation for our findings. Recent studies have demonstrated that the allele responsible for the ability to digest lactose in European adults arose in the same area around the Lake Balaton (Burger et al., 2007; Itan et al., 2009), indicating that dairying played a significant role among the earliest farmers, probably shaping the cattle genome in parallel due to immense selection pressure.

The domestication history of *Capra hircus*

Molecular genetic studies on modern mitochondrial DNA have revealed that domesticated goats (*Capra hircus*), in contrast to all other Neolithic farm animals, show extremely high genetic diversity all over the world and almost no geographical structuring (Naderi et al., 2007). It has been suggested that the structuring was lost over time through the intensive trading of the easily transportable goats after their initial domestication in Eastern Anatolia and/or the Fertile Crescent (Luikart et al., 2001; Bruford et al., 2003). If so, ancient DNA studies on samples that predate possible admixture events, like the widespread Bronze Age trade networks across the Black Sea or the Mediterranean, have the potential to detect past structuring by recovering a "Neolithic signal" like the one seen in cattle. In the only previously published ancient DNA study on 19 early Neolithic goats from the archaeological site of Baume d'Oullen in mod-

Table 3 | Caprine haplotype diversity of different chronological and geographical groups. Values were calculated using the ARLEQUIN v. 3 program (Excoffier et al., 2005)

Sample sets	# individuals	Haplotype diversity
1400–700 calBC	6	1.0000
2700–2200 calBC	7	1.0000
5000–4250 calBC	3	1.0000
5500–5000 calBC	14	0.9560 ± 0.0447
6200–5500 calBC	6	0.9333 ± 0.1217
6200–5000 calBC	19	0.9532 ± 0.0305
4500–700 calBC	17	0.9853 ± 0.0252
all circum-pontic	36	0.9667 ± 0.0168
Baume d'Oullen	19	0.6140 ± 0.0750
modern European	932	0.9903 ± 0.0012

ern-day South-Western France (Fernandez et al., 2006), mitochondrial haplotype diversity is extremely low compared to that of present-day European goats (0.61 compared to 0.99, calculated on the basis of 932 previously published modern European goat sequences). In addition to the possibility that the homogeneity among these goats is due to a small number of goats that reached Southern France following the Mediterranean route of Neolithization, one could also argue that the pattern seen at one archaeological site need not necessarily be representative of the Neolithic genetic diversity of the surrounding area. Thus a broader survey of mtDNA sequences from different geographic regions and points in time is needed in order to further investigate and compare the modern and the ancient genetic variability of goats.

In our study on 36 domesticated goats from Turkish Thrace (20), Bulgaria (7), Romania (2), Georgia (6) and Western Anatolia (1), we sequenced 130 bp of the HVRI using the same fragment analysed in the Baume d'Oullen study. The overall haplotype diversity, with no consideration of geographical or chronological groups, is 0.97 and is thus notably higher than that seen in ancient France and almost as high as that among modern European goats (exact values are given in Table 3). The comparison of chronological groups reveals an increase in haplotype diversity over time, with (for example) the Neolithic sequences dating to 6,200–5,000 cal BC being less divergent than samples less than 5,000 years old (0.95 compared to 0.99). The extremely high number of different haplotypes already present in the earliest Neolithic layers and in the geographically restricted area around the Black Sea indicates that the present-day high mtDNA diversity of goats may not result from recent worldwide admixture of animals. Instead we must assume that either a large number of goats were domesticated or wild goats were subsequently introduced into early domestic herds. One of two processes might have been responsible for the observed level of ancient mtDNA-diversity in South-Eastern Europe: i) the introduction of a large number of animals or ii) subsequent and repeated introduction of goats from different areas. The latter scenario would be consistent with the observed increase in haplotype diversity over time. Further studies are planned to estimate the effective population size of goats that arrived in SE Europe and to test whether these first goats on the European continent show genetic continuity to the modern European population or if more complex scenarios like trading and backcrossing of goats with the wild population have to be considered to explain both the ancient and modern diversity.

The domestication history of *Sus domestica*

Throughout history and to this day, managed pig herds in many places of the world (e.g. New Guinea) have been allowed to forage at will in local forests; interbreeding between wild and domestic animals occurs regularly. This circumstance and the proven introgression of Asian genetic material into the European gene pool complicate the analysis of domestication history and human-mediated dispersal of pigs (Albarella et al., 2006).

Molecular analyses has revealed a long and significant genetic distance between pigs derived from Asia and those from Europe, indicating that at least two independent domestication processes occurred in Eastern and Western Eurasia (Giuffra et al., 2000; Fang and Andersson, 2006). There is also persistent debate about the number and location of possible further domestication centres (Larson et al., 2005). It is now widely accepted that European pigs were domesticated in the Near East and then brought to Europe by immigrant famers. A genetic study conducted by Larson and colleagues using mitochondrial DNA analysis showed that Near Eastern domesticated pigs entered Europe in the Neolithic but left no genetic signature in modern breeds (Larson et al., 2007). However, there is still an ongoing debate about the processes following this introduction of Near Eastern pigs. On the one hand there could have been an additional attempt at autochthonous local domestication of the European wild boar lineages with a subsequent replacement of the imported animals, possibly as a consequence of the introduction of domesticated pigs to the European continent (Larson et al., 2007). Alternatively, the genetic pattern observed in modern European domesticated pigs, which show lineages similar to the indigenous wild boar population, could instead be due to a consistent introgression of local European wild boars into the Near Eastern stock as a consequence of interbreeding between the domestic and wild populations.

Our ancient DNA study on 510 bp of the hypervariable region of the mtDNA of 31 wild boars and 64 domesticated pigs clearly supports the assumption that domesticated animals were introduced to Europe. The mitochondrial lineages of the Neolithic domesticated pigs sampled in South-Eastern Europe are different from the lineages of the wild boars living at the same time in this area. Furthermore, the domesticated pigs sampled in Turkey belong to the same population as the domesticated pigs in the Balkans. Our subsequent finding of two Turkish wild boars from a Chalcolithic cave in the Latmos Mountains provides a first indication of the ancestral population, although a crossbreeding between the domestic and local wild boars at that time cannot be excluded. In middle Neolithic samples from Turkish Thrace we detected for the first time domestic animals that possess lineages identical to the local wild boar population, and in the late Neolithic site of Uivar there is one wild boar showing a "domestic lineage". So it seems that after an initial clear separation of domestic and wild boar populations, early farmers began to crossbreed their domestic stock with the wild boars while, at the same time, domestic pigs mixed into local wild boar populations. And possibly – as time went by over many generations – the original domestic lineages completely vanished from the population and were replaced by the original maternal wild lineages. The observation of the introgression of wild lineages is supported by the findings from the Bronze Age samples of Kanlıgeçit. However, the Neolithic pigs from the Caucasus region possess lineages different from those of both the Neolithic domestic pigs in Western parts of the Black Sea and modern domestic European pigs. In contrast, the comparison of the Neolithic domestic pigs with modern wild boars from this area showed similar mitochondrial lineages. But as we do not have ancient Neolithic wild boars living in the Caucasus, we are unable to draw a conclusion from our data about the origin of this population, possible introgression, or (local) domestication.

The domestication history of *Ovis aries*

Unlike other domesticated species, there still remains some uncertainty about the wild ancestors of *Ovis aries*. Three wild species indigenous to Eurasia can be regarded as putative progenitors to the domestic sheep: the Urial (*Ovis vignei*), the Argali (*Ovis ammon*) and the European and Asiatic moufflon (*Ovis orientalis*). The only wild form that is found in Europe today is the European moufflon, but it is now widely accepted that the moufflons found on Corsica, Sardinia and Cyprus are the feral descendants of the first domesticated sheep imported to Europe (Vigne, 1999).

The first genetic analyses of ovine mtDNA detected two main lineages in domesticated sheep (Wood and Phua, 1996; Hiendleder et al., 1998). They were termed A and B and classified by phylogeographic means as "Asiatic" and "European", respectively. Furthermore, it was shown that neither the wild species of the Urial nor the Argali have contributed to the domestic gene pool. However, the question of the wild founder population(s) remained unsolved. Recent investigations of Eurasian wild sheep point to the species of *Ovis orientalis* as the putative ancestor, but more investigations and a consistent nomenclature of the genus are needed (Hiendleder et al., 2002; Rezaei et al., 2010). When new individuals in more countries were studied, the earlier results were confirmed and three additional lineages were found and designated C–E according to the nomenclature devised by Hiendleder. Haplogroup C has been found mostly in China, but also in minor frequencies on the Iberian Peninsula and in Turkey (Guo et al., 2005; Pedrosa et al., 2007; Bruford and Townsend, 2006). The last two lineages, D and E, are very rare and have been detected only in single individuals from Turkey, Israel and the Caucasus (Tapio et al., 2006; Meadows et al., 2007). The only ancient DNA study conducted so far analysed the remains of eight sheep from China: they were all attributed to the lineage A (Cai et al., 2007). Thus all five haplogroups can be found in areas near the initial domestication centre, but genetic variability decreases with the geographic distance from this region, as has been shown for other domestic animals (see above).

The observations fit the assumptions of an initial domestication in the Near East with a subsequent dispersal of the domesticated stocks to Europe. Furthermore, it has been suggested that the proliferation and spread of just a few founder individuals is responsible for the dominance of a single maternal lineage throughout Europe. The high level of nucleotide diversity and the estimation of the divergence and expansion time between the different lineages, have led many authors to speculate that sheep were independently domesticated at least three times (Tapio et al., 2006; Meadows et al., 2007; Pedrosa et al., 2005).

The results of our palaeogenetic analysis of the mtDNA of 52 Neolithic and Bronze Age sheep samples from South-Eastern Europe, Western Anatolia and the Caucasus match the present distribution of modern day sheep lineages. The predominance of the B lineage observed in the present can also be seen in Neolithic periods in South-Eastern Europe, with only two individuals carrying the A type. In the eastern region of the Black Sea we have an admixture of three different lineages: Haplogroup A is found in slightly higher proportions than B, and one animal from the early Neolithic site of Aruchlo is a member of the D lineage. This sample from Aruchlo is the only individual in the study carrying this type. The higher variability in the Caucasian area is in accordance with the geographical closeness of this region to the initial domestication centre. In general, the low genetic variability found in European sheep today is not due to a loss of variability during the Neolithic expansion but was present already in Neolithic herds in the area around the Black Sea. Therefore, it can be assumed that just a few founder animals carrying the B lineage were imported to Europe and later proliferated within the European continent.

Summary

On the basis of our comprehensive ancient DNA study on the first four domesticated livestock species from the Balkans, Western Anatolia and the Caucasus, we gained insight into demographic processes that shaped their genetic variability in these different geographic regions over a time period of six millennia.

For cattle, the decline of diversity putatively connected to the Neolithic expansion is not gradual, but occurred in a stepwise fashion with a significant loss in the area northwest of the Balkans. We suggest a connection with the rise of the LBK culture and possibly also selective pressures due to the increasing importance of dairy farming. The small variability in sheep can already be seen among the first animals that reached South-Eastern Europe, indicating that effective population size of introduced sheep may have been very low, possibly even lower than that of cattle. Goats differ from both sheep and cattle, as genetic variability for goats was shown to be extremely high and comparable to the worldwide modern population. The reason for this could lie either in an extremely diverse and large effective founder population or in intense backcrossing with wild goats during the early stages of their domestication history. In the case of pigs, however, we found strong evidence for constant crossbreeding of domesticated pigs with the local wild boar population after their initial introduction into Europe. The original domestic lineages completely vanished and were replaced by the original local maternal wild boar lineages, probably due to sustained introgression.

Although the range of distribution of domestic goat, sheep, pig, and cattle expanded along similar or identical routes to South-Eastern and Central Europe, the gene pools of those animals were shaped in very different ways by demographic processes during the first millennia of domestication. Future research on functional markers coding for specific selected traits, such as milk and meat quality or coat colour, will allow us to reconstruct an even more detailed picture of the coexistence of humans and their farm animals after the Neolithic transition.

Acknowledgements

The project was funded by the German Archaeological Institute. The authors would like to thank S. Alpaslan-Roodenberg, C. Becker, C. Çakirlar, A. and C. Çilingiroğlu, Z. Derin, R. Gleser, S. Hansen, R. Hofmann, R. Krauß, M. Lichardus-Itten, I. Motzenbäcker, N. Müller-Scheeßel, M. Özdoğan, R. Pinhasi, S. Scharl, W. Schier and B. Weninger for providing bone material and for helpful discussions.

References

Albarella, U., Dobney, K., Rowley-Conwy, P., 2006. The Domestication of the Pig (Sus scrofa), in: Zeder, M.A., Emshwiller, E., Smith, B.D., Bradley, D.G. (Eds.), Documenting Domestication: The Intersection of Genetics and Archaeology. University of California Press, Berkeley, pp. 209–227.

Benecke, N., 1994. Der Mensch und seine Haustiere, Theiss Verlag, Stuttgart.

Benecke, N., 2006: Zur Datierung der Faunensequenz am Abri Šan-Koba (Krim, Ukraine). Beiträge zur Archäozoologie und Prähistorischen Anthropologie 5, 12–15.

Bollongino, R., Edwards, C.J., Burger, J., Alt, K.W., Bradley, D.G., 2006. Early history of European domestic cattle as revealed by ancient DNA. Biology Letters 2, 155–159.

Boyadzhiev, Y.D., 2006. The role of absolute chronology in clarifying the Neolithisation of the eastern half of the Balkan Peninsula, in: Gatsov, I., Schwarzberg, H. (Eds.), Aegean – Marmara – Black Sea: The Present State of Research on the Early Neolithic. Beier & Beran, Langenweissbach, pp. 7–14.

Bökönyi, S., 1974. History of Domestic Mammals in Central and Eastern Europe. Akadémiai Kiadó, Budapest.

Bruford, M.W., Bradley, D.G., Luikart, G., 2003. DNA markers reveal the complexity of livestock domestication. Nature Reviews 4, 900–910.

Bruford, M.W., Townsend, S., 2006. Mitochondrial DNA diversity in modern sheep, in: Zeder, M.A., Emshwiller, E., Smith, B.D., Bradley, D.G. (Eds.), Documenting Domestication: The Intersection of Genetics and Archaeology. University of California Press, Berkeley, pp. 306–316.

Burger, J., Kirchner, M, Bramanti, B, Haak, W, Thomas, M.G., 2007. Absence of the lactase-persistence associated allele in early Neolithic Europeans. Proceedings of the National Academy of Sciences of the USA 104, 3736–3741.

Cai, D.W., Han, L., Zhang, XL., Zhou, H., Zhu, H., 2007. DNA analysis of archaeological sheep remains from China. Journal of Archaeological Science 34, 1347–1355.

Çilingiroğlu, C., 2009: Central-West Anatolia at the end of 7th and beginning of 6th millennium BCE in the light of pottery from Ulucak (Izmir). Dissertation published online: http://nbn-resolving.de/urn:nbn:de:bsz:21-opus-42785.

Edwards, C.J., Bollongino, R., Scheu, A., Chamberlain, A., Tresset, A., Vigne, J.-D., Baird, J.F., Larson, G., Ho, S.Y.W., Heupink, T.H., Shapiro, B., Freeman, A.R., Thomas, M.G., Arbogast, R.-M., Arndt, B., Bartosiewicz, L., Benecke, N., Budja, M., Chaix, L., Choyke, A.M., Coqueugniot, E., Döhle, H.-J., Göldner, H., Hartz, S., Helmer, D., Herzig, B., Hongo, H., Mashkour, M., Özdogan, M., Pucher, E., Roth, G., Schade-Lindig, S., Schmölcke, U., Schulting, R.J., Stephan, E., Uerpmann, H.-P., Vörös, I., Voytek, B., Bradley, D.G., Burger, J., 2007. Mitochondrial DNA analysis shows a Near Eastern origin for domestic cattle and no indication of comestication of European aurochs. Proceedings of the Royal Society B, 1377–1385.

Excoffier, L., Laval, G., Schneider, S., 2005. Arlequin (version 3.0): An integrated software package for population genetics data analysis. Evolutionary Bioinformatics Online 1, 47–50.

Fang, M., Andersson, L., 2006. Mitochondrial diversity in European and Chinese pigs is consistent with population expansions that occurred prior to domestication. Proceedings of the Royal Society B, 273, 1803–1810.

Fernández, H., Hughes, S., Vigne, J.-D., Helmer, D., Hodgins, G., Miquel, C., Hänni, C., Luikart, G., Taberlet, P., 2006. Divergent mtDNA lineages of goats in an Early Neolithic site, far from the initial domestication areas. Proceedings of the National Academy of Sciences of the USA 103 (42), 15375–15379.

Giuffra, E., Kijas, J.M., Amarger, V., Carlborg, O., Jeon, J.T., Andersson, L., 2000. The origin of the domestic pig: independent domestication and subsequent introgression. Genetics 154, 1785–1791.

Görsdorf, J., Bojadžiev, J., 1996. Zur absoluten Chronologie der bulgarischen Urgeschichte. Berliner 14C-Datierungen von bulgarischen archäologischen Fundplätzen. Eurasia Antiqua 2, 105–173.

Guo, J., Du, L.X., Ma, Y.H., Guan, W.J., Li, H.B., Zhao, Q.J., Li, X., Rao, S.Q., 2005. A novel maternal lineage revealed in sheep (Ovis aries). Animal Genetics 36, 331–336.

Hansen, S., Mirtskhulava, G., Bastert-Lamprichs, K., Benecke, N., Gatsov, I., Nedelcheva, P., 2007. Aruchlo 2005–2006. Bericht über die Ausgrabungen in einem neolithischen Siedlungshügel. Archäologische Mitteilungen aus Iran und Turan 38, 1–34

Hansen, S., Toderaş, M., Reingruber, A., Gatsov, I., Klimscha, F., Nedelcheva, P., Neef, R., Prange, M., Price, T.D., Wahl, J., Weniger, B., Wrobel, H., Wunderlich, J., Zidarov, P., 2008. Der Kupferzeitliche Siedlungshügel M052gura Gorgana bei Pietrele. Ergebnisse der Ausgrabungen im Sommer 2007. Eurasia Antiqua 14, 19–100.

Hansen, H., Mirtskhulava, G., Bastert-Lamprichs, K., Görsdorf, J., Neumann, D., Ullrich, M., Gatsov, I., Nedelcheva, P., 2009. Aruchlo 2007. Bericht über die Ausgrabungen im neolithischen Siedlungshügel. Archäologische Mitteilungen aus Iran und Turan 39, 1–31

Hiendleder, S., Kaupe, B., Wassmuth, R., Janke, A., 2002. Molecular analysis of wild and domestic sheep questions current nomenclature and provides evidence for domestication from two different subspecies. Proceedings of the Royal Society B 269, 893–904.

Hiendleder, S., Mainz, K., Plante, Y., Lewalski, H., 1998. Analysis of mitochondrial DNA indicates that domestic sheep are derived from two different ancestral maternal sources: no evidence for contributions from urial and argali sheep. Journal of Heredity 89, 113–120.

Hofmann, R., Kujundžić-Vejzagić, Z., Müller, J., Müller-Scheeßel, N., Rassmann, K., 2007. Prospektionen und Ausgrabungen in Okolište (Bosnien-Herzegowina): Siedlungsarchäologische Studien zum zentralbosnischen Spätneolithikum (5300–4500 v.Chr.). Berichte der Römisch-Germanischen Kommission 86, 41–212.

Itan, Y., Powell, A., Beaumont, M.A., Burger, J., Thomas, M.G., 2009. The origins of lactase persistence in Europe. PLoS Computational Biology 5, e1000491.

Krauß, R., 2008. Karanovo und das südosteuropäische Chronologiesystem aus heutiger Sicht. Eurasia Antiqua 14, 117–150.

Larson, G., Dobney, K., Albarella, U., Fang, M., Matisoo-Smith, E., Robins, J., Lowden, S., Finlayson, H., Brand, T., Willerslev, E., Rowley-Conwy, P., Andersson, L., Cooper, A., 2005. Worldwide phylogeography of wild boar reveals multiple centers of pig domestication. Science 307, 1618–1621.

Larson, G., Albarella, U., Dobney, K., Rowley-Conwy, P., Schibler, J., Tresset, A., Vigne, J.D., Edwards, C.J., Schlumbaum, A., Dinu, A., Balacsescu, A., Dolman, G., Tagliacozzo, A., Manaseryan, N., Miracle, P., Van Wijngaarden-Bakker, L., Masseti, M., Bradley, D.G., Cooper, A., 2007. Ancient DNA, pig domestication, and the spread of the Neolithic into Europe. Proceedings of the National Academy of Sciences of the USA 104, 15276–15281.

Luikart, G., Gielly, L., Excoffier, L., Vigne J.-D., Bouvet, J., Taberlet, P., 2001. Multiple maternal origins and weak phylogeographic structure in domestic goats. Proceedings of the National Academy of Sciences of the USA 98 (10), 5927–5932.

Lüning, J., 2000. Steinzeitliche Bauern in Deutschland – die Landwirtschaft im Neolithikum. Verlag Rudolf Habelt GmbH, Bonn.

Meadows, J.R., Cemal, I., Karaca, O., Gootwine, E., Kijas, J.W., 2007. Five ovine mitochondrial lineages identified from sheep breeds of the Near East. Genetics 175, 1371–1379.

Naderi, S., Rezaei H.-R., Taberlet, P., Zundel, S., Rafat, S.-A., Naghash, H.-R., El-Barody M.A.A., Ertugrul, O., Pompanon, F., 2007. Large-scale mitochondrial DNA analysis of the domestic goat reveals six haplogroups with high diversity. PLoS ONE 10, e1012.

Nobis, G., 1975. Zur Fauna des ellerbekzeitlichen Wohnplatzes Rosenhof in Ostholstein I. Schriften des Naturwissenschaftlichen Vereins Schleswig-Holstein 45, 5–30.

Özdoğan, M., 2007. Von Zentralanatolien nach Europa. Die Ausbreitung der neolithischen Lebensweise, in: Lichter, C. (Ed.), Vor 12000 Jahren in Anatolien. Die ältesten Monumente der Menschheit. Badisches Landesmuseum Karlsruhe. Theiss Verlag, Stuttgart, pp. 150–165

Pedrosa, S., Uzun, M., Arranz, J.J., Gutierrez-Gil, B., San, P.F., Bayon, Y., 2005. Evidence of three maternal lineages in Near Eastern sheep supporting multiple domestication events. Proceedings of the Royal Society B 272, 2211–2217.

Pedrosa, S., Arranz, J.J., Brito, N., Molina, A., San, P.F., Bayon, Y., 2007. Mitochondrial diversity and the origin of Iberian sheep. Genetics Selection Evolution 39, 91–103.

Rezaei, H.R., Naderi, S., Chintauan-Marquier, I.C., Taberlet, P., Virk, A.T., Naghash, H.R., Rioux, D., Kaboli, M., Pompanon, F., 2010. Evolution and taxonomy of the wild species of the genus Ovis (Mammalia, Artiodactyla, Bovidae). Molecular Phylogenetics and Evolution 54, 315–326.

Rowley-Conwy, P., 2003. Early domestic animals in Europe: Imported or locally domesticated? In: Ammerman, A.J., Biagi, P. (Eds.), The Widening Harvest. The Neolithic Transition in Europe: Looking back, looking forward. Archaeological Institute of America, Boston, pp. 99–117.

Scheu, A. Hartz, S., Schmölcke, U., Tresset, A., Burger; J., Bollongino, R., 2008. Ancient DNA provides no evidence for independent domestication of cattle in Mesolithic Rosenhof, Northern Germany. Journal of Archaeological Science 35, 1257–1264.

Schier, W. and Draşovean, F., 2004. Vorbericht über die rumänisch-deutschen Prospektionen und Ausgrabungen in der befestigten Tellsiedlung von Uivar, jud. Timiş, Rumänien (1998–2000). Prähistorische Zeitschrift 79, 145–230

Tapio, M., Marzanov, N., Ozerov, M., Cinkulov, M., Gonzarenko, G., Kiselyova, T., Murawski, M., Viinalass, H., Kantanen, J., 2006. Sheep mitochondrial DNA variation in European, Caucasian, and Central Asian areas. Molecular Biology and Evolution 23, 1776–1783.

Troy, C.S., MacHugh, D.E., Bailey, J.F., Magee, D.A., Lotfus, R.T., Cunningham, P., Chamberlain, A.T., Sykes, B.C., Bradley, D.G., 2001. Genetic evidence for Near-Eastern origins of European cattle. Nature 410, 1088–1091.

Uerpmann, H.-P., 2007. Von Wildbeutern zu Ackerbauern – Die Neolithische Revolution der menschlichen Subsistenz. Mitteilungen der Gesellschaft für Urgeschichte 16, 55–74.

Vigne, J.D., 1999. The large "true" mediterranean islands as a model for the holocene human impact on the european vertebrate fauna? Recent data and new reflections, in: Benecke, N. (Ed.), The Holocene History of the European Vertebrate Fauna. Modern aspects of research. Verlag Marie Leidorf GmbH, Rahden/Westfalen, pp. 295–322.

Wood, N.J., Phua, S.H., 1996. Variation in the control region sequence of the sheep mitochondrial genome. Animal Genetics 27, 25–33.

Zeder, M., 2008. Domestication and early agriculture in the Mediterranean Basin: Origins, diffusion, and impact. Proceedings of the National Academy of Sciences of the USA 105(33), 11597–11604.

*Lars Fehren-Schmitz**

Population dynamics, cultural evolution and climate change in pre-Columbian western South America

* Historical Anthropology and Human Ecology, Johann-Friedrich-Blumenbach Department of Zoology and Anthropology, University Goettingen, Germany: lfehren @gwdg.de

Abstract

This paper reports on an archaeogenetic study that was embedded in a transdiciplinary research project with the principal aim of understanding the cultural development in pre-Columbian Southern Peru. Ancient DNA analyses were conducted on over 300 pre-Columbian individuals from various archaeological sites in coastal Southern Peru and the Andean highlands, from periods ranging from the middle Formative Period (approx. 1000 BC) to the end of the Late Intermediate Period (approx. AD 1400). The data obtained were compared against a large set of data on contemporary and ancient South American populations to reveal biological affinities across the southern Andes and, more broadly, on the continental level, and contextualized with the archaeological and palaeoecological record.

The results, albeit preliminary, shed light on population-dynamic processes accompanying cultural transformations in several archaeological periods. Changes in socioeconomic complexity and ecological alterations seem to have influenced migrational behaviour and the genetic diversity of the prehistoric central Andean populations. On the continental scale the results point to a discrete initial peopling of the western South American coast and the Andean highlands.

Keywords

Ancient DNA, Nasca, Paracas, population genetics, mitochondrial DNA, cultural change

Introduction

Central western South America offers the perfect conditions for the study of the reciprocal effects of cultural, ecological and population-dynamic processes. The pre-Columbian cultural landscape is characterized by two adjacent main cultural areas with extremely different ecological conditions: the Pacific Coast, including the western slopes of the Andes, and the Andean Highlands. Within a time span of approximately 13,000 years (Dixon, 2001; Dillehay, 2009) the two areas witness the transition from small nomadic groups to sedentism, the evolution of complex societies and even states. These developments are the results of complex patterns of interaction between the two areas, with constantly altering reciprocal interferences, and changes in the intensity and direction of cultural transmission. To what extent these cultural processes were accompanied or influenced by population-dynamic processes and alterations of mobility patterns and even gene flow is a question that remains for the most part unanswered.

I report on an archaeogenetic study that was embedded in a transdisciplinary research project with the principal aim of understanding the cultural development in pre-Columbian Southern Peru. The research area forms a transect of about 100 km spanning from the Pacific coast to the highlands, with levels of elevation ranging from 0 to 4500 above sea level, and thus traversing the main cultural areas and a multitude of different ecological zones. Ancient DNA analyses were conducted on over 300 pre-Columbian individuals from various cemeteries in the Palpa area, the Rio Grande estuary, the Paracas-Peninsula, and the adjacent Andean highlands (Fig. 1), from periods ranging from the Formative Period to the Late Intermediate Period (LIP) to reveal the population dynamics in this settlement chamber in a timeframe of approx. 2,200 years. The data obtained were compared against a large dataset on contemporary and ancient South American populations to reveal biological affinities across the Andes and,

Fig. 1 | Map of the research area in southern Peru. Numbers indicate the sampling areas: 1 Palpa; 2 Upper Valleys – Highlands; 3 Monte Grande; 4 Paracas Peninsula (Copyright / source of the map: German Archaeological Institute (DAI) 2002–2011)

more broadly, on the continental level, and contextualized with the rich basis of archaeological and ecological data from our transdisciplinary research project.

The following two sections will give a brief introduction to the genetics of indigenous South American populations and the observations of archaeology and palaeoecology.

The indigenous population of South America

Despite the richness of their cultures and the richness of the environments that they inhabit, the Native Americans harbour a relatively low level of genetic diversity. Nearly all Native American mtDNA haplotypes belong to one of four ancestral lineages, the mt haplogroups designated A, B, C, and D (Torroni et al., 1993). These lineages are widely found throughout the Americas, but there is a lot of variation in frequencies among populations and geographic regions. A fifth founding mitochondrial haplogroup, des-

ignated X, is found only in indigenous populations of northern North America (Dornelles et al., 2005). All of those five major matrilineages (mt haplogroups) were represented by only one (Schurr and Sherry, 2004) or a few (Kemp et al., 2007; Tamm et al., 2007; Perego et al., 2009; Malhi et al., 2010) sublineages (mt haplotypes) in the initial founding population. The mt haplogroups are definitely of Asian ancestry, and the genetic data indicate that the ancestral source population probably originated in south-central Siberia, from whence it migrated to Beringia and then into the New World (Schurr and Sherry, 2004). According to the current state of knowledge, the most parsimonious model from genetic data features a single initial migration with relatively few individuals about 20,000–14,000 years ago along a Pacific coastal route (Merriwether et al., 1995; Schurr and Sherry, 2004; Lewis et al., 2007a) and maybe a second wave later following the ice-free corridor (Perego et al., 2009), maintaining recurrent gene flow with Asia following the initial peopling (Ray et al., 2010). With respect to Y-chromosomal DNA, most male Native Americans belong to one of the two principal founding lineages C and Q (nomenclature: Y-Chromosome Consortium 2002). The haplogroup Q1a3a* (formerly Q-M3) is the most frequent in Native South American males, at 77% (Bortolini et al., 2003; Karafet et al., 2008).

There is compelling archaeological and genetic evidence to suggest that South America had been peopled by 14–13,000 BP (Dillehay, 1999; Fuselli et al., 2003). Recent genetic comparison of modern Native American populations from all over South America show that although there are regional differences in the patterns of genetic variation, the low overall variance among these regions gives no evidence for several migrational waves (Lewis et al., 2007a; Lewis, Jr., 2009). Although this most parsimonious interpretation is therefore that the continent was peopled by one founding population, the exact routes they followed, and whether the wave split into different groups when passing the Isthmus of Panama, remain unknown (Lalueza et al., 1997; Keyeux et al., 2002; Lewis et al., 2007b). In the past, the classic assumption was that eastern and western South America show different grades of genetic diversity (Fuselli et al., 2003; Lewis, Jr. et al., 2005; Lewis, Jr. and Long, 2008). Although newer studies based on autosomal DNA haven proven that diversity in the two regions is comparable and that previous studies suffered from sampling biases (Lewis, Jr., 2009), the complex patterns of diversity observed are far from being understood. There is a very specific regional distribution of mitochondrial haplogroup frequencies (Fig. 2) and a high frequency of mt haplotypes that are unique and not shared among different regions. When concentrating on western South America there is a gradient with high frequencies of Haplogroup A in the north-west, followed by the predominance of Haplogroup B throughout the Central Andean area, and D in southernmost South America.

The number of palaeogenetic studies conducted for South America is still small. Only recently has there been an increased interest in palaeogenetic studies of pre-Columbian Central Andean populations from the coast (Shimada et al., 2004; Moraga et al., 2005; Fehren-Schmitz et al., 2009; Fehren-Schmitz et al., 2010) and the highlands (Shinoda et al., 2006; Lewis et al., 2007a; Kemp et al., 2009; Carnese et al., 2009; Fehren-Schmitz et al., 2011).

Archaeology and ecology of the Palpa region

Beginning with the Middle Archaic Period (3800 BC), the archaeological record in the Palpa region provides evidence of a nearly continuous occupation until the Late Horizon (AD 1400–1532), represented by the Inca culture. The earliest definitely permanent settlement structures date to the Initial Period (1800–800 BC). With the Early Horizon (800–200 BC), there is a continuous increase in the number of

Fig. 2 | Gradient map showing the continental mt-haplogroup frequency distribution in South America. The white line indicates the major expansion of the Inca Empire. The map is based on haplogroup data on 198 modern indigenous populations (Fehren-Schmitz, 2008) and was drawn using MapViewer™, employing the Kriging mode of interpolation

sites in the Palpa region and, with that, in settlement density. The Early Horizon of the Peruvian south coast is characterized by the Paracas culture (Tello, 1959) described by the ceramic inventories from the Ica Valley (Menzel et al., 1964) about 80 km north of Palpa. It has been possible to attest to the presence of the Paracas culture in the region over the whole Early Horizon through archaeological evidence from excavations and field surveys in the Palpa valleys (Reindel and Isla-Cuadrado, 2003; Isla Cuadrado and Reindel, 2003; Reindel et al., 2004; Reindel and Isla-Cuadrado, 2006), challenging the earlier hypothesis that the spatial extension of the Paracas culture did not reach the Rio Grande de Nasca until the late phases (Silverman, 1994). The detection of Paracas sites in the northern heartlands of the Nasca culture contravenes previously formulated hypotheses of Nasca origin. It is commonly stated that the Nasca tradition evolves out of the Paracas culture (Menzel et al., 1964; Silverman and Proulx, 2002). The fact that, until recently, there was little to no evidence for Paracas occupation in the main territory of the Nasca culture (Orefici, 1996; Schreiber and Lancho Rojas, 2003; Vaughn and Gijseghem, 2007) was interpreted as evidence that the Nasca culture did not emerge autochthonously in the Rio Grande drainage. It was postulated that in the Late Paracas period people migrated from the Ica area into the Rio Grande de Nasca drainage, where they accounted for the formation of the Proto Nasca culture (ca. 200 BC–AD 60 [Silverman, 1994]). The archaeological evidence from the Palpa region, along with the discovery of petroglyphs and geoglyphs in the Palpa area dating to the Early Horizon, was interpreted by Reindel et al. (2004) as proving that the Nasca culture developed autochthonously in the Rio Grande drainage.

Palaeoecologic data show that both the flourishing of the early Nasca and the development of irrigation systems correlate with increasing aridity and slight aggravation of the ecological conditions for the inhabitants of the south coast valleys (Eitel et al., 2005). A great number of sites have been detected for the Early and Middle Nasca phases. In addition to numerous rural settlements, two large (urban) settlement centres, with planned layout, central buildings and other characteristics of formal settlements, have been excavated in the Palpa valleys (Reindel and Isla-Cuadrado, 2001). The multilevel hierarchy settlement patterns observed, the complex cultural landscape, and the large elite burials encountered in La Muña indicated that the Nasca reached a far higher grade of political organization than had previously been assumed (Isla-Cuadrado and Reindel, 2006).

During the Late Nasca Period (A.D. 430–600) the number of sites in the Palpa region starts to decrease. Previous hypotheses assumed that the decline of the Nasca culture may have been caused by the militaristic expansion of the Wari from the Central Andean highlands at the beginning of the Middle Horizon (Allison, 1979). There is no evidence in the archaeological record in Palpa for an increased foreign impact or warlike activities that would justify the assumption of invasion or elite dominance scenarios. In the Middle Horizon (A.D. 600–1000) the Palpa region was nearly abandoned (Reindel and Isla-Cuadrado, 2000). The palaeoecologic data show that with the Late Nasca period came a major increase in aridity, causing the desert margin to shift eastward. Based on these observations, Eitel and Mächtle (2006) postulate that the end of Nasca was caused by the deterioration of ecological conditions and desertification of the settlement area.

This situation changed again around AD 1000 when climatic conditions became more humid (Eitel and Mächtle, 2009) and population density increased considerably. People concentrated in large habitation sites like Ciudad Perdida and population numbers must have equalled those of Early Nasca times. Beginning in 1400, as the prehispanic period drew to a close, climatic conditions again became dryer and the number of settlements in the area decreased to a minimum (Reindel and Gruen, 2006).

Table 1 | Sampled archaeological sites tabulated by site and chronological period

Site	Area	n (total)	Early Horizon	Early Intermediate Period	Middle Horizon	Late Intermediate Period
Chillo	Foothills (Palpa)	20				20
Hanaq Pacha	Foothills (Palpa)	21		19	2	
Jauranga	Foothills (Palpa)		69	48	21	
Los Molinos	Foothills (Palpa)	42		27	15	
La Muna	Foothills (Palpa)	7		7		
Mollake Chico	Foothills (Palpa)	14	10	4		
Pernil Alto	Foothills (Palpa)	20	5	15		
Botigiriayocc	Upper Valleys	15				15
Huayuncalla	Upper Valleys	8				8
Layuni	Upper Valleys	10				10
Ocoro	Upper Valleys	10			10	
Pacapaccari	Upper Valleys	16				16
Yacotogia	Upper Valleys	31			31	
Monte Grande	Coast	35		15		20
Caverna 6	Paracas Peninsula	12	12			
Total		330	75	108	58	89

Materials and methods

Samples

Bone and teeth samples from 350 skeletons or mummified human individuals were collected in several field campaigns (2004–2009). Of those, 193 were from various archaeological sites in the Andean foothills (Chala ecological zone) around the modern city of Palpa. The Palpa samples were collected from chronologically varying sites, allowing the investigation of a timeframe stretching from the Formative period (approx. 1000 BC) to the Late Intermediate Period (LIP: AD 1000–1400). Sites with burials from more than one archaeological phase were preferred, in order to reveal population continuities or discontinuities. An additional 90 individuals were sampled from sites dating to the MH and LIP located in the upper valleys of the Rio Palpa and Rio Viscas, directly adjacent to the Andean Puna at an altitude of approximately 3000–4000 m – Quechua and Suni ecological zones (Pulgar-Vidal, 1979) – in the environs of the modern town of Laramate, 50 km to the east of Palpa. Forty individuals (EIP and LIP) derive from the coastal site Monte Grande, located at the Rio Grande estuary, and additionally, 12 individuals derive from the Early Horizon coastal site Paracas Caverna 6, Paracas Peninsula, 150 km north of Palpa. Sampled sites, their chronological classifications, and the number of sampled individuals sampled from each site for each chronological period are listed in Table 1. All samples were acquired under strict observance of the established precautions for ancient DNA studies (Bollongino et al., 2008). Material was immediately sealed to prevent contamination and documented anthropologically before being exported to our laboratories in Germany with the permission of the Institute of Peruvian Cultural Heritage. The preparation of the bone and tooth samples for DNA extraction followed a standardized protocol (Hummel, 2003) and was performed in facilities dedicated solely to ancient DNA research (SAM-LAB). DNA

extractions were conducted utilizing a new protocol combining complete demineralization (Loreille et al., 2007), DNA binding to silica (Rohland and Hofreiter, 2007), and automated purification (Fehren-Schmitz et al., 2010). Further information on the methods and protocols used to extract DNA from the ancient specimens are described in Fehren-Schmitz et al. (2010, 2011).

Additionally, published comparative haplogroup frequency and sequence data from over 5000 individuals of modern and ancient Native South American populations were obtained. A complete listing of all populations considered has been published by the present author (Fehren-Schmitz, 2008).

Genetic markers

The studies presented here were mainly based on the analysis of mtDNA, and hence of matrilinear population dynamics. Further investigations concerning y-chromosomal binary markers (y-chromosomal haplogroups; Fehren-Schmitz et al., 2011), autosomal STRs (genetic fingerprints) and chromosomal markers associated with birth weight, adaptation to highland habitats and other issues of anthropological genetics are still in process.

To type the mitochondrial haplotypes, we analyzed a 388 bp fragment of the mitochondrial HVR I (nucleotide position 16021–16408 relative to the revised Cambridge reference sequence (rCRS) [Andrews et al., 1999]) employing an analysis system consisting of eight primers generating overlapping PCR products. The generated PCR products were further analyzed by direct sequencing. For information regarding analysis parameters, protocols, primer sequences and PCR conditions see the work of Fehren-Schmitz and colleagues (2010). In addition to the analysis of the mitochondrial haplogroups based on specific HVR I polymorphisms, we analyzed four specific polymorphisms of the mitochondrial coding region, determining the groups A, B, C, and D (Fig. 2). Three of the groups – A, C, and D – are characterized by SNPs (single base transversions or transitions) and Group B is characterized through a 9 bp deletion at nucleotide position (np) 8272–8280 of the mitochondrial genome (Merriwether et al., 1995). Additional polymorphisms determining the main groups M, N, R, L3 were typed together with the four polymorphisms described above in a multiplex SBE assay to discriminate between possible contaminating sequences and authentic sequences (Fehren-Schmitz et al., 2011). This twofold analysis system for mt-haplogroups was developed to authenticate results due to the high risk of false determinations associated with the possibility of rapidly evolving mutational hotspots at the HVR I and miscoding lesions caused by postmortem DNA damage (Meyer et al., 1999; Willerslev and Cooper, 2005; Gilbert et al., 2007). Both methods were used on the same DNA extracts. For every sample there were at least two independent extracts. For further information refer to Fehren-Schmitz et al. (2011).

Standard genetic diversity indices, interpopulation distances, population structure, and other population genetic standard parameters were calculated for all populations analyzed, employing the Arlequin software package (version 3.1, Excoffier et al., 2005). Exact tests of haplogroup and haplotype frequency differences were also conducted for all populations (Schneider and Excoffier, 1999). Similarities between populations and across time periods were graphically assessed using Principal Component Analysis (PCA), and Multi Dimensional Scaling (MDS), and distance-based phylogenetic trees and MJ-networks from sequence data were calculated using the Mega 4.0 software (Tamura et al., 2007) and Network 4.5 (Bandelt et al., 1999). Further information regarding the population genetic analyses and detailed results have already been published (Fehren-Schmitz, 2008; Fehren-Schmitz et al., 2009; Fehren-Schmitz et al., 2010; Fehren-Schmitz et al., 2011).

Fig. 3 | Mitochondrial haplogroup frequencies observed in the studied ancient populations grouped by geographical and chronological context

Results

To date it has been possible to reproducibly determine the mt haplogroups of 220 individuals (63 %), through the analysis of coding region polymorphisms, and to obtain the mt haplotypes (complete 388 bp HVR I sequence) of 201 individuals (57 %) from a total of 350 individuals sampled in the project. The successfully analyzed samples represent the entire range of archaeological sites and periods that have been sampled (cf. Table 1). Amplification of chromosomal DNA has thus far been successful for 25 individuals (Fehren-Schmitz et al., 2011; Fehren-Schmitz, 2008), most of whom were from the highland sites, but the chromosomal investigations have only just begun and all results are preliminary.

Generally it can be stated that the quality of DNA preservation found in the individuals from the highland sites proved better than that in the individuals from desert burials. The burial environment encountered in the chullpas and burial caves, where most of the highland samples were collected, is characterized by a stable level of humidity and temperature. The bones in such sites have only little soil contact. These conditions have proven to be very good for DNA preservation in other studies (Burger et al., 1999). The poorer DNA preservation in the Palpa area may be explained in part by higher temperature and soil pH-value, but it may also be due to the changes in environmental conditions over time (Eitel and Mächtle, 2006) and the associated changes in storage conditions of the region.

All successfully typed individuals belong to one of the four Native American haplogroups A, B, C and D, with the findings independently confirmed through the coding region polymorphisms and HVR I sequences. The haplogroup distribution of the studied pre-Columbian populations, grouped by prov-

Fig. 4 | PCA plot based on the mt-haplogroup frequencies (cf. Table 2) of the studied ancient populations and of previously published ancient and modern South American populations. (ASC-EH = ancient south coast, Early Horizon; ASC-EIP = ancient south coast, Early Intermediate Period; ASC-MH = ancient south coast, Middle Horizon; ASC-LIP = ancient south coast, Late Intermediate Period; ANC-MH = ancient north coast, Middle Horizon; SMC = southern Middle Chile; TdF = Tierra del Fuego; AH-MH = ancient highlands, Middle Horizon; AH-LIP = ancient highlands, Late Intermediate; AH-SH = ancient highlands, Late Horizon; NCA = northern Central Andean area; SCA-Qu = southern Central Andean area – Quechua; SCA-Ay = southern Central Andean area – Aymara; GCH = Gran Chaco; BOL = Bolivian Lowlands; AMA = Amazonia; NCO = Northern Colombia)

enance and chronological context, is shown in the histogram (Fig. 3). The EIP Nasca populations of the Palpa area are further subdivided into rural and urban (Los Molinos, La Muna) settlement associations. Haplogroup D (60–70 %) is predominant in the coastal Paracas and rural Nasca populations, followed by Haplogroup C. Haplogroup B, predominant in the MH and LIP highland populations (55–57 %), first appears in the coastal populations in the EIP with low frequencies (11–18 %). High frequencies of the groups D and C persist in the coastal populations into the MH but in the LIP the observed mitochondrial haplogroup distribution in the coastal populations (coast and Palpa area) changes completely, now exhibiting high frequencies of Group B (50–60 %), rendering it similar to the highland populations in that respect. The haplogroup frequencies of the ancient populations under study were compared to a large dataset on other ancient and modern Native South American populations. Comparison results are displayed in a PCA plot based on pairwise F_{ST} derived from frequency data (Fig. 4). The populations clearly group into two clusters separated by the first PCA. One cluster is made up of the ancient EH to MH Peruvian south coast populations, a MH north coast population (Shimada et al., 2004) and the modern

Table 2 | Mitochondrial haplogroup frequencies and haplotype diversity (HD) for the analyzed pre-Columbian and the ancient and modern Native South American reference populations

Group	Population	Date	n[a]	H[b]	A	B	C	D	Hd[c]
Ancient coast	South Coast (Peninsula)[1]	EH	10 (6)	5	0.00	0.00	0.30	0.70	0.93
	South Coast (Palpa)[1]	EH	28(25)	15	0.07	0.00	0.14	0.79	0.95
	Nasca-Rural (Palpa)[1]	EIP	37(30)	26	0.02	0.11	0.22	0.65	0.98
	Nasca-Urban (Palpa)[1]	EIP	28(25)	17	0.00	0.18	0.43	0.39	0.97
	South Coast (Palpa)[1, 15]	MH	11	9	0.00	0.27	0.36	0.36	0.95
	South Coast[15]	LIP	22 (25)	16	0.08	0.52	0.24	0.16	0.97
	North Coast[2]	MH	(36)	n.d.	0.19	0.22	0.06	0.31	n.d.
Ancient highlands	Ancient Upper Valleys [3]	MH	27(30)	13	0.07	0.57	0.37	0.00	0.91
	Ancient Upper Valleys [3]	LIP	38(42)	25	0.05	0.55	0.31	0.10	0.97
	Conchapata[4]	MH	10	9	0.29	0.50	0.14	0.07	0.98
	Chen Chen[5]	MH	(23)	n.d.	0.39	0.39	0.17	0.04	n.d.
	Huari[4]	LIP	17	12	0.17	0.22	0.55	0.06	0.94
	Paucarcancha[6]	LH	(35)	n.d.	0.09	0.66	0.23	0.03	n.d.
Northern Colombia	Chibchan[7]	.	80	7	0.81	0.01	0.18	0.00	0.68
	Arawaken[7]		29	4	0.28	0.28	0.44	0.00	0.77
Northern Peru	Ancash[8]		33	27	0.09	0.52	0.18	0.21	0.98
	San Martin[9]		21	14	0.10	0.57	0.05	0.29	0.93
	Tupe[10]		16	9	0.00	0.69	0.31	0.00	0.87
	Yungay[10]		36	20	0.03	0.47	0.36	0.14	0.95
Southern Peru	Arequipa[9]		22	18	0.09	0.68	0.14	0.09	0.98
	Puno (Quechua)[10]		30	22	0.07	0.60	0.23	0.10	0.97
	Puno (Aymara)[10]		14	11	0.00	0.71	0.14	0.14	0.97
	Tayacaja [9]		59	40	0.22	0.34	0.31	0.13	0.96
South Middle Chile	Mapuche[11]		34(111)	9	0.00	0.07	0.44	0.49	0.84
	Pehuenche[11]		24(105)	13	0.03	0.11	0.41	0.46	0.90
Tierra del Fuego	Yaghan[11]		15 (21)	7	0.00	0.00	0.48	0.52	0.88
Amazonia	Gaviao[12]		27	7	0.15	0.15	0.00	0.70	0.87
	Xavante[12]		25	4	0.16	0.84	0.00	0.00	0.68
	Yanomamö[13]		155	6	0.00	0.56	0.32	0.12	0.66
	Zoro[12]		30	9	0.20	0.07	0.13	0.60	0.77
Gran Chaco	Gran Chaco (Pool)[14]		204	46	0.16	0.42	0.13	0.28	0.94

References: [1]Fehren-Schmitz et. al. 2010; [2]Shimada et al. 2004; [3]Fehren-Schmitz et al. 2011; [4]Kemp et al. 2009; [5]Lewis et. al. 2007b; [6]Shinoda et al. 2006; [7]Carnese et al. 2010; [8]Lewis et al. 2004; [9]Fuselli et al. 2003; [10] Lewis et al. 2007a; [11]Moraga et al. 2000; [12]Ward et al. 1996; [13]Williams et al. 2002; [14]Cabana et al. 2006; [15] Fehren-Schmitz (unpublished data)

a n = Number of individuals with successful haplogroup determination. The number of individuals with successfully determined mt-Haplotypes follows in brackets
b H = Number of determined different haplotypes in the population
c Hd = Haplotype diversity (Nei 1987). The value relates to the HVR I sequence data not to the haplogroup data

Fig. 5 | Mt-haplotypes (nonfounding) shared between the four main research areas in southern Peru. The colours of the arrows distinguish between the archaeological periods where shared haplotypes occur (blue= Early Horizon (Paracas); green= Early Intermediate period (Nasca); red= Late Intermediate period)

indigenous populations of southern Middle Chile (e.g. Mapuche, Pehuenche) and Tierra del Fuego. The other cluster consists of the ancient Peruvian highland populations, and modern Central Andean, Amazonian and Gran Chaco populations, plus the LIP populations from the Peruvian south coast. The second PCA mainly distinguishes the northern Colombian population from the rest of the South American populations.

The HVR I sequence data from the 201 successfully typed individuals could be assigned to 106 mitochondrial haplotypes (H). A summary of the analysed mt haplotypes spanning 388 bp of the HVR I (np 16021–16408) and of their distribution over the different sites and chronological periods has been published by the present author and colleagues (2008, 2010, 2011). The Native American founding haplotypes A2, B2, C1 and D1 (Tamm et al., 2007) are the most frequent for every haplogroup. Overall there are 59 singleton haplotypes in the whole dataset. The others are shared synchronously between different sampled archaeological sites or diachronically between periods in the geographic region (Fig. 5). Distinct haplotypes – different from the founding haplotypes – are shared between the coastal EH populations from Palpa and the Peninsula, and the EH, rural and urban EIP, and MH populations in the Palpa area. One individual from the elite burials of La Muna also shares a distinct group C haplotype with two individuals from sites associated with rural settlements. The MH and LIP highland sites also share several

Fig. 6 | MDS plot based on pairwise FST values derived from mitochondrial HVR I sequences. Raw stress was 0.082. (NCA = Northern Columbia; AH-MH = ancient highlands – Middle Horizon; AH-LIP = ancient highlands – Late Intermediate Period; NP = North Peru; SP = South Peru; GC = Gran Chaco; SMC = southern Middle Chile; TdF = Tierra del Fuego; ASC-EIP = ancient south coast – Early Intermediate Period; ASC-EH = ancient south coast – Early Horizon; ASC-LIP = ancient south coast – Late Intermediate Period)

distinct haplotypes synchronously and diachronically. Despite the low geographic distance between the Palpa and the upper valley highland sites the populations share no haplotypes until the LIP. All analyzed ancient Peruvian populations show a high level of genetic diversity (Table 2) congruent with those from other known central Andean populations (cf. Lewis et al., 2007b). Although there is a diachronic and group-specific change in the haplogroup frequencies in the coastal communities, there is no increase of overall mitochondrial genetic variability.

Genetic distance calculations based on the HVR I sequence data support the considerations derived from the haplogroup data. Very low and non-significant distances can be determined between both Paracas period populations and the rural Nasca group. The rural and urban Nasca, and Nasca and Middle Horizon comparisons also yield low and non-significant F_{ST} values (0.053; 0.070) All ancient coastal populations exhibit a high distance to the pre-Columbian highland populations (F_{ST}: 0.251–0.354), despite the fact that coastal populations date to the LIP (F_{ST} Coast-Highland LIP: 0.031). In the MDS plot (Fig. 6) the EH, EIP and MH coast populations form a cluster with the populations from Tierra del Fuego, whereas the pre-Columbian Andean highland populations and the Amazonian population pool form a distinct cluster that also includes the coastal populations dating to the LIP (Fig. 6). The modern indigenous populations of Peru cluster close to the latter group. These observations are also supported by AMOVA and other statistical analyses not reported here (cf. Fehren-Schmitz et al., 2011).

Discussion

Population dynamics and cultural evolution in the Palpa Area

When consolidated with the archaeological and ecological knowledge, the genetic data obtained can be translated to reconstruct the population-dynamic processes in pre-Columbian southern coastal Peru. The genetic similarity of the Paracas populations from the Palpa area and the Peninsula, as well as the low genetic distance between them, allows the conclusion that the Paracas period communities in the Ica-Valley, Paracas Peninsula region and the northern Rio Grande de Nasca drainage were not only culturally (Reindel, 2009) but also biologically related. This assumption is supported by the high gene flow detected within the distribution area of the Paracas culture and by the lack of a significant genetic exchange with the surrounding populations, for example, from the Andean highlands (Fehren-Schmitz, 2008, Fehren-Schmitz et al., 2010, 2011). Since the archaeological data and the individuals genetically analyzed in this study also date to the early phases of the Paracas culture (Ocucaje 3–4) it can be assumed that this relationship did not result from a migration out of the Ica area in the late Paracas period (Ocucaje 8–9), as has been suggested by, e.g., Silverman (1994). Distance calculations and distribution patterns also suggest that a constant population in the Palpa area persists into the Nasca period, but of course these assumptions have to be validated by further statistical analysis. These findings, combined with archaeological evidence, such as parallels in ornaments and the existence of early geoglyphs (Reindel and Isla-Cuadrado, 2006; Lambers, 2006), suggest that the Nasca culture of this area probably evolved autochthonously from the bearers of the Paracas culture. Although the urban and rural Nasca populations do exhibit a degree of genetic distance, there is no evidence that that distance results from foreign influences, as one would expect from an elite dominance scenario (Renfrew, 1987). This assumption is supported by the fact that individuals from the elite burials of La Muna share mt haplotypes with the rural populations. The emergence of Haplogroup B and the differences between the rural and urban populations suggest that there is a higher amount of genetic exchange with populations from outside the investigated coast area, maybe the highlands. One must bear in mind that until the LIP the studied coastal and highland populations share no distinct haplotypes other than the founding haplotypes, but the high frequencies of B in the highland populations make them a possible source population for immigration. This might be a result of the increase of socioeconomic complexity in the Nasca period, which would have caused a concurrent augmentation of the migrational pull-factor of this area (Lee, 1972). A grade of social complexity such as that reached in the Nasca culture requires craft and administration specialists (Service, 1962). The fact that the genetic population structure changes slightly in the Nasca period and that the urban Nasca population differs from the rural one might possibly be explained by the immigration of foreign specialists into the urban settlements. There is no significant genetic distance between the Nasca period and Middle Horizon populations from the coast and hence no evidence for population discontinuities in the coastal research area (cf. simulations in Kemp et al. [2009]). The MH populations from the upper valley highland sites and other MH highland populations published previously (Kemp et al., 2009) exhibit significant matrilineal differences from the MH Palpa populations. This observation suggests that invasion or colonization scenarios (cf. (Allison, 1979) seem implausible as a cause for the demise of the Nasca culture in this area. The decrease of population density in the Late Nasca period and the Middle Horizon juxtaposed by the constantly high mt haplotype diversity fits best with scenarios suggesting that the carrying capacity of the main settlement area decreases as a consequence of climatic aggravations and their inhabitants emigrate, possibly eastward into

the Andean valleys (Eitel and Mächtle, 2006). But, neither the MH nor the LIP populations of the highland sites studied show any signs of intermixture with the observed coastal genetic signatures. On the contrary, the coastal populations of the LIP exhibit a high affinity to the MH and LIP highland populations and the modern populations of the Central Andean region. The latter phenomenon is best explained by a massive repopulation of the coastal areas in the short humid phase between AD 1000 and 1400 (Eitel and Mächtle, 2009). The genetic homogeneity observed and the evidence of distinct haplotypes shared between both areas make it most likely that the people repopulating the coastal area derived from the adjacent highlands.

One possible model of explanation for the phenomenon that the upper valley populations show no signs of intermixture with the proximate coastal populations that allows for the possibility that there were immigrations from the coast can be based on the effect that physical stressors can have on unadapted humans at altitudes above 2500 m (Fehren-Schmitz et al., 2009). There is evidence from historical sources and high-altitude medicine that the risk of stillbirth is significantly higher among unadapted women coming to the highlands than among women who are adapted to high altitude habitats (Moran, 2000; Moore et al., 2004; Gonzales et al., 2008). Although the coastal women may have adapted to the physical stressors in the highlands over a period of time, one could argue that they had a quantitative reproductive disadvantage compared to the women who had lived in the highlands since birth (Gonzales and Tapia, 2009). Thus, the demographic maternal influence on the populations above 2500 m is too low to have a significant impact on the mitochondrial haplogroup frequencies.

Ancient DNA and the peopling of western South America

The comparison of the ancient DNA data to the continental dataset also allows some issues regarding the initial peopling of western South America to be addressed. Since the pre-Columbian regional distinctions between coast and highlands do not persist in the contemporary populations of Peru, and the ancient highland populations have a high affinity to the modern Peruvians significant changes must have taken place in the last 1000 years, causing the homogenization observed in the central Andean area (Fehren-Schmitz et al., 2010; 2011). The ancient highland and modern central Andean populations have a matrilineal genetic affinity to the Amazonian populations from eastern South America, as do the ancient coastal populations for the modern populations from the southernmost parts of South American (cf. Fig. 2; 4; 6). As mentioned before, the overall genetic variability and the genetic structure of the Native South American populations provide strong evidence that the continent was peopled by only one initial founding population (Wang et al., 2007; Lewis, Jr. and Long, 2008; Lewis, Jr., 2009). Recent studies (Lewis, Jr., 2009) also show that the patterns of genetic variability observed in South America are not consistent with a west-coast-only peopling scenario followed by a spread through the Andes into eastern South America (cf. Dillehay, 2009). Combining these discoveries with the given ancient and modern genetic data suggests a modified version of a peopling scenario previously postulated (Rothhammer et al., 2001). When the first settlers entered South America, they split up, following two or more main routes, one along the west coast, one along the north coast and then into the Amazonian Basin, and possibly an additional group along the eastern slopes of the Andes, with the latter two groups peopling the Andean highlands from the east. The settlers who chose the route along the western coast would, then, probably be the direct ancestors of the ancient coastal and modern southern South American populations. Population-biological exchange, at least matrilineal, remained marginal for the follow-

ing periods. Then, in a time frame starting possibly with the Middle Horizon and at latest with the Late Intermediate Period, populations from the Central Andean highland areas rapidly expand throughout the whole region, intermixing and demographically outnumbering the coastal populations. Of course this would not have been a simple mass migration phenomena: state-influenced migration and relocation have to be taken into account, as they are known for the Wari and Inca (Schreiber, 1992; Tung, 2007; Heggarty, 2008). The emergence of both cultures presumably also had an influence on the general migrational behaviour and the demography and genetic composition of the Central Andean populations through urbanization and changes in social complexity. Figure 2 shows that the maximum southward geographic expansion of the Inca Empire is congruent with the recent border between populations exhibiting mitochondrial distribution patterns similar to recent Peruvian populations and Chilean populations that exhibit the ancient coastal patterns. But it has to be stated that although this scenario seems plausible, it is still statistically incapable of proof on the recent data basis.

Conclusion and prospects

This study presents the potential of ancient DNA analysis for the investigation of population-dynamic processes that occurred in pre-Columbian western South America. Since the number of such studies remains small, all results and interpretations aiming at the supraregional context can only be seen as preliminary. All assumptions made in this study have been based on population affinities derived from biological distance measures and more. These methods, of course, allow no definite determination as to whether population continuities or discontinuities occurred. The data obtained has to be tested to reveal whether the differences or similarities observed could be explained by the effect over time of evolutionary forces like drift, and to reveal which demographic scenario best explains the observed values. We are currently starting a new project with Christian Anderson (Harvard University, developer of Bayesian SerialSimCoal, Anderson et al., 2005) to validate our hypotheses, comparing several complex demographic scenarios. Another recent study conducted in cooperation with Brendan O'Fallon (Felsenstein Lab, Univ. of Washington), analyzing the data presented here with Bayesian statistics, addresses the prehistoric demographic development of indigenous American populations, and it will also help to increase our understanding of the relationships of the pre-Columbian Peruvian populations (publication submitted). Although the results presented here are preliminary from the viewpoint of a statistician, the whole dataset containing genetic, ecological, and cultural data for a restricted geographic area over more than 3000 years is absolutely unique. The ongoing research will uncover more information about the reciprocal effects of cultural and environmental developments in a microevolutionary perspective.

Acknowledgements

The authors greatly thank the German Federal Ministry of Education and Research for funding (Grant number: 01UA0804B & 03HEX1VP) our research and all Peruvian and German colleagues in the research group "Andentransekt – Climate Sensitivity of pre-Columbian Men-Environment-Systems" for their scientific collaboration. We also thank the Peruvian Institute for Cultural Heritage (Instituto Nacional de Cultura del Perú) for granting us permission to export the sample material.

References

Allison, M. 1979. Palaeopathology in Peru. Natural History 88, 74–82.

Anderson, C.N., Ramakrishnan, U, Chan, YL, and Hadly, EA. 2005. Serial SimCoal: a population genetics model for data from multiple populations and points in time. Bioinformatics 21, 1733–1734.

Andrews R.M., Kubacka, I, Chinnery, P.F., Lightowlers, R.N., Turnbull, D.M., and Howell N., 1999. Reanalysis and revision of the Cambridge reference sequence for human mitochondrial DNA. Nature Genetics 23, 147.

Bandelt, H.J., Forster, P., Rohl, A., 1999. Median-joining networks for inferring intraspecific phylogenies. Molecular Biology and Evolution 16, 37–48.

Bollongino, R., Tresset, A., Vigne, J.D., 2008. Environment and excavation: pre-lab impacts on ancient DNA analyses. Comptes rendus Palevol 7, 91–98.

Bortolini, M.C., Salzano, F.M., Thomas, M.G., Stuart, S., Nasanen, S.P., Bau, C.H., Hutz, M.H., Layrisse, Z., Petzl-Erler, M.L., Tsuneto, L.T., Hill, K., Hurtado, A.M., Castro-De-Guerra, D., Torres, M.M., Groot, H., Michalski, R., Nymadawa, P., Bedoya, G., Bradman, N., Labuda, D., Ruiz-Linares, A., 2003. Y-chromosome evidence for differing ancient demographic histories in the Americas. American Journal of Human Genetics 73, 524–539.

Burger, J., Hummel, S., Hermann, B., Henke, W., 1999. DNA preservation: a microsatellite-DNA study on ancient skeletal remains. Electrophoresis 20, 1722–1728.

Carnese, F.R., Mendisco, F., Keyser, C., Dejean, C.B., Dugoujon, J.M., Bravi, C.M., Ludes, B., Crubezy, E., 2009. Paleogenetical study of pre-Columbian samples from Pampa Grande (Salta, Argentina). American Journal of Physical Anthropology 141, 452–462.

Dillehay, T.D., 1999. The Late Pleistocene cultures of South America. Evolutionary Anthropology 7, 206–216.

Dillehay, T.D., 2009. Probing deeper into first American studies. Proceedings of the National Academy of Sciences of the USA 106, 971–978.

Dixon, E.J., 2001. Human colonization of the Americas: timing, technology and process. Quaternary Science Reviews 20, 277–299.

Dornelles, C.L., Bonatto, S.L., De Freitas, L.B., Salzano, F.M., 2005. Is haplogroup X present in extant South American Indians? American Journal of Physical Anthropology 127, 439–448.

Eitel, B., Hecht, S., Mächtle, B., Schukraft, G., Kadereit, A., Wagner, G., Kromer, B., Unkel, I., Reindel, M., 2005. Geoarchaeological evidence from desert loess in the Nazca-Palpa region, Southern Peru: Paleoenvironmental changes and their impact on the Pre-Columbian cultures. Archaeometry 47, 137–158.

Eitel, B., Mächtle, B., 2006. Holozäner Umweltwandel in der nördlichen Atacama und sein Einfluss auf die Nasca-Kultur (Südperu). Geographische Rundschau 58, 30–36.

Eitel, B., Mächtle, B., 2009. Man and Environment in the Eastern Atacama Desert (South Peru): Holocene Climate Changes and Their Impact on Pre-Columbian Cultures, in: Reindel, M., Wagner, G. (Eds.), New Technologies for Archaeology: Multidisciplinary Investigations in Palpa and Nasca, Peru. Springer, Berlin, Heidelberg, New York, pp.17–37.

Excoffier L, Laval G, Schneider S., 2005. Arlequin ver. 3.0: An integrated software package for population genetics data analysis. Evolutionary Bioinformatics Online 1, 47–50.

Fehren-Schmitz, L. 2008. Molekularanthropologische Untersuchungen zur präkolumbischen Besiedlungsgeschichte des südlichen Perus am Beispiel der Palpa Region. Ph.D. thesis, University Goettingen.

Fehren-Schmitz, L., Hummel, S., Hermann, B., 2009. Who where the Nasca? Population Dynamics in Pre-Columbian Southern Peru Revealed by Ancient DNA Analyses, in: Reindel M., Wagner, G. (Eds.), New Technologies for Archaeology: Multidisciplinary Investigations in Palpa and Nasca, Peru. Springer, Berlin, Heidelberg, New York, pp. 159–172.

Fehren-Schmitz, L., Reindel, M., Tomasto-Cagigao, E., Hummel, S., Herrmann, B., 2010. Pre-Columbian population cynamics in coastal Southern Peru: A diachronic investigation of mtDNA patterns in the Palpa region by Ancient DNA analysis. American Journal of Physical Anthropology 141, 208–221.

Fehren-Schmitz, L., Warnberg, O., Reindel, M., Seidenberg, V., Tomasto-Cagigao, E., Isla-Cuadrado, J., Hummel, S., Hermann, B., 2011. Diachronic investigations of mitochondrial and Y-chromosomal genetic markers in pre-Columbian Andean Highlanders from South Peru. Annals of Human Genetics 75, 266–283.

Fuselli S., Tarazona-Santos, E., Dupanloup, I., Soto, A., Luiselli, D., Pettener, D., 2003. Mitochondrial DNA diversity in South America and the genetic history of Andean highlanders. Molecular Biology and Evolution 20, 1682–1691.

Gilbert, M.T., Binladen, J., Miller, W., Wiuf, C., Willerslev, E., Poinar, H., Carlson, J.E., Leebens-Mack, J.H., Schuster, S.C., 2007. Recharacterization of ancient DNA miscoding lesions: insights in the era of sequencing-by-synthesis. Nucleic Acids Research 35, 1–10.

Gonzales, G.F., Tapia, V., 2009. Birth weight charts for gestational age in 63,620 healthy infants born in Peruvian public hospitals at low and at high altitude. Acta Paediatrica 98, 454–458.

Gonzales, G.F, Tapia, V., Carrillo, C.E., 2008. Stillbirth rates in Peruvian populations at high altitude. International Journal of Gynecology and Obstetrics 100, 221–227.

Heggarty, P., 2008. Linguistics for archaeologists: a case-study in the Andes. Cambridge Archaeological Journal 18, 35–56.

Hummel, S., 2003. Ancient DNA Typing: Methods, Strategies and Applications. Springer, Berlin, Heidelberg, New York.

Isla Cuadrado, J., Reindel, M., 2003. Jauranga: un sitio Paracas en el valle de palpa, costa sur del Peru. Beiträge zur allgemeinen und vergleichenden Archäologie 23, 227–274.

Isla-Cuadrado, J., Reindel, M., 2006. Burial Patterns and Sociopolitical Organization in Nasca 5 Society, in: Isbell, W.H., Silverman, H. (Eds.), Andean Archaeology III. North and South. Springer, New York, pp. 374–400.

Karafet, T.M., Mendez, F.L., Meilerman, M.B., Underhill, P.A., Zegura, S.L., Hammer, M.F., 2008. New binary polymorphisms reshape and increase resolution of the human Y chromosomal haplogroup tree. Genome Research 18, 830–838.

Kemp, B.M., Malhi, R.S., McDonough, J., Bolnick, D.A., Eshleman, J.A., Rickards, O., Martinez-Labarga, C., Johnson, J.R., Lorenz, J.G., Dixon, E.J., Fifield, T.E., Heaton, T.H., Worl, R., Smith, D.G., 2007. Genetic analysis of early holocene skeletal remains from Alaska and its implications for the settlement of the Americas. American Journal of Physical Anthropology 132, 605–621.

Kemp, B.M., Tung, T.A., Summar, M.L. 2009. Genetic continuity after the collapse of the Wari empire: Mitochondrial DNA profiles from Wari and post-Wari populations in the ancient Andes. American Journal of Physical Anthropology 140, 80–91.

Keyeux, G., Rodas, C., Gelvez, N., Carter, D., 2002. Possible migration routes into South America deduced from mitochondrial DNA studies in Colombian Amerindian populations. Human Biology 74, 211–233.

Lalueza, C., Perez-Perez, A., Prats, E., Cornudella, L., Turbon, D., 1997. Lack of founding Amerindian mitochondrial DNA lineages in extinct aborigines from Tierra del Fuego-Patagonia. Human Molecular Genetics 6, 41–46.

Lambers, K., 2006. The Geoglyphs of Palpa, Peru: Documentation, Analysis, and Interpretation. Linden Soft, Bonn.

Lee, E.S., 1972. Eine Theorie der Wanderung, in: Szell, G. (Ed.), Regionale Mobilität. Nymphenburger Verlag, München, pp. 115–129.

Lewis, C.M., Jr., 2009. Hierarchical modeling of genome-wide Short Tandem Repeat (STR) markers infers native American prehistory. American Journal of Physical Anthropology 141, 281–289.

Lewis, C.M., Buikstra, J.E., Stone, A.C., 2007a. Ancient DNA and genetic continuity in the South Central Andes. Latin American Antiquity 18, 145–160.

Lewis, C.M., Lizarraga, B., Tito, R.Y., Medina, A., Martinez, R., Polo, S., Caceres, A.M., Stone, A.C., 2007b. Mitochondrial DNA and the peopling of South America. Human Biology 79, 159–178.

Lewis, C.M., Jr., Long, J.C., 2008. Native South American genetic structure and prehistory inferred from hierarchical modeling of mtDNA. Molecular Biology and Evolution 25, 478–486.

Lewis, C.M., Jr., Tito, R.Y., Lizarraga, B., Stone, A.C., 2005. Land, language, and loci: mtDNA in Native Americans and the genetic history of Peru. American Journal of Physical Anthropology 127, 351–360.

Loreille, O.M., Diegoli, T.M., Irwin, J.A., Coble, M.D., Parsons, T.J., 2007. High efficiency DNA extraction from bone by total demineralization. Forensic Science International: Genetics 1, 191–195.

Malhi, R.S., Cybulski, J.S., Tito, R.Y., Johnson, J., Harry, H., Dan, C., 2010. Brief communication: mitochondrial haplotype C4c confirmed as a founding genome in the Americas. American Journal of Physical Anthropology 141, 494–497.

Menzel, D., Rowe, J.H., Dawson, L.E.,1964. The Paracas Pottery of Ica: A Study in Style and Time. University of California Press, Berkeley.

Merriwether, D.A., Rothhammer, F., Ferrell, R.E., 1995. Distribution of the four founding lineage haplotypes in Native Americans suggests a single wave of migration for the New World. American Journal of Physical Anthropology 98, 411–430.

Meyer, S., Weiss, G., von Haeseler, A., 1999. Pattern of nucleotide substitution and rate heterogeneity in the hypervariable regions I and II of human mtDNA. Genetics 152, 1103–1110.

Moore, L.G., Shriver, M., Bemis, L., Hickler, B., Wilson, M., Brutsaert, T., Parra, E., Vargas E. 2004. Maternal adaptation to high-altitude pregnancy: an experiment of nature – a review. Placenta 25, Suppl. A, S60–S71.

Moraga, M,. Santoro, C.M., Standen, V.G., Carvallo, P., Rothhammer, F., 2005. Microevolution in prehistoric Andean populations: chronologic mtDNA variation in the desert valleys of northern Chile. American Journal of Physical Anthropology 127, 170–181.

Moran, E.F., 2000. Human Adaptability: An Introduction to Ecological Anthropology. Westview Press, Oxford.

Orefici, G., 1996. Nuevos enforques sobre la transicion Paracas-Nasca en Cahuachi (Peru). Andes 1, 173–189.

Perego, U.A., Achilli, A., Angerhofer, N., Accetturo, M., Pala, M., Olivieri, A., Kashani, B.H., Ritchie, K.H., Scozzari, R., Kong, Q.P., Myres, N.M., Salas, A., Semino, O., Bandelt, H.J., Woodward, S.R., Torroni, A. 2009. Distinctive Paleo-Indian migration routes from Beringia marked by two rare mtDNA haplogroups. Current Biology 19, 1–8.

Pulgar-Vidal, J., 1979. Geografía del Perú; Las Ocho Regiones Naturales del Perú. Lima, Universo S.A.

Ray, N., Wegmann, D., Fagundes, N.J., Wang, S., Ruiz-Linares, A., Excoffier, L., 2010. A statistical evaluation of models for the initial settlement of the American continent emphasizes the importance of gene flow with Asia. Molecular Biology and Evolution 27, 337–345.

Reindel, M., 2009. Life at the Edge of the Desert – Archaeological Reconstruction of the Settlement History in the Valleys of Palpa, Peru, in: Reindel, M., Wagner, G. (Eds.), New Technologies for Archaeology: Multidisciplinary Investigations in Palpa and Nasca, Peru. Springer, Berlin, Heidelberg, New York, pp. 439–462.

Reindel, M., Gruen, A. 2006. The Nasca-Palpa Projekt: a cooperative approach of photogrammetry, archaeometry and archaeology, in: Baltsavias, E., Gruen, A. (Eds.), Recording, Modeling and Visualization of Cultural Heritage. Taylor & Francis, London, pp. 21–32.

Reindel, M., Isla-Cuadrado, J., 2000. Ausgrabungen in Los Molinos und La Muña. Ergebnisse der Grabungskampagne 1999 des Archäologischen Projektes Nasca-Palpa, Süd-Peru. Jahresbericht der Schweizerisch-Liechtensteinischen Stiftung für Archäologische Forschungen im Ausland 2000, 3–31.

Reindel, M., Isla-Cuadrado, J., 2001. Los Molinos und La Muna. Zwei Siedlungszentren der Nasca-Kultur in Palpa, Südperu. Beiträge zur allgemeinen und vergleichenden Archäologie 21, 241–319.

Reindel, M., Isla-Cuadrado, J., 2003. Archäologisches Projekt "Paracas in Palpa", Peru: Bericht über die Grabungskampagne 2003. Jahresbericht der Schweizerisch-Liechtensteinischen Stiftung für Archäologische Forschungen im Ausland 2003, 137–156.

Reindel, M., Isla-Cuadrado, J., 2006. Archäologisches Projekt "Paracas in Palpa", Peru – Ausgrabungen und Forschungen im Jahr 2005. Schweizerisch-Liechtensteinische Stiftung für Archäologische Forschungen im Ausland – Jahresbericht 2005, 30–59.

Reindel, M., Isla-Cuadrado, J., Lambers, K., 2004. Archäologisches Projekt "Paracas in Palpa", Peru – Ausgrabungen und Forschungen 2004. Schweizerisch-Liechtensteinische Stiftung für Archäologische Forschungen im Ausland – Jahresbericht 2004, 25–44.

Renfrew, C., 1987. Archaeology and Language. Cambridge University Press, Cambridge.

Rohland, N., Hofreiter, M., 2007. Ancient DNA extraction from bones and teeth. Nature Protocols 2, 1756–1762.

Rothhammer, F., Llop, E., Carvallo, P., Moraga, M., 2001. Origin and evolutionary relationships of native Andean populations. High Altitude Medicine and Biology 2, 227–233.

Schneider, S., Excoffier, L., 1999. Estimation of past demographic parameters from the distribution of pairwise differences when the mutation rates vary among sites: application to human mitochondrial DNA. Genetics 152, 1079–1089.

Schreiber, K.J., 1992. Wari Imperialism in Middle Horizon Peru. Museum of Anthropology, University Michigan, Ann Arbor.

Schreiber, K.J., Lancho Rojas, J., 2003. Irrigation and Society in the Peruvian Desert: The Puquios of Nasca. Lexington Books, Lanham (MD).

Schurr, T.G., Sherry, S.T., 2004. Mitochondrial DNA and Y chromosome diversity and the peopling of the Americas: evolutionary and demographic evidence. American Journal of Human Biology 16, 420–439.

Service, E., 1962. Primitive Social Organisation. Random House, New York.

Shimada, I., Shinoda, K., Farnum, J., Corruccini, R., Watanabe, H., 2004. An integrated analysis of pre-Hispanic mortuary practices. Current Anthropology 45, 369–390.

Shinoda, K., Adachi, N., Guillen, S., Shimada, I., 2006. Mitochondrial DNA analysis of ancient Peruvian highlanders. American Journal of Physical Anthropology 131, 98–107.

Silverman, H., 1994. Paracas in Nazca: New Data on the Early Horizon Occupation of the Rio Grande de Nazca Drainage, Peru. Latin American Antiquity 5, 359–382.

Silverman, H., Proulx, D.A., 2002. The Nasca. Blackwell, Oxford.

Tamm, E., Kivisild, T., Reidla, M., Metspalu, M., Smith, D.G., Mulligan, C.J., Bravi, C.M., Rickards, O., Martinez-Labarga, C., Khusnutdinova, E.K., Fedorova, S.A., Golubenko, M.V., Stepanov, V.A., Gubina, M.A., Zhadanov, S.I., Ossipova, L.P., Damba, L., Voevoda, M.I., Dipierri, J.E., Villems, R., Malhi, R.S., 2007. Beringian standstill and spread of Native American founders. PLoS ONE 2, e829.

Tamura, K., Dudley, J., Nei, M., Kumar, S., 2007. MEGA4: Molecular Evolutionary Genetics Analysis (MEGA) software version 4.0. Molecular Biology and Evolution 24, 1596–1599.

Tello, J.C., 1959. Paracas: Primera Parte. Publicationdel Proyecto 8b del Programa 1941–42 del Institute of Andean Research of New York. Lima.

Torroni, A., Schurr, T.G., Cabell, M.F., Brown, M.D., Neel, J.V., Larsen, M., Smith, D.G., Vullo, C.M., Wallace, D.C., 1993. Asian affinities and continental radiation of the four founding Native American mtDNAs. American Journal of Human Genetics 53, 563–590.

Tung, T.A., 2007. Trauma and violence in the Wari empire of the Peruvian Andes: Warfare, raids, and ritual fights. American Journal of Physical Anthropology 133, 941–956.

Vaughn, K.J., Gijseghem, H., 2007. A compositional perspective on the origins of the "Nasca cult" at Cahuachi. Journal of Archaeological Science 34, 814–822.

Wang, S., Lewis, C.M., Jakobsson, M., Ramachandran, S., Ray, N., Bedoya, G., Rojas, W., Parra, M.V., Molina, J.A., Gallo, C., Mazzotti, G., Poletti, G., Hill, K., Hurtado, A.M., Labuda, D., Klitz, W., Barrantes, R., Bortolini, M.C., Salzano, F.M., Petzl-Erler, M.L., Tsuneto, L.T., Llop, E., Rothhammer, F., Excoffier, L., Feldman, M.W., Rosenber, N.A., Ruiz-Linares, A., 2007. Genetic variation and population structure in Native Americans. PLoS Genetics 3, e185.

Willerslev, E., Cooper, A., 2005. Ancient DNA. Proceedings of the Royal Society B: Biological Sciences 272, 3–16.

Stable isotopes and genetics

Malcolm C. Lillie[a,*], *Inna Potekhina*[b], *Chelsea Budd*[c], *Alexey G. Nikitin*[d]

Prehistoric populations of Ukraine:
Migration at the later Mesolithic to Neolithic transition

* Corresponding Author: m.c.lillie@hull.ac.uk.
a Department of Geography, University of Hull, United Kingdom
b Department of Bioarchaeology, Institute of Archaeology, National Academy of Sciences of Ukraine, Kiev, Ukraine
c Radiocarbon Laboratory for Archaeology and the History of Art, Dyson Perrins Building, Oxford, United Kingdom
d Biology Department, Grand Valley State University, Allendale, MI, USA

Abstract
This paper focuses on the identification of population movements during the Mesolithic and Neolithic periods in the Dnieper Basin region of Ukraine. We assess the evidence for migration from the perspective of individual life histories using a combination of palaeoanthropology/pathology, radiocarbon dating, stable isotopic studies of diet, and mtDNA.

Keywords
Mesolithic, Neolithic, Mariupol-type cemeteries, Bioarchaeology, mtDNA, Migration, Cultural transition, Life History

Dedication: The authors would like to dedicate this paper to the memory of Professor Dmitry Telegin who passed away on 1st January 2011 at the age of 91. Professor Telegin was a commensurate archaeologist and the patriarch of Ukrainian archaeology (Potekhina and Mallory 2011). He was the Head of the Department of Stone Age Archaeology at the Institute of Archaeology NAS Ukraine for 20 years, and published around 500 scientific papers and monographs during his career. He influenced a generation of Ukrainian archaeologists, and a number of western researchers, particularly with his generous, patient and open approach to Ukrainian prehistory and changes in method and theory, during this time. An outstanding scholar, his intellect and insightfulness will be sorely missed.

Introduction

The cemeteries of the Dnieper Basin (Fig. 1) have been the subject of a considerable amount of reinvestigation and analysis since they were originally reported in a synthetic volume by Telegin and Potekhina in 1987. An interim stage of these investigations was marked by the completion of Lillie's PhD research in 1998 (Lillie, 1998a), during the production of which a number of preliminary papers were published (e.g. Lillie, 1996, 1997, 1998b, 1998c). We worked closely with Professor Telegin to refine the chronology of the Mariupol-type cemeteries, and the Ukrainian chronology in general (Telegin et al., 2000, 2002, 2003), and whilst disagreements persist in relation to the assumed cultural affinities of the various sites and cemeteries investigated, a greater chronological resolution has been achieved. Elements of the scheme have been questioned due to the use of conventional dates from the Kiev radiocarbon facility, which often appear to produce ages that are too young (Lillie, 1998a), and because the resolution of the culture-chronologies needs to be considered with caution (Anthony, 2007; Dolukhanov and Shilik, 2007; Rassamakin, 1999; Velichko et al., 2009). Significantly, more recently we have identified a reservoir effect impacting upon the precision of these dates (Lillie et al., 2009).

In addition to the on-going studies of chronology, we have been actively investigating the evidence for diet and subsistence strategies at a number of sites in Ukraine (Fig. 1). These studies have demonstrated variability in access to dietary proteins across the Epipalaeolithic to Eneolithic periods (Lillie,

Fig. 1 | Location map showing cemeteries and sites used in the current study. Legend: 1 Vyazivok, 2 Molukhov Bugor, 3 Dereivka, 4 Voloshskoye, 5 Nikolskoye, 6 Vasilyevka II, III, V, 7 Marievka, 8 Vovnigi I, 9 Yasinovatka, 10 Vil'nyanka, 11 Rogalik II, 12 Fat'ma-Koba

1996, 1997, 1998a, 2003), alongside a significant input of freshwater resources during each of these periods (Lillie, 1998a; Lillie and Richards, 2000; Lillie et al., 2003; Lillie and Jacobs, 2006; Lillie and Budd, 2011; Lillie et al., 2011). The studies undertaken to date, focussing on palaeopathology and stable isotope analyses of diet, have demonstrated an absence of 'typical' dental pathologies commensurate with carbohydrate consumption (i.e. caries) and the consistent presence of calculus, indicative of protein consumption (Lillie, 1996; Haeussler and Potekhina, 2001, 2002). Similarly, the stable isotope data reflects the exploitation of freshwater resources and herbivores, but the method lacks the resolution necessary to allow an evaluation of the relative contribution of plants, or cereals in particular to the diets of the populations under study. To some degree this reflects the nature of the analyses undertaken to date and the fact that the number of sites investigated is limited in relation to the identification of domesticated plants, and plant use in general (Kotova and Pashkevich, 2002), as many of the earlier Neolithic cemeteries investigated are considered to be those of pastoralists as opposed to agriculturalists. Targeted archaeobotanical investigations are required if we are to enhance our understanding of the contribution of cereals to subsistence economies (e.g. Motuzaite Matuzeviciute et al., 2009; Motuzaite Matuzeviciute, 2010).

In the current report we present the results of anthropological analyses of craniometrics (Potekhina, 1999a), alongside preliminary results from ancient mitochondrial DNA (mtDNA) studies and an overview of the stable isotope data for the individuals studied. The methodological approaches include the craniometric analysis of ca. 300 skulls from the sites of Dereivka I (119 individuals), Nikolskoye (30 individuals), Vovnigi I and II (74 individuals), Vilnyanka (33 indiviudals), Vasilyevka II (16 individuals) and Kapulovka (16 individuals) (Potekhina, 1987). Six individuals from the cemetery of Yasinovatka have been analysed with respect to their aDNA composition, and 113 of the 300 individuals from the Dnieper Rapids cemeteries have also been analysed for their $\delta^{13}C$ and $\delta^{15}N$ stable isotope values (Lillie and Richards, 2000; Lillie et al., 2003; Lillie and Jacobs, 2006; Lillie et al., 2011).

The mtDNA analysis of past populations has been enhanced considerably over the past decade, with recent studies indicating that all modern haplogroups coalesce in Africa around 150,000 years ago (e.g. Cann et al., 1987; Forster, 2004), and that most present-day haplogroups found in Europe likely evolved in the Middle East some 40,000 years ago. At this time branches of the N* node diffused into Europe through Anatolia and across the lower Danube Basin. Other branches of the same node, notably members of the J/T cluster, advanced into Europe via the same route with the advent of agriculture (Richards et al., 2000; Roostalu et al., 2007; after Nikitin et al., 2009). As almost all major human mtDNA haplogroups follow a regionally specific pattern of distribution, mtDNA polymorphism allows for the identification of haplotypes in past populations and can provide insights into the origins of human founder lineages in Europe.

The main cemeteries considered in the current study include Vasilyevka II, Dereivka I and Yasinovatka. Vasilyevka II is dated to 7300–6220 calBC (Lillie and Jacobs, 2006; Potekhina and Telegin, 1995). The site is located on the left bank of the Dnieper, in the rapids region near the village of Vasilyevka. It was excavated by A.D. Stolyar (1959), who uncovered twenty-seven graves, with 32 individuals interred in the extended position. Subsequently, eleven male and five female skulls were analysed by Gokhman (1966), and some discussion of this site is also provided by Konduktorova (1974). Lillie (1998a) analysed twelve males and five females, and also recorded the presence of the dentitions of three nonadult individuals in the collections housed in Kiev. Grave goods found in association at this cemetery include fish and deer teeth, turtle, flint tools and bone bracelets (Telegin and Potekhina, 1987; Kotova, 2003).

Dereivka I is located on the right bank of the river Omelnik close to its confluence with the Dnieper. The largest of the Mariupol-type cemeteries, with 165 Neolithic burials, it is located on the boundary between the forest-steppe and steppe zones. Telegin and Zhilyaeva investigated 144 burials in 1960 and 1961, and a further 20 were subsequently studied by Telegin in 1965 and 1967 (Telegin, 1991). Single and grouped burials were recovered from two areas of the site, the central area having been destroyed by earth-moving activities before the excavations (Telegin and Potekhina, 1987). The human remains from these investigations were studied by Zinevich (1967) and Potekhina (1978, 1987, 1999a).

Lillie (1998a) analysed 104 of the individuals interred at Dereivka I, and obtained dates for 5 of the interments. These dates indicated a main period of use at ca. 5270–4950 calBC, but with at least one individual of later Mesolithic date at 6360–5880 calBC. Given the fact that the Mesolithic individual, Nº 84, is located amongst a number of individual burials to the north/north-east of the cemetery, some distance away from the main clusters of burials, it is conceivable that a small proportion of the cemetery population is in fact dateable to this earlier chronological period.

Grave goods include fragments of pottery with either stroked or comb ornamentation, a decorated plate of Mariupol-type, deer and fish tooth pendants, flint knives, annular beads, spear points and a flint scraper.

At Yasinovatka, 68 individuals were excavated, with the burials in this cemetery falling into three groups. The A-type burials (dated to ca. 5550–4930 calBC), were interred in oval grave pits (Telegin and Potekhina, 1987). The second and third groups are found in the Б group graves, with the Б–1 graves dating to 5550–4750 calBC and the Б–2 graves dating to 4980–4460 calBC (Lillie, 1998a) (all at 2σ). Some of the individuals interred in the A-type burials at Yasinovatka were severely contracted at the sides, especially at the shoulders, with the legs straightened and in a closed position. It is likely that this is a result of the practice of binding or 'swaddling' of the dead (Telegin and Potekhina, 1987).

During excavation, the Б stage burials (Б–1 and Б–2) were found to be in a greater state of disarticulation when compared to the A-stage burials. In addition to a considerable degree of recutting of the graves and disarticulation of the interred individuals, many single bones of destroyed skeletons were also present in the pits. This led Telegin to conclude that the evidence reflected the repeated use of the Б stage burial area, and disarticulation prior to the full decomposition of the bodies. Many of the burials at Yasinovatka (e.g. A-type burials in the oval grave pits, group graves and the Б group graves) contained a range of grave goods, including pottery, small flint implements, knife-like blades, boar-tusk plates, Unio shells, fish- and deer tooth pendants.

These cemeteries are in effect a small component of the available skeletal inventory for the Dnieper Rapids region. Their cultural affiliations, as designated by various researchers, and the resource base available during the Mesolithic and earlier Neolithic are subjects of widespread discussion. Of interest is the recent suggestion that Mesolithic economies developed in an environment of growing scarcity of hunting resources (Dolukhanov, 2008) and that the dietary focus of the populations interred in the Dnieper cemeteries cannot be taken to reflect a long-term trend in dietary preferences in Ukraine. However, this assertion is somewhat erroneous and reflects a misinterpretation of the evidence presented by Jacobs (1994), Lillie (1996), Lillie and Richards (2000) and others. The latter authors have constantly emphasised the fact that the cemeteries they study belong to the cultures that occupied the middle and lower Dnieper Basin to the south of Kiev and that the general subsistence evidence does not suggest an impoverished resource base during the Mesolithic period. In addition, the cemeteries studied do reflect long-term dietary preferences in central, and probably eastern/south-eastern Ukraine.

The subsistence strategies followed from the Epipalaeolithic through to earlier Neolithic periods reflect similar strategies adopted by human groups throughout the European landmass at the transition to the earlier Holocene, and are fundamentally a reflection of the ease with which these populations adapted to changes in the available resource base. Hunting, fishing and gathering are all attested in the archaeoenvironmental record for Ukraine; the degree to which an individual or group placed an emphasis on a particular resource, or range of resources reflects both individual preference and socio-economic, political and even ritual influences. It should also be remembered that, as will be discussed below, the human groups occupying the Dnieper basin were not necessarily all indigenous to the region, even during the Mesolithic period. To suggest otherwise would be to ignore the evidence, and as suggested by Lillie (1998a), it is methodologically unsound to assume that close geographic proximity equates to close socio-economic and cultural proximity in the absence of evidence to support such an assertion.

Methodology

In the course of the current study it became apparent that in some cases the original age/sex identifications differed from those reached in the more recent analyses (e.g. Gokhman, 1966; Potekhina, 1978, 1981; Lillie, 1998a). We attribute these differences to a number of causes; including the fact that *in situ* analyses will have allowed for the assessment of the post-cranial skeletal material, much of which was too poorly preserved to warrant curation. This has resulted in a reliance on cranial material for ageing and sexing of the skeletal remains in the more recent studies. The use of cranial suture closure in ageing in earlier studies has been critiqued by Lillie (1998a), as in many instances complete closure accompanies a low functional wear stage of the dentitions. We have sought a balance in many cases by offering a combination of the earlier and later classification as reached by different researchers. Lillie (1998a) was able to seek the opinion of Professor Gokhman whilst he was researching in St. Petersburg in relation to the Vasilyevka III and II ageing and sexing, but for the later cemeteries some discrepancies still exist. We will be working on these in future collaborations.

The age groupings used by earlier researchers in Eastern Europe follow the standard set by V.P. Alekseev and G.F. Debets (1964), these being:

Infantalis I = <6–7 yrs.
Infantalis II = <13–14 yrs (or until appearance of M2).
Juvenis = 13–20 yrs.
Adultus = up to 30–35 yrs.
Maturus = up to 50–55 yrs.
Senilis = +55 yrs.

These categories are included where the analyses undertaken by colleagues such as Potekhina (1978, 1981, 1999a) differ from those undertaken by Lillie (1998a).

Craniometrics

In the current study craniometric data is used to determine whether the individuals being studied represent a local or nonlocal physical type in the populations being studied (Potekhina, 1987). Assignment of an individual on the basis of the metric data (after Martin and Saller, 1957; Alekseev and Debets, 1964; Buikstra and Ubelaker, 1994; Bass, 1995) relates to the determination of whether the individual studied exhibited a combination of traits characteristic of either (a) the indigenous Proto-European Mesolithic population (classed as Craniological Type I); or (b) the nonlocal ancient hypermorphic north-European populations (classed as Craniological Type II).

This latter group is believed to represent one of the Late Palaeolithic anthropological types (Potekhina, 1987). Studies by Gokhman (1958) at Vasilyevka; Zinevich (1967) and Zinevich and Kruts (1968) at Nikolskoye and Kapulovka, Zinevich (1967) and Potekhina (1978) at Dereivka have distinguished two craniological variants: dolichocranic and mesobrachy- or mesochranic. The suggestion is that some degree of heterogeneity exists in the populations of the Dnieper Basin.

Stable isotopes

The stable isotope analysis of the recently studied Ukrainian material (Lillie et al., 2011) was carried out at the Research Laboratory for Archaeology and the History of Art (RLAHA), University of Oxford, by one of the authors (CB). The earlier analyses of Vasilyevka II and a limited number of samples from Marievka, Vasilyevka V, Dereivka I and Yasinovatka (Lillie and Richards, 2000; Lillie et al., 2003, Lillie and Jacobs, 2006), were undertaken by Mike Richards while he was at the RLAHA. In the current study 35 isotope analyses are included for the cemeteries studied (Table 1). A number of additional, as yet only partially published isotope ratios (Potekhina, 1999b, 2005), are also included in the current study, bringing the total number of samples available for consideration in the entire Dnieper cemetery series to 113 (Lillie et al., 2011).

As outlined by Lillie and colleagues (2011), in the earlier work on the Dnieper basin skeletal material the collagen was extracted from human bone samples following the protocol outlined in Richards (1998). This method is similar to other published methods of collagen extraction (e.g. Brown et al., 1988; Ambrose, 1990), with occasional variation, and is summarised as follows. For each sample a solution of 0·5 M HCl was added to approximately 100–300 mg of cleaned whole bone (with a preference for cortical bone), and the bone was left to demineralise at approximately 5°C for 3–5 days. The remaining solid was rinsed in H_2O and then gelatinised in a sealed sample holder (in a pH3 HCl solution and heated at approximately 70°C for 24 hr). This solution was then filtered through an 8 μm polyethylene filter, and then centrifuged at 65°C for 15 hr under a vacuum in order to evaporate water and acid. The resultant residue was then rehydrated in 2–3 ml of distilled H_2O, and then lyophilised for 48 hr (Lillie and Richards, 2000).

In the more recent stable isotope work, the samples were prepared using a modified version of the pre-treatment protocol which is set out in Ramsey et al. 2004. Approximately 0.6g of bone were shot-blasted using aluminium oxide and crushed into powder. The samples then underwent demineralization in 0.5HCl at 4degrees C. The acid is changed 3 times during this process and samples are left for 3-5 days or until the CO_2 ceases to evolve. The samples are then rinsed 3 times in deionised MilliQ water and placed in sealed tubes in HCl pH3 and gelatinsed at 75degreesC for 48h. The supernatant produced from this process is then filtered using a 5-8mm Ezee filter. The soluble gelatine fraction is then placed in liquid nitrogen and freeze-dried for 48h. All of the samples were measured in triplicate; 3 samples were taken from each skeletal sample and the average isotope value was calculated. The samples were analysed using an automated carbon and nitrogen analyzer and a continuous-flow isotope-ratio-monitoring mass-spectrometer (Carlo Erba carbon and nitrogen elemental analyser coupled to a Europa Geo 20/20 mass spectrometer). Typical replicate measurement errors were of the order of ±0.2‰ for $\delta^{13}C$ and $\delta^{15}N$. Only samples which produced collagen yields with a C:N ratio between 2.9-3.6 (DeNiro, 1985) were used in the analysis of palaeodiet.

DNA analysis

In the current study six Neolithic osteological samples from the Yasinovatka cemetery were subjected to mtDNA analysis with the goal of retrieving mtDNA sequences to investigate maternal genetic origins of the individuals studied. This stage of the research was undertaken by one of of the authors (AN at Grand Valley State University, Michigan, USA).

All manipulations related to sample preparation and DNA analysis were performed in facilities specially dedicated to aDNA research, spatially separating cleanup, DNA extraction, and amplification processes, in accordance with the standards for working with ancient DNA (Cooper and Poinar, 2000). MtDNA was typed by amplifying key segments of the coding region and the first hypervariable segment (HV1) of the control region. The HV1 region was amplified in four overlapping segments and amplicons were subsequently cloned and sequenced, or subjected to direct DNA sequencing after amplification. The coding region amplicons were analyzed by the RFLP method.

Results

Craniometrics

The morphology of all of the individuals interred at the cemetery of Vasilyevka II (8020–7620 calBC), indicates that these individuals are related to the ancient hypermorphic north-European population i.e. they are nonlocal in origin, having ancestral links to more northerly regions of Europe (Fig. 2 and Table 1).

Whilst 27 graves were investigated by Stolyar in 1953, Konduktorova (1974) reported that only 11 male and 5 female skulls proved suitable for analysis. The finds associated with the interments included the characteristic fish and deer tooth pendants, fragments of tortoise shell and a unique artefact for the Dnieper (Mariupol-type) cemeteries, decorated bone bracelets/arm rings.

At this cemetery, analysis by Lillie (1998a) has indicated that there are 12 adult males (3 of which could not be assigned an age estimate), and 5 adult females. The males are aged between 20–60 years (identified in 10 year age brackets e.g. 20–30, 30–40, etc.), with all age categories represented. The females are aged 18–60, but there are no females in the 25–40 year age bracket. Three of the females are aged 18–25 years – Individuals 11 (18–25 years), 15 (18–25 years) and 18 (18–22 years) – one is aged 40–50 (Individual 17) and the remaining female (Individual 2) is aged 50–60. This is a small, nonlocal, cemetery population. The lack of evidence for females in the 25–40 year age categories is difficult to explain, but it could relate to the nature of the group dynamic for a mobile/immigrant population, optimum carrying capacity, optimum breeding structure, differential burial practices, exogamy, or even intergroup theft of marriage partners.

At Dereivka (Fig. 2 and Table 1), 173 individuals were interred in both single and grouped burials. Konduktorova reported that only ca. 50 % of the cemetery population were sufficiently well preserved for craniological analysis. Potekhina (1978, 1981) studied the age-sex distribution at Dereivka (113 skeletons), identifying 53 males, 31 females and 29 children. Lillie (1998a) studied 104 adults from this cemetery population, identifying 66 male and 18 female individuals, with 20 adults of indeterminate sex. In the latter study the reliance on the crania appears to have weighted the results in favour of a male biological sex determination in a number of cases, although associated post-cranial remains, when available, were considered in the study (Lillie, 1998a).

At this cemetery the local Proto-European Mesolithic population is attested by Individual 42 (female 18–20). The nonlocal ancient hypermorphic north-European population is attested by Individuals 5 (male-senilis), 29 (male-maturus), 31 (male 18–25), 33 (male 18–25 [female Potekhina 1981]), 35 (male-maturus), 38 (male 18–22 [female Potekhina, 1981]), 46 (male 18–22), 49 (male 20–30 [maturus Potekhina, 1981]), 84 (female 35–55), 109 (male-maturus) and 130 (ND). The richest burial in terms of grave goods is No. 49 (nonlocal [male 20–30] [maturus Potekhina, 1981]), which is dated to

Table 1 | Correlation of numbers in Figure 2 with burials in the Dnieper cemeteries

Vovnigi II		Dereivka		Vovnigi I	
Figure 2 N°	Burial N°	Figure 2 N°	Burial N°	Figure 2 N°	Burial N°
1	26	29	39	52	15
2	39	30	41	Nikolskoye I	
3	40	31	68	Figure 2 No.	Burial No.
4	47	32	129	53	3
5	52	33	134	54	41
6	54	34	150	55	42
7	62	35	162	56	106
8	75	36	9	57	58
9	76	37	52	Yasinovatka	
10	77	38	141	Figure 2 No.	Burial No.
11	36	39	142	58	27
12	84	Vil'nyanka		36	
			59		
13	85	Figure 2 No.	Burial No.	60	44
14	91	40	8	61	55
15	92	41	20	Vasilyevka II	
16	102	42	31	62	11
17	58	43	32	63	12
18	78	44	34	64	16
19	81	45	38	65	17
20	28	46	39	66	19
21	17	47	40	67	20
22	119	48	17	Kapulovka	
23	53	49	18	Figure 2 No.	Burial No.
24	51	50	28	68	7
25	50	Osipovka			
26	71	Figure 2 No.	Burial No.		
27	72	51	18		
28	116				

5245–4940 calBC. This individual had deer tooth pendants, a Mariupol-type plate and 35 fish teeth in association.

Interestingly, Lillie (1998) dated Individual 84 (nonlocal female 35–55) to the Mesolithic period at 6360–5880 calBC, whilst Individuals 42 (local female 18–20 [maturus Potekhina, 1981]), 33 (nonlocal male 18–25), 49 (nonlocal male 20–30) and 109 (nonlocal female-maturus) were all dated to the earlier Neolithic period ca. 5260–4750 calBC.

At Yasinovatka (Fig. 2 and Table 1), ca. 68 individuals were identified during the excavations. Potekhina (1988) identified 36 males, 15 females, 13 children and 4 individuals of indeterminate sex. Forty-eight of the original 68 individuals at Yasinovatka were available for analysis by Lillie (1998a), who recorded 23 male and 9 female individuals, with 9 adults of indeterminate biological sex. The cemetery

Fig. 2 | Analysis of craniometric data for the Dnieper populations: Variant I = proto-European Mesolithic population; Variant II = ancient hypermorphic north-European populations; Variant III = hybridisation between these two physical types; Variant IV = Dereivka (129 and 136), Vovnigi II and Kapulovka – these four individuals are characterised by a sharp horizontal facial profile and distinct differentiation from the other groups, however, this group is poorly represented in the skeletal series and requires further study

comprised two discrete forms of interment, A-type burials in grave pits of oval form, and Б-type burials in a large sub-rectangular pit that was highlighted by a red staining from the use of ochre in the burial ritual. The local portion of this cemetery includes Individuals 18 (male-maturus), 19 (female 20–25), 45 (male 20–25), 55 (male 25–30), 57 (male-indeterminate age), 60 (male-indeterminate age) and 63 (male-indeterminate age), whilst the nonlocal individuals are 35 (male 30–40) and 36 (male 25–30).

Individual 19 (local female 20–25) is an A-stage burial, which was dated by Lillie (1998) to 5435–5220 calBC, the earlier Neolithic, whilst Individual 45 (local male 20–25), the only stage Б–1 type burial with grave goods in association, is dated to 5430–5150 calBC. The other local individual that was dated by Lillie (1998a) is Individual 18 (male-maturus), who was interred in the stage Б–2 type burials and is dated to 5310–5050 calBC. The nonlocal Individual 36 (male 25–30) was dated by Lillie (1998a) to 5565–4780 calBC. This individual was associated with the stage Б–1 type burials.

In many of the earlier Neolithic cemeteries in the Dnieper Basin. the first stage of interment appears to be primarily associated with a local population base, whilst the second stage exhibits a more mixed character with both local (Variant I) and nonlocal (Variant II – proto-European) types, with hybridization between these two types (Variant III) in evidence (Fig. 2). A significant number of the individuals identified as being nonlocal at Dereivka I and Yasinovatka are either young adult males or maturus (based on Potekhina's analyses). Whilst a much more detailed study is needed for each of these cemetery populations, e.g. through the application of Sr analysis of tooth enamel, it is interesting to note that during the earlier Neolithic period in the Dnieper Basin, young adult males (but also males generally) appear to predominate in the nonlocal portion of the population. This contrasts somewhat with the situation in evidence in earlier LBK farming populations further west, where females appear to

dominate in the nonlocal part of the cemetery population (e.g. Price et al., 2001). This may be a reflection of the fact that populations of the Dnieper region exploit what are effectively hunter-fisher-gatherer subsistence strategies during the earlier Neolithic period, with only limited integration of domesticated animals in evidence (depending on location), indicating that, in subsistence terms, these populations are effectively continuing to follow Mesolithic food procurement strategies.

Clearly, the local versus nonlocal identifications based on the craniometric data are intriguing, and they may offer an opportunity for further investigations using strontium (and probably $\delta^{18}O$) studies in order to reinforce the inferred local/nonlocal components in these prehistoric populations.

Stable isotopes

The stable isotope data (Fig. 3) does not indicate any distinct separation between the local and nonlocal individuals as identified from the craniometric data. The main exception to this general rule appears to be the cemetery of Vasilyevka II, which plots to the right of the main cluster, for ^{13}C, although the ^{15}N is consistent with the other groups studied. This cemetery has been shown to exhibit one of the highest ranges of $\delta^{15}N$ for the entire cemetery series analysed (Lillie et al., 2011), and is second only to Yasinovatka (and one nonlocal from Dereivka I) in terms of the elevated nitrogen levels in evidence. The $\delta^{13}C$ ratios for Vasilyevka II are also more positive than those obtained for any of the other cemeteries analysed to date, suggesting that the source of carbon in the diet may potentially differ from the main sources throughout the Dnieper Basin, as attested at sites such as Vasilyevka III, Marievka, Yasinovatka, Nikolskoye, Dereivka I and Vasilyevka V.

The data from Vasilyevka II might support the suggestion, based on the craniometric data, that this population is intrusive to the Dnieper Basin. Elsewhere, the data for Dereivka I highlights a very depleted $\delta^{13}C$ source, perhaps indicating that the exploitation of a different range of freshwater fish species occurs at this site, or that a small number of the nonlocal individuals (e.g. the 3 outliers from Dereivka I) retain some of the $\delta^{13}C$ source data from their place of origin (e.g. it is possible that the nonlocal individuals may have moved to the new area shortly before death and as a consequence have not had time to incorporate the local dietary signal).

Despite these inferences, in general the data presented in Figure 2 fails to highlight any discrete separation between the two Neolithic populations studied from the region in terms of the $\delta^{13}C$ and $\delta^{15}N$ values of the dietary sources being consumed. That being the case, with the exception of the individuals interred at Vasilyevka II, we might anticipate that the majority of the individuals interred in the earlier Neolithic cemeteries moved into the region and were resident for some time (>10 years) prior to their deaths. The variation in individuals which is evident at Dereivka, e.g. Individuals 49 (−23.4‰ and 9.9‰), 33 (−21.7‰ and 10.5‰) and 31 (−22.32‰ and 15.48‰), might reflect either specific dietary choice or the recent arrival of these nonlocal individuals into the region, thereby allowing us to 'see' them as distinct from the main subsistence patterns in evidence.

The main point is that the analysis of $\delta^{13}C$ and $\delta^{15}N$ ratios is not intended to be used to distinguish local from nonlocal individuals in a region. Despite this, Vasilyevka II remains atypical in relation to the core distribution of $\delta^{13}C$ and $\delta^{15}N$ ratios, perhaps suggesting that this later Mesolithic population had recently moved into the region and had not resided for a length of time sufficient to allow their stable isotope ratios to reach equilibrium with the local environmental ranges.

Fig. 3 | Average human and animal δ13C and δ15N data for the Ukrainian cemetery series. All means expressed as ±1σ

Ancient mtDNA

Preliminary results of the mtDNA analysis (Table 2) revealed a heterogenic composition of mtDNA lineages of the Yasinovatka occupants. Of the samples analyzed to date, lineages of west Eurasian and east Eurasian origin have been obtained. The west Eurasian lineages were represented by members of the U clade, identified in sample Ya19, and possibly Ya17, and the T clade. Lineages of the U clade are common in Neolithic remains from other locations in Europe (Sampietro et al., 2007; Bramanti et al., 2009; Malmström et al., 2009). In modern populations, the frequency of U1 is rather low in Europe except for the Mediterranean region, with higher frequencies observed in the Middle East. U3 (Yas19) is related to the founder haplotypes that probably entered Europe from the Near East or Caucasus during the Neolithic (Richards et al., 2002; Roostalu et al., 2007). It is typical of populations from West Asia and the Caucasus region (Derenko et al., 2007, and references therein; Roostalu et al., 2007). It may also have been part of the LUP population expansion in the Near East and Caucasus. Clade T is considered to have originated in the Near East, from where it spread into Europe at the end of the Pleistocene. Within Europe, T is common in the east and the north, particularly around the eastern Baltic Sea.

Table 2 | Individual life history data for selected individuals from Yasinovatka as based on the mtDNA analysis

Cemetery	Individual	Sex/Age	Chronological Age (calBC)	Clade/haplogroup	Likely origin of the haplogroup
Yasinovatka	Yas54	♂ 30–40	5616–5482	T	Near East/West Eurasia
"	Yas19	♀ 20–25	5434–5221	U3	Near East/Caucasus
"	Yas17	adultus	5437–5090	Likely U1	West Eurasia
"	Yas45	♂ 20–25	5432–5148	C	East Eurasia
"	Yas34	infantilis	ND (not-dated)	C	East Eurasia
"	Yas32	♂ 30–40	ND (not-dated)	T	Near East/West Eurasia

East Eurasian lineages were represented by the C clade (Ya34 and Ya45), which is uncommon in ancient or present-day European populations, but is found in Neolithic populations, as well as contemporary populations from South Siberia, where this lineage is most likely originated (Starikovskaya et al., 2005; Mooder et al., 2006).

Of interest in this context is the fact that the analysis of Neolithic cemeteries of the Baikal region has suggested that a depopulation event occurred in that region during the 6th millennium BP (Mooder et al., 2006). As such, the dating of Yasinovatka (at ca. 6440–6080 [Hedges et al., 1995]) suggests that there is a possible link between the Baikal depopulation event and the appearance of the C lineage of mtDNA in the North Pontic region.

Whilst the analysis is limited in terms of the numbers of individuals analysed to date, it is of some interest that individual Yas19 (female 20–25) has been identified by Potekhina as being of local origin, and the U3 clade is linked to the founder haplotypes that probably entered Europe from the Near East or Caucasus, possibly linked to the LUP population expansion. A detailed report of the results of the genetic analysis of these specimens is in preparation at the time of writing.

Discussion and Conclusions

The current study has sought to assess the validity of using craniometrics alongside mtDNA to assess local versus nonlocal origins for a number of individuals interred in the cemeteries of the Dnieper river system to the south of Kiev. In addition to these techniques, AMS dating and anthropological and stable isotope analysis has been used to enhance the resolution of the study. In essence, the suggested origins of certain individuals in the cemeteries of Dereivka I and Yasinovatka has been linked to their individual life histories using a combination of standard palaeoanthropological, palaeopathological, craniometric, isotopic and DNA studies. In a number of cases the identification of a nonlocal origin has been shown to exhibit a strong link to biological sex, which appears to be weighted towards males in the earlier Neolithic period at the cemetery of Dereivka I.

The stable isotope data, whilst not intended to function as a means for identifying local versus nonlocal origins for the populations studied, has consistently marked the Vasilyevka II subsistence data as being divergent from the general trend for the Dnieper region (e.g. Lillie and Jacobs, 2006; Lillie et al., 2011). Potekhina (1987, 1999a) has outlined in some detail the craniometric studies undertaken to date on the Dnieper cemeteries, and in general there is good evidence to support the suggestion that there

are two distinct physical types in the cemetery populations, and that the Vasilyevka II population may well be one of the earliest intrusive groups in this region.

A number of individuals at Dereivka I also exhibit $\delta^{13}C$ and $\delta^{15}N$ ratios that plot apart from the main cluster of the data. Interestingly, whilst these three nonlocal adults diverge from the general trend, the divergence itself is not systematic. Individual 31 (male 18–25 [female, Potekhina, 1981]) exhibits a very high $\delta^{15}N$ of 15.48‰, very similar to those identified in the Iron Gates region by Bonsall and coworkers (Bonsall et al., 1997, 2000, 2004). Individual 33 (male 18–25) has a more positive $\delta^{13}C$ value of −21.7‰ (with a low $\delta^{15}N$ value of 10.5‰), which is very close to the more negative Vasilyevka II $\delta^{13}C$ values, and finally, Individual 49 (male 20–30 [matures, Potekhina, 1981]) exhibits the lowest $\delta^{15}N$ values for the individuals considered here, at 9.9‰. This lattermost individual also represents the richest burial at Dereivka, with fish and deer tooth pendants and a Mariupol-type plate in association.

Whilst the consumption of freshwater resources has consistently been highlighted for the Dnieper cemeteries, it is intriguing to note that a number of the Vasilyevka II and Dereivka I individuals that are identified as being of nonlocal origin through the craniometric studies, also differ to some degree in relation to their subsistence preferences as attested by the stable isotope data.

Finally, the mtDNA analysis has resulted in the successful recovery of ancient DNA from the populations of the Dnieper region, and revealed heterogeneity in the mtDNA lineages that have been obtained. These preliminary results indicate that there is considerable potential for the application of mtDNA analysis to the Ukrainian cemetery populations, and whilst limited, the results are informative. The data presented above highlights evidence for both western and eastern Eurasian mtDNA lineages in the Dnieper cemeteries and suggests that we have indications of shared maternal lineages for the populations in the Dnieper region. The direct assessment of local versus nonlocal derivation for individuals from the cemeteries considered here offers an intriguing avenue for research as the craniometric data can be assessed using both mtDNA and Sr analysis in future studies.

It is apparent that the integration of a wide range of analytic techniques has facilitated a detailed consideration of a number of individuals from the Dnieper cemeteries of Dereivka I and Yasinovatka. Whilst the strands of evidence that have been linked in the current study were not initially intended to act as a synergetic study, they have been shown to offer some important informative potential when considering the nature of population migrations in the region. Our future research directions will focus on filling in the gaps, whereby those individuals that have been dated, aged, sexed and subjected to craniometric studies and stable isotope analysis will form the basis for an enhanced resolution study incorporating mtDNA and Sr analysis. This dataset will form the foundation for a refined research agenda aimed at the detailed analysis of entire cemetery populations in order to provide an holistic overview of Mesolithic to Neolithic populations dynamics in the Dnieper region of Ukraine and beyond.

References

Alekseev, V.P., Debets, G.F., 1964. Kraniometriya: Metodika antropologicheskih issledovaniy. Nauka, Moskva.

Ambrose, S.H., 1990. Preparation and characterization of bone and tooth collagen for stable carbon and nitrogen isotope analysis. Journal of Archaeological Science 17, 431–451.

Anthony, D. W., 2007. Pontic-Caspian Mesolithic and Early Neolithic Societies at the Time of the Black Sea Flood: A Small Audience and Small Effects, in: Yanko-Hombach, V., Gilbert, A.S., Panin, N., Dolukhanov, P.M. (Eds.), The Black Sea Flood Question. Changes in Coastline, Climate and Human Settlement. Springer, Dordrecht, pp. 345–370.

Bass, W.M., 1995. Human osteology. A laboratory and field manual. 3rd ed. Missouri Archaeological Society (Special Publication No.2), Columbia.

Bonsall, C., Cook, G., Lennon, R., Harkness, D., Scott, M., Bartosiewicz, L., McSweeney, K., 1997. Stable isotopes, radiocarbon and the Mesolithic–Neolithic transition in the iron gates: a palaeodietary perspective. Journal of European Archaeology 5 (1), 50–92.

Bonsall, C., Cook, G., Lennon, R., Harkness, D., Scott, M., Bartosiewicz, L., McSweeney, K., 2000. Stable isotopes, radiocarbon and the Mesolithic–Neolithic transition in the Iron Gates. Documenta Praehistorica 27, 119–132.

Bonsall, C., Cook, G.T., Hedges, R.E.M., Higham, T.F.G., Pickard, C., Radovanoviç, L., 2004. Radiocarbon and stable isotope evidence of dietary change from the Mesolithic to the Middle Ages in the Iron Gates: New results from Lepenski Vir. Radiocarbon 46 (1), 293–300.

Bramanti, B., Thomas, M.G., Haak, W., Unterlaender, M., Jores, P., Tambets, K., Antanaitis-Jacobs, I., Haidle, M.N., Jankauskas, R., Kind, C-J., Lueth, F., Terberger, T., Hiller, J., Matsumura, S., 2009. Genetic discontinuity between local hunter-gatherers and Central Europe's first farmers. Science 326, 137–140.

Brown, T.A., Nelson, D.E., Vogel, J.S., Southon, J.R., 1988. Improved collagen extraction by modified Longin method. Radiocarbon 30 (2), 171–177.

Buikstra, J.E., Ubelaker, D.H. (Eds.), 1994. Standards for data collection from human skeletal remains. Arkansas Archaeological Survey Research Series No. 44. Arkansas Archeological Survey, Fayetteville.

Cann, R.L., Stoneking, M., Wilson, A.C., 1987. Mitochondrial DNA and human evolution. Nature 325, 31–36.

Cooper, A., Poinar, H., 2000. Ancient DNA: Do it right or not at all. Science 289, 1139.

DeNiro, M.J., 1985. Post-mortem preservation and alteration of in vivo bone collagen isotope ratios in relation to paleodietary reconstruction. Nature 317, 806–809.

Derenko, M., Malyarchuk, B., Grzybowski, T., Denisova, G., Dambueva, I., Perkova, M., Dorzhu, C., Luzina, F., Lee, H.K., Vanecek, T., Villems, R., Zakharov, I., 2007. Phylogeographic analysis of mitochondrial DNA in northern Asian populations. American Journal of Human Genetics 81 (5), 1025–1041.

Dolukhavov, P.M., 2008. The Mesolithic of European Russia, Belarus, and the Ukraine, in: Bailey, G., Spikins, P. (Eds.), Mesolithic Europe. University Press, Cambridge, pp. 280–301.

Dolukhanov, P. M., Shilik, K.K., 2007. Environment, sea-level changes, and human migrations in the Northern Pontic area during Late Pleistocene and Holocene times, in: Yanko-Hombach, V., Gilbert, A.S., Panin, N., Dolukhanov, P.M. (Eds.), The Black Sea Flood Question. Changes in Coastline, Climate and Human Settlement. Springer, Dordrecht, pp. 297–318.

Forster, P., 2004. Ice ages and the mitochondrial DNA chronology of human dispersals: a review. Philosophical Transactions of the Royal Society London B 359, 255–264.

Gokhman, I.I., 1958. Palaeoantropologicheskie materialy iz neolithicheskogo mogilnika Vasilyevka II v Dnieprovskom Nadpoozhie. Sovetskaya Ethnografiya 1, 24–38.

Gokhman, I.I., 1966. Naselenie Ukrainy v epokhu mezolita i neolita: anthropologicheskiy ocherk. (The population of the Ukraine in the mesolithic and neolithic periods: an anthropological outline). Nauka, Moscow.

Haeussler, A.M., Potekhina, I.D., 2001. North Pontic Populations in the Mesolithic-Neolithic: osteological, dental, subsistence, and cultural factors. American Journal of Physical Anthropology, Annual Meeting Issue 74.

Haeussler, A.M., Potekhina, I.D., 2002. The ancient Neolithic people of Ukraine: osteological and dental considerations. American Journal of Physical Anthropology, Annual Meeting Issue 80.

Hedges, R.E.M., Housley, R.A., Bronk Ramsey, C., Van Klinken, G.J., 1995. Radiocarbon dates from the Oxford AMS System: Archaeometry Datelist 20. Archaeometry 37, 417–430.

Jacobs, K., 1994. Reply to Anthony on subsistence change at the Mesolithic-Neolithic transition. Current Anthropology 35, 52–59.

Konduktorova, T.S., 1974. The ancient population of the Ukraine: from the Mesolithic Age to the first centuries of our era. Anthropologie Brno XII (1&2), 5–149.

Kotova, N.S., 2003. Neolithisation in Ukraine. BAR International Series S1109. Archaeopress, Oxford.

Kotova, N.S., Pashkevich, G.A., 2002. Katalog otpechatkov kulturnykh rasteniy na keramik eneoliticheskih kultur Ukrainy, in: Kotova, N.S. (Ed.), Neolitizatsiya Ukrainy. Lugansk, Shlyakh, pp. 106–108.

Lillie, M.C., 1996. Mesolithic and Neolithic populations of Ukraine: Indications of diet from dental pathology. Current Anthropology 37, 135–142.

Lillie, M.C., 1997. Women and children in Prehistory: Resource sharing and social stratification at the Mesolithic-Neolithic transition in Ukraine, in: Moore, J., Scott, E. (Eds.), Invisible People and Processes: Writing Gender and Childhood into European Archaeology. Leicester University Press, London, pp. 213–228.

Lillie, M.C., 1998a. The Dnieper Rapids region of Ukraine: A consideration of chronology, dental pathology and diet at the Mesolithic-Neolithic transition. PhD thesis, University of Sheffield.

Lillie, M.C., 1998b. The Mesolithic-Neolithic transition in Ukraine: new radiocarbon determinations for the cemeteries of the Dnieper Rapids region. Antiquity 72, 184–88.

Lillie, M.C., 1998c. Cranial surgery dates back to Mesolithic. Nature 391, 854.

Lillie, M.C. 2003. Tasting the forbidden fruit: gender based dietary differences among prehistoric hunter-gatherers of Eastern Europe? Before Farming 2 (3), 1–16.

Lillie, M.C., Richards, M.P., 2000. Stable isotope analysis and dental evidence of diet at the Mesolithic-Neolithic transition in Ukraine. Journal of Archaeological Science 27, 965–972.

Lillie, M.C., Jacobs, K., 2006. Stable isotope analysis of fourteen individuals from the Mesolithic cemetery of Vasilyevka II, Dnieper Rapids region, Ukraine. Journal of Archaeological Science 33, 880–886.

Lillie, M.C., Richards, M.P., Jacobs, K., 2003. Stable isotope analysis of twenty-one individuals from the Epipalaeolithic Cemetery of Vasilyevka III, Dnieper Rapids region, Ukraine. Journal of Archaeological Science 30, 743–752.

Lillie, M.C., Budd, C.E., Potekhina, I.D., Hedges, R.E.M., 2009. The radiocarbon reservoir effect: New evidence from the cemeteries of the Middle and Lower Dnieper Basin, Ukraine. Journal of Archaeological Science 36, 256–264.

Lillie, M.C., Budd, C., 2011. The Mesolithic-Neolithic Transition in Eastern Europe: integrating stable isotope studies of diet with palaeopathology to identify subsistence strategies and economy, in: Pinhasi, R., Stock, J. (Eds.), Human Bioarchaeology of the Transition to Agriculture. Wiley-Liss, New York, pp. 43–62.

Lillie, M.C. Budd, C.E., Potekhina, I.D., 2011. Stable isotope analysis of prehistoric populations from the cemeteries of the Middle and Lower Dnieper Basin, Ukraine. Journal of Archaeological Science 38 (1), 57–68.

Malmström, H., Gilbert, M.T., Thomas, M.G., Brandström, M., Storå, J., Molnar, P., Andersen, P.K., Bendixen, C., Holmlund, G., Götherström, A., Willerslev, E., 2009. Ancient DNA reveals lack of continuity between Neolithic hunter-gatherers and contemporary Scandinavians. Current Biology 19, 1758–1762.

Martin, R., Saller, K., 1957. Lehrbuch der Anthropologie in systematischer Darstellung. G. Fischer, Stuttgart.

Mooder, K.P., Schurr, T.G., Bamforth, F.J., Bazaliiski, V.I., Savel'ev, N.A., 2006. Population affinities of Neolithic Siberians: A snapshot from prehistoric Lake Baikal. American Journal of Physical Anthropology 129, 349–361.

Motuzaite Matuzeviciute, G. 2010. An archaeobotanical approach to the earliest appearance of domesticated plant species in Ukraine. PhD Thesis, Cambridge University.

Motuzaite Matuzeviciute, G., Hunt, H.V., Jones, M.K., 2009. Multiple Sources for Neolithic European Agriculture: Geographical Origins of Early Domesticates in Moldova and Ukraine, in: Dolukhanov, P., Sarson, G.R., Shukurov, A.M. (Eds.), The East European Plain on the Eve of Agriculture. BAR International Series S1964. Archaeopress, Oxford, pp. 53–64.

Nikitin, A.G., Kochkin, I.T., June, C.M., Willis, C.M., McBain, I., Videiko, M.Y., 2009. Mitochondrial DNA sequence variation in the Boyko, Hutsul, and Lemko populations of the Carpathian Highlands. Human Biology 8 (1), 43–58.

Potekhina, I.D., 1978. K anthropologicheskoy kharakteristike Dereivskogo neolithicheskogo mogilnika. Ispolzovaniye metodov estestvennykh nauk v arkheologii. Kiev, pp. 109–28.

Potekhina, I.D., 1981. K voprosu o prodolzhitel'nosti zhizni cheloveka kamennogo veka na Ukraine (About the lifespan of the Stone Age populations of Ukraine). Drevnosti Srednego Podneprovia. Naukova Dumka, Kiev, pp. 21–30.

Potekhina, I.D., 1987. The Neolithic population of the Dnieper Basin, in: Telegin, D.Ya. and Potekhina, I.D., Neolithic cemeteries and populations in the Dnieper Basin. BAR International Series 383. Archaeopress, Oxford, pp. 148–181

Potekhina, I.D., 1988. Kraniologicheskie materialy iz neoliticheskogo mogilnika Yasinovatka na Dnepre. (Craniological material from the Neolithic cemetery of Yasinovatka on the Dnieper). Sovetskaya Archeologiya 1, 144–154.

Potekhina, I.D., 1999a. Naselenie Ukrainy v epokhi Neolita i rannego Eneolita po antropologicheskim dannym. (Populations of the Ukraine in the Neolithic to Eneolithic periods from the anthropological data). Institut Arkheologii NANU, Kiev.

Potekhina, I.D., 1999b. O rekonstrukcii diety neoliticheskogo naseleniya Podneprov'ya (Dietary reconstruction of the Neolithic populations in the Dnieper Basin), in: III Kongress etnografov i antropologov Rossii. Tezisy dokladov, Moskva, pp. 153–154.

Potekhina, I.D., 2005. Bioarkheologichni doslidzhennya pervisnogo nasalennya Ukrainy: novi pidhody do starykh problem (Bioarchaeological study of prehistoric populations of Ukraine: new approach to old problems), in: Kam'yana Doba Ukrainy, Vol. 7, Kyiv, pp.168–172.

Potekhina, I.D., Mallory, J.P., 2011. Obituary: D.Ya. Telegin. European Journal of Archaeology 39 (1-2), 1–3.

Price, T.D., Bentley, R.A., Lüning, J., Gronenborn, D., Wahl J., 2001. Human migration in the Linearbandkeramik of central Europe. Antiquity 75, 593–603.

Rassamakin, Y., 1999. The Eneolithic of the Black Sea Steppe: Dynamics of Cultural and Economic Development 4500–2300 BC, in: Levine, M., Rassamakin, Y., Kislenko, A. and Tatarintseva, N., Late Prehistoric Exploration of the Eurasian Steppe. McDonald Institute for Archaeological Research, Cambridge, pp. 52–182.

Richards, M., 1998. Palaeodietary Studies of European Human Populations using Bone Stable Isotopes. PhD. Thesis, University of Oxford.

Richards, M., Macauley, V., Hickey, E., Vega, E., Sykes, B., Guida, V., Rengo, C., Sellitto, D., Cruciani, F., Kivisild, T., Villems, R., Thomas, M., Rychkov, S., Rychkov, O., Rychkov, Y., Gölge, M., Dimitrov, D., Hill, E., Bradley, D., Romano, V., Calì, F., Vona, G., Demaine, A, Papiha, S. Triantaphyllidis, C., Stefanescu, G., Hatina, J., Belledi, M., Di Rienzo, A., Novelletto, A., Oppenheim, A., Nørby, S., Al-Zaheri, N., Santachiara-Benerecetti, S., Scozari, R., Torroni, A., Bandelt, H.J., 2000. Tracing European founder lineages in the Near Eastern mtDNA pool. American Journal of Human Genetics 67, 1251–1275.

Richards, M., Macaulay, V., Torroni, A., Bandelt, H.-J., 2002. In search of geographical patterns in European mitochondrial DNA. American Journal of Human Genetics 71, 1168–1174.

Roostalu, U., Kutuev, I. Loogvä, E.-L., Tambets, K., Reidla, M., Khusnutdinova, E.K., Usanga, E., Kivisild, T., Villems, R., 2007. Origin and expansion of haplogroup H, the dominant human mitochondrial DNA lineage in west Eurasia: The Near Eastern and Caucasian perspective. Molecular Biology and Evolution 24, 436–448.

Sampietro, M.L., Lao, O., Caramelli, D., Lari, M., Pou, R., Martí, M., Bertranpetit, J., Lalueza-Fox, C., 2007. Palaeogenetic evidence supports a dual model of Neolithic spreading into Europe. Proceedings of the Royal Society B 274, 2161–2167.

Starikovskaya, E.B., Sukernik, R.I., Derbeneva, O.A., Volodko, N.V., Ruiz-Pesini, E., Torroni, A., Brown, M.D., Lott, M.T., Hosseini, S.H., Huoponen, K., Wallace, D.C., 2005. Mitochondrial DNA Diversity in Indigenous Populations of the Southern Extent of Siberia, and the Origins of Native American Haplogroups. Annals of Human Genetics 69, 67–89.

Stolyar, A.D., 1959. Pervyi Vasilyevskii mezolithicheskii mogilnik. Arkheologicheskii Sbornik 1, 78–158.

Telegin, D.Ya., 1991. Neoliticheskie Mogilniki Mariupolskogo Tipa. Naukova dumka, Kiev.

Telegin, D.Ya., Potekhina, I.D., 1987. Neolithic cemeteries and populations in the Dnieper Basin. Oxford: BAR International Series 383. Archaeopress, Oxford.

Telegin, D.Ya., Potekhina, I.D., Kovaliukh, M.M., Lillie, M.C., 2000. Chronology of the Mariupol-type cemeteries and the problem of the periodisation of the Neolithic to Copper Age cultures of Ukraine. Radiocarbon & Archaeology 1 (1), 59–74.

Telegin, D.Ya., Lillie, M.C., Potekhina, I.D., Kovaliukh, M.M., 2003. Settlement and Economy in Neolithic Ukraine: a new chronology. Antiquity 77 (279), 456–470.

Telegin, D.Ya., Potekhina, I.D., Lillie, M.C., Kovaliukh, M.M., 2002. The Chronology of the Mariupol-type cemeteries of Ukraine re-visited. Antiquity 76, 356–363.

Velichko, A.A., Kurenkova, E.I., Dolukhanov, P.M., 2009. Human Socio-Economic Adaptation to Environment in Late Palaeolithic, Mesolithic and Neolithic Eastern Europe. Quaternary International 203 (1–2), 1–9.

Zinevich, G.P., 1967. Ocherki Paleoantropologii Ukrainy. Kiev.

Zinevich, G.P., Kruts, S.I., 1968. Antropologichna Kharakteristika Davnyego Nasalennya Territorii Ukrainy. Kiev.

Vyacheslav I. Molodin[a], Alexander S. Pilipenko[b,*], Aida G Romaschenko[b], Anton A. Zhuravlev[b], Rostislav O. Trapezov[b], Tatiana A. Chikisheva[a], Dmitriy V. Pozdnyakov[a]

Human migrations in the southern region of the West Siberian Plain during the Bronze Age: Archaeological, palaeogenetic and anthropological data

* Corresponding author: alexpil@mail.ru
a Institute of Archaeology and Ethnography, Siberian Branch, Russian Academy of Sciences, Novosibirsk, Russia
b Institute of Cytology and Genetics, Siberian Branch, Russian Academy of Sciences, Novosibirsk, Russia

Abstract

In this paper we present archaeological and anthropological data on human migrations in the Western Siberian forest-steppe region during the Bronze Age (4th–beginning of 1st millennium BC). These data, accumulated over forty years of intensive research in the region, are compared to new results showing the diversity of mitochondrial DNA (mtDNA) lineages in this region during that period (92 mtDNA samples from seven ancient human groups). Preliminary analyses have demonstrated the usefulness of ancient DNA in tracing and unravelling patterns of past human migrations.

Keywords

West Siberian forest steppe, Bronze Age cultural groups, human migrations, ancient mtDNA

Introduction

Western Siberia is a vast area of approximately 3 million square kilometers in North Asia. It ranges from the Ural Mountains in the east to the Yenisei River in the west, and from the Arctic Ocean in the north to the mountainous regions of Central Asia in the south. The southern part of the region comprises zones of steppe and forest steppe and has been inhabited by anatomically modern humans since the Stone Age (Upper Palaeolithic period).

Our work is devoted to the analysis of human migration processes that occurred during the Bronze Age (4th–early 1st millennium BC) in the forest steppe zone between the Ob and Irtysh rivers (about 800 km from west to east). This area, known as Baraba forest steppe, stretches over 200 km from the taiga zone in the north to the steppes in the south.

Several factors make the ancient Baraba populations interesting objects of study. Firstly, intensive archaeological research has been conducted in the Baraba region during the last 30 years. As a result, a large set of data about all ethno-cultural groups that occupied this territory, from about 14 thousand years ago to the Late Middle Ages, including the Bronze Age, is currently available. Secondly, the ancient human groups of Baraba exhibit all general features of the ancient West Siberian population, yet with some specific features (Molodin, 1985, 2001). Thirdly, we have a unique collection of palaeoanthropological remains for all Baraba populations from the Bronze Age. The high degree of preservation of these bones enables their analysis using methods from both physical anthropology and molecular genetics. It is also important that these remains were obtained from burial grounds located within a small territory (Fig. 1). As a result, the populations occupying this territory were to some extent culturally homogenous during each of the historical periods considered.

Using this material we have attempted to assess changes in the composition of mtDNA lineages in the gene pools of ancient Baraba populations during the Bronze Age, comparing the genetic results with the archaeological and anthropological evidence pointing to the putative migratory events thought to have occurred during this period.

Fig. 1 | Location of the archaeological sites from which samples for the genetic studies were obtained. 1 Sopka-2; 2 Tartas-1; 3 Preobrazhenka-6; 4 Stariy Sad; 5 Chicha-1 (including Kurgan Zdvinsk-1)

Table 1 | The Bronze Age West Siberian cultural groups studied

Ancient human group	Date (millennium BC)	Archaeological sites	Periods
Ust-Tartas Culture	4th – first half of 3rd	Sopka-2/3, Sopka-2/3A	Early Metal Period
Odinovo Culture	Beginning of 3rd	Sopka-2/4A Preobrajenka-6	Early Bronze Age
Early Krotovo Culture	End of 3rd – beginning of 2nd	Sopka-2/4B	Middle Bronze Age
Late Krotovo Culture	First quarter of 2nd	Sopka-2/5, Tartas-1	Middle Bronze Age
Andronovo (Fedorovo) Culture	First half of 2nd	Tartas-1	Middle Bronze Age
Baraba Late Bronze Age Culture	End of 2nd	Stariy Sad	Late Bronze Age
Late Irmen Culture	9th–8th centuries BC	Chicha-1	Transition from Bronze to Iron Age

Materials and methods of the palaeogenetic study

The ancient West Siberian groups studied are listed in Table 1 and Figure 2. DNA was extracted from the compact material of long bones (femur, tibia or humerus) and/or from the teeth. Whenever possible, samples were taken from different parts of the skeleton (eg, postcranial bone and tooth) from each individual. For a minority of individuals different parts of the same bone had to be used.

DNA was extracted according to the method described by Pilipenko and colleagues (2008, 2010). In brief, surfaces of bone and tooth samples were cleaned mechanically followed by treatment by bleach

and UV. Bone powder was drilled from the internal area of the samples. DNA was extracted from the powder with a 5M guanidinium thiocyanate (GuSCN) buffer (pH 11.0) for 48 hours at 65°C followed by phenol/chlorophorm extraction. The DNA was precipitated from the aqueous phase with isopropanol in the presence 1M NaCl. At least two extractions were conducted for each individual under study (in most cases, three).

Amplification of Hyper-Variable Region (HVR) I of mtDNA was performed using three different techniques: amplification using four overlapping fragments (Haak et al., 2005), amplification with primer pairs HA1 and HA3, HB1 and HB3, HC1 and HC3 that produced three overlapping fragments (Adcock et al., 2001) and nested PCR (two reaction rounds) that produced one long fragment (Pilipenko et al., 2008).

Cloning of PCR products and sequencing of clones have been performed for a half of the samples. For the remaining samples the cloning procedure is in progress. A set of PCR products was cloned with pGEM-T Easy Vector Sestem Kit (Promega, USA) and a minimum of 30 clones were sequenced for each individual.

Sequencing reactions were performed with an ABI Prism BigDye Terminator Cycle Sequencing Ready Reaction Kit (Applied Biosystems, USA), according to the manufacturer's instructions. The sequences of the products were analyzed on an ABI Prism 3100 Genetic Analyzer (Applied Biosystems, USA) at the DNA Sequencing Center (Novosibirsk, Russia, www.sequest.niboch.nsc.ru).

The sequencing results were analysed using Sequence Scanner v1.0 (Applied Biosystems, USA) and DNAStar Lasergene v. 7.1.0 (DNASTAR, USA) software. The phylogenetic tree was constructed using Network 4.5.1.0 software (http://www.fluxus-engeneering.com).

Precautions against contamination: All stages of work with ancient material were carried out in specially equipped, isolated clean rooms with positive air pressure, using special cloth, facemasks, glasses and sterile gloves. All work surfaces were routinely cleaned with a 5% solution of bleach and irradiated by UV light. Blank controls were run in parallel with samples throughout the extraction and amplification procedures to identify possible contamination. MtDNA HVR I sequences were determined for all employees working with ancient DNA and (to the extent possible) for participants of excavations and anthropologists who might have had contact with remains.

Results and discussions

The degree of contamination and the authenticity of the aDNA results obtained

Despite the strict experimental conditions we were unable to eliminate the problem of contamination completely. In particular, contamination was ascertained in a small proportion of the extraction and PCR blank controls (less than 1% of control number). All extracts or PCR-products were discarded in such cases. Additionally, we identified singular divergent sequences among clones from several mtDNA samples studied. These sequences were regarded as the results of contamination as they were not reproducible in the second PCR or/and extraction. The other necessary conditions for the authenticity of obtained ancient DNA sequences were as follows: consistency of the results obtained in repeated PCR from one extract (for the same region or for several overlapping DNA fragments). Consistency between the results of multiple (at least two) DNA extractions (including extractions from different parts of the skeleton, such as the femur and teeth). The divergence of obtained aDNA sequences from those of staff members (geneticists, archaeologists, anthropologists) who may have had contact with the samples be-

Fig. 3 | Phylogenetic tree of 92 mtDNA samples obtained from the seven Bronze Age cultural groups from the Baraba region. Color coding of the groups as in Figure 2

Fig. 2 | Chronological time scale of Bronze Age Cultures from the Baraba region

fore or during the genetic study. Presence among the clones of a specific pattern of biochemical degradation (cytosine deamination). In our opinion, these criteria meet the main modern requirements for verification of aDNA data.

In total, we successfully analyzed 92 mtDNA samples from seven ancient human groups from Baraba and adjacent areas (Fig. 3; Table 2–3 see appendix).

The genesis of West Siberian forest-steppe populations during the Neolithic and Early Metal periods

In order to estimate the impact of the migration waves on ethnogeny it is necessary to characterize the archaeological, anthropological and genetic contexts preceding the migratory events. For this purpose, it is also necessary to investigate the early populations of the region.

In contrast to the occupation of the southern region of West Siberia, modern humans arrived in the Ob-Irtysh interfluve relatively late, at the end of the Pleistocene, about 13–14 thousand years ago (Okladnikov, Molodin, 1983; Petrin, 1986). The absence of burials dating back to this period in the region does not allow us to conduct a biological investigation of this earliest population. The most ancient anthropological material available is from the Neolithic period (4^{th}–5^{th} millennium BC). More than two dozen

Fig. 4 | Typical collective burial of Ust-Tartas Culture representatives (Burial N 655, Sopka-2/3 burial ground)

Neolithic burials have been excavated to date. The material from these excavations has allowed the characterization of specific aspects of the material culture and anthropological type of the Neolithic group (Polos'mak et al., 1989; Molodin, 2001). The anthropological analysis of the material allowed us to detect a specific craniological type in the Baraba population, which was assigned to one of the anthropological formations discovered by V.V. Bunak in 1956 through the analysis of Neolithic materials from the northern forest zone of the East European Plain. Bunak called it the "northern Eurasian anthropological formation" (Bunak, 1956).

This anthropological type developed in a zone that is intermediate to the geographic areas occupied by the classic Caucasoids and the Mongoloids. The exists substantial anthropological evidence showing a wide geographic distribution of this anthropological formation: from the Trans-Urals forest and the Barabian province of Western Siberia in the east to Karelia and the Baltic in the west (Chikisheva, 2010).

It is therefore possible to determine the cultural and anthropological background that existed in the Baraba region in the beginning of the Bronze Age. The availability of a small number of materials suitable for DNA analysis will also allow us to determine the composition of mtDNA lineages of the Baraba population from the Neolithic (the first results have already been obtained, but are not discussed in this paper).

The earliest group from the Bronze Age in the Baraba region is represented by the Ust-Tartas population (Molodin, 2001). Several Ust-Tartas burial grounds with more than 150 graves have been excavated to date (Fig. 4), some of which revealed the presence of bronze adornments. The results of archaeo-

logical and radiocarbon dating allow us to date this culture to between the 4th millennium BC and the first half of the 3rd millennium BC.

Another cultural group in the Baraba region existed contemporaneously with the Ust-Tartas culture, the "Comb-pit Ware culture". Unlike the Ust-Tartas, the materials from the Comb-pit Ware culture are associated predominantly with settlements. In addition, several burials have been investigated, making it possible to reconstruct the burial practices of this culture (Molodin, 1985, 2001).

Representatives of the Ust-Tartas culture belonged to a single craniological type preceding the Neolithic populations of the region (Chikisheva, 2010). Craniometric analyses of materials from burials with comb-pit ware also show the characteristic features of the northern Eurasian anthropological formation, but demonstrate greater affinity with the northern periphery of the West Siberian Neolithic cultures (Chikisheva, 2010), suggesting a predominantly autochthonous development of the Baraba populations from the Early Metal period.

We have analyzed 18 mtDNA samples from the Ust-Tartas population to date (Fig. 3). The results obtained thus far allow us to draw several preliminary conclusions about the genetic background in the region in the beginning of the Bronze Age. By the Early Metal Period the mtDNA pool structure was already mixed and consisted of both Western and Eastern Eurasian haplogroups in nearly equal proportions. The eastern Eurasian mtDNA cluster was represented by Haplogroups A, C, Z, D, which are most typical of modern and perhaps ancient populations located in the east of the region studied. Haplogroups C and D were predominantly represented by widely distributed root haplotypes. A lineage of Haplogroup A that was detected in two Ust-Tartas samples represents a subcluster that is apparently characteristic of West Siberia and the Volga-Ural Region. The observed presence of Haplogroup Z lineages with a high frequency in the Ust-Tartas group was unexpected, since these lineages are nearly absent in the gene pool of modern indigenous West Siberian populations.

It is worth noting that the Western Eurasian mtDNA haplogroups in the Ust-Tartas series were represented only by Haplogroup U lineages, and specifically by the three subgroups – U2e, U4, U5a1. These results are in agreement with previous data indicating that Haplogroup U lineages (particularly Subgroups U5 and U4) predominated in Eastern, Central and Northern European hunter-gatherer groups from 14000 to 4000 years ago (Bramanti et al., 2009; Malmstrom et al., 2009), and possibly in earlier periods (Krause et al., 2010). The geographic area within which this genetic feature is observed appears to be broad (Fig. 5). Apparently, Baraba was near the eastern periphery of this area.

The Early and the beginning of Middle Bronze Age populations: an autochthonous evolution

The local evolution of the cultural groups described above led to the emergence of a new group in the Baraba region in the beginning of the 3rd millennium BC. This group, referred to as Odinovo culture, differed in terms of their grave goods and funerary practices (Fig. 6) (Molodin, 2008).

The study of Odinovo culture settlements and several burial grounds with characteristic funerary practices showed that its carriers had well-developed bronze casting and weapons of the Seima-Turbino type (Molodin, 2008). The material culture of this group combined features of the preceding Comb-pit ware and Ust-Tartas archaeological cultures. It is possible that both these substrates were involved in the formation of the Odinovo culture. Anthropological evidence confirms the autochthonous development of the culture. An anthropological affinity of the group to the Ust-Tartas and the Neolithic craniological series from the Baraba forest steppe has been established (Chikisheva, 2010).

Fig. 5 | Location of ancient human groups with a high frequency of mtDNA haplogroups U5, U4 and U2e lineages. The area of Northern Eurasian anthropological formation is marked by yellow region on the map (References: 1 Bramanti et al., 2009; 2 Malmstrom et al., 2009; 3 Krause et al., 2010; 4 this study)

At the end of the 3rd and beginning of the 2nd millennium BC, a striking and original culture existed in the West Siberian forest steppe zone. The culture, known as Krotovo, obviously developed autochthonally (Molodin, 1985). Undoubtedly, one of its ancestral components was the preceding Odinovo group. However, undeniable innovations are observed in the Krotovo funerary practices and inventories. These new features were probably associated with episodic migrations of representatives of the Petrovo culture from the modern North Kazakhstan territory (Zdanovich, 1988) to the Baraba forest steppe. Moreover, present among the Krotovo materials were specific forms of daggers, stalked spearheads and beads of chalcedony, jaspilite and enstatite (the nearest deposits of these minerals are located in Central Asia and Kazakhstan) (Fig. 7a,b,c), suggesting the influence of Central Asian cultures in the Baraba region during the Middle Bronze Age (end of 3rd–beginning of 2nd millennium BC) (Molodin, 1988). This is the most ancient external influence on the material culture of the Baraba population from the Bronze Age that might have been accompanied by a migration wave.

The craniological analysis of early Krotovo populations, however, showed the presence of an autochthonous morphological complex that was typical of earlier groups in the region, except for a higher cranium in Krotovo males (Chikisheva, 2010).

The genetic analysis of the Odinovo and Krotovo groups (10 and 6 samples, respectively) (Fig. 3) did not reveal any differences between them and the previous Ust-Tartas group, such as the presence of new mtDNA haplogroups. The mtDNA pool structure was still mixed. The East Eurasian haplogroups were

Fig. 6 | A burial of Odinovo culture representatives (Sopka-2/4A burial ground)

Fig. 7 | Specific spearhead (a), daggers (b) and beads (c) from the Early Krotovo Culture sites, indicating the influence of Central Asian cultures in the Baraba region during the Middle Bronze Age

represented by the D, C, Z (in both the Odinovo and Krotovo groups) and A (in the Krotovo group) haplogroups. The East Eurasian lineages identified were phylogenetically close (lineages of haplogroups A, C, Z) or even identical (D haplogroup, 16223–16362 lineages) to the samples from the Ust-Tartas group. The West Eurasian part of the samples were represented by the U5a1 (Odinovo group) and U2e (Krotovo group) haplogroup lineages.

Although only a small series of samples have been investigated thus far, the data obtained reveal continuity between the Odinovo and Krotovo populations and the earlier Ust-Tartas group. These findings are consistent with the autochthonous development of the Baraba populations during the Early and the beginning of the Middle Bronze Age, as well as with the anthropological evidence.

Our data did not allow us to detect any Central Asian genetic influence on the Krotovo population, although this conclusion is still preliminary due to the small sample sizes involved.

The Middle and Late Bronze Age: significance of the Andronovo (Fedorovo) population migration wave

The Krotovo culture continued to develop indigenously for several centuries. At the beginning of the 2nd millennium BC, the migration of the Andronovo culture population to the south of the West Siberian Plain started, probably originating in the territory of present-day Central Kazakhstan. Apparently, this migration wave, which spread from its epicenter to the west, north and east (Kuz'mina, 1994), was a highly significant phenomenon in Asia.

The newly arrived Caucasian Andronovo population had a great influence on the development of the indigenous cultures of the West Siberian steppe and forest steppe regions (including the Baraba forest steppe). According to the archaeological evidence, the newly arrived groups coexisted with the aborigines for some time, which can be explained by the differing nature of their economic activities (nomadic and seminomadic pastoralism in the Andronovo group and sedentary or semisedentary pastoralism in the aboriginal Late Krotovo group). During this time the migrants had a strong impact on the material culture of the indigenous group. As a result, the bronze weapons and adornments of the aboriginal cultural group changed from Seima-Turbino to Srubno-Andronovo forms (Fig. 8a; 9a). The contact between these two groups is also reflected in their funerary practices and inventories, which combined novel and traditional features of the Baraba region. Archaeological evidence indicates that the Andronovo impact on the Late Krotovo population was in fact manifold.

The adaptation of the migrant Andronovo group in the West Siberian forest steppe was a long process that resulted in the absolute dominance of this population in the region. The Krotovo populations were partially displaced to the north and partly assimilated. The material and spiritual culture of the Andronovo group in West Siberia gradually returned to its classical tradition (Fig. 8b; 9b), although with some new unique features.

At the late stage of the development of the Krotovo culture, the craniological complex had changed markedly in comparison to the anthropological type common in all preceding Neolithic and Bronze Age populations in the Baraba region. The changes observed in males from the Late Krotovo group could be attributed to the influence of Andronovo representatives. Some Mongoloid features, which were not related to the previous autochthonous substrate, appeared in females from the Late Krotovo group. The Europoid component observed in these females does not fall within the generally accepted criteria for the Andronovo anthropological type.

Fig. 8a | Typical burials of the Late Krotovo Culture; b. typical burial of the Andronovo (Fedorovo) Culture

Fig. 9a | Daggers of Srubno-Andronovo form; b. Ceramic pot with specific ornamentation of the Andronovo (Fedorovo) Culture

Some anthropological data suggest that the Krotovo population probably did not interact directly with the Andronovo populations, but rather with population groups displaced from the south and west by the Andronovo migration wave. In these groups, the Andronovo influence was already present (Chikisheva, 2010).

The anthropological analysis of representative groups of the local Andronovo culture in southern West Siberia revealed a complex population composition. It suggests the existence of different genetic roots and different degrees of involvement of autochthonous Mongoloid component in their genesis.

The anthropological analysis of the West Siberian Andronovo population shows at least four craniological types. Three types are related to the Palaeocaucasian race and are represented by proto-European anthropological type variants. The fourth, Mongoloid, component is autochthonous. The most intensive interactions between the Andronovo migrants and the indigenous populations apparently occurred in the Baraba forest steppe and the right bank of the upper Ob River (Chikisheva and Pozdnyakov, 2003).

To investigate the putative impact of Andronovo migrants on the mtDNA pool structure of the indigenous populations in Baraba, mtDNA samples from the Late Krotovo (n=20) and Andronovo (n=20) groups in this region were analyzed (Fig. 3) and compared to recently published data (n=10) (Keyser et al., 2009) and our own unpublished data (n=6) on mtDNA lineages from West Siberian Andronovo populations located outside the Baraba forest steppe.

The genetic influence of migrants can be detected by the appearance of a new mtDNA haplogroup that was absent in the populations preceding the migration wave. This new mtDNA haplogroup, a West Eurasian T haplogroup, was detected in the Late Krotovo population. The T haplogroup appears simultaneously (with a 15% frequency) in the Krotovo and Andronovo groups, but was completely absent in all preceding Baraba populations. We therefore consider the appearance of the Haplogroup T-lineage as the most likely genetic marker of the Andronovo migration wave to the region.

This assumption is confirmed by mtDNA studies of Andronovo groups from other West Siberian areas. Haplogroup T lineages were found, with a frequency of 25%, in the samples (n=16) taken from two Andronovo groups from the Krasnoyarsk and upper Ob River areas.

We also detected another remarkable feature in the mtDNA pool of the Andronovo group from Baraba. Most mtDNA samples belonged to haplogroups, such as the East Eurasian A and C haplogroups, that are typical of preceding Baraba indigenous populations. Still, these haplogroups were not found in the other West Siberian Andronovo groups. Apparently, the Andronovo group from Baraba assimilated the aboriginal Krotovo population, from which it obtained these East-Eurasian mtDNA haplogroups. Obviously, there was reciprocal genetic contact between the migrant and indigenous groups in the region.

The above mentioned ethno-cultural processes had a strong influence on the genesis of the cultural groups from the Late Bronze Age in this area. The Andronovo group in the south of West Siberia was replaced by the Irmen culture, which was originally from the West Siberian steppe and forest steppe zones around the 14th century BC, and occupied the region extending from the Achinsk and Mariinsk forest steppe in the east to the Irtysh River in the west (Molodin, 1985; Bobrov et al., 1993; Matveev, 1993). The culture existed in the region for more than five hundred years and was characterized by a powerful economy, which included animal husbandry and agriculture.

A considerable number of Irmen culture settlements and burial grounds have been investigated. As a result, the characteristic features of the Irmen ceramics, inventory and funerary practices have been identified. However, the processes underlying the development of this group are not yet completely

understood. Obviously, one major component in the genesis of the group is represented by the preceding Andronovo population, which had already assimilated features from West Siberian aborigines.

Analysis of the anthropological material from the Irmen culture in the Baraba region showed that their average craniological features are consistent with Caucasoid values, or indicate the presence of a small Mongoloid admixture. Anthropologically, the local Irmen group from Baraba was relatively homogenous. The results of the cross-group statistical analysis confirm the participation of the Andronovo population in the development of the anthropological type of all local Irmen groups (Chikisheva, 2010).

The study of mtDNA samples from the Irmen population is at an early stage and will not be discussed in this paper.

The Irmen population engaged in intense contact with neighbouring groups in different parts of its vast territory. These interactions are reflected in the peculiarities of its material and spiritual culture and in the structure of the Irmen population as based on the physical anthropology data available. In the east, the Irmen population interacted with the neighbouring Karasuk culture group (Chlenova, 1972). In the west, including the Baraba forest steppe region, interactions with neighbours were of a different nature. Several migration waves to Baraba occurred in this period. The first was associated with the migration of representatives of the Suzgun culture from the north-west. Accordingly, a syncretic culture, known as the Baraba variant of Suzgun culture, emerged in the northern part of the Baraba forest steppe (Molodin, Chemyakina, 1984). Two other migratory waves simultaneously occurred in the southern part of the West Siberian forest steppe. The first was associated with the Roller Ware Culture, which occupied the vast Eurasian steppes during the Late Bronze Age (Chernykh, 1983). This population also spread from the West Siberian steppe zone up to Kulunda steppe in the east. Apparently, a small proportion of this group migrated to the southern forest steppe, as evidenced by the presence of roller ware in the Irmen settlements (Molodin et al., 2000).

The largest migration wave to the steppe and forest steppe zones of Western Siberia was that of the Begazy-Dandybay populations during the Final Bronze Age, who came from the territory currently corresponding to modern Central Kazakhstan. The adaptation of these populations in the West Siberian steppe zone resulted in the development of syncretic groups, which then spread farther north and east. One such group was the Pahomov culture (Korochkova, 2009). This group migrated to the Baraba forest steppe and interacted intensively with the Irmen and Suzgun populations. A consequence of this process is the emergence of archaeological sites, such as the Stariy Sad burial ground in the Baraba region, where specific burial practices and anthropological types are found (Molodin and Neskorov, 1992). This cultural group is referred to as Baraba Late Bronze Age culture. The anthropological analysis revealed differences between males and females in the population that cannot be explained by sexual dimorphism. This suggests that the series originated from anthropologically similar but not identical sources. The main craniological type detected in the population is similar to the Southern Eurasian Anthropological Formation. The female series shows similarities with the Andronovo populations from Northern Kazakhstan, which suggests that the latter populations were involved in the development of the Baraba Late Bronze Age culture. Alternatively, the specific pattern of marriage may have caused the migration of females from the Begazy-Dandybay population, which possibly brought the southern ceramic tradition to the Baraba region (Chikisheva, 2010).

A small but informative series of mtDNA samples from the Baraba Late Bronze Age culture population (n=5) was analyzed (Fig. 3), revealing the presence of MtDNA lineages (East Eurasian A and C lineages) that mark the genetic continuity with aboriginal Baraba groups. At the same time, the series includes the Haplogroup-T lineage, which we believe marks the Andronovo migration wave to West

Siberia. Our data is therefore consistent with the putative origin of the West Siberian Late Bronze Culture population as the result of interaction between the Baraba indigenous genetic substrate and the newly arrived group. However, the migration of Begazy-Dandybay culture representatives to the Baraba region is still questionable.

The transition from the Late Bronze Age to the Early Iron Age: a southern influence

Thus, a complex ethno-cultural structure developed in the end of the Bronze Age in the West Siberian forest steppe region, becoming even more complex during the transition from the Bronze to the Early Iron Age (9^{th}–8^{th} century BC). The abrupt cooling of the climate of Western Siberia (at its strongest in the Holocene [Levina, Orlova, 1993]) led to the deterioration of ecological conditions in the taiga zone. In consequence, intense migration of taiga populations to the forest steppe zone in the south occurred in the territory that extends from the Urals in the west to the Yenisei River in the east. As a result, an ensemble of syncretic archaeological cultures developed in the West Siberian forest steppe region, including the Gamajun, Krasnoozersk and Zavyalovo cultures. This powerful migration wave triggered intense movement of various ethnic and cultural groups in the forest, forest steppe and even steppe zones towards the meridional and latitudinal directions. The study of the Baraba forest steppe area suggests that such processes occurred. On the one hand, the autochthonous Irmen culture evolved into the Late Irmen culture, an evolutionary process that was detected in the materials obtained from a large number of archaeological sites. On the other hand, the discovery and excavation of the Chicha-1 settlement in the south of the Baraba forest steppe demonstrated both the occasional appearance of migrants from the north (representatives of the Suzgun and even northern taiga Atlym cultures) and permanent migration flows of representatives from the Krasnoozersk culture from the north-west and from the Berlik culture from the Kazakhstan steppes in the south-west (Fig. 10) (Molodin et al., 2009). It is important to note that the members of the above mentioned cultural groups and the aboriginal Late Irmen group lived in different parts of the same settlement (Molodin and Parzinger, 2009). Obviously, this led to intense interactions between the ethno-cultural groups, resulting both in the combination of cultural traits and traditions, as well as in the genetic admixture of populations as a result of intergroup marriages.

The analysis of mtDNA samples from the Chicha-1 population revealed some interesting patterns. Crucial changes in the composition of mtDNA haplogroups in the gene pool were observed as compared to the earlier Baraba groups studied (Fig. 3). Dominance of Western Eurasian haplogroups and the near absence of East Eurasian were observed. Additionally, several new West Eurasian haplogroups appeared in the region, including Haplogroups U1a, U3, U5b, K, H, J and W.

The phylogeographic analysis suggests that the distribution and diversification centres of several of these mtDNA haplogroups and specific lineages are located on the west and south west of the Baraba forest steppe region, on the territory corresponding to modern-day Kazakhstan and Western Central Asia (Fig. 10). Apparently, the migration wave from the south strongly influenced the gene pool of the Baraba population in the transitional period from the Bronze to the Early Iron Age. The impact of the northern human groups was probably less evident in the south of the Baraba forest steppe, at least at the mtDNA level.

The frequencies of the new haplogroups mentioned above in the mtDNA pools of modern West Siberian populations show a different pattern however. The haplogroup lineages U1a and U3 are found only sporadically in the modern populations. Conversely, Haplogroup H is one of the most frequent West

Fig. 10 | Directions of migration waves in West Siberian forest steppe region during the transition from Bronze to Early Iron Age

Eurasian haplogroups in the modern indigenous populations of the region. Unexpectedly, the H-haplogroup lineages appear in the region only during the transition from the Bronze to the Early Iron Age.

Subsequently, in the Scythian-Sarmatian period, a large cultural group, called the Sargat culture, developed in the region. Its representatives were widespread across the region, from the Ob River to the Urals. Their development represented one of the most significant cultural events in North Asia.

Conclusions

According to the archaeological and anthropological evidence, the continuity between ethno-cultural groups from different periods and the inheritance of new cultural and genetic components as a result of several migration waves markedly affected the genesis of the populations in the West Siberian forest steppe zone during the Bronze Age.

Ancient mtDNA analyses have confirmed the key role played by autochthonous genetic components in composing the gene pool of the populations, especially during the Early and Middle Bronze Age. These components were represented by the Eastern Eurasian haplogroups A, C and Z, and the Western Eurasian haplogroup U5a.

On the other hand, the results also reveal some changes in the mtDNA pool structure throughout the Bronze Age. Some of these changes, which point to migration waves to the West Siberian forest

steppe zone, are in agreement with the archaeological and anthropological evidence. The most relevant migration waves occurred during the Middle Bronze Age (represented by the migration of the Andronovo culture, probably marked by Haplogroup-T lineages) and the transition from the Bronze to the Iron Age (represented by the migration from the south, marked by the U1a, U3 and H haplogroup lineages). These preliminary results indicate the usefulness of ancient DNA analysis as an additional tool for the reconstruction of migratory and ethnogenic processes in the Western Siberian region. To improve the efficacy of genetic methods it will be necessary to analyze other genetic markers in addition to mitochondrial DNA.

References

Adcock, G.J., Dennis, E.S., Easteal, S., Huttley, G.A., Jermiin, L.S., Peacock, W.J., Thorne, A., 2001. Mitochondrial DNA sequences in ancient Australians: Implications for modern human origins. Proceedings of the National Academy of Sciences of the USA 98, 537–542.

Bobrov, V.V., Chikisheva, T.A., Mikhailov, Ju.N., 1993. Mogil'nik epokhi pozdnei bronzy Zhuravlevo-4. Nauka, Novosibirsk.

Bramanti, B., Thomas, M.G., Haak, W., Unterlaender, M., Jores, P., Tambets, K., Antanaitis-Jacobs, I., Haidle, M.N., Jankauskas, R., Kind, C.-J., Lueth, F., Terberger, T., Hiller, J., Matsumura, S., Forster, P., Burger, J., 2009. Genetic discontinuity between local hunter-gatherers and central Europe's first farmers. Science 326, 137–140.

Bunak, V.V., 1956. Chelovecheskie rasy i puti ikh obrazovaniya. Sovetskaya etnografiya. 4, 86–105.

Chernykh, E.N., 1983. Problema obshchnosti kul'tur valikovoi keramiki v stepyakh Evrazii, in: Bronzovyi vek stepnoi polosy Uralo-Irtyshskogo mezhdurech'ya. BashGU, Chelyabinsk, pp. 81–99.

Chikisheva, T.A., 2010. Dinamika antropologicheskoi differentsiatsii naseleniya yuga Zapadnoi Sibiri v epokhi neolita – rannego zheleznogo veka: Avtoreferat Doctoral Dissertation, Novosibirsk.

Chikisheva, T.A., Pozdnyakov, D.V., 2003. Naselenie zapadnosibirskogo areala andronovskoj kul'turnoj obshchnosti po antropologicheskim dannym. Arkheologiya, etnografiya i antropologiya Evrazii. 15 (3), 132–148.

Chlenova, N.L., 1972. Khronologiya pamjatnikov karasukskoi epokhi. Nauka, Moscow.

Haak, W., Forster, P., Bramanti, B., Matsumura, S., Brandt, G., Tanzem, M., Villems R., Renfrew, C., Gronenborn, D., Alt, K.W., Burger J. Ancient DNA from the first European farmers in 7500-year-old Neolithic sites. Nature 406, 1016–1018.

Keyser, C., Bouakaze, C., Crubezy, E., Nikolaev, V.G., Montagnon, D., Reis, T., Ludes, B., 2009. Ancient DNA provides new insights into the history of south Siberian Kurgan people. Human Genetics 126, 395–410.

Korochkova, O.N., 2009. The Pakhomovskaya culture of the Late Bronze Age. Archaeology, Ethnology and Anthropology of Eurasia 37, 75–84.

Krause, J., Briggs, A.W., Kircher, M., Maricic, M., Zwyns, N., Derevianko, A., Paabo, S., 2010. A complete mtDNA genome of an early modern human from Kostenki, Russia. Current Biology 20, 1–6.

Kuz'mina, E.E., 1994. Otkuda prishli Indoarii? Material'naya kul'tura plemen andronovskoi obshchnosti i proiskhozhdenie indoirantsev. Vostochnaya literatura, Moscow.

Levina, T.P., Orlova, L.A., 1993. Klimaticheskie ritmy yuga Zapadnoj Sibiri. Geologiya i geofizika 3, 38–55.

Malmstrom, H., Gilbert, M.T.P., Thomas, M.G., Brandstrom, M., Stora, J., Molnar, P., Andersen, P.K., Bendixen, C., Holmlund, G., Gotherstrom, A., Willerslev, E, 2009. Ancient DNA reveals lack of continuity between Neolithic hunter-gatherers and contemporary Scandinavians. Current Biology 19, 1758–1762.

Matveev, A.V., 1985. Irmenskaya kul'tura v lesostepnoi Priob'e. NGU, Novosibirsk.

Molodin, V.I., 1985. Baraba v epokhu bronzy. Nauka, Novosibirsk.

Molodin, V.I., 1988. O yuzhnykh svyazyakh nositelei krotovskoi kul'tury, in: Istoriografiya i istochniki izucheniya istoricheskogo opyta osvoeniya Sibiri. Dosovetskij period. II FiF SO AN, Novosibirsk, pp. 36–37.

Molodin, V.I., 2001. Sopka-2 site on the Om river bank (the cultural-chronological analysis of the burial sites belonging to the Neolithic and Early Metal Periods). IAE SB RAS, Novosibirsk.

Molodin, V.I., 2008. Odinovskaya kul'tura v Vostochnom Zaural'e i Zapadnoi Sibiri. Problema vydeleniya,

in: Rossiya mezhdu proshlym i budushim: istoricheskii opyt natsional'nogo razvitiya: Materialy Vserossiskoi Nauchnoi konferentsii Ekaterinburg, pp. 9–13.

Molodin, V.I. Chemyakina M.A., 1984. Poselenie Novochekina-3 – pamyatnik epokhi pozdnei bronzy na severe Barabinskoi lesostepi, in: Arkheologiya i etnografiya Yuzhnoi Sibiri. AGU, Barnaul, pp. 40–62.

Molodin, V.I., Myl'nikova, L.N., Durakov, I.A., Kobeleva, L.S., 2009. Kul'turnaya prinadlezhnost' gorodishcha Chicha-1 po dannym statistiko-planigraficheskogo izucheniya keramicheskikh kompleksov na raznykh uchastkakh pamyatnika, in: Molodin. V.I., Parzinger H. (Eds.), Chicha- gorodishche perekhodnogo ot bronzy k zhelezu vremeni v Barabinskoi lesostepi. Novosibirsk, Berlin, pp. 44–50.

Molodin, V.I., Neskorov, A.V., 1992. O svyazyakh naseleniya Zapadnosibirskoi lesostepi i Kazakhstana v epokhu pozdnei bronzy. Margulanovskie chteniya. Tom 1. Moscow, pp. 93–97.

Molodin, V.I., Novikov, A.V., Sofejkov, O.V., 2000. Arkheologicheskie pamyatniki Zdvinskogo rayona Novosibirskoi oblasti. Novosibirsk.

Molodin, V.I., Parzinger, H., 2009. Khronologiya pamyatnika Chicha-1, in: Molodin. V.I., Parzinger H. (Eds.), Chicha–gorodishche perekhodnogo ot bronzy k zhelezu vremeni v Barabinskoi lesostepi. Novosibirsk, Berlin, pp. 51–77.

Okladnikov, A.P., Molodin, V.I., 1983. Palaeolit Baraby, in: Palaeolit Sibiri. Nauka, Novosibirsk, pp. 101–106.

Petrin, V.T., 1986. Palaeoliticheskie pamyatniki Zapadno-Sibirskoi ravniny. Nauka, Novosibirsk.

Pilipenko, A.S., Romaschenko, A.G., Molodin, V.I., Kulikov, I.V., Kobzev, V.F., Pozdnyakov, D.V., Novikova, O.I., 2008. Infant burials in dwellings at Chicha-1, in the Baraba forest-steppe: results of DNA analysis. Archaeology, Ethnology and Anthropology of Eurasia 34, 57–67.

Pilipenko, A.S., Molodin, V.I., Romaschenko, A.G., Parzinger, H., Kobzev, V.F., 2010. Mitochondrial DNA studies of the Pazyryk people (4th to 3rd centuries BC) from northwestern Mongolia. Archaeological and Anthropological Sciences 2, 231–236.

Polos'mak, N.V., Chikisheva, T.A., Balueva, T.S., 1989. Neoliticheskie mogil'niki Severnoi Baraby. Nauka, Novosibirsk.

Zdanovich, G.B., 1988. Bronzovyi vek Uralo-Kazakhstanskikh stepei (osnovy periodizatsii). Izdatel'stvo Uralskogo Gosudarstvennogo Universiteta, Sverdlovsk.

Table 2 | List of samples from Baraba forest-steppe Bronze Age populations studied

Sample number	Sample name	Archaeological site	Burial number (skeleton number)a	Archaeological culture	MtDNA haplogroup
1	Ut2	Sopka-2/3	600	Ust-Tartas	U2e
2	Ut3	Sopka-2/3	655(C)		D
3	Ut4	Sopka-2/3	655(D2)		C
4	Ut5	Sopka-2/3	655(D4)		A
5	Ut7	Sopka-2/3A	627(C)		C
6	Ut9	Sopka-2/3A	658(A)		U5a1
7	Ut12	Sopka-2/3A	611(K)		U2e
8	Ut14	Sopka-2/3A	619		U5a1
9	Ut16	Sopka-2/3A	611(B)		C
10	Ut17	Sopka-2/3A	611(C)		U2e
11	Ut19	Sopka-2/3A	358		U4
12	Ut31	Sopka-2/3A	341(3)		Z
13	Ut32	Sopka-2/3A	628		Z
14	Ut33	Sopka-2/3	656(F)		Z
15	Ut34	Sopka-2/3	656(G)		Z
16	Ut37	Sopka-2/3	655(A)		C
17	Ut38	Sopka-2/3	655(B)		A
18	Od1	Preobrazhenka-6	18	Odinovo	C
19	Od2	Preobrazhenka-6	2		Z
20	Od3	Preobrazhenka-6	36		D
21	Od12	Sopka-2/4A	184(2)		D
22	Od13	Sopka-2/4A	194(1)		D
23	Od27	Sopka-2/4A	258(2)		D
24	Od29	Sopka-2/4A	523		C
25	Od65	Sopka-2/4A	520(1)		D
26	Od66	Sopka-2/4A	594		U5a1
27	Od67	Sopka-2/4A	588(1)		D
28	Kr1	Sopka-2/4B	407(1)	Early Krotovo	C
29	Kr5	Sopka-2/4B	171(1)		Z
30	Kr10	Sopka-2/4B	177(1)		A
31	Kr79	Sopka-2/4B	305		U2e
32	Kr80	Sopka-2/4B	46		U2e
33	Kr87	Sopka-2/4B	65		D
34	Pkr1	Sopka-2/5	108(1)	Late Krotovo	T*
35	Pkr2	Sopka-2/5	126		T*
36	Pkr3	Sopka-2/5	123		U5a*
37	Pkr4	Sopka-2/5	141		U5a*
38	Pkr5	Sopka-2/5	117		T*
39	Pkr6	Sopka-2/5	140(2)		U5a1
40	Pkr7	Sopka-2/5	349(2)		G2a
41	Pkr8	Sopka-2/5	334		A
42	Pkr9	Sopka-2/5	376		U5a1
43	Pkr10	Sopka-2/5	625(1)		C
44	Pkr11	Sopka-2/5	132		C
45	TK1	Tartas-1	85		C
46	TK2	Tartas-1	77		C
47	TK3	Tartas-1	76		A
48	TK4	Tartas-1	15		C
49	TK5	Tartas-1	73		U5a1
50	TK6	Tartas-1	84		C
51	TK7	Tartas-1	80(2)		C
52	TK8	Tartas-1	72		C

Table 2 | continued

Sample number	Sample name	Archaeological site	Burial number (skeleton number)a	Archaeological culture	MtDNA haplogroup
53	TK21	Tartas-1	75	Andronovo (Fedorovo)	A
54	TA5	Tartas-1	227(1)		T*
55	TA4	Tartas-1	227(2)		T*
56	TA7	Tartas-1	218(1)		A
57	TA8	Tartas-1	225		C
58	TA9	Tartas-1	217(1)		C
59	TA10	Tartas-1	217(2)		U5a1
60	TA11	Tartas-1	213		U5a1
61	TA13	Tartas-1	211		C
62	TA14	Tartas-1	180		C
63	TA15	Tartas-1	182(1)		T*
64	TA16	Tartas-1	182(2)		C
65	TA17	Tartas-1	189		A
66	TA18	Tartas-1	223(1)		U5a1
67	TA20	Tartas-1	188		C
68	TA21	Tartas-1	196		C
69	TA22	Tartas-1	208(1)		U5a1
70	TA23	Tartas-1	240		C
71	TA25	Tartas-1	124		A
72	TA26	Tartas-1	137		C
73	TA27	Tartas-1	176		C
74	Sts1	Stariy Sad	1	Baraba Late Bronze Age	C
75	Sts11	Stariy Sad	49		A
76	Sts7	Stariy Sad	27		C
77	Sts9	Stariy Sad	59		U5a
78	Sts10	Stariy Sad	62		T1
79	Ch1*	Chicha-1	D10-B1	Baraba population of transition from the bronze to the Early Iron Age (Chicha-1 Settlement population)	J
80	Ch2*	Chicha-1	D10-B2		H
81	Ch3*	Chicha-1	D20-B1		U5b
82	Ch4*	Chicha-1	D20-B2		U4
83	Ch5*	Chicha-1	D9-B1		U1a
84	Ch6	Chicha-1	D3a-B1		K
85	Ch7*	Chicha-1	D3a-B.2		K
86	Ch8	Chicha-1	D8-B.1		D
87	Ch9	Chicha-1	IIIa		U3
88	Ch10	Chicha-1	12		W
89	CSh11	Chicha-1	6(2)		K
90	Ch12	Zdvinsk-1	1(2)		U4
91	Ch13	Zdvinsk-1	2		U4
92	Ch14	Zdvinsk-1	4		H6a1

a For the Chicha-1 site burial designations indicate the following: for samples Ch1–Ch8 (infants buried in dwellings of Chicha-1 settlements) – D=dwelling number, B=burial number in that dwelling; Ch9 – individual was buried between dwellings in the section IIIa of the settlement territory; Ch10, 11 – individuals buried in the ground part of the Chicha-1 necropolis; Ch12–14 individuals buried in the kurgan part of the Chicha-1 necropolis (previously designated "Zdvinsk-1")

* These samples were preliminarily published by Pilipenko and colleagues (2008), but were subsequently reanalyzed using more strict experimental conditions and verification criteria

Table 3 | List of mtDNA HVR polymorphic sites

Nº of mtDNA HVR I haplotype	MtDNA haplogroup	mtDNA HVR I polymorphic sites	Names of samples
1	A	223T-227C-290T-311C-319A	Kr10, TK3, Sts11
2	A	148T-223T-227C-290T-311C-319A	Ut5, Ut38
3	A	223T-227C-278T-290T-311C-319A	TA17
4	A	189C-223T-290T-319A	Pkr8, TA25
5	A	223T-242T-290T-319A	TK21
6	A	188T-189C-223T-290T-319A-356C-362C	TA7
7	C	223T-298C-327T	Ut4, Ut7, Ut16, Ut37, Pkr10, TK1, TK2, TA9, TA13, TA14, TA16, Sts7
8	C	129C-223T-298C-327T	TK6, TK7, TK8, TA26, TA27
9	C	223T-297C-298C-327T	Od29, Od1
10	C	223T-298C-325C-327T	Kr1, TA23
11	C	223T-298C-325C-327T-362C	TA8, Sts1
12	C	148T-223T-288C-298C-327T	Pkr11, TK4, TA20, TA21
13	D	223T-362C	Ut3, Od12, Od13, Od27, Od65, Od67, Od3, Kr87
14	D	223T-294T-362C	Ch8
15	G2a	223T-227G-278T-362C	Pkr7
16	Z	185T-223T-260T-298C-300G	Ut31, Ut32
17	Z	185T-223T-260T-263C-298C	Ut33, Ut34
18	Z	185T-223T-260T-271C-298C	Kr5
19	Z	185T-223T-260T-298C	Od2
20	U1a	183C-189C-249C	Ch5
21	U2e	129C-189C	Ut2
22	U2e	129C-189C-246G	Ut12, Ut17
23	U2e	129C-189C-256T	Kr79, Kr80
24	U3	343G	Ch9
25	U4	356C	Ut19, Ch12, Ch13
26	U4	356C-362C	Ch4
27	U5a1	192T-256T-270T	Ut9, Pkr6, TK5
28	U5a1	192–256–270–318	Ut14
29	U5a1	172–192–256–270	Od66
30	U5a1	192–256–270–304	Pkr9, TA18
31	U5a1	192T-239T-256T-270T	TA10, TA11, TA22
32	U5a	256T-270T	Sts9
33	U5a	192T-270T	Pkr3, Pkr4
34	U5b	189C-260T-270T	Ch3
35	K	093C-224C-311C	Ch6, Ch7
36	K	213A-224C-311C	Ch11
37	T	126C-294T	Pkr1, Pkr2, TA4, TA5
38	T2b	126C-189T-292T-294T-296T	Pkr5
39	T	086C-126C-140C-294T-296T	TA15
40	T1	126C-163G-186T-189C-294T	Sts10
41	J	069T-126C	Ch1
42	H	366T	Ch2
43	H	111T-362C	Ch14
44	W	223T-292T	Ch10

Christina Sofeso[a], Marina Vohberger[a], Annika Wisnowsky[a],
Bernd Päffgen[b], Michaela Harbeck[c], *

Verifying archaeological hypotheses: Investigations on origin and genealogical lineages of a privileged society in Upper Bavaria from Imperial Roman times (Erding, Kletthamer Feld)

* Corresponding author: M.Harbeck@lrz.uni-muenchen.de
a Department of Biology I, Biodiversity Research/Anthropology, Ludwig Maximilian University, Munich, Germany
b Institute for Pre- and Protohistoric Archaeology and Archaeology of the Roman Provinces, Ludwig-Maximilian-University, Munich, Germany
c State Collection of Anthropology and Palaeoanatomy, Munich, Germany

Abstract

During the years 2005 and 2006 approximately 2000 archaeological finds ranging from the Neolithic Period to Late Antiquity were found on the Kletthamer Feld (Erding, Upper Bavaria). Out of this context a burial site was examined comprising 13 individuals, some of them rich in precious grave goods. The inhumations were dated to the second half of the 4th to the first half of the 5th century – a time of upheavals in relation to the demographic structure of the former Roman province Raetia (today southern Bavaria).

The high proportion of male individuals within the skeletal population as well as the finding of a Roman fibula, which is seen as part of Roman military clothing, led to distinct hypotheses which we have attempted to support in this study. The hypothesis that the skeletal remains reflect a founder population from a Germanic region north of the Danube River could be rejected on the basis of stable isotope analyses. The theory of a buried family clan had to be dismissed as well, or rather, be extended to the scenario of several families being buried there with their servants. The results obtained fit the third presumption best, namely that the buried individuals were the members of a military unit interred with their families.

Keywords

late roman imperial period; stable isotope analyses; kinship analyses

Introduction

In 2005 and 2006 a small yet remarkable burial site was found in the east of Erding (Kletthamer Feld, Upper Bavaria). It consisted of 13 inhumations and was dated to the second half of the 4th to the first half of the 5th century.

The cemetery can be assigned to the Late Imperial Roman Period and thus falls into a rarely investigated transition period between Roman Times and Migration Period – a time of social upheavals in the former Roman province Raetia (today southern Bavaria):

After the Roman occupation of the Alpine foothills 15 BC, today's Bavaria underwent several years of intense Romanization, leading to considerable affluence in many places (Fehr, 2010). From the middle of the third century AD onward, continuous attacks by Germanic tribes, who repeatedly forced their way into the Roman territory, finally resulted in the settlement of non-Roman inhabitants in Raetia. Due to the ongoing attacks, the recruitment of Germanic mercenaries for the Roman army had already become more and more common decades before, and hence the military force in the west of the empire in the 4th century was largely composed of barbarians (Steidl, 2006). The dethronement of the last Roman emperor by the barbaric military commander Odoaker in the year 476 heralded the end of the Roman rule north of the Alps. It seems that in the course of the general economic decline during the years that followed, supraregional trading networks gradually collapsed, the population as well as the army size decreased and Roman soldiers ceased to receive salaries towards the end of the 5th century.

Table 1 | Morphological results and results of molecular sex typing by amplification of the X-Y homologous gene amelogenin.

Sample	Age at death*	Sex	
		morphological	genetical
1662	m	male	male
1663	a	female	female
1664	m	male	male
1665	j – a	male	male
1699	a	male	male
1700	m – s	female	female
1702	a	female	/
1703	a	male?	male
1704	a – m	male?	male
1717	m	male	male
1719	m – s	male	male
1720	inf I	male?	/
1721	a – m	female?	female

* inf I = 1–6y, j = 13–20y, a = 20–40y, m = 40–60y, s = 60+

Furthermore, an increase in the influx of Germanic immigrants from regions north of the Danube River set in (Fehr, 2010).

The cemetery was located within a large complex of prehistoric and Roman archaeological findings, though remnants of settlement features specifically associated with the burials could not be found. A remarkable discovery was that of abundant funerary goods in certain graves which can be considered as unique for rural Raetia at that time: three adult to mature women were buried with gold jewellery and several glass vessels, indicating wealth or a superior standard of living. The male burials contained no grave goods, except for one. The individual in question was interred with a fibula (cross-bow brooch) which is considered to be an element of Roman military clothing. The fact that grave goods were found at all suggests that the buried people were of Germanic descent. Furthermore, the ratio of sexes at the burial site reveals a striking dominance of male individuals (c.f. Table 1). Moreover, only one child could be identified.

These findings make it necessary to answer one question before further interpretations concerning the way of life of the people interred at these times can be considered: What kind of society lies buried here?

The archaeological data, the historic circumstances and the morphological results suggest several hypotheses that should be considered:

1. The age and sex distribution could be indicative of a founder population (far more males than females, Staskiewicz, unpublished report of the morphological examination) that, based on the historical background, probably consisted of Germanics from north of the Danube River

2. The deceased might be members of a single small-sized but well-situated family that lived at an estate located near the burial place that has not yet been discovered (Biermeier and Pietsch, 2006)

3. The buried men might have been members of a Roman military unit – perhaps road guards who lived there with their families

In this case it is possible to verify two of the theories through archaeometric analyses according to the following assumptions:

- If this was a founder population, the majority of the individuals should have spent their childhood at a location other than the area of the burial site. This can be validated by stable strontium (as geological marker) and oxygen (as ecological marker) isotope analysis, given sufficient geological and ecological differences between the place of origin and the place of destination. Differences in diet detected through stable isotope analysis of carbon and nitrogen can also be relevant for the identification of nonlocal individuals (c.f. Hakenbeck et al., 2010)
- If a single family was buried at the site, there should be a detectable genetic relationship among the individuals. The reconstruction of maternal and paternal lineages can be achieved by DNA analyses.

The third hypothesis cannot be verified by archaeometric methods. However, data acquired using these scientific methods can be evaluated in respect of the conclusiveness regarding the hypothesis in order to ascertain whether these are the remains of a small military unit buried with their family members. If so, one could expect an outcome in which the group is comprised mainly of unrelated male individuals.

Material and methods

The Late Roman cemetery Kletthamer Feld is located in Erding (Upper Bavaria, Germany) and was excavated in 2006 by Stefan Biermeier and Axel Kowalski.

Osteological analysis of the thirteen individuals was undertaken by Dr. Anja Staskiewicz. The state of preservation of bones varied widely; as a result, age at death and sex could therefore not be definitively determined in every case, an overview is given in Table 1.

Animal bones were found in some of the graves, Dr. Anja Staskiewicz performed species identification. To provide values for comparison with the human samples, stable isotope analysis of animal bone collagen and apatite was performed. Three cattle and five chicken bones were examined.

Stable isotope analyses

For the purpose of stable isotope analyses of light elements (C, N and O), human bone samples were taken from long bones (0.5 g) where possible, using a diamond-edged cutting wheel. Spongiosa was removed. The animal bones analyzed were heavily fragmented and therefore used in total.

The first molar was preferably used, whenever possible, for stable strontium isotope analyses. In cases where the first molar was unavailable, the second molar was taken. No tooth material was available in the case of Individuals 1702 and 1721, so they had to be excluded from the strontium isotope investigation.

To extract collagen, 1M HCl was added to bone powder for 20 min on a shaker for demineralization. Samples were washed, than incubated overnight, shaking in 0.125M NaOH to precipitate humic impurities. For gelatinization, samples were left in 0.001M HCl for 10–17 hours in a 90°C water bath. The gelatine was filtrated and lyophilized prior to mass spectrometry.

Carbon and nitrogen isotope analyses of "organic materials" were performed with an elemental analyser (Carlo-Erba1110) connected online to a ThermoFinnigan Delta Plus mass spectrometer. All car-

bon isotope values are reported in the conventional δ notation in per mil relative to V-PDB (Vienna-PDB). Nitrogen isotope ratios are reported in ‰ relative to atmospheric N_2 (AIR). Accuracy and reproducibility of the analyses was checked by replicate analyses of international standards (USGS 40). Reproducibility was better than ± 0.10‰ for carbon and ± 0.04‰ for nitrogen (1σ).

To extract the structural carbonate, bone powder was immersed in 4% NaOCl for at least 48 hours; the solution was changed daily. All organic substances are solubilized when gas bubbles are no longer generated. Samples were incubated in 5 ml 1M calcium acetate buffer (pH 4.75) for half a day under constant motion, removing adsorbed carbonate. After being washed in distilled water, the samples were lyophilized prior to mass spectrometry.

Carbonate powders were reacted with 100% phosphoric acid at 70°C using a Gasbench II connected to a ThermoFinnigan Five Plus mass spectrometer. All values are reported in per mil relative to V-PDB by a $\delta^{18}O$ value of –2.20‰ to NBS19. Reproducibility was checked by replicate analysis of laboratory standards and is better than ± 0.04‰ (1σ).

For strontium isotopic analyses, tooth enamel was separated from dentine and then cleaned in an ultrasonic bath in concentrated formic acid for 5 min twice (acid changed) to remove surface contamination. Samples were ashed at 500°C for 12 hours. After ashing 15 to 35 mg of enamel was dissolved in concentrated HNO_3 on a heating plate at 100°C. Following vaporization of the concentrated acid, the samples were dissolved in 6N HNO_3 for separation in cation exchange columns (Sr resin, Eichrom). This step separates rubidium from strontium prior to mass spectrometry.

Samples were loaded on Wolfram single filaments. Isotope analyses of Sr were performed on a thermal ionisation mass spectrometer (TIMS, MAT 261.8, Thermo-Finnigan). Isotope mass fractionation during analysis was corrected by referencing to an invariant $^{88}Sr/^{86}Sr$ value of 8.37521. The achieved precision of strontium isotope measurements normally is <0.003% (2σm). A combined uncertainty (precision + accuracy) for $^{87}Sr/^{86}Sr$ is <0.005%.

DNA analyses

Teeth with intact roots were preferred for DNA analyses. In the cases of individuals 1702 and 1721 no tooth material was available, so samples were taken from long bones (humerus and tibia).

The necessary precautions were observed in all preparatory steps for DNA analysis in order to avoid any form of contamination:

All pre-PCR steps were performed in a clean laboratory dedicated solely to ancient DNA, equipped with UV light in the ceiling and an UV Air Flow Cleaner (Kisker-Biotech). Full body overalls with hoods, single-use disposable gloves, hair and face masks were used. All chemicals and reagents were of analytical grade or the highest purity available. PCR tubes, reaction tubes and pipette tips were free of human DNA, as guaranteed by the manufacturer (Peqlab, Eppendorf). All pretreatment steps were performed under a Clean Air Bench and all PCR reactions were performed in an Ultraviolet Sterilizing PCR Workstation (Peqlab) inside the clean laboratory. The laboratory devices and work spaces were cleaned before and after every work-step by UV radiation and by wiping the surface with bleach.

The bone and tooth samples were cleaned mechanically with a paper cloth soaked in 1% NaOCl solution. The tooth samples were then bathed in a 0.4% NaOCl solution followed by subsequent washing steps with ultrapure water. After drying for about 2 days the samples were UV irradiated at 254nm for 15 min on each side shortly before the homogenisation by mortar and swing mill (Retsch).

Table 2 | Primer, fragments, and length of amplification products

Primer	Sequence (5' → 3')	Fragment	Length of amplification product	Annealing-temperature	Reference
L16055	GAAGCAGATTTGGGTACCAC	1A	123bp	56°C	Rudbeck et al. 2005
H16139	TACTACAGGTGGTCAAGTAT				
L16131	CACCATGAATATTGTACGGT	1B	126bp	56°C	Gabriel et al. 2001
H16218	TGTGTGATAGTTGAGGGTTG				
L16209	CCCCATGCTTACAAGCAAGT	2A	133bp	46°C	Gabriel et al. 2001
H16303	TGGCTTTATGTACTATGTAC				
L16287	CACTAGGATACCAACAAACC	2B	143bp	52°C	Gabriel et al. 2001
H16391	GAGGATGGTGGTCAAGGGAC				

The DNA was extracted using a modified version of the protocol of Yang and colleagues (1998) (Wiechmann and Grupe, 2005).

Mitochondrial DNA was amplified and sequenced several times from the hypervariable region 1 (HVR 1) of the mitochondrial control region using four overlapping segments (c. f. Table 2). The 25 μl PCR reaction (30–35 cycles) using the Platinum® taq high fidelity polymerase was performed as previously described in Rudbeck and colleagues (2005). PCR was followed by electrophoretic separation in an agarose gel stained with ethidium bromide. The products were extracted from the gel using the NucleoSpin ® Extract II kit (Macherey-Nagel). Cycle sequencing was done with BigDye Terminator chemistry (Applied Biosystems) with either the forward or reserve primer used for amplification. Sequences were aligned against the revised Cambridge Reference Sequence (rCRS, Andrews et al., 1999) using Codon Code Aligner Software. Presumable assignments of haplogroups were implemented based on HVR I sequences using an online mitochondrial phylogenetic tree as well as a mitochondrial motif database (http://www.phylotree.org and http://mtmanager.yonsei.ac.kr/) and the corresponding literature (e.g. Alvarez-Iglesias et al., 2009; Grignani et al., 2009; Palanichamy, 2004; Richards et al., 2000; Achilli 2004, 2005). The frequencies were estimated applying the EMPOP Database (http://empop.org), developed by the Institute of Legal Medicine (GMI), Innsbruck Medical University and the Institute of Mathematics, University of Innsbruck.

To confirm haplogroups and to verify the obtained sequence motif, a single primer extension assay developed by Nelson et al. (2007) was carried out. This assay enables the determination of twelve mtDNA haplogroup specific polymorphisms (for primers, protocol and details c. f. Nelson et al., 2007).

The used SNP multiplex provides a determination of mtDNA haplogroups A, B, C, D, E, F, G, H, L1/L2, L3, M and N by typing 12 SNPs (8272–8280 del, 13263, 1719, 5178, 663, 10398, 10400, 3594, 7028, 12406, 4833, 7600).

To check on chromosomal DNA preservation and for molecular sex typing, a part of the X–Y homologous amelogenin gene was amplified using the primers published by Mannucci and colleagues (1994) and separated by polyacrylamide gel electrophoresis (c. f. protocol Wiechmann and Grupe, 2005). Furthermore, comparing the results of the molecular sex typing with the morphological sex typing can give evidence for the authenticity of DNA amplification (Meyer et al., 2000).

Table 3 | Stable light isotope and strontium isotope data of human samples. 1699 was excluded due to poor preservation, 1717 was used up in mass spectrometry. 1702 and 1721 had no teeth for strontium analysis

Sample	Collagen					Carbonate	Strontium	
	$\delta^{13}C$ vs. V-PDB	$\delta^{15}N$ vs. AIR	C/N molar	C%	N%	$\delta^{18}O$ vs. V-PDB	Tooth	Ratio $^{87}Sr/^{86}Sr$
EKF 1662	−19.9	10.0	3.2	37.7	13.8	−8.4	4.3	0.70897
EKF 1663	−19.5	9.1	3.1	35.1	13.1	−9.8	4.6	0.70908
EKF 1664	−19.8	9.1	3.2	38.8	14.1	−8.7	1.6	0.70880
EKF 1665	−19.7	9.0	3.1	32.6	12.3	−8.9	3.6	0.71007
EKF 1699	−20.0	11.2	2.6	33.6	15.0	−8.6	3.7	0.70937
EFK 1700	−19.5	9.4	3.1	39.6	15.0	−8.1	4.6	0.70929
EFK 1702	−19.7	10.0	2.9	39.5	15.7	−9.9	−	−
EFK 1703	−19.5	8.9	3.2	40.4	14.9	−8.3	2.6	0.70937
EFK 1704	−20.0	9.4	3.2	38.8	14.1	−9.1	1.7	0.70895
EKF 1717	−	−	−	−	−	−9.1	4.3	0.70954
EKF 1719	−19.4	9.7	3.2	39.0	14.1	−8.8	1.6	0.70909
EKF 1720	−19.5	12.0	3.1	38.2	14.2	−8.9	4.6	0.70913
EKF 1721	−17.0	10.4	3.1	32.5	12.4	−7.7	−	−
Mean	−19.5	9.8	3.1	37.1	14.0	−8.8		0.70924

Fig. 1 | Carbon and nitrogen values of human and animal samples

When a male sample showed positive amelogenin results, Y-chromosomal STRs were amplified using the Mentype® Y-MHQS PCR Amplification Kit (Biotype), according to the manufacturer's instruction, with 35 cycles each. This amplified the nine Y-chromosomal STR loci of the minimal haplotype standard.

Further steps taken to ensure the authentication of the results were:
- Negative controls accompanied every extraction and PCR.
- To exclude the possibility that a member of the laboratory staff or the anthropologist who did the cleaning and morphological investigation of the skeletons was the source of the amplified DNA, all aDNA sequences obtained were compared with the HVR I sequences and the Y-STR profile of the individuals in question.
- Only sequences of the HVR I region which could be reproduced at least three times from two different teeth were taken into account.
- Chromosomal Y-STR analyses were also carried out at least three times per individual to avoid erroneous allele determination.

Results and Discussion

Reconstruction of diet and provenance by stable isotope analyses

Bone collagen provides the basis for reconstructing dietary patterns of ancient populations. It mirrors the isotopic signature of food and liquids consumed during the last years of an individual's life. By measuring the ratios of stable carbon and nitrogen isotopes ($\delta^{13}C$, $\delta^{15}N$) the origin of the protein portion of a diet can be ascertained (Ambrose, 1990; Katzenberg, 2000; Schoeninger and DeNiro, 1984). It should be borne in mind though that in the course of degradation processes during the inhumation period losses of amino acids, e.g., can occur, leading to alterations of the original isotopic signal (e. g. Ambrose, 1990). For this reason, it was necessary to check the state of collagen preservation first, as the integrity of collagen is essential for the validity of the isotopic data.

All samples yielded enough collagen for mass spectrometry and fulfilled quality criteria (>0,5 w%) according to van Klinken (1999) and Harbeck and Grupe (2009). One specimen (EKF 1699) had to be excluded from further interpretations as the C/N molar ratio was below the accepted range of 2.8 to 4.0 (Harbeck and Grupe, 2009). Human isotopic ratios for carbon and nitrogen are listed in Table 3; data sets for animals are in Table 4.

Nitrogen in bone collagen is exclusively related to dietary protein. Consumers on higher trophic levels exhibit more positive $\delta^{15}N$ values (Ambrose, 1993; DeNiro and Epstein, 1981; Schoeninger and DeNiro, 1984). This pronounced trophic level effect is caused by the enrichment in ^{15}N according to species-specific metabolic pathways in steps of 3–5‰ (Minagwa and Wada, 1984; Schoeninger and DeNiro, 1984).

The adults show $\delta^{15}N$ values between 8.9‰ and 10.4‰, indicating high quality, meat-based nutrition. The highest values might even suggest greater consumption of milk or egg-based products, as $\delta^{15}N$ exceeding 10‰ point to food sources richer in protein than meat alone, similar to the carnivore effect in breast-fed children (Katzenberg, 2000; Richards et al., 2002). Individual 1720 represents the only child (2–3a) found in the complex. It shows the highest $\delta^{15}N$ value (12.01‰), which is in accordance with signatures found in infants that are still being fed on breast milk by their mothers (for weaning effects c. f.: Katzenberg, 2000; Richards et al., 2002).

Table 4 | Stable light isotopic data of animal samples. EKF 1706 / 482–4 provided insufficient material for both apatite and collagen extraction

Animals	Collagen					Carbonate	Species
	$\delta^{13}C$ vs. V-PDB	$\delta^{15}N$ vs. AIR	C/N molar	C%	N%	$\delta^{18}O$ vs. V-PDB	
EKF 1662 / 459–2	–21.7	6.3	3.3	39.8	14.2	–8.1	cattle 1
EKF 1663 / 461	–20.6	8.2	3.2	40.0	14.6	–8.7	chicken 1
EKF 1663 / 462–1	–21.0	8.4	3.1	34.2	13.0	–11.0	cattle 2
EKF 1663 / 462–2	–20.1	7.9	3.2	40.0	14.5	–9.2	chicken 2
EKF 1664 / 465	–21.3	6.4	3.2	38.9	14.2	–8.3	cattle 3
EKF 1706 / 482–2	–20.6	8.2	3.1	36.1	13.4	–7.8	chicken 3
EKF 1706 / 482–3	–20.5	8.2	3.2	38.2	13.8	–8.8	chicken 4
EKF 1706 / 482–4	–20.3	8.4	3.2	41.0	15.0	–	chicken 5
mean	–20.8	7.8	3.2	38.5	14.1	–8.8	

Fig. 2 | Oxygen isotopic values of human and animal samples. The range of oxygen isotopic values for the animal samples is highlighted in grey; these have been assumed to reflect local signatures. Most humans fall within this range, excepting three individuals

The δ¹³C of the consumer's bone collagen reflects mostly the protein part of its diet (Ambrose, 1990). In terrestrial environments, major fractionations occur during plant photosynthesis. C_3 plants (Calvin cycle), for example, discriminate against the heavy isotope ¹³C to a significantly greater degree than do C_4 plants (Hatch-Slack cycle). The average δ¹³C value of C_3 plants is −26‰ but the actual range is rather large, due to differences in temperature and precipitation. C_4 plants are not able to thrive in dense forests, preferring warm and more arid environments. Their δ¹³C values are less variable and average about −12‰.

Apart from EKF 1721 (δ¹³C = −16.96‰), the rather narrow range of δ¹³C values varies between −19.97‰ and −19.36‰ (c. f. Table 3, Fig. 1). The cattle show an average value of −21.3‰ (Table 4, Fig. 1). They reflect the signature of typical Central European terrestrial plant consumption (Ambrose 1993).

Unlike the other individuals, EKF 1721 must have had a C_4 plant containing diet, based on the δ¹³C values. The fact that C_4 plants did not grow in Central Europe at that time means that a C_4 plant signature can be expected in bones belonging to an "immigrant" to the site (Lösch, 2006).

Hakenbeck et al. (2010) analysed several samples from different early medieval graveyards in Bavaria. Among these were also ten of the analysed individuals of Erding, Kletthamer Feld (1662, 1663, 1664, 1665, 1700, 1702, 1703, 1719, 1720, 1721). Their results were consistent with those in our study, varying only in insignificant ranges (δ¹³C ±0.42‰; δ¹⁵N ±0.68‰). These differences might be due to a slight difference in the extraction method (0.5M HCl instead of 1M HCl, no NaOH or gelatinization in 0.005M HCl).

The correlation between temperature and δ¹⁸O in water is well known, and δ¹⁸O has frequently proved to be a valid palaeothermometer in the past (Aitken, 1990). Since the δ¹⁸O in meteoric water varies with temperature, latitude, altitude and distance from the coast (Fry, 2006), δ¹⁸O in bone can serve as a valuable tool to establish the ecological origins of immigrants to the site. However, as the structural carbonate of bone reflects the isotopic signature of liquids consumed during the last years of an individual's life, it only allows the detection of recent migration movements.

Human and animal isotopic ratios for oxygen are listed in Table 3 and 4. Individual 1702 and 1663 show the most negative δ¹⁸O values among the group (c. f. Table. 3, Fig. 2). They seem to have used a drinking water source different than that used by the rest. This might be evidence of migration from a climatically different area at a higher altitude and/or cooler temperatures.

The most positive δ¹⁸O value is shown by individual EKF 1721. EKF 1721 also displayed "conspicuous" carbon values, pointing to a possible Mediterranean origin. More positive oxygen isotopic data support this assumption, as they reflect a water source from a warmer and drier area and a possible marine influence (Fry, 2006). Unfortunately, there were no teeth preserved for strontium isotope analysis to prove this supposition.

Strontium isotopes are geochemical markers used to allocate archaeological finds to a certain geological region and to trace mobility during an individual's life time. Stable strontium isotope ratios of bones and teeth reflect the geochemical signature of the region where the individual under study lived (Grupe et al., 1997; Bentley, 2006; Bentley and Knipper, 2005; Price et al., 2002).

Tooth enamel, used in this study, is not remodelled (in contrast to bone) and therefore preserves the isotopic signature of the environment in which the individual spent its childhood (or juvenile years, depending on the type of tooth analysed).

Kletthamer Feld is located in the geologically rather uniform pre-Alpine lowlands south of the Danube River (Fig. 3). Oligocene/Miocene marine sediments are covered by freshwater and loess deposits. The expected range for the carbonate area south of the Danube, which marks the border of the Roman

Fig. 3 | Location of Erding, Kletthamer Field in the Southern Bavarian carbonate area (after Schweissing and Grupe, 2003b, modified)

territory, lies at about 0.7080 to 0.7095 (Schweissing and Grupe, 2003a). This area south of the river has not been geologically mapped for Sr isotope ratios yet, but is characterized by values lower than 0.710 for granite (Grupe et al., 1997). Grupe et al. (1997) measured sediments from this area ranging between 0.70899 and 0.70992.

$^{87}Sr/^{86}Sr$ isotope analyses produced values between 0.70880 (EKF 1664) and 0.71007 (EKF 1665). All of the individuals show $^{87}Sr/^{86}Sr$ values lying within the local range except for one:

EKF 1665 (0.71007) (c. f. Table 3 and Fig. 4).

For comparison: Bentley and Knipper (2005) presented pig teeth from Altdorf-Aich, Inzigkofen, Mintraching, Wang and Wittislingen showing $^{87}Sr/^{86}Sr$ values (n = 8) with a rather narrow range of 0.7097 ± 0.0008. Specifically, the pig teeth from Wang (0.71046; 0.71033; 0.70964) and Altdorf (0.70982), 35 km and 43 km away from the Kletthamer Feld, respectively, present an average value of 0.71006. The authors admit the possibility that the pigs could have been traded. Assuming that the pigs were local, individual 1665 (0.71007) would be located at the upper limit of the possible local $^{87}Sr/^{86}Sr$ range.

The shortest distance to the granite area northeast of the Danube is 80 to 90 km, a distance that could be covered by walking or riding in 2 to 3 days. $^{87}Sr/^{86}Sr$ values slightly above the limit of 0.7100 might be the result of a mixture between granite-based and carbonate-based isotopic influence. This could be caused by moving from one geological region to another during childhood while tooth enamel formation is occurring. Another possibility is the consumption of food produced in both regions.

Thus the strontium data obtained from tooth material suggest one putatively mobile individual (EKF 1665) that might have lived in a different area during childhood years.

Fig. 4 | $^{87}Sr/^{86}Sr$ values of humans. The expected local range for carbonate is highlighted in grey

Assessment of family relationships by means of DNA analyses

It was possible to retrieve DNA from 11 out of 13 individuals and to reproduce unambiguous mtDNA profiles of the HVR I region for 9 individuals. Both samples for which no DNA could be obtained were of osseous material. Furthermore, sections of HVR I segment A could not be amplified or sequenced for samples 1700 and 1717, resulting in a limited degree of interpretability. Analyses of the second extract supported the results.

The purpose of the mtDNA analyses was to test whether some of the individuals were maternally related.

Table 5 shows the mtDNA profiles of the analysed individuals (eight different mtDNA-haplotypes could be observed) and the presumable assignments of haplogroups.

As the sequences were assembled out of four overlapping fragments, haplogroup allocations were checked by SNP-multiplex typing in order to exclude mosaic patterns, whereas the differentiation of H and non-H haplogroups was of special interest.

The SNP profiles for 6 of 9 individuals (2 individuals could not be typed) contained the C to T substitution at nucleotide position 7028, assigning these individuals as non-H (Macaulay et al., 1999). In all cases the sequencing results of the HVR I and the SNP-typing of the coding region were conform.

One female (EKF 1663) and two male individuals (EKF 1664 and 1704) display identical haplotypes. Given the small size of the burial site in combination with the low haplotype frequencies (although the latter can only be used to a restricted degree as they were calculated on the basis of recent data) the

Table 5 | Results of DNA-analyses

Sample	HVR I region	Frequency	Assumed haplogroup	Coding sequence	Macro-haplogroup	DYS391	DYS393	DYS19	DYS390	DYS389-I	DYS385	DYS392	DYS389-II
EKF 1662	16126C, 16294T, 16296T, 16304C	1,6 %	T2b	–	–	10	13*	14	24		11/14	13	
EKF 1663	16126C, 16163G, 16186T, 16189C, 16294T	1,3 %	T1a	7028 T	N								
EKF 1664	16126C, 16163G, 16186T, 16189C, 16294T	1,3 %	T1a	7028 T	N	10	16	15	24	12	13/16.3	11	28
EKF 1665	No difference to rCRS	11 %	H	No difference to rCRS	H	10	13*	14*	23*	12*	14	13*	
EKF 1699	16298C	1,6 %	HV0	7028 T	N	11	13*	14	24	12	14*	11*	30*
EKF 1700	16183C, 16189C, 16362C		(K)	7028 T	N	11	13	14	24	13	17/18	11*	30*
EKF 1703	16192T, 16256T, 16270T	0,75 %	U5a	7028 T	N								
EKF 1704	16126C, 16163G, 16186T, 16189C, 16294T	1,3 %	T1a	7028 T	N	10	16	15*	24	12*	13/16.3*	11	28*
EKF 1717	16124C, 16224C, 16311C		(H)	–	–	10*	13*	13*	25*		19*		
EKF 1719	No difference to rCRS	11 %	H	No difference to rCRS	H	10	13	14*		12	13/14	11*	
EKF 1720	16092C; 16140C; 16265G; 16265G, 16293G, 16311T	0,02 %	H11	No difference to rCRS	H								

* = proven once only, () = parts of HVR I are missing, – = not sure, blank field = no results

chances of a coincidental concordance seem to be small to none. Hence a maternal relationship can be assumed for those individuals.

The male individuals 1665 and 1719 also show equivalent DNA haplotypes. However, as they share today's most common European haplotype, this provides only limited support for the assumption of a maternal relationship.

Maternal relationship can be excluded among the remaining individuals. Moreover, the mother of the only child in the group could not be detected. However, she might be one of the two females whose mtDNA sequences could not be successfully extracted.

Results of molecular sex typing via the amelogenin test could be obtained from 10 out of 13 individuals. Again the bone samples yielded no and sample 1720 inconclusive results. As can be seen in Table 1, the outcomes of morphological and molecular genetic sex typing match.

The analyses of Y chromosomal STRs revealed a pattern typical of ancient DNA, characterized by a decreasing rate of successful amplification inversely correlated with amplicon length of considered loci. While short-sized alleles like DYS391 and DYS393 (about 120bp) could mostly be amplified, the success rate grew weaker with increasing allele length with the amplification of locus DYS 389-II (about 380bp) producing only a few results.

Reproducible genotypes of four to eight loci could be retrieved from five individuals (EKF 1662, EKF 1664, EKF 1703, EKF 1704, EKF 1719). The rate of successful amplifications was lower for the remaining three individuals, mostly restricted to one PCR, which confirms the statements in respect of family relationships amongst them.

But the Y-STR pattern of male individuals 1664 and 1704 concurs and it could only be found in three out of 82251 analysed individuals from recent populations using the Y-STR haplotype reference database (www.yhrd.org). This consideration seems to make a paternal relationship quite likely. Because these individuals also had identical mt-haplotypes indicating maternal relations, they might be siblings.

The same situation is reflected in the findings of male individuals 1719 and 1665, where a maternal relation could be found and a paternal relationship cannot be excluded, due to potentially equivalent Y-STR profiles. Because of the incomplete patterns and the lack of reproducibility of some of the loci, this assumption cannot be completely verified though.

The remaining STR profiles differ in more than one locus so that affiliations to matching paternal lineages can be rejected. In total, six divergent Y-STR patterns could be observed.

In general, it is not possible to prove the authenticity of human aDNA (Pääbo et al., 2004). This is mainly due to the fact that human contamination can never be ruled out entirely. For this reason, the results of the present DNA analyses have to be considered and interpreted with reservation, despite all precautions taken to prevent contamination. There are certain points, however, that speak for the authenticity of the data:

- Systematic contamination of one or more skeletons can be ruled out, given the fact that none of the mtDNA haplotypes found are represented among the staff involved in morphological examination, sampling or laboratory work.
- All teeth selected for this work were still sitting firm in the alveoli. This guaranteed the best root protection possible during previous archaeological handling of the remains. Furthermore, the results of morphological sex typing concurred with the genetic sex typing, which also points to systemic contamination being highly unlikely.
- The primer-set for HVR I typing was used for the first time in our laboratory and no sample analyzed in any earlier project corresponded with the haplo- or genotypes of the Erding samples.

Extraction and PCR blanks were constantly negative. Therefore, intralaboratory contamination can be characterized as extremely unlikely.
- The observation of eight different and plausible haplotypes among eleven ancient individuals speaks for the authenticity of the results. If contaminant DNA was the source, it would seem highly unlikely that the remains of nearly all of the individuals were each contaminated with DNA of a different haplotype.
- The interpretation of the identical mitochondrial haplotype data and Y-STR profiles concerning samples EKF 1663, EKF 1664 and EKF 1704 as familial relationships and not as contamination is supported by the fact that one woman and two men shared this profile. Both the sex of the woman and the sex of the two men were correctly typed by molecular genetic means. For that reason it seems unlikely that the source of the presumed contaminating DNA is a male individual (which it would have to be because of the identical Y-STR patterns) who left only mitochondrial DNA and no chromosomal DNA, as would have had to be the case in view of the woman.
- The mtDNA HVR I sequences do not appear to be the mosaic results of combined, genetically unrelated fragments. The retrieved sequences can also be observed in recent populations and the HVR I profile-based assignments of haplogroups could be affirmed by SNP-typing of the coding region.
- The DNA analyses followed the expected patterns of appropriate molecular behaviour. This means no results could be obtained from bones, which are known to be more prone to degradation of DNA than teeth (Burger et al., 1997). In addition to that, the analyses of Y chromosomal STRs revealed a pattern typical of ancient DNA: decreasing rate of successful amplifications inversely correlated with single product lengths of considered loci. Furthermore the good preservation of another biomolecule under investigation, the collagen (see stable isotope quality criteria), generally also favours the preservation of DNA.

Conclusions

Archaeometric analyses were performed in order to validate or invalidate the previously postulated hypotheses. Considering the given results in conjunction with the morphological investigations, as well as the historical context, the following statements can be made:

The hypothesis of the founder population was the only one that could be clearly rejected. On the basis of the isotopic data, we can rule out the possibility that the buried individuals were pioneers. None of the eleven individuals spent his/her childhood in an area with a differing Sr signature. Only one individual showed slight evidence for mobility during early childhood.

It must be pointed out that strontium analysis does not allow the detection of immigrants from regions that display a signature that is geochemically identical to the local signature. But if the skeletal population of the Kletthamer Feld was a Germanic founder population, their provenance would have to be from a region beyond the Danube, which separated the Roman Empire from the barbarians in the north. The nearer northern regions are characterized by distinctively higher Sr signatures, though. For this reason, Germanic immigration from northern border regions can very probably be ruled out.

Furthermore, stable isotopes of light elements, which provide an indication of diet, climatic and environmental conditions of the final years of an individual's life, were analysed. Here, too, the majority of the samples produced values that concur with those one would expect to obtain for the area of the burial

site. Interestingly, three out of the four females (EKF 1702, EKF 1663; EKF 1721), but none of the males, display distinctive features.

Given the relatively slow remodelling rates of bone (mineral 3 %/year; organics 24 %/year; Dempster, 1999; Price et al., 2000) and considering the relatively early ages of death (adult) of these three women, these findings could suggest that the individuals in question spent parts of their adolescence in territories with different climates and settled down in Erding only in the final years of their lives. As the individuals in question were classified exclusively as females, this might be an indication of an exogamous marriage system, a phenomenon which has also been described in other studies analysing patterns of exogamous female mobility during the Late Roman and Early Medieval (Hakenbeck et al., 2010).

Due to the bone remodelling rates, differing signatures can be detected only for those women who died within their first years of marriage and hence shortly after their change of location.

This would explain why EKF 1700 is the only female who showed no irregularities regarding the isotopic ratios of the light elements pointing to immigration, as she lived to a mature or even to senile age. There would, then, have been enough time for her bones to remodel after a potential marriage and adjust the isotopic composition of a foreign territory.

Thus, it is unlikely that the skeletal remains belong to a newly established society in Erding; rather, they appear to represent a male population invariable in territory with potential female immigration.

This interpretation makes evident the complexity of migration: it cannot always be recognized by strontium analyses alone but rather requires a combination of multiple isotopic systems, as well as morphological traits such as age at death and sex.

Unlike the females, the majority of the men died at a mature age. It must be pointed out that differing climatic conditions experienced during adolescent years – hence before a potential relocation to this area – would remain unrecognised as the bones of these individuals would have had sufficient time to remodel and adjust their isotopic composition, as may have been the case with the female individual 1700.

The second theory, which described the buried population as a single small-sized family who administered an estate situated near the burial place, can only be partially rejected.

Relational ties are more than likely between at least three individuals. There are two men (EKF 1664 and 1704) whose common maternal and paternal lineage point to their relationship as siblings. These men can be associated with Individual 1663, probably a female.

Furthermore, there are indications suggesting maternal and paternal relationships between the males 1665 and 1719. However, the DNA data have to be considered with caution.

The great variability, in particular that detected with respect to paternal lineages (8 individuals, 6–7 different haplotypes), speaks against the identity of the buried people as members of an extended family. An exogamous marriage system would explain the also large variability of the maternal lineages (11 individuals, 8 haplotypes) but not that of the paternal lineages. So the interred individuals most probably do not belong to a single family clan. However, one cannot rule out the possibility that one or multiple nuclear families who managed one or various farms nearby were buried here with their servants.

However, the pattern of family relationships revealed in the analyses also fits in with the third hypothesis – that the buried men were members of a Roman military unit who lived together with their families near the burial place. In addition to the finding of the Roman fibula, the observed preponderance of men and the diversity of the Y-haplotypes support this supposition. EKF 1665 is an exception though, displaying Sr values that differ slightly from the local signature.

Overall, however, the results obtained best support the hypothesis that the buried individuals were members of a military unit and their families. Direct affirmation by archaeometric analyses is not possible in this case though.

Acknowledgements

We thank K. Anslinger (Institute of Forensic Medicine, Ludwig Maximilian University, Munich) for the molecular typing of the Y-STRs and A. Staskiewicz (State Collection of Anthropology and Palaeoanatomy, Munich) for providing the anthropological information and the identification of animal species. Special thanks to N. Hoke (Department Biology I, Ludwig-Maximilians-Universität, Munich) for technical assistance and for her help regarding proofreading, I. Wiechmann (Department Biology I, Ludwig-Maximilians-Universität, Munich) for help with the DNA analyses, and G. Grupe (Department Biology I, Ludwig Ludwig-Maximilians-Universität, Munich) for her encouragement and support of this work.

References

Achilli, A., Rengo, C., Magri, C., Battaglia, V., Olivieri, A., Scozzari, R., Cruciani, F., Zeviani, M., Briem, E., Carelli, V., Moral, P., Dugoujon, J.M., Roostalu, U., Loogväli, E.L., Kivisild, T., Bandelt, H.J., Richards, M., Villems, R., Santachiara-Benerecetti, A.S., Semino, O., Torroni, A., 2004. The molecular dissection of mtDNA haplogroup H confirms that the Franco-Cantabrian glacial refuge was a major source for the European gene pool. American Journal of Human Genetics 75, 910–918.

Achilli, A., Rengo, C., Battaglia, V., Pala, M., Olivieri, A., Fornarino, S., Magri, C., Scozzari, R., Babudri, N., Santachiara-Benerecetti, A.S., Bandelt, H.J., Semino, O., Torroni, A., 2005. Saami and Berbers – an unexpected mitochondrial DNA link. American Journal of Human Genetics 76, 883–886.

Aitken, M.J., 1990. Science-based Dating in Archaeology. Longman, London, New York.

Álvarez-Iglesias, V., Mosquera-Miguel, A., Cerezo, M., Quintáns, B., Zarrabeitia, M.T., Cuscó, I.; Lareu, M.V., García, O., Pérez-Jurado, L., Carracedo, A., Salas, A., 2009. New population and phylogenetic features of the internal variation within mitochondrial DNA macro-haplogroup R0. PLoS One 4:e5112.

Ambrose, S.H., 1990. Preparation and characterization of bone and tooth collagen for isotopic analysis. Journal of Archaeological Science 17, 431–451.

Ambrose, S.H., 1993. Isotopic analysis of paleodiets: Methodological and interpretive considerations, in: Sandford, M.K., (Ed.), Investigation of Ancient Human Tissue. Gordon and Breach, Langhorne, Pennsylvania, pp. 59–127.

Andrews, R.M., Kubacka, I., Chinnery, P.F., Lightowlers, R.N., Turnbull, D.M., Howell, N., 1999. Reanalysis and revision of the Cambridge reference sequence for human mitochondrial DNA. Nature Genetics 23, 147.

Bentley, R.A., 2006. Strontium isotopes from the earth to the archaeological skeleton: A review. Journal of Archaeological Method and Theory 13, 135–187.

Bentley, R.A., Knipper, C., 2005. Geographical patterns in biologically available strontium, carbon and oxygen isotope signatures in prehistoric SW Germany. Archaeometry 47, 629–644.

Biermeier, S., Pietsch, M., 2006. Vielfalt in Erdings Westen: Vom Neolithikum bis zur Spätantike. Landkreis Erding, Oberbayern. Archäologisches Jahr in Bayern 2006, 107–110.

Burger, J., Hummel, S., Herrmann, B., 1997. Nachweis von DNA-Einzelkopiesequenzen aus prähistorischen Zähnen. Liegemillieu als Faktor für den Erhalt von DNA. Anthropologischer Anzeiger 55, 193–198.

Dempster, D.W., 1999. New concepts in bone remodelling, in: Seibl, M.J., Robins, S.P., Bilezikian, J.P. (Eds.), Dynamics of Bone and Cartilage Metabolism. Academic Press, San Diego, New York, Boston, pp. 261–273.

DeNiro, M.J., Epstein, S., 1981. Influence of diet on the distribution of nitrogen isotopes in animals. Geochimica et Cosmochimica Acta 45, 341–351.

Fehr, H., 2010. Unsichere Zeiten – Bayern um 500, in: Wamser, L. (Ed), Karfunkelstein und Seide, Neue Schätze aus Bayerns Frühzeit, Ausstellungskataloge der Archäologischen Staatsammlung 37. Verlag Friedrich Pustet, Regensburg.

Fry, B. 2006. Stable Isotope Ecology. Springer Verlag, New York.

Grignani, P., Turchi, C., Achilli, A., Pelosoa, G., Alué, M., Ricci, U., Robinog, C., Pelotti, S., Carnevali, E., Boschi, I., Tagliabracci, A., Previdere, C., 2009. Multiplex mtDNA coding region SNP assays for molecular dissection of haplogroups U/K and J/T. Forensic Science International: Genetics 4, 21–25.

Grupe, G., Price, T.D., Schröter, P., Söllner, F., Johnson, C.M., Beard, B.L., 1997. Mobility of Bell Beaker people revealed by strontium isotope ratios of tooth and bone: a study of southern Bavarian skeletal remains. Applied Geochemistry 12, 517–525.

Hakenbeck, S., McManus, E., Geisler, H., Grupe, G., O'Connel, T., 2010. Diet and mobility in Early Medieval Bavaria: A study of carbon and nitrogen stable isotopes. American Journal of Physical Anthropology, DOI: 10.1002/ajpa.21309.

Harbeck, M., Grupe, G., 2009. Experimental chemical degradation compared to natural diagenetic alteration of collagen: implications for collagen quality indicators for stable isotope analysis. Archaeological and Anthropological Sciences 1, 43–57.

Katzenberg, M.A., 2000. Stable isotope analysis: A tool for studying past diet, demography, and life history, in: Katzenberg, M.S., Saunders, S.R. (Eds.), Biological Anthropology of the Human Skeleton. John Wiley and Sons Inc., New York, Chichester, Weinheim, pp. 305–327.

Lösch, S., Grupe,G., Peters, J., 2006. Stable isotopes and dietary adaptations in humans and animals at pre-pottery Neolithic Nevalli Çori, southeast Anatolia. American Journal of Physical Anthropology 131, 181–198.

Macaulay, V., Richards, M., Hickey, E., Vega, E., Cruciani, F., Guida, V., Scozzari, R., Bonné-Tamir, B., Sykes, B., Torroni, A., 1999. The emerging tree of West Eurasian mtDNAs: A synthesis of control-region sequences and RFLPs. American Journal of Human Genetics 64, 232–249.

Mannucci, A., Sullivan, K.M., Ivanov, P.L., Gill, P., 1994. Forensic application of a rapid and quantitative DNA sex test by amplification of the X-Y homologous gene amelogenin. International Journal of Legal Medicine 106, 190–193.

Meyer, E., Wiese, M., Bruchhaus, H., Claussen, M., Klein, A., 2000. Extraction and amplification of authentic DNA from ancient human remains. Forensic Science International 113, 87–90.

Minagawa, M., Wada, E., 1984. Stepwise enrichment of ^{15}N along food chains: Further evidence and the relation between $\delta15N$ and animal age. Geochimica et Cosmochimica Acta 48, 1135–1140.

Nelson, T.M., Just, R.S., Lereille, O., Schanfield, M.S., Podini, D., 2007. Development of a multiplex single base extension assay for mitochondrial DNA haplogroup typing. Croatian Medical Journal 48, 460–472.

Pääbo, S., Poinar, H., Serre, D., Jaenicke-Despres, V., Hebler, J., Rohland, N., Kuch, M., Krause, J., Vigilant, L., Hofreiter, M., 2004. Genetic analyses from ancient DNA. Annual Review of Genetics 38, 645–679.

Price, T.D., Manazanilla, L., Middleton, W.D., 2000. Immigration and the ancient city of Teotihuacan in Mexico: A study using strontium isotope ratios in human bone and teeth. Journal of Archaeological Science 27, 903–913.

Price, T.D., Burton, J.H., Bentley, R.A., 2002. The characterization of biologically available strontium isotope ratios for the study of prehistoric migration. Archaeometry 44, 117–135.

Richards, M., Macaulay, V., Hickey, E., Vega, E., Sykes, B., Guida, V., Rengo, C., Sellitto, D., Cruciani, F., Kivisild, T., Villems, R., Thomas, M., Rychkov, S., Rychkov, O., Rychkov, Y., Golge, M., Dimitrov, D., Hill, E., Bradley, D., Romano, V., Cali, F., Vona, G., Demaine, A., Papiha, S.,Triantaphyllidis, C., Stefanescu, G., 2000. Tracing european founder lineages in the near eastern mtDNA pool. American Journal of Human Genetics 67, 1251–1276.

Richards, M.P., Mays, S., Fuller, B.T., 2002. Stable carbon and nitrogen isotope values of bone and teeth reflect weaning age at the Medieval Wharram Percy site, Yorkshire, UK. American Journal of Physical Anthropology 119, 205–210.

Rudbeck, L., Gilbert, M.T.P., Willerslev, E., Hansen, A.J., Lynnerup, N., Christensen, T., Dissing, J., 2005. mtDNA analysis of human remains from an early Danish Christian cemetery. American Journal of Physical Anthropology 128, 424–429.

Schoeninger, M.J., DeNiro, M.J., 1984. Nitrogen and carbon isotopic composition of bone collagen from marine and terrestrial animals. Geochimica et Cosmochimica Acta 48, 625–639.

Schweissing, M.M., Grupe, G., 2003a. Tracing Migration Events in Man and Cattle by stable strontium isotope Analysis of Appositionally Grown Mineralized Tissue. International Journal of Osteoarchaeology, 13, 96–103.

Schweissing, M.M., Grupe, G., 2003b. Stable strontium isotopes in human teeth and bone: a key to migration events of the late Roman period in Bavaria. Journal of Archaeological Science 30, 1373–1383.

Steidl, B., 2006. Söldner, Überläufer, Sklaven – Germanen im Römischen Reich, in: Archäologie, Fenster zur Vergangenheit in Bayern. Verlag Friedrich Pustet, Regensburg.

van Klinken, G.J., 1999. Bone collagen quality indicators for palaeodietary and radiocarbon measurements. Journal of Archaeological Science 26, 687–695.

Wiechmann, I., Grupe, G., 2005. Detection of Yersinia pestis DNA in two early medieval skeletal rinds from Aschheim (Upper Bavaria, 6th century A.D.). American Journal of Physical Anthropology. 126, 48–55.

Yang, D.Y., Eng, B., Waye, J.S., Dudar, J.C., Saunders, S.R., 1998. Technical note: improved DNA extraction from ancient bones using silica-based spin columns. American Journal of Physical Anthropology 105, 539–543.

Stable isotopes

Marek Zvelebil[a] †, *Malcolm C. Lillie*[b,] *, *Janet Montgomery*[c], *Alena Lukes*[d], *Paul Pettitt*[a], *Mike P. Richards*[e]

The emergence of the LBK: Migration, memory and meaning at the transition to agriculture

* Corresponding Author: m.c.lillie@hull.ac.uk
a Department of Archaeology, Northgate House, Sheffield, United Kingdom (Deceased)
b Department of Geography, University of Hull, United Kingdom
c Archaeological, Geographical and Environmental Sciences, University of Bradford, West Yorkshire, United Kingdom
d Department of Anthropology, University of Winnipeg, Manitoba, Canada
e Department of Anthropology, The University of British Columbia, Vancouver, Canada

Abstract

This paper represents one element of a collaborative research project, funded by the AHRC, which focussed on a multidisciplinary study of the Earlier Neolithic cemetery of Vedrovice, Moravia, Czech Republic. One of the key aims of this project was the generation of new knowledge in relation to the emergence of the Linear Pottery, or Linearbandkeramik (LBK) culture in Europe. The current paper focuses on the evidence for the shift from hunting and gathering to farming from the perspective of individual life histories and the transmission of knowledge through migration and cultural exchanges.

Keywords

Linearbandkeramik (LBK), Bioarchaeology, Neolithic, Strontium, aDNA, Migration, Cultural transition

Dedication: This paper is dedicated to the memory of the first author, Professor Marek Zvelebil who died unexpectedly on the 7th July 2011 aged 59. For over 30 years Marek was a leading figure in archaeology, and internationally he was widely regarded as being among the most important and influential archaeological thinkers of his generation. Marek was a consummate intellectual who lived life to the full, he was a mentor, friend and inspiration to many in a generation of archaeologists, he will be sorely missed.

Introduction

The Linearbandkeramik Culture (LBK) is central to current debate concerning the origins and spread of agriculture in Europe (e.g. Lukes and Zvelebil, 2006; Lüning, 1988; Modderman, 1988; Zvelebil et al., 2008). Despite earlier assertions that this culture represented an homogenous entity, reflecting a rapid east–west colonization event, recent research has increasingly highlighted significant local and regional diversity in the material culture inventories and subsistence strategies of the individual groups (e.g., Bánffy, 2004; Gronenborn, 1999, 2003, 2004; Lukes, 2004, 2006; Lukes and Zvelebil, 2004; Mateiciucová, 2004; Price, 2000; Rulf, 1995, 1997; Whittle, 1996; Zvelebil, 2000a, 2000b, 2004; Zvelebil et al., 2008). The diversity, as identified, has in many cases been interpreted as representing continuity in indigenous lifeways and the integration of indigenous hunter-forager material culture and world views into the LBK, as various elements of food-production economies are transmitted into Europe.

In order to begin to generate meaningful narratives addressing the role of indigenous groups within the LBK we began our research at the site level. This focus allows us to consider a single community at a single site where individuals actively engaged with the materiality of life in the daily cycle of practice and negotiation of identity. Their activities were undertaken in accordance with both individual and communal motives (as per the concepts of agency, habitus and practice discussed elsewhere by Barrett [1994,

1997], Bourdieu [1977, 1990], Dobres and Robb [2000], Giddens [1979, 1984], Hodder [1992, 2000], and Shanks and Tilley [1992]) (Lukes et al., 2008). One of the advantages of this site-level focus is that it enables us to explore how individual identities are constructed (and/or deconstructed/reconstructed) through the memories and learned experiences that are bound up in established socio-political traditions.

From this initial perspective, the current paper will inform the key debates in relation to the three main approaches used to model the emergence of the LBK culture:
- Migrationist models, which highlight the role of incoming colonists (Cavalli-Sforza and Cavalli-Sforza, 1995; Childe, 1957; Piggott, 1965; van Andel and Runnels, 1995; Vencl, 1986);
- Indigenist models, which focus on the role of local indigenous groups (Barker, 1985; Dennell, 1983; Pluciennik, 1998; Tilley, 1994; Whittle, 1996);
- Integrationist models, which explore the interaction of both population groups (Chapman, 1994; Price, 1987; Renfrew, 1996; Zvelebil, 1986, 1995, 1996).

In outlining the nature of social interaction, participation and the intergenerational transmission of knowledge at the Mesolithic–Neolithic transition, the above models allow for the understanding of the LBK at the communal level through the identification of the intergenerational transmission and acquisition of knowledge. This transmission/acquisition is, to some degree, structured and motivated by social context as expressed through variation in stylistic elements of material culture (Lukes et al., 2008). As such, whilst the focus of the research reported here is on the evidence for migration at the Vedrovice cemetery/settlement, the overarching research agenda comprises an examination of personal biographies and communal identity derived from the application of bioarchaeological analyses to human and material remains (e.g. Lillie, 2008; Lukes et al., 2008; Richards et al., 2008; Smrčka et al., 2005, 2008; Zvelebil and Pettitt, 2008). By generating information aimed at elucidating personal biographies, through the use of bioarchaeology, AMS dating and isotopic studies, we are able to identify those individuals who were indigenous to the region and those who had migrated into the region, and ascertain which individuals might be considered as having had the fundamental knowledge essential for the development of food production strategies.

The site

The site that forms the basis for the current study is Vedrovice, Moravia in the Czech Republic (Fig. 1). This site has two key earlier Neolithic components: a settlement featuring traces of the materiality of daily life (Podborský, 1993, 2002; Čižmář, 2002) and the focus of the current study, which is a cemetery that has produced one of the largest collections of Neolithic human remains in Central Europe (Podborský, 2002). Fortunately there are well-documented records of the material culture for both the cemetery and settlement site. Vedrovice is located in southern Moravia in the southeastern part of the Czech Republic, near Moravský Krumlov in the Znojmo district (Ondruš 2002).

The inhumations in the Široká u Lesa cemetery at Vedrovice were deposited over the course of the 53rd century BC, possibly continuing a little into the early 52nd century BC, a period spanning five or six generations (Pettitt and Hedges, 2008). In the wider context Vedrovice falls within the middle LBK Flomborn phase, which saw a major expansion of the LBK into Central Europe (Gronenborn, 1999; Price et al., 2001). To a certain extent then, the Vedrovice community can be seen as a pioneer in the region, existing as it did at a time when agriculture was newly established in Central Europe.

Fig. 1 | Map showing the location of Vedrovice in the Czech Republic (right side) and the Neolithic sites at Vedrovice (left side) as identified between 1961 and 2000 (based on Ondruš in Podborský [2002]). The main cemetery (I) is located to the top left side of the plan in the area Široká u lesa, whilst indications of settlement and ca. 22 Neolithic burials were recovered between the C19th and the 1950s in the area Za dvorem (centre and right side of map). Between 1961 and 1989, an LBK settlement of ca. 5000m² was investigated in the area of Široká u lesa by the archaeology department of the Moravian Museum in Brno

The material culture inventory and skeletal collection from Vedrovice includes ceramic vessels, miniature vessels, weights, drilled ceramic disks and figurine fragments, post holes from housing structures, pits, ovens, flaked and polished stone tools, grinding stones, faunal remains and bone tools (Berkovec, 2003; Berkovec and Veselá, 2003–2004; Berkovec et al., 2004; Humpolová, 2001; Humpolová and Ondruš, 1999; Ondruš, 2002; Podborský, 2002; Lukes, 2006). In addition, there are ca. 81 individuals interred in the Neolithic Široká u Lesa cemetery, and a further 23 burials from the Neolithic settlement (Podborský, 2002; Crubézy et al., 1997; Smrčka et al., 2005; Lillie, 2008).

In general the material from the cemetery has a much greater degree of preservation and smaller frequency of fragmentation than does that of the settlement site, yielding, for instance, a higher percentage of intact vessels (Čižmář, 2002; Lukes, 2006). Furthermore, differences in the composition and type of the material culture inventory between the cemetery and settlement have been identified, leading to the suggestion that "the world of the living had been kept separate from the world of the dead" (Berkovec et al., 2004). Hence, individual burials provide a unique opportunity to apply objective bioarchaeological approaches, supplemented by material culture in the form of grave goods, in order to construct individual biographies that facilitate an exploration of the nature of individual identity in contrast to the communal identity that is evident at the settlement.

Methodology

Sulphur isotope analysis

In the original research programme, sulphur isotope analysis was carried out on the collagen of 50 individuals from the Vedrovice cemetery (Richards et al., 2008). This method requires that large amounts of collagen be available for analysis, as Richards et al. (2001, 186) have noted that previous work on archaeological and palaeontological bone has been limited by the difficulty of measurement, as bone collagen contains very little sulphur (0.16 wt%, calculated from amino acid composition). Furthermore these authors have also noted that the collagen becomes increasingly chemically degraded over time. The methodology for the measurement of sulphur isotopes in the bone collagen followed that of Richards and colleagues (2001, 2003). Sulphur isotopes are somewhat indicative of diet, but are most useful in determining the geographical location in which the individual resided during formation of the collagen. Collagen is formed over the preceding one to two decades, yielding values reflecting fairly recent locations (compared to strontium, discussed in the next paragraph). In general sulphur isotope values vary between about –20 and +20 per mil, i.e., a total range of about 40 per mil; in the recent study at Vedrovice the data generated indicated clustering around the value of 0, with a range of –2 to +2. This is consistent with Vedrovice's location in central Europe (Richards et al., 2011).

Strontium isotope analysis

We measured the strontium isotope ratios and concentrations in tooth enamel; these values reflect the geological location where the individual spends his or her childhood, when their enamel is formed (Price et al., 2002). Unlike bone, enamel, once formed, is not remodelled and, unlike bone and dentine, it is highly resistant to postmortem diagenesis (Budd et al., 2000; Hoppe et al., 2003; Trickett et al., 2003). Therefore strontium isotope values for enamel tell us whether adult individuals spent their childhoods in locations other than those at which they were eventually buried as adults (Richards et al., 2008).

The methodology used for the analysis of strontium isotopes followed that outlined by Richards and colleagues (2008). Twenty-two individuals from Vedrovice were investigated during this stage of the study. Three samples of the underlying crown dentine were obtained for use as proxies for the mobile soil strontium (Budd et al., 2000; Hoppe et al., 2003; Montgomery et al., 2007). Chemical separation and analysis of the enamel samples was undertaken at the Max Planck Institute for Evolutionary Anthropology, Leipzig, Germany, using plasma ionization multicollector mass spectrometry (PIMMS) following the methods outlined by Copeland and colleagues (2008). $^{87}Sr/^{86}Sr$ values measured for SRM987 (NIST international strontium carbonate isotope standard), which was analysed concurrently with the samples, were 0.71027 ± 0.000015 (1s, n = 7), which is well within its certified value of 0.71034 ± 0.00026.

Results

The results obtained from this stage of the analysis (Table 1) have demonstrated that migration occurred in the population interred at Vedrovice. We will use the results presented below to evaluate the degree to which migration represents 'local' movements between groups/individuals in a discrete geographical

Table 1 | Isotope ratios for twenty-two individuals at the Vedrovice cemetery, Czech Republic

S-EV A	Individual	%Coll	δ¹³C	δ¹⁵N	%C	%N	C:N	%S	δ³⁴S	⁸⁷/⁸⁶Sr	Sr ppm
3216	15/75	3.0	−19.2	10.0	40.6	14.4	3.3	0.2	−0.1	0.710847	71
3215	16/75	6.1	−19.9	9.7	44.3	15.9	3.2	0.2	−1.4	0.711150	77
1319	30/76	2.4	−19.5	9.5	32.2	11.0	3.4	0.1	2.6	0.710831	88
1300	38/76 tooth									0.710407	137
1308	42/77	1.2	−19.5	9.8	38.6	14.0	3.2	0.2	−1.1	0.711011	113
1320	43/77	3.0	−20.0	9.7	42.7	14.9	3.4	0.2	1.1	0.711242	78
3233	48/75	1.5	−19.8	10.3	37.0	12.9	3.3	0.2	−1.2	0.711032	82
3240	51/77	0.5	−20.7	9.5	40.7	11.7	4.0			0.709112	190
3237	54/78	6.5	−19.6	10.1	44.2	15.4	3.3	0.2	0.8	0.711092	58
1302	59/78	0.7	−19.4	10.3	27.8	9.8	3.3			0.711441	109
1309	62/78	1.0	−19.9	9.4	36.2	12.7	3.3	0.2	−0.3	0.711293	127
4011	66/70		n/a							0.711529	104
3217	73/79	4.9	−19.7	10.2	43.9	15.5	3.3	0.2	1.8	0.711009	75
3239	75/79	4.3	−19.5	9.3	44.7	15.3	3.4	0.2	0.9	0.711177	119
3219	79/79	3.9	−19.6	10.0	43.7	15.7	3.3	0.2	−3.4	0.709852	202
3218	82/79	3.8	−19.1	10.6	42.0	15.1	3.2	0.2	−0.6	0.711331	101
3222	84/80	2.2	−20.2	9.9	30.6	10.5	3.4	0.2	−1.4	0.710971	100
3235	93a/80	3.6	−19.8	10.2	41.6	14.3	3.4	0.2	2.4	0.711515	119
3244	102/81	4.4	−20.0	9.2	43.6	15.5	3.3	0.2	−0.2	0.712627	101
3236	104/81	2.5	−19.9	9.8	39.5	13.4	3.4	0.2	−1.5	0.711201	98
3242	105/81	7.3	−19.7	9.0	44.9	15.9	3.3	0.2	−0.1	0.711301	91
3238	107/82	4.9	−19.3	8.9	45.4	16.2	3.3	0.2	1.3	0.711373	49

Fig. 2 | Strontium ratio and concentration data

area or longer-distance migrations from a wider interregional context; we will also consider the material culture inventory of the cemetery population.

Sulphur isotope analysis

There is some evidence for variability in this population (Table 1), with two adult males (63/78 and 95/80) and one adult female (14/75) having S values higher than those of the others, and one adult male (79/79) and one adult female (101/81) having S values that are lower than the others. The suggestion is that these individuals resided somewhere other than in Vedrovice during the last 10–20 years of their lives, although the absence of comparative data prevents further elucidation on this point (Richards et al., 2008).

Strontuim isotope analysis

In the current study, the enamel strontium concentrations have a mean equal to 105 ± 36 ppm 1s and a range of 49–202 ppm, n=23. These are consistent with omnivorous humans in non-coastal, temperate Europe (Montgomery, 2002; Montgomery et al., 2007). Most of the individuals share a similar strontium isotope value: 18 of the 22 individuals analysed form a cluster with a strontium isotope range of 0.7108–0.7115 and a mean equal to 0.7112 ± 0.0002 1s, n=18 (Table 1 and Fig. 2). This group includes all of the juveniles, and is co-incident with the range of dentine ratios indicative of local mobile strontium (Montgomery et al., 2007). The dentine range (0.7110–0.7114) corresponds well with values of 0.7110–0.7112 obtained for bone and dentine from the loess LBK site at Asparn-Schletz, in Lower Austria (Prohaska et al., 2002). It has been suggested that juveniles provide a useful way of estimating the range of local strontium values for a community as they would, potentially, have had much less time in which to undertake migration when compared to the adults (Evans and Tatham, 2004; Montgomery et al., 2005; Schutkowski, 2002).

There are some exceptions however. One female (102/81) has a strontium isotope value higher than the majority of the others, and two males (38/76 and 79/79) and one female (51/77) have values lower than the majority, although the isotope ratio of individual number 38/76 is close to the main Vedrovice cluster. These four individuals, who were buried in four different regions of the cemetery, appear to have spent part of their childhoods at a location other than Vedrovice. None of the values for these individuals are consistent with an origin in regions of geologically young rocks, such as recent volcanic basalts, or marine sediments, such as Cretaceous chalks (McArthur et al., 2001; Montgomery et al., 2005; Price et al., 2004). Neither do they result entirely from origins on Precambrian granites and gneisses of the Bohemian Massif, where strontium ratios from pigs have been found to exceed 0.718 (Bentley and Knipper, 2005). However, the female 102/81 has a strontium isotope ratio of 0.7126, indicative of some dietary contribution from Palaeozoic or Precambrian rocks, which are found principally to the north and west in upland regions (Bentley and Knipper, 2005). The values for the two individuals with the lowest strontium isotope ratios (79/79 and 51/77) are consistent with younger Mesozoic rocks, such as those found to the east and south of Vedrovice.

Furthermore, Smrčka et al. (2005) have noted the presence of individuals buried at the adjacent settlement site whose Sr ratios point to nonlocal origins (child aged 6–7 years, Grave 3/1966, and child

aged 7–8 years, Grave 4/1969), as well as individuals whose strontium values suggest that they might have moved more than once during their lifetime (child aged 5–6 years, Grave 5/1971, and male aged 40–50 years, Grave 10/1974).

Discussion

Using isotopic studies to detect migration/mobility

As noted at the outset of this paper, the data presented here represent one part of a much wider-ranging study aimed at understanding the biosocial aspects of earlier LBK communities. Within this research agenda, humans are recognised as being both biological organisms and social creatures; the research emphasises the interaction between these two aspects of the human condition (Bush and Zvelebil, 1991; Meiklejohn and Zvelebil, 1991; Larsen, 1997; Eriksson, 2003; Zvelebil and Pettit, 2008).

As there are around 300 known burials for the Moravian LBK, it is apparent that they represent an important resource, given that the number of burials declined through the LBK as cremation rose in importance. Cremation becomes a standard form of burial in the succeeding Middle and Late Neolithic (only eight inhumations are known for the Stroke-Ornamented Pottery culture and 40 for the Moravian Painted Ware [Lengyel] Culture [Dočkalová and Čižmář, 2008]), resulting in a paucity of inhumation burials for study. Although flexed burial was the norm in the Moravian LBK, several forms of mortuary disposal were involved, including the following: inhumation in cemeteries associated with small hamlets, group inhumations within settlements, group inhumations outside settlements, single inhumations within settlements, inhumations within house structures, inhumations bearing traces of violence, and the recovery of disarticulated skeletal parts.

In relation to the designation 'pioneer', we sought to establish precisely how many individuals could be identified as being nonlocal, and thereby potentially influential in the social interactions, and intergenerational transmission of knowledge that is intimately tied up with the integration/adoption of agriculture within the region. The results from the analyses in the sulphur and strontium studies suggest that whilst the majority of the population of Vedrovice remained indigenous to the study region, at least five individuals who spent at least a part of their adult lives in different locations (sulphur isotopes) and three (perhaps four) individuals who were either born elsewhere, or who spent a portion of their childhood elsewehere (strontium isotopes), are interred in the cemetery population (Table 1). Only one of the individuals studied was shown by both methods to be of nonlocal birth/residence (individual 79/79), thus we potentially have at least 4 males and 3 females who were not lifelong inhabitants of Vedrovice (Fig. 3).

On the basis of the sulphur and strontium analysis it appears that individual 79/79, an adult male, appears have spent much of his childhood and adulthood away from the Vedrovice area, possibly in coastal regions where marine resources were utilised. The only individual who is perhaps difficult to determine within this stage of the analysis is individual 38/76, whose isotope ratio is close to the main Vedrovice cluster. Moreover, as mentioned in the end of the previous section, Smrčka and colleagues (2005), reporting on their analysis of the individual buried in the settlement, note that 2 children were nonlocal, while one child and one adult male may have moved on more than one occasion during their lifetimes.

Richards and colleagues (2008) report that individuals 51/77, 79/79 and possibly individual 38/76 at Vedrovice exhibit strontium signatures that are consistent with European lowland loess regions

Fig. 3 | Grave clusters within the Vedrovice cemetery indicating internal structuring. Based on Ondruš in Podborský (2002) with alterations and additions by authors based on new analyses

(e.g., Gallet et al., 1998, Price et al., 2001, 2004). The average bone strontium value obtained from the sites closest to Vedrovice, Alicenhof in Austria and Moravská Nová Ves in the Czech Republic, is 0.7104 (Price et al., 2004) which is lower than the average of 0.7110 obtained from the enamel samples at Vedrovice but consistent with individual 38/76. The lower strontium ranges obtained for other loess-based sites in Europe suggests that there is an enhanced contribution from Precambrian and Paleozoic rocks to the loess in the vicinity of Vedrovice, which may reflect its position on the edge of the Bohemian Massif. Consequently, it should be possible to identify immigrants to the site from the regions of Tertiary and Quaternary geology to the east and south of Vedrovice, such as the Hungarian Plain, where lower biosphere strontium ratios, such as those obtained from individuals 51/77, 79/79, are found (Giblin, 2005; Price et al., 2004).

The sulphur and strontium analyses have shown that the isotopic values of most of the individuals at Vedrovice suggest that they probably spent all, or the majority, of their lives at or near Vedrovice. How-

Table 2 | Comparison of individuals in terms of local or exotic habitation, based on strontium (start of life) and sulphur (later life) isotopes (Richards et al., 2008; Smrčka et al., 2008). Where only strontium (Sr) or sulphur (S) measurements are known for a specific individual we make the default assumption that individuals are local in the missing dimension (following Zvelebil and Pettitt, 2008)

	Later life: local resident	Later life: local travellers
Start of life: locally born	adult males 15/75, 23/75 (S only*), 25/75 (S only), 50/77 (S only), 54/78, 57/78 (S only), 59/78 (Sr only), 66/70 (Sr only), 71/79 (S only), 73/79, 77/79 (S only), 82/79, 95/80 (S only), 99/81, 108/84 (S only), adult females 13/75 (S only), 38/76 (S only), 42/77, 48/75, 62/78, 64/78, 72/79 (S only), 75/79, 80/79, 86/78 (S only), 86/80 (S only), 87/80 (S only), 91/80 (S only), 93a/80, 97/80 (S only), 100/81 (S only), 104/81, 107/82, unsexed adults 89/80 (S only), 90/80 (S only), 96/80 (S only), children 16/75, 17/75 (S only: high sulphur probably due to breastfeeding/development), 28/76 (S only), 30/76, 31/76 (S only), 39/80, 43/77, 44/77 (S only), 56/78 (S only), 81b/79 (newborn), 84/80, 105/81, 106/82 (S only) **(n=48)**	adult females 14/75 (S only) and 101/81 (S only), adult male 63/78 (S only) and very old male 95/80 **(n=4)**
Start of life: exotic: born elsewhere	adult females 38/76 (Sr only), 51/77 (Sr only), 102/81, 70/79 **(n=4)**	adult male 79/79, adult female (51/77)? **(n=1)**

* Where only strontium (Sr) or sulphur (S) measurements are known for a specific individual we make the default assumption that individuals are local in the missing dimension (after Zvelebil and Pettitt, 2008)

ever, there appear to be a few individuals who lived elsewhere as children or adults. Specifically, three adult males and two adult females had sulphur isotope values indicating that they had lived elsewhere within the period preceding their deaths (i.e. over the last 10 to 20 years of life), and two males and two adult females had strontium isotope values indicating that they lived elsewhere as children.

The male adult (79/79), whose sulphur and strontium values differed from those of the rest of the population, indicating that he had lived elsewhere both as a child and in the period preceding his death, and who thus must have been a recent immigrant to Vedrovice, was buried with one of the richest grave goods assemblages in the cemetery. This assemblage included a shoe-last adze; a bowl; imported Polish flint blade fragments, possibly indicative of a hunter's status; boar tusk and a Spondylus pendant (Zvelebil and Pettitt, 2008).

The results of our studies to date suggest that a small but significant percentage of the Vedrovice community (about 10%) were exotic to the settlement and originated in/or interacted with areas at all points of the compass. This includes upland areas to the north, west and east and the Danube basin to the south. There have been archeological findings that suggest that at this point of time the upland areas would still have been supporting Mesolithic hunter-gatherer communities (see Pavlů, 2005; Lukes and Zvelebil, 2006; more broadly, Gronenborn, 2003; Svoboda, 2003; but cf. Vencl and Fridrich, 2007). This is difficult to confirm on chronological grounds give the paucity of dateable archaeological evidence, but given the lack of early Neolithic settlement in these areas we suspect that derivation from or interaction with hunter-gatherers is highly likely. However, the evidence presented here clearly indicates that both males and females were mobile into and out of the Vedrovice area.

Life biographies

As part of the main research agenda we have considered the individual life histories of a number of the individuals interred at Vedrovice (Zvelebil and Pettitt, 2008). The memory and meaning that is intertwined with burial practice and patterns of behaviour at Vedrovice allows us to generate insights into the individual, mediated, and shared identities of the people who were born, lived, emigrated and immigrated to the region during the life of the settlement/cemetery, whose knowledge and experience would have informed, modified and influenced social interactions at Vedrovice.

Of the individuals identified as having spent part of their adult life in different locations, or those that spent a portion of their childhood elsewhere (Table 2; Fig. 3), the following three individuals have been studied in some detail.

Individual 79/79: This relatively healthy individual was a late incomer into the Vedrovice community, who was born and spent the last 10–20 years of his life in coastal regions utilising marine resources. Given that his age at death was about 30 years, and considering trace elemental indicators, a coastal location in south-eastern Europe seems the best option as the place of this individual's birth, childhood and adult life. Yet he ended up buried at Vedrovice, and his grave is one of the richest in the community. His head was covered in red ochre. Two pots, a boar tusk, and six flint blades – two made from an imported Polish flint – were placed around his head, while a perforated spondylus pendant was placed into his left palm, and two Krakow (Polish) flint blades and a shoe-last adze were placed along the body. So, although a newcomer to the Vedrovice community, he received respect and achieved a high social status, indicated by the presence of imported flint tools, shoe-last adze and spondylus. Was he a lifelong traveller maintaining contact between communities of different traditions (LBK and, in this case, Vinča), facilitating the transfer of knowledge, information and exchange of goods?

Individual 51/77: This woman falls into the same category as the man 79/79 in terms of her travels and possibly of birthplace. Both have a strontium profile suggesting marine diet and coastal environment, probably somewhere in southeast Europe. Were they partners (or closely related) in their life and travels? She lived to around 50 years of age, having led a relatively healthy life, with no significant pathologies recorded. Her grave was disturbed by a later Neolithic feature (Moravian Painted Ware) so we cannot be sure of the full range of her grave goods; certainly fragments from two pottery vessels were found in the undisturbed part of the grave.

Individual 102/81: This woman died as a mature individual aged 40–45 between 5300 and 5040 BC (with the time of death being most probably in the 53rd century BC according to analysis undertaken by Pettitt and Hedges (2008)). Despite her relatively advanced age, she appears to have been relatively healthy: no pathology was recorded on the postcranial skeleton, the molars show heavy traces of wear normal for her age, but no other pathologies. She was born in an area to the north or northwest of Vedrovice, in the uplands of the Bohemian Massif, where older regions of geology, granites or gneiss, generate a specific strontium signature. She might have joined the Vedrovice community in young adulthood, coming either from the last hunter-gatherer communities living in the uplands of that area, or from the first farming settlements that were just becoming established in eastern Bohemia. Though buried oriented to the east-southeast, she was laid, unconventionally, on her right side, arms flexed, hands folded. She was, then, part of the group of individuals interred at Vedrovice who had links to regions of Bohemia to the northwest. A double perforated spondylus pendant was placed around her waist or hip, and her head was covered by red ochre. The lack of ceramics combined with a state of health which was free of dietary stressors associated with farming is thought-provoking: was she born a hunter-

gatherer who turned farmer upon joining the Vedrovice community? Her liminal identity is symbolised by the exclusion of ceramics: ceramics being the most standard in the range of grave goods typical for a Vedrovice female.

These individuals highlight the fact that there is evidence at Vedrovice, a community that existed at the earlier part of the LBK cultural development, to suggest that ca. 10% of the population were immigrants to a community that was indigenous to the region. As the origin, emergence, and dispersal of this cultural tradition have been much debated subjects in the archaeology of the Neolithic and in reconstructions of events that led to the formation of Neolithic Europe, the insights afforded by a multidisciplinary approach to the study of the settlement and cemetery sites at Vedrovice have proven invaluable. In the Conclusions section we consider the significance of the data we have generated.

Conclusions

For some time now the LBK has been viewed as a classical case of demic diffusion, a migration of entire farming communities from Southeast Europe into Central Europe in the first instance; and then beyond into Western Europe and the North European plain (see Childe, 1925, 1957; Ammerman and Cavalli-Sforza, 1984; Ammerman and Biagi, 2003; Gkiasta et al., 2002; cf. Gronenborn, 2007; for a critique of this Anglo/American-centric position).

More recently the debate has shifted, with the proposal and discussion by various authors of alternative forms of the origin and dispersal of the LBK, involving a major genetic and cultural contribution to the formation of the LBK by local hunter-gatherer communities of the Mesolithic (e.g. Tillmann, 1993; Gronenborn, 1999, 2003, 2007; Zvelebil, 2000b, 2004, 2005; Lukes and Zvelebil, 2004; Whittle, 1996). The fact that the question has not been resolved through the consideration of LBK groups at the community or population level has obscured the fine detail of socio-cultural interactions at this pivotal time in the formation of Neolithic Europe.

Summarizing the results of our bioarchaeological research at Vedrovice, we envisage a settlement of first farmers in southern Moravia that also served as a gateway community both in terms of incoming individuals and, we would like to argue, individuals leaving to begin other early farming communities. It is possible that Vedrovice was founded by a small community of incomers, founders who would probably have originated in western Hungary towards the end of the formative phase of the LBK (Phase 1a/1b) some time before 5300 BC.

Soon after Vedrovice was founded, it began attracting people from hunting-gathering communities within the region and outside it. It is at this point or shortly after, at around 5300 BC, that the Široká u Lesa cemetery was founded to serve the Vedrovice community, upslope from the settlement. The burial here of incomers who had been born elsewhere shows the increasingly cosmopolitan nature of the settlement, where women, in particular, seem to have joined the society from outside. Judging by their material cultural associations, and in one case by biochemical analysis, these immigrants seem for the most part to have come from the region of the Bohemian-Moravian uplands and from northeast Bohemia.

Vedrovice also served as a focal point of a far-flung contact network that facilitated the exchange of goods and information. This included regions located at a considerable distance from southern Moravia, notably southern Poland, northern Bohemia, western Hungary, and coastal south-eastern Europe. These connections are evident in the material culture, which utilized resources from those areas, such as the spondylus ornaments, southern Polish flint, Hungarian radiolarite, or schist/amphibolite from

northern Bohemia (Zvelebil and Pettitt, 2008). It is also made evident by the burial of "travellers" in the cemetery – people that had spent much of their adult life away from Vedrovice but ended up buried there – and in one case, by the presence of a man who was both born elsewhere and who had lived most of his adult life away from the settlement. In most cases, these people had gained high social status and were buried accordingly. The importance of these individuals in facilitating exchange of information and transmission of knowledge, as well as in contributing to the overall cultural coherence of the LBK tradition as a social phenomenon, cannot be overestimated.

Our research to date has, we believe, facilitated the development of a more holistic understanding of the meanings embedded in material culture, burial and social interactions at the start of the LBK. Our assessment of the ways in which memory and meaning are integral to the processes of cultural transmission, the intergenerational passage of knowledge and reception of information through contact during these formative stages of the LBK have expanded our understanding of the role that immigration, emigration and 'travelling' play in individual life histories. It is no longer acceptable to classify the LBK within a normative paradigm, for, as Zvelebil and Pettitt (2008) emphasize, "we ... now understand that archaeological cultures were the taphonomically sorted, observable end results of socially structured cultural transmission processes, and [the product] of their transformations through [both] individual and collective agency and routine practice".

Acknowledgements

The research discussed in this paper is the result of an international collaborative partnership between the following institutions: University of Sheffield; Anthropos Institute of the Moravské zemské Museum in Brno; researchers from the Czech Republic (Anthropos Institute and Charles University); Germany (Mainz University, Max Planck Institute for Evolutionary Anthropology, Leipzig) and the United Kingdom (Hull University, Bradford University, Oxford University). It was originally funded by a grant from the Arts and Humanities Research Council (B/RG/AN185/APN18452).

Annette Weiske and Stephanie Bösel are thanked for their assistance with the isotopic measurements.

References

Ammerman, A.J., Cavalli-Sforza, L.L., 1984. The Neolithic Transition and the Genetics of Population in Europe. University Press, Princeton.

Ammerman, A.J., Biagi P. (Eds.), 2003. The Widening Harvest. Archaeological Institute of America, Boston.

Bánffy, E., 2004. Advances in the research of the Neolithic transition in the Carpathian Basin, in: Lukes, A., Zvelebil M. (Eds.), LBK Dialogues: Studies in the Formation of the Linear Pottery Culture. British Archaeological Reports International Series 1304, Archaeopress, Oxford, pp. 49–70.

Barker, G., 1985. Prehistoric Farming in Europe. Cambridge University Press, Cambridge.

Barrett, J.C., 1994. Fragments from Antiquity: An Archaeology of Social Life in Britain 2900–1200 BC. Blackwell, Oxford.

Barrett, J.C., 1997. Stone age ideologies. Analecta praehistorica Leidensia 29, 121–129.

Bentley, R.A., Knipper, C., 2005. Geographical patterns in biologically available strontium, carbon and oxygen isotope signatures in Prehistoric SW Germany. Archaeometry 47 (3), 629–644.

Berkovec, T., 2003. Plastika na sídlišti kultury s lineární keramikou ve Vedrovicích (okr. Znojmo). Ročenka 2003, Archeologické centrum Olomouc, Olomouc, 46–62.

Berkovec, T., Veselá B., 2003–4. Pece na sídlišti kultury s lineární keramikou ve Vedrovicích. Sborník Prací Filosofické Fakulty Masarykovi Univerzity–Řada Archaeologická M8–9, 7–30.

Berkovec, T., Dreslerová, G., Nývlotova-Fišáková, M., Švédová J., 2004. Bone industry of the Linear Pottery Culture (LBK) at Vedrovice, Moravia, in: Lukes, A., Zvelebil, M. (Eds.), LBK Dialogues: Studies in the Formation of the Linear Pottery Culture. British Archaeological Reports International Series 1304, Archaeopress, Oxford, pp. 159–176.

Bourdieu, P., 1977. Outline of a Theory of Practice. University Press, Cambridge.

Bourdieu, P., 1990. The Logic of Practice. Polity Press, Cambridge.

Budd, P., Montgomery, J., Barreiro, B., Thomas, R.G., 2000. Differential diagenesis of strontium in archaeological human dental tissues. Applied Geochemistry 15 (5), 687–694.

Bush, H., Zvelebil, M. (Eds.), 1991. Health in Past Societies: Biocultural Interpretations of Human Skeletal Remains in Archaeological Contexts. British Archaeological Reports, International Series 567. Tempus Reparatum, Oxford.

Cavalli-Sforza, L.L., Cavalli-Sforza, F., 1995. The Great Human Diasporas: The History of Diversity and Evolution. Addison-Wesley, New York.

Chapman, J., 1994. The origins of farming in South East Europe. Prehistoire Européenne 6, 133–156.

Childe, V.G., 1957. The Dawn of European Civilisation. 6th ed. Routledge and Kegan Paul, London.

Čižmář, Z. 2002. Keramika z pohřebiště Široká u Lesa, in: Podborský, V. (Ed.) Dvě pohřebiště neolitického lidu s lineární keramikou ve Vedrovicích na Moravě. Ústav Archeologie a Muzeologie Filozofické Fakulty Masarykovy Univerzity, Brno, pp. 151–190.

Copeland, S.R., Sponheimer, M., Lee-Thorpe, J.A., Le Roux, P.J., Grimes, V., De Ruiter, D.J., Richards, M.P., 2008. Strontium isotope ratios (87Sr/86Sr) of tooth enamel: A comparison of solution and laser ablation MCICPMS methods. Rapid Communications in Mass Spectrometry 22 (3), 187–194.

Crubézy, E., Murail, P., Bruzek, J., Jelinek, J., Ondruš, J., Pavuk, J., Teschler-Nicola, M., 1997. Sample characterisation of Danubian cemeteries in central Europe: the examples of Vedrovice (Moravia) and Nitra-Horne Krskany (Slovakia), in: Le Néolithique danubien est ses marges entre rhin et seine. Actes du 22e colloque interrégional sur le Néolithique. Cahiers de l'Association pour la Promotion de la Recherche Archéologique en Alsace, pp. 9–15.

Dennell, R. 1983. European Economic Prehistory. Academic Press, London.

Dobres, M.A., Robb, J.E., 2000. Agency in archaeology: paradigm or platitude, in: Dobres, M.A., Robb, J.E. (Eds.) Agency in Archaeology. Routledge, London, pp. 3–17.

Dočkalová, M., Čižmář, Z., 2008. Neolithic settlement burials of adult and juvenile individuals in Moravia, Czech Republic. Anthropologie 46 (1), 29–68.

Eriksson, G. (Ed.), 2003. Norm and Difference. Stone Age dietary practice in the Baltic Region. Archaeological Research Laboratory, Stockholm.

Evans, J.A., Tatham, S., 2004. Defining "local signature" in terms of Sr isotope composition using a tenth–twelfth century Anglo-Saxon population living on a Jurassic clay-carbonate terrain, Rutland, UK, in. Pye, K., Croft, D.J. (Eds.), Forensic Geoscience: Principles, Techniques and Applications. Geological Society of London Special Publication, London, pp. 237–248.

Gallet, S., Jahn, B.M., Lanoe, B.V., Dia, A., Rossello, E., 1998. Loess geochemistry and its implications for particle origin and composition of the upper continental crust. Earth and Planetary Science Letters 156 (3–4), 157–172.

Giblin, J., 2005. Strontium isotope and trace element analysis of Copper Age human skeletal material from the Great Hungarian Plain. PhD dissertation. Florida State University.

Giddens, A., 1979. Central Problems in Social Theory: Action, Structure and Contradiction in Social Analysis. Macmillan, London.

Giddens, A., 1984. The Constitution of Society: Outline of the Theory of Structuration. Polity Press, Cambridge.

Gkiasta, M., Russel, T., Shennan, S., Steele, J., 2002. Neolithic transition in Europe: the radiocarbon record revisited. Antiquity 77 (295), 45–62.

Gronenborn, D., 1999. A variation on a basic theme: the transition to farming in southern Central Europe. Journal of World Prehistory 13 (2), 123–209.

Gronenborn, D., 2003. Migration, acculturation, and culture change in western temperate Eurasia, 6500–5000 cal BC. Documenta praehistorica 30, 79–91.

Gronenborn, D., 2004. Comparing contact-period archaeologies: the expansion of farming and pastoralist societies to continental temperate Europe and to southern Africa. Before Farming [Online Version] 2004 (4), Article 3, 1–35.

Gronenborn, D., 2007. Beyond the models: "Neolithisation" in Central Europe. Proceedings of the British Academy 144, 73–98.

Hodder, I., 1992. Theory and Practice in Archaeology. Routledge, London.

Hodder, I., 2000. Agency and individuals in long-term processes, in: Dobres, M.A., Robb, J.E. (Eds.), Agency in Archaeology. Routledge, London, pp. 21–33.

Hoppe, K.A., Koch, P.L., Furutani, T.T., 2003. Assessing the preservation of biogenic strontium in fossil bones and tooth enamel. International Journal of Osteoarchaeology 13, 20–28.

Humpolová, A., 2001. Rondeloid číslo III lidu s Moravskou malovanou keramikou ve Vedrovicích, in: Podborský, V. (Ed.), 50 let archeologických výzkumů Masarykovy univerzity na Znojemsku. Ústav archeologie a muzeologie filosofická fakulta Masarykovy univerzity, Brno, pp. 157–166.

Humpolová, A., Ondruš, V., 1999. Vedrovice, okres Znojmo, in: Podborský, V. (Ed.) Pravěká sociokulturní architektura na Moravě. Ústav archeologie a muzeologie filosofická fakulta Masarykovy univerzity, Brno, pp. 167–219.

Larsen, C.S., 1997. Bioarchaeology: Interpreting Behavior from the Human Skeleton. University Press, Cambridge.

Lillie, M.C., 2008. Vedrovice: demography and palaeopathology in an early farming population. Anthropologie XLVI (1–2), 135–152.

Lukes, A., 2004. Social perspectives on the constitution of the Linear pottery culture (LBK), in: Lukes, A., Zvelebil, M. (Eds.), LBK Dialogues: Studies in the Formation of the Linear Pottery Culture. British Archaeological Reports International Series 1304, Archaeopress, Oxford, pp. 17–33.

Lukes, A., 2006. The Constitution of the Czech LBK Culture: A Social Perspective. PhD thesis, University of Sheffield, Sheffield.

Lukes, A., Zvelebil, M. (Eds.), 2004. LBK Dialogues: Studies in the Formation of the Linear Pottery Culture. British Archaeological Reports International Series 1304, Archaeopress, Oxford.

Lukes, A., Zvelebil, M., 2006. Inter-generational transmission of culture and LBK origins, some indications from eastern-central Europe, in: Bailey, D., Whittle, A., Hofmann, D. (Eds.), Living Well Together? Settlement and Materiality in the Neolithic of South-East and Central Europe. Oxbow Books, Oxford, pp. 139–150.

Lukes, A., Zvelebil, M., Petitt, P., 2008. Biological and cultural identity of the first farmers: Introduction to the Vedrovice Bioarchaeology Project. Anthropologie XLVI (1–2), 117–124.

Lüning, J., 1988. Frühe Bauern in Mitteleuropa im 6. und 5. Jahrtausend v. Chr. Jahrbuch des Römisch-Germanischen Zentralmuseums 35 (1), 27–93.

Mateiciucová, I., 2004. Mesolithic traditions and the origin of the Linear pottery culture (LBK), in: Lukes, A., Zvelebil, M. (Eds.), LBK Dialogues. Studies in the Formation of the Linear Pottery Culture. British Archaeological Reports International Series 1304, Archaeopress, Oxford, pp. 91–107.

McArthur, J.M., Howarth, R.J., Bailey, T.R., 2001. Strontium isotope stratigraphy: LOWESS version 3: best fit to the marine Sr-isotope curve for 0–509 Ma and accompanying look-up table for deriving numerical age. Journal of Geology 109 (2), 155–170.

Meiklejohn, C., Zvelebil, M., 1991. Health status of European populations at the agricultural transition and the implications for the adoption of farming, in: Bush, H., Zvelebil, M. (Eds.), Health in Past Societies: Biocultural Interpretations of Human Skeletal Remains in Archaeological Contexts. British Archaeological Reports (International Series) 567, Tempus Reparatum, Oxford, pp. 129–145.

Modderman, P.J.R., 1988. The Linear Pottery culture: diversity in uniformity. Berichten van de rijksdienst voor het outheidkundig bodemonderzoek 38, 63–139.

Montgomery, J., 2002. Lead and strontium isotope compositions of human dental tissues as an indicator of ancient exposure and population dynamics. PhD dissertation, University of Bradford.

Montgomery, J., Evans, J.A., Powlesland, D. and Roberts, C.A., 2005. Continuity or colonization in Anglo-Saxon England? Isotope evidence for mobility, subsistence practice, and status at West Heslerton. American Journal of Physical Anthropology 126 (2):123–138.

Montgomery, J., Evans, J.A., Cooper. R.E., 2007. Resolving archaeological populations with Sr-isotope mixing models. Applied Geochemistry 22 (7), 1502–1514.

Ondruš, V., 2002. Dvě pohřebiště Lidu s Neolitickou lineární keramikou ve Vedrovicích, in: Podborský, V. (Ed.), Dvě pohřebiště Neolitického lidu s lineární keramikou ve Vedrovicích na Moravě. Ústav archeologie a muzeologie filosofická fakulta Masarykovy univerzity, Brno, pp. 9–122.

Pavlů, I., 2005. Neolitizace Evropy. Archeologické rozhledy 57, 293–302.

Pettitt, P., Hedges, R.E.M., 2008. The age of the Vedrovice cemetery: the AMS radiocarbon dating programme. Anthropologie XLVI (2–3), 125–34.

Piggott, S., 1965. Ancient Europe. Edinburgh University Press, Edinburgh.

Pluciennik, M., 1998. Deconstructing 'the Neolithic' in the Mesolithic-Neolithic transition, in: Edmonds, M.R., Richards, C. (Eds.), Understanding the Neolithic of North-Western Europe. Routledge, London, pp. 61–83.

Podborský, V. (Ed.), 1993. Pravěké dějiny Moravy. Muzejní a Vlastivědná Společnost v Brně, Brno.

Podborský, V. (Ed.), 2002. Dvě pohřebiště Neolitického lidu s lineární keramikou ve Vedrovicích na Moravě. Ústav archeologie a muzeologie filosofické fakulty Masarykovy univerzity, Brno.

Price, T.D., 1987. The Mesolithic in Western Europe. Journal of World Prehistory 1, 225–332.

Price, T.D., 2000. Europe's first farmers: an introduction, in: Price, T.D. (Ed.), Europe's First Farmers. University Press, Cambridge, pp. 1–18.

Price, T.D., Bentley, R.A., Lüning, J., Gronenborn, D., Wahl, J., 2001. Prehistoric human migration in the Linearbandkeramik of Central Europe. Antiquity 75 (289), 593–603.

Price, T.D., Burton, J.H., Bentley, R.A., 2002. The characterization of biologically available strontium isotope ratios for the study of prehistoric migration. Archaeometry 44 (1), 117–135.

Price, T.D., Knipper, C., Grupe, G., Smrčka, V., 2004. Strontium isotopes and prehistoric human migration: the Bell Beaker Period in Central Europe. European Journal of Archaeology 7 (1), 9–40.

Prohaska, T., Latkoczy, C., Schultheir, G., Teschler-Nicola, M., Stingeder, G., 2002. Investigation of Sr isotope ratios in prehistoric human bones and teeth using laser ablation ICP–MS after Rb/Sr separation. Journal of Analytical Atomic Spectrometry 17 (8), 887–891.

Renfrew, C., 1996. Prehistory and identity of Europe, or don't let's be beastly to the Hungarians, in: Graves-Brown, P. Jones, S., Gamble, C. (Eds.), Identity and Archaeology. The Construction of European Communities. Routledge, London.

Richards, M.P., Fuller, B.F., Hedges, R.E.M., 2001. Sulphur isotopic variation in ancient bone collagen from Europe: Implications for human palaeodiet, residence mobility, and modern pollutant studies. Earth and Planetary Science Letters 191, 185–190.

Richards, M.P., Fuller, B.T., Sponheimer, M., Robinson, T., Ayliffe, L., 2003. Sulphur isotope measurements in archaeological samples: some methodological considerations. International Journal of Osteoarchaeology 13, 37–45.

Richards, M.P., Montgomery, J., Nehlich, O., Grimes, V., 2008. Isotopic analysis of humans and animals from Vedrovice. Anthropologie XLVI (1–2), 185–194.

Rulf, J., 1995. Provinces, regions and sub-regions: the Labe/Elbe group of Linear Pottery Culture example, in: Kuna, M., Venclová, N. (Eds.), Whither Archaeology? Papers in Honour of Evžen Neustupný. Institute of Archaeology, Prague, pp. 299–312.

Rulf, J., 1997. Die Elbe-Provinz der Linearbandkeramik. Památky archeologické, supplementum 9. Archeologický Ústav, Prague.

Schutkowski, H., 2002. Mines, meals and movement: a human ecological approach to the interface of 'history and biology', in: Smith, M. (Ed.), Human Biology and History. Society for the Study of Human Biology Series 42. Taylor and Francis, London, pp. 195–202.

Shanks, M., Tilley, C., 1992. Re-Constructing Archaeology: Theory and Practice. 2nd ed. Routledge, London.

Smrčka, V., Bůzek, F., Erban, V., Berkovec, T., Dočkalová, M., Neumanová, K., Fišáková, M.N., 2005. Carbon, nitrogen and strontium isotopes in the set of skeletons from the Neolithic settlement at Vedrovice (Czech Republic). Anthropologie (Brno) XLIII (2–3), 315–323.

Smrčka, V., Mihaljevič, M., Zocová, J., Šebek, O., Humpolova, A., Berkovec, T., Dočkalová, M., 2008. Trace-elemental analysis of skeletal remains of humans and animals at the Neolithic settlement in Vedrovice (Czech Republic). Anthropologie (Brno) XLVI (2–3), 219–226.

Svoboda, J. (Ed.), 2003. Mezolit Severních Čech. Brno.

Tilley, C., 1994. A Phenomenology of Landscape: Places, Paths and Monuments. Berg, Oxford.

Tillmann, A., 1993. Kontinuität oder Diskontinuität? Zur Frage einer bandkeramischen Landnahme im südlichen Mittleleuropa. Archäologische Informationen 16 (2), 157–187.

Trickett, M.A., Budd, P., Montgomery, J., Evans, J., 2003. An assessment of solubility profiling as a decontamination procedure for the Sr-87/Sr-86 analysis of archaeological human skeletal tissue. Applied Geochemistry 18 (5), 653–658.

Van Andel, T.H., Runnels, C.N., 1995. The earliest farmers in Europe. Antiquity 69, 481–500.

Vencl, S., 1986. The role of hunting-gathering populations in the transition to farming: a central European perspective, in: Zvelebil, M. (Ed.), Hunters in Transition: Mesolithic Societies of Temperate Eurasia and their Transition to Farming. University Press, Cambridge. pp. 43–52.

Vencl, S., Fridrich, J., 2007. Archeologie Pravěkých Čech 2. Paleolit a Mezolit. Archeologický ústav AVCR, Prague.

Whittle, A., 1996. Europe in the Neolithic: The Creation of New Worlds. University Press, Cambridge.

Zvelebil, M. (Ed.), 1986. Hunters in Transition: Mesolithic Societies of Temperate Eurasia and Their Transition to Farming. University Press, Cambridge.

Zvelebil, M., 1995. Neolithisation in eastern Europe: a view from the frontier. Poročilo o raziskovanju paleolitika, neolitika in eneolitika v Sloveniji 22, 107–150.

Zvelebil, M., 1996. The agricultural frontier and the transition to farming in the circum-Baltic region, in:

Harris, D. (Ed.), The Origins and Spread of Agriculture and Pastoralism in Eurasia. University College London Press, London, pp. 323–345.

Zvelebil, M., 2000a. Les derniers chasseurs-collecteurs d'Europe tempérée, in: Les derniers chasseurs-cuilleurs d'Europe occidentale (13000–5500 av. J.-C.), Actes du colloque international de Besançon, octobre 1998. Presses Universitaires Franc-Comtoises, Besançon, pp. 379–406.

Zvelebil, M., 2000b. The social context of the agricultural transition in Europe, in: Renfrew, C., Boyle, K. (Eds.), Archaeogenetics: DNA and the population prehistory of Europe. McDonald Institute Monographs, Cambridge, pp. 57–79.

Zvelebil, M., 2004. Who were we 6000 years ago? In search of prehistoric identities, in: Jones, M. (Ed.), The Traces of Ancestry: Studies in Honour of Colin Renfrew. McDonald Institute Monographs, Cambridge, pp. 41–60.

Zvelebil, M., 2005. Homo habitus: agency, structure and the transformation of tradition in the constitution of the TRB foraging-farming communities in the North European plain (ca. 4500–2000 BC). Documenta Praehistorica XXXII, 87–101.

Zvelebil, M., Pettitt, P., 2008. Human condition, life, and death at an early Neolithic settlement: bioarchaeological analyses of the Vedrovice cemetery and their biosocial implications for the spread of agriculture in Central Europe. Anthropologie (Brno) XLVI (2–3), 195–218.

Zvelebil, M., Lukes, A., Pettitt, P., 2010. The emergence of the LBK culture: Search for the ancestors. in: Gronenborn, D., Petrasch, J. (Eds.), Die Neolithisierung Mitteleuropas [The Spread of the Neolithic to Central Europe]. Verlag des Römisch-Germanischen Zentralmuseums, Mainz, pp. 301–326.

Rouven Turck[a,*], Bernd Kober[b], Johanna Kontny[b], Fabian Haack[c], Andrea Zeeb-Lanz[c,+]

"Widely travelled people" at Herxheim? Sr isotopes as indicators of mobility

* Corresponding author: rouven.turck@geow.uni-heidelberg.de
a Institut für Ur- und Frühgeschichte und Vorderasiatische Archäologie, Ruprecht-Karls-Universität Heidelberg
b Institut für Geowissenschaften, Ruprechts-Karls-Universität Heidelberg
c Generaldirektion Kulturelles Erbe Rheinland-Pfalz, Direktion Landesarchäologie, Außenstelle Speyer
+ Translation

Abstract

This paper presents the strontium (Sr) isotope composition of the teeth of Neolithic individuals from the Linearbandkeramik (LBK) pit-enclosure of Herxheim (South Palatinate, Germany). The Sr isotope analyses are vital for the comprehension of the extraordinary site of Herxheim with the abundant human bone modifications found there. The large number of dead individuals, as well as the various exotic styles of high quality pottery of the latest LBK phase, found with the fragmented human skeletons, support movement from foreign places to Herxheim. Sr isotopes of tooth enamel have been analyzed to establish the possible origins of the individuals at Herxheim. Initial results for individuals found in the regular Bandkeramik burial position and for samples from a concentration of fragmented skeletons indicate the presence of a significant amount of nonlocal individuals, in a proportion higher than reported for other LBK settlements to date. None of the modified skeletal remains from the site investigated thus far belong to indigenous individuals. The observed Sr isotope ratios often indicate basement rock signatures. A subgroup of individuals has high $^{87}Sr/^{86}Sr$ ratios of 0.712–0.715, suggesting similarities to a group of five juveniles found in the Neolithic settlement of Nieder-Mörlen/Hesse.

Keywords

Linearbandkeramik, Sr isotopes, ritual, cannibalism

Sr isotopes for LBK settlements in SW-Germany

Sr isotopes have been used for analysing prehistoric movement strategies for Central European communities since the 1990s (Price et al., 1994; Grupe et al., 1997). In the last ten years a number of LBK sites from south-western Germany have been the subject of isotopic research: Flomborn, Schwetzingen (Price et al., 2001), Talheim (Price et al., 2006), Stuttgart-Mühlhausen (Price et al., 2003), Dillingen (Bentley et al., 2002), Vaihingen (Bentley et al,. 2003) and Nieder-Mörlen (Nehlich et al., 2009) (Fig. 1). Another LBK project of Sr sampling is still in progress (Bickle and Hofmann, 2007). These sites belong to different phases of the Bandkeramik culture. Samples have been taken from inhumation burials in cemeteries, settlement burials and from the mass grave of Talheim to analyse movement strategies and social relations of early farmers in Central Europe (e. g. Bentley, 2007; Price and Bentley, 2005). Herxheim can be related to and discussed in the framework of all these well-known LBK settlements.

Fig. 1 | Bandkeramik sites with Sr isotope analyses in Southwest Germany. 1 Flomborn; 2 Schwetzingen; 3 Talheim; 4 Vaihingen; 5 Stuttgart-Mühlhausen; 6 Dillingen; 7 Nieder-Mörlen; 8 Herxheim (GDKE Rheinland-Pfalz, Direktion Landesarchäologie, Außenstelle Speyer)

Overview: features and findings of Herxheim[1]

The site of Herxheim represents an early Neolithic settlement, inhabited from the older Bandkeramik (Flomborn-phase, ca. 5300 BC) up to the end of the culture in Central Europe (ca. 4950 BC). The village was surrounded by an earthwork of two parallel structures which consist of many overlapping oblong pits (Fig. 2). The pits were obviously rather quickly refilled and new pits, cutting the filled ones, were dug continuously (Schmidt, 2004; Haack, 2009). This type of "pseudo-ditch" is called the "Rosheim type" (Jeunesse and Lefranc, 1999). Many of the overlapping pits of the Herxheim enclosure revealed spectacular concentrations of dissected human skeletons, the bones having been smashed into small frag-

[1] Since 2004 the site is examined in the framework of a project funded by the Deutsche Forschungsgemeinschaft (DFG). The project members constitute an international team of specialists: Andrea Zeeb-Lanz (project director), Bruno Boulestin, Anne-Sophie Coupey, Silja Bauer (anthropology), Christian Jeunesse, Anthony Denaire (pottery analyses), Fabian Haack (feature analyses, bone artefacts), Rose-Marie Arbogast (archaeozoology), Dirk Schimmelpfennig (stone artefacts), Rouven Turck (isotope analyses), Nicole Boenke (archaeobotany) and Samuel van Willigen (correspondence analyses of pottery).

Fig. 2 | Herxheim. Plan of the pit enclosure and the excavated settlement areas with designation of the sampled teeth from Concentrations 2 and 3 (black ellipse) as well as the two "Hocker" burials in their concentrations which were sampled also (black dots) (GDKE Rheinland-Pfalz, Direktion Landesarchäologie, Außenstelle Speyer)

ments (Zeeb-Lanz et al., 2007; Boulestin et al., 2009; Zeeb-Lanz et al., 2009). The skulls of the dead had been subjected to a specific treatment that left only the skull caps intact. In addition to these manipulated human remains, the concentrations contained quite a lot of high-quality pottery with elaborate decoration (Zeeb-Lanz et al., 2006; Jeunesse et al., 2009) from the last phase of the Bandkeramik culture. The pots had obviously also been intentionally smashed before being deposited in the pits (Denaire, 2009). Furthermore the concentrations revealed partly destroyed stone tools, crushed grinding stones and a variety of animal bones, animal bone tools and jewellery made from shells and snails, as well as animal and human teeth (Arbogast, 2009; Zeeb-Lanz et al., 2007).

These extraordinary concentrations, comprising the battered remains of hundreds of human individuals, have given rise to much speculation and various hypotheses about their origin. The violent destruction was initially interpreted as an indicator of mass murder and warfare at the end of the LBK culture (e.g. Spatz, 1998; Golitko and Keeley, 2007). An economically critical situation, resulting from

climate aggravation, hunger and diseases, was discussed as a possible reason for such a crisis. Initial examinations of diet and bones at Herxheim (Dürrwächter et al., 2003, 2006; Haidle and Orschiedt, 2001; Orschiedt and Haidle, 2009) disproved these ideas: there were no indicators of hunger, diseases and malnutrition or regular injuries of violence leading to death detected. The concentrations in the double pit enclosure of Herxheim are associated with a previously unknown extraordinary and violent ritual. It is possible that that ritual was triggered by a specific form of socio-cultural crisis which might perhaps be described as a "crisis of mind" (Zeeb-Lanz, 2009). The manipulation of the human bones attests to a systematic dismemberment of the bodies in a fresh state. This standardized treatment has recently been interpreted as an indicator of a special form of cannibalism integrated into the mysterious rituals (Boulestin et al., 2009); a specific ceremony including the strict dissociation of the perishable and nonperishable parts of the dead bodies has also been considered (Zeeb-Lanz et al., 2009).

Altogether, the remains of about 500 or even more individuals have been excavated. This extremely high number of dead individuals contrasts with the situation in normal LBK burial grounds (Nieszery, 1995). The estimate is based on the number of skulls, skull caps or fragments of skull. Various studies (c.f., Lüning, 1991) have shown that such an extraordinary number of people cannot have lived at the site in the small span of 50 years estimated from the dating of the pottery.

In addition to the human bones, the pottery deserves special attention. All the decorated ceramic from the concentrations dates to the final phase of the LBK – but it is unlikely that all of the vases come from the site itself or the vicinity (Zeeb-Lanz et al., 2006). The vessels exhibit eight different regional styles of decoration, e.g. the Rhine-Main hatching style, some from as far away as the Elbe valley (Šarka style) or the Elster-Saale region (Houbre, 2007). Recent attempts to fit together fragments of pots found in the same pit or from different concentrations (Denaire, 2009) revealed that the pottery was destroyed on site, probably as part of the supposed ritual. In some cases, sherds which could successfully be refitted were found in concentrations that lay rather far apart (up to 120 m).

The range of decorative styles hints at origins of the pottery in quite a lot of different regions north and east of Herxheim.

Some years ago, investigations of stable isotopes (C, N) of bone material from the pit enclosure at Herxheim were carried out by C. Dürrwächter and colleagues (2003, 2006), who were investigating diets. Those authors discussed the origin of the Herxheim individuals in the context of migration from distant places (Dürrwächter et al., 2003; Dürrwächter et al., 2006).

Basically N and C isotopes do not directly pertain to mobility but instead shed light on dietary variation. But in the case of Herxheim it might be possible that the varying N isotope ratios reflect differences in nutrition due to the derivation of deposited individual from varying macroregions. Thus the data might be seen as indirectly pointing to people originating in different regions.

There are several arguments for the origin of quite a number of the Herxheim individuals in foreign places:

1. At least 500 individuals were deposited in the concentrations of the pit enclosure within a rather short time span.

2. The area of the settlement is not large enough to have housed hundreds of people in the short time span of about 50 years (latest phase of the LBK; the pottery in the concentrations dates the events leading to the concentrations to this phase).

3. The associated pottery exhibits decorations in many regional styles, some of which clearly derive from distant geographical areas.

4. Some of the measured nitrogen-isotope ratios may not be compatible with indigenous diets.

The suggested migration of so many Neolithic individuals to Herxheim leaves the question of their specific places of origin open. The use of Sr isotopes represents a promising approach to set limits on the range of possible geographical districts involved. Sr isotope ratios of the skeletal remains may help to provide evidence of the presence of strangers in Herxheim; it can tell us whether local people were also deposited in the pit system, and it may help to identify different places of origin among the individuals studied.

A small number of regular Bandkeramik graves in the settlement area inside the pit enclosure which follow the usual pattern of LBK inhumation burials have been documented (Orschiedt, 1998). In those cases, the dead were placed in rectangular grave pits in a crouched position, the legs flexed – the so-called "Hocker" burial (Fig. 3). In a few cases, pits dug into the sides of some of the enclosure features revealed additional regular inhumation burials. A small number of skeletons in different concentrations of the pit enclosure constitute torsi, still showing vertebrae of the spinal column in articulation and connected to the skull. In other cases parts of the spinal column are still in the anatomical position and linked to the pelvis. Whole extremities like arms with hands or legs with feet exist as well. There are also various states of bone preservation represented in the concentrations. Some concentrations revealed "nests" of skulls, others consisted of mostly unbroken long bones, but the predominant picture is that of massively fragmented bone material. Jawbones and their fragments are relevant for Sr investigations, as tooth enamel is needed for the isotope analyses.

It must be emphasized that overall the features in the pit enclosure present a consistent picture. Human bones, as well as artefacts like pottery and stone tools, were systematically destroyed and deposited in the enclosure. But neither the amounts of bones and artefacts and their distribution nor the size of the concentrations follow a discernible pattern with respect to associations of finds. Moreover, the degree of destruction of the human bones varies markedly (Zeeb-Lanz et al., 2007). In the face of the above mentioned facts, two concentrations which have already been published (Zeeb-Lanz et al., 2007) were chosen for this paper. They act as representatives for the much larger number of sampled individuals from the site. They provide a representative cross-section with respect to the finds and exhibit good preservation of the tooth material.

The archaeological features

A total of five individuals could be sampled from the human remains in two concentrations, from the excavations in 1996–1998 (Fig. 4). An additional individual (HXM 14) cannot definitely be assigned to a specific concentration. Two of the samples presented in this paper were taken from the only two intact skeletons in flexed position which can, due to their association with pottery sherds, skull caps and battered human bones, chronologically be connected to the "concentration horizon". Two recent radiocarbon dates from these skeletons (Zürich ETH-39377: 5220–4930 cal BC; Florida Beta-265223: 5220–5000 cal BC) confirm this assumption. The remainder of bone material of the concentrations to which these skeletons can be linked has not yet been analyzed in detail.

Concentrations 2 and 3, which provide most of the isotope ratios discussed here, lie in the southern part of the inner pit ring and have already been published in detail (Zeeb-Lanz et al., 2007; Haack, 2009). Concentration 2 lies approximately 0.20 m above the base of a long pit, containing the remains of at least four individuals. Among these are the mandible of an adult and the fragmented lower jaw of a child, both of which could be used for sampling (HXM 16, HXM 17). In the concen-

Fig. 3 | Complete skeleton in flexed position ("Hocker") in a concentration (Sample HXM 39) GDKE Rheinland-Pfalz, Direktion Landesarchäologie, Außenstelle Speyer

Fig. 4 | Graphic rendering of the main level of the find situation in Concentrations 2 and 3 (after Zeeb-Lanz et al., 2007)

tration, which lies in a conglomeration of soil reaching a thickness of up to 0,25 m, some articulated human remains are also present, including the bones of a hand, a foot and the lower part of a spinal column attached to the pelvis. In general the skeleton parts appear to be less degraded in this concentration than in other areas of the pits, as a few larger segments of long bones and completely intact bones were excavated.

Also found in the concentration with the human remains were three small fragments of decorated pottery of indeterminate regional style, the larger part of a vase ornamented in the style of the Palatinate

and, especially conspicuous, two refittable fragments from the bottom of a pot ornamented in the Rhine-Moselle style (Fig. 5). In addition to these pottery sherds, Concentration 2 revealed six flint artefacts, two fragments of grinding stones and part of a bone tool. The mottled skull of a dog and piece of deer antler are further proof that the established pattern of the animal bones in the concentrations is not part of the normal butchery waste (Arbogast, 2009).

Concentration 3 is situated 0.40 m higher than Concentration 2 and runs further to the east; it is separated from Concentration 2 by a massive layer of charcoal. Seven human individuals could be identified in this concentration (Zeeb-Lanz et al., 2007), three of which provided teeth adequate for sampling (HXM 10, HXM 11, HXM 13). Fragments of skulls represent nearly half of all the human remains in this concentration and are thus explicitly overrepresented. Two skull caps, characteristic finds in the concentrations of Herxheim, are included in the human remains. In addition to two pottery sherds decorated in the Palatinate style and two undecorated fragments from storage pots, two pieces of a pot ornamented in the "Leihgestern" style, common in the Hessian region north of the Main, belong to the corpus of finds from Concentration 3 (Fig. 5).

Concentration 3 also featured a flint blade and two flint flakes, a grinding stone and a bone scraper. At least four cattle are represented by a small number of vertebrae, skull fragments and parts of a few long bones.

The two whole human skeletons were also found in concentrations in the inner pit ring (see Fig. 2). Sample HXM 39 was taken from the tooth of a human individual found lying on its back with extremely bent legs (Fig. 3). The skeleton lay along the long axis of the pit ring in an east–west direction, face to the north.

The second complete skeleton (HXM 40) was excavated around 50 m east of the first. The skeleton, likewise placed in the concentration in a flexed position, also followed the orientation of the pit enclosure. While similar in orientation to the individual from Concentration 2, with the head in the east, this skeleton lay on the other side, face to the south. Both of the skeletons represent men over 30 years of age at death.

Samples and methods

The samples discussed in this article were taken from dental enamel. It is generally accepted that dental enamel is the most reliable archive and best suited for the identification of bioavailable Sr components. The series of selected samples focuses on the first molars of various individuals. The first molar is developed during the early infancy. The composition of the enamel does not change during the lifetime of the individual, which means that the Sr isotope values of the first molars reflect the environments of the individuals during the first two years of their life (Knipper, 2004; Bentley, 2006). The differentiated analysis of the teeth led to the exclusion of some individuals as their teeth did not preserve any suitable enamel. The loss of tooth enamel due to chewing abrasion as well as to diagenetic phenomena after burial excluded further individuals from sampling. In the end only six of the ten fragmented jaws from the two concentrations could be analyzed (see Zeeb-Lanz et al., 2007).

Routine procedures were applied for Sr isotope analysis using thermal ion mass spectrometry (TIMS). To avoid the mixing of enamel with dentine, we used a new method of tooth cutting and drilling. This modified procedure of sample preparation yields high precision and accuracy of analysed Sr isotope ratios. More details of the procedures will be published shortly (Kober et. al., submitted paper).

Fig. 5 | Pottery from Concentration 2 (A) and Concentration 3 (B). 1, 4 local style of the Palatinate; 2 Rhone-Moselle-style; 3, 5 Style "Leihgestern". 1, 2 scale 1:3; 3–5 scale 1:2 (GDKE Rheinland-Pfalz, Direktion Landesarchäologie, Außenstelle Speyer; after Zeeb-Lanz et al., 2007)

Local loess from the site was analyzed in order to estimate the biologically available Sr isotope ratio (e.g. Bentley et al., 2004) in the Herxheim area. In addition, some animal teeth found in the pits were analysed. In addition to the animal teeth, human teeth were selected for analysis from places situated in the southern part of the enclosure. Some of the human teeth were sampled from isolated jaws, a few others from whole skeletons found in the normal crouched burial position, but integrated in concentrations with skull caps and smashed long bones.

First results of Sr data

The results from animal teeth indicate local $^{87}Sr/^{86}Sr$ ratios of about 0.7095 which are interpreted as the bioavailable Sr isotope ratio in the Neolithic Herxheim environment. The mean enamel $^{87}Sr/^{86}Sr$ value from animal teeth is 0.70953 ±0.00008 (1 σ). The local range is defined using the 95% confidence level

Fig. 6 | Plot of ^{87}Sr/^{86}Sr values of Herxheim individuals (GDKE Rheinland-Pfalz, Direktion Landesarchäologie, Außenstelle Speyer)

Table 1 | ^{87}Sr/^{86}Sr values from enamel samples of the first molar (M1) of the individuals from the Concentrations 2 and 3 from Herxheim and from two whole skeletons in flexed position in the upper level of two further concentrations (GDKE Rheinland-Pfalz, Direktion Landesarchäologie, Außenstelle Speyer & Institut für Geowissenschaften Universität Heidelberg [B. Kober, J. Kontny])

Sample	Jawbones	^{87}Sr/^{86}Sr ratio	Context	Age	Sex
HXM 10	Mandible	0.71493 (5)	Concentration 3	infans	?
HXM 11	Mandible	0.71283 (2)	Concentration 3	adult	?
HXM 13	Maxilla (fragment)	0.71126 (8)	Concentration 3	juvenile	?
HXM 14	Mandible (fragment)	0.71099 (7)	Concentration 2 or 3	infans	?
HXM 16	Mandible	0.71351 (9)	Concentration 2	adult	?
HXM 17	Mandible (fragment)	0.71156 (9)	Concentration 2	infans	?
HXM 39	Mandible	0.70944 (9)	Complete skeleton, Concentration	adult +30 years	male
HXM 40	Maxilla (fragment)	0.7092 (1)	Complete skeleton, Concentration	adult +30 years	male

(2σ): 0.70937 to 0.70969 (Fig. 6). These values are consistent with data from Schwetzingen and Flomborn though wider local ranges were determined (Price et al., 2001), and with a few single data collected by Bentley and Knipper (2005) in the vicinity of the Rhine Valley.

There is a systematic difference in the analyses between tooth samples from concentrations of skeletal remains which had been smashed and fragmented and tooth material from conventionally buried individuals. The tooth enamel from individuals with skeletal modifications yielded ^{87}Sr/^{86}Sr

values above 0.711 (Fig. 6; Table 1). Some of the samples even showed values of 0.7128 to 0.715. These high values indicate that the respective individuals must have passed their childhood and youth on geological contexts different from loess and lowland areas like the Rhine valley. Most of the data are compatible with highland areas and outcropping crystalline basement rocks (e. g. Aubert et al., 2002; Kober et al., 2007; Ufrecht and Hölzl 2006; Tichomirowa et al., 2010). Three measurements (HXM 10, 11, 16) yield significantly higher $^{87}Sr/^{86}Sr$ ratios than nearly all other published Sr data for Bandkeramik individuals (e.g. Price and Bentley, 2005). Lower $^{87}Sr/^{86}Sr$ ratios (HXM 13, 14 and 17) may also be compatible with Sr components released from Triassic sandstones. Taken as a whole, the rather high but variable Sr isotope ratios, all of them above the bioavailable Herxheim value of 0.71, indicate that these individuals migrated to Herxheim from distant places. However, further data are needed to identify the different groups among the migrants based on the Sr isotopes on a more detailed level.

Mountainous regions are so far not known as Bandkeramik settlement areas. This appears to be in contradiction to the observed high $^{87}Sr/^{86}Sr$ ratios of the teeth from the Bandkeramik individuals of Herxheim. However, recent studies (Valde-Nowak and Kienlin, 2002; Ramminger, 2006; Knipper et al., 2007) have indicated a possible LBK presence in these terrains. Further intensive surveys to monitor possible mountainous Bandkeramik sites are required. Our current knowledge about LBK settlements is that most of the villages lie on – or at least on the border of – areas with loess substrate. The idea of fields for agriculture situated far away from the settlements – and in totally different geographical areas – does not appear convincing at the present time (Lüning, 2000; Bogaard, 2004). A. Heier and colleagues (2009) have shown that carbonized grain Sr isotope analyses may have a high potential for the determination of the areas of agriculture and for the discussion as to whether the prehistoric settlements were supplied with local field crops or with grain from distant areas.

One might speculate that groups of LBK people (among them children and juveniles) left their lowland settlements seasonally, e.g. for pasture in mountainous regions (e. g., Bentley et al., 2004; Knipper, 2009). In the uplands, they would have ingested highland diets with basement-type isotope signatures and elevated $^{87}Sr/^{86}Sr$ ratios. This hypothesis has important implications; for example, long term transhumance would have had to include very young children and childbearing women, as the analyzed teeth derive from the earliest childhood of the sampled individuals.

It is an important fact that one individual (HXM 39), who was buried "regularly" in a "Hocker" position, revealed Sr data that is compatible with the Sr isotope composition we have identified as Herxheim local reference value (~ 0.7095). The second one (HXM 40) is also compatible with sediments of the Rhine Valley but probably not from Herxheim. However, this is not yet a database sufficient for the conclusion that the conventionally buried individuals in Herxheim were generally indigenous persons. But definitely the present set of available Sr isotope data supports the thesis that the individuals who migrated to Herxheim had different places of origin – and it suggests a systematic pattern: it seems that all individuals whose skeletons have been modified were nonlocals.

Various available Sr isotope data sets for LBK sites in southwest Germany (see above and Fig. 1) can be used to discuss the data from Herxheim. A direct comparison of cemeteries and settlement burials with the situation in Herxheim is difficult and has to be done with care, due to differences of local development and functions of the various places and their dating. However, from the available data in the literature it is evident that in nearly every investigated LBK settlement or cemetery there were some potentially nonlocal individuals with $^{87}Sr/^{86}Sr$ ratios elevated compared to the typical local Sr isotope compositions (e. g. review of Price and Bentley, 2005).

Consequently, the observation of Early Neolithic people with high mobility seems to be rather typical, especially for early LBK people (Bentley, 2007). Obviously these strangers were integrated into Bandkeramik communities and also buried in accordance with the local traditions. Herxheim definitely differs from other sampled sites insofar as here, nonlocals were the subject of violent ritual actions, possibly even cannibalism (Boulestin et al., 2009). High maximum $^{87}Sr/^{86}Sr$ ratios comparable to the ones at Herxheim (especially samples HXM 10, 11, 16) are reported for only one of the reference sites, Nieder-Mörlen in Hesse (Nehlich et al., 2009). Isotope studies in Central Europe have so far revealed only a small number of individuals with very high radiogenic data. Usually either an origin from mountainous areas is supposed or the diet of these individuals is interpreted as having had a specific relation to such regions (e. g. Schutkowski, 2002; Müller et al., 2003; Heyd et al., 2005; Price and Bentley, 2005; Schweissing, 2005; Haak et al., 2008). All other places show $^{87}Sr/^{86}Sr$ ratios between 0.7083 and 0.710, with only a few values in the range of 0.710–0.712. The observed range of $^{87}Sr/^{86}Sr$ values in Herxheim is markedly higher. The data sets of Nieder-Mörlen and Herxheim are unique among the rest of the Neolithic locations. Nieder-Mörlen dates from the older to the youngest phase of the LBK (e. g. Schade-Lindig 2002; Schade-Lindig 2003). The concentration of the maximum $^{87}Sr/^{86}Sr$ values from Herxheim verified to date, at about 0.7128–0.715, appears very similar to values for a subgroup of five Nieder-Mörlen individuals (Nehlich et al. 2009), buried in the settlement. It suggests that certain groups of individuals who lived during their childhood in areas with similar crystalline rock-type isotope signatures can be identified in both sites. These subgroups can be classified as nonindigenous individuals for both sites on the basis of their similar and rather well-defined homogeneous Sr isotope composition ($^{87}Sr/^{86}Sr$ ~ 0.714–0.715) and from archaeological arguments (Nehlich et al. 2009). Nehlich and colleagues report that all five members of this subgroup of Nieder-Mörlen were juveniles and children, meaning that they were far away from their original living space when they died in Nieder-Mörlen – none of them surviving to adulthood. Nehlich et al. discuss possible places of origin of these nonlocal adolescent individuals, proposing areas like the Bavarian Forest and the Black Forest (Bentley and Knipper, 2005; Schutkowski, 2002), as well as North and South Tyrol (Hoogewerff et al. 2001; Müller et al. 2003) where there are outcroppings rocks with Sr isotope ratios that match the human enamel Sr isotope compositions.

Nehlich and colleagues also discuss the possibility of transhumance for these juveniles. Following this hypothesis, even small children – presumably with their mothers – would have been taken to the mountains for herding. Naturally there is also the possibility that these children and adolescents came from mountainous regions (Taunus area?) to Nieder-Mörlen and died there (Nehlich et al., 2009). Whether they might have been slaves or war prisoners or whether friendly reasons were responsible for their residence in Nieder-Mörlen cannot be determined either by archaeological or from natural science methods. The individuals from Nieder-Mörlen were obviously integrated in the community as they were buried in the usual way for LBK people. Obviously, the possibility of certain groups of Bandkeramik people who lingered for longer periods in the mountains – or even had their domiciles there – during different phases of the LBK must be considered. Apparently these groups left few or no material traces. At least we can conclude from the available LBK isotope analyses that a higher proportion of younger people seem to have come from foreign, mountainous places to Bandkeramik settlements and died there.

For Herxheim, these implications raise the question whether the Neolithic migrants belonged to the LBK, to some other Neolithic/Mesolithic population or instead to LBK subgroups that have not yet been detected. The observed pottery styles suggest source areas which do not fit with the upland-type Sr

isotope signatures. These signatures cannot be attributed to the Sr isotope compositions that have been reported for various LBK settlements so far.

Conclusions

The first set of investigated teeth, collected from animal remains found in the enclosure and in settlement pits, were suitable to estimate the average Sr isotope composition of bioavailable strontium in the palaeoenvironment of Herxheim. This reference isotope composition agrees well with data reported for other Neolithic settlements in the Rhine valley. The currently available Sr isotope data are adequate to distinguish between remains of local and nonlocal individuals. Our first series of Sr isotope data shows a clear distinction between tooth material from individuals with modified skeletons from the concentrations of the pit enclosure and tooth material from conventionally buried individuals.

The Sr isotope composition of tooth enamel from two individuals who were buried in regular LBK fashion matches the local Herxheim composition and lowland areas well, although their skeletons were found in close vicinity to concentrations of fragmented human remains. All of those individuals investigated whose bones were fragmented could be identified as nonlocal persons. Their native places are characterised by sandstone or crystalline rock in upland areas. This rather large group of Early Neolithic people with clear associations with mountainous homelands is yet unknown for LBK times, with the exception of Nieder-Mörlen and a very few individuals from regular cemeteries. We suspect that during Early Neolithic times there may have been people who continuously have resided in mountainous areas – e.g. for herding or mining. In the majority of cases these people were not buried in the cemeteries or settlements that have been investigated thus far, or their skeletal remains were generally not preserved at their home areas for other reasons.

We have found significant variation of the enamel Sr isotope ratios, which we interpret as indicators of different native places of the dead who were deposited in the concentrations of Herxheim. This observation would seem to be compatible with the various latest LBK pottery styles documented at the location. On the other hand, the individuals represented by manipulated skeletal remains in the concentrations definitely grew up in highland areas. A mountainous origin, however, cannot be assumed as the source of the richly ornamented pottery found with the fragmented skeletons. In fact there is an obvious discrepancy between the Sr isotope values of the dead and the ornamented LBK pottery. At the moment it would seem that the manipulated dead are not connected to the ceramic finds in the concentrations. It will be necessary to consider the various possible explanations for these contradictions and followed them up during the further analysis of the site, its features and findings.

Prospects

It is essential that more data be collected – including data from stable isotopes – from a variety of geological formations, biologically available local strontium and different sites, in order to reach a point where widespread and reliable comparison can give us the chance to formulate more definite hypotheses concerning the origin of inhabitants of LBK settlements as well as those who are found in cemeteries of this culture.

Acknowledgements

The authors would like to thank the Deutsche Forschungsgemeinschaft (DFG) which has been sponsoring the scientific project of Herxheim since 2004. Thanks also to Rosemarie Arbogast who was so kind to provide the identification of the animal teeth. We would furthermore like to thank our colleagues Ludger Schulte (Speyer) and Joachim Fillauer (Heidelberg; both dental technicians) for technical support and essential assistance, as well as Silja Bauer (Speyer). Corina Knipper (Mainz) kindly pointed us to some references and was always open for discussion and support.

References

Arbogast, R.-M., 2009. Les vestiges de faune associés au site et structures d'enceinte du site rubané de Herxheim (Rhénanie-Palatinat, Allemagne), in: Zeeb-Lanz, A., (Ed.) Krisen – Kulturwandel – Kontinuitäten. Zum Ende der Bandkeramik in Mitteleuropa. Beiträge der internationalen Tagung in Herxheim bei Landau (Pfalz) vom 14.–17. 06. 2007. Internationale Archäologie: Arbeitsgemeinschaft, Tagung, Symposium, Kongress 10. Verlag Marie Leidorf, Rahden/Westfalen, pp. 53–60.

Aubert, D., Probst, A., Stille, P., Viville, D., 2002. Evidence of hydrological control of Sr behavior in stream water (Strengbach catchment, Vosges Mountains, France). Applied Geochemistry 17, 285–300.

Bentley, R. A., 2006. Strontium isotopes from the earth to the archaeological skeleton: a review. Journal of Archaeological Method and Theory 13, 2006, 135–187.

Bentley, R. A., 2007. Mobility, specialisation and community diversity in the Linearbandkeramik: isotopic evidence from the skeletons. Proceedings of the British Academy of Sciences 144, 117–140.

Bentley R., A., Knipper, C., 2005. Geographical patterns in biologically available strontium, carbon and oxygen isotope signatures in prehistoric SW Germany. Archaeometry 47, 629–644.

Bentley, R. A., Price, T. D., Lüning, J., Gronenborn, D., Wahl, J., Fullagar P. D., 2002. Prehistoric migration in Europe: strontium isotope analysis of early Neolithic skeletons. Current Anthropology 43, 799–804.

Bentley, R. A., Krause, R., Price, T. D., Kaufmann, B., 2003. Human mobility at the Early Neolithic settlement of Vaihingen, Germany: Evidence from strontium isotope analysis. Archaeometry 45, 471–486.

Bentley, R. A., Price, T. D., Stephan, E., 2004. Determining the 'local' $^{87}Sr/^{86}Sr$ range for archaeological skeletons: a case study from Neolithic Europe. Journal of Archaeological Science 31, 365–375.

Bickle, P., Hofmann, D., 2007. Moving on: The contribution of isotope studies to the early Neolithic of Central Europe. Antiquity 81, 1029–1041.

Bogaard, A., 2004. Neolithic Farming in Central Europe. An Archaeobotanical Study of Crop Husbandry Practices. Routledge, London.

Boulestin, B., Zeeb-Lanz, A., Jeunesse, Ch., Haack, F., Arbogast, R.-M., Denaire, A., 2009. Mass Cannibalism in the Linear Pottery culture at Herxheim (Palatinate, Germany). Antiquity 83, 968–982.

Denaire, A., 2009. Remontage de la céramique des fossés/Zusammensetzungen von Keramik in den Grubenringen, in: Zeeb-Lanz, A., (Ed.) Krisen – Kulturwandel – Kontinuitäten. Zum Ende der Bandkeramik in Mitteleuropa. Beiträge der internationalen Tagung in Herxheim bei Landau (Pfalz) vom 14–17.06.2007. Internationale Archäologie: Arbeitsgemeinschaft, Tagung, Symposium, Kongress 10. Verlag Marie Leidorf, Rahden/Westfalen, pp. 79–86.

Dürrwächter, C., Craig, O. E., Taylor, G., Collins, M. J., Burger, J., Alt, K. W., 2003. Rekonstruktion der Ernährungsweise in den mittel- und frühneolithischen Bevölkerungen von Trebur/Hessen und Herxheim/Pfalz anhand der Analyse stabiler Isotope. Bulletin der Schweizerischen Gesellschaft für Anthropologie 9 (2), 1–16.

Dürrwächter, C., Craig, O. E., Collins, M. J., Burger, J., Alt, K.W., 2006. Beyond the grave: variability in Neolithic diets in Southern Germany? Journal of Archaeological Science 33, 39–48.

Golitko, M., Keeley, L. H., 2007. Beating ploughshares back into swords: Warfare in the "Linearbandkeramik". Antiquity 81, 332–342.

Grupe G., Price, T. D., Schröter, P., Söllner, F., Johnson, C. M., Beard, B. L., 1997. Mobility of Bell Beaker people revealed by strontium isotope ratios of tooth and bone: a study of southern Bavarian skeletal remains. Applied Geochemistry, 12, 517–525.

Haack, F., 2009. Zur Komplexität der Verfüllungsprozesse der Grubenanlage von Herxheim: Zwei Konzentrationen aus Menschenknochen, Keramik, Tierkno-

chen und Steingeräten der Grabungen 2005 bis 2008, in: Zeeb-Lanz, A., (Ed.), Krisen – Kulturwandel – Kontinuitäten. Zum Ende der Bandkeramik in Mitteleuropa. Beiträge der internationalen Tagung in Herxheim bei Landau (Pfalz) vom 14.–17. 06. 2007. Internationale Archäologie: Arbeitsgemeinschaft, Tagung, Symposium, Kongress 10. Verlag Marie Leidorf, Rahden/Westfalen, pp. 27–40.

Haak, W., Brandt, G., de Jong, H. N., Meyer, Ch., Ganslmeier, R., Heyd, V., Hawkesworth, Ch., Pike A. W. G., Meller, H., Alt, K. W., 2008. Ancient DNA, Strontium isotopes, and osteological analysis shed light on social and kinship organization of the Later Stone Age. Proceedings of the National Academy of Sciences 105 (47), 18226–18231.

Haidle, M. N., Orschiedt, J., 2001. Das jüngstbandkeramische Grabenwerk von Herxheim, Kreis Südliche Weinstraße: Schauplatz einer Schlacht oder Bestattungsplatz: Anthropologische Ansätze. Archäologie in der Pfalz: Jahresbericht 2000, 147–153.

Heier, A., Evans, J. A., Montgomery, J., 2009. The potential of carbonized grain to preserve biogenic $^{87}Sr/^{86}Sr$ signatures within the burial environment. Archaeometry 51, 277–291.

Heyd, V., Winterholler, B., Böhm, K., Pernicka, E., 2005. Mobilität, Strontiumisotopie und Subsistenz in der süddeutschen Glockenbecherkultur. Bericht der Bayerischen Bodendenkmalpflege 43–44, 2002–2003, 109–135.

Hoogewerff, J., Papesch, W., Kralik, M., Berner, M., Vroon, P., Miesbauer, H., Gaber, O., Künzel, K.-H., Kleinjans, J., 2001, The last domicile of the Iceman from Hauslabjoch: a geochemical approach using Sr, C and O isotopes and trace element signatures. Journal of Archaeological Science 28, 983–989.

Houbre, A., 2007. La Céramique Rubanée de Herxheim (Palatinat, Allemagne). Unpubl. Mémoire de Maîtrise, Université Marc Bloch Strasbourg.

Jeunesse, Ch., Lefranc, P., 1999. Rosheim "Sainte-Odile" (Dep. Bas-Rhine), un habitat rubané avec fossé d'enceinte. Première partie: les structures et la céramique. Cahiers de l'Association pour la Promotion de la Recherche Archaeologique en Alsace 15, 1–111.

Jeunesse, Ch., Lefranc, P., van Willigen, S., 2009. Die Pfälzische Bandkeramik: Definition und Periodisierung einer neuen Regionalgruppe der Linearbandkeramik, in: Zeeb-Lanz, A. (Ed.), Krisen – Kulturwandel – Kontinuitäten. Zum Ende der Bandkeramik in Mitteleuropa. Beiträge der internationalen Tagung in Herxheim bei Landau (Pfalz) vom 14.–17. 06. 2007. Internationale Archäologie: Arbeitsgemeinschaft, Symposium, Tagung, Kongress 10. Verlag Marie Leidorf, Rahden/Westfalen, pp. 61–77.

Knipper, C., 2004. Die Strontiumisotopenanalyse: Eine naturwissenschaftliche Methode zur Erfassung von Mobilität in der Ur- und Frühgeschichte. Jahrbuch des Römisch-Germanischen Zentralmuseums 51 (2), 589–685.

Knipper, C., 2009. Mobility in a sedentary society: insights from isotope analysis of LBK human and animal teeth, in: Hofmann, D., Bickle, P. (Eds.), Creating Communities. New Advances in Central European Neolithic Research. Oxbow Books, Oxford, pp. 142–158.

Knipper, C., Fisher, L., Harris, S., Schreg, R., 2007. Jungsteinzeitliche Hornsteingewinnung in Blaubeuren-Asch "Borgerhau" im Kontext der neolithischen Siedlungslandschaft auf der Blaubeurer Alb, Alb-Donaukreis. Archäologische Ausgrabungen in Baden-Württemberg 2007, 36–41.

Kober, B., Schwalb, A., Schettler, G., Wessels, M., 2007. Constraints on paleowater dissolved loads and on catchment weathering over the past 16 ka from $^{87}Sr/^{86}Sr$ ratios and Ca/Mg/Sr chemistry of freshwater ostracode tests in sediments of Lake Constance, Central Europe. Chemical Geology 240, 361–376.

Kober, B., Kontny, J., Fillauer, J., Turck, R., Haack, F., Zeeb-Lanz, A., submitted paper. Micro-core sampling and the Sr isotope and trace multi-element analysis of pre-historic teeth: case study Early Neolithic site of Herxheim/SW-Germany. Open Journal of Archaeometry.

Lüning, J., 1991. Frühe Bauern in Mitteleuropa im 6. und 5. Jahrtausend v.Chr. Jahrbuch des Römisch-Germanischen Zentralmuseums 35, 27–93.

Lüning, J., 2000. Steinzeitliche Bauern in Deutschland. Die Landwirtschaft im Neolithikum. Universitätsforschungen Prähistorische Archäologie 58. Verlag Habelt, Bonn.

Müller, W., Fricke, H., Halliday, A. N., McCulloch M. T., Wartho, J.-A. 2003. Origin and migration of the Alpine Iceman. Science 302, 862–866.

Nehlich, O., Montgomery, J., Evans, J., Schade-Lindig, S., Pichler, S.L., Richards, M.P., Alt, K.W., 2009. Mobility or migration: a case study from the Neolithic settlement of Nieder-Mörlen (Hessen, Germany). Journal of Archaeological Science 36, 1791–1799.

Nieszery, N., 1995, Linearbandkeramische Gräberfelder in Bayern. Internationale Archäologie 16, Verlag Marie Leidorf, Espelkamp.

Orschiedt, J., 1998. Bandkeramische Siedlungsbestattungen in Sudwestdeutschland. Internationale Archäologie 43. Verlag Marie Leidorf, Rahden/Westfalen.

Orschiedt, J., Haidle, M. N., 2009. Die menschlichen Skelettreste von Herxheim, in: Zeeb-Lanz, A. (Ed.), Krisen – Kulturwandel – Kontinuitäten. Zum Ende der Bandkeramik in Mitteleuropa. Beiträge der inter-

nationalen Tagung in Herxheim bei Landau (Pfalz) vom 14.–17. 06. 2007. Internationale Archäologie. Arbeitsgemeinschaft, Tagung, Symposium, Kongress 10. Verlag Marie Leidorf, Rahden/Westfalen, pp. 41–52.

Price, T. D., Bentley, R. A., 2005. Human mobility in the Linearbandkeramik: An archaeometric approach, in: Lüning J., Fridrich Ch., Zimmermann, A. (Eds.), Die Bandkeramik im 21. Jahrhundert. Internat. Arch. Arbeitsgemeinschaft, Symposium, Tagung, Kongress 7. Verlag Marie Leidorf, Rahden/Westfalen, pp. 203–215.

Price, T. D., Grupe, G., Schröter, P., 1994. Reconstruction of migration patterns in the Bell Beaker period by stable strontium isotope analysis. Applied Geochemistry 9, 413–417.

Price, T. D., Bentley, R. A., Lüning, J., Gronenborn, D., Wahl, J., 2001. Prehistoric human migration in the Linearbandkeramik of Central Europe. Antiquity 75, 593–603.

Price, T. D., Wahl, J., Knipper, C., Burger-Heinrich, E., Kurz, G., Bentley, R. A., 2003. Das bandkeramische Gräberfeld vom 'Viesenhäuser Hof' bei Stuttgart-Mühlhausen: Neue Untersuchungsergebnisse zum Migrationsverhalten im frühen Neolithikum. Fundberichte aus Baden-Württemberg 27, 23–58.

Price, T. D., Wahl, J., Bentley, R. A., 2006. Isotopic evidence for mobility and group organization among Neolithic farmers at Talheim, Germany, 5000 BC. European Journal of Archaeology 9, 259–284.

Ramminger, B., 2006. Zur wirtschaftlichen Nutzung des Vogelsberges zur Zeit der Bandkeramik. Berichte der Kommission für Archäologische Landesforschung in Hessen 8, 2004–2005, 103–112.

Schade-Lindig, S., 2002, Idole und sonderbar verfüllte Gruben aus der bandkeramischen Siedlung "Hempler" in Bad Nauheim-Nieder-Mörlen, in: Varia Neolithica II [Beiträge der Sitzung der AG Neolithikum 2001 in Trier]. Verlag Beier & Beran, Weissbach, pp. 99–115.

Schade-Lindig, S., 2003, Vorbericht zur bandkeramischen Siedlung in Bad Nauheim-Nieder-Mörlen "Hempler" (Wetteraukreis/Hessen). Starinar 52, 117–136.

Schmidt, K., 2004. Das bandkeramische Erdwerk von Herxheim bei Landau, Kreis Südliche Weinstraße. Untersuchung der Erdwerksgräben. Germania 82, 333–349.

Schutkowski, H., 2002. Mines, meals and movement. A human ecological approach to the interface of 'history and biology', in: Smith, M. (Ed.), Human Biology and History. Taylor and Francis, London, pp. 195–202.

Schweissing, M. M., 2005. Archäometrische Analyse spätantiker Gräber aus Bayern, in: Moosbauer, G., Kastell und Friedhöfe der Spätantike in Straubing. Römer und Germanen auf dem Weg zu den ersten Bajuwaren, Passauer Universitätsschriften zur Archäologie 10. Verlag Marie Leidorf, Rahden/Westfalen, pp. 249–293.

Spatz, H., 1998. Krisen, Gewalt, Tod – zum Ende der ersten Ackerbauernkultur Mitteleuropas, in: Häußer, A. (Ed.), Krieg oder Frieden? Herxheim vor 7000 Jahren. Herxheim. Katalog zur Sonderausstellung "Krieg oder Frieden – Herxheim vor 7000 Jahren, Villa Wieser 1998. Landesamt für Denkmalpflege, Archäologische Denkmalpflege, Amt Speyer, pp. 10–19.

Tichomirowa, M., Heidel, C., Junghans, J., Haubrich, F., Matschullat, J., 2010. Sulfate and strontium water source identification by O, S and Sr isotopes and their temporal changes (1997–2008) in the region of Freiberg, central-eastern Germany. Chemical Geology 276, 104–118.

Ufrecht, W., Hölzl, S., 2006. Salinare Mineral- und Thermalwässer im Oberen Muschelkalk (Trias) im Großraum Stuttgart – Rückschlüsse auf Herkunft und Entstehung mit Hilfe der $^{87}Sr/^{86}Sr$-Strontium-Isotopie. Zeitschrift der deutschen Gesellschaft für Geowissenschaften 157, 299–316.

Valde-Nowak, P., Kienlin, T. L., 2002. Neolithische Transhumanz in den Mittelgebirgen: Ein Survey im westlichen Schwarzwald. Prähistorische Zeitschrift 77 (1), 29–75.

Zeeb-Lanz, A., 2009. Gewaltszenarien oder Sinnkrise? Die Grubenanlage von Herxheim und das Ende der Bandkeramik, in: Zeeb-Lanz, A. (Ed.), Krisen – Kulturwandel – Kontinuitäten. Zum Ende der Bandkeramik in Mitteleuropa. Beiträge der internationalen Tagung in Herxheim bei Landau (Pfalz) vom 14.–17. 06. 2007. Internationale Archäologie: Arbeitsgemeinschaft, Tagung, Symposium, Kongress 10. Verlag Marie Leidorf, Rahden/Westfalen, pp. 87–102.

Zeeb-Lanz, A., Arbogast, R.-M., Haack, F., Haidle, M. N., Jeunesse, Ch., Orschiedt, J., Schimmelpfennig, D., Schmidt, K., van Willigen, S., 2006. Die bandkeramische Siedlung mit "Grubenanlage" von Herxheim bei Landau (Pfalz). Erste Ergebnisse des DFG-Projektes, in: Beier H.-J., in cooperation with AG Neolithikum (Eds.), Varia Neolithica IV. Verlag Beier und Beran, Weissbach, pp. 63–81.

Zeeb-Lanz A., Haack, F., Arbogast, R.-M., Haidle, M. N., Jeunesse, Ch., Orschiedt, J., Schimmelpfennig, D., 2007. Außergewöhnliche Deponierungen der Bandkeramik – die Grubenanlage von Herxheim. Vorstellung einer Auswahl von Komplexen mit menschlichen Skeletttresten, Keramik und anderen Artefaktgruppen. Germania 85, 199–274.

Zeeb-Lanz, A., Boulestin, B., Haack, F., Jeunesse, Ch., 2009. Außergewöhnliche Totenbehandlung – Überraschendes aus der bandkeramischen Anlage von Herxheim bei Landau (Südpfalz). Mitteilungen der Berliner Gesellschaft für Anthropologie, Ethnolgie und Urgeschichte 30, 115–126.

Claudia Gerling[a, b, *], Volker Heyd[c], Alistair Pike[c], Eszter Bánffy[d], János Dani[e], Kitti Köhler[d], Gabriella Kulcsár[d], Elke Kaiser[a, b], Wolfram Schier[a, b]

Identifying kurgan graves in Eastern Hungary:
A burial mound in the light of strontium and oxygen isotope analysis

[*] Corresponding author: claudia.gerling@topoi.org
[a] Cluster of Excellence 264 Topoi, Free University Berlin, Germany
[b] Institute of Prehistoric Archaeology, Free University Berlin, Germany
[c] Department of Archaeology and Anthropology, University of Bristol, United Kingdom
[d] Institute of Archaeology, Hungarian Academy of Sciences, Budapest, Hungary
[e] Déri Museum, Debrecen, Hungary

Abstract

Isotopic analyses of human tooth enamel are increasingly applied to provide answers to archaeological questions. $^{87}Sr/^{86}Sr$ and $\delta^{18}O$ analyses are used to investigate small- and large-scale mobility and migration of prehistoric human individuals. Within a pilot study looking into the kurgan graves in the Eastern Carpathian Basin, we analysed the tooth enamel of 8 humans from the Early Bronze Age burial mound of Sárrétudvari-Őrhalom, Hungary. According to the archaeological record, the kurgan is linked to the Northern Pontic Yamnaya regional groups. Certain foreign burial traditions suggest that the connection is close, or even that the individuals buried in the mound had migrated from the East into the Great Hungarian Plain. Strontium and oxygen isotope analyses reveal an earlier period of 'local' burials, spanning the period 3300–2900 BC, followed by burials that postdate 2900 BC that exhibit 'nonlocal' isotopic signatures. The combination of the isotope values and the grave goods associated with the nonlocal burials point to the foothills of the Carpathian Mountains as the nearest location representing a possible childhood origin of this nonlocal group.

Keywords

Mobility, $^{87}Sr/^{86}Sr$ and $\delta^{18}O$ analyses, Early Bronze Age, Yamnaya, Hungary, Sárrétudvari-Őrhalom.

Introduction

Within the Excellence Cluster 264 TOPOI, based at the *Freie Universität* and *Humboldt-Universität* in Berlin, one research group concentrates on the spatial effects of technological innovations and changing ways of life. One of the subprojects being conducted by that group uses isotope analysis to investigate mobility and subsistence strategies in the Western Eurasian steppes and adjacent areas. We concentrate on the Late Eneolithic and Early Bronze Age (3500–2000 calBC), but for reasons of comparison Early Iron Age individuals, with their historically attested high degree of mobility, are also sampled. In this paper we focus on the preliminary results of the investigation of a burial site of Yamnaya individuals located in the eastern part of the Great Hungarian Plain (Fig. 1), which is part of a research cooperation between *Freie Universität* Berlin, the University of Bristol (UK), and the Hungarian Academy of Sciences.

In prehistoric times the eastern part of the Great Hungarian Plain was a region undergoing profound cultural changes. In the Early Bronze Age and the transition period leading to it, new elements in burial traditions, differing from the local traditions, appear to the east of the river Tisza. These foreign elements are generally explained in terms of some kind of influence from the east. In the past, several archaeologists postulated that an expansion of steppe people took place, described on various occasions as, in the most extreme terms, a "steppe invasion by the kurgan culture" (Gimbutas, 1979) in its most extreme form, as "moving shepherd tribes" (Ecsedy, 1979), or as an infiltration of Yamnaya individuals into the eastern European lowlands (Häusler, 1985). Even today, many researchers share the opinion that the foreign features are to be explained by migration to the Lower Danube and Eastern Hungary (Anthony, 2007; Harrison and Heyd, 2007).

Fig. 1 | Relief map of Hungary and adjacent areas (© Institute of Archaeology HAS, modified)

Yamnaya groups were present in the Northern Pontic region from the end of the 4th millennium BC to c. 2500/2400 calBC (Kaiser, 2011; Rassamakin and Nikolova, 2008: 2900 to 2300 calBC). The Yamnaya population is considered highly mobile, its economy primarily based on stockbreeding, with agriculture in a subordinate role. Despite a lack of unambiguous archaeological evidence, most researchers believe the Yamnaya to have been an at least partly pastoralist society (e.g. Bunyatyan, 2003; Anthony, 2007). At about 3000 calBC, they appear, rather abruptly, west of their original homeland (Heyd, in press); although a phenomenon described as the pre-Yamnaya intrusion occurs as early as 3400/3300 calBC. The fact that burials in this eastern tradition are only found under the steppe-like environmental conditions of the eastern European plains could well be an indication that people themselves – rather than ideas alone – were on the move and introduced new cultural elements to the West. However, there is as yet no substantive set of scientific data that would support the assumption of such a westward migration of Early Bronze Age steppe.

West of the Black Sea, the 'Yamnaya phenomenon' is represented by several hundred burials, characterized by a funeral rite similar to that of the Northern Pontic Yamnaya groups. These burials are situated in the lowlands of modern Bulgaria, Romania, Serbia and Eastern Hungary, and are restricted chronologically to the very end of the 4th and the first half of the 3rd millennium calBC. The graves are mostly west–east in orientation, and a supine position with flexed legs is typical for this burial tradition, as is the crouched position. The skeletons were buried in oval or rectangular grave pits, either covered by a single burial mound or arranged in groups or chains. Wooden beams or stone slabs usually overlay the grave pits, and walls and bottoms of the graves are sometimes covered with mats of some kind of organic material. Grave goods are characteristically scanty or completely missing. While ochre staining on the grave bottom or the skeleton itself and/or pieces of ochre are frequently found, ceramics are extremely rare. Somewhat more abundant are offerings consisting of meat, flint, as well as necklaces and chains of perforated animal teeth. The objects most frequently found, although generally in low numbers per burial,

Fig. 2 | Contour map of the burial mound of Sárrétudvari-Őrhalom. Modified after Dani and Nepper (2006, p. 30 Fig. 2.1)

are hair rings and hair spirals made of gold, silver and natural electrum (Dani and Nepper, 2006). Tools and weapons hardly ever occur. The majority of the burials are those of adult males, though all age groups and both sexes are represented (see Heyd, in press, for further literature).

Archaeological setting

The burial mound of Sárrétudvari-Őrhalom (Fig. 1–2) was excavated in the second half of the 1980s by Nepper. Nepper and Dani were able to distinguish two phases of kurgan construction, with an earlier mound covering the primary burial (Grave 12) and a second mound covering Graves 4, 7/7a, 8, 9, 10 and 11. According to the radiocarbon data, the burial mound was in use between the end of the 4th millennium and the mid 3rd millennium calBC (Dani and Nepper, 2006; Szántó et al., 2006).

Both stratigraphically and archaeologically, Graves 8, 10, and 12 are the earliest burials of the mound. Grave 12 (3361–3097 calBC, 2σ, OxCal 4.0; deb-6869) contains the remains of a juvenile lying in a NW–SE orientation in a strongly contracted side position. Multiple strands of evidence, based on ^{14}C dating, stratigraphy, the lack of grave goods and the non-Yamnaya-like burial style, indicate a late Copper Age date. Grave 10 is the second oldest (3090–2894 calBC, 2σ; deb-6639) and contained a W–E oriented

maturus male, found in a slightly contracted position. In addition to traces of ochre on the bones, the excavators found a grinding stone that can be considered as belonging to the burial; bones of horse and cattle were found in the grave filling. As Grave 8 had been thoroughly disturbed, it could only be reported that the skeleton might have been oriented NW–SE or SE–NW and was laid on some kind of mat, covered by something like a blanket, the organic remains of which are still evident.

A second 'group' of younger graves consists of Graves 4, 7/7a, 9 and 11. In Grave 4 (2886–2503 calBC, 2σ; deb-7182) the poorly preserved skeleton of an ENE–WSW oriented elderly adult (*maturus*) male was found. He was buried in a slightly contracted position on his left side. The skeleton was probably covered by some kind of organic material, probably leather. With a ceramic vessel, two *Lockenringe* and an animal bone, the grave is relatively well equipped. Grave 7/7a also contains rich burial objects: a ceramic vessel, *Lockenringe*, a copper axe and a dagger, as well as a lump of ochre. In addition, the bottom of the grave was covered by some kind of organic substance. A NE–SW oriented *maturus* male was buried next to a child (5 to 7 years old). A young adult male in supine position on his back with legs flexed in rhomboid position was found in Grave 9 (2861–2472 calBC, 2σ; deb-6871). The disturbed grave consisted of a ceramic vessel, a dog's tooth in the fill and some kind of organic substance on the grave bottom. Grave 11 was disturbed to such an extent that only a NW–SE(?) position of the skeleton, a ceramic vessel and cattle bones in the grave filling could be reported (cf. Dani and Nepper, 2006).

Application of isotope analyses

Increasingly, researchers are turning to geochemical methods, particularly strontium, oxygen and, less frequently, lead and sulphur isotope analyses, to identify human mobility and migration in prehistoric central Europe (e.g. Price et al., 1994; Grupe et al., 1997; Bentley et al., 2003, 2004; Price et al., 2004; Bentley and Knipper, 2005; Nehlich et al., 2009, Nehlich et al., 2010). Nevertheless, until now, no study has attempted to identify mobility patterns for Early Bronze Age individuals in regions occupied by Yamnaya groups. The only similar study on the region of South-eastern Hungary was conducted by J. I. Giblin, who investigated mobility patterns for individuals of the Neolithic/Copper Age transition (Giblin, 2009).

Strontium isotope analysis is based on differences in underlying geology, or more precisely, differences in the isotope ratios in rocks and sediments which vary according to their age and composition (Ericson, 1985; Faure, 1989). Weathering causes strontium to pass from bedrock into sediments, water and plants, with the isotope ratio remaining almost unchanged, as fractionation is minimal. At the end of the food chain, it reaches animals and humans, where it is incorporated into their bones and teeth. Because tooth mineralization is complete by the end of childhood and the strontium ratio in teeth does not change after mineralization and because enamel is not subject to severe diagenetic changes while deposited in soil (Budd et al., 2000; Evans et al., 2006; Montgomery et al., 2005), the $^{87}Sr/^{86}Sr$ ratio in tooth enamel reflects the local geology of the region where an individual spent his or her childhood. Within a pool of individuals buried in one location, one can distinguish between those who grew up locally and those who migrated later in life by comparing the isotope ratios in their tooth enamel with local isotopic signatures established by sampling local sediments, plants and modern or ancient animals local to the site under study (Price et al., 2002; Bentley et al., 2004; Sjögren et al., 2009). Where there is a lack of other reference samples, dentine has been used to establish the local range, or at least the $^{87}Sr/^{86}Sr$ ratio of the immediate burial environment on the basis of dentine's susceptibility to the uptake of Sr (Beard and Johnson, 2000; Montgomery et al., 2007; Nehlich et al., 2009).

Oxygen isotope analysis is based on differences in drinking water that are associated with the isotopic composition of rainfall in varying geographical regions (Longinelli, 1984; Luz et al., 1984). The $\delta^{18}O$ value of meteoric water is enriched in warmer climates or temperatures while in cooler surroundings it is depleted (Dansgaard, 1964). Furthermore, $\delta^{18}O$ values are dependent on the distance from an ocean as well as altitude (Craig, 1961). Seasonal variations caused by huge differences in summer and winter temperatures can complicate the situation. The fact that all available comparative data is based on modern climate situations and models, which do not necessarily mirror the palaeoclimate of 5000 years ago, creates additional complications. Yet more problems are associated with breastfeeding and weaning, which result in an enrichment of $\delta^{18}O$ in the teeth that mineralize in earlier childhood, i.e. first (and second) molars (White et al., 2004).

Material and methods

We sampled dental enamel from eight individuals from the burial mound of Sárrétudvari-Őrhalom. Since first molars were not available in every case, the set of samples for strontium and oxygen isotope analyses comprised two second premolars, two first molars, two second molars and two third molars. Tooth identification data and the results of the analyses are provided in Table 1. Various authors have proposed different sampling strategies for establishing the local Sr signature (cf. Price et al., 2002; Bentley et al., 2004). As bulk rock samples do not necessarily reflect biologically available strontium, most researchers recommend the collection of tooth enamel of small modern animals, such as rodents, or prehistoric animals whose range is locally restricted, e.g. pigs. In the absence of other samples, we analysed one soil, one plant sample and one ancient and one modern sheep bone. In addition, we sampled the dentine from four of the eight human individuals (Table 2).

Samples were prepared at the laboratory of the Department of Archaeology and Anthropology, University of Bristol, and analysed at the laboratories of the Department of Earth Sciences, University of Bristol ($^{87}Sr/^{86}Sr$), and at the Research Laboratory for Archaeology and the History of Art and the laboratory of the Department of Earth Sciences, University of Oxford ($\delta^{18}O$). The strontium isotope analysis was performed according to the procedure described in Haak and colleagues (Haak et al., 2008), with minor modifications. Oxygen isotope analysis followed the general procedure of the Bristol Isotope Group as described by Wilson and colleagues (Wilson et al., in press). For both Sr and O isotope analysis a longitudinal wedge of tooth enamel was removed using a flexible diamond-impregnated dental saw. The inner and outer surfaces of the enamel were cleaned using a tungsten carbide dental burr. After sequential washings with ultrapure water and drying in an oven, one enamel section was transferred to the laboratories of the Department of Earth Sciences, University of Bristol. Another longitudinal section of enamel was ground to powder in an agate mortar and the powder was weighed in minispin tubes and sent to the Research Laboratory of Archaeology, University of Oxford, for analysis. For strontium isotope analysis, the clean enamel section was dissolved in 3 ml 7N HNO_3, dried down and redissolved in 3N HNO_3. A 3 mg aliquot of this solution was made up to 0.5 ml with 3N HNO_3 and loaded onto ion exchange columns. Strontium was separated using standard ion exchange chromatography (70 µl of Eichrom Sr Spec resin). The eluant after column chemistry was dried down and loaded onto preconditioned rhenium filaments. Isotope ratios were measured using a ThermoFinnegan Triton Thermal Ionization Mass Spectrometer. Strontium ratios are corrected to a value for NBS 987 of 0.710248. Each sample was reanalysed to check reproducibility: results were identical to the fifth decimal place. For oxygen isotope

Table 1 | Summary of the anthropological data (after Zoffmann, 2006) and results of $^{87}Sr/^{86}Sr$ and $\delta^{18}O$ analysis for the sampled individuals of the Sárrétudvari kurgan. Errors for $^{87}Sr/^{86}Sr$ are given at 2σ; typical errors for oxygen values are 0.2‰

Grave	Sex	Age at death	Sample	$^{87}Sr/^{86}Sr$	$\delta^{18}O_{water}$
4	male	old adult	maxilla M3	0.710905 ± .000004	−11.75
7a	?	child	M1	0.710161 ± .000004	−7.30
7	male	old adult	mandibula M2(?)	0.711015 ± .000003	−11.44
8	?	young adult	M1	0.710339 ± .000003	−8.27
9	male	young adult	mandibula M3 (?)	0.710976 ± .000004	−10.94
10	male	old adult	maxilla M2	0.710470 ± .000003	−7.18
11	male?	young adult	maxilla P2	0.711566 ± .000004	−10.54
12	female	juvenile	maxilla P2 (?)	0.709963 ± .000003	−8.48

Table 2 | Results of $^{87}Sr/^{86}Sr$ analysis for reference material for the estimation of the local signature of the region around Sárrétudvari. Errors are given at 2σ

Location	Sample	Period	Contamination	$^{87}Sr/^{86}Sr$
grave 9	dentine	prehistoric	diagenetic changes	0.710360 ± .000003
grave 10	dentine	prehistoric	diagenetic changes	0.710271 ± .000003
grave 11	dentine	prehistoric	diagenetic changes	0.710475 ± .000003
grave 12	dentine	prehistoric	diagenetic changes	0.710164 ± .000003
field	soil	modern	very probable	0.711224 ± .00001
field	plant	modern	unknown	0.710534 ± .000003
grave 8	bone sheep/goat	prehistoric	diagenetic changes	0.710205 ± .000003
field	bone sheep/goat	modern?	unknown	0.710430 ± .000004

analysis at Oxford samples were treated with 0.5 ml of 3 % NaOCl in 1.5 ml centrifuge tubes for 24 hours and sequentially rinsed in deionized water in a centrifuge. After a treatment with 0.5 ml of 1M calcium acetate buffered with acetic acid (24 hours), samples were sequentially rinsed with distilled water and dried in an oven. This was done following a procedure described by Koch and colleagues (1997). At the Department of Earth Sciences, oxygen isotopes were measured on a VG Isogas Prism II mass spectrometer with an on-line VG Isocarb common acid bath preparation system. Calibration against the NOCZ Carrara Marble standard had a reproducibility of < 0.02 %. O ratios are reported relative to the VPDB international standard. Data was converted to $\delta^{18}O_{water}$ using Daux's version of Longinelli's equation (Daux et al., 2008; Longinelli, 1984).

Results and discussion

The results of the strontium and oxygen isotope analyses are shown in Table 1 and Figure 3. The $^{87}Sr/^{86}Sr$ ratios of the human enamel from individuals in Graves 4, 7, 7a, 8, 9, 10, 11 and 12 show a limited variability between 0.7100 and 0.7116. The values appear to group into two clusters. The primary burial, Grave 12, is the least radiogenic. Its value is close to those determined for Graves 7a, 8 and 10. A second

Fig. 3 | Results for Sárrétudvari-Őrhalom, $\delta^{18}O$ plotted against $^{87}Sr/^{86}Sr$. The Sr local range (0.710348 ± 2σ) and expected $\delta^{18}O$ values (~ –9 to –7) are highlighted. Sr local range given by Giblin is also demarcated (0.7091–0.7104)

cluster can be made out for Graves 4, 9, 7 and 11. The same two clusters can be distinguished in the $\delta^{18}O$ ratios. The values for Graves 10, 7a, 8 and 12 range between –7.18 and –8.48, those for Graves 11, 9, 7 and 4 between –10.54 and –11.75.

The local $^{87}Sr/^{86}Sr$ range was determined by analyzing samples of modern plants, modern and archaeological sheep bones and dentine samples from four individuals. The use of dentine is problematic as in some cases values for dentine can fall midway between the enamel and the diagenetic signal best represented by bone. Here, though, we found that the dentine values (mean 0.710318) are indistinguishable from the animal bone values (mean 0.710318), and thus we have combined both dentine and bone values to define the local range. The results are given in Table 2. Calculating a two-standard-deviation envelope around the mean of the comparative samples results in a local Sr signature of 0.7101 to 0.7106. This narrow range for Sr values is not surprising in view of the geological homogeneity in the eastern part of the Carpathian Basin and bearing in mind that bones and dentine were used as baseline samples: those substances reveal the Sr isotope ratio of the immediate burial environment rather than that of the wider region. A sample of sediment taken from a field under cultivation gave a more radiogenic signal at odds with all other baseline samples, including the plant matter. This value was ignored as we presumed it to be associated with a high risk of contamination by fertilizers.

The use of dentine and bone samples to define the local range is less than ideal, since the diagenetic Sr signal obtained from such samples probably represents the immediate burial environment, rather than a more meaningful average strontium value for the broader dietary catchment area of a single locally based community. While we did find a high level of correspondence between the Sr isotopic values of our local proxy samples of dentine, plant and animal bone and three of the human

enamel samples, we have not measured further indicators of local and regional strontium variability that would allow us to capture the size of the local catchment area. We can, though, get an indication of the Sr variability of the region from other studies. Giblin analysed prehistoric faunal samples from the sites Vésztő-Mágor, Vésztő-Bikeri, Okány 6 and Gyula 114, all of which are situated within an 80 km radius from our study site (Giblin, 2009). These samples define the local Sr range for her study area as 0.7091 to 0.7104, and overlap with 3 of the enamel samples we take to be local. Additionally, water samples from the rivers Danube and Tisza gave $^{87}Sr/^{86}Sr$ ratios of 0.7089 and 0.7096 (Palmer and Edmond, 1989; Price et al., 2004), although these probably represent average Sr values from the very wide catchment of the river. Despite the considerable variability in Sr values across these studies, there is sufficient overlap between our local range and that of Giblin to present difficulties in defining a meaningful local range for the Sárrétudvari-Őrhalom burial mound. This is perhaps to be expected for a site on the geologically homogenous Hungarian Plain that is composed of sediments, sands, silts and clays that derive from tertiary and quaternary rocks (Trunkó, 1969), young rocks that should result in relatively low $^{87}Sr/^{86}Sr$ ratios. The values for our "local group" are consistent with an origin here though. More importantly, the 'local group' is distinct with respect to both Sr and O isotope values from the individuals in the second cluster, which, we can be confident, do not have their origins in a location similar to that of the first group.

No comparison data is available for the results of oxygen isotope analysis. In an attempt to get an idea of what O values one should expect for the region around Sárrétudvari, we used the Online Isotopes in Precipitation Calculator (www.waterisotopes.org). According to the OIPC, modern $\delta^{18}O$ ratios in precipitation for the Eastern Great Hungarian Plain should range between −6.5 and −8.5‰. Annual average temperature in the Carpathian Basin in around 5000 BP was slightly lower than it is today (<−1 °C), therefore we would expect prehistoric $\delta^{18}O$ values to be marginally more negative (Paleoclimate Modelling Intercomparison Project Phase II; http://pmip2.lsce.ipsl.fr). Yurtsever and Gat have estimated a difference of 0.5‰ per °C (Yurtsever and Gat, 1981).

Both isotopic systems suggest a distinction between the same two clusters of data for the burials (Fig. 3). Graves 12, 7a, 8 and 10 form one group that falls within the local $^{87}Sr/^{86}Sr$ range of ~ 0.7101 and 0.7106 and within the expected regional $\delta^{18}O$ range of ~−7 to −9‰. Grave 12 is slightly outside the limits of the local $^{87}Sr/^{86}Sr$ range but, as mentioned above, our local range represents only the immediate vicinity rather than the likely dietary catchment area of an individual, and the individual in Grave 12 does fall within the Sr signature that Giblin determined for her area of study. According to ^{14}C dates, Graves 12 and 10 are the oldest burials. Grave 8 is not dateable, and according to the grave goods the double burial of Graves 7a and 7 are of a later date. Grave 7a belongs to a child, and the isotopes suggest that this child was born in the same region in which it died.

Summarizing, we can state that the individuals in the first group of graves lived during their childhood in the region around Sárrétudvari or a region geologically and geographically similar to that of our study site. A second cluster consisting of Graves 4, 7, 9 and 11, can be identified as 'nonlocals' on the basis of their $^{87}Sr/^{86}Sr$ and $\delta^{18}O$ ratios. The two graves of younger date (Graves 4 and 9) and the two graves with exceptional burial objects cluster together in this group. The Sr value of the individual in Grave 11 is more radiogenic than the values of the other individuals, but its O value falls into the same range defined by the other three values of below −10.5‰. Here, in contrast to the values for the first group, both isotopic systems suggest a place of origin different from the region around Sárrétudvari. More radiogenic strontium ratios together with more negative oxygen ratios indicate regions of older rocks, and higher altitudes or more inland eastward regions.

The regions of the Carpathian Mountains, with their geological variety, come into consideration with respect to the place of origin of the individuals in the second cluster. These nearby regions, being composed of both very old rock and very young rock units, offer a huge variety of Sr values. Expected modern oxygen isotopic values range between −8 and −11‰ for the lower Carpathians (OIPC, www.waterisotopes.org). Again, taking the slightly colder average temperature of the Early Bronze Age into account (Paleoclimate Modelling Intercomparison Project Phase II; http://pmip2.lsce.ipsl.fr), the $δ^{18}O$ values of the second cluster would overlap with the expected values for the hilly parts of the Carpathian Mountains. Consequently, the Carpathians represent one possible place of origin for the individuals in the second cluster of graves. 'Place of origin' as we use the term here does not necessarily refer to the birthplace. Since we were not able to test first molars in every case, we can speak only of a stage in the childhood of the individual in question. Furthermore, one must bear in mind that variations in Sr values can also be caused by differences in food sources or subsistence strategies, while climate fluctuations can account for variations in O values.

We can simplify the search for possible places of origin of the 'nonlocal' individuals in the second cluster by incorporation the archaeological information concerning burial traditions in our analysis. According to the excavators, parallels for the ceramics can be found in local Makó/Kosihy-Čaka groups. Some of the vessels, however, can be connected with finds associated with the Transylvanian Livezile group, which is located on the eastern boundary of the Apuseni Mountains, a part of the Carpathian Mountain range. The metal objects, by contrast, show connections to both the eastern Balkans and the Northern Pontic region (Dani and Nepper, 2006). The combination of 1) local and nonlocal funerary equipment in association with 2) a burial rite (inhumation in pit graves covered by a burial mound), which is not characteristic of Early Bronze Age archaeological groups in Eastern Hungary, but is probably linked to the Yamnaya burial rite of the Northern Pontic steppes, and 3) Sr as well as O isotope values that would not be expected for the eastern part of the Great Hungarian Plain opens different possible scenarios for consideration:

1) Probable is the connection between the Sárrétudvari nonlocals and the Transylvanian Livezile group, which is chiefly distributed in the eastern belt of the Apuseni Mountains and shows similarities in burial tradition (Ciugudean, 1996, 1998). Both the isotopes and some of the burial objects suggest that the Sárrétudvari nonlocals spent at least a part of their childhoods in a hillier region, possibly the mountainous area southeast of the study site.

2) Differences in subsistence or a wider subsistence range might explain the variety in the isotopic values, e.g. an economy based on transhumance could produce an average of mountainous and lowland isotopic values.

3) Some of our Early Bronze Age study sites in the Northern Pontic have yielded similar $^{87}Sr/^{86}Sr$ ratios and oxygen values. Therefore we cannot exclude a Northern Pontic place of origin for the Sárrétudvari individuals. Furthermore, Northern Pontic individuals might have picked up the Transylvanian isotopic signature or a mixed signature on their way to the Eastern Great Hungarian Plain.

To sum up, we can state that initially, at the transition to and the very beginning of the Bronze Age, individuals with 'local' signatures were buried in a nonlocal tradition in the Eastern Great Hungarian Plain, i.e. the Sárrétudvari-Őrhalom burial mound. These individuals might have had exchange systems, kinship and descendent or other relational links to the east that resulted in their adopting this burial tradition. Subsequently individuals with a 'nonlocal' isotopic signature and, to some degree, 'nonlocal' funerary equipment were buried in the same mound. Wherever they came from and whoever they were,

some of the burials are equipped with prestigious goods. The inference is that they may have held positions of some importance in a population made up of a mixture of locals and immigrants from the East or in an immigrant population that coexisted with local groups (cf. Kulcsár, 2009, for further literature).

Conclusion

From the end of the 4th until the middle of the 3rd millennium calBC, burial elements that are linked to the Northern Pontic steppe region are found in the South-eastern European lowlands. These are indicators for a connection to the Early Bronze Age Yamnaya groups, which are considered to have led a highly mobile way of life. The key argument for Yamnaya mobility is not only their abrupt appearance west of the Pontic, but also the small number of known settlements in the Northern Pontic, the lack of settlements in the Western Pontic and their dependence on steppe-like environment. To investigate the mobility of the individuals deposited in the burial mound of Sárrétudvari-Őrhalom, we drew on strontium and oxygen isotope analyses, two methods that are independent indicators for the origin of humans, with $\delta^{18}O$ correlating to hydrology and $^{87}Sr/^{86}Sr$ to geology. Both methods yielded results suggesting nonlocal origins for some of the individuals (Fig. 3). The individuals in the older graves grew up locally, while individuals in the later graves show 'nonlocal' isotopic signals. Not least because this result is in itself surprising, despite the small size of the sample set, further analysis is already in progress to confirm our conclusions with regard to the westward migration of Yamnaya groups.

Acknowledgements

We would like to thank both our colleagues Zsuzsanna K. Zoffmann (Budapest) and Ildikó Pap (Hungarian Natural History Museum, Budapest) for supplying samples for this study. Further acknowledgement goes to BIG (Bristol Isotope Group), especially Chris Coath and Tim Elliot from the Department of Earth Sciences, University of Bristol, for providing help and equipment in their laboratories. Oxygen isotope analysis was conducted by Peter Ditchfield at the RLAHA, Oxford. The work was funded by the Excellence initiative *Topoi* at the *Freie Universität* Berlin as part of the first author's PhD thesis. Useful comments were given by Hege Usborne, University of Bristol.

References

Anthony, D.W., 2007. The Horse, the Wheel, and Language. How Bronze Age Riders from the Eurasian Steppes Shaped the Modern World. Princeton University Press, Princeton, Oxford.

Beard, B.L., Johnson, C.M., 2000. Strontium isotope composition of skeletal material can determine the birth place and geographic mobility of humans and animals. Forensic Science International 45, 1049–1061.

Bentley, R.A., Krause, R., Price, T.D., Kaufmann, B., 2003. Human mobility at the early Neolithic settlement of Vaihingen, Germany: evidence from strontium isotope analysis. Archaeometry 45, 471–486.

Bentley, R.A., Price, T.D., Stephan, E., 2004. Determining the 'local' $^{87}Sr/^{86}Sr$ range for archaeological skeletons: a case study from Neolithic Europe. Journal of Archaeological Science 31, 365–375.

Bentley, R.A., Knipper, C., 2005. Geographical patterns in biologically available strontium, carbon and oxygen isotope signatures in prehistoric SW Germany. Archaeometry 47, 629–644.

Budd, P., Montgomery, J., Barreiro, B., Thomas, R.G., 2000. Differential diagenesis of strontium in archaeological human dental tissues. Applied Geochemistry 15, 687–694.

Bunyatyan, K.P., 2003. Correlations between agriculture and pastoralism in the Northern Pontic steppe area during the Bronze Age, in: Levine, M., Renfrew, C., Boyle, K. (Eds.), Prehistoric Steppe Adaptation and the Horse. MacDonald Institute for Archaeological Research, Cambridge, pp. 269–286.

Ciugudean, H., 1996. Epoca timpurie a bronzului în centrul şi sud-vestul Transilvaniei (The Early Bronze Age in Central and South-Western Transylvania). Bibliotheca Thracologica 13. Bucureşti.

Ciugudean, H., 1998. The early Bronze Age in western Transylvania, in: Ciugudean, H., Gogâltan, F. (Eds.), The Early and Middle Bronze Age in the Carpathian Basin. Proceedings of the International Symposium in Alba Iulia 1997. Biblioteca Musei Apulensis VIII. Alba Iulia, pp 67–83.

Craig, H., 1961. Isotopic variations in meteoric waters. Science 133, 1702–1703.

Dani, J., Nepper, I.M., 2006. Sárrétudvari-Őrhalom. Tumulus grave from the beginning of the EBA in Eastern Hungary. Communicationes Archaeologicae Hungariae 2006, 29–63.

Dansgaard, W., 1964. Stable isotopes in precipitation. Tellus XVI, 436–468.

Daux, V., Lécuyer, C., Héran, M.-A., Amiot, R., Simon, L., Fourel, F., Martineau, F., Lynnerup, N., Reychler, H., Escarguel, G., 2008. Oxygen isotope fractionation between human phosphate and water revisited. Journal of Human Evolution 55, 1138–1147.

Ecsedy, I., 1979. The People of the Pit-grave Kurgans in Eastern Hungary. Fontes Archaeologici Hungariae. Akadémiai Kiadó, Budapest.

Ericson, J.E., 1985. Strontium isotope characterization in the study of prehistoric human ecology. Journal of Human Evolution, 14 (5), 503–514.

Evans, J.A., Chenery, C.A., Fitzpatrick, A.P., 2006. Bronze Age childhood migration of individuals near Stonehenge, revealed by strontium and oxygen isotope tooth enamel analysis. Archaeometry 48(2), 309–321.

Faure, G., 1986. Principles of Isotope Geology. Wiley, New York.

Giblin, J.I., 2009. Strontium isotope analysis of Neolithic and Copper Age populations in the Great Hungarian Plain. Journal of Archaeological Science 36, 491–497.

Gimbutas, M., 1979. The three waves of the kurgan people into Old Europe, 4500–2500 BC, in: Dexter, M.R., Jones-Bely, K. (Eds.), Gimbutas, M., The Kurgan Culture and the Indo-Europeanization of Europe. Selected Articles from 1952 to 1993. Journal of Indo-European Studies Monographs 18. Institute for the Study of Man, Washington, D.C., pp. 240–266.

Grupe, G., Price, T.D., Schröter, P., Söllner, F., Johnson, C.M., Beard, B.L., 1997. Mobility of Bell Beaker people revealed by strontium isotope ratios of tooth and bone: a study of southern Bavarian skeletal remains. Applied Geochemistry 12, 517–525.

Haak, W., Brandt, G., de Jong, H.N., Meyer, Ch., Ganslmeier, R., Heyd, V., Hawkesworth, Ch., Pike, A.W.G., Meller, H., Alt, K.W., 2008. Ancient DNA, Strontium isotopes, and osteological analyses shed light on social and kinship organization of the Later Stone Age. Proceedings of the National Academy of Sciences 105 (47), 18226–18231.

Häusler, A., 1985. Kulturbeziehungen zwischen Ost- und Mitteleuropa im Neolithikum. Jahresschrift Mitteldeutsche Vorgeschichte 68, 21–74.

Harrison, R., Heyd, V., 2007. The transformation of Europe in the third millennium BC: the example of 'Le Petit-Chasseur I + II' (Sion, Valais, Switzerland). Prähistorische Zeitschrift 82 (2), 129–214.

Heyd, V., in press. Yamnaya groups and tumuli west of the Black Sea, in: Müller-Celka, S., Borgna, E. (Eds.), Ancestral Landscapes: Burial Mounds in the Copper and Bronze Ages (Central and Eastern Europe – Balkans – Adriatic – Aegean, 4th–2nd Millennium BC). International Conference, Udine (IT), 15–18 May 2008.

Kaiser, E., 2011. Egalitäre Hirtengesellschaft versus Nomadenkrieger? Rekonstruktion einer Sozialstruktur der Jamnaja- und Katakombengrabkulturen (3. Jt. v. Chr.), in: Hansen, S., Müller, J. (Eds.), Sozialarchäologische Perspektiven: Gesellschaftlicher Wandel 5000–1500 v. Chr. zwischen Atlantik und Kaukasus. Internationale Tagung 15.–18. 10. 2007 in Kiel. Archäologie in Eurasien 24. von Zabern, Mainz, pp. 193–210.

Kulcsár, G., 2009. The Beginnings of the Bronze Age in the Carpathian Basin: The Makó–Kosihy–Čaka and the Somogyvár–Vinkovci Cultures in Hungary. Varia Archaeologica Hungarica 23. Archaeological Institute of the Hungarian Academy of Sciences, Budapest, 2009.

Longinelli, A., 1984. Oxygen isotopes in mammal bone phosphate: a new tool for palaeohydrological and palaeoclimatological research? Geochimica et Cosmochimica Acta 48, 385–390.

Luz, B., Kolodny, Y., Horowitz, M., 1984. Fractionation of oxygen isotopes between mammalian bone-phosphate and environmental drinking water, Geochimica et Cosmochimica Acta 48, 1689–1693.

Montgomery, J., Evans, J.A., Powlesland, D., Roberts, C.A., 2005. Continuity or colonization in Anglo-Saxon England? Isotope evidence for mobility, subsistence

practice, and status at West Heslerton. American Journal of Physical Anthropology 126, 123–138.

Montgomery, J., Cooper, R.E., Evans, J.A., 2007. Foragers, farmers or foreigners? An assessment of dietary strontium isotope variation in Middle Neolithic and Early Bronze Age East Yorkshire, in: Larsson, M., Parker Pearson, M. (Eds.), From Stonehenge to the Baltic. Living with cultural diversity in the third millennium BC. British Archaeological Reports 1692. Archaeopress, Oxford, pp. 65–75.

Nehlich O., Montgomery J., Evans J., Schade-Lindig S., Pichler S.L., Richards M.P., Alt K.W., 2009. Mobility or migration – A case study from the Neolithic settlement of Nieder-Mörlen (Hessen, Germany), Journal of Archaeological Science 36 (8), 1791–1799.

Nehlich, O., Borić, D., Stefanović, S., Richards, M.P., 2010. Sulphur isotope evidence for freshwater fish consumption: a case study from the Danube Gorges, SE Europe. Journal of Archaeological Science 37, 1131–1139.

OIPC. The Online Isotopes in Precipitation Calculator. Available at http://www.waterisotopes.org/, 2010.

Palmer, M.R., Edmond, J.M., 1989. The strontium isotope budget of the modern ocean. Earth and Planetary Science Letters 92, 11–26.

Price, T.D., Grupe, G., Schröter, P., 1994. Reconstruction of migration patterns in the Bell Beaker period by stable strontium isotope analysis. Applied Geochemistry 9, 413–417.

Price, T.D., Burton, J.H., Bentley, R.A., 2002. The characterization of biologically available strontium isotope ratios for the study of prehistoric migration. Archaeometry 44, 117–135.

Price, T.D. Knipper, C., Grupe, G., Smrcka, V., 2004. Strontium isotopes and prehistoric human migration: the Bell Beaker period in Central Europe. European Journal of Archaeology 7, 9–40.

Rassamakin Y.Ya., Nikolova, A.V., 2008. Carpathian imports and imitations in context of the Eneolithic and Early Bronze Age of the Black Sea steppe area, in: Biehl P.F., Rassamakin, Y.Ya. (Eds.), Import and Imitation in Archaeology. Schriften des Zentrums für Archäologie und Kulturgeschichte des Schwarzmeerraumes 11. Beier und Beran, Langenweißbach, pp. 51–87.

Sjögren, K.-G., Price, T.D., Ahlström, T., 2009. Megaliths and mobility in south-western Sweden. Investigating relationships between a local society and its neighbours using strontium isotopes. Journal of Anthropological Archaeology 28, 85–101.

Szántó, Zs.A., Molnár, M., Svingor, É., Sándorné Mogyorósi, M., 2006. Radiocarbon analysis of the Sárrétudvari-Őrhalom's graves. Communicationes Archaeologicae Hungariae 2006, 48–49.

Trunkó, L., 1969. Geologie von Ungarn. Beiträge zur regionalen Geologie der Erde. Borntraeger, Berlin, Stuttgart.

White, Ch., Longstaff, F.J., Law, K.R., 2004: Exploring the effects of environment, physiology and diet on oxygen isotope ratios in ancient Nubian bones and teeth. Journal of Archaeological Science 31, 233–250.

Wilson, J.C., Usborne, H., Taylor, C., Ditchfield, P., Pike, A.W.G., in press. Strontium and oxygen isotope analysis on iron age and early historic burials around the Great Mound at Knowth, Co. Meath, in: Eogan, G. (Ed.), Excavations at Knowth 5: The Archaeology of Knowth in the First and Second Millennia AD. Royal Irish Academy, Dublin.

Yurtsever, Y., Gat, J.R., 1981. Atmospheric waters, in: Gat, J.R., Gonfiantini, R. (Eds.), Stable Isotope Hydrology: Deuterium and Oxygen-18 in the Water Cycle. Technical Report Series 210, International Atomic Energy Agency, Vienna, pp. 103–142.

Zoffmann, Zs.K., 2006. Anthropological finds of the Pit Grave Culture from the Sárrétudvari-Őrhalom site. Communicationes Archaeologicae Hungariae 2006, 51–58.

Natalia Shishlina[a,] *, *Vyacheslav Sevastyanov*[b], *Robert E.M. Hedges*[c]

Isotope ratio study of Bronze Age samples from the Eurasian Caspian Steppes

- * Corresponding Author: nshishlina@mail.ru
- a State Historical Museum, Moscow, Russia
- b Vernadsky Institute of Geochemistry and Analytical Chemistry, Russian Academy of Sciences, Moscow, Russia
- c Research Laboratory for Archaeology and the History of Art, Oxford University, United Kingdom

Abstract

This paper presents result of the isotope study of human, faunal and plant archaeological samples from Bronze Age kurgans and graves of the Eurasian Steppes. Isotope data reveal a very broad range of $\delta^{13}C$ and $\delta^{15}N$ values for the Bronze Age cultures. The more ancient a sample is in age, the lower are its $\delta^{13}C$ and $\delta^{15}N$ values. Stable isotope values of plants, animal and humans are very sensitive to climate change. Annual precipitation and temperature were key factors driving the overall isotope trend. The data obtained helped us propose two fodder models for domesticated animals and three diet models for humans. $\delta^{13}C$ and $\delta^{15}N$ values in animal bones indicate that different pastures were used by local mobile groups. Some archaeological plant samples dating to the period of aridization are characterized by very high ^{15}N values. These were probably included in animal fodder, which was reflected in the isotope ratio of domesticated animals. Humans had a mixed diet, which is why regular patterns of changes in the isotope ratios of carbon and nitrogen are more subtle. There is a small group of humans from North Caucasus who consumed mainly vegetable foods (C_3 plants) and the flesh/milk of domesticated animals. The diet system characteristic for the humans whose main area of occupation was the steppe included the flesh/milk of herbivores, river and lake aquatic foods, and wild C_3 plants. The third group of humans consumed marine food. The isotope data we have obtained demonstrate that the human diet system changed due to changes in economy, nature of exploited local food resources, and climate.

Keywords

Stable isotopes, collagen, diet, Bronze Age, Eurasian Caspian Steppes

Introduction

Isotope analysis of archaeological and contemporary samples plays an important role in the investigation of the main components of ancient human subsistence (Buchachenko, 2007). Isotopes help researchers to more precisely define the chronology of ancient populations (Cook et al., 2002); they are used in ecological studies (Lecolle, 1985), and they provide unique information on the diet system, which forms part of the human technological base (Iacumin et al., 1998; Richards et al., 2003; Shishlina et al., 2009; Hollund et al., 2010).

Dietary information can be obtained from $\delta^{13}C$ and $\delta^{15}N$ values of human and faunal bone collagen (Lanting and van der Plicht, 1998; Richards et al., 2003). Carbon and nitrogen constitute part of the trophic food chain. Investigations of such chains have revealed that isotope values in bone collagen of humans (as consumers) deviate from values for constituents of the diet by 5‰ for carbon and 3–4‰ for nitrogen (Iacumin et al., 1998). Differences in $\delta^{13}C$ and $\delta^{15}N$ values point to differences in diet systems, which can be reconstructed for different population groups (Lanting and van der Plicht, 1998; Thompson et al., 2005; Jay and Richards, 2006; Keenleyside et al., 2009).

The ranges of isotope values determined for major sources of organic matter are shown in Table 1. Bone collagen isotope values, therefore, can help us ascertain what main food products humans consumed during the last 10–20 years of their lives; i.e. whether they subsisted mainly on vegetable foods, or a mixed diet with vegetable food and meat; what proportion of their diet consisted of marine and river/lake products; or what proportion of C_3 and C_4 plants.

One difficulty associated with the reconstruction of ancient diet is that the ^{13}C and ^{15}N values associated with a specific dietary component can be influenced by the local environment. It can be argued that

Table 1 | Ranges of isotope values for major sources of organic matter

Organic matter source	$\delta^{13}C_{VPDB}$, ‰	$\delta^{15}N_{air}$, ‰
Human (mixed diet)	−22 to −15	7 to 14
Human (marine diet)	−15 to −13	17 to 18
Animals (herbivore)	−23 to −20	3 to 9
Fish from lake (littoral)	−22 to −12	9 to 12
Fish from lake (pelagic)	−24 to −20	7 to 13
Terrestrial plants C3	−27 (−32 to −22)	−10 to 10
Terrestrial plants C4	−13 (−16 to −9)	−10 to 10

aridization of climate caused a decrease in precipitation, leading to changes in vegetation and processes of water preservation, as well as the deposit of ^{15}N-depleted wastes, such as urea. These factors can lead to an increase in δ^{15}N in human and animal collagen in the arid areas (Schwarcz et. al., 1999). It is therefore necessary to take into account ecological characteristics of the region in question as well as data obtained through different approaches.

The area of investigation

The Caspian Steppes are adjacent to the North Caucasus, the Volga and the Don Rivers. They comprise an area of wormwood and gramineous Eurasian and Kazakhstan steppes, or a southern sub-zone of dry steppes, transitional to semi-deserts (Lavrenko, 1991; Bobrov, 2002). The climate is continental and arid. Summer are hot and dry; snow cover in winter is thin, and sometimes frost is severe. Average temperatures are −4–−5°C in January and +25.5–+26°C in July; average annual temperature is +10°C. Average annual rainfall is between 180 and 350 mm. The average snow cover over much of the region is 3–8 cm, up to 10–11 cm in the north. The environment, i.e. landscape, climate, hydrology, and vegetation, differs in the river valleys, in the upper part of the watershed plateau, and the open steppe. Research into the regional palaeoclimate has revealed frequent and sometimes very dramatic climate changes during the period 4000–2000 calBC (Demkin et al., 2002; Shishlina, 2008).

The cultural context

Starting in the Eneolithic Age and throughout the Bronze Age, the Caspian Steppes represent a distinct cultural province that developed a mobile pastoralism (Shishlina, 2008). The Eneolithic population was the first to exploit steppe landscapes, at the end of the fifth millennium BC. The Steppe Majkop population penetrated into the steppe from the North Caucasus area at the end of the first half of the fourth millennium BC. Then the Yamnaya culture population settled on the steppe, opening a new period of its exploitation. In the subsequent period the cultural situation changed and we see a mosaic of cultures emerging. Open steppe southern boundaries and developed river routes are linked with the spreading of a new Steppe North Caucasus population. During a relatively short period multiple cultural groups, i.e. the Late Yamnaya, Early Catacomb and Steppe North Caucasus, must have coexisted. At the end of this period the East Manych Catacomb population appeared. The last cultures that appeared at the end of the

Table 2 | Chronology of the cultures analyzed

Culture	Time interval
Eneolithic	4300–3800 calBC
Majkop	3500–3000 calBC
Yamnaya	3000–2500 calBC
Early Catacomb	2700–2400 calBC
Steppe North Caucasus	2500–2300 calBC
East Manych Catacomb	2500–2200 calBC
Lola and Krivaya Luka	2200–2000 calBC

second millennium BC were the Lola and Krivaya Luka cultures. Table 2 provides data on the chronology of the cultures. The time interval covered is 4300–2000 calBC.

Method and objects

The main source for the historical reconstruction of the lives the first pastoralists living in the region in question is that of funerary sites, i.e. kurgans (burial mounds) and graves. Many organic materials, such as human and animal bones, wood, plant remains, fibres and seeds, have been preserved in these sites due to specific arid conditions of soils and the depth to the ground water.

To conduct the study, we collected samples from the kurgan burial grounds located in the Caspian Steppes, the Lower Volga and the Don regions and the North Caucasus (Fig. 1).

The following types of samples were analyzed in the project ($\delta^{13}C$ and $\delta^{15}N$ isotope analysis):
- human and animal bones of the Bronze Age;
- archaeological plant remains dating to the Bronze Age.

Most isotope ratio measurements were performed at the Vernadsky Institute of Geochemistry and Analytical Chemistry, Russian Academy of Sciences, with the use of isotope Mass Spectrometer DELTA Plus XP (ThermoFinnigan), connected to the Flash EA element analyzer. Each sample was measured in triplicate, the analytical error was ± 0.2‰ for $\delta^{13}C$ and ±0.2–0.3‰ for $\delta^{15}N$. The rest of the measurements were performed at Oxford University and Groningen University.

The objective of this paper is to demonstrate that a traditional archaeological source preserves very important chemical information and to discuss the results of the study of samples from Bronze Age sites in that context. The focus will be on:
- possible components of the diet system of the Bronze Age population, which exploited steppe areas of the Caspian Steppes, Don River valleys and the North Caucasus;
- domesticated animal fodder in these areas in the Bronze Age.

An additional task is to study archaeological plants and reconstruct a vegetation pattern and ascertain the ratio of C_3 to C_4 plants.

Fig. 1 | Caspian Steppes archaeological sites. 1 Baga-Burul; 2 Zunda-Tolga and East Manych, 3 Chilguir, 4 Yergueni, 5 Mandjikiny; 6 Krivaya Luka; 7 Chogray; 8 Khar-Zukha; 9 Mu-Sharet; 10 Temrta, Ulan and Sukhaya Termista; 11 Ostrovnoy; 12 Shakhaevskaya; 13 Sharakhalsun

Results

In order to examine the reliability of radiocarbon dates obtained for the region in question, we started by measuring $\delta^{13}C$ in human and animal bone collagen (Shishlina et al., 2007). The addition of $\delta^{15}N$ values helped launch an study of diet models proposed for humans. Isotope ratios were also measured in animal bone collagen (Shishlina, 2008; Shishlina et al., 2009). Over the past years, 96 human, 65 animal, 2 fish and 1 dolphin archeological samples have been subjected to analysis. Almost all data have already been published (Shishlina et al., 2009): they are presented again here in Tables 3 and 4 (see appendix).

Animal stable isotope values vary and they can be divided into two groups based on differences in the average values of $\delta^{13}C$ and $\delta^{15}N$. The first group (n=44) is characterized by a ^{13}C range from –24.1 to –17.3‰ and $\delta^{15}N$ from +4 to +10‰, with average values of –20.7‰ and +7.0‰, respectively. The second group (n=18) is characterized by a $\delta^{13}C$ range from –21.5 to –14.2‰ and $\delta^{15}N$ from +9.9 to +14.9‰, with average values of –17.9‰ and +12.4‰.

Human stable isotope values also show large variations. The values obtained fall into three groups. The first group (n=6) is characterized by a $\delta^{13}C$ range from –20.7 to –18.4‰ and $\delta^{15}N$ from +8.9 to +10.5‰, with average values of –19.6‰ and +9.7‰. The second group (n=64) is characterized by a $\delta^{13}C$ range from –22.2 to –17.5‰ and $\delta^{15}N$ from +9.4 to +17.1‰, with average values of –19.9‰ and

Table 5 | Isotope values of archaeological plants of the Bronze Age

Site name	Sample	Species	$\delta^{13}C$, ‰	$\delta^{15}N$, ‰
Yamnaya culture period: 3000–2500 calBC				
Mu-Sharet 1	kurgan 5, grave 3	seeds of Amaranths	−26.5	+6.4
Early Catacomb culture period: 2700–2400 calBC				
East Manych, Left Bank, III	kurgan 29, grave 8	plant mat, reed?	−24.3	+15.6
Mandjikiny 1	kurgan 14, grave 6	seeds (*Lithosperpum officinale*)	−26.6	+13.0
Mandjikiny1	kurgan 14, grave 6	plant mat, gramineous plants	−24.6	+13.9
Temrta 1	kurgan 1, grave 2	plant mat, reed?	−25.2	+1.9
Temrta 1	kurgan 1, grave 2	plant mat, reed	−28.6	+4.6
Ulan IV	kurgan 3, grave 14	plant mat, reed?	−25.9	+6.5
Ulan IV	kurgan 3, grave 15	plant mat, reed?	−25.4	+13.0
Ulan IV	kurgan 3, grave 15	plant mat, reed?	−25.48	+10.3
Steppe North Caucasus culture period: 2700–2400 calBC				
Kislovodsk	tomb 3	karakas seeds	−19.6	+1.5
East Manych, Left Bank, III	kurgan 12, grave 13	reed?	−24.0	+11.8
East Manych and West Manych Catacomb cultures period: 2500–2200 calBC				
Mandjikiny 1	kurgan 14, grave1	reed	−23.9	+17.4
Mandjikiny 1	kurgan 14, grave 1	plant mat, stem of reed	−25.7	+21.1
Yergueni	kurgan 10, grave 2	reed	−25.4	+19.1
Shakhaevskaya	kurgan 4, grave 35	gramineous plants from the pot	−27.2	+5.6
Shakhaevskaya	kurgan 4, grave 32	seeds (Lithospermum officinale)	−22.6	+9.6
Sharakhalsun-6	kurgan 3, grave 4	plant mat, reed stem	−28.0	+11.9
Lola culture period: : 2200–2000 calBC				
Ostrovnoy,	kurgan 3, grave 39	seeds of winter-cress,	−22.6	+10.7

+13.3‰. The third group (n=18) is characterized by a $\delta^{13}C$ range from −18.2 to −15.3‰ and $\delta^{15}N$ from +11.1 to +18.4‰, with average values of −16.8‰ and +14.8‰.

Archaeological plant samples: An additional pilot isotope study was conducted into archaeological Bronze Age plants. $\delta^{13}C$ values for C_3 and C_4 plants differ greatly. The average value of C_3 plants, which are predominant in the steppe zone, is around −26‰; the average $\delta^{13}C$ value for C_4 plants is around −12‰. Table 5 shows the isotope data obtained for archaeological samples of reed, some seeds and gramineous plants. All samples have values appropriate for C_3 plants.

It is worth mentioning that some of the reed samples obtained from different areas are characterized by very high $\delta^{15}N$ values. Two samples of wild gramineous plants, attributed to C_3 plants, and are characterized by a very high value of nitrogen as well.

Fig. 2 | Average values of δ¹³C and δ¹⁵N for humans and animals from analyzed cultures. 1 Eneolithic, 2 Majkop, 3 Yamnaya, 4 Early Catacomb, 5 East Manych Catacomb, 6 Lola and Krivaya Luka

Discussion

The results demonstrate a very broad range of δ¹³C and δ¹⁵N values for Bronze Age cultures of the area under discussion. The greater the age of the sample, the lower are the values of δ¹³C and δ¹⁵N. Stable isotope values obtained show a positive correlation of δ¹³C and δ¹⁵N ratios (see Fig. 2) with average values for cultures and demonstrate the same trend both for animals and humans.

Our data also helped us to propose two fodder models for domesticated animals (Fig. 3) and three diet models for humans (Fig. 4).

Model 1, for domesticated animal fodder (isotope group 1), is based on the use of pastures with the predominance of C_3 plants (a period of Eneolithic, Steppe Majkop and Yamnaya cultures with mild and humid climate; it is assumed that such pastures existed in some areas during the Catacomb and Lola cultures as well).

Model 2, for domesticated animal fodder (isotope group 2), is based on the use of pastures with mixed C_3 and C_4 plants typical for the period of aridization.

Thus variations in isotope data are characteristic for domesticated animals, especially animals that date back to the period of aridization, i.e. around 2300–2200 calBC. The large range in the isotope values for Bronze Age herbivores was identified by Hollund and colleagues (2010) for the North Caucasus as well. Several sheep dating to this time (Baga-Burul; Zunda-Tolga-1, Chilguir, Yergueni) have a very high δ¹⁵N value (from +10.39 to +13.72‰) and a very high δ¹³C value (from –16.74 ‰ to –14.27). Similarly high values for δ¹⁵N in animal bone samples have been reported for a faunal collection dated to the Majkop North Caucasus culture (Hollund et al., 2010).

Model 1
Domesticated animals
(*Eneolithic, Majkop, Yamnaya, Catacomb, Lola cultures*)
Pastures with predominance of C₃ vegetation
$\delta^{13}C$ from -24.1 to -17.3‰ (-20.7‰)
$\delta^{15}N$ from +4.0 to +10.0‰ (+7.0‰)

Model 2
Domesticated animals
(*Yamnaya, Catacomb, Lola cultures*)
Pastures with predominance of C₃ plants, mixed C₃ and C₄ vegetation
$\delta^{13}C$ from -21.5 to -14.2‰ (-17.9‰)
$\delta^{15}N$ from +9.9 to +14.9‰ (+12.4‰)

Fig. 3 | Models of domesticated animal fodder in Eneolithic-Bronze Age

Throughout all ages the life of ancient populations was closely linked to sources of water. This link necessarily became substantially stronger in pastoral economies. While an individual does not need more than tow litres of water per day for personal consumption, in a pastoral economy with a mobile life style the population is forced to return to sources of water once or twice a day in order to water their animals.

Changes in pasture vegetation might also be responsible for differences in isotope values in animal bone collagen. One scenario is that of the occurrence of extremely severe droughts, resulting in disastrous wind erosion, an increase in the concentration of water-soluble components in soils and the deflation of the upper horizon of soils in watershed areas. Plant remains in soil samples taken from kurgan profiles and primary graves provide information about the local vegetation during the time of kurgan construction and the existence of various cultures. Soil samples associated with Early Catacomb culture (2700–2400 calBC) have been shown to contain pollen and phytoliths of numerous plants: wormwood (*Artemisia*), leguminous plants (*Fabaceae*), grass plants (*Poaceae*), goosefoot (*Chenopodiaeceae*), lily (*Liliaceae*), and dicotyledonous mixed grasses (*Silenaceae, Asteraceae, Polygonaceae*). This vegetation is typical for a mixed grass steppe. Samples for Catacomb culture (2500–2200 calBC) contained pollen and phytoliths of *Artemisia, Chenopodiaeceae, Asteraceae*. So here we see local vegetation changing to semi-desert landscapes with a predominance of wormwood-fescue associations. The Lola and Krivaya Luka cultures (2200–2000 calBC) existed in a desert with a predominance of wormwood associations (Shishlina, 2008). A vegetation change of this kind could well have altered the forage plant isotope values, which would be reflected in the isotope values in domesticated animal bone collagen.

We believe that such values could have been caused by climate change and the concomitant long distance migrations necessitated by the stress on domesticated animals associated with the lack of pasture and the fact that water resources are scattered all over environmental niches of the Steppe and the North Caucasus. Some C₄ plants started growing in certain steppe areas and were gradually incorporated into sheep fodder. As noted in the introduction, a high $\delta^{15}N$ value may characterize C₃ plants in an arid climate, i.e. in Egypt (Thompson et al., 2005) or in Anatolia (Richards et al., 2003).

The isotope data obtained for archaeological plants also vary. Such plants respond to the climate change in a way similar to that seen in human and animal bones, enabling us to elaborate the proposed models of the animal fodder system. Data confirm findings on the predominance of C_3 plants in the region in question. This observation is in agreement with pollen and phytoliths obtained from the archaeological context (Shishlina, 2008) and with the description of vegetation from contemporary pilot pastures (Novikova, 2001). It is possible that some C_4 plants were present in the animal fodder but if so their proportion was very low.

However, some archaeological plants have a very high $δ^{15}N$ isotope value. Several archaeological sheep bone collagen samples also yield very high nitrogen values. These were probably caused by the inclusion of plants with a high nitrogen value in the animals' fodder, although fractionation within the sheep, when under drought stress, may also be a factor.

A great deal of moisture evaporates from large masses of leaves and stems of reed. The high value of nitrogen in the archaeological samples might be a signal of stressed plants suffering from a lack of water during drought. Reed is used as winter fodder for domesticated animals. In 1988 we saw reed being cut in Lake Deed-Khulsun to be preserved as winter fodder. Almost the entire population of Kormovoye village was engaged in preparing reed for winter animal fodder, which is traded across the Republic of Kalmykia. We took samples from the lake in 2008. Local pastoralists whom we interviewed confirmed that they cut reed and used it as animal fodder.

One of the main requirements for Kazakh winter pastures is proximity to sources of reed and cane (Masanov, 1995). Apparently, reed and cane were used as winter fodder for domesticated animals in the Bronze Age as well, especially in times of drought when pasture was inadequate during summer and winter seasons. That is probably the reason that archaeological samples reveal a high value of nitrogen in animal bone collagen. Sheep bones with a high level of nitrogen were found in graves containing mats made of reed (Shishlina, 2008). Kurgan burial grounds containing such finds were located not far from rivers with reed banks. Sheep with a high nitrogen value date from the period of aridization.

Aridization had an impact on all components of the landscape, i.e. vegetation, soil, water resources. Dry-steppe and semi-desert species appeared. They produced much less biomass per square kilometre than their predecessor plants did. Winter precipitation rate dropped; intensity of heavy showers in summer grew, leading to erosion processes. Climate changes caused a change in vegetation which led to changes in the isotope values in animal bone collagen. In addition, human management may have brought about overgrazing, causing degradation of soil and vegetation. Animals have a direct impact on plant cenosis, as they eat terrestrial parts of plants (overgrazing), destroy the upper part of soils with their hooves, and leave droppings. A substantial share of the mineral elements contained in the plants that animals eat get back into soil via droppings. Hence, a large amount of organic matter rich with nitrogen that appears on the soil surface improves soil microbiological activity and vital functions of soil mesofauna. The impact of animal droppings on soil and plants is defined not only by their amount but by their chemical composition, physical properties, and shape, as well as by their distribution pattern across the surface. Sheep droppings are especially rich in the minerals important for plants. The largest source of the nitrogen and potassium input to pastures is animal urine. Concentrated urine can burn plants and is the main reason for a drastic increase in their alkalinity. Sheep droppings are distributed across the soil surface evenly and do not have an adverse mechanical impact on plants. During their decomposition, mineral elements contained in droppings gradually get back into the soil (Masanov, 1995). Recent studies have shown the impact of manuring on nitrogen isotope ratios on plants (Bogaard et al., 2007).

Model 1
Human
(*Eneolithic, Majkop cultures*)
Flesh/milk of herbivore animals, wild C_3 plants
$δ^{13}C$ from -20.7 to -18.4‰
(-19.6‰)
$δ^{15}N$ from +8.9 to +10.5‰
(9.7‰)

Model 2
Human
(*Majkop, Yamnaya, Catacomb, Lola, Krivaya Luka cultures*)
Flesh/milk of herbivore animals, river and lake aquatic products, wild C_3 plants
$δ^{13}C$ from -22.2 to -17.5‰
(-19.9‰)
$δ^{15}N$ from +9.4 to +17.1‰
(+13.3‰)

Model 3
Human
(*Yamnaya, Early Catacomb, East Manych Catacomb* cultures)
marine products are predominant
$δ^{13}C$ from -16.9 to -15.3‰
(-16.8‰)
$δ^{15}N$ from +11.1 to +18.4‰
(+14.8‰)

Fig. 4 | Models of human diet obtained for Eneolithic and Bronze Age cultures

It is also possible that degradation of pastures led to appearance of xerophytes and a decline in pasture productivity. Animals destroyed the upper part of the soil with their hooves and this led to the change in vegetation pattern (Dinesman and Bold, 1992). The result of this is the change of economy and, first of all, pastoral routes.

Data obtained for humans with a mixed and multicomponent diet system form the basis for discussing three diet system models (Fig.4).

Model 1 is characteristic for several representatives of the Eneolithic and Steppe Majkop cultures (Khvalynsk, Nalchik, Mandjikiny) who ate mostly vegetable food, resulting in lower values for $δ^{13}C$ and $δ^{15}N$ (isotope group 1).

Model 2 is based on the consumption of large quantities of aquatic resources (fish, mollusks, water plants) and wild C_3 plants (isotope group 2). It was the most widespread and developed economy in the steppe environment associated with mobile pastoralists of the Eneolithic-Bronze Age. Stress (as dis-

cussed above) caused by the struggle to survive and the aridity of climate increased values of the nitrogen isotope ratio in human collagen. This means that population groups of the Khvalynsk, Majkop, Yamnaya, Catacomb, Lola and Krivaya Luka cultures made use of all food resources in the exploited areas of the Volga, Don, the Caspian Steppes and steppes of the North Caucasus areas.

This interpretation of isotope data is confirmed by certain archeological finds: sheat-fish (*Silurus glanis*) bones and special fishing tools, i.e. hooks and harpoons found at Eneolithic sites (Agapov et al., 1990); finds of river fish bones and shells of edible molluscs (like pearl oysters) in the Yamnaya, Early Catacomb and Catacomb burials; imprints of knotless net preserved on the bottom of clay pots of the Yamnaya and Catacomb cultures (Orfinskaya et al., 1999), the bones of pike uncovered at the Catacomb Rykan site (excavation of E.I.Gak in the Voronezh region). The increasing wetness of the climate led to abundance of water reservoirs, i.e. steppe rivers and lakes, with a lot of fish.

Model 3 is based on the consumption of seafood (Isotope Group 3). This group, for example, includes an old man from a Chilguir Caspian Plain grave and three females aged 14–17 and 45–50 years from the Middle and South Yergueni Hills (Mandjikiny-2, Khar-Zukha and Mu-Sharet-4). The diet system of these individuals was based on marine food. Seasonality data obtained from these graves indicate that these people were seasonal pastoralists and apparently moved from one pasture to another. Possibly, the two young women aged 14–17 were born somewhere near the coastlines of the Caspian or Black Seas and later married and moved to the steppe. As newcomers they lived in a new steppe environment for a short period before death. At least the isotope data point to this outcome as the isotope values of the two females differ from the isotope values of other local people, whose diet system was typical for Model 2.

Several individuals of the Early Catacomb cultures (for example, *senilis* female from Khar-Zukha) have a very high $\delta^{13}C$ value, i.e. −15.42‰, and a very high $\delta^{15}N$ value, i.e. +18.10‰. The woman in the example consumed marine food. She may have moved to the open steppe from the coastline region. She died surrounded by people whose diet system was different from her own.

It is possible that East Manych Catacomb individuals buried at Temrta III, Kurgan 1, Grave 6 (20–30 years old); Mandjikiny-1, Kurgan 10, Grave 2 (female of 45–50) and Mandjikiny-1, Kurgan 14, Grave 1 (male of 30–35) were members of family groups that migrated during the winter seasons to the coastline areas of the Azov and the East Black seas. These three individuals have the highest values of nitrogen and carbon. These values indicate marine food consumption.

The humans analyzed (n=96) lived in diverse areas and at different times. We assume that almost all individuals concerned (except one male from the Nalchik cemetery) were mobile pastoralists, though it is evident that development of a new mode of pastoral life does not authomatically change diet. It is possible that severe conditions of the steppe environment and constant dependence on pasture productivity and water availability let the mobile steppe population to use all food resources they could find in the exploited areas.

Variations among isotope data obtained for each culture, as well as among individuals buried in different burial grounds, can be explained by the migration of small family groups along numerous routes across diverse geographical zones. Apparently, these groups used different food resources. There were summer and winter pastures in open steppe areas and near river valleys, as well as in the North Caucasus foothills and along the coastline of the Caspian and Black Seas. Mobility patterns also varied. Yamnaya groups migrated along rivers in the winter, moving short distances in the summer. They moved within a small area not more that 10–20 km distant from the river to watershed plateaus. Catacomb herders, by contrast, travelled over greater distances, sometimes hundreds of kilometres (Shishlina, 2008).

Fig. 5 | Mean annual precipitation during archaeological cultures (Demkin et al., 2002). 1 Eneolithic, 2 Majkop, 3 Yamnaya, 4 Early Catacomb, 5 East Manych Catacomb, 6 Lola and Krivaya Luka

The dependence of $\delta^{15}N$ values in human and animal collagen on annual precipitation has been discussed for several arid zones, where this ecological factor causes $\delta^{15}N$ enrichments in plants and soil. Reduced precipitation causes low $\delta^{15}N$ values in herbivores as well (Iacumin et al., 1998; Schwarcz et al., 1999).

Therefore, aridization on the Caspian Steppes and in the Don River area that occurred in the second half of 3000 BC caused changes in pasture and sources of water. The lack of water and deficiency of pastures led to more frequent movements and this, perhaps, caused stress in animals and the enrichment of nitrogen in the animal bone collagen as well as in plants. We assume that the most likely key drivers of the overall trend are temperature changes and the amount of precipitation (Fig.5).

Hence, our hypothesis states that the values of the isotope ratios in humans and animals as well as in plants may be due to climate, i.e. temperature, precipitation, day length, glaciation; the ecosystem and stress, i.e. volcanic eruptions, floods and even the struggle to survive. Changes in precipitation are reflected in changes in isotope values (Table 6).

Average values for $\delta^{13}C$ and $\delta^{15}N$ obtained for human and domesticated animal collagen from the cultures analyzed demonstrate a linear correlation with climate characteristics as well as the geographical area exploited and possible types of economic models. Such changes occurred during 4000–3000 calBC.

This is illustrated by the example with animals (Fig. 6). Over time, the $\delta^{13}C$ value shifts from −22.5 to −16‰; $\delta^{15}N$ values changes from +5 to +9–10‰. The similar trend is illustrated by the example with humans (Fig. 7). Over time the $\delta^{13}C$ value shifts from −22.5 to −16‰; $\delta^{15}N$ values change from +5 to +14–15‰.

Table 6 | Correlation of average isotope data obtained for humans, animals and plants when are available from cultures in question and annual precipitation

Culture/human/animal	δ¹³C, ‰	δ¹⁵N, ‰	Annual precipitation (Demkin et al. 2002)
Eneolithic (4300–3800 calBC)			
Human	−21.0	+13.3	400–420 mm
domesticated animal	−20.0	+7.3	
plants	n/a	n/a	
Steppe Majkop (3500–3000 calBC)			
Human	−18.1	+14.1	400–420 mm
domesticated animal	−22.5	+5.5	
plants	n/a	n/a	
Yamnaya (3000–2500 calBC)			
Human	−17.2	+15.2	350–380 mm
domesticated animal	−19.4	+6.5	
plants	−24.3 (n=1)	+6.4 (n=1)	
Early Catacomb (2700–2400 calBC)			
human	−17.8	+15.0	350–300 mm
domesticated animal	−18.7	+8.4	
plants	−25.9 (n=8)	+8.1 (n=8)	
East Manych Catacomb (2500–2200 calBC)			
human	−17.2	+15.3	250–300 mm
domesticated animal	−17.6	+9.0	
plants	−25.5 (n=6)	+14.1 (n=6)	
Lola and Krivaya Luka (2200–2000 calBC)			
human	−18.1	+14.7	300 mm
domesticated animal	−18.0	+8.4	
plants	−22.6 (n=1)	+10.72 (n=1)	

Conclusions

Isotope data demonstrate a very broad range in δ¹³C and δ¹⁵N values for the Bronze Age cultures of the area under discussion. The more ancient a sample in age, the lower the δ¹³C and δ¹⁵N values found. Stable isotope values in plants, animal and humans are very sensitive to climate changes. Annual precipitation and temperature were key factors in driving the overall isotope trend.

The data obtained has helped us propose two fodder models for domesticated animals and three diet models for humans. δ¹³C and δ¹⁵N values in animal bones indicate that different pastures were used by local mobile groups. Apparently such pastures were located in different ecological environments. Indirectly this points to population movements across the exploited area. Some archaeological plant samples dating to the period of aridization are characterized by very high δ¹⁵N values. Such plants were probably included in the animal fodder and this was reflected in the isotope ratio in domestic animals.

Humans had a mixed diet, which is why regular patterns of changes in the isotope ratios of carbon and nitrogen are more subtle. There is a small group of humans from the North Caucasus who con-

Fig. 6 | Graph plotting average values of δ¹³C and δ¹⁵N for domesticated animals against annual precipitation

sumed mostly vegetable food (C_3 plants) and the flesh/milk of domesticated animals. The diet system characteristic for the humans whose main area of occupation was the steppe included the flesh/milk of herbivores, river and lake aquatic products, and wild C_3 plants. These data are confirmed by ethnobotanical evidence (Shishlina et al., 2007). The third group of people consumed marine food. They may have moved to the open steppe from the North Caucasus coastline region and then died surrounded by people whose diet system was different from their own. We have not been able to identify the reasons for their move to the deep steppes from a maritime coastline (Black Sea? Azov Sea? Caspian Sea?), but it is clear that the last 10 years of their lives were not spent on the steppe but instead very close to the sea (Shishlina et al., 2009).

Fig. 7 | Graph plotting average values of $\delta^{13}C$ and $\delta^{15}N$ in humans against annual precipitation

The isotope data we have obtained demonstrate that the human diet system changed due to economy, nature of exploited local food resources and climate changes, and in particular, aridization of climate and change in the level of precipitation in the second half of the 3rd millennium BC.

Acknowledgement

This work was supported by RFFI grants, Nos. 05–06–80082 and 08–06–00069.

References

Agapov, S. A.,Vasiliev, I. B. and Pestrikova, V.I., 1990. The Khvalynsk Eneolithic burial ground (Khvalynsky eneolitichesky mogilnik). Saratov University Publishing House, Saratov. (In Russian).

Bobrov, A. A., 2002. Phytolith analyses of contemporary and buried soils from kurgan burial grounds in Kalmykia (Fitolitny analiz sovremennykh i pogrebennykh pochv kurgannykh mogilnikov Kalmykii), in: Shishlina, N.I., Tsutskin, E.V. (Eds.), Ostrovnoy kurgan burial ground. Results of interdisciplinary investigation of North-western Caspian archaeological sites. State Historical Museum, Moscow, pp. 137–166. (In Russian).

Bogaard, A., Heaton, T.H.E., Poulton, P., Merbach, I., 2007. The impact of manuring on nitrogen isotope ratios in cereals: archeological implications for reconstruction of diet and crop management practices. Journal of Archaeological Science 34, 335–343.

Buchachenko, A.L., 2007. New isotope research in chemistry and biochemistry. Nauka, Moscow (In Russian).

Cook, G.T., Bonsall, C., Hedges, R.E.M., McSweeney, K., Boroneant, V., Bartosiewicz, L., Pettitt, P.B., 2002. Problems of dating human bones from the Iron Gates. Antiquity 76, 77–85.

Demkin, V.A., Borisov, A. V., Demkina, T.S., Yeltsov, M.V., Borisova, M.A., Klepikov, V.M., Sergatskov, I.V., Dyachenko, A.N., Shishlina, N. I., Tsutskin, E. V., 2002. The Yergueni Hills soil and environment development during the Eneolithic and Bronze Ages (Razvitiye pochv i prirodnoy sredy Ergeninskoy vozvyshennosty v epochi eneolita i bronzy), in: Shishlina, N.I., Tsutskin, E.V. (Eds.), Ostrovnoy kurgan burial ground. Results of interdisciplinary investigation of North-western Caspian archaeological sites. State Historical museum, Moscow, 107–131. (In Russian).

Dinesman, L.G., Bold G., 1992. History of animal grazing and development of pasture degradation in the Mongolia Steppes, in: Historical ecology of wild and domesticated ungulate animals. Nauka, Moscow, pp. 10–35. (In Russian).

Hollund, H.I., Higham, T., Belinskij, A., Korenevskij, S., 2010. Investigation of palaeodiet in the North Caucasus (South Russia) Bronze Age using stable isotope analysis and AMS dating of human and animal bones. Journal of Archaeological Science 37, 2971–2983.

Iacumin, P., Bocherens, H., Chaix, L., Marioth, A., 1998. Stable Carbon and Nitrogen Isotopes as Dietary Indicators of Ancient Nubian Populations (Northern Sudan). Journal of Archaeological Science 25, 293–301.

Jay, M., Richards, M.P., 2006. Diet of the Iron Age cemetery population at Wetwang Slack, East Yorkshire, UK: carbon and nitrogen stable isotope evidence. Journal of Archaeological Science 33, 653–662.

Keenleyside, A., Schwarcz, H.P, Stirling, L., Lazreg, N.B., 2009. Stable isotopic evidence for diet in a Roman and Late Roman population from Leptiminus, Tunisia. Journal of Archaeological Sciences 36, 51–63.

Lanting, J.N., van der Plicht, J., 1998. Reservoir effects and apparent ^{14}C-ages. The Journal of Irish Archaeology IX, 151–165.

Lavrenko, E.M., Karamysheva, Z.V., Nikulina, R.I., 1991. Eurasian Steppes (Stepi Evrazii). Nauka, Leningrad (In Russian).

Lecolle, P., 1985. The Oxygen isotope composition of landsnail shells as a climate indication: application to hydrogeology and paleoclimatology. Chemical Geology (Isotope Geosciences Section), 157–181.

Masanov, N., 1995. Nomadic civilization of the Kazaks (the base of the vital functions of nomadic society) (Kochevaya tsivilizatsiya kazakhov) (osnovy zhiznedeyatelnosti nomadnogo obschestva). Sotsinvest–Gorizont, Almaty-Moscow. (In Russian).

Novikova, M.A., 2001. Short description of vegetation of MuSharet-1 and Mu-Sharet-4 watershed plateau in the Iki-Burul rayon of Kalmykia, in: Shishlina, N.I., Tsutskin, E.V. (Eds.), Mu-Sharet burial grounds in Kalmykia: interdisciplinary investigation. State Historical museum, Moscow, pp. 43–50.

Orfinskaya, O. V., Golikov, V. P., Shishlina, N.I., 1999. Complex experimental research of textile goods from the Bronze Age Eurasian Steppes (Kompleksnoye experimentalnoye issledovaniye tekstilnykh izdeliy epokhi bronzy Evraziyskikh stepey), Shishlina, N.I. (Ed.), Textile of the Bronze Age Eurasian Steppe. Papers of the State Historical Museum. Vol. 109. State Historical Museum, Moscow, pp. 58–184. (In Russian).

Richards, M.P., Pearson, J.A., Molleson, T.I., Russel, N., Martin, L., 2003. Stable Isotope Evidence of Diet at Neolithic Catalhoyuk, Turkey. Journal of Archaeological Sciences 30, 67–76.

Schwarcz, H.P., Dupras, T.L., Fairgrieve, S.I., 1999. d^{15}N Enrichment in the Sahara: In Search of a Global Relationship. Journal of Archaeological Science 26, 629–636.

Shishlina, N., 2008. Reconstruction of the Bronze Age of the Caspian Steppes. Life styles and life ways of pastoral nomads. BAR International Series 1876. Archaeopress, Oxford.

Shishlina, N. I., van der Plicht, J., Hedges, R. E.M., Zazovskaya E. P., Sevastianov V. S., Chichagova, O. A., 2007. The catacomb cultures of the North-west Caspian steppes: ^{14}C chronology, reservoir effect, and paleodiet. Radiocarbon 49 (2), 713–726.

Shishlina, N.I., Zazovskaya, E.P., van der Plicht, J., Hedges, R.E.M., Sevastyanov, V.S., Chichagova, O.A., 2009. Paleoecology, Subsistence and ^{14}C Chronology of the Eurasian Caspian Steppe Bronze Age. Radiocarbon 51 (2), 481–500.

Thompson, A.H., Richards, M.P., Shortland, A., Zakrzewski, S.R., 2005. Isotopic paleodiet studies of Ancient Egyptian fauna and humans. Journal of Archaeological Science 32, 451–463.

Table 3 | Faunal stable isotope data from the Caspian and Volga Steppes and the North Caucasus area

Site name	Sample	Species	$\delta^{13}C$, ‰	$\delta^{15}N$, ‰
Eneolithic period: 4300–3800 calBC				
Khvalynsk II	grave 10	cattle (*Bos*)	−20.0	+7.5
Khvalynsk I	grave 127	animal? bone	−20.7	+14.5
Khvalynsk I	grave 147	sheep (*Ovis aries*)	−17.8	+11.6
Myskhako I	B-39, level 15	dolphin	−13.5	+9.2
Myskhako I	E-24, level 16	cattle (*Bos*)	−19.6	+7.9
Myskhako I	E-24, level 16	cattle (*Bos*)	−20.0	+6.41
Steppe Majkop period: 3500–3000 calBC				
Novosvobodnaya/Klady	kurgan 2	deer teeth	−22.9	+6.9
Novosvobodnaya/Klad y	kurgan 2	deer teeth	−22.1	+4.0
Yamnaya culture period: 3000–2500 calBC				
Mu-Sharet-4	kurgan 1, grave 3	sheep (*Ovis aries*)	−18.8	+7.2
Zynda-Tolga-3	kurgan 1, grave 4	sheep (*Ovis aries*)	−23.5	+11.8
Sukhaya Termista	kurgan 1, grave 11	ungulate bone	−19.9	+5.7
Panitskoye	grave 6A	ungulate bone	−19.4	n/a
Early Catacomb culture period: 2700–2400 calBC				
Peschany-V	kurgan 1, ritual place 1	horse (*Equus caballus*)	−21.1	+4.6
Peschany-V	kurgan 5, grave 3	saiga (*Saiga tatarica*)	19.3	+8.5
Peschany-V	kurgan 5, grave 3	sheep (*Ovis aries*)	−18.5	+9.5
Peschany-V	kurgan 5, grave 3	sheep (*Ovis aries*)	−19.3	+8.5
Temrta III	kurgan 1, ritual place 7	sheep (*Ovis aries*)	−19.4	+9.5
Temrta III	kurgan 1, ritual place 1	horse (*Equus caballus*)	−19.9	+5.9
Temrta-I	kurgan 1, grave 3	sheep (*Ovis aries*)	−21.5	+12.4
Temrta-I	kurgan 1, grave 3	sheep (*Ovis aries*)	−18.2	+11.2
Baga-Burul	kurgan 5, grave 19	sheep (*Ovis aries*)	−18.5	+9.9
Mandjikiny-1	kurgan 54, ritual place	sheep (*Ovis aries*)	−18.6	+7.4
Zunda-Tolga-5	kurgan 1, grave 4	sheep (*Ovis aries*)	−17.9	+12.6
Zunda-Tolga-5	kurgan 1, grave 7	ungulate bone	−20.0	+5.3
Temrta V	kurgan 1, grave 2	ungulate animal bone	−18.2	+8.7
Temrta V	kurgan 1, grave 7	ungulate bone	−21.0	+5.3
VMLBII,66	kurgan 80, grave 3	sheep (*Ovis aries*)	−17.9	+9.0
VMLBII,66	kurgan 9, grave 2	sheep (*Ovis aries*)	−18.6	+6.8
Steppe North Caucasus culture period: 2700–2400 calBC				
Zunda-Tolga-1	kurgan 1, grave 11	sheep (*Ovis*)	−18.1	+8.2
Mu-Sharet-1	kurgan 1, grave 6	sheep (*Ovis*)	−16.5	+11.3
Mu-Sharet-1	kurgan 1, grave 6	sheep (*Ovis*)	−20.2	+13.0
Mu-Sharet-1	kurgan 1, grave 6	sheep (*Ovis*)	−16.5	+11.3
East Manych and West Manych Catacomb cultures period: 2500–2200 calBC				
Baga-Burul	kurgan 5, ritual place 4	horse (*Equus caballus*)	−20.6	+6.2
Baga-Burul	kurgan 5, ritual place 4	cattle (*Bos*)	−16.6	+9.9

Table 3 | continued

Site name	Sample	Species	δ¹³C, ‰	δ¹⁵N, ‰
Baga-Burul	kurgan 5, ritual place 15	sheep (*Ovis aries*)	−19.3	+8.2
Baga-Burul	kurgan 1, grave 3	cattle (*Bos*)	−19.1	+9.2
Baga-Burul	kurgan 1, grave 3	sheep (*Ovis aries*)	−19.3	+7.3
Baga-Burul	kurgan 5, grave 12	sheep (*Ovis aries*)	−16.6	+10.7
Baga-Burul	kurgan 5, grave 8	sheep (*Ovis aries*)	−17.4	+9.2
Ostrovnoy	kurgan 5, grave 38	sheep (*Ovis aries*)	−19.2	+6.6
Ostrovnoy	kurgan 5, grave 9	sheep (*Ovis aries*)	−17.7	+6.4
Ostrovnoy	kurgan 3, grave 9	sheep (*Ovis aries*)	−18.1	+7.6
Ostrovnoy	kurgan 6, grave 8	sheep (*Ovis aries*)	−19.5	+8.1
Ostrovnoy	kurgan 6, grave 8	sheep (*Ovis aries*)	−18.2	+7.5
VMLBI,65	kurgan 43, grave 1	sheep (*Ovis aries*)	−19.9	+9.7
Zunda-Tolga-1	kurgan 8, grave 1	sheep (*Ovis aries*)	−18.6	+8.7
Zunda-Tolga-1	kurgan 9, grave 1	sheep (*Ovis aries*)	−17.3	+9.7
Zunda-Tolga-1	kurgan 10, grave 3	sheep (*Ovis aries*)	−18.8	+5.1
Chilgir	kurgan 1, grave 4	sheep (*Ovis aries*)	−15.5	+12.0
Chilgir	kurgan 2, grave 5	sheep (*Ovis aries*)	−21.5	+9.2
Chilgir	kurgan 3, ritual place B	cattle (*Bos*)	−16.1	+11.9
Temrta V	kurgan 1, grave 4	sheep (*Ovis aries*)	−16.0	+10.1
Yergueni	kurgan 6, grave 3	sheep (*Ovis aries*)	−14.2	+12.7
Yergueni	kurgan 6, grave 2	sheep (*Ovis aries*)	−15.5	+12.0
Yergueni	kurgan 6, grave 5	sheep (*Ovis aries*)	−16.2	+13.1
Yergueni	kurgan 6, grave 10	sheep (*Ovis aries*)	−15.9	+10.3
Mandjikiny-I	kurgan 14, grave 1	sheep (*Ovis aries*)	−16.3	+10.3
Mandjikiny-I	kurgan 14, ritual place 21	sheep (*Ovis aries*)	−24.1	+10.3
Shakhaevskaya	kurgan 4, grave 32	fish pike	−16.5	+14.9
Kovalevka*	kurgan 3 grave 2	fish (*Rutilus frisii* (Nordm)	−23.8	+8.5
Rykan**	level 2	cattle (*Bos*)	−19.8	+5.2
Rykan**	level 2	cattle (*Bos*)	−19.8	+6.7
Lola culture period: 2200–2000 calBC				
Ostrovnoy	kurgan 3, grave 39	sheep (*Ovis aries*)	−16.3	+12.3
Ostrovnoy	kurgan 6, grave 9	sheep (*Ovis aries*)	−15.8	+4.6
Temrta-1	kurgan 2, grave 8	cattle (*Bos*)	−18.6	+9.7
Sukhaya Termista I	kurgan 1, grave 10	ungulate bone	−18.9	+7.0

* Excavation of V.A.Gorodsov, Donets River region, State Historical museum collection
** Rykan Catacomb culture site is located in the Voronezh area, Middle Don River region

Table 4 | Human stable isotope data from the Caspian and Volga Steppes and the North Caucasus area

Site name	Sample	Sex/age	δ^{13}C, ‰	δ^{15}N, ‰
Eneolithic period: 4300–3800 calBC				
Khvalynsk II	grave 10	male	−20.3	+13.9
Khvalynsk II	grave 18	human	−22.3	+13.5
Khvalynsk II	grave 24	human	−20.2	+13.7
Khvalynsk II	grave 34	human	−20.5	+10.2
Khvalynsk II	grave 35	human	−21.9	+13.7
Nalchik	grave 86	male adult	−20.7	+8.9
Steppe Majkop period: 3500–3000 calBC				
Mandjikiny-1	kurgan 14, grave 13	male	−18.8	+11.6
Sharakhalsun-6	kurgan 5, grave 7	child	−16.7	+15.2
Sharakhalsun-6	kurgan 2, grave 17	child	−18.3	+13.4
Aygursky-2	kurgan 17, grave 6	human	−18.5	+15.9
Zolotarevka-1	kurgan 22, grave 11	human	−18.5	+14.1
Yamnaya culture period: 3000–2500 calBC				
Mu-Sharet-4	kurgan 12, grave 1	male 17–20	−18.0	+14.3
Mandjikiny-2	kurgan 11, grave 2	male 35–45	−17.5	+15.2
Mandjikiny-2	kurgan 11, grave 3	women 45–50	−16.6	+18.0
Mandjikiny-1	kurgan 14, grave 12	male 17–25	−18.6	+14.1
Mandjikiny-1	kurgan 14, grave 10	male 20–25	−18.1	+14.0
Mu-Sharet-4	kurgan 11, grave 3	woman 14–17	−16.5	+15.3
Khar-Zukha	kurgan 2, grave 3	woman 20	−16.0	+13.7
Poludny	kurgan 2, grave 7	male 45	−17.4	+15.0
Chilgir	kurgan 2, grave 3	male *matures*	−15.4	+17.6
Peschany V	kurgan 1, grave 3	male 30–40	−18.8	+13.2
Sukhaya Termista	kurgan 1, grave 11	female	−15.7	+16.6
Grachevka	kurgan 5, grave 2	juveniles	−19.0	+10.5
Yashkul 1	kurgan 1, grave 18	adult	−15.3	+18.4
Early Catacomb culture period: 2700–2400 calBC				
Peschany V	kurgan 1, grave 1	female 25–35	−18.2	+14.1
Peschany V	kurgan 1, grave 5	human adult	−16.2	+16.5
Peschany V	kurgan 2, grave 3	male 40–45	−18.1	+15.7
Peschany V	kurgan 3, grave 1	male 45–50	−17.0	+17.1
Peschany V	kurgan 3, grave 2	male 40–45	−21.5	+15.2
Peschany V	kurgan 4, grave 1	male 50–60	−17.3	+16.1
Peschany V	kurgan 5, grave 6	child 4	−17.7	+16.1
Peschany V	kurgan 5, grave 5	adult	−17.5	+15.2
Temrta III	kurgan 1, grave 1	female 30–35	−18.3	+14.9
Temrta III	kurgan 1, grave 4	male 40–45	−18.1	+14.7
Temrta III	kurgan 2, grave 1	male? 45–50	−17.8	+14.1
Temrta-I	kurgan 1, grave 2	female 20–25	−17.5	+13.1
Temrta-I	kurgan 1, grave 3	child 10–11	−17.6	+15.5

Table 4 | continued

Site name	Sample	Sex/age	δ13C, ‰	δ15N, ‰
Temrta-I	kurgan 2, grave 3	child 10	−17.5	+16.2
Baga-Burul	kurgan 5, grave 6	male 30–35	−18.7	+12.6
Mandjikiny-2	kurgan 37, grave 3	male 15–16	−16.5	+16.5
Mandjikiny-2	kurgan 42, grave 1	female 40–45	−17.1	+17.2
Mandjikiny-2	kurgan 42, grave 4	child 3–4	−15.2	+18.1
Mandjikiny-2	kurgan 45, grave 2	male 17–20	−17.1	+17.5
Mandjikiny-2	kurgan 54, grave 6	female 25–35	−17.5	+15.0
Mandjikiny-1	kurgan 14, grave 6	male 55–65	−17.5	+15.4
Mu-Sharet	kurgan 8, grave 3	female 17–19	−17.4	+15.5
Ulan-Zukha	kurgan 3, grave 8	adult	−17.5	+14.4
Zunda-Tolga-2	kurgan 1, grave 1	male adultus	−17.4	+16.1
Zunda-Tolga-2	kurgan 2, grave 1	male >50	−17.2	+16.6
Zunda-Tolga-2	kurgan 2, grave 3	male around 35	−18.6	+13.9
Zunda-Tolga-5	kurgan 1, grave 5	male senilis	−18.6	+14.0
Zunda-Tolga-5	kurgan 1, grave 7	female 50–55	−17.7	+14.9
Temrta V	kurgan 1, grave 2	female 17–20	−17.9	+12.4
Temrta V	kurgan 1, grave 2	male 20–25	−20.6	n/a
Temrta V	kurgan 1, grave 3	female 40–50	−17.9	+10.7
Temrta V	kurgan 1, grave 3	female 40–50	−17.4	+15.4
Temrta V	kurgan 1, grave 3	male 40–50	−17.7	+12.7
Temrta V	kurgan 1, grave 3	male 40–50	−17.1	+15.6
Khar-Zukha –1	kurgan 5, grave 3B	female senilis	−15.4	+18.1
Khar-Zukha –1	kurgan 7, grave 4	male 30–35	−18.1	+14.1
Khar-Zukha –1	kurgan 1, grave 5	male 45–50	−17.6	+15.6
Sukhaya Termista I	kurgan 1, grave 2	adult	−18.9	+11.9
Sukhaya Termista I	kurgan 3, grave 20	male 40–45	−19.2	+13.6
Sukhaya Termista I	kurgan 1, grave 3	female 18–20	−17.5	+15.0
Sukhaya Termista II	kurgan 1, grave 11	female 25–30	−15.7	+16.4
Sukhaya Termista II	kurgan 1, grave 13	male >55	−16.8	+15.2
Steppe North Caucasus culture period: 2700–2400 calBC				
Zunda-Tolga-1	kurgan 1, grave 11	male 15–17	−18.4	+12.2
Mandjikiny-2	kurgan 7, grave 2	male 30–40	−17.7	+16.0
Yashkul 1	kurgan 1, grave 13	juvenile	−17.7	+12.1
East Manych and West Manych Catacomb cultures period: 2500–2200 calBC				
Baga-Burul	kurgan 5 grave 11	female 25–35	−16.9	+15.8
Baga-Burul	kurgan 5, grave 21	male < 45	−17.8	+14.2
Ostrovnoy	kurgan 3, grave 10	male 35	−17.6	+12.7
Zunda-Tolga-1	kurgan 9, grave 1	male 50	−16.9	+14.1
Zunda-Tolga-1	kurgan 10, grave 2	female 50–60	−16.5	+16.3
Zunda-Tolga-1	kurgan 10, grave 3	male 35	−19.3	+14.1
Zunda-Tolga-5	kurgan 1, grave 5	male 50–60	−18.6	+14.0
Chilgir	kurgan 1, grave 4	female < 45	−17.2	+15.7

Table 4 | continued

Site name	Sample	Sex/age	δ^{13}C, ‰	δ^{15}N, ‰
Temrta V	kurgan 1, grave 4	female 25–35	−17.7	+ 9.4
Temrta III	kurgan 1, grave 6	human 25–30	−15.4	+18.6
Peschany-V	kurgan 1, grave 4	male 30–35	−16.0	+16.1
Peschany-V	kurgan 5, grave 5	male 50–60	−17.5	+15.2
Mandjikiny-I	kurgan 10, Grave 2	female 45–40	−16.7	+17.2
Mandjikiny-I	kurgan 14, grave 1	male 30–35	−16.5	+17.6
Chogray IX	kurgan 14, grave 8	adult	−17.7	+14.5
Chogray IX	kurgan 8, grave 2	adult	−17.9	+15.4
Lola and Krivaya Luka cultures period: 2200–2000 calBC				
Ostrovnoy	kurgan 3, grave 39	female 20–30	−17.3	+16.0
Mandjikiny-1	kurgan 9, grave1	male 35–40	−17.1	+15.0
Yashkul 1	kurgan 1, grave 19	juvenile	−16.3	+18.3
Temrta-1	kurgan 2, grave 8	male 40–50	−18.4	+12.9
Temrta-1	kurgan 2, grave 5	male	−16.9	+11.1
Sukhaya Termista	kurgan 1, grave 2	adult	−18.9	+11.1
Sukhaya Termista	kurgan 1, grave 10	female 45–35	−17.3	−14.5
Sukhaya Termista	kurgan 1, grave 4	juvenile 16–18	−16.9	+14.9
Khar-Zukcha	kurgan 5, grave 2A	adult	−17.9	+14.5
Linevo	kurgan 6, grave 6	adult	−19.1	+8.9
Linevo	kurgan 8, grave 2	adult	−18.4	+9.6

Johanna Irrgeher[a,1], *Maria Teschler-Nicola*[b], *Katrin Leutgeb*[a], *Christopher Weiß*[a], *Daniela Kern*[c], *Thomas Prohaska*[a,*]

Migration and mobility in the latest Neolithic of the Traisen Valley, Lower Austria: Sr isotope analysis

*	Corresponding author: thomas.prohaska@boku.ac.at
a	University of Natural Resources and Life Sciences Vienna, Department of Chemistry, Division of Analytical Chemistry, VIRIS Laboratory, Tulln, Austria
b	Natural History Museum Vienna, Department of Anthropology, Vienna, Austria
c	Project 'The Endneolithic of the Lower Traisen valley', Vienna, Austria
1	Recipient of a DOC-fFORTE fellowship of the Austrian Academy of Sciences

Abstract

In the last forty years, continuing rescue excavations in the Lower Traisen valley (Unteres Traisental) in Lower Austria have identified about 180 burials dating to the final Neolithic (2600–2200 BC). They belong to the Corded Ware culture and Late Bell Beaker culture. Enamel from permanent teeth of a total of 49 individuals originating from Subsites I, II and III of the Franzhausen (FH) excavation area were analysed with respect to their strontium isotopic composition. The aim was to identify locals and nonlocals and to contribute to questions of mobility and migration. We applied a validated routine procedure for Sr isotope ratio measurements using solution-based multiple collector inductively coupled plasma mass spectrometry (MC-ICP-MS). In addition, recent soil samples from the Franzhausen area were extracted by ammonium nitrate solutions in order to delimit the local isotope signal of bioavailable Sr in the region. $^{87}Sr/^{86}Sr$ ratios in the enamel revealed that about 88 % of the investigated individuals are autochthonous. These data were subjected to a further detailed evaluation with respect to the individuals' age at death and sex, as well as to a possible spatial differentiation (FH I, II and III) and cultural affiliation. Sr isotope ratio data show no pattern regarding age at death. Higher mobility was found for male individuals compared to that for females. Results evaluated according to chronological and spatial subgroups imply differences in mobility. Distinct groups of representatives of the Corded Ware culture in the subsites were identified as nonlocals, whereas all of the investigated individuals assigned to the Late Bell Beaker culture were locals.

Keywords

Strontium isotopes, MC-ICP-MS, Traisen Valley, Austria, Corded Ware, Bell Beaker

Introduction

The application of strontium (Sr) isotopic analysis to investigate movement, mobility and/or migration, as well as to reconstruct dietary characteristics of both humans and animals, has developed as a key tool in archaeological, archaeozoological, archaeobotanical and anthropological science (Ericson, 1985; Ezzo et al., 1997; Grupe et al., 1997; Latkoczy et al., 1998; Price et al., 1998; Burmeister, 2000; Schweissing and Grupe, 2003; Price et al., 2004; Bentley, 2006; Bendrey et al., 2009; Towers et al., 2009; Copeland et al., 2010; Montgomery, 2010). It is a well known fact that Sr stands out due to its unique properties concerning significant regional differences in its isotopic composition (geological fingerprint), ubiquity in nature and accessibility in a broad set of diverse sample matrices (Ericson, 1985; Capo et al., 1998). For that reasons, researchers in a range of disciplines conduct Sr isotope analyses using either thermal ionization mass spectrometry (TIMS) or multiple collector inductively coupled plasma mass spectrometry (MC-ICP-MS) (Capo et al., 1998, Prohaska et al., 2002; Fortunato et al., 2004; Grousset and Biscaye, 2005; Swoboda et al., 2008; Brunner et al., 2010). Due to its chemical similarity to calcium (Ca), Sr acts as a proxy for Ca. As a consequence, dietary Sr is easily incorporated into Ca-rich tissues such as tooth and bone. During this process the Sr isotopic signature specific to a particular location is also stored in the human skeleton and therefore has the potential, depending on the type of tissue and its specific turnover, to reflect Sr uptake during a specific time period of an individual's life (Capo et al.,

1998; Bentley, 2006). Human enamel, with its compact physical structure and growth characteristics, has been shown to act as a reservoir of the bioavailable Sr taken up during the early years of an individual's life and thus represents a reliable matrix for mobility and migration studies. It is widely accepted that enamel is less susceptible to significant diagenetic changes (Budd et al., 1998; Lee-Thorp and Sponheimer, 2003; Prohaska et al., 2003; Hoppe et al., 2004; Price et al., 2006; Shaw et al., 2009; Montgomery, 2010). Nonetheless, a cautious approach to interpretation is obligatory when attempting to determine the local signal and the dietary Sr sources of the investigated individuals (Price et al., 2002; Montgomery, 2010).

Determining the locally specific bioavailable Sr isotopic signature is an essential prerequisite to answering questions about residence changes, migration and mobility behaviour or the provenance of food sources. So far, approaches to defining and delimiting a 'cut-off' range for the Sr isotopic background of a region differ greatly: ranges have, e.g., been based on values determined for local rock, soil or ground water (Beard and Johnson, 2000), on human bone within an investigated group (Grupe et al., 1997) and on fossil and/or modern local animals (Price et al., 2002).

The burial grounds of Franzhausen in the Lower Traisen Valley have been dated to approximately 2600–2200 BC. The individuals buried at the site belong to the Corded Ware culture and Late Bell Beaker culture and therefore coincide with the transitional period from the Neolithic to the Bronze Age. A number of studies underline evidence of locally varying mobility and/or migration in Europe at this transitional period (Price et al., 1994; Grupe et al., 1997; Price et al., 1998; Grupe et al., 1999; Price et al., 2004; Haak et al., 2008; Nehlich et al., 2009). The project presented here is the first comprehensive transdisciplinary study on an End-Neolithic population in Eastern Austria combining geographic background, mortuary practice, anthropological studies (sex, age, pathology, demography, enthesopathies, and $^{87}Sr/^{86}Sr$ isotope analysis), typology and raw-material analysis of the grave goods, use-wear analysis, experimental studies and radiocarbon dating. Detailed description of grave goods, archaeological features and considerations, as well as background information on the site itself, can be found in the archaeological part of this study presented in Kern (this volume); this paper addresses the $^{87}Sr/^{86}Sr$ isotope analysis.

Materials and methods

All preparatory laboratory work was performed in a Class 100,000 clean room. Type I reagent-grade water (18 MΩ cm) (F+L GmbH, Vienna, Austria) was further purified by subboiling distillation (Milestone-MLS GmbH, Leutkirch, Germany). Nitric acid (HNO_3) was prepared by double subboiling distillation of analytical reagent grade acid (65% m/m) (Merck KGaA, Darmstadt, Germany). All polyethylene (PE) flasks, tubes and pipette tips (VWR International GmbH, Vienna, Austria), as well as perfluoroalkoxy (PFA) screw cap vials (Savillex, Minnetonka, USA), were cleaned in a two-stage washing procedure using HNO_3 (10% m/m and 1% m/m) and were then rinsed with Type I reagent-grade water before use.

Table 1 | Parameters and strontium isotope results

Sample description			Anthropological data**			Sample weight	Sr isotope ratios		Sr	Rb	
sample code	site	grave number	tooth	age of death/y	biol. sex	arch. sex	mg	$^{87}Sr/^{86}Sr$	SD (1σ)	µg g^{-1}	ng g^{-1}
1	I	34	36	8 ± 24 m	undet.	f	0,0123	0,71034	0,00002	95,1	1182,0
2	I	117	36	35–45	m	m	0,0270	0,71040	0,00001	104,5	185,5
3	I	351	36	25–30	m?	m	0,0175	0,70916	0,00001	162,2	348,5
4	I	352	46	35–50	f	f	0,0254	0,70957	0,00001	123,2	1213,8
5	I	353	36	15–17	undet.	m	0,0246	0,71178	0,00001	131,5	725,2
6	I	357	37	40–60	f	f	0,0142	0,71035	0,00001	99,0	264,3
7	I	358	46	20–30	f	m	0,0197	0,71001	0,00002	119,6	944,9
8	I	548	15	20–40	undet.	m	0,0190	0,71016	0,00001	159,9	115,3
9	I	585	37	35–45	f	f	0,0232	0,70990	0,00001	141,9	121,4
10	III	1	36	20–30	m	m	0,0289	0,70913	0,00001	94,8	162,5
11	III	2	16	25–30	m	m	0,0164	0,71272	0,00002	75,9	438,6
12	III	4	36	12–13	undet.	f	0,0219	0,71013	0,00003	78,1	250,0
13	III	5	36	5 ± 16 m	undet.	m	0,0160	0,70980	0,00004	81,2	1260,8
14	III	6	46	30–40	m	m	0,0169	0,71245	0,00002	91,7	231,3
15	III	7	36	6–7	undet.	f	0,0217	0,70932	0,00002	87,3	209,1
16	III	8	36	30–40	m?	m	0,0140	0,70866	0,00003	126,3	815,3
17	III	9	46	19–22	f	f	0,0207	0,71032	0,00003	122,8	612,1
18	III	738	47	21–25	f	f	0,0249	0,71251	0,00004	97,4	182,3
19	III	1055	26	25–35	f	f	0,0213	0,71308	0,00006	73,3	191,0
20	II	56A	26	30–40	f	f	0,0211	0,70974	0,00002	79,3	281,7
21	II	57	47	30–40	indiff.	m	0,0776	0,70957	0,00001	92,4	89,1
22	II	103	28	40–60	m	f	0,0171	0,71044	0,00003	161,9	192,1
23	II	400	46	20–25	indiff.(f??)	m	0,0135	0,70975	0,00001	161,1	81,1
24	II	643	26	40–60	f??	f	0,0250	0,70937	0,00002	133,9	106,4
25	II	685	36	30–50	f?	f	0,0109	0,71022	0,00001	91,3	71,7
26	II	730	36	20–25	indiff.	f	0,0196	0,70924	0,00004	224,6	47,9
27	II	767	36	30–40	f	f	0,0233	0,70992	0,00001	95,0	73,9
28	II	768	36	15–20	f?	f	0,0170	0,70921	0,00001	128,7	18,4
29	II	1188	36	20–25	(f)	f	0,0195	0,70934	0,00001	119,6	64,2
30	II	1300	36	7 ± 24 m	undet.	f	0,0185	0,70975	0,00002	107,3	177,5
31	II	1301	27	30–40	m	m	0,0409	0,70926	0,00001	81,6	195,4
32	II	2112	27	40–60	f	f	0,0096	0,71070	0,00001	90,4	< LOQ
33	II	3083	36	25–35	f	f	0,0133	0,71003	0,00001	70,6	35,3
34	II	3167	16	14–16	undet.	f	0,0147	0,70966	0,00002	144,7	95,7
35*	II	3342	36	25–35	f	f	0,0133	0,71076	0,00003	128,6	23,5
36	II	3346	17	35–45	f?	f	0,0376	0,70991	0,00001	115,5	70,8
37	II	3348	26	18–20	f	f	0,0181	0,71004	0,00002	164,7	172,8
38	II	3369	37	40–60	m	m	0,0414	0,71046	0,00002	112,6	49,2
39*	II	3373	16	6–7	undet.	?	0,0171	0,71009	0,00002	188,1	45,7
40*	II	3376	46	30–35	f	f	0,0293	0,70968	0,00001	248,2	64,1
41*	II	3377	46	5–6	undet.	f	0,0148	0,70989	0,00003	193,6	84,5
42*	II	3378	36	9–11	undet.	f	0,0200	0,71088	0,00001	119,4	31,3
43*	II	3380	46	5–6	undet.	m	0,0126	0,70971	0,00002	103,6	136,5
44*	II	3382	26	30–50	m	m	0,0149	0,70890	0,00009	92,5	73,5
45	II	3386	26	25–30	f?	f	0,1170	0,71033	0,00001	75,2	66,0
46*	II	3407	17	25–35	m	m	0,0126	0,71084	0,00001	132,6	49,6
47	II	3409	36	30–40	f	f	0,0185	0,71010	0,00003	88,0	50,7
48	II	3419	26	30–45	f	f	0,0112	0,71031	0,00001	128,4	< LOQ
49	II	3422	36	6–7	undet.	m	0,0146	0,71001	0,00001	102,9	53,5

* Bell Beaker culture / **Anthropological data after Margit Berner and Karin Wiltschke-Schrotta

Samples and sample preparation

Permanent teeth were sampled from 49 individuals from the Franzhausen subsites I (n = 9), II (n = 30) and III (n = 10). Selection was based on availability and state of preservation. Forty-one individuals buried in the three areas belong to the Corded Ware culture, whilst 8 individuals originating from subsite Franzhausen II were identified on the basis of archaeological findings as representatives of the Late Bell Beaker culture (Kern, this volume). One permanent tooth was extracted from each individual. Parameters are given in Table 1.

Tooth samples were sonicated for approximately 5 minutes in HNO_3 (1% m/m) followed by a rinsing step using Type I reagent-grade water to eliminate surface contamination. The samples were dried at room temperature. Entire tooth fragments of enamel or a few mg of tooth material (Table 1) were sampled using a dental diamond drill (Edenta AG, Au, Switzerland). Samples were digested in a mixture of 1 mL analytical grade H_2O_2 (30% m/m) (Merck KGaA, Darmstadt, Germany) and 2 mL doubly subboiled HNO_3 (65% m/m) by hot plate (IKA, Staufen, Germany) assisted acid digestion at temperatures of approximately 120–150°C for 2 hours. Precleaned PFA screw cap vials were used for digestion. The digested samples were transferred to PE vessels, which were filled up to 10 g using HNO_3 to obtain a final molar concentration of 8 mol L^{-1}. One blank was generated for each digestion run consisting of 9 samples.

In addition, 6 recent soil samples from the burial grounds of Franzhausen were randomly taken during the excavation and ~ 20 g thereof were further processed for isotopic analyses. The soil samples were spread in open Petri dishes, dried in an oven (WTB Binder, Binder GmbH, Tuttlingen, Germany) overnight at 60°C and subsequently passed through a 2-mm sieve. The bioavailable metal fractions were extracted in duplicates from the samples by NH_4NO_3 extraction, which was performed according to DIN V 19730 (1997). Therefore, ~ 25 mL 1 mol L^{-1} NH_4NO_3 (Rectapur, VWR International GmbH, Vienna, Austria) were added to ~ 10 g of dried soil sample and shaken at 20 rpm at room temperature for 2 hours using a GFL 3040 overhead rotator (GFL Gesellschaft für Labortechnik GmbH, Burgwedel, Germany). After sedimentation, the extracts were filtered using folded filters (Munktell Filter AB, Falun, Sweden) and acidified with doubly subboiled HNO_3 (65% m/m) to a final concentration of 1% (m/m) for stabilization.

Elemental analysis by inductively coupled plasma quadrupole mass spectrometry (ICP-QMS)

Strontium and rubidium (Rb) concentration analysis was performed using an ICP-QMS (ELAN DRCe, Perkin Elmer, Ontario, Canada) by external calibration (9-point calibration ranging from 0.05 ng g^{-1} to 200 ng g^{-1}) with standards prepared gravimetrically from a commercially available multi-element stock solution (multi-element standard Merck VI, 10 mg L^{-1}; Merck KGaA) including 10 ng g^{-1} indium (In) as internal normalization standard (Merck KGaA). Samples were diluted, digested tooth samples at 1:12.5 and extracted soil samples at 1:50, prior to measurement using HNO_3 (1% m/m). Blank correction was accomplished by aspirating HNO_3 (1% m/m) and intensities were normalized to ^{115}In. Instrumental parameters are given in Table 2.

Table 2 | Operating parameters of ICP-QMS (ELAN DRCe)

RF power	1300 W
Auxilliary gas flow rate	0.75 L min^{-1}
cool gas flow rate	13.0 L min^{-1}
nebuliser gas flow rate	0.98–1.02 L min^{-1}
sampler cone	nickel
skimmer cone	nickel
detection system	secondary electron multiplier
sample introduction system	cyclonic spray chamber with Micromist nebuliser
sample uptake rate	500 µL min^{-1}

Table 3 | Operating parameters of MC-ICP-MS (Nu Plasma HR)

RF power	1300 W
auxilliary gas flow rate	1.2 L min^{-1}
cool gas flow rate	13.0 L min^{-1}
typical sensitivity on Sr	600–730 V per µg g^{-1}
sampler cone	nickel
skimmer cone	nickel
measurement statistics	6 blocks of 10 measurements
detection system	Faraday collectors
masses monitored (m/z)	82, 83, 84, 85, 86, 87, 88
resolution mode	low resolution (m/Δm = 300)
axial mass (m/z)/mass separation	86/0.5
sample introduction system	DSN 100 with PFA nebuliser
sample uptake rate	130 µL min^{-1}
DSN nebuliser pressure	30–40 psi
DSN hot gas flow	0.3–0.4 L min^{-1}
DSN membrane gas flow	2.5–3.5 L min^{-1}
DSN spray chamber temperature	112–113°C
DSN membrane temperature	120–123°C

Sr isotope ratio measurements by MC-ICP-MS

Sr/matrix separation prior to isotopic analysis was performed according to the method described in Swoboda et al. (2008) using a Sr specific resin (ElChrom Industries, Inc., Darien, IL, USA) with a particle size of 100 µm to 150 µm. Three mL frit tubes (Separtis, Grenzach-Wyhlen, Germany) and filters (pore size: 10 µm) (Separtis, Grenzach-Wyhlen, Germany) were used for separation. Approximately 0.5 mL of resin in the column was conditioned and washed using 6–8 mol L^{-1} HNO$_3$. Sample elution was performed using subboiled water. The eluted samples were screened for the efficiency of the Sr/matrix separation as well as for determination of the Sr concentration after separation. For that purpose, ICP-QMS (monitoring the isotopes ^{85}Rb and ^{88}Sr) was used (instrumental parameters are shown in Table 2). In order to attain optimal signal intensity and stability for subsequent MC-ICP-MS analysis, the samples were diluted to approximately 10 ng g^{-1} Sr with 1% HNO$_3$ (m/m).

Fig. 1 | Sr isotope ratios of enamel arranged by increasing values and evaluated by age at death. Solid data points represent subadult individuals (age at death: <20 y); open data points represent adult individuals (age at death: >20 y). The dashed line corresponds to the mean $^{87}Sr/^{86}Sr$ ratio in the mobile phase of the soil. The defined local Sr isotopic range of the area is indicated by the black lines (lower and upper limit) and is defined as 2σ of the values after outlier-correction (see text)

Strontium isotope ratio measurements were taken with a MC-ICP-MS instrument (Nu Plasma HR, Nu Instruments Ltd., Wrexham, UK). A desolvation nebulisation membrane unit (DSN 100, Nu Instruments Ltd.) was used in combination with a PFA nebuliser (Microflow ST Nebuliser, Elemental Scientific Inc., Nebraska, USA) as sample introduction system. Instrumental parameters for Sr isotopic analysis are summarized in Table 3. The detector arrangement and optimized measurement conditions are described in detail elsewhere (Ohno and Hirata, 2007; Swoboda et al., 2008). Blank correction was performed using the 'measure zero' method implemented in the Nu Plasma instrument software by aspirating solutions of 1% HNO_3 (m/m) prior to every set of 6 samples. Stock solutions in the µg g^{-1} range of NIST SRM 987 $SrCO_3$ (NIST, Gaithersburg, MD, USA) were prepared gravimetrically in 1% HNO_3 (m/m). The certified absolute abundance ratios are $^{86}Sr/^{88}Sr$ (0.11935 ± 0.00325), $^{87}Sr/^{86}Sr$ (0.71034 ± 0.00026) and $^{84}Sr/^{86}Sr$ (0.05655 ± 0.00014), whereas the generally accepted values of $^{87}Sr/^{86}Sr$ are 0.71026 (Balcaen et al., 2005; Faure and Mensing, 2005) and 0.710245 (Müller et al., 2003; Faure and Mensing, 2005). A solution of 10 ng g^{-1} Sr of NIST SRM 987 was measured as quality control every sixth sample and showed a mean $^{87}Sr/^{86}Sr$ ratio of 0.71030 ± 0.00014 (1σ). Mass bias correction and correction for residual Rb in the sample was performed according to Ehrlich et al. (2004). A relative standard uncertainty (RSU, k = 1) of 0.005% was calculated according to EURACHEM/GUM (Eurachem, 1993; ISO, 1993) taking into account blank, Rb and mass bias correction.

Table 4 | Sr isotopic composition of soil extracts

Sample code	$^{87}Sr/^{86}Sr$	RSU (%, k = 1)
FH 67–2	0,71007	0,005
FH 73–5	0,70989	0,005
FH 78–3	0,70991	0,005
FH 80–7	0,70992	0,005
FH 80–8	0,70994	0,005
FH 09–6	0,71000	0,005
Mean	0,70995	0,005

Results and discussion

The Sr isotopic signal of the local soil was determined through the analysis of an ammonium nitrate extraction. This extract directly reflects the isotopic signature of bioavailable Sr in the mobile phase of the soil in the area of Franzhausen. The fact that the bioavailable Sr in a distinct area is reflected by soil extraction is supported by previous studies (Beard and Johnson, 2000; Schweissing and Grupe, 2003; Swoboda et al., 2008; Brunner et al., 2010). Isotopic data of the samples overlap within their uncertainties (Table 4) and show a mean $^{87}Sr/^{86}Sr$ ratio of 0.70995 ± 0.00011 (1σ).

The Sr isotopic composition of the enamel samples is given in Table 1 and Figure 1 shows the $^{87}Sr/^{86}Sr$ ratios in the enamel of all individuals sorted in order of increasing values. In order to check the homogeneity of the isotopic composition of the investigated individuals, we calculated a mean value and used the ± 2σ range to identify the outlying individuals found at the site. The mean value of all $^{87}Sr/^{86}Sr$ ratios is 0.71016 ± 0.00095 (1σ). This value accords (within the uncertainties) with the prior determined signal of the bioavailable Sr of the area.

As a consequence, samples 11, 14, 18 and 19 fell outside of a 2σ range (0.70826–0.71206) of the mean $^{87}Sr/^{86}Sr$ ratio in enamel samples and were therefore not included in the second iteration. The mean value and the corresponding 2σ range of the remaining 45 samples were recalculated, yielding a final $^{87}Sr/^{86}Sr$ mean value of 0.70994 and a range (2σ) of 0.70876–0.71111 (Fig. 1). On the basis of this definition of the autochthonous signal, six nonlocal individuals (samples 5, 11, 14, 16, 18, 19) were characterized among the investigated group of 49 people, corresponding to a total of 12 % nonlocals. Some of these individuals archaeometrically identified as "nonautochthonous" individuals were also characterized as nonlocal on the basis of their grave goods. E.g. Grave 8/Sample 16 contained the skeletal remains of a 30 to 40-year-old man, who was equipped with a needle of foreign shape, which can be seen as an additional indicator for his nonlocal origin. The 25 to 35-year-old woman found in Grave 1055/Sample 19 was buried in a magnificent grave that included a large set of grave goods (three vessels, copper earrings and copper beads, stone tools and a dagger made of Arnhofen tabular flint) (for details see Kern, this volume).

The assessment of the age of death of the individuals is shown in Figure 1. Age categories used in this study were adult and subadult, with the cut-off of age determined as death at 20 years. We counted 36 adults (>20 y) and 13 subadult individuals (<20 y), thus comprising fractions of 73 % and 27 %, respectively. The individuals of the three subareas reveal similar fractions of adult and subadult individuals (I: 78 % adult/22 % subadult; II: 73 % adult/27 % subadult; III: 70 % adult/30 % subadult). Five out of the six nonlocal individuals (Samples 11, 14, 16, 18, 19) are adult; the age at death for the sixth individual (Sample 5) was estimated at between 15 and 17 years. That individual originates in Area I.

Amongst the adults (n = 36), five individuals (14 %, Samples 11, 14, 16, 18, 19) were identified as nonlocal, whereas among the subadults (n = 13), one individual (8 %, Sample 5) was found to be of nonlocal origin.

According to the archaeological sex determination (including all individuals) – based on gender specific bipolar burial orientation (Kern, this volume) (Fig. 2a) – 30 individuals were female and 18 were male. Out of those, two of the females (7 %, Samples 18, 19) and four of the males (22 %, Samples 5, 11, 14, 16) were identified as nonlocals. The gender of one individual could not be determined (Sample 39).

Out of the 22 female adults, two individuals (9 %, Samples 18, 19) were identified as nonlocals, whereas among the 14 male adults, three individuals (21 %, Samples 11, 14, 16) were identified as nonautochthonous.

According to the anthropological determination of the sex of the individuals (Fig. 2b), 22 individuals were female and 11 were male. Out of these, two female individuals (9 %, Samples 18, 19) and three males (27 %; Samples 11, 14, 16) were identified as nonlocals. Sex could not be determined for 16 individuals (33 %); one of those 16 individuals (Sample 5) was identified as nonlocal.

Among 11 adult males, three (27 %, Samples 11, 14, 16) were identified as nonlocals, whereas two of the 21 adult females (10 %, Samples 18, 19) were of nonlocal origin. The results resulting from the two approaches do not differ conspicuously and imply higher mobility among male individuals.

Figure 3 shows the distribution of the investigated individuals with respect to Burial Areas I, II and III. One of the six nonlocals originates from Area I (Sample 5). Five (Samples 11, 14, 16, 18, 19) out of six nonlocal individuals were buried in Area III, resulting in a fraction of 50 % nonlocals within the investigated group (n = 10), thus revealing a higher fraction of nonlocals in comparison to those determined for Subarea I (11 % nonlocals) and Subarea II (0 % nonlocals). Due to the total number of individuals involved, it is clear that the statistical relevance of this finding is limited, and that caution must be used in its interpretation. However, it is interesting to consider that not only are these individuals grouped with respect to the location of the burial site (Franzhausen III) but that they also represent the chronologically earliest Corded Ware group investigated in Franzhausen.

In the following, we compare the results of the Sr isotope ratios of the representatives of the Corded Ware culture with those of the Bell Beaker culture individuals (Fig. 4). The $^{87}Sr/^{86}Sr$ ratios in enamel from all eight individuals for whom archaeological evidence indicates affiliation with the Bell Beaker culture (Samples 35, 39, 40, 41, 42, 43, 44, 46) are within the local Sr isotope range determined for the area of Franzhausen and all of these eight samples originate from Subarea II. Fifty percent of those individuals belonging to the Late Bell Beaker culture are subadults.

Conclusions

Approximately 88 % of the individuals recovered at the Franzhausen site were classified as local individuals based on Sr isotopic composition of their tooth enamel.

With regard to the autochthony of the individuals within the three spatially distributed subareas (I, II and III), we obtained evidence that a higher number of individuals can be assigned a nonautochthonous origin in Subarea III than is the case for individuals buried at Subareas I and II. With respect to the chronology of these graves, the results of our Sr isotope investigation seem to indicate that the migration rate was highest in the earliest Corded Ware phase.

Fig. 2a | Sr isotope ratios of enamel arranged by increasing values and evaluated by archaeological sex. Solid data points represent male individuals; open data points represent female individuals. The black triangle indicates one individual with undeterminable sex. The dashed line corresponds to the mean $^{87}Sr/^{86}Sr$ ratio in the mobile phase of the soil. The defined local Sr isotopic range of the area is indicated by the black lines (lower and upper limit) and is defined as 2σ of the values after outlier-correction (see text)

Fig. 2b | Sr isotope ratios of enamel arranged by increasing values and evaluated by anthropological sex. Solid data points represent male individuals; open data points represent female individuals. The black triangles indicate individuals with undeterminable sex. The dashed line corresponds to the mean $^{87}Sr/^{86}Sr$ ratio in the mobile phase of the soil. The defined local Sr isotopic range of the area is indicated by the black lines (lower and upper limit) and is defined as 2σ of the values after outlier-correction (see text)

Fig. 3 | Sr isotope ratios of enamel arranged by increasing values and evaluated by burial areas. Solid triangles correspond to individuals found in Subarea I; open data points represent individuals buried in Subarea II; black rectangular data points represent individuals from Subarea III. The dashed line corresponds to the mean ^{87}Sr/^{86}Sr ratio in the mobile phase of the soil. The defined local Sr isotopic range of the area is indicated by the black lines (lower and upper limit) and is defined as 2σ of the values after outlier-correction (see text)

Fig. 4 | Sr isotope ratios of enamel arranged by increasing values and evaluated by their assignment to Corded Ware or Bell Beaker culture. Solid data points correspond to individuals representing the Bell Beaker culture; open data points represent individuals belonging to the Corded Ware culture. The defined local Sr isotopic range of the area is indicated by the black lines (lower and upper limit) and is defined as 2σ of the values after outlier-correction (see text)

Several morphometric studies have reported differences between the mobility of males and females belonging to ancient groups that subsequently populated the same area (e.g. early Bronze Age populations) (Teschler-Nicola, 1993; Pellegrini et al., 2010). As we were aware of these findings, our intention was to shed light on the mobility pattern of their predecessors. Interestingly, we found that the mobility of males was approximately twice as high as that of the females investigated. This result is independent of whether biological characteristics or grave goods are used for sex determination. This – again – runs counter to previous studies on Bell Beaker as well as Corded Ware migration, which have found higher proportions of migrants among females than among males (Price et al., 2004, Haak et al. 2008).

Unlike other studies on Bell Beaker migration in Europe, this study found that the representatives of the Bell Beaker culture who inhabited the Lower Traisen Valley around Franzhausen were all indigenous. This runs counter to published data in the field, which showed substantial mobility in the Bell Beaker period in Central Europe (Grupe et al., 1997; Price et al., 2004). However, considering the small number of individuals investigated, we have to be careful when drawing a general conclusion. Still, local variability is likely to exist in the migratory behaviour of the purportedly highly mobile Bell Beaker people. This study, in which, for the first time, Corded Ware people are also included, should be extended to other sites to permit a reliable answer to be found to a question of population dynamic phenomena at this particular transitional period that has been discussed for some time.

As these initial results look promising, further investigations will include the analysis of teeth from the remaining individuals in order to complete the data set on the burial grounds (including all subareas) and complete the study within the investigated population. Additionally, direct radiocarbon dating of human skeletal remains should shed light on unanswered questions about the chronology of all the subareas differentiated at the site, including the subareas IV, V and VI, which have not yet been subjected to radiocarbon dating and Sr isotope analysis.

Acknowledgements

Many thanks go to the Austrian Academy of Sciences and the Austrian Science Fund FWF (START project 267 N11 'VIRIS'; project P21404-B17 'IsoMark' and project P18131 'The Endneolithic of the Lower Traisen valley') for the financial support of this work. We thank Margit Berner and Karin Wiltschke-Schrotta from the Natural History Museum Vienna for providing anthropological data as given in Table 1. The authors are grateful to the Department of Forest and Soil Science of the University of Natural Resources and Life Sciences Vienna for providing the equipment needed for soil extraction.

References

Balcaen, L., De Schrijver, I., Moens, L., Vanhaecke, F., 2005. Determination of the Sr-87/Sr-86 isotope ratio in USGS silicate reference materials by multi-collector ICP-mass spectrometry. International Journal of Mass Spectrometry 242, 251–255.

Beard, B.L., Johnson, C.M., 2000. Strontium isotope composition of skeletal material can determine the birth place and geographic mobility of humans and animals. Journal of Forensic Sciences 45, 1049–1061.

Bendrey, R., Hayes, T.E., Palmer, M.R., 2009. Patterns of Iron Age horse supply: An analysis of strontium isotope ratios in teeth. Archaeometry 51, 140–150.

Bentley, R.A., 2006. Strontium isotopes from the earth to the archaeological skeleton: A review. Journal of Archaeological Method and Theory 13, 135–187.

Brunner, M., Katona, R., Stefánka, Z., Prohaska, T., 2010. Determination of the geographical origin of processed

spice using multielement and isotopic pattern on the example of Szegedi paprika. European Food Research and Technology. doi 10.1007/s00217-010-1314-7.

Budd, P., Montgomery, J., Cox, A., Krause, P., Barreiro, B., Thomas, R.G., 1998. The distribution of lead within ancient and modern human teeth: Implications for long-term and historical exposure monitoring. Science of the Total Environment 220, 121–136.

Burmeister, S., 2000. Archaeology and migration – Approaches to an archaeological proof of migration. Current Anthropology 41, 539–567.

Capo, R.C., Stewart, B.W., Chadwick, O.A., 1998. Strontium isotopes as tracers of ecosystem processes: theory and methods, in: National Meeting of the Soil Science Society of America, Elsevier Science Bv, Seattle, Washington, pp. 197–225.

Copeland, S.R., Sponheimer, M., Lee-Thorp, J.A., le Roux, P.J., de Ruiter, D.J., Richards, M.P., 2010. Strontium isotope ratios in fossil teeth from South Africa: Assessing laser ablation MC-ICP-MS analysis and the extent of diagenesis. Journal of Archaeological Science 37, 1437–1446.

DIN V 19730, 1997. Bodenbeschaffenheit-Extraktion von Spurenelementen mit Ammoniumnitratlösung, Beuth, Berlin.

Ehrlich, S., Ben-Dor, L., Halicz, L., 2004. Precise isotope ratio measurement by multicollector-ICP-MS without matrix separation. Canadian Journal of Analytical Sciences and Spectroscopy 49, 136–147.

Ericson, J.E., 1985. Strontium isotope characterization in the study of prehistoric human etiology. Journal of Human Evolution 14, 503–514.

Eurachem, 1993. Quantifying Uncertainty in Analytical measurement. LGC, Teddington, UK.

Ezzo, J.A., Johnson, C.M., Price, T.D., 1997. Analytical perspectives on prehistoric migration: A case study from East-Central Arizona. Journal of Archaeological Science 24, 447–466.

Faure, G., Mensing, T., 2005. Isotopes: Principles and Applications, 3rd ed., Wiley, Hoboken, NJ, USA.

Fortunato, G., Mumic, K., Wunderli, S., Pillonel, L., Bosset, J.O., Gremaud, G., 2004. Application of strontium isotope abundance ratios measured by MC-ICP-MS for food authentication. Journal of Analytical Atomic Spectrometry 19, 227–234.

Grousset, F.E., Biscaye, P.E., 2005. Tracing dust sources and transport patterns using Sr, Nd and Pb isotopes. Chemical Geology 222, 149–167.

Grupe, G., Price, T.D., Schröter, P., Sollner, F., Johnson, C.M., Beard, B.L., 1997. Mobility of Bell Beaker people revealed by strontium isotope ratios of tooth and bone: a study of southern Bavarian skeletal remains. Applied Geochemistry 12, 517–525.

Grupe, G., Price, T.D., Söllner, F., 1999. Mobility of Bell Beaker people revealed by strontium isotope ratios of tooth and bone: A study of southern Bavarian skeletal remains. A reply to the comment by Peter Horn and Dieter Müller-Sohnius. Applied Geochemistry 14, 271–275.

Haak, W., Brandt, G., De Jong, H.N., Meyer, C., Ganslmeier, R., Heyd, V., Hawkesworth, C., Pike, A.W.G., Meller, H., Alt, K.W., 2008. Ancient DNA, strontium isotopes, and osteological analyses shed light on social and kinship organization of the later stone age. Proceedings of the National Academy of Sciences of the United States of America 105, 18226–18231.

Hoppe, K.A., Stover, S.M., Pascoe, J.R., Amundson, R., 2004. Tooth enamel biomineralization in extant horses: Implications for isotopic microsampling. Palaeogeography, Palaeoclimatology, Palaeoecology 206, 355–365.

ISO, 1993. Guide of Expression to Uncertainty in Measurement, Geneva.

Latkoczy, C., Prohaska, T., Stingeder, G., Teschler-Nicola, M., 1998. Strontium isotope ratio measurements in prehistoric human bone samples by means of high-resolution inductively coupled plasma mass spectrometry (HR-ICP-MS). Journal of Analytical Atomic Spectrometry 13, 561–566.

Lee-Thorp, J., Sponheimer, M., 2003. Three case studies used to reassess the reliability of fossil bone and enamel isotope signals for paleodietary studies. Journal of Anthropological Archaeology 22, 208–216.

Montgomery, J., 2010. Passports from the past: Investigating human dispersals using strontium isotope analysis of tooth enamel. Annals of Human Biology 37, 325–346.

Müller, W., Fricke, H., Halliday, A.N., McCulloch, M.T., Wartho, J.A., 2003. Origin and Migration of the Alpine Iceman. Science 302, 862–866.

Nehlich, O., Montgomery, J., Evans, J., Schade-Lindig, S., Pichler, S.L., Richards, M.P., Alt, K.W., 2009. Mobility or migration: a case study from the Neolithic settlement of Nieder-Mörlen (Hessen, Germany). Journal of Archaeological Science 36, 1791–1799.

Ohno, T., Hirata, T., 2007. Simultaneous determination of mass-dependent isotopic Fractionation and radiogenic isotope variation of strontium in geochemical samples by multiple collector-ICP-mass spectrometry. Analytical Sciences 23, 1275–1280.

Pellegrini, A., Teschler-Nicola, M., Bookstein, F.L., Mitteroecker, P., in press. Geometric Morphometric Analysis of Cranial Morphology in Austrian early Bronze Age Populations. Journal of Archaeological Science.

Price, T.D., Grupe, G., Schröter, P., 1994. Reconstruction of migration patterns in the Bell Beaker period by stable strontium isotope analysis. Applied Geochemistry 9, 413–417.

Price, T.D., Grupe, G., Schröter, P., 1998. Migration in the Bell Beaker period of central Europe. Antiquity 72, 405–411.

Price, T.D., Burton, J.H., Bentley, R.A., 2002. The characterization of biologically available strontium isotope ratios for the study of prehistoric migration. Archaeometry 44, 117–135.

Price, T.D., Knipper, C., Grupe, G., Smrcka, V., 2004. Strontium isotopes and prehistoric human migration: The Bell Beaker period in central Europe. European Journal of Archaeology 7, 9–40.

Price, T.D., Wahl, J., Bentley, R.A., 2006. Isotopic evidence for mobility and group organization among neolithic farmers at Talheim, Germany, 5000 BC. European Journal of Archaeology 9, 259–284.

Prohaska, T., Latkoczy, C., Schultheis, G., Teschler-Nicola, M., Stingeder, G., 2002. Investigation of Sr isotope ratios in prehistoric human bones and teeth using laser ablation ICP-MS and ICP-MS after Rb/Sr separation. Journal of Analytical Atomic Spectrometry 17, 887–891.

Prohaska, T., Latkoczy, C., Schultheis, G., Teschler-Nicola, M., Stingeder, G., 2003. Investigation of stable Sr isotope ratios in prehistoric human bones and teeth using laser ablation ICP-MS. American Journal of Physical Anthropology, Suppl. 36, 171–171.

Schweissing, M.M., Grupe, G., 2003. Stable strontium isotopes in human teeth and bone: A key to migration events of the late Roman period in Bavaria. Journal of Archaeological Science 30, 1373–1383.

Shaw, B.J., Summerhayes, G.R., Buckley, H.R., Baker, J.A., 2009. The use of strontium isotopes as an indicator of migration in human and pig Lapita populations in the Bismarck Archipelago, Papua New Guinea. Journal of Archaeological Science 36, 1079–1091.

Swoboda, S., Brunner, M., Boulyga, S.F., Galler, P., Horacek, M., Prohaska, T., 2008. Identification of Marchfeld asparagus using Sr isotope ratio measurements by MC-ICP-MS. Analytical and Bioanalytical Chemistry 390, 487–494.

Teschler-Nicola, M., 1993. Untersuchungen zur Bevölkerungsbiologie der Bronzezeit in Österreich. Habilitationsschrift, University of Vienna.

Towers, J., Montgomery, J., Evans, J., Jay, M., Pearson, M.P., 2009. An investigation of the origins of cattle and aurochs deposited in the Early Bronze Age barrows at Gayhurst and Irthlingborough. Journal of Archaeological Science 37, 508–515.

*Daniela Kern**

Migration and mobility in the latest Neolithic of the Traisen valley, Lower Austria: Archaeology

* Free lance archaeologist: Vienna: Daniela-eve.kern@aon.at

Abstract

In the course of the project "Das Endneolithikum im Unteren Traisental (The Endneolithic of the Lower Traisen valley)",184 graves from 16 grave groups situated at 10 sites were investigated. Most of the graves belonged to the Corded Ware culture and 27 graves to the Bell Beaker culture. In this article we concentrate on the grave groups designated Franzhausen I, Franzhausen II and Franzhausen III. "Foreign" types and raw materials were concentrated in the graves of Franzhausen III but not in those of Franzhausen I. This raises the question of whether these two grave groups, which differ in material culture and chronologically, also differ with respect to the associated migration patterns. To answer this question, the human remains were investigated by $^{87}Sr/^{86}Sr$ isotope analysis. Franzhausen II, which features graves belonging to almost all of the Late Neolithic phases found in Franzhausen, was used as a control group. Samples of the teeth needed for analysis were available for 49 individuals. Among these 49 individuals, six were identified as outliers; five of those came from Franzhausen III.

The investigation of the archaeological material and the $^{87}Sr/^{86}Sr$ isotope analyses of skeletal remains of the Late Neolithic of Traisen valley revealed that both types of investigation are capable of detecting human mobility and they can provide mutual confirmation of results. For the population of this period we have ascertain that the migration rate for the earlier phase of the Corded Ware culture was greater, whereas a more sedentary life style can be discerned for the later phase of the Corded Ware culture and the later phase of the Bell Beaker culture. Nevertheless as the numbers of investigated individuals are still low, we must treat these results with caution and steer clear of far-reaching interpretations.

Keywords

Migration, Corded Ware culture, Bell Beaker culture, Austria, Traisen valley, Franzhausen

Background

As we are living in "the Age of Migration" (Castles and Miller, 2003), it is not surprising that migration is a topic of discussion among archaeologists as well. Migration is a complex social process, one which affects both migrating and non-migrating persons and societies, as well as the places that migrating individuals are associated with or come into contact with (Oswald, 2007; Strasser, 2009). Crossing borders as it does, migration is a topic of interest in many disciplines of the sciences and humanities: sociology (individual and social causalities and consequences, transformations and social consequences), political science (political participation of migrants, citizenship, integration, comparison of migration and asylum policy of different countries), jurisprudence (rights of migration and asylum, also in different countries), economics (economic causalities and consequences of migration, changes of the labour market and the job situation), geography (structure of populations, demographic changes, migration as a spatial and social phenomenon), history (social-historical and economic-historical comparisons and descriptions of migrations), psychology (individual causalities and consequences of migration, mastering and development of identity during and after migration), cultural and social anthropology (social intercourse with alien or foreign values, research on (new) social and cultural behaviours of migrant and nonmigrant populations, analyses of politics and integration measures, of transnational and global processes und their local impacts, as well as of questions of identity and ethnicity) (Oswald, 2007; Strasser, 2009) and physical anthropology and human biology (demography, evolution) (Gage, 2000; Huss-Ashmore, 2000).

Migration and mobility in archaeology

Archaeologists have been interested in migration and mobility for as long as the discipline has existed, drawing on those topic to explain, for example, cultural change (*siedlungsarchäologische Methode, Kulturkreislehre* [Bernbeck, 1997; Demoule, 2006]) and foreign artefacts (Childe,1950). Having been banned from use in archaeological interpretations in the second half of the 20th century, particularly by processual archaeologists, (see also Beran, 2009; Pyzel, 2009) migration theories made a come-back in the new millennium (Andresen, 2004; Burmeister, 2000; Demoule, 2006; Prien, 2005)

In the fields of archaeology and physical anthropology, the terms migration and mobility are often used as synonyms, which is not the case (see also Nehlich et al., 2009). "Migration" translated literally means wandering (lat. migrare = to wander), meaning movement of individuals or groups in geographical or social space (Strasser, 2009). On the basis of various criteria, such as duration, distance, motivation etc., migrations are classified into various subtypes (Oswald 2007, 16; Strasser, 2009; Treibel, 2008). If one focuses on geographical space, migration can be defined as a change of residence, together with change of the social relations and crossing of social, (political) and/or cultural borders (Oswald, 2007), that may associated with push or pull factors in the form of living conditions, climate, conflicts (Demoule, 2006) or, last but not least, marriage. In contrast, mobility describes short-term movement, for example that associated with hunting, gathering, collecting, exchange and trade of raw materials and items; attending rituals or visiting relations or the acquisition of knowledge and skills (Thomas, 2005). In this paper, the terms migration and mobility are used with these different meanings, since the two phenomena leave different traces in the archaeological record. Migration can be detected by recognizing the presence of new or foreign technologies, for instance; mobility in the use of raw materials of foreign origin and syncretistic grave goods. The two phenomena can also be traced by performing different isotope analyses, migration, e.g., by $^{87}Sr/^{86}Sr$ isotope analyses. Nevertheless it is hard to distinguish between mobility and migration in the archaeological record, because in a highly mobile society the statistical chance of dying and being buried abroad is higher than it is for less mobile societies (Kern, 2003).

The Late Neolithic with its widespread distribution areas of cultural phenomena, such as the Corded Ware and Bell Beaker cultures, was the period selected for (early) isotope analyses in prehistory (Price et al., 1994; Grupe et al., 1997; Price et al., 1998; Grupe et al., 2001; Price et al., 2004; Heyd et al., 2005).

Migration and mobility in the Traisen valley in the Late Neolithic

The Traisen valley

The Traisen is a river that rises in the Alps, and, flowing northward, reaches the Danube near Traismauer, approximately 40 km west of Vienna (Fig. 1). The geological subsoil in the southern part of the valley is made up of sandstone and limestone from the Alps, while in the north there are glacial sediments, like gravel covered by loess. Northwest of the Traisen valley are the granites and gneisses of the Bohemian Massive. Over the last 40 years, large scale rescue excavations conducted for the most part due to gravel extraction, hundreds of thousands of post-holes and thousands of settlement pits and graves from the Early Neolithic to the Middle Ages have been uncovered, causing the Traisen valley to

Fig. 1 | Austria and Traisen valley

become one of the best known archaeological areas in Austria. Preliminary report about this excavations are published since 1981 in "Fundberichte aus Österreich" (e.g. Neugebauer, Gattringer;1981). In the course of the project "Das Endneolithikum im Unteren Traisental (The Endneolithic of the Lower Traisen valley)" 184 graves from 16 grave groups situated at 10 sites were investigated. Most of the graves belonged to the Corded Ware culture; 27 graves were from the Bell Beaker culture. Both cultures were distributed over wide areas of Europe in the 3rd millennium BC. Both cultures buried their dead in a crouched position, with males and females oriented differently. In the Corded Ware culture males were buried with their heads to the west; females' heads were oriented to the east. Both men and women faced south. In the Bell Beaker culture, males were buried with their heads to the north, females with their heads to the south, both sexes faced east. Anthropological analyses have shown that adherence to these rules was very high, with only a few exceptions (Kern, 2001).

The project on the latest Neolithic in the Traisen valley mentioned above is the first comprehensive synthetic study for this period in Eastern Austria dealing with geographic background, mortuary practice, anthropological studies, biomechanics, typology and raw material analyses of the grave goods, such as ceramic and stone artefacts, bone/antler artefacts and copper artefacts, use-wear analyses, experimental studies (Kern and Lobisser; 2010; Grömer and Kern, 2010), archaeological investigations, radiocarbon dating and $^{87}Sr/^{86}Sr$ isotope analyses.

Franzhausen

The most important site investigated in this project is Franzhausen, which holds 135 graves in six spatially divided grave groups (Franzhausen I – Franzhausen VI). In this paper we will concentrate on Franzhausen I, II and III, as isotope analyses were performed on skeletal remains from these groups. Franzhausen I is the latest grave group of the Corded Ware groups from Franzhausen. No decorated beakers were found in any of the 15 graves, but excavators did find a lot of other vessels, such as jugs and jars and large amphorae, that were not present in some other grave groups of Franzhausen. Only two graves contained tools made of flint and in only one grave was there an axe. Copper artefacts were found in four graves. Only one grave did not contain any grave goods. None of the graves were completely empty, but two did not contain skeletal remains. $^{87}Sr/^{86}Sr$ isotope analyses could be performed on teeth from 9 individuals. Of the 71 graves of Franzhausen II, 57 belong to the Corded Ware culture and 15 to the late Bell Beaker culture. Franzhausen II encompasses the earliest grave in Franzhausen that contained a beaker with cord impressions; it also contained a footed bowl that is typical for the Kosihy-Čaka-Makó Group (Kern, in press). There were nine completely empty graves (eight Corded Ware, one Bell

Beaker), ten graves that contained human remains but no grave goods (based on skeletal orientation, seven of these were Corded Ware, three Bell Beaker) and 6 that had no human remains but did have grave goods. Teeth from thirty individuals could be used for isotope analyses. The 16 graves of Franzhausen III can be divided chronologically into two phases. Both phases predate Franzhausen I. Pottery is scarce in most of these graves. The graves of male individuals often contain only tools made of stone and bone (Fig. 2–3). In the graves of the later phase, pottery typologically similar to that in Franzhausen I was found, but the surface was often roughened. The grave group from the later phase had only one grave with copper artefacts. Only one grave had skeletal remains but no grave goods and there were no empty graves. Three graves contained grave goods but not skeletal remains.

Comparing Franzhausen I, Franzhausen II and Franzhausen III, we can see that the number of vessels per grave increases over time while the number of graves with stone artefacts decreases.

The raw materials making up the grave goods can be separated into three groups: local materials that were available within 20 km, regional materials available within 100 km and nonregional materials that were brought from a distance of over 100 km. Examples for nonregional materials are daggers (Fig. 5.15) made of Arnhofen tabular flint from present-day Bavaria and tools made of erratic flint that must have been brought from at least as far away as present-day northern Bohemia or northern Moravia. Analyses of the copper artefacts have revealed that the copper came from Slovakia. This confirms the movement of raw materials and items which, obviously, entails the movement of individuals. Given all this mobility of raw material, human mobility must have been high in the Traisen valley in the late Neolithic. But what can we say about migration?

Some of the vessels, like the footed bowl mentioned above, show close connections to neighbouring areas. Bowls of that type are distributed in the Carpathian Basin and are rare in Austria and Moravia (Kulcsár, 2002; Matějíčková,1999; Ruttkay, 1973). Some of the decorated beakers are similar to beakers found in present-day Moravia; others resemble beakers that have been found in present-day Bavaria. Thin section analyses of 39 vessels of the Corded Ware and the Bell Beaker cultures from Franzhausen II showed that almost all of these vessels were locally produced. That means that it was not the vessels that moved, but the persons who made them. "Foreign" types (e.g. cord decorated beaker, hammer headed pin (*Krückennadel*) were present in Franzhausen III but not in Franzhausen I. That raised the question of whether a difference in the migration patterns associated with these two grave groups, which are different in terms of material culture and chronology, also exists. To answer that question, $^{87}Sr/^{86}Sr$ isotope analyses were performed on the human remains (Irrgeher et al., this volume). Franzhausen II, which contains graves belonging to almost all of the Late Neolithic phases found in Franzhausen, was used as a control group. Samples of the teeth needed for analyses were available for 49 individuals. Among these 49 individuals, six were identified as outliers (Irrgeher et al., this volume).

Archaeological interpretation of the results of the $^{87}Sr/^{86}Sr$ isotope analyses

Franzhausen I

The grave of only one nonindigenous individual (Feature 353) was found in the grave group of Franzhausen I. Unfortunately the grave of this juvenile male (sexed archaeologically based on skeletal orientation) did not contain any items (Fig. 2, top).

Fig. 2 | Franzhausen I, Feature 353 and Franzhausen III, Feature 2

Pl. 2

Franzhausen III
Grave feat. 6

Franzhausen III
Grave feat. 8

Fig. 3 | Franzhausen III, Feature 6 and Feature 8

Fig. 4 | Franzhausen III, Feature 738

Franzhausen III
Grave feat. 738

MIGRATION AND MOBILITY IN THE LATEST NEOLITHIC OF THE TRAISEN VALLEY, LOWER AUSTRIA 219

The low migration rate in this group also seems to be reflected in the local types of pottery, which show more similarity to vessels of the Pannonian plain. In this grave group, silex artefacts were present in only two rich male graves. It is probable that as connections to present-day Moravia were cut off objects made of erratic flint became precious. On the other hand, though the results point to a low migration rate, this may be misleading: migration of persons coming from the east can pass unrecognized due to the similarity of the strontium isotope values of the regions (Price et al., 1994)

Franzhausen II

A total of 30 individuals were analysed, 22 belonging to the Corded Ware and 8 to the Late Bell Beaker culture. All individuals analysed were indigenous. That is interesting with respect to the Corded Ware Culture, because several influences and foreign artefacts and types were found in the graves of the investigated individuals: evidently, these were not connected with migration.

For the Late Bell Beaker culture, the low migration rate is reflected in the local types of pottery.

Franzhausen III

Out of ten individuals analysed, five were indigenous; three male and two female individuals were of foreign origin, all with values that likely reflect the older metamorphic highlands. In the graves of two males (Features 2 and 6) only artefacts made of bone and stone were found (Fig. 2, bottom, and Fig. 3, top). The axes were made of amphibolite and the chipped tools of erratic flint. The stone knife of Grave 6 is typologically comparable to the "flammförmige Messer" of the Corded Ware Culture found in Moravia and Bohemia (Valde-Nowak, 2000). In the grave Feature 738 (female) a stamp decorated beaker was found (Fig. 4.2) and in Feature 1055 (female) as well as in Feature 8 (male) there were beakers decorated with stamp and cord impressions (Fig. 3.2, bottom, and Fig. 5.6–7). The grave Feature 8 also contained a "Krückennadel" (Fig. 3.3) characteristic for Middle Germany and Eastern Europe (Gessner, 2005). Feature 1055 was a richly furnished grave of a woman aged 25–35 years. It contained three vessels, copper earrings and stone tools made of various foreign raw materials, such as a dagger of Arnhofen tabular flint. The concentration of foreign materials and types in this early Corded Ware Group correlates with the high migration rate of the individuals.

Comparison to earlier results

These strontium analyses were the first for the Corded Ware culture in Lower Austria and, as far as I know, none have been conducted on material from Moravia either (though there may exist as-yet unpublished results). Comparing the results with Corded Ware graves from Central Germany, where a higher mobility rate, or, in my terms, migration rate was detected for women (Haak et al., 2008), we can see a different migration pattern emerging for the Late Neolithic population in the Traisen valley.

Price and colleagues (2004) have published strontium isotope analyses on Bell Beaker individuals from Lower Austria. Researchers have investigated skeletal remains taken from five graves from three

Fig. 5 | Franzhausen III, Feature 1050

sites: Graves 8 and 16 from Zwingendorf-Alicenhof (Kern, 2001; Wiltschke-Schrottaet al., 2001); Graves 2 and 3 from Henzing (Friesinger, 1976; Jungwirth, 1976; Neugebauer, 1994), cited as Henzig in Price et al. (2004); and one from Hetzmannsdorf (Hasenhündl, 1990). Chronologically these three sites represent three slightly different phases. Zwingendorf is the oldest site and featured one decorated beaker in a grave (unfortunately without skeletal remains, therefore no isotope analysis was possible), Henzing is comparable to Franzhausen II, and the Hetzmanndorf site falls on the border of the Early Bronze Age. Henzing is geographically (marked on Fig. 4 and 6 in Price et al. [2004] as HN, not HE as indicated in the text) and chronologically closest to the late Bell Beaker graves from Franzhausen II. Grave 8 (young female) from Zwingendorf unfortunately did not contain any grave goods; in Grave 16 (male) were found one bowl, two jugs and one tiny fragment of a big vessel. Migration has been suggested for the two individuals from Henzing (Price et al., 2004). However, as the graves of Henzing were destroyed during gravel extraction, and the archaeological and anthropological remains were collected only afterwards, the connections between grave goods and skeletal remains are not clear. Thus the inventory of Grave 2 and Grave 3 cannot be seen as closed finds. Nevertheless an investigation of the archaeological objects of all the graves mentioned above indicates that they belong to the later phase of the Bell Beaker culture, as do the individuals of the Bell Beaker culture at Franzhausen II. No bell beaker was found in any of those graves; where pottery was present it was regional ware (*Begleitkeramik*). The low migration rate in the Bell Beaker graves of Franzhausen II supported the findings of Grupe et al. (1997) and Price et al. (1998), who also saw a more sedentary population in the younger phase of the Bell Beaker culture in contrast to a tendency for more migration in the older phase

Summary

The investigation of the archaeological material and the $^{87}Sr/^{86}Sr$ isotope analyses of skeletal remains of the Late Neolithic of Traisen valley revealed that both types of investigation are capable of detecting human mobility and can be used to confirm one another's results. With respect to the population under study, we can state that a higher migration rate exists for the earlier phase of the Corded Ware culture, whereas a more sedentary lifestyle can be discerned for the later phase of the Corded Ware Culture and the later phase of the Bell Beaker culture. Nevertheless as the numbers of investigated individuals are still low, we must treat the results with caution and steer clear of far-reaching interpretations.

Acknowledgements

I want to thank the Austrian Science Fund FWF for financing the project P 18131 "Das Endneoithikum in Unteren Traisental (The Endneolithic of the Lower Traisen valley)". Many thanks go to Vera Albustin and Ludwig Albustin (experimental archaeology – ceramics, Bell Beaker), Margit Berner and Karin Wiltschke-Schrotta (anthropological studies), Michael Brandl (raw material analyses – chipped stone tools), Monika Derndarsky (chert tool, use wear analyses), Michael Götzinger (raw material analyses – axes,) Karina Grömer (analyses of the cord impressions and experimental archaeology), Hajnolka Herold (raw material analyses – ceramic), Monika Krammer (geographical background), Wolfgang Lobisser (experimental archaeology – bone and antler items), Mathias Mehofer and Ernst Pernicka (raw material analyses – copper), Christine Neugebauer-Maresch (mortuary practice), Doris Pany (biomech-

anics), Erich Pucher (archaeozoology), Maria Wild (^{14}C-dates) and, last but not least, Johanna Irrgeher, Katrin Leutgeb, Thomas Prohaska, Maria Teschler-Nicola and Christopher Weiß (^{87}Sr/^{86}Sr isotope analyses; in this volume).

References

Andresen, M., 2004. Studien zur Geschichte und Methodik der archäologischen Migrationsforschung. Waxmann, Münster, New York, München, Berlin.

Beran, J., 2009. Trichterbecher und donauländische Restgruppen. Populationsdynamik zwischen norddeutscher Tiefebene und Mittelgebirgszone im Lichte neuer paläogenetische Untersuchungen. Beiträge zur Ur- und Frühgeschichte Mitteleuropas 53, 73–87.

Bernbeck, R., 1997. Theorien in der Archäologie. UTB, Tübingen, Basel.

Burmeister, S., 2000. Archaeology and migration. Approaches to an archaeological proof of migration. Current Anthropology 41 (4), 539–567.

Castles, St., Miller M., 2003. The Age of Migration: International Population Movements in the Modern World, 3rd ed., Guilford, New York, Palgrave Macmillan, Bassingstoke.

Childe V. G., 1950. Prehistoric migrations in Europe. Institutet for Sammenlignende Kulturforskning, Oslo.

Demoule, J.-P., 2006. Migrations et théories migratoires aux époques préhistoriques et protohistoriques, in: Vitali, D. (Ed.), Celtes et Gaulois. L'Archéologie face à l'histoire. La Préhistoire des Celtes. Actes de la table ronde de Bologna 28–29 mai 2005. Collection Bibracte 12 (2), pp. 17–28.

Friesinger, I., 1976. Glockenbecherzeitliche Grabfunde aus Henzing, Gemeinde Sieghartskirchen, politischer Bezirk Tulln, Niederösterreich. Annalen des Naturhistorischen Museums in Wien 80, 823–828.

Gage, T. B., 2000. Demography, in: Stinson, S., Bogin, B., Huss-Ashmore, R., O'Rourke, D. (Eds.), Human Biology: An Evolutionary and Biocultural Perspective. Wiley-Liss, New York, pp. 507–551.

Gessner, K. 2005. Vom Zierrat zum Zeichen von Identitäten. Soziokulturelle Betrachtungen auf der Grundlage des endneolithischen Schmucks im Mittelelbe-Saale Gebiet, Ethnographisch-Archäologische Zeitschrift 46, 1–26.

Grömer, K., Kern, D., 2010. Technical data and experiments on corded ware. Journal of Archaeological Science 37, 3136–3145.

Grupe, G., Price, T.D., Schröter P., Söllner, F., Johnson, C.M., Beard, B.L., 1997. Mobility of Bell Beaker people revealed by strontium isotope ratios of tooth and bone: a study of southern Bavarian skeletal remains. Applied Geochemistry 12, 517–525.

Grupe, G., Price, T. D., Schröter, P., 2001. Zur Mobilität in der Glockenbecherkultur. Eine archäometrische Analyse südbayerischer Skelettfunde. Internationale Archäologie. Arbeitsgemeinschaft, Symposium, Tagung, Kongress 2. VML, Rahden/Westfalen, pp. 207–213.

Haak, W., Brandt, G., De Jong, H.N., Meyer, C., Ganslmeier, R., Heyd, V., Hawkesworth, C., Pike, A.W.G., Meller, H., Alt, K.W., 2008. Ancient DNA, strontium isotopes, and osteological analyses shed light on social and kinship organization of the later Stone Age. Proceedings of the National Academy of Sciences of the United States of America 105, 18226–18231.

Hasenhündl, G., 1990. Hetzmannsdorf. Fundberichte aus Österreich 29, 193–194.

Heyd, V., Winterholler, B., Böhm, K., Pernicka, E., 2005. Mobilität, Strontiumisotopie und Subsistenz in der süddeutschen Glockenbecherkultur. Bericht der Bayerischen Bodendenkmalpflege 43–44, 2002–2003, 109–135.

Huss-Ashmore, R., 2000. Theory in human biology: Evolution, ecology, adaptability, and variation, in: Stinson, S., Bogin, B., Huss-Ashmore, R., O'Rourke, D. (Eds.), Human Biology: An Evolutionary and Biocultural Perspective. Wiley-Liss, New York, pp. 1–25.

Jungwirth, J., 1976. Vier spätneolithische Skelette aus Henzing, Gemeinde Sieghartskirchen, Niederösterreich. Annalen des Naturhistorischen Museums in Wien 80, 829–842.

Kern, D., 2000–2001. Endneolithisches Gräberfeld mit Glockenbechern von Zwingendorf/Alicenhof, VB Mistelbach, Niederösterreich, Archaeologia Austriaca 84–85, 307–328.

Kern, D., 2003. Glockenbecher in Ostösterreich – Andere Fragen andere Antworten?, in: Czebreszuk J., Szmyt, M. (Eds.), The Northeast Frontier of Bell Beakers. Proceedings of the symposium held at the Adam Mickiewicz University, Poznań (Poland) May 26–29 2002. BAR International Series 1155. Archaeopress, Oxford, pp. 249–254.

Kern, D., in press. Ostösterreich im Endneolithikum – Am Ende der Welt?, Publication Arbeitsgemeinschaft Neolithikum Meeting Greifswald.

Kern, D., Lobisser W., 2010. Pupperl und Pfeiferl – Zu einer schnurkeramischen Kinderbestattung von Franzhausen, Niederösterreich. Mitteilungen der Anthropologischen Gesellschaft in Wien 140.

Kulcsár, G., 2002. A Kárpát-medence kora bronzkori problémái a Makó-Kosihy-Čaka-és a Somogyvár-Vinkovci-kultúra időszakában. PhD thesis, Budapest.

Matějíčková, A. 1999. Eneolitické hroby z Modřic (Äneolithische Gräber von Modřice). Pravěk 9, 211–221.

Nehlich, O., Montgomery, J., Evans, J., Schade-Lindig, S., Pichler, S.L., Richards, M.P., Alt, K.W., 2009. Mobility or migration: a case study from the Neolithic settlement of Nieder-Mörlen (Hessen, Germany). Journal of Archaeological Science 36, 1791–1799.

Neugebauer, J.-W., 1994. Bronzezeit in Ostösterreich, Wissenschaftliche Schriftenreihe Niederösterreich 98/99/100/101.

Neugebauer, J.-W., Gattringer A., Die Kremser Schnellstraße S33. Vorbericht über Probleme und Ergebnisse der archäologischen Überwachung des Großbauvorhabens durch die Abteilung für Bodendenkmale des Bundesdenkmalamtes, Fundberichte aus Österreich 20, 1981, 157–190.

Oswald, I., 2007. Migrationssoziologie. UTB, Konstanz.

Price, T. D., Grupe, G., Schröter, P., 1994. Reconstruction of migration patterns in the Bell Beaker period by stable strontiom isotope analysis. Applied Geochemistry 9, 413–417.

Price, T. D., Grupe, G., Schröter, P., 1998. Migration in the Bell Beaker period of Central Europe. Antiquity 72, 57–71.

Price, T. D., Knipper, C., Grupe, G., Smrcka, V., 2004. Strontium isotopes and prehistoric human migration: The Bell Beaker period in Central Europe. European Journal of Archaeology 7 (1), 9–40.

Prien, R., 2005. Archäologie und Migration. Vergleichende Studien zur archäologischen Nachweisbarkeit von Wanderungsbewegungen. Universitätsforschungen zur Prähistorischen Archäologie 120. Habelt, Bonn.

Pyzel, J., 2009. Migration und Kontakte in der Bandkeramik Kujawiens. Beiträge zur Ur- und Frühgeschichte Mitteleuropas 53, 49–50.

Ruttkay, E., 1973. Über einige Fragen der Laibach-Vucedol-Kultur in Niederösterreich und im Burgenland. Arheološki vestnik 24, 38–52.

Strasser, E., 2009. Was ist Migration? Zentrale Begriffe und Typologien, in: Six-Hohenbalken, M., Tošić, J. (Eds.), Anthropologie der Migration. Theoretische Grundlagen und interdisziplinäre Aspekte, Facultas. wuv, Vienna, pp. 15–28.

Thomas, J., 2005. Ceremonies of the horseman? From megalithic tombs to beaker burials in Prehistoric Europe, in: Rojo Guerro, M., Garrido Pena, R., Martínez de Lagrán, I. G. (Eds.), El campaniforme en la península Ibérica y su contextu Europeo (Bell Beakers in the Iberian Peninsula and their European context), Serie Arte y arqueología 21. Universidad de Valladolid, Valladolid, pp. 91–135.

Treibel, A. 2008. Migration in modernen Gesellschaften. Soziale Folgen von Einwanderung, Gastarbeit und Flucht, 4th ed., Juventa, Weinheim, Munich.

Valde-Nowak, P., 2000. Flammförmige Messer der Schnurkeramikkultur, in: Kadrow, S. (Ed.), A Turning of Ages – Im Wandel der Zeiten. Jubilee Book Dedicated to Professor Jan Machnik on his 70th Anniversary, Institute of Archaeology and Ethnology, Polish Academy of Sciences, Cracow, pp. 467–479.

Wiltschke-Schrotta, K., Berner, M., Teschler–Nicola, M., 2001. Anthropologische Auswertung der menschlichen Überreste aus den Gräbern der Glockenbecherzeit von Zwingendorf/Alicenhof, VB Mistelbach. Archaeologia Austriaca 84–85, 241–255.

Julia K. Koch[b,*], *Katharina Kupke*[a,b]

Life-course reconstruction for mobile individuals in an Early Bronze Age society in Central Europe: Concept of the project and first results for the cemetery of Singen (Germany)

* Corresponding author: jkkoch@uni-leipzig.de
a MPI of Evolutionary Anthropology. Dept. of Human Origin, Leipzig, Germany
b Department of History – Chair of Pre- and Protohistory, University Leipzig, Germany

Abstract

The German Ministry of Education and Research sponsored project "Life course reconstruction of mobile individuals in sedentary societies", run by the Chair of Proto- and Prehistory, University of Leipzig, and by the Dept. of Human Evolution, Max Planck Institute of Evolutionary Anthropology (MPI-EVA), investigates mobility as part of the human life course in cultural groups during the beginnings of the Bronze and Iron Ages in Central Europe. Starting with the basic question 'What role do individual mobility and the integration of foreign persons play in the development of prehistoric sedentary societies?' the archaeological subproject investigates the links between the mobility of individuals and gender roles and between the former and the transfer of technologies in prehistoric sedentary societies. The results of isotope analyses now offer the chance to compare data on geographical provenance with cultural data. So the research of the MPI-EVA's component of the project focuses on the analysis of five stable isotopes – strontium, oxygen, sulphur, carbon, and nitrogen – to reconstruct dietary habits and provenance in different life stages. The project focuses on the Early Bronze Age cemetery of Singen (district of Constance) and the Early Iron Age burial mound the Magdalenenberg near Villingen-Schwenningen (Schwarzwald-Baar district), both in Baden-Württemberg, Germany.

Keywords

Early Bronze Age, Central Europe, Integration, Mobility, Diet, Multiple Isotope Analysis, Social Analysis

Introduction

The project "Life course reconstruction of mobile individuals in sedentary societies", run by the Chair of Proto- and Prehistory, University of Leipzig, and by the Dept. of Human Evolution, Max Planck Institute of Evolutionary Anthropology, investigates mobility as part of the human life course in cultural groups during the beginning of both metal periods in Central Europe. Thus unlike other archaeological projects involving isotope analyses, it does not address the question of mass-migration, but examines instead the mobility of individuals and its significance with respect to cultural developments, especially innovations.

Definition of life course

Before we present the main strands of the project, we will provide a definition of the term 'life course', because this key concept – adopted from Gender Archaeology (Sofaer Derevenski, 1997; Gilchrist, 2000) – together with the term "lifecycles" forms a complement to "life history", which has often been used in recent anthropological studies (Koch, 2010).

Life course is understood by R. Gilchrist (2000) as the progression through which members of social groups pass during their physical lifecycle, embedded in their own cultural context with all of the continuities and discontinuities associated therewith. An individual's life course is influenced both by cultural categories, which are mutable, such as gender, status, cultural origin or diet, and by biological

Fig. 1 | Model of the influences on a prehistoric life course

ones, such as sex, biological age or natural environment (Fig. 1). Hence a life course is perceived as 'a series of stages, hierarchical grades or physical thresholds, that may be marked by public or private rites of passage. Alternatively, the passage of an individual life may be linked with daily, seasonal or annual cycles, with natural and personal time-scales fully integrating the lifecycle of the wider social community' (Gilchrist, 2000). In addition, the life course concept implies that no single social group should be studied in isolation, but that an examination should encompass all groups in order to study interactions, boundaries and convergences, as well as to identify differences and similarities among gender and age groups (cf. Gilchrist 1999).

The term 'life history' is more commonly used in physical anthropology, but in contrast to 'life cycle', it entails an individual and very personal level which can be gleaned through a combination of human being and object (Gilchrist, 2000). In archaeology the temptation to reconstruct the life history of a particular person (i.e. grave owner) is frequently very great; however in our opinion an individual-specific approach approximation must be accompanied by careful analysis that takes into account all critical objections regarding sources. In prehistoric anthropology, focusing on biographical aspects on the basis of individual skeletons would seem the simpler approach (Alt, 2004).

Project organisation and research questions

The project comprises two component projects: one at the MPI-EVA, one at Leipzig University (Fig. 2). On the side of archaeometric science, the project team, coordinated by Michael Richards, is carrying out a multiple-isotope analysis (strontium, oxygen, sulphur, carbon and nitrogen) to obtain information about the provenance and diet of the human individuals. The second team, supervised by Sabine Rieckhoff, is focusing on a newly developed integration analysis, which aims to determine the degree of cultural integration of individuals. Finally, a synthesis brings together the results for the two, chronologically widely separated, case studies to tease out the structural relationships between gender, social age, status, mobility and diet, while also considering possible changes during different life courses. The aim is to outline new, well-substantiated models for the interrelationship between mobility and cultural development based on a diachronic comparison.

Beginning with the basic question 'What role do individual mobility and the integration of foreign persons play in the development of prehistoric sedentary societies?' the archaeological project cluster investigates the links between the mobility of individuals and gender roles and between the former and the transfer of technologies in prehistoric sedentary societies. The starting point is the hypothesis that individuals, depending on their social status as defined by age and gender, will, firstly, show differences in their mobility pattern and, secondly, be able to implement different models of integration. Hence the phenomenon of the 'mobile person' is not being investigated by concentrating on just one age or gender

Fig. 2 | Organisation of the project "Life course reconstruction of mobile individuals in sedentary societies"

Reconstruction of the lifecourse of mobile individuals in sedentary societies — Coordination Sabine Rieckhoff

Mobility and Diet in the Early Bronze Age and Early Iron Ages in southern Germany. Two aspects of multiple-isotope analysis (2008-11) *Coordination Michael Richards*	Integration of foreign individuals in societies of Early Bronze Age and Early Iron Age in southern Germany. An archaeological analysis (2009-11) *Coordination Sabine Rieckhoff*
Study about geographical mobility in Singen and in Magdalenenberg — *PhD-thesis Viktoria Oelze*	Study about the integration of cultural foreign individuals in Singen and in Magdalenenberg — *Project Julia K. Koch*
Possibilities of diet reconstruction on the basis of N- and C-isotope-analysis *MA-thesis Katharina Kupke*	EBA: Methods of social analysis *MA-thesis Susanne Mittag* / EIA: Case study (hair pins) *MA-thesis Mario Schmidt*

group, or even from a 'genderless' perspective, but instead it is seen as integral to the entirety of the existing social structures, which influenced individual biographies in their turn.

The methodological question concerns ways of identifying mobile individuals. In the past, archaeologists have happily assumed that the presence of "foreign" artefacts or burial rites represents evidence of the presence of actual foreigners, even when there was no reason to suppose an intimate link between the objects and the individuals buried. Another problematic aspect is that it is possible for one-time "foreigners" to be so well integrated that they are no longer visible culturally, while people who never actually left their societies might be represented as "mobile individuals" due to their association with imported objects. Isotope analyses now offer researchers an opportunity to compare data on geographical provenance with cultural data. The rate of integration can, but does not have to be conditioned by any actual spatial movement. Isotopic analysis of diet takes up an intermediary position here. It is necessary to provide background data to aid in interpretation the isotopes shedding light on individual movements and also provides additional evidence relating to the rate of integration, since diet is culturally dependent.

Research in the MPI component project focuses on the analysis of five stable isotopes – strontium, oxygen, sulphur, carbon, and nitrogen – to allow the reconstruction of dietary habits and provenance in different life stages. The set of samples encompasses all available skeletons and some animal bones from both sites. By examining the carbon, nitrogen and sulphur stable isotope ratios in combination, we are able to detect the exploitation of terrestrial, marine and freshwater resources. Due to its potential for ascertaining differences or similarities in diet that are related to age, sex and gender, this investigation into diet using carbon and nitrogen isotope values represents one piece of the puzzle that is life-course reconstruction. It also, however, serves as a control element in respect of the other isotope ratios, particularly in cases of extreme values. To shed light on the question of human mobility, isotope ratios of strontium and oxygen in human tooth enamel and sulphur isotopes in bone collagen will be analysed. The signature of strontium isotopes in the human enamel should reflect the geological origin of food and drinking water consumed during enamel formation in early childhood; oxygen isotopes in the enamel should correspond to those of the local drinking water. Sulphur isotopes are measured in bone collagen, which reflects the geological origin of food consumed in the last decade of life (Nehlich and Richards, 2009); this signature can hence also be used to distinguish between local and nonlocal indi-

viduals (Richards et al., 2001; Buchardt et al., 2007; Bol et al., 2007; Vika, 2009). By combining both methods we can reconstruct early childhood (strontium, oxygen) and adult provenance (sulphur).

The project focuses on the Early Bronze Age and the Early Iron Age in south-western Germany, as each of these represents an important horizon of innovation. The introduction of, respectively, tin bronze and iron processing presupposes a transfer of technologies with far-reaching consequences, but evidence for the movement of larger groups is lacking. Therefore, this project envisages an increase in the mobility of single individuals and very small groups. The Early Bronze Age cemetery of Singen (district of Constance) and the Early Iron Age burial mound known as the Magdalenenberg near Villingen-Schwenningen (Schwarzwald-Baar district), both in Baden-Württemberg, Germany, form the core of the two case studies, each of which is being investigated separately.

The decisive factors in the choice of these two sites were the conditions they provide: substantial find assemblages, comprehensive and reliable publications, including anthropological data and specialist reports, as well as scientific dates. In addition, certain elements of burial treatment can be shown to vary with the social categories of age and gender in both communities. That makes correlations between patterns of social behaviour, such as mobility and integration, and variables of age and gender very likely for both communities as well. Another reason for the selection was the existence of published suggestions of mobility in relation to certain grave complexes, which we set out to test.

As our project is still in progress, the focus of the present article is on the conceptual aspects of the project and on first results from the MA thesis concerned with the diet of the chosen populations. The case study of Singen will be used to illustrate the working methods.

The sites

The 96 graves in the cemetery of Singen in the Hegau region are divided into five groups (Fig. 3) and have been dated to the Early Bronze Age, i.e. Reinecke A1 or, in absolute dates, the 22^{nd}–20^{th} century cal BC (Krause, 1988). A further grave, Singen Grave 71, has so far been assigned to the Early Bronze Age burial ground in the literature, although its ^{14}C-date of 972±53 cal BC (HD 8977–9156) suggests a Late Bronze Age date and supports its allocation to the corresponding cremation cemetery in the same area (cf. Krause, 1988; Brestrich, 1998). The date was calibrated using CalPal (online version). In spite of the generally poor conditions for bone preservation in the Hegau region, 36 graves yielded bone fragments and teeth, constituting one of the largest assemblages for the North Alpine Early Bronze Age. Rüdiger Krause (1988), the first to work on the Singen material, interpreted the site as the burial place of a 'socially and politically dominant group' within the northern Alpine metallurgy network (Krause, 1988; 2002; 2009). The finds themselves confirm contacts with the Atlantic Early Bronze Age and as far as Hungary to the east. On the basis of foreign elements in the funerary rite, Krause (1988) interpreted the isolated Group IIb, consisting of six graves, as the burials of immigrants.

For the sake of completeness, the second site should be mentioned briefly: the 139 individuals from 127 graves within the Magdalenenberg near Villingen-Schwenningen at the eastern edge of the Black Forest have been dendro-dated to the beginning of the late Hallstatt period (ca. 616–570/560 BC) (Spindler 1971–80; 1999; 2004). More skeletal material is preserved here, albeit in a fragile state. A total of 99 individuals are represented (Gallay, 1977; Wahl and Zäuner, 2010). Some grave good inventories contain stone tools for metalworking, suggesting that several persons were familiar with the newly introduced iron metallurgy (Spindler, 1999). In spite of this connection with a transfer of technology, the

Fig. 3 | Singen, district of Constance, Baden-Württemberg, Germany. View to the west from the volcanic mountain Hohentwiel above the city of Singen, with Lake Constance in the background. The site of the five EBA grave groups is marked in red (Photo: J. Koch)

excavator, Konrad Spindler (1999), was of the opinion that a local population was buried in the Magdalenenberg, given the homogenous grave good inventory largely typical for Ha D1 in south-western Germany. However, individual imported pieces, such as elements of southern Alpine dress (cf. Schmid-Sikimić, 2002), as well as exotic raw materials such as coral and amber, reinforce the idea that this burial site, too, contains individuals integrated into interregional networks.

Thus both sites provide an excellent basis for assessing the hypothesis of gender-differentiated mobility and integration behaviours using diachronic comparison of two chronological phases, both characterised by the introduction of new metalworking technologies, as well as for the reconstruction of the social repercussions of cultural changes potentially caused by 'foreigners'.

Scientific project: Early Bronze Age diet

Though analyses on the strontium, oxygen and sulphur isotopes are not yet complete (Oelze et al., submitted manuscript), the results of the carbon and nitrogen analyses can be briefly summarised here (Kupke, 2011). The question of diet is an important aspect for the reconstruction of prehistoric life courses. As the choice of foods is determined not only culturally, but also depends on the immediate environment, different connections within the framework of prehistoric life courses can be investigated on the basis of this reconstruction.

Materials and methods

Bone samples were taken from 33 individuals of the 97 Bronze Age inhumations at Singen (Fig. 4). All age groups, from infants to adults over 60 years of age, are represented. Of these, 13 individuals have been identified anthropologically as male, six as female and 14 as indeterminate.

With the exception of one herbivore (Grave 80), no animal bone from Singen or its immediate surroundings was available to be sampled. Instead, isotope data for herbivores from different chronological periods – the Neolithic cemeteries of Trebur, district of Groß-Gerau (Dürrwächter et al. 2003), and Pestenacker, district of Landsberg am Lech (Asam et al. 2006); the Urnfield cemetery at Neckarsulm, district of Heilbronn (Nehlich and Wahl, 2010); and the Magdalenenberg, Schwarzwald-Baar district (Kupke, 2011) – were collated to obtain a rough indication of characteristic dietary values for herbivores. Collagen extraction was carried out on the basis of the method developed by Longin (1971), as modified by Brown et al. (1988) and further developed by Richards and Hedges (1999) and Müldner and Richards (2005). Samples were measured in a Delta XP mass spectrometer with Flash EA 2112 (Thermo-Finnigan®). The analytical measurement error of duplicate collagen samples was below ±0.1‰. All statistical analyses of carbon and nitrogen isotope data were undertaken with the statistics program R (R Development Core Team 2009).

Results

The carbon and nitrogen isotopes were subjected to the usual quality criteria (Ambrose, 1990; DeNiro, 1985; van Klinken, 1999). Although a collagen yield of less than one percent is regarded as problematic, samples were not discarded as long as they passed other quality controls, since due to the ultra-filtration used, there was a greater loss of degraded collagen (Müldner and Richards, 2005). Apart from two samples which did not contain sufficient collagen, it was possible to extract collagen from all samples, and carbon and nitrogen isotope data could be obtained. Six other samples were also rejected as they did not satisfy the quality criteria. The mean of all usable isotope data from the Singen cemetery is –20.4 ± 0.3‰ for the $\delta^{13}C$ values, with a maximum of –19.6‰ and a minimum of –21.2‰. The $\delta^{15}N$ values scatter between 10.5‰ and 7.9‰, with a mean of 9.6 ± 0.6‰.

Discussion of isotope data

The data for animals provide the basis for the interpretation of human carbon and nitrogen isotope data. Herbivore isotope values allow the botanical and regional climatic conditions of the time period in question to be determined and subsequently compared with human diet (Jay and Richards, 2006). With the exception of the possible herbivore from the Singen cemetery, no other animals were available, and hence the herbivore baseline, which forms the basis for the interpretation of the human isotope data, is missing.

To allow us to interpret the carbon and nitrogen isotope data for the humans from the Singen cemetery despite this absence, the herbivores from the sites listed in the section on materials and methods were used to gain an approximate idea of the characteristic dietary values for herbivores.

The increase of the $\delta^{13}C$ mean values of the herbivores and humans measures about 1–2‰; the increase in the $\delta^{15}N$ mean values between herbivores and humans was 3–4‰, thus corresponding to one trophic level (DeNiro and Epstein, 1978, 1981; Ambrose and Norr, 1993) (cf. Kupke, 2011).

Fig. 4 | Singen, district of Constance, Baden-Württemberg, Germany. Distribution of individuals yielding samples (Map: from Krause, 1988, p. 28 Fig. 6; mapping: Katharina Kupke)

Fig. 5 | Singen, district of Constance, Baden-Württemberg, Germany. Data for carbon and nitrogen isotope analyses of the Singen individuals in comparison with isotope values for animals from other sites. (Graphic: Katharina Kupke)

The scatter of both the δ¹³C values and the δ¹⁵N values for the Singen individuals is small. The range of δ¹³C values is between –19.6‰ and –20.8‰, the δ¹⁵N values range from 8.9‰ to 10.5‰ (children of the infans I age group were excluded, as their values could have been influenced by breastfeeding). The values suggest a terrestrial diet based on C_3 plants and herbivorous animals. Dietary input from C_4 plants (δ¹³C values between –9‰ and –16‰) can be excluded (Vogel, 1980). This result is confirmed by archaeobotanical finds. The most important cereal species cultivated in the Early Bronze Age was spelt, followed by emmer, common wheat and barley (Frank, 2006). In addition to lentils and peas, gathered plants, such as blackberry, elderberry, wild strawberry, raspberry, hazelnuts, sloe and apple, were also consumed (Frank, 2006; Köninger, 2006; Körber-Grohne, 1995). A starting point for the reconstruction of the meat component of the diet is provided by Layer A of the slightly younger settlement at Bodman-Schachen I on Lake Constance. There, cattle, sheep, goat, pig and, to a lesser extent, horse and wild animals such as red deer, wild boar, roe deer, rabbit and birds are attested (Kokabi, 1987, 1990). In addition to providing meat, however, animals may have contributed products such as eggs, milk and other dairy produce to the human diet.

As is also the case for other sites in Germany (e.g., Asam et al., 2006), the δ¹³C values for the Singen cemetery do not show a canopy effect. A canopy effect would be manifested by more negative values (Ambrose and Norr, 1993; Van der Merwe and Medina, 1991; Van Klinken et al., 2000). This result confirms data from pollen profiles in the surroundings of Singen and Lake Constance. Thus, we were able to ascertain that a clearance episode during which the dense mixed beech forest was thinned out occurred at the time of the Singen cemetery (Rösch, 1990a, 1990b). Areas now devoid of trees were used for agriculture (Frank, 2006).

Breastfeeding has an impact on the isotope ratios of children in the infant age group (under 6 years). Since young infants absorb their mother's protein through breast milk, their δ¹⁵N values are about 3–4‰ higher than those of the adult females in the population (Mays et al., 2002; Richards et al., 2002). Only the child from Grave 46 could be assigned to the infant age group. It has been anthropologically aged to between 1.5 and 6 years, but exhibits a very low δ¹⁵N value of 7.9‰. There is thus no evidence for any influence through breast milk. Indeed, this child had very probably already been weaned and received an omnivorous diet with a focus on vegetarian food.

Furthermore, we investigated whether dietary differences existed among the morphologically defined age and sex groups and whether there was a relationship between the social index values and diet. No statistically significant results could be obtained with respect to relationships between the isotope

Fig. 6 | Singen, district of Constance, Baden-Württemberg, Germany. Correlation between age groups and δ15N values. Infans I were excluded due to the possible impact from breastfeeding (Graphic: Katharina Kupke)

values for carbon and nitrogen and sex or the social index values, i.e., women and men consumed the same foods (protein) and there were no discernable dietary differences among individuals assigned different social index values. In order to identify possible statistically significant differences in diet among the different age groups, Spearman's rank correlation coefficient was applied and significance tested for. The relationship between age groups and δ15N values is significant, i.e. the older the individuals were, the more meat they consumed (ϱ=0.56; p-value=0.04). Since this observation is based on only 14 individuals, the significance of this result must be seen as particularly marked. There is hence a certain justification for assuming that a positive correlation between age and the proportion of meat in the diet applies to the Singen cemetery as a whole (Fig. 6).

Archaeological project

Research questions

The prehistoric component project concentrates on the question of the socio-cultural integration of each single individual in the Singen or Magdalenenberg populations at the point of his or her burial. Thus the main question is to what degree were individuals who have 'foreign' characteristics in their grave good assemblage or their funerary rites actually integrated into the burial community? This approach resulted in a methodological shift away from an emphasis on detecting mobility, as archaeology is capable of recognising ideas and/or objects as foreign, but not really the individuals themselves. Instead, research here focuses on integration, which is manifested as an individual combination and admixture of grave inventories.

Methodologically, the integration analysis is the centrepiece of the prehistoric study. This analysis is inspired by a standardised psychometric personality test borrowed from Psychology (cf. Hossiep, 2007) and is designed to measure the culturally determined degree of integration of an individual within his or her burial community by considering foreign elements. 'Foreign' in this context means that a) the main area of distribution of a given trait lies outside the cemetery and the regional grouping to which it be-

longs and/or b) the type in question is only rarely present. In practice, lists of questions are used to determine the chorological character of selected elements for each burial complex; in a further step, social groups are defined on the basis of multivariate statistics.

Steps of analysis

Again, at this point we can present only the first steps, since the project team is currently in the middle of testing the integration analysis with the first case study, having completed general preparations in the first year of the project.

In detail, the procedure will be as follows:

1. A list of the relevant finds and funerary rites for the cemetery will be drawn up.

2. The frequency of the selected elements in a) the cemetery and b) the surrounding regions will be identified. It is here that the discussion as to what can be classified as 'normal' or as 'foreign' begins.

3. The main areas of distribution of the selected finds and ritual elements will be identified and plotted on maps. These maps will form the basis for the definition of wider regions, which is required for the subsequent "questionnaire" stage, to allow the contact regions from which foreign elements were derived to be investigated.

4. A list of questions will be drawn up for use in the analysis and the corresponding values will be calculated.

5. Finally, we will attempt to define groups with different integration characteristics with the aid of correspondence and cluster analysis.

The Singen cemetery contains only inhumation graves, within which the dead were buried in a crouched position differentiated by gender (Fig. 8). Women were buried crouched on their right, head to the south; men, crouched on their left with head to the north (see Rieckhoff, 1998). R. Krause (1988) defined seven types of grave structures, ranging from grave pits containing only stone wedges for a possible log coffin to stone cists. The Early Bronze Age grave good spectrum comprised essentially three types of pin (racket-headed pins [*Ruderkopfnadeln*], disc-headed pins [*Scheibenkopfnadel*] and disc-headed pins with a thin wire connecting the top with the neck [*Typ Horkheim*]), awls, triangular daggers with two to five rivets, spiral arm-rings, ingot torque (*Ösenhalsring*), a so-called diadem, bone rings and various pendants and beads, including one of the earliest faïence beads found in southern Germany (Krause, 1988; Weiss, 1998). The materials used comprise bone, three different bronze alloys with increasing tin content, silver, jet and a little pottery. Only the right-crouched inhumations (i.e. the women) contained racket-headed pins (*Ruderkopfnadeln*), neck-rings with turned ends and awls. Daggers occur mostly with left crouched inhumations (i.e., men), but in two cases they were recovered in graves archaeologically identified as those of women. All other grave goods are found with equal frequency for both sex groups or come from graves without bone preservation, i.e. where reconstruction of the the position and hence gender of the deceased is impossible and which therefore cannot be classified with certainty. Also, some grave goods occur only once. A third of the graves were unfurnished.

The most frequent grave goods are spiral arm-rings, daggers of the *Straubing-Adlerberg* type and racket-headed pins [*Ruderkopfnadeln*] (Fig. 7). At the infrequent end of the grave good list are a bone button, a lunula pendant, a diadem, two silver wire rings, a pair of ankle rings, several spiral coils, assorted beads and four daggers, perhaps from Early Bronze Age southern England or Brittany. At this stage, the discussion of where the boundary between rare and more frequent grave goods, between 'normal' and

Fig. 7 | Singen, district of Constance, Germany. Frequency of types within the grave inventories (Graphic: Julia Koch)

'possibly foreign', should be drawn has not yet been resolved. A record of the frequency of other elements of the funerary rite also exists. For example, certain grave goods occur relatively frequently, but show a divergent position in only a few graves. Figure 8 is a schematic representation showing all grave goods with known positions. As the majority of goods were found around the head, chest and arms, divergent examples such as tutuli or a bone ring on the back, a dagger at the hip or a pair of ankle rings are extremely conspicuous (see Rieckhoff, 1998). Might these also represent 'foreign characteristics'? Thus frequency alone cannot be used as a straightforward detector of 'foreign individuals' but it is an analytical step necessary in order to sort the material and to organize the subsequent investigation more systematically.

Fig. 8 | Singen, district of Constance, Germany. Schematic representation of all artefacts with known position in the graves, including daggers, pins (racket-headed pins [*Ruderkopfnadeln*], disc-headed pins [*Scheibenkopfnadel*] and disc-headed pins with a thin wire connecting the top with the neck [*Typ Horkheim*]), spiral rings, tutuli, pendants and beads, neck rings with turned ends, bone rings und awls. Black symbol: known position; symbol with dotted line: known approximate position (Graphic: Julia Koch)

The next step consists of compiling the distributions of the individual elements of grave furnishings, the decorations on the pins and different aspects of the funerary rite, such as the position of goods, the position and orientation of the deceased and any structures in the grave. The map depicts three examples whose main areas of distribution lie in three different cardinal directions (Fig. 9). Four daggers point as far as Brittany or southern England (Krause, 1988; Gerloff, 1975), while the lunula pendant finds its most frequent parallels in the Alpine Valais (Krause, 1988; Primas, 1997) and diadems are mostly distributed along the Danube (Krause, 1988; critically: Gallay, 1991).

Maps like these will serve as the basis for the general map of contact regions, which has yet to be completed. Currently a work in progress, the creation of that map entails the analysis of the distribution patterns and boundaries of the different artefacts and funerary rites. The collected maps of artefacts and other markers will be classified on the basis of the distribution patterns. Markers with a very widespread, regular multicultural distribution, such as awls, are less suited for the analysis of cultural contacts. Of greater interest are those markers associated with a more restricted regional distribution or with clear distribution centres and only few outliers. Focussing to Singen, we then have to find out where the oldest examples of each marker occur, if it is possible to identify them (cf. the discussion regarding the origin of the "Linienbandwinkel" decoration pattern [i.e. linear bands at right-angle]: Schwenzer, 2004).

The subsequent methodological steps, such as drawing up the list of questions (including questions such as "Where is the main distribution area (i.e. contact region) for the position the jewellery, weapons etc. take in the grave?"), calculating the integration analysis values and then carrying out the correspondence and cluster analyses will keep the project team busy in the coming weeks and months.

Finally, the results will be compared with the available anthropological data, with the results of published studies such as the social index analysis carried out by Sylvia Sprenger (1993, 1995), and, of course, with the results of the natural sience partner project. In the moment stage of work [2010], we are not yet in a position to illustrate precisely what impact the integration of isotopic data will have on the overall analysis, and have focussed instead on how the archaeological data sets for the comparison will be developed.

Outlook

After comparing the data from the two projects, the aim for the final year, 2011, is to interpret the different integration clusters and to develop a synthesis, encompassing models for the interconnections between mobility and cultural development. The reconstruction of social life courses involves not only the basic archaeological and anthropological data on age, sex, gender, social status and dating, but also data on diet and mobility at different ages and the cultural integration into a burial community at the end of the individual's life. Returning to the basic question the project seeks to address, the role of individual mobility and integration in the development of prehistoric sedentary societies, it would be important to show whether the differences between social groups are due to mobility or to other factors, such as the probably age-determined difference in diet at Singen. This project cluster synthesis combines the results from both component projects into an overall picture of individual geographic mobility on the one hand, and, on the other, the cultural integration of nonlocals and/or semi-integrated persons. This will enable the reconstruction of a mobility spectrum for the cases under study. The aim is to utilize

Fig. 9 | Three distribution maps of EBA artefact types found at the cemetery of Singen (from Krause 1988, p. 59 Fig. 21; p. 89 Fig. 45; p. 92 Fig. 47)

these reconstructed life courses to investigate the postulated relationship between individual mobility and the introduction of new metallurgical knowledge connected to fundamental innovations in Bronze Age and Iron Age societies over a short time scale.

Acknowledgements

This paper is one of the publications of the research project, publicly funded in 2008–11 by the Federal Ministry of Education and Research, Germany, with the support code 01UA0811. The authors are responsible to the content of this paper.

We thank Claudia Hofmann, Oxford, for translation. Sabine Rieckhoff and Michael Richards are thanked for supervision of the project and Olaf Nehlich for introduction in isotope-analysis. We thank for samples making available Joachim Wahl, Konstanz, Jürgen Hald, Kreisarchäologie Konstanz, and Ralph Stephan, Hegau-Museum Singen.

References

Alt, K.W., 2004. Dimensionen von Alter und Geschlecht in der Ontogenese des Menschen – Archäologische Implikationen. Ethnographisch-Archäologische Zeitschrift 46 (2–3), 153–164.

Ambrose, S.H., 1990. Preparation and characterization of bone and tooth collagen for isotopic analysis. Journal of Archaeological Science 17, 431–451.

Ambrose, S.H., Norr, L., 1993. Experimental evidence for the relationship of the carbon isotope rations of whole diet and dietary protein to those of bone collagen and carbonate, in: Lambert, J.B., Grupe, G. (Eds.), Prehistoric Human Bone: Archaeology at the Molecular Level. Springer-Verlag, New York, pp. 1–39.

Asam, T., Grupe, G., Peters J., 2006. Menschliche Subsistenzstrategien im Neolithikum: Eine Isotopenanalyse bayrischer Skelettfunde. Anthropologischer Anzeiger 64, 1–23.

Berry, J.W., 1990. Psychology of acculturation: Understanding moving between cultures, in: Brislin, R.W. (Ed.), Applied Cross-Cultural Psychology: Cross-cultural Research and Methodology Series 14. Sage, Newbury Park, pp. 232–253.

Bol, R., Marsh J., Heaton, T.H., 2007. Multiple stable isotope (^{18}O, ^{13}C, ^{15}N and ^{34}S) analysis of human hair to identify the recent migrants in a rural community in SW England. Rapid Communications in Mass Spectrometry 21, 2951–2954.

Brestrich, W., 1998. Die mittel- und spätbronzezeitlichen Grabfunde auf der Nordstadtterrasse von Singen am Hohentwiel. Forschungen und Berichte zur Vor- und Frühgeschichte in Baden-Württemberg 67. Theiss, Stuttgart.

Brown, T.A., Nelson, D.E., Vogel, J.S., Southon, J.R., 1988. Improved collagen extraction by modified Longin method. Radiocarbon 30 (2), 171–177.

Buchardt, B., Bunch, V., Helin, P., 2007. Fingernails and diet: Stable isotope signatures of a marine hunting community from modern Uummannaq, North Greenland. Chemical Geology 244, 316–329.

DeNiro, M.J., 1985. Postmortem preservation and alteration of *vivo* bone collagen isotope ratios in relation to palaeodietary reconstruction. Nature 317, 806–809.

DeNiro, J.M., Epstein, S., 1978. Influence of diet on the distribution of carbon isotopes in animals. Geochimica et Cosmochimica 42, 495–506.

DeNiro, M.J., Epstein, S., 1981, Influence of diet on the distribution of nitrogen isotopes in animals. Geochimica et Cosmochimica Acta 45, 341–351.

Dürrwächter, C., Craig, O., Taylor, G., Collins, M., Burger, J., Alt, K.W., 2003. Rekonstruktion der Ernährungsweise in den mittel- und frühneolithischen Bevölkerungen von Trebur/Hessen und Herxheim/Pfalz anhand der Analyse stabiler Isotope. Bulletin Societé Suisse d'Anthropologie 9, 1–16.

Frank, K.S., 2006. Botanische Makroreste aus Tauchgrabungen in den frühbronzezeitlichen Seeufersiedlungen Bodman-Schachen I am nordwestlichen Bodensee unter besonderer Berücksichtigung der Morphologie und Anatomie der Wildpflanzenfunde. Aussagemöglichkeiten zu Nutzpflanzen, Vegetationsverhältnissen und zur Lage des Siedlungsareals, in: Köninger, J. (Ed.), Die frühbronzezeitliche Ufersiedlung von Bodman-Schachen I – Befunde und Funde

aus den Tauchsonden 1982–1984 und 1986. Siedlungsarchäologie im Alpenvorland VIII. Forschungen und Berichte zur Vor- und Frühgeschichte in Baden-Württemberg 85. Theiss, Stuttgart, pp. 431–566.

Gallay, G., 1977. Die Körpergräber aus dem Magdalenenberg bei Villingen, in: Spindler, K., Der Magdalenenberg. Der hallstattzeitliche Fürstengrabhügel bei Villingen im Schwarzwald 5. Neckar-Verlag, Villingen, pp. 79–118.

Gallay, G., 1991. Book review "Rüder Krause, Die endneolithischen und frühbronzezeitlichen Grabfunde auf der Nordstadtterrasse von Singen am Hohentwiel. Forschungen und Berichte zur Vor- und Frühgeschichte Baden-Würtemberg 32. Theiss, Stuttgart 1988". Germania 69, 204–207.

Gerloff, S., 1975. The Early Bronze Age daggers in Great Britain and a reconsideration of the Wessex Culture. Prähistorische Bronzefunde VI, 2. C.H. Beck, Munich.

Gilchrist, R., 1999. Gender and Archaeology: Contesting the Past. Routledge, London.

Gilchrist, R., 2000. Archaeological biographies: Realizing human lifecycles, -courses and -histories. World Archaeology 31, 325–328.

Hossiep, R., 2007. Messung von Persönlichkeitsmerkmalen, in: Schuler, H., Sonntag, K. (Eds.), Handbuch der Arbeits- und Organisationspsychologie. Hogrefe, Göttingen, pp. 450–458.

Jay, M., Richards, M.P., 2006. Diet in the Iron Age cemetery population at Wetwang Slack, East Yorkshire, UK: Carbon and nitrogen stable isotope evidence. Journal of Archaeological Science 33, 653–662.

Koch, J.K., 2010. Mobile Individuen in sesshaften Gesellschaften der Metallzeiten Mitteleuropas. Anmerkungen zur Rekonstruktion prähistorischer Lebensläufe, in: Meller, H., Alt, K. (Eds.), Anthropologie, Isotopie und DNA – biographische Annäherung an namenlose vorgeschichtliche Skelette? 2. Mitteldeutscher Archäologentag Halle an der Saale 2009. Tagungen des Landesmuseums für Vorgeschichte 3. Landesmuseum für Vorgeschichte, Halle, pp. 95–100.

Kokabi, M., 1987. Die Tierknochenfunde aus den neolithischen Ufersiedlungen am Bodensee – Versuch einer Rekonstruktion der einstigen Wirtschafts- und Umweltverhältnisse mit der Untersuchungsmethode der Osteologie. Archäologische Nachrichten Baden 38–39, 61–66.

Kokabi, M., 1990. Ergebnisse der osteologischen Untersuchungen an den Knochenfunden von Hornstaad im Vergleich zu anderen Feuchtbodenfundkomplexen Südwestdeutschlands. Bericht der Römisch-Germanischen Kommission 71, 145–160.

Köninger, J., 2006. Die frühbronzezeitliche Ufersiedlung von Bodman-Schachen I – Befunde und Funde aus den Tauchsonden 1982–1984 und 1986. Siedlungsarchäologie im Alpenvorland VIII. Forschungen u. Berichte zur Vor- und Frühgeschichte in Baden-Württemberg 85. Theiss, Stuttgart.

Körber-Grohne, U., 1995. Nutzpflanzen in Deutschland. Von der Vorgeschichte bis heute. Theiss, Stuttgart.

Krause, R., 1988. Die endneolithischen und frühbronzezeitlichen Grabfunde auf der Nordstadtterrasse von Singen am Hohentwiel. Forschungen und Berichte zur Vor- und Frühgeschichte Baden-Württemberg 32. Theiss, Stuttgart.

Krause, R., 2002. Sozialstrukturen und Hierachien – Überlegungen zur frühbronzezitlichen Metallurgiekette im süddeutschen Alpenvorland, in: J. Müller (Ed.), Vom Endneolithikum zur Frühbronzezeit. Muster sozialen Wandels? Tagung Bamberg 2001. Universitätsforschungen zur Prähistorischen Archäologie 90. Habelt, Bonn, pp. 45–59.

Krause, R., 2009. Bronze Age copper production in the Alps: Organisation and social hierarchies in mining communities, in: Kienlin, T.L., Roberts, B.W. (Eds.), Metals and Societies. Studies in Honour of Barabara S. Ottoway. Universitätsforschungen zur Prähistorischen Archäologie 169. Habelt, Bonn, pp. 47–66.

Kupke, K., 2011. Ernährungsrekonstruktion mittels Kohlenstoff- und Stickstoffisotopen aus dem frühbronzezeitlichen Gräberfeld von Singen, Kr. Konstanz und den früheisenzeitlichen Gräbern im Magdalenenberg bei Villingen, Schwarzwald-Baar-Kreis. Master thesis, Leipzig University.

Longin, R., 1971. New method of collagen extraction for radiocarbon dating. Nature 230, 241–242.

Mays, S.A., Richards, M.P., Fuller, B.T., 2002. Bone stable isotope evidence for infant feeding in Mediaeval England. Antiquity 76, 654–656.

Müldner, G., Richards, M.P., 2005. Fast or feast: reconstructing diet in later medieval England by stable isotope analysis. Journal of Archaeological Science 32, 39–48.

Nehlich, O., Richards, M.P., 2009. Establishing collagen quality criteria for sulphur isotope analysis of archaeological bone collagen. Archaeological and Anthropological Sciences 1, 59–75.

Nehlich, O., Wahl, J., 2010. Binnengewässer – eine unterschätzte Nahrungsressource – Stabile Kohlenstoff-, Stickstoff- und Schwefelisotope aus dem Kollagen menschlicher und tierischer Knochenreste aus der urnenfelderzeitlichen Nekropole von Neckarsulm. Fundberichte aus Baden-Württemberg 31, 97–113.

Oelze, V., Nehlich, O., Richards, M.P. (submitted manuscript/revised). 'There's no place like home' –

No isotopic evidence for mobility at the Early Bronze Age cemetery of Singen, Germany. Archaeometry.

Primas, M., 1997. Der frühbronzezeitliche Depotfund von Arbedo-Castione (Kt. Tessin, Schweiz), in: Becker, C. et al. (Eds.), Χρόνος. Beiträge zur Prähistorischen Archäologie zwischen Nord- und Südosteuropa. Festschrift B. Hänsel. Internationale Archäologie – Studia honoraria 1. Leidorf, Espelkamp, pp. 287–296.

Richards, M.P., in press. Stable Isotopes in Archaeology. Cambridge Manuals in Archaeology. Cambridge University Press.

Richards, M.P., Hedges, R.E.M., 1999. Stable isotope evidence for similarities in the types of marine foods used by late Mesolithic humans at sites along the Atlantic Coast of Europe. Journal of Archaeological Science 26, 717–722.

Richards, M.P., Fuller, B.T., Hedges, R.E.M., 2001. Sulphur isotopic variation in ancient bone collagen from Europe: implications for human palaeodiet, residence mobility, and modern pollutant studies. Earth and Planetary Science Letters 191, 185–190.

Richards, M.P., Mays, S., Fuller, B.T., 2002. Stable carbon and nitrogen isotope values of bone and teeth reflect weaning age at the Medieval Wharram Percy Site, Yorkshire, UK. American Journal of Physical Anthropology 119, 205–210.

Rieckhoff, S., 1998. Gräber der Bronzezeit, in: Das Geheimnis des Bernstein-Colliers. Ingolstadt, pp. 73–84.

Rösch, M., 1990a. Vegetationsgeschichtliche Untersuchungen im Durchenbergried, in: Siedlungsarchäologie im Alpenvorland II. Forschungen und Berichte zur Vor- und Frühgeschichte in Baden-Württemberg 37. Theiss, Stuttgart, pp. 9–64.

Rösch, M., 1990b. Veränderung von Wirtschaft und Umwelt während Neolithikum und Bronzezeit am Bodensee. Bericht der Römisch-Germanischen Kommission 71 (1), 161–186.

Schmid-Sikimić, B., 2002. Mesocco Coop (GR). Eisenzeitlicher Bestattungsplatz im Brennpunkt zwischen Nord und Süd. Universitätsforschungen zur Prähistorischen Archäologie 88. Habelt, Bonn.

Schwenzer, St., 2004. Frühbronzezeitliche Vollgriffdolche. Kataloge Vor- und Frühgeschichtlicher Altertümer 36. Verlag RGZM, Mainz.

Sofaer Derevenski, J., 1997. Engendering Children, Engendering Archaeology, in: Moore, J., Scott, E. (Eds.), Invisible People and Processes: Writing Gender and Childhood into European Archaeology. London, Leicester University Press, pp.192–202.

Spindler, K., 1971–80. Der Magdalenenberg. Der hallstattzeitliche Fürstengrabhügel bei Villingen im Schwarzwald 1–6. Neckar-Verlag, Villingen.

Spindler, K., 1999. Der Magdalenenberg bei Villingen. Ein Fürstengrabhügel des 7. vorchristlichen Jahrhunderts. Führer archäologische Denkmäler Baden-Württemberg 5, 2nd ed. Theiss, Stuttgart.

Spindler, K., 2004. Der Magdalenenberg bei Villingen im Schwarzwald: Bilanz nach dreißig Jahren, in: B. Hänsel (Ed.), Parerga Praehistorica. Jubiläumsschrift zur Prähistorischen Archäologie. 15 Jahre UPA. Universitätsforschungen zur Prähistorischen Archäologie 100. Habelt, Bonn, pp. 135–159.

Sprenger, S., 1993. Untersuchungen zu Sozialstrukturen und Geschlechterrollen am frühbronzezeitlichen Gräberfeld von Singen. MA thesis, University Freiburg.

Sprenger, S., 1995. Untersuchungen zu Sozialstrukturen und Geschlechterrollen am frühbronzezeitlichen Gräberfeld von Singen. Ethnographisch-Archäologische Zeitschrift 36, 191–200.

Steuer, H., 2001. Mobilität, in: Reallexikon Germanischer Altertumskunde Vol. 20, 2nd ed. de Gruyter, Berlin, pp. 118–123.

Van der Merwe, J.N., Medina, E., 1991. The canopy effect, carbon isotope ratios and foodwebs in Amazonia. Journal of Archaeological Science 18, 249–259.

Van Klinken, G.J., 1999. Bone collagen quality indicators for paleodietary and radiocarbon measurements. Journal of Archaeological Science 26, 687–695.

Van Klinken, G.J., Richards, M.P., Hedges, R.E.M., 2000. An overview of causes for stable isotopic variations in past European human populations: Environmental, ecophysiological, and cultural effects, in: Ambrose, S.H., Katzenberg, M.A. (Eds.), Biochemical Approaches to Paleodietary Analysis. Advances in Archaeological and Museum Science. New York, pp. 39–63.

Vika, E., 2009. Strangers in the grave? Investigating local provenance in a Greek Bronze Age mass burial using $\delta^{34}S$ analysis. Journal of Archaeological Science 36, 2024–2028.

Vogel, J.C., 1980. Fractionation of the carbon isotopes during photosynthesis, in: Vogel, J.C. (Ed.), Sitzberichte der Heidelberger Akademie der Wissenschaften 3, 109–135.

Wahl, J., Zäuner, St., 2010. Zur demographischen Struktur der Bestattungen im späthallstattzeitlichen Grabhügel vom Magdalenenberg (unpublished manuscript, Dep. of Archaeological Heritage Baden-Württemberg).

Weiss, R.-M., 1998. Ein Grabfund der frühen Bronzezeit aus Mangolding, Lkr. Regensburg. Ein Beitrag zum frühesten Glas in Mitteleuropa. Beiträge zur Archäologie in der Oberpfalz 2, 225–240.

*Argyro Nafplioti**

Late Minoan IB destructions and cultural upheaval on Crete: A bioarchaeological perspective

* British School at Athens, Greece: argyro.nafplioti@googlemail.com

Abstract

This paper discusses representative results from strontium isotope ratio ($^{87}Sr/^{86}Sr$) and biodistance analyses of archaeological human skeletal material carried out to assess the validity of the theory of a LMIB (ca. 1490/1470 BC) Mycenaean invasion of Crete and imposed political domination of Knossos, and thus shed more light onto the question of the LMIB destructions and the subsequent cultural upheaval on the island. These analyses show that the people buried in post-LMIB tombs at Knossos, traditionally associated with Mycenaeans based on material culture evidence, were in fact born locally and not in the Argolid. Further, the analyses presented reject the possibility that these people may represent the descendants of immigrants from the latter region. Additional negative evidence for the theory tested comes from further cranial and dental morphological analyses presented in the author's doctoral thesis, as well as the material culture itself, briefly discussed here.

Keywords

$^{87}Sr/^{86}Sr$, biodistance, craniometry, population movement, destructions, cultural upheaval, Bronze Age Crete

Introduction

This paper investigates a long-standing, highly debated question concerning destructions, cultural discontinuity and population movement in Bronze Age Aegean archaeology, using integrated strontium isotope ratio ($^{87}Sr/^{86}Sr$) and biodistance analyses of human skeletal remains. This work largely derives from the author's doctoral and on-going post-doctoral research; it represents the first attempt to use osteoarchaeological evidence to explore the question of a Mycenaean presence at Knossos dating from the Late Minoan IB (LMIB) onwards in relation to the widespread destructions and the subsequent cultural upheaval on the island. Due to space limitations, this paper discusses only selected results of the work carried out, while more detailed publications are either already available (Nafplioti, 2008) or currently under preparation.

Archaeological background

At the end of the LMIB (ca. 1490/1470 BC), widespread destructions appear to have swept the island of Crete. In some cases, there is evidence that the sites had been abandoned prior to their destruction and that they were not reoccupied for approximately a hundred years. The above, coupled with evidence that the most serious damage at the depleted sites was concentrated at their operating administrative centres, attest to the anthropogenic, forced nature of the destructions, and to the aggression being directed towards a specific segment of the society (Driessen and Macdonald, 1997; Rehak and Younger, 2001).

In more recent years, however, the contemporaneity of these destructions has been seriously questioned in the light of detailed studies of material culture and archaeomagnetic data. These suggest that the LMIB destructions probably span a period of one or two generations, rather than represent a single horizon (see Driessen and Macdonald, 1997). Similarly, the palace of Knossos, originally thought to have

escaped any attacks at the end of LMIB, may have not been fully functional in this period due to rebuilding operations (Macdonald, 2002).

Further, the LMIB destructions appear to signal discontinuity in the Minoan culture. In the succeeding periods, novel features are introduced in many aspects of the material culture on island, such as the writing and administration, the domestic and funerary architecture, the sphere of religion, ritual and mortuary practices, and the thematography of the representational art and utility artefacts. Moreover, they are similar to contemporary developments in the Mainland (Popham, 1994; Treuil et al., 1996; Rehak and Younger, 2001). Nevertheless, as will be later discussed, these novel cultural features do not all simultaneously occur shortly after the LMIB destructions. Moreover, some are probably already present on Crete from the LMIA.

The predominant models proposed to interpret the LMIB destructions and the subsequent cultural upheaval on Crete include the following: interstate warfare and a Knossian take-over of the island, intrastate factional competition and social unrest, and a Mycenaean invasion and political domination of Knossos. Despite the critique directed at the lattermost model in more recent years (Niemeier, 1985; Catling, 1989; Driessen and Macdonald, 1997; Preston, 2004; Nafplioti, 2008), this theory is still very influential in archaeological thinking and in models attempting to interpret the processes that brought about discontinuity in the Late Bronze Age (Late Minoan) culture history of Crete.

The principal constituent elements of the theory of a LMIB Mycenaean invasion of the island and political domination of Knossos include the introduction of the Linear B writing system, on the one hand, and discontinuity in the mortuary practices – mainly the funerary architecture and the material culture associated with the dead – on the other hand.

Because the Linear B writing system is associated with the Mycenaeans, the recovery of Linear B tablets from Knossos has been taken to confirm the hypothesis of an actual Mycenaean presence and political domination of this site dating from the LMII (Driessen, 1990), the LMIIIA1–2 (Popham, 1970), or the LMIIIB (Hallager, 1977, 2010; Niemeier, 1985); The date put forth varies with the date adopted for the final destruction of the Knossos palace, when the majority of the Linear B tablets were conflagrated.

As regards mortuary practices in the LMII–IIIA, affinities between cemeteries at Knossos and the Mainland in terms of the abundance of bronze items and the combination of pottery types in burial assemblages (Alberti, 2004), and principally funerary architecture and burial practices, have been viewed as evidence for the presence of Mycenaeans at Knossos. 'Warrior graves', 'burials with bronzes' and the single-chamber tombs with dromos or tombs of Mainland architecture that occur for the first time in the Mainland (Popham, 1994; Driessen and Macdonald, 1984; Doxey, 1987; Driessen, 1990), have been excavated at post-LMIB sites on Crete, mainly in its central section, and their presence there has been associated with the settlement of Mycenaeans. Tombs of this type at Knossos include the LMII–III tombs in the cemeteries of Sellopoulo and Mavrospelio, the area south of the Palace (KSP), at Ayios Ioannis, Isopata and Zapher Papoura, and the Hutchinson's Tomb. All these cemeteries are located less than 2 kilometres from the Knossos palace, and the present study used all of the human skeletal material currently available from them.

Materials and methods

The present paper uses a bioarchaeological research framework to investigate the validity of the theory of Mycenaean political domination of Knossos following the LMIB destructions. The two forms of analysis employed, $^{87}Sr/^{86}Sr$ and biodistance analyses of human skeletal remains (in this case mainly from central Crete and the Argolid) are complementary: the former can detect first generation Mycenaean immigrants at Knossos, while the latter assesses issues of intra- and inter-population biological variation and distance to reconstruct population biological history and provide time depth to this research.

Strontium isotope ratio ($^{87}Sr/^{86}Sr$) analysis

Principles of the analysis

Studies of human population movement and residential mobility use $^{87}Sr/^{86}Sr$ analysis of human skeletal tissues as a proxy of local geology to determine the geographical origin of the individuals examined and distinguish between locals and nonlocals at the sites investigated. In this paper, $^{87}Sr/^{86}Sr$ analysis was performed on dental enamel samples from LMII–III archaeological collections from Knossos to explore whether nonlocals from Mycenae, or generally the Argolid, are present in tombs at Knossos associated with Mycenaeans.

In nature, strontium occurs in the form of four stable isotopes, i.e. ^{87}Sr, ^{88}Sr, ^{86}Sr, ^{84}Sr. ^{87}Sr is radiogenic and is the product of the radioactive decay of the rubidium isotope ^{87}Rb (half-life of approximately 47 billion years), while none of the other three strontium isotopes are radiogenic (Faure, 1986). Therefore the ratio of ^{87}Sr to ^{86}Sr in any local geology depends on the relative abundance of rubidium and strontium and on the age of the rocks (Rogers and Hawkesworth, 1989). Although other factors, such as proximity to marine environments (Veizer, 1989), atmospheric deposition (Miller et al., 1993) and – in modern contexts – fertilizers can also have an impact on local $^{87}Sr/^{86}Sr$ signatures, they are largely a reflection of mineral weathering (Bentley, 2006). $^{87}Sr/^{86}Sr$ passes from the bedrock into the soil and groundwater and hence into the food chain, reaching human tissue by way of the food and water consumed, with no fractionation related to biological processes (Graustein, 1989; Blum et al., 2000). Thus $^{87}Sr/^{86}Sr$ in human tissue largely reflects local geology.

Because dental enamel is a cell-free tissue that forms during early childhood and does not remodel thereafter (Hillson, 2002), it is possible to identify migrants who moved between geologically and isotopically different regions by comparing ratios measured in their tooth enamel samples and the local biologically available $^{87}Sr/^{86}Sr$ at the site where the respective individuals were buried (Price et al., 2002; Bentley, 2006).

Due to high tectonic activity, the geology of the Aegean region is complex, and the region can be divided into isopic/tectonic zones that comprise groups of rocks sharing a common geological history (Higgins and Higgins, 1996) (Fig. 1). For information on the geological context of this study see Nafplioti (2008).

Fig. 1 | Geological map of the study area, after Higgins and Higgins (1996: Fig. 2.2). Marked on it are the sites mentioned in the text. Key: 1 Knossos (Ailias, Gypsades, Knossos South of the Palace, Sellopoulo, Mavrospelio), 2 Moni Odigitra, 3 Mycenae, 4 Tiryns, 5 Koilada, 6 Kranidi, 7 Apatheia Galatas

Table 1 | Materials used in this paper

Region	Site	Material analysed	Date	Analyses applied
Crete, South-Central	Moni Odigitria	Human skeletal material	EMII-MMII	Craniometric analysis
Crete, North-Central	Knossos, Ailias	Human skeletal material	MMII-MMIII	Craniometric and $^{87}Sr/^{86}Sr$ analyses
	Knossos, Gypsades	Human and animal skeletal material	MMII-LMIA	Craniometric and $^{87}Sr/^{86}Sr$ analyses
	Knossos, Sellopoulo	Human and animal skeletal material	Chamber Tombs 3 and 4: LMII-LMIIIA1, Shaft grave: LMIIIA1, Chamber Tombs 1 and 2: LMIIIA2	Craniometric and $^{87}Sr/^{86}Sr$ analyses
	Knossos, Knossos South of the Palace (KSP)	Human skeletal material	LMII-LMIIIA	$^{87}Sr/^{86}Sr$ analysis
	Knossos, Mavrospelio	Human skeletal material	LMIII	Craniometric analysis
	Knossos	Snail shells	Modern	$^{87}Sr/^{86}Sr$ analysis
Mainland, Argolid	Apatheia, Galatas	Human skeletal material	LHII-LHIII	Craniometric analysis
	Mycenae	Animal skeletal material	LHI	$^{87}Sr/^{86}Sr$ analysis
		Snail shells	Modern	$^{87}Sr/^{86}Sr$ analysis
	Tiryns	Snail shells	Modern	$^{87}Sr/^{86}Sr$ analysis
	Koilada	Snail shells	Modern	$^{87}Sr/^{86}Sr$ analysis
	Kranidi	Snail shells	Modern	$^{87}Sr/^{86}Sr$ analysis

Key: EM=Early Minoan, MM=Middle Minoan, LH=Late Helladic, LM=Late Minoan

Determination of the local biologically available $^{87}Sr/^{86}Sr$ signatures

As the author's doctoral and on-going post-doctoral research were the first to apply $^{87}Sr/^{86}Sr$ analysis in the Aegean Archaeology (Nafplioti, 2007, 2008, 2009a, 2009b, 2010), and due to the paucity of useful published $^{87}Sr/^{86}Sr$ data for Aegean rocks, a substantial share of the analyses performed (67 samples of archaeological and modern animal skeletal tissue) were aimed at assessing the variation of local biologically available $^{87}Sr/^{86}Sr$ values in the Aegean; thereby, the first map of such signatures in this region (Nafplioti, 2011). For reasons explained in detail in earlier publications of the author (Nafplioti, 2008, 2009a), following Price and colleagues (2002) this research principally used skeletal samples of local archaeological and modern animals to characterise the local biologically available $^{87}Sr/^{86}Sr$ signatures at the sites investigated.

In particular, the data discussed in this paper were recovered from nine archaeological animal enamel samples, eighteen modern snail shells and three archaeological human bone samples. Briefly, animal dental enamel was preferred as it is more resistant to post-depositional chemical and physical modifications compared to bone and dentine (Kohn et al., 1999; Bentley, 2006). The selection of the modern snail shell samples in relation to issues of contamination from pollutants and/or soil fertilizers and their relatively small home ranges has been described in earlier relevant publications (Nafplioti, 2008, 2009a, 2011). Finally, for reasons relating to bone physiology (Parfitt, 1983), archaeological human bone was also sampled to determine local biologically available $^{87}Sr/^{86}Sr$. These data, however, are used with caution due to the possibility of post-depositional contamination of bone from local ground waters, and the possibility that recent immigrants may be present within the sampled indigenous population.

In order to provide an objective means of distinction between locals and nonlocals at a site, the author calculated the range of the mean local biologically available $^{87}Sr/^{86}Sr$ determined from archaeological animal enamel, modern snail shells and archaeological human bone samples, ± 2 standard deviations, as in Price et al. (2002). If an individual was born, raised and spent at least the last 7 to 10 years of his/her life in the local area, $^{87}Sr/^{86}Sr$ values for samples of his/her dental enamel and bone should fall within the above confidence limits.

Analytical procedure

The author personally carried out the preparation and analysis of all samples for $^{87}Sr/^{86}Sr$ at the National Oceanography Centre in Southampton. The protocol followed for most of the samples is that described by Nafplioti (2008). The small modification to the procedure at the stage of the acetic acid cleaning of samples for the removal of diagenetic strontium, outlined in Nafplioti (2009a), concerns the archaeological animal enamel sample from Mycenae and the modern snail shells from Tiryns, Koilada and Kranidi in the Argolid only. The $^{87}Sr/^{86}Sr$ of the samples was measured to the sixth decimal digit by a VG-Micromass Sector 54 thermal ionization mass spectrometer (MS).

Biodistance analysis

Biological distance or biodistance analysis refers to the measurement and interpretation of biological relatedness or divergence between populations or subgroups within populations (Buikstra et al., 1990). Under the terms 'biological distance' and 'biological variance' are grouped both genotypic and pheno-

typic distance and variance, which are assumed to be proportional (Cheverud, 1988; Williams-Blangero and Blangero, 1989; Konigsberg and Ousley, 1993, 1995). In studies of past populations, the two broad categories of polygenic traits used in the assessment of biological relationships are: 1) metric or continuous variables obtained by linear measurements or indices calculated from measurements used to describe the size and shape of skeletal elements, and 2) non-metric or quasi-continuous anatomical variables often expressed as gradations from absence to full expression.

Although the author's doctoral research employed analysis of both metric and non-metric cranial and dental morphology, this paper will present selected results of the analysis of cranial metric morphology only. The analysis is oriented in time both vertically (providing time depth) and horizontally (allowing the comparative examination of contemporary but geographically distinct populations). By monitoring inter- and intra-population biological variation and distance over the course of time, this study explores the biological history of the examined populations for continuity or discontinuity. The latter would probably constitute positive evidence for the arrival and admixture of biologically different population groups, while the former would constitute negative evidence to that effect.

Drawing on Howells' (1973) classic study of cranial variation in human populations, this research adopted Howells' set of fifty-seven cranial measurements (Nafplioti, 2007). Measurements were taken following Howells' definitions (Howells, 1973), using four types of instruments, as appropriate, and the data were analysed using univariate and multivariate analytical techniques (SPSS version 12.0). For a detailed description of craniometric data collection and analysis, see Nafplioti (2007).

Materials

The human skeletal collections studied using analysis of cranial metric morphology and/or $^{87}Sr/^{86}Sr$ analysis of selected enamel samples, as well as the samples used as controls for the local biologically available $^{87}Sr/^{86}Sr$, their provenance and dating are given in Table 1, and marked on the map in Fig. 1.

Results

Proof statements

In order to confirm the theory examined in this paper, the following conditions need to be met:

1) The people buried in the so-called "warrior graves" or tombs of Mainland architecture are non-locals at Knossos; they were born at Mycenae. Mycenae in the Argolid amongst all other Mycenaean centres of that time appears to be the strongest "candidate" capable of invading and politically dominating Knossos.

2) The biological history of the Bronze Age Knossos population is disrupted at the end of the LMIB. Discontinuity in the biological history is manifested as follows.

2.1) The intra-population variation increases for the Knossos population samples postdating the LMIB destructions compared to earlier ones, due to the arrival of biologically different individuals from the Argolid.

2.2) The inter-population distance of the successive Bronze Age Central Cretan population samples increases between the samples dating immediately prior and following the suggested migration.

3) The distance between the populations from the Argolid and Knossos district decreases for the samples postdating the suggested migration, due to the influx into Knossos of people from the Argolid.

Strontium isotope ratio ($^{87}Sr/^{86}Sr$) analysis

Because most of the results of $^{87}Sr/^{86}Sr$ analysis of dental samples from individuals from Knossos dating to the period following the LMIB destructions have already been published elsewhere (Nafplioti, 2008), they are only briefly presented and discussed here, emphasizing more recent corroborative data for the local biologically available $^{87}Sr/^{86}Sr$ signatures in the regions examined (Nafplioti, 2011).

In order to confirm the hypothesis tested in this paper, the $^{87}Sr/^{86}Sr$ values recovered from enamel samples of individuals from 'warrior burials' or tombs of Mainland architecture at Knossos postdating the LMIB destructions (i.e. the shaft-grave and chamber tombs at Sellopoulo and the KSP chambers tombs) should (i) be different from the local biologically available $^{87}Sr/^{86}Sr$ values at Knossos and (ii) fall within the confidence limit for characterising the local at Mycenae population.

Patterning of the data on the local biologically available $^{87}Sr/^{86}Sr$ at Knossos in Central Crete, Mycenae, Tiryns, Koilada and Kranidi in the Argolid clearly suggests that there is enough variation between Knossos on Crete and the Argolid in the Mainland to allow for population movement between the two regions to be detectable (Fig. 2, Table 2).

Fig. 2 | Inter-regional variation in biologically available $^{87}Sr/^{86}Sr$ signatures: $^{87}Sr/^{86}Sr$ values in archaeological and modern animal skeletal samples from Knossos on Crete and Mycenae, Tiryns, Koilada and Kranidi in the Argolid

Table 2 | Strontium isotope ratio (^{87}Sr/^{86}Sr) values in archaeological and modern animal skeletal tissue, and archaeological human bone used to characterise the local biologically available ^{87}Sr/^{86}Sr at sites on Crete and the Argolid

Region	Site	Species	Element	^{87}Sr/^{86}Sr value	± 2 S.E.
Crete	Knossos	Pig	PM4	0.708985	0.000011
		Sheep/goat	PM3	0.708989	0.000014
		Sheep/goat	I	0.708679	0.000013
		Pig	M1	0.709092	0.000011
		Sheep/goat	M1	0.708534	0.000011
		Pig	M1	0.709024	0.000011
		Cow	M2	0.708992	0.000011
		Pig	M1	0.708995	0.000010
		Snail	Shell	0.708991	0.000010
		Snail	Shell	0.709026	0.000010
		Snail	Shell	0.708974	0.000011
		Snail	Shell	0.708952	0.000011
		Human (archaeological)	Femur	0.709022	0.000013
		Human (archaeological)	Tibia	0.709044	0.000011
		Human (archaeological)	Femur	0.709000	0.000013
Argolid	Mycenae	Pig	M3	0.708082	0.000010
		Snail	Shell	0.708262	0.000010
		Snail	Shell	0.708254	0.000014
		Snail	Shell	0.708226	0.000011
		Snail	Shell	0.708328	0.000011
	Tiryns	Snails (4)	Shell	0.708261*	0.000013
	Koilada	Snails (3)	Shell	0.708154*	0.000017
	Kranidi	Snails (3)	Shell	0.708451*	0.000011

Key: M=molar, M1=1st molar, M2=2nd molar, M3=3rd molar, PM3=3rd premolar, PM4=4th premolar.
The asterisk (*) marks ^{87}Sr/^{86}Sr grouping values for shell samples of equal quantity from more than one snails analysed as a single composite sample. The number of snails analysed is given in parenthesis in the third column of this table

^{87}Sr/^{86}Sr values measured in enamel (n=32) and bone samples (n=3) from four human skeletal collections from Knossos are given in Table 3 and graphically represented in Figure 3. Black bars represent individual enamel values, while the white ones represent values for bone samples.

The three horizontal bands in Figure 3 mark the confidence limits (mean ^{87}Sr/^{86}Sr ± 2 s.d.) for the distinction between locals and nonlocals at Knossos based on values recovered from archaeological animal enamel (grey colour), modern snail shells (hatched lines, oriented to the right) and archaeological human bone samples (hatched lines, oriented to the left), and overlap at 0.708978 to 0.709047. The confidence limit based on archaeological animal enamel values (0.708521 to 0.709302) is wider compared with the other two, and is used here to identify any nonlocals for reasons outlined earlier in the methodology section.

The mean ^{87}Sr/^{86}Sr measured in enamel samples from the Sellopoulo individuals (n=11) was calculated as 0.708958 ± 0.000138 and the values range between 0.708604 and 0.709128. With the exception of individuals SEL1, IV (0.708604 ± 0.000013) and SEL/58 (0.709128 ± 0.000011), ^{87}Sr/^{86}Sr values for the remaining nine Sellopoulo individuals fall within (or slightly above in the single case of

Fig. 3 | Strontium isotope ratio ($^{87}Sr/^{86}Sr$) values for Knossos individuals, dental enamel and bone

LATE MINOAN IB DESTRUCTIONS AND CULTURAL UPHEAVAL ON CRETE 249

Table 3 | Strontium isotope ratio (^{87}Sr/^{86}Sr) values for Knossos individuals, dental enamel and bone

Individual	Skeletal collection	Element	^{87}Sr/^{86}Sr value
AIL 1	Ailias	M1	0.709212
AIL 2	Ailias	M1	0.708970
AIL 6	Ailias	M1	0.709000
AIL 15	Ailias	M1	0.709042
AIL 90	Ailias	M1	0.709014
AIL 98	Ailias	M1	0.709227
AIL 102	Ailias	M1	0.708999
AIL 103	Ailias	M1	0.709050
GYP XVIII, II	Gypsades	M1	0.709021
GYP XVIII, III	Gypsades	M1	0.709053
GYP XVIII, III	Gypsades	M1	0.709029
GYP XVIII,VI	Gypsades	M1	0.709058
GYP XVIII,VII	Gypsades	M1	0.709025
LGI, F	Gypsades	M2	0.708997
LGI, F5	Gypsades	PM4	0.709035
LGI, E6	Gypsades	M1	0.709085
LGI, Larnax	Gypsades	M1	0.709033
LGI, Larnax	Gypsades	Femur	0.709022
SEL1, II	Sellopoulo	M1	0.709062
SEL1, III	Sellopoulo	M1	0.708967
SEL1, III NE	Sellopoulo	M1	0.708934
SEL1, IV	Sellopoulo	M1	0.708604
SEL1, IV	Sellopoulo	M1	0.708984
SEL1, VII	Sellopoulo	M1	0.708933
SEL2, N B.	Sellopoulo	M1	0.709016
SEL2, SE B.	Sellopoulo	M1	0.709075
SEL4	Sellopoulo	M1	0.708888
SEL4, 3	Sellopoulo	M1	0.708943
SEL1, III	Sellopoulo	Tibia	0.709044
SEL1, VII	Sellopoulo	Femur	0.709000
SEL/58	Sellopoulo	M1	0.709128
KSP I, I	Knossos south of the palace	M1	0.708963
KSP I, III	Knossos south of the palace	M1	0.708910
KSP IV, I	Knossos south of the palace	M1	0.708478
KSP B26	Knossos south of the palace	M1	0.709037

Key: M1=1st molar, M2=2nd molar, PM4=4th premolar.

SEL2, SE B.: 0.709075 ± 0.000011) the confidence limit(s) for characterising the local Knossos population based on modern snails (0.708923 to 0.709047) and/or human bone values (0.708978 to 0.709066). However, $^{87}Sr/^{86}Sr$ values for all eleven Sellopoulo individuals analysed fall within the confidence limit for the distinction between locals and nonlocals at Knossos based on animal enamel values (0.708521 to 0.709302).

Moreover, the mean $^{87}Sr/^{86}Sr$ measured in enamel samples from the KSP collection (n=4) was calculated as 0.708847 ± 0.000251, and the values range between 0.708478 and 0.709037. Ratios measured in the enamel of three of the KSP individuals analysed fall within (two cases) or slightly below (one case) the confidence limit(s) based on human bone and/or modern snails from Knossos. Using the animal enamel criterion (0.708521 to 0.709302), however, none of these three KSP individual can be identified as nonlocal at Knossos. Moreover, the value measured in the enamel of the fourth KSP individual analysed, i.e. KSP IV, I (0.708478 ± 0.000011) is also very close to the lower limit of the range of local at Knossos biologically available $^{87}Sr/^{86}Sr$ values determined from archaeological animal enamel samples.

Further, $^{87}Sr/^{86}Sr$ values measured in samples from all the Sellopoulo and KSP individuals, except for SEL1, IV and KSP IV, I, are very similar to those recovered from the earlier Ailias and Gypsades collections, which are assumed to represent the local Knossos population.

Regarding the two low enamel values recovered from the SEL1, IV (0.708604) and KSP IV, I (0.708478) individuals, the fact that a value of 0.708535 measured in the dental enamel of a sheep/goat from Gypsades, used in this study as a control for the local biologically available $^{87}Sr/^{86}Sr$ at Knossos, is very close to the first two demonstrates that it is not illegitimate to characterise the two individuals in question as locals at Knossos.

Additional negative evidence for the presence of Mycenaeans among the Sellopoulo and KSP individuals derives from the local biologically available $^{87}Sr/^{86}Sr$ at Mycenae. This was determined from one archaeological animal enamel sample, and four modern snail shell samples (Table 2). The mean $^{87}Sr/^{86}Sr$ for the latter was calculated as 0.708267 ± 0.000043 and the range for 2 s.d. is 0.708181 to 0.708353. This is used here as the confidence limit for characterising the local Mycenae population and is marked in Figure 4 by the horizontal band of squares. The horizontal interrupted line on the same graph marks the $^{87}Sr/^{86}Sr$ value measured in the dental enamel of an archaeological pig from Mycenae (0.708082 ± 0.000010). $^{87}Sr/^{86}Sr$ values for all individuals from Knossos (0.708478 to 0.709227) clearly fall above the confidence limit for the distinction between locals and nonlocals at Mycenae. Thereby, according to the present data none of the Knossos individuals analysed may have been born and raised at Mycenae.

In Figure 5 the horizontal band of squares marks the confidence limit for the distinction between locals and nonlocals in the Argolid, determined from $^{87}Sr/^{86}Sr$ values recovered from modern snails from three sites in this region in addition to Mycenae, i.e. Tiryns, Koilada and Kranidi (Table 2). Again the values for all the Knossos individuals fall above that range. Therefore, based on the above results the hypothesis that nonlocals from Mycenae, or generally the Argolid, are present at Knossos from the LMII onwards can be rejected.

Fig. 4 | Strontium isotope ratio ($^{87}Sr/^{86}Sr$) values for Knossos individuals, dental enamel and bone

Fig. 5 | Strontium isotope ratio ($^{87}Sr/^{86}Sr$) values for Knossos individuals, dental enamel and bone

Table 4 | Mean squared Mahalanobis distance of population samples to the Central Cretan population centroid

Skeletal collection/ Population sample	Mean squared Mahalanobis distance to the Bronze Age Central Cretan population centroid
Moni Odigitria	2.1879
Ailias	0.8161
Gypsades	1.1732
Sellopoulo	0.6257
Mavrospelio	0.7518
Mean distance to population centroid	1.0391

Biodistance analysis

Cranial metric morphology: Intra-population variation and inter-population distance of Central Cretan population samples

This section investigates the biological history of the Bronze Age Knossos population for evidence of discontinuity. Analysis of cranial metric morphology focuses on the relationship (relatedness vs. divergence) between the Ailias and Gypsades collections on the one hand, and the Sellopoulo and Mavrospelio collections on the other. The first two antedate the LMIB destructions (MMII–LMIA), whereas Sellopoulo and Mavrospelio postdate them (LMII–III).

Fluctuations in the intra-population variation over the course of time due to differential amounts of gene flow from extraregional source(s) can be monitored by measuring the mean distance of the population samples studied to the regional population centroid. According to population genetic theory, if all populations within a region exchange migrants from an external source at an equal rate, the relationship between the average intra-population variation and genetic distance of each population to the regional population centroid (i.e. the average heterozygosity of all subpopulations) should be linear. When one population increases the rate of genetic exchange with external sources, its intra-population heterogeneity will increase due to the influx of new genes and the linear relationship will be violated (Harpending and Ward, 1982; Relethford and Blangero, 1990).

As regards the theory examined in this paper, if Mycenaeans invaded Crete at the end of LMIB, politically dominated and settled at Knossos, the mean distance of the Knossos population samples to the regional (Central Crete) population centroid would be expected to increase for those postdating the destructions. Thus, higher values for the mean distance to the Central Cretan population centroid are anticipated for the Sellopoulo and Mavrospelio samples, which postdate the destructions, compared to the earlier Ailias and Gypsades.

Mean squared Mahalanobis distance (D^2) to the centroid of the Central Cretan population was calculated for the Moni Odigitria, Ailias, Gypsades, Sellopoulo and Mavrospelio population samples. Distances were calculated for six cranial metric variables that describe the cranial length, breadth and height, and the midline curvature of the calvaria (GOL, XCB, VRR, PAC, PAS and PAS–see Nafplioti [2007, 348] for a description of the codes for metric variables) and the results are shown in Table 4.

Based on the above results, Moni Odigitria shows the highest value for the mean squared Mahalanobis distance (D^2) to the regional Central Cretan population centroid. This is not surprising given the geographical distance of Moni Odigitria to the Knossos region, where all other collections tested derive from, and will be further discussed in the section, which assesses inter-population distances for the Cen-

Fig. 6 | Inter-sample distance; Early, Middle and Late Bronze Age Central Crete population samples, sexes pooled but separated by symbol (♂ and ♀): PCA results for variables describing the length and breadth of the cranium

tral Cretan population samples. Moreover, the lowest values calculated for the above analysis were for the Sellopoulo and Mavrospelio samples. Thus these results falsify the hypothesis for an increase in the distance of the Knossos population samples to the regional population centroid for the samples postdating the LMIB destructions compared to the earlier Gypsades and Ailias, as a result of an influx of biologically different population elements and an increase of intra-population variation.

Principal Component Analysis (PCA) was applied to variables describing cranial length and breadth (GOL, XCB, XFB, FRC and PAC) in order to assess inter-population distance for population samples from Central Crete spanning the Bronze Age. Table 5 shows the amount of variance explained by the two extracted components and Table 6 the component loadings for PCA of cranial size and shape. Despite the relatively low sample size (n=43), plotting of the PCA results in Figure 6 clearly shows that the Sellopoulo and Mavrospelio individuals, postdating the LMIB destructions, tend to have a cranial shape very similar to the earlier Gypsades sample, also from the Knossos district. The male and female individuals from Gypsades, Sellopoulo and Mavrospelio appear to have a cranium that is rather broad relative to its length when compared to individuals of the same sex from Ailias and more so to Moni Odigitria from South-central Crete.

Table 5 | Amount of variance explained by the 2 extracted PCs

Component	Eigenvalues	% of variance	Cumulative %
1	2.765	55.301	55.301
2	1.367	27.336	82.638

Table 6 | Component loadings for PCA of variables describing the cranial length and breadth

Cranial metric variables	Component	
	1	2
GOL	.866	−.400
XCB	.558	.746
XFB	.696	.614
FRC	.836	−.167
PAC	.721	−.496

Therefore these results suggest a gradual rounding of the cranial shape for the Central Cretan population in the course of the Bronze Age, resulting from the increase of the cranial breadth in relation to cranial length. They further provide negative evidence for a disruption of the biological history of the Knossos population following the LMIB destructions due to an increase in the biodistance between the samples dating immediately prior and following the destructions.

The gradual rounding of the cranial shape of the Central Cretan population over the course of the Bronze Age and the very similar shape of the Gypsades, Sellopoulo and Mavrospelio crania can be more clearly appreciated by plotting the Cranial Index (100*maximum cranial breadth/glabello – occipital length) data. The Cranial Index describes the cranial shape and higher cranial indices reflect a more rounded cranium. In Figure 7, the Cranial Indices for all the above-mentioned Central Cretan population samples are plotted in chronological order, from the Early to Late Bronze Age. Cranial Indices were calculated separately for males and females from each sample.

The gradual increase in Cranial Index over the Bronze Age most probably reflects gene-flow from population/s biologically different from the Early Bronze Age Cretan population and from inter-population biological interactions (admixture) in the succeeding periods. An alternative interpretation implicating the thermoregulatory model of Beals et al. (1984) and adaptation to colder climatic conditions carries less weight.

Therefore, analysis of cranial metric morphology provided negative evidence for a disruption of the biological history of the Knossos population at the end of the LMIB.

Cranial metric morphology: Inter-population distance between the Argolid and Central Cretan populations

If the examined hypothesis is true, biodistance between the Argolid and Knossos populations is expected to decrease following the LMIB destructions. PCA was applied to explore the relationship (relatedness vs. divergence) between the three successive MMII–LMIII samples from the Knossos district (Gypsades, Mavrospelio, Sellopoulo) on the one hand, and the LMII–III Apatheia sample from the Argolid on the other. The inter-population relationship was assessed using the same variables (GOL, XCB, XFB, FRC and PAC), which were analysed to explore the relationship between the Central Cretan population samples, and the results are given in Tables 7 and 8 (n=24).

Fig. 7 | Box and whisker plot of cranial shape of the Central Crete population samples, Cranial Index. Key: 1 Moni Odigitria, 2 Ailias, 3 Gypsades, 4 Sellopoulo, 5 Mavrospelio

Table 7 | Amount of variance explained by the 2 extracted PCs

Component	Eigenvalues	% of variance	Cumulative %
1	2.174	43.472	43.472
2	1.695	33.903	77.376

Table 8 | Component loadings for PCA of variables describing the cranial length and breadth

Cranial metric variables	Component	
	1	2
GOL	.931	.118
XCB	−.155	.891
XFB	−.111	.886
FRC	.761	.296
PAC	.831	−.119

Fig. 8 | Inter-population distance; Late Bronze Age Central Crete and Argolid population samples, sexes pooled but separated by symbol (♂ and ♀): PCA results for variables describing the length and breadth of the cranium

Plotting of the data in Figure 8 shows a distinct separation between the Late Bronze Age Knossos samples and the roughly contemporary Apatheia from the Argolid. All but one female individual from Apatheia appear to have crania that are narrow for their length in comparison to their contemporaries from Crete. The representation of the two sexes in the tested samples excludes the possibility that the difference in cranial morphology between the Cretan and Argolid samples is due to sexual dimorphism and differences in the representation of males and females in the population samples tested. Concerning the brief overlap of the Argolid and the Cretan samples, the Knossos male that groups with the Apatheia individuals is from the Gypsades collection that dates to the period before the LMIB destructions. Hence patterning of the data shows a distinct separation of the LMII–III Knossos individuals from their contemporaries of the same sex from Apatheia (Mainland).

In order to further investigate the above relationship, biasterionic breadth (ASB) was substituted for maximum frontal breadth (XFB) in the PCA; the former variable describes the posterior breadth of the

Fig. 9 | Inter-population distance; Late Bronze Age Central Crete and Argolid population samples, sexes pooled but separated by symbol (♂ and ♀): PCA results for variables describing the length and breadth of the cranium

cranium, while the latter the breadth of the anterior cranial region. The results of the analysis are given in Tables 9 and 10 (n=27), and their plotting in Fig. 9 confirms the conclusions of the previous analysis (Fig. 8).

To sum up, based on the results of cranial metric morphological analysis presented here, both hypotheses for a disruption of the biological history of the Bronze Age Knossos population and a decrease in the biological distance between the Argolid and Knossos populations from the LMII onwards can be rejected. Additional analyses of cranial and dental metric and non-metric morphology not presented here due to space limitations corroborate the above findings (see Nafplioti, 2007).

Table 9 | Amount of variance explained by the 2 extracted PCs

Component	Eigenvalues	% of Variance	Cumulative %
1	1.958	39.165	39.165
2	1.583	31.653	70.818

Table 10 | Component loadings for PCA of variables describing the cranial length and breadth

Cranial Metric Variables	Component	
	1	2
GOL	.918	−.187
XCB	.040	.857
ASB	.467	.706
FRC	.630	.256
PAC	.707	−.499

Discussion and Conclusions

$^{87}Sr/^{86}Sr$ analysis provided negative evidence for the presence of nonlocals in LMII–IIIA tombs at Knossos that have been associated with Mycenaeans, and specifically rejected the possibility that any of the individuals tested could have been born and raised at Mycenae or generally the Argolid. Moreover, even if the individuals analysed do not represent first generation immigrants from the Argolid, but their descendants, this gene flow into the Knossos population should have been detectable in skeletal morphology. However, analysis of cranial metric morphology on the one hand suggested that the Late Bronze Age Argolid and the roughly contemporary Knossos population samples are biologically distant enough to allow tracing of fluctuations in their biological relationship resulting from interregional population movement and biological interactions. On the other hand, the analysis showed continuity in the biological history of the Knossos population from the Middle to Late Bronze Age. The above results are not consistent with one of the two principal constituent elements of the theory of a LMIB Mycenaean invasion of Crete and political domination of Knossos; they show that the "warrior burials", "burials with bronzes" or tombs of Mainland architecture at Knossos need not necessarily be associated with Mycenaeans. Therefore, on present data the theory tested can be rejected.

Additional negative evidence for this theory derives from further analyses of cranial and dental metric and non-metric morphology presented in the author's unpublished doctoral thesis (Nafplioti, 2007), as well as the material culture itself. As regards to the latter, the timing of LMIB destructions on Crete and the inference that they represent a single horizon have been seriously questioned in more recent studies of archaeomagnetic and material culture data that demonstrated a rather broad contemporaneity of one or two generations for these destructions (Driessen and Macdonald, 1997).

Likewise, regarding cultural discontinuity, it is not the case that all novel cultural features in post-LMIB Crete were simultaneously introduced shortly after the destructions, nor do earlier Cretan traditions generally cease. There is ongoing debate over the timing of introduction of the Linear B writing system to Knossos, which constitutes the second principal constituent of the theory of a Mycenaean invasion. The dates suggested range from the LMII (Driessen, 1990) to the LMIIIA1–2 (Popham, 1970), or even the LMIIIB (Hallager, 1977, unpubl.; Niemeier, 1985); more than a hundred years after the destruc-

tions. The suggested 'abrupt' nature of cultural change in the funerary architecture and mortuary practices, which fits this theory well, is largely exaggerated by archaeological bias and the paucity of cemeteries on Crete dating immediately prior to the destructions. Moreover, there is evidence from the Poros cemetery (Lembessi, 1967), 5 kilometres north of Knossos, for a transitional architectural type between the Cretan-Minoan and the Mainland-Mycenaen chamber tomb, dating to the LMIA.

Based on the above, the author argues here that even if at some time in the LMII–III period Mycenaeans were present at Knossos, their presence there did not take the form of invasion and imposed political domination, nor were they responsible for the LMIB destructions on the island. After all, the absence of refuge sites on Crete dating to this period is more consistent with the hypothesis for an internal rather than an external enemy (Driessen and Macdonald, 1997). As has been discussed in more detail elsewhere (Nafplioti, 2007, 2008), the results of this study appear to be compatible with more recent archaeological theories for the LMIB destructions and the subsequent cultural upheaval that emphasize factors internal to the Cretan society, social competition and unrest, probably linked to the economic and psychological consequences of natural disasters (e.g. Marinatos, 1993; Driessen and Macdonald, 1997; Rehak and Younger, 2001; Preston, 2004). According to these, the new local leaders, whether affiliated to some extent with the Mycenaeans or not, adopted a rather new, largely Mycenaean in origin, symbolic system that was not completely unknown to them due to ongoing inter-regional contacts, in order to justify the political change and legitimize their power (Schallin, 1993).

References

Alberti, L., 2004. The Late Minoan II–IIIA1 warrior graves at Knossos: the burial assemblages, in: Cadogan, G., Hatzaki, E., Vasilakis, A. (Eds.), Knossos: Palace, City, State. Proceedings of the Conference in Herakleion organized by the British School at Athens and the 23rd Ephoreia of Prehistoric and Classical Antiquities of Herakleion, in November 2000, for the Centenary of Sir Arthur Evans's Excavations at Knossos, British School of Athens Studies 12. Barber, London, pp. 127–136.

Beals, K.L., Smith, C.L., Dodd, S.M., 1984. Climate and the evolution of brachycephalization. American Journal of Physical Anthropology 62, 1–13.

Bentley, R.A., 2006. Strontium isotopes from the earth to the archaeological skeleton: A review. Journal of Archaeological Method and Theory 13, 135–187.

Blum, J.D., Taliaferro, E.H., Weisse, M.T., Holmes, R.T., 2000. Changes in Sr/Ca, Ba/Ca, and $^{87}Sr/^{86}Sr$ ratios between trophic levels in two forest ecosystems in the Northeastern USA. Biogeochemistry 49, 87–101.

Buikstra J.E., Frankenberg, S.R., Konigsberg, L.W., 1990. Skeletal biological distance studies in American physical anthropology: Recent trends. American Journal of Physical Anthropology 82, 1–7.

Catling, H., 1989. Some Problems in Aegean Prehistory c. 1450–1380 BC. Leonard's Head Press, Oxford.

Cheverud, J.M., 1988. A comparison of genetic and phenotypic correlations. Evolution 42, 958–968.

Doxey, D., 1987. Causes and effects of the fall of Knossos in 1375 B.C. Oxford Journal of Archaeology 6, 301–315.

Driessen, J., 1990. An Early Destruction in the Mycenaean Palace at Knossos: A New Interpretation of the Excavation Field – Notes of the South-East Area of the West Wing. Acta Archaeologica Lovaniensia Monographiae 2. Leuven, Belgium.

Driessen, J., Macdonald, C.F., 1984. Some military aspects of the Aegean in the late fifteenth and the early fourteenth centuries B.C. Annual of the British School at Athens 79, 49–70.

Driessen, J., Macdonald, C. F., 1997. The Troubled Island: Minoan Crete before and after the Santorini Eruption. Aegaeum 17. Université de Liège, Liège.

Faure, G., 1986. Principles of Isotope Geology. John Wiley & Sons, New York.

Graustein, W.C., 1989. $^{87}Sr/^{86}Sr$ ratios measure the sources and flow of strontium in terrestrial ecosystems, in: Rundel, P.W., Ehleringer, J.R., Nagy K.A. (Eds.), Stable Isotopes in Ecological Research. Springer-Verlag, New York, pp. 491–512.

Hallager, E., 1977. The Mycenaean Palace at Knossos. Evidence for Final Destruction in the III B Period. Medelhavsmuseet, Stockholm.

Hallager, E., 2010. The dating of the Mycenaean administrative documents at Knossos. (unpublished Seminar presentation, Minoan Seminar, 19 March 2010, Archaeological Society, Athens).

Harpending, H.C., Ward, R.H., 1982. Chemical systematics and human populations, in: Nitecki, M. (Ed.), Biochemical Aspects of Evolutionary Biology. University of Chicago, Chicago, pp. 213–256.

Higgins, M.D., Higgins, R., 1996. A Geological Companion to Greece and the Aegean. Duckworth, London.

Hillson, S., 2002. Dental Anthropology, 3rd ed. Cambridge University Press, Cambridge.

Howells, W.W., 1973. Cranial Variation in Man: A Study by Multivariate Analysis of Patterns of Difference among Recent Human Populations. Harvard University, Papers of the Peabody Museum of Archaeology and Ethnology, 67.

Kohn, M.J., Schoninger, M.J., Barker, W.W., 1999. Altered states: effects of diagenesis on fossil tooth chemistry. Geochimica et Cosmochimica Acta 63, 2737–2747.

Konigsberg, L.W., Ousley, S.D., 1993. Multivariate quantitative genetics of anthropometrics from the Boas data. American Journal of Physical Anthropology Supplement 16, 127–128.

Konigsberg, L.W., Ousley, S.D., 1995. Multivariate quantitative genetics of anthropometric traits from the Boas data. Human Biology, 67, 481–498.

Lembessi, A., 1967. Anaskafi tafou eis Poron Herakleioy (in Greek). Praktika tis en Athinais Archaeologikis Etaireias, 195–209.

Macdonald, C.F., 2002. The Neopalatial palaces of Knossos, in: Driessen, J., Schoep, I., Laffineur, R. (Eds.), Monuments of Minos. Rethinking the Minoan Palaces. Proceedings of the International Workshop "Crete of the Hundred Palaces?" held at the Université Catholique de Louvain, Louvain-la-Neuve, 14–15 December 2001. Aegaeum 23, Liege, pp. 35–54.

Marinatos, N., 1993. Minoan Religion: Ritual, Image and Symbol. University of South Carolina Press, Columbia.

Miller, E.K., Blum, J.A., Friedland, A.J., 1993. Determination of soil exchangable-cation loss and weathering rates using Sr isotopes. Nature 362, 438–441.

Nafplioti, A., 2007. Population bio-cultural history in the South Aegean during the Bronze Age. PhD dissertation. University of Southampton, Southampton.

Nafplioti, A., 2008. Mycenaean political domination of Knossos following the LMIB destructions on Crete: negative evidence from strontium isotope ratio analysis ($^{87}Sr/^{86}Sr$). Journal of Archaeological Science 35, 2307–2317.

Nafplioti, A., 2009a. Mycenae revisited part 2. Exploring the local vs. nonlocal origin of the individuals from Grave Circle A at Mycenae: evidence from strontium isotope ratio ($^{87}Sr/^{86}Sr$) analysis. Annual of the British School at Athens 104, 279–291.

Nafplioti, A., 2009b. Early Bronze Age Manika on Euboea (Greece): A 'colony' or Not? Evidence from strontium isotope ratio ($^{87}Sr/^{86}Sr$) analysis. Geochimica et Cosmochimica Acta, 73 (13), Supplement 1, A925.

Nafplioti, A., 2010. The Mesolithic occupants of Maroulas on Kythnos: Skeletal isotope ratio signatures of their geographic origin, in: Sampson, A., Kaczanowska, M., Kozłowski, J. K. (Eds.), The Prehistory of the Island of Kythnos (Cyclades, Greece) and the Mesolithic Settlement at Maroulas. The Polish Academy of Arts and Sciences, Krakow, pp. 207–215.

Nafplioti, A. 2011. Tracing population mobility in the Aegean using isotope geochemistry: a first map of biologically available $^{87}Sr/^{86}Sr$ signatures. Journal of Archaeological Science 38, 1560–1570.

Niemeier, W.D., 1985. The archaeological dating of the Knossian Linear B tablets reconsidered. A Summary. Ta Pepragmena tou E' Diethnoys Kritologikoy Synedrioy (Agios Nikolaos, 25 Septemvrioy – 1 Oktovrioy 1981). Etairia Kritikon Istorikon Meleton, Irakleio, pp. 259–263.

Parfitt, A.M., 1983. The physiologic and clinical significance of bone data, in: Recker, R.R. (Ed.), Bone Histomorphometry: Techniques and Interpretation. CRC Press, Boca Raton, pp. 143–223.

Popham, M.R., 1970. The Destruction of the Palace at Knossos. Pottery of the Late Minoan IIIA Period. Studies in Mediterranean Archaeology, Vol. XII. Astrom editions, Göteborg.

Popham, M.R., 1994. Late Minoan II to the End of the Bronze Age, in: Evely, D., Hughes-Brock, H., Momigliano, N. (Eds.), Knossos: A Labyrinth of History. Papers Presented in Honour of Sinclair Hood, British School at Athens. Oxbow Books, Oxford, pp. 89–103.

Preston, L., 2004. A mortuary perspective on political changes in Late Minoan II–IIIB Crete. American Journal of Archeology 108, 321–348.

Price, T.D., Burton, J.H., Bentley, R.A., 2002. The characterization of biologically available strontium isotope ratios for the study of prehistoric migration. Archaeometry 44, 117–135.

Rehak, P., Younger, J.G., 2001. Review of Aegean Prehistory VII: Neopalatial, Final Palatial, and Postpalatial Crete, in: Cullen, T. (Ed.), Aegean Prehistory: a Review. Archaeological Institute of America, Boston, pp. 383–465.

Relethford, J.H., Blangero, J., 1990. Detection of differential gene flow from patterns of quantitative variation. Human Biology 62, 5–25.

Rogers, G., Hawkesworth, C.J., 1989. A geochemical traverse across the North Chilean Andes: evidence for crust generation from the mantle wedge. Earth and Planetary Science Letters 91, 271–285.

Schallin, A.L., 1993. Islands under Influence. The Cyclades in the Late Bronze Age and the nature of the Mycenaean presence. Studies in Mediterranean Archaeology, Vol. CXI. Paul Åstroms Förlag, Jonsered.

Treuil, R., Darcque, P., Poursat, J., Touschais, G., 1996. Oi Politismoi toy Aegaeoy kata tin Epochi toy Chalcoy (Les Civilisations Égéennes du Néolithique et de l'Âge du Bronze, translation in Greek). Kardamitsa, Athina.

Veizer, J., 1989. Strontium isotopes in seawater through time. Annual Review of Earth and Planetary Sciences 1, 141–167.

Williams-Blangero, S., Blangero, J., 1989. Anthropometric variation and the genetic structure of the Jirels of Nepal. Human Biology 61, 1–12.

Elisabeth Stephan[a,*], Corina Knipper[b], Kristine Schatz[a], T. Douglas Price[c], Ernst Hegner[d]

Strontium isotopes in faunal remains: Evidence of the strategies for land use at the Iron Age site Eberdingen-Hochdorf (Baden-Württemberg, Germany)

* Corresponding author: elisabeth.stephan@rps.bwl.de
a Regierungspräsidium Stuttgart, Landesamt für Denkmalpflege, Konstanz, Germany
b Institut für Anthropologie, Universität Mainz, Germany
c Laboratory for Archaeological Chemistry, Anthropology Department, University of Wisconsin, Madison, Wisconsin, USA
d Department für Geo- und Umweltwissenschaften, Sektion Mineralogie, Petrologie und Geochemie, Universität München, Germany

Abstract

This paper presents the results of an investigation into the process of centralization that took place north of the Alps during the Late Hallstatt and Early Latène Culture, conducted within the framework of a special research program. The focus of the archaeozoological project was on investigating livestock farming and the supply of Early Celtic hillfort sites and their rural environs. The Early Latène site Hochdorf in southwestern Germany, near the princely seat Hohenasperg, was a wealthy settlement characterized by crop farming, stock breeding, wool production, and weaving.

The $^{87}Sr/^{86}Sr$ ratios in Iron Age livestock teeth from Hochdorf indicate that predominantly areas above the geologic unit Keuper were used for pasture, and that some portion of the livestock were probably kept at a distance of about 15–30 km from the site or were imported from further away. The intra-species, intra-individual, and intra-tooth variations reflect movements and non-permanent pastures for cattle, caprines, and even pigs. The high variations among the $^{87}Sr/^{86}Sr$ values found in livestock render domestic animals not always suited for use in determining the local strontium signature for the region of Hochdorf. Modern snail shell and water samples reflect the local geology nicely; though they too yield highly variable values, too, reflecting the varied geology of the region.

Keywords

Iron Age, Hochdorf, animal teeth and bones, pasture, strontium isotopes

Introduction

Isotopic proveniencing of human and animal remains has been employed in archaeology for approximately 20 years. Investigations have focused predominantly on the mobility of prehistoric human populations or that of single individuals (e.g. Grupe et al., 1997; Price et al., 1998, 2003; Bentley et al., 2003; Schweissing, 2004). For the most part, researchers have used analyses of animal remains from archaeological sites to define the local range (Price et al., 2002; Bentley et al., 2003; 2004; Bentley and Knipper, 2005a; Giblin, 2009; Gillmaier et al., 2009). Knipper (2004) discussed the mobility of humans and animals in detail, but few investigations have dealt with the provenance and the transport of animals (Horn et al., 1997; Schweissing and Grupe, 2003; Bentley and Knipper, 2005b; Poll et al., 2005; Sykes et al., 2006; Bendrey et al., 2009). A combination of strontium, carbon, and oxygen isotope ratios in teeth has been used to investigate the seasonal mobility of sheep and cattle in South Africa, to document herd movement patterns of modern caribou, and those of cattle and horses in Bronze Age Georgia and Germany (Balasse et al., 2002; Britton et al., 2009; Knipper et al., 2008; Knipper, in press). Brubaker and colleagues (2006) have begun studies tracking seasonal and longer-term Bronze Age horse migration in the Botai region in Kazakhstan. Viner and colleagues (2010) found evidence of cattle movement over significant distances during the Late Neolithic period in Britain, probably connected with large-scale feasting activities.

This study uses strontium isotopes in Iron Age animal teeth to explore herd movement and the mobility habits of livestock, and to acquire knowledge about pasture grounds in the environs of the settle-

Fig. 1 | Relief map of southwest Germany and the location of the Iron Age princely seats Hohenasperg, Ipf, and Heuneburg and the surrounding settlements

ments. It was conducted as part of the special research program "Early Processes of Centralisation and Urbanisation – Studies on the Development of Early Celtic Princely Seats and Their Hinterland", which was funded by the German Research Council (DFG). The aim of the program was to investigate the processes of centralisation that took place north of the Alps during the Late Hallstatt (ca. 650 to 450 B.C.) and Early Latène cultures (ca. 450 to 300 B.C.). Princely seats, the German *Fürstensitze*, are defined as rich fortified settlements, mainly situated on hilltops that have large and rich burial mounds in their vicinity and are associated with finds of imported goods, mainly ceramics from the Mediterranean. The Fürstensitze seem to be the result of a social and maybe even cultural change or transformation in the Protoceltic societies, one that we still do not fully understand. Among the better known, important princely seats are the Heuneburg, the Hohenasperg, and the Ipf (Fig. 1). Other sites, such as Hochdorf, Walheim, and Kirchheim, represent open rural settlements or farmsteads located in the area surrounding the *Fürstensitze*. About 20 projects were conducted, with researchers in the fields of history, geography, palaeobotany, and archaeozoology, as well as archaeology, participating. The goal of the project "The Archaeozoology of Early Celtic Faunal Remains" was to reconstruct the subsistence strategies and hunting behaviours of the Iron Age populations during the processes of centralization. The archaeozoological and isotopic work involved faunal remains from about 20 sites of different size, function, and age in southwest and western Germany (Schatz and Stephan, 2008).

The rationale of strontium isotope analyses

The isotope ^{87}Sr is formed over time through the radioactive decay of the isotope ^{87}Rb. It comprises approximately 7.04 % of total strontium in nature (Faure, 1986). Other isotopes of strontium are nonradiogenic and include ^{84}Sr (~ 0.56 %), ^{86}Sr (~ 9.87 %), and ^{88}Sr (~ 82.53 %). Variations in the strontium isotope composition found in natural materials are generally expressed as ^{87}Sr/^{86}Sr ratios. ^{87}Sr/^{86}Sr ratios vary depending on the age and composition of the rocks forming the earth's crust. The value of the ^{87}Sr/^{86}Sr ratios in fossils is a function of the Rb/Sr ratio in the basement rocks (and in the soils derived from them) and the time that elapsed since the basement rocks were formed. So-called inherited ^{87}Sr/^{86}Sr is negligible in crustal rocks and soil. Strontium is easily mobilized in rocks through weathering and is transported into soil and ground water, finally ending up in plants and the food chain. Due to the small difference in the relative masses of the ^{87}Sr and ^{86}Sr isotopes, only minute fractionation takes place during the intake of the biologically available strontium in plants and animals, its metabolism, and incorporation in bones and teeth. It is possible to correct for the fractionation that does occur, though, by normalizing the isotope ratios to an internal standard, which is the ^{86}Sr/^{88}Sr isotope ratio, with an assumed value of 0.1194. Thus, the strontium isotope composition in groundwater, soil, plants, and animals is closely related to local geology (discussed in detail by Price and colleagues [2002]) and it can be used as a tracer to characterize the provenance of fossil animals and humans.

The settlement of Eberdingen-Hochdorf

The settlement of Eberdingen-Hochdorf "Reps" is located northwest of the city of Stuttgart is one of a group of sites in the environs of the Early Celtic princely seat "Hohenasperg" (Fig. 1). The site is located in a fertile region of the Neckar River, an area with a hilly landscape and soils of high quality (Küster, 1985; Balzer and Biel, 2008). The excavation of the entire settlement area, 1989–1993, uncovered about 40 pit houses, several granaries, earth cellars, small ditches and large amounts of ceramics, loom weights, spindle whorls, metal objects, and faunal remains (Biel, 1995). The archaeological finds demonstrated that Hochdorf was a wealthy settlement characterized by crop farming, stockbreeding, wool production, and handicraft activities, particularly weaving.

Most of the animal remains were found in pit houses or cellars and have been dated to the Early Latène period, from about 450 to 300 B.C. Some few finds came from pits that represent the remnants of a settlement of the Early Neolithic Linear Pottery Culture (Linearbandkeramik, LBK). Almost all Iron Age bones are from domestic cattle, sheep, goat, and pig (Schatz, 2009). Finds include a few horse, dog and chicken remains and, very rarely, remains of wild animals like red deer, roe deer, wild boar, wolf, fox, and beaver. Cattle were predominantly used as draught animals for fieldwork. Sheep were bred for meat and wool production, and pig served as source for meat and fat. Dog and chicken were also consumed. Different methods of dismembering and preparing the slaughtered animals produced differences in the quality of the meat and point to social differences among the inhabitants.

Fig. 2 | Schematic geological map of the middle Neckar region and the location of the site Eberdingen-Hochdorf. Numbers 1–6 indicate the location of modern snail shell and water samples from different geologic units in the surroundings of the site

The geological setting of the study area

The environment of Hochdorf is geologically heterogeneous and characterized by extended glacial loess deposits as well as Triassic Keuper and Muschelkalk formations (Fig. 2). Keuper sandstones and Muschelkalk (limestone) are visible where loess is eroded. Muschelkalk is present in the areas southwest of Hochdorf and is exposed predominantly along the valley slopes. The Keuper formation characterizes the hilly landscape of the Löwenstein and Stromberg mountains and larger areas of the lowlands northwest of the Swabian Alb (Jurassic limestone). Alluvial sediments exist in the river valleys, i.e. those of the Neckar and the Enz. The site itself is located on loess.

Comparatively low strontium isotope ratios predominate in most of these regions. The strontium isotope signatures of Muschelkalk and loess vary between 0.7080 and 0.7097 and 0.7085 and 0.7100 (Table 1), respectively. More detailed investigations of modern and archaeological faunal and human remains of the Early Neolithic (LBK) sites of Vaihingen and Stuttgart-Mühlhausen near Hochdorf have yielded $^{87}Sr/^{86}Sr$ values ranging from 0.7091 to 0.7098 (Price et al., 2003; Bentley et al., 2003, 2004). Isotopic ratios determined for the water and a freshwater mollusc of the Neckar and for modern mice bone from Schwetzingen near Heidelberg in the Neckar valley are slightly lower (0.7086 and 0.70883±0.00015, resp.; Buhl et al., 1991; Bentley et al., 2003). The analyses of human and animal bones and teeth from the LBK site of Schwetzingen yielded slightly higher ratios (0.7095±0.0003; Bentley et al., 2002, 2003).

The petrographic diversity of the Keuper sediments is reflected in their highly variable strontium isotope ratios (Table 1). Some of the Keuper ratios, in particular those for groundwater and the soluble fractions of the rocks from the middle and upper formations, overlap with the values for loess and Muschelkalk, but values for the lower Keuper formation in the close vicinity of Hochdorf almost all fall above 0.710 (Ufrecht and Hölzl, 2006). Comparatively radiogenic ratios were also well represented in the samples of tree leaves from the middle Keuper layers of the Stromberg hills, ca. 15 km north of

Table 1 | ^{87}Sr/^{86}Sr values of modern and archaeological samples from different geologic units in southwest Germany

Geologic unit	Material	n	^{87}Sr/^{86}Sr range	References
Loess	Sediment; modern snail shells, mice; LBK cattle, sheep/goat, pig, dog, red deer enamel, human bone and enamel	178	0.7085–0.7100	Taylor 1983; Price et al. 2003; 2006; Bentley et al. 2003; 2004
Neckar valley	Rock, sediment, river water; modern molluscs, mice; LBK: human & pig bone and enamel	43	0.7085–0.7100	Buhl et al. 1991; Horn et al. 1994; 1997; Bentley et al. 2002; 2003; Bentley & Knipper 2005a
Muschelkalk	Muschelkalk (limestone), groundwater	33	0.7080–0.7097	Price et al. 2004; Ufrecht & Hölzl 2006
Keuper	Keuper (sandstone), groundwater; modern roe deer bone	28	0.7080–0.7115 (–0.7170)	Tütken 2003; Ufrecht & Hölzl 2006; Knipper 2009
Jurassic (limestone; Swabian Alb)	Jurassic (limestone); modern horse & roe deer bone; IA pig enamel	div. 5	0.7070–0.7095	Veizer et al. 1997; Tütken 2003; Bentley & Knipper 2005a
Buntsandstein (Black Forest & Odenwald)	Groundwater; modern snail shells; Middle Ages pig enamel	29	0.7090–0.7210	Bentley et al. 2003; Bentley & Knipper 2005a; Ufrecht & Hölzl 2006
Crystalline Basement (granite, gneiss; Black Forest & Odenwald)	Rocks, groundwater; modern snail shells, fish; Middle Ages pig enamel	133	0.7090–2.9270	Hofmann & Köhler 1973; Drach et al. 1974; Brewer & Lippolt 1974; Kalt et al. 1994; Altherr et al. 1999; Bentley et al. 2003; Bentley & Knipper 2005a; Ufrecht & Hölzl 2006

Hochdorf (Knipper, 2009). In the case of Hochdorf, the lower isotope values should represent exclusively Muschelkalk and loess. In contrast, the crystalline basement rocks, granite and gneiss, as well as the sandstones (Buntsandstein) of the Black Forest and the Odenwald, exhibit substantially higher values (Table 1).

Samples and procedure

Samples

Tooth enamel from the main Iron Age domestic species – horse, cattle, pig, sheep and goat – were chosen for the analyses (Table 2). Enamel is very resistant to post-mortem diagenesis and thus better suited for isotope analysis than are bone finds (e.g. Chiaradia et al., 2003; Richards et al., 2008). Unlike

Table 2 | ^{87}Sr/^{86}Sr values of Iron Age domestic animal tooth samples from Eberdingen-Hochdorf

Sample No.	Feature	Species	Sample	^{87}Sr/^{86}Sr ± 2 s.e. (last digits)		
				Top	Middle	Bottom
Eq-Ho 1[a]	Cellar 1605/1	Horse	Maxilla M1/2	0.709129 ± 11	0.708932 ± 10	0.709819 ± 10
Eq-Ho 2[a]	Cellar 1902/3	Horse	Mandible M3	0.709684 ± 07	0.709010 ± 09	0.709611 ± 10
Eq-Ho 3[a]	Cellar 1906/3	Horse	Mandible P2	0.710336 ± 07	0.710634 ± 10	0.709374 ± 11
Eq-Ho 4[a]	Cellar 2106/1	Horse	Mandible P3	0.711403 ± 11	0.711404 ± 10	0.710526 ± 11
Eq-Ho 5[a]	Cellar 2106/1	Horse	Mandible P4	0.711485 ± 11	0.711424 ± 38	0.708871 ± 13
Bo-Ho 6[a]	Pit house 1303/12	Cattle	Maxilla M3	0.709809 ± 09	0.709947 ± 21	0.709952 ± 11
Bo-Ho 7.1[b]	Pit house 2000/1	Cattle	Mandible M1		0.709652 ± 15	0.709499 ± 10
Bo-Ho 7.2[b]	Pit house 2000/1	Cattle	Mandible M2	0.709278 ± 24	0.709375 ± 27	0.709286 ± 34
Bo-Ho 7[a]	Pit house 2000/1	Cattle	Mandible P4	0.709353 ± 11	0.709337 ± 14	0.709526 ± 11
Bo-Ho 8[a]	Pit house 2002/1	Cattle	Maxilla M3	0.710191 ± 10	0.710366 ± 11	0.710525 ± 09
Bo-Ho 9[a]	Pit house 2002/1	Cattle	Mandible M3	0.710009 ± 09	0.709977 ± 10	0.710121 ± 09
Bo-Ho 10.1[b]	Cellar 1605/1	Cattle	Mandible M1	0.710505 ± 16	0.710342 ± 24	0.710327 ± 12
Bo-Ho 10.2[b]	Cellar 1605/1	Cattle	Mandible M2	0.710754 ± 22	0.711162 ± 18	0.711277 ± 26
Bo-Ho 10[a]	Cellar 1605/1	Cattle	Mandible M3	0.711171 ± 10	0.711620 ± 10	0.710937 ± 11
Bo-Ho 11[a]	Cellar 1608/2	Cattle	Mandible M3	0.710166 ± 10	0.709711 ± 32	0.710403 ± 18
OC-Ho 12[a]	Pit house 1303/12	Sheep/Goat	Mandible M3	0.709624 ± 10	0.709338 ± 10	0.709741 ± 10
OC-Ho 13.1[b]	Pit house 2002/1	Sheep/Goat	Mandible M1	0.710471 ± 16	0.710595 ± 28	0.710644 ± 15
OC-Ho 13.2[b]	Pit house 2002/1	Sheep/Goat	Mandible M2	0.710760 ± 11	0.710779 ± 17	0.710880 ± 30
OC-Ho 13[a]	Pit house 2002/1	Sheep/Goat	Mandible M3	0.710865 ± 14	0.710179 ± 09	0.710933 ± 10
OC-Ho 14[a]	Pit house 2409/1	Sheep/Goat	Mandible M3	0.712106 ± 11	0.712308 ± 13	0.710161 ± 10
OC-Ho 15[a]	Cellar 1608/2	Sheep/Goat	Mandible M3	0.710035 ± 09	0.710634 ± 11	0.710891 ± 10
OC-Ho 16[a]	Cellar 1707/6	Sheep/Goat	Mandible M3	0.709892 ± 10	0.710036 ± 11	0.710268 ± 10
OC-Ho 17.1[b]	Cellar 2004/2	Sheep/Goat	Maxilla M1	0.708615 ± 25	0.708692 ± 22	0.708606 ± 15
OC-Ho 17[a]	Cellar 2004/2	Sheep/Goat	Maxilla M2	0.708509 ± 10	0.708538 ± 13	0.708551 ± 13
Su-Ho 18[a]	Pit house 1303/12	Pig	Maxilla P4	0.710334 ± 09	0.710599 ± 13	0.710569 ± 11
Su-Ho 19[a]	Pit house 1505/1	Pig	Maxilla M3	0.710161 ± 10	0.710212 ± 10	0.710494 ± 14
Su-Ho 20.2[b]	Pit house 1603/1	Pig	Mandible M2		0.710971 ± 13	0.711539 ± 13
Su-Ho 20.1[b]	Pit house 1603/1	Pig	Mandible P4		0.710971 ± 10	0.711539 ± 13
Su-Ho 20[a]	Pit house 1603/1	Pig	Mandible M3	0.710898 ± 23	0.710549 ± 10	0.710282 ± 09
Su-Ho 21[a]	Cellar 1805/3	Pig	Mandible M3	0.710302 ± 09	0.710371 ± 10	0.711093 ± 10
Su-Ho 22[a]	Cellar 1902/3	Pig	Mandible M3	0.710579 ± 11	0.710632 ± 11	0.710327 ± 10

[a] Universtity of North Carolina; [b] University of Munich

bone tissue, enamel, once formed, is not remodelled, preserving instead the original isotope signatures associated with the place of residence during its formation. Because enamel is formed in incremental layers over a period lasting from several months to several years (Hillson, 1986, 113pp; Passey and Cerling, 2002), the sequential sampling of enamel at different locations along the tooth height offers the possibility of detecting a chronological record of the strontium isotopic composition.

The permanent third molar (M3) and fourth premolar (P4) were selected for this study in most cases. These last teeth to erupt are formed mainly during the second and third year of life (Silver, 1969; Habermehl, 1975; Wilson et al., 1982; Hillson, 1986; Amorosi, 1989). The first and second molars (M1, M2), and second and third premolars (P2, P3), which form earlier on, were also analyzed, when available, in order to provide additional information about the animals' place of residence during their infancy.

Mineralization time varies with type of the tooth and species and only very limited data relating to the timing and process of crown formation in different species have been published (e.g. Brown et al., 1960; McCance et al., 1961; Hillson, 1986; Bryant et al., 1996; Hoppe et al., 2004; Niven et al., 2004). Estimations of the rates of enamel mineralization are complicated by the maturation processes that follow the initial deposition of enamel (Passey and Cerling, 2002) and by the fact that original tooth height is often unknown. Furthermore one has to keep in mind that the growth patterns and the homogenizing influence of transverse sampling result in attenuating effects (Balasse et al., 2002; Passey and Cerling, 2002; Balasse, 2003; Hoppe et al., 2004).

Skeletal remains of wild and small domestic animals found at the site, and modern snail shells and river water of the immediate vicinity were used to define the strontium isotope characteristics of the local environment (Tables 3–4). Teeth were preferred for these analyses, too, but bones were used when teeth were not available. Figure 2 shows the locations at which the modern snail shells (multiple species) and river water were sampled in the north and northwest of the Iron Age settlement. To avoid contamination from modern fertilizers, no samples were collected from fields (cf. Wolff-Boenisch, 1999; Probst et al., 2000; Price et al., 2002). Location 1 consists of shrubbery grassland, Locations 2 and 3 are small forested areas, and Locations 4 and 5 are abandoned Muschelkalk quarries. The forested areas are characterized by a good and stable nutrient supply and have not been chalked in the past (Official information of the Forest Administration 2010, Landratsamt Ludwigsburg, Fachbereich Forsten, Forstamt, Vaihingen/Enz). The exact positions of the sampling locations and the underlying geology were determined using topographical and geological maps with a scale of 1:25,000 and 1:50,000, respectively.

Analytical procedures

Before sampling, tooth surfaces were cleaned with a diamond abrasive drill bit and the cementum of horse teeth was removed. The enamel samples were taken as powder with a diamond-coated dental drill. All of the teeth were sampled at three locations from cusp to cervix: close to the top, in the middle, and close to the cervix at the bottom (Fig. 3). In cases where only teeth with a severe abrasion were available, the drill sampling was only done at the middle and bottom location. The enamel powders weighed between 10 to 20 mg. The snail shell samples were cleaned ultrasonically in distilled water and ground, and about 5 mg were processed for isotopic analyses.

The samples were analysed at the laboratory for Archaeological Chemistry at the University of Wisconsin in Madison; the Department of Geological Sciences at the University of North Carolina, Chapel

Table 3 | $^{87}Sr/^{86}Sr$ values of Iron Age domestic and wild animal tooth samples including snail shells from Eberdingen-Hochdorf (University of Munich)

Sample No.	Feature	Species	Sample	$^{87}Sr/^{86}Sr$ ± 2 s.e. (last digits)		
Gg-Ho 125	Cellar 1504/1	Chicken	Humerus		0.710004 ± 14	
Gg-Ho 126	Cellar 2408/2	Chicken	Humerus		0.710027 ± 20	
Gg-Ho 127	Cellar 2007/3	Chicken	Femur		0.709518 ± 13	
Cn-Ho 123.2	Cellar 397/2	Dog	Mandible		0.710137 ± 19	
Cn-Ho 124.2	Cellar 397/2	Dog	Mandible		0.709916 ± 11	
				Top	Middle	Bottom
Cn-Ho 123.1	Cellar 397/2	Dog	Mandible M1	0.710413 ± 13		0.710087 ± 14
Cn-Ho 124.1	Cellar 397/2	Dog	Mandible M1	0.710473 ± 19		0.710078 ± 12
Fe-Ho 128	Pit house 1707/7	Wild cat	Maxilla Canine		0.708118 ± 15	
Bo-Ho 144	Pit house 1505/1	Bison	Mandible M3		0.710723 ± 16	0.710819 ± 17
Ce-Ho 145	Cellar 1103/5	Red deer	Mandible M3		0.709765 ± 13	0.709908 ± 15
Od-Ho 146	Pit house 1704/1	Roe deer	Mandible M3		0.710248 ± 14	0.710311 ± 12
Ss-Ho 147	Pit house 1302/7	Wild boar	Mandible M3		0.712659 ± 15	0.712382 ± 13
Cn-Ho 148	Cellar 1302/4	Wolf	Maxilla M1	0.712416 ± 19		0.711585 ± 13
Le-Ho 149	Pit house 1707/7	Hare	Mandible P3		0.710091 ± 14	
Cs-Ho 150	Pit house 1707/7	Beaver	Mandible M3		0.708557 ± 14	
Ml-Ho 129	Pit house 1704/1	*Unio crassus*	Snail shell		0.708540 ± 11	
Ml-Ho 130	Pit house 1704/1	*Cepaea hortensis*	Snail shell		0.709410 ± 20	
Ml-Ho 131	Cellar 397/2	*Cepaea nemoralis*	Snail shell		0.708831 ± 16	
Ml-Ho 132	Cellar 397/2	*Helix pomatia*	Snail shell		0.709385 ± 19	
Ml-Ho 133	Cellar 397/2	*Bradybaena fruticum*	Snail shell		0.709773 ± 19	

Table 4 | $^{87}Sr/^{86}Sr$ values of modern snail shell and water samples from different geologic units in the surroundings of Eberdingen-Hochdorf (University of Munich; locations see Fig. 2)

No.	Field name	Geologic unit	Sample No.	Sample	$^{87}Sr/^{86}Sr$ ± 2 s.e. (last digits)
1	Hölle	Loess	Ml-Ho 134	*Fruticicola fruticum*	0.709363 ± 19
1	Hölle	Loess	Ml-Ho 135	*Cepaea hortensis*	0.709056 ± 20
2	Pulverdinger Holz	Loess / Keuper	Ml-Ho 136	*Helix pomatia*	0.709712 ± 16
3	Rubholz	Keuper	Ml-Ho 137	*Helicodonta obvoluta*	0.711457 ± 18
4	Rieter Tal, quarry northeast of Riet	Muschelkalk	Ml-Ho 139	*Perforatella incarnata*	0.709320 ± 18
5	Heulenberg, quarry east of Riet	Muschelkalk	Ml-Ho 140	*Helix pomatia*	0.709191 ± 16
5	Heulenberg, quarry east of Riet	Muschelkalk	Ml-Ho 141	*Cepaea nemoralis*	0.708861 ± 18
5	Heulenberg, quarry east of Riet	Muschelkalk	Ml-Ho 142	*Cepaea nemoralis/hortensis*	0.708441 ± 13
6	Strudelbach, Riet	Muschelkalk	W-Ho 143	Stream water	0.708455 ± 14

Fig. 3 | Schematic figure of the enamel formation (left; mod. from Fricke and O'Neil, 1996, Fig. 2A) and the sampling of animal cheek teeth shown for a cattle molar

Hill (Table 2); and the Department of Earth and Environmental Sciences at the University of Munich (Table 2–4).

At the University of Wisconsin, the enamel samples were dissolved in 5 M HNO_3. Strontium was separated using EiChrom Sr-Spec resin and the strontium isotopic compositions were analyzed on a VG Sector 54 thermal ionization mass spectrometer (TIMS) at the Department of Geological Sciences, University of North Carolina at Chapel Hill (UNC-CH). At Chapel Hill strontium was loaded on a single Re filaments and analyzed with a dynamic quintuple-collector data-collection mode. Within-run precision of the $^{87}Sr/^{86}Sr$ ratios in the Iron Age samples is ≤ ±0.000038 (2 s.e.). Analyses of the strontium reference material NIST 987 yielded a $^{87}Sr/^{86}Sr$ ratio of 0.710260 ± 0.000010 (2 s.d., N = 30). The $^{87}Sr/^{86}Sr$ ratios were corrected for thermal fractionation using $^{86}Sr/^{88}Sr$ = 0.1194. Total procedural blanks for strontium are <100 picograms, which is not significant for the amounts of strontium processed.

In Munich the enamel, bone and snail shell sample powders were dissolved in 2 ml 4 M HNO_3 in PFA beakers over a period of 1 day at 80°C. Strontium was separated on quartz columns with a 5 ml resin bed of AG 50W-X12 of 200–400 mesh (Hegner et al., 1995). The carbonate samples were dissolved in 2.5 M HCl. Strontium was loaded on a single W-filament using TaF_5 as emitter and the isotopic composition was measured on an upgraded MAT 261 mass spectrometer employing a dynamic double collector routine. $^{87}Sr/^{86}Sr$ ratios are normalized to $^{86}Sr/^{88}Sr$ = 0.1194. Within-run precision of the $^{87}Sr/^{86}Sr$ ratios in the Iron Age samples is ≤ ±0.000036 (2 s.e.). Over the course of the study the NIST SRM 987 strontium reference material yielded $^{87}Sr/^{86}Sr$ = 0.710244 ± 0.000008 (2 s.d., N = 15). Total procedural blanks are <500 pg Sr and not significant for the samples analyzed.

For inter-laboratory comparison, duplicate analyses were performed on five Iron Age teeth samples. Two replicates yielded almost identical results, two replicates correspond to the within-run precisions (differences of the $^{87}Sr/^{86}Sr$ ratios: 0.000010; 0.000038), and one replicate exhibits a slightly higher difference of 0.000059.

Results and discussion

Modern samples

The strontium isotope ratios of modern snail shells and river water of the immediate vicinity are consistent with the values published for the different geological formations of the region (Table 4; Fig. 4). Values of shells from soils above loess and Muschelkalk, including the Strudelbach water, vary over a range of 0.7084 to 0.7097. The ratio determined for one shell from a small forested area on Keuper is considerably higher and corresponds with the high signatures of the lower Keuper formations of the region. The signature of the snail from Location 2 is more radiogenic than those of the other loess samples. According to the geological map, Location 2 should represent pure loess, but the vegetation points to only a thin layer of loess that covers the underlying Keuper. Therefore, the strontium ratio represents a mixture of the Keuper and loess signals.

Strontium-rich snail shells have been suggested as representing samples well-suited for use in characterizing the strontium signatures of a particular location (e.g. Price et al., 2002). Snails have a small home range and it is assumed that the strontium isotope signatures in their shells represent the average of the values of the food they have consumed. However, Evans and colleagues (2009, 2010) reported that modern snail shells in Scotland and Britain do not reflect the average biosphere values obtained from plants, but instead yield a rainwater-muted signature. According to those authors this may be caused by the snails' need for relatively large amounts of water to sustain their body fluid levels, which results in a much stronger contribution by rainwater to their isotope composition.

The carbonate necessary to form the shell of pulmonate land snail is chiefly ingested with the food and water from the upper layers of the soil (air-soil water and dew). Where there is a shortage of calcium capable of contributing to the carbonate of the shell, the mollusc is generally able to compensate by increasing the input from other sources, incorporating external water through the skin and feeding upon soil and shells of other molluscs (Heller and Magaritz, 1983; Leng et al., 1998; Yates et al., 2002). The effect of soil carbonate and external water on the strontium isotope signatures is expected to be small, because several studies have demonstrated that $^{13}C/^{12}C$ ratios in snail shell carbonate are influenced primarily by diet with little to no influence from ingested carbonate (e.g. Stott, 2002; Metref et al., 2003; McConnaughey and Gillikin, 2008). Nevertheless, varying contributions of carbon from local limestone carbonate and external water may contribute to scatter in the relationship (e.g. Goodfriend and Hood, 1983; Yanes et al., 2008). No shortages of calcium have been determined for the area of Hochdorf and the strontium isotope ratios in modern snail shells reflect what one would expect based on the local geology.

Archaeological samples

The $^{87}Sr/^{86}Sr$ ratios of the archaeological snail shells vary within the range of loess, Muschelkalk, and the modern shells (Fig. 4, Table 3). However, the strontium values of the wild animals found at the site of Hochdorf show a large variation (Fig. 4, Table 3). The ratios of the wildcat and beaver samples fall within the Muschelkalk and loess range. Their habitats could have been the river valleys. Wolf and wild boar samples exhibit very radiogenic values in the range of Buntsandstein, granite and gneiss. These animals probably originated from the Black Forest or the Odenwald. The variation of the isotope signatures determined for hare, roe deer, red deer, and bison lie within the range of the values of the livestock teeth.

Fig. 4 | $^{87}Sr/^{86}Sr$ values in Iron Age teeth and bone samples of domestic and wild animals from Eberdingen-Hochdorf and of modern snail shell and water samples from the surroundings compared with Sr isotope signatures of the geological formations of the region (data of the LBK site of Vaihingen from Bentley et al. 2004) The typical analytical error (±2 sigma s.e.) is smaller than symbol size

Fig. 5 | Intra-tooth variation of ^{87}Sr/^{86}Sr values in Iron Age horse teeth of different individuals from Eberdingen-Hochdorf. M1/2/3: first/second/third molar; P2/3/4: second/third/fourth premolar; (+): in line but not or slightly worn; +: slightly worn; +(+): slightly to moderately worn; ++: moderately worn; +++: heavily worn. The typical analytical error (±2 sigma s.e.) is smaller than symbol size

Therefore, the wild ruminants used areas for grazing and/or browsing that were isotopically similar to those used by domestic animals. The values recovered from cattle, pig, and caprine teeth are highly variable and the datasets of these species overlap widely (Table 2, Fig. 4). Very few values for horse, cattle, and caprines reflect Muschelkalk and/or loess. The majority of the values are considerably higher, ranging from 0.710 on up to 0.7115. They correspond with the strontium signatures of Keuper. There are smaller Keuper areas close to the site. The Stromberg and Löwenstein mountains represent large Keuper areas located in the north and east of the settlement in a distance of about 15 to 30 km, the foreland of the Swabian Alb is another, further away (Fig. 2). These could also have been used for pasturing. Furthermore, pasturing in the Buntsandstein areas of the Black Forest in a distance of about 20 km west of the site cannot be ruled out. The isotope signatures of dog and chicken lie well within the range of the values of the livestock teeth. No significant differences could be observed between bone and tooth samples.

Intra-tooth variation

Intra-tooth variations in the individual teeth are shown in Figures 5 to 8. Variation in the analytical data for one tooth reflects a situation in which the pasture areas of the animals in question were not restricted to a single geological unit: mobility sometimes played a significant role in domestic animal

Fig. 6 | Intra-tooth variation of $^{87}Sr/^{86}Sr$ values in Iron Age cattle teeth of different individuals from Eberdingen-Hochdorf. Types of teeth and abrasion see Figure 5. The typical analytical error (±2 sigma s.e.) is smaller than symbol size

husbandry. The ratios of the top, middle, and bottom of the teeth are arranged according to the distance, in mm, between the sampling location and the cervical margin. The time span which is represented ranges from a few months to more than a year, depending on the species, tooth type, and the stage of abrasion. The high variations of the strontium ratios in individual horse teeth point to a greater mobility of those animals and possibly the use of horses for transport, i.e. riding (Fig. 5). Judging by size and degree of abrasion, Eq-Ho 1, 2, and 3 originate from three different individuals. Both of the first two, Eq-Ho 1 and 2, seemed to have lived predominantly in loess and Muschelkalk regions: Eq-Ho 1 during the first six month of its life and Eq-Ho 2 between ca. the 18th and 40th month of its life. Eq-Ho 3 reveals a higher degree of mobility on the part of this individual in the beginning of the 3rd year of its life. Samples Eq-Ho 4 and 5 probably belong to one individual. The crown of the third and fourth premolar starts to mineralize at about the same time and the strontium signatures for these samples show a similar pattern. High $^{87}Sr/^{86}Sr$ ratios associated with the end of the second year reflect Keuper areas (top and middle ratios of both teeth), but during the third year, the horse moved to a Muschelkalk and/or loess region (bottom ratio Eq-Ho 5). The bottom ratio of the third premolar is higher, due to the shorter mineralization time of the P3 compared to that of the fourth premolar.

The intra-tooth variation found in cattle, pig, and caprine samples is generally lower (Fig. 6, 7, 8). Judging by body side, tooth size, and abrasion, all single premolars and molars originate from different individuals. More individuals are represented in rows of maxillary or mandible premolars and molars. Figure 6 shows the individual strontium profiles of the cattle teeth Bo-Ho 6, 8, and 9. The isotope ratios indicate that these cattle consumed an isotopically homogeneous diet and remained in a geologically homogeneous loess or Muschelkalk area during tooth crown formation. The data from the first and second molar and forth premolar of sample Bo-Ho 7 are comparable. Nevertheless, their interpretation is difficult because of the considerable abrasion of the teeth, which results in a gap in the isotope record. The $^{87}Sr/^{86}Sr$ ratios of the slightly worn M3 (sample Bo-Ho 11) reflect a greater mobility during the second year of life. The greatest mobility is revealed by the molars of sample Bo-Ho 10 (0.7094 to 0.71162). During the first half year of its life, the individual stayed in more or less isotopically homogeneous areas, but afterwards it moved to pasture grounds associated with higher Keuper signals, probably situated at some distance in the Löwenstein and Stromberg mountains.

The strontium signatures in molar rows of caprines provide evidence that almost no changes in the isotopic features of the pasture land occurred during the eight or nine months of the animals' lives (Fig. 7). Individual OC-Ho 17 seems to have been fed exclusively in a Muschelkalk area. Although the maxilla teeth could not be identified to the species level, it is conceivable that this individual was a goat, feeding on the steep Muschelkalk slopes of the Strudelbach. Individual OC-Ho 13 initially lived in Keuper regions. Its diet during the first half of its second year of life, reflected in the third molar, was more heterogeneous and shows what was probably an "excursion" to loess areas. The signatures in the third molars of Individuals 12, 15, and 16 reflect mainly Keuper, and based on the relatively large variations, the animals grazed in isotopically different Keuper areas. The more radiogenic ratios in the top and middle location of the third molar of Individual 14 point to pasture land above Buntsandstein or granite and gneiss. The individual may have been raised, up to an age of about 12 months, in the Black Forest. Evidence of such a practice has been obtained from animal finds from the princely seat Heuneburg in southwest Germany (Stephan, 2009). The $^{87}Sr/^{86}Sr$ values at the end of the mineralization of the M3 of Individual 14, at about 1.5 years, demonstrate that the animal moved or was brought to the site of Hochdorf within a relatively short time.

Fig. 7 | Intra-tooth variation of $^{87}Sr/^{86}Sr$ values in Iron Age caprine teeth of different individuals from Eberdingen-Hochdorf. Types of teeth and abrasion see Figure 5. The typical analytical error (±2 sigma s.e.) is smaller than symbol size

STRONTIUM ISOTOPES IN FAUNAL REMAINS 279

Fig. 8 | Intra-tooth variation of ^{87}Sr/^{86}Sr values in Iron Age pig teeth of different individuals from Eberdingen-Hochdorf. Types of teeth and abrasion see Figure 5. The typical analytical error (±2 sigma s.e.) is smaller than symbol size

Strontium signatures in pig teeth show less marked variation than those of the samples of horse and the large and small ruminants (Fig. 8). All data reflect Keuper and as was the case for the other animals, the variations suggest that the pigs were fed in isotopically different Keuper areas. We assume that pigs fed predominantly in forests during the Iron Age (Stephan et al., 2010), as they are known to done in medieval times (e.g. Regnath, 2008). Because soils suitable for crop farming were formed above loess, forests are expected predominantly in Keuper regions. Pig pasture may for that reason have been restricted to Keuper regions.

Local range and spatial organization of domestic animal husbandry

In studies of human mobility, the definition of the "local range" of biologically available strontium isotope ratios is usually based either on human bones or dentine from archaeological contexts (Grupe et al., 1997; Price et al., 2002; Bentley et al., 2004; Schweissing, 2004; Nehlich et al., 2009) or on tooth en-

amel from domestic animals that are considered to have been raised locally, primarily pigs (Price et al., 2002; Bentley et al., 2004; Bentley and Knipper, 2005a). Due to diagenesis, bones usually reflect the strontium in the immediate burial environment: biogenic values that once differed are often overprinted (Horn and Müller-Sohnius, 1999; Price et al., 2002; Schweissing and Grupe, 2003; Viner et al., 2010). The use of pig teeth is based on the assumption that pigs were kept near the human settlements and reflect an average of the biologically available strontium of the cultivated plots of land.

The strontium isotope data from animal teeth from the Early Latène period are very variable and reflect larger areas with diverse geological conditions (Fig. 4; Tables 3–4). The loess in the immediate vicinity of Hochdorf is represented only in some few teeth and bones of horse, cattle, sheep/goat, and chicken, as well as in modern and some archaeological snail shells. This raises questions concerning the practice of basing the definition of the "local range" on domestic animal teeth. For instance, the arithmetic mean ± 2σ of the pig teeth (0.709861–0.711500; Fig. 4 yellow bar) does not primarily represent the local loess, but rather is consistent with more radiogenic values, such as have been reported for Keuper (cf. Ufrecht and Hölzl, 2006; Knipper, 2009; modern snail shell, this study). Taking the ratios of archaeological snails and most of the modern snails, the 2 sigma range includes only lower values and overlaps only slightly with the pig local range. This underlines the importance of a comparison with a range of independent data from soils, meteoric and ground water and modern sympatric plants and fauna (cf. Price et al., 2002; Bentley et al., 2004; Evans and Tatham, 2004; Evans et al., 2009; 2010; Knipper et al., this volume). Furthermore, it seems appropriate to locate the pasture grounds based on already published and newly created data for the biologically available strontium of the different geological units.

In contrast, the strontium isotope ratios in teeth of cattle, sheep and/or goat from Linearbandkeramik pits in Hochdorf, which were analyzed in the scope of the NSF-Project "*Pastures, Chert Sources, and Upland-Lowland Mobility in Neolithic Southwest Germany*" (Award BCS – 0316125), vary in a small range between about 0.7091 and 0.710 and fall well within the loess range (Knipper, unpublished data). The values are consistent with the 2 sigma local range based on pig teeth from the LBK settlement of Vaihingen, which is situated about 6 km to the north, in similar geological conditions dominated by loess and Keuper (Bentley et al., 2004: 0.709130–0.709794; Fig. 4 grey bar). For the Early Neolithic the $^{87}Sr/^{86}Sr$ values in domestic animal teeth represent a preference of pasture grounds on loess in the immediate vicinity of the sites and a rather small-scale husbandry system (cf. Knipper, 2009).

The large variations of the Iron Age strontium isotope data also provide insights into changes in husbandry practises and land use from the Neolithic to the Early Latène period. None of the Iron Age livestock species seem to have been kept solely on loess in the immediate vicinity of the site. Investigations of the faunal and botanical remains from the Early Latène site of Hochdorf and in the Neckar region gave evidence for an open landscape intensively used for crop farming and a decreasing stock of wild animals (Schatz, 2009; Stika, 2009). The high quality of the soils in the surroundings of Hochdorf (6 km radius) suggests that most of this area was permanently cultivated for barley, wheat, and legumes (Fischer et al., 2010.). The land exploited for livestock production could have been located in the meadows along the valley slopes (Muschelkalk), the fields during the fallow (loess and partly Keuper), and the forested areas (mainly above Keuper) in the immediate vicinity and at some distance from the site.

Due to their dietary requirements, different species need different pasture grounds and it is suggested that horses and the large and small domestic ruminants grazed in open landscape i.e. grass- and meadowland and that pigs were predominantly fed in forests, although cattle can browse in forested areas and pig can collect their fodder in meadows with humid conditions, i.e. flood plains. Clear separations of the pasture areas for different species are not evident in the strontium isotope ratios. The intra-

tooth and intra-individual variations reflect movements and non-permanent pastures but no obvious seasonal herding practice. This kind of livestock management required access to adequate pasture areas, and communication between the inhabitants of Hochdorf and the population of the contemporary settlements and farmsteads in the surrounding area (Balzer and Biel, 2008). It can be suggested that different kinds of exchange and trade occurred between the settlements of the regions and that the inhabitants might have managed the livestock pasturing in common.

Conclusions

The site of Eberdingen-Hochdorf "Reps" in southwestern Germany belongs to a group of Iron Age settlements in the vicinity of the princely seat Hohenasperg. The site lies in a fertile region of the Neckar River, which is characterized by a hilly landscape and areas of varied geology. During the Early Latène period Hochdorf was a wealthy settlement characterized by crop farming, stock breeding of cattle, sheep, goat, and pig, wool production, and weaving. Some features provided evidence of a settlement of the Early Neolithic Linear Pottery Culture (LBK), which also yielded animal bone finds.

Strontium isotope ratios in animal teeth were used to explore the herd movements and the mobility habits of livestock, and to obtain information about the pasture grounds in the environs of the settlements. The values recovered from the teeth of the livestock from the Early Latène settlement of Hochdorf are highly variable and the data overlap widely. The $^{87}Sr/^{86}Sr$ values in pig teeth as well as in cattle and caprine teeth are not suited for use in determining the local strontium signature for the region of Hochdorf. Modern snail shell and water samples reflect the local geology nicely; though they too yield highly variable values, too, reflecting the varied geology of the region. For the most part, areas above the geologic unit Keuper were used for pasture, and part of the livestock was probably kept in the Stromberg and/or Löwenstein mountains at a distance of about 15–30 km from the site. Nevertheless the possibility that animals were imported from further away cannot be ruled out. The intra-tooth and intra-individual variations in cattle, sheep/goat, and pig samples reflect movements and non-permanent pastures, but no obvious seasonal herding practice. The high variations of the strontium ratios in single horse teeth point to a greater mobility and possibly the use of horses for transport i.e. riding. In contrast to the Iron Age finds, the isotope signatures of the Early Neolithic livestock from Hochdorf and the Linearbandkeramik settlement of Vaihingen, a site situated near Hochdorf, indicate that animal herding concentrated in loess areas close to the settlements and that seasonal movements to geologically different areas, including Keuper, were exceptions (Bentley and Knipper, 2005b; Knipper, 2009).

Acknowledgements

We would like to express thanks to Dr. U. Neumann (Institut für Geowissenschaften, Arbeitsbereich Mineralogie und Geodynamik, Universität Tübingen) for his advice concerning the geological setting in the surroundings of Hochdorf and his support in collecting modern samples. We thank Dr. J. H. Burton (Laboratory for Archaeological Chemistry, Anthropology Department, University of Wisconsin) and L. Iaccheri (Department für Geo- und Umweltwissenschaften, Sektion Mineralogie, Petrologie und Geochemie, Universität München) for measuring $^{87}Sr/^{86}Sr$ values in archaeological and modern teeth, bones, snail shells, and water.

Role of the funding source

The archaeozoological and isotope research of the Iron Age samples was funded by the German Research Council (Deutsche Forschungsgemeinschaft, DFG) within the framework of the special research program SPP 1171 *"Early Processes of Centralisation and Urbanisation – Studies on the Development of Early Celtic Princely Seats and Their Hinterland"*.

References

Altherr, R., Henjes-Kunst, F., Langer, C., Otto, J., 1999. Interaction between crustal-derived felsic and mantle-derived mafic magmas in the Oberkirch Pluton (European Variscides, Schwarzwald, Germany). Contribution to Mineralogy and Petrology 137, 304–322.

Amorosi, T., 1989. A Postcranial Guide to Domestic Neo-Natal and Juvenile Mammals. The Identification and Aging of Old World Species. BAR International Series 533. Archaeopress, Oxford.

Balasse, M., 2003. Potential biases in sampling design and interpretation of intra-tooth isotope analysis. International Journal of Osteoarchaeology 13, 3–10.

Balasse, M., Ambrose, S., Smith, A.B., Price, T.D., 2002. The seasonal mobility model for prehistoric herds in the south-western Cape of South Africa assessed by isotopic analysis of sheep tooth enamel. Journal of Archaeological Science 29, 917–932.

Balzer, I., Biel, J., 2008. Die Erforschung der Siedlungsdynamik im Umfeld des frühkeltischen Fürstensitzes Hohenasperg, Kr. Ludwigsburg, auf archäologischen und naturwissenschaftlichen Grundlagen, in: Krausse, D. (Ed.), Frühe Zentralisierungs- und Urbanisierungsprozesse. Zur Genese und Entwicklung frühkeltischer Fürstensitze und ihres territorialen Umlandes. Kolloquium des DFG-Schwerpunktprogramms 1171 (Blaubeuren, 9.–11. Oktober 2006). Forschungen und Berichte zur Vor- und Frühgeschichte in Baden-Württemberg 101, Theiss, Stuttgart, pp. 143–161.

Bendrey, R., Hayes, T. E., Palmer, M. R., 2009. Patterns of Iron Age horse supply: an analysis of strontium isotope ratios in teeth. Archaeometry 51, 140–150.

Bentley, R.A., Knipper, C., 2005a. Geographical patterns in biologically available strontium, carbon and oxygen isotope signatures in prehistoric SW Germany. Archaeometry 47, 629–644.

Bentley, R.A., Knipper, C., 2005b. Transhumance at the early Neolithic settlement at Vaihingen (Germany). Antiquity 70 (306), 1–4.

Bentley, R.A., Krause, R., Price, T.D., Kaufmann, B., 2003. Human mobility at the Early Neolithic settlement of Vaihingen, Germany: Evidence from strontium isotope analysis. Archaeometry 45, 471–486.

Bentley, R.A., Price, T.D., Lüning, J., Gronenborn, D., Wahl, J., Fullagar, P.D., 2002. Prehistoric human migration in Europe: strontium isotope analysis of early Neolithic skeletons. Current Anthropology 43, 799–804.

Bentley, R.A., Price, T.D., Stephan, E., 2004. Determining the "local" ^{87}Sr, ^{86}Sr range for archaeological skeletons: a case study from the Neolithic Europe. Journal of Archaeological Science 31, 365–375.

Biel, J., 1995. Die Siedlung der Späthallstatt-/Frühlatènezeit von Hochdorf/Enz, Kreis Ludwigsburg. In: Fürstensitze – Höhensiedlungen – Talsiedlungen. Bemerkungen zum frühkeltischen Siedlungswesen in Baden-Württemberg. Archäologische Informationen aus Baden-Württemberg 28, Stuttgart, 30–37.

Brewer, M.S., Lippolt, H.J., 1974. Rb-Sr age determinations of pre-tectonic granites from the Southern Schwarzwald. SW Germany. Neues Jahrbuch für Mineralogie, Monatshefte 1974, 28–41.

Britton, K., Grimes, V., Dau, J., Richards, M., 2009. Reconstructing faunal migrations using intra-tooth sampling and strontium and oxygen isotope analyses: a case study of modern caribou (*Rangifer tarandus granti*). Journal of Archaeological Science 36, 1163–1172.

Brown, W.A.B., Christofferson, P.V., Massler, M., Weiss, M.B., 1960. Postnatal tooth development in cattle. American Journal of Veterinary Research 21/80, 7–34.

Brubaker, T.M., Fidler, E.C., Capo, R.C., Olsen, S.L., Hynicka, J.D., Sikorka, M T., Rosenmeier, M.F., 2006. Strontium isotopic investigation of horse pastoralism at Eneolithic Botai settlements in northern Kazakhstan. Geological Society of America, Annual Meeting 2006, Paper 83-14, Abstracts with Programs 38, 215.

Bryant, J.D., Froelich, P.N., Showers, W.J., Genna, B.J., 1996. Biologic and climatic signals in the oxygen isotopic composition of Eocene-Oligocene equid enamel phosphate. Paleogeography, Paleoclimatology, Paleoecology 126, 75–89.

Buhl, D., Neuser, R.D., Richter, D.K., Riedel, D., Roberts, B., Strauss, H., Veizer, J., 1991. Nature and nurture: environmental isotope story of the river Rhine. Naturwissenschaften 78, 337–346.

Chiaradia, M., Gallay, A., Todt, W., 2003. Different contamination styles of prehistoric human teeth at a Swiss necropolis (Sion, Valais) inferred from lead and strontium isotopes. Applied Geochemistry 18, 353–370.

Drach, V.v., Lippolt, H.J., Brewer, M.S., 1974. Rb-Sr-Altersbestimmungen an Graniten des Nordschwarzwaldes. Neues Jahrbuch für Mineralogie, Abhandlungen 123, 38–62.

Evans, J.A., Tatham, S., 2004. Defining "local signature" in terms of Sr isotope composition using a tenth- to twelfth-century Anglo-Saxon population living on a Jurassic clay-carbonate terrain, Rutland, UK. in: Pye, K., Croft, D.J. (Eds.), Forensic Geoscience: Principles, Techniques and Applications. Geological Society, London, Special Publications 232, pp. 237–248.

Evans, J.A., Montgomery, J., Wildman, G., 2009. Isotope domain mapping of $^{87}Sr/^{86}Sr$ biosphere variation on the Isle of Skye, Scotland. Journal of the Geological Society, London 166, 617–631.

Evans, J.A., Montgomery, J., Wildman, G., Boulton, N., 2010. Spatial variations in biosphere $^{87}Sr/^{86}Sr$ in Britain. Journal of the Geological Society, London 167, 1–4, including Supplementary Publications No. SUP18388.

Faure, G., 1986. Principles of isotope geology. 2nd ed. Wiley, New York.

Fischer, E., Rösch, M., Sillmann, M., Ehrmann, O., Liese-Kleiber, H., Vogt, R., 2010. Landnutzung im Umkreis der Zentralorte Hohenasperg, Heuneburg und Ipf. Archäobotanische Untersuchungen und Modellberechnungen zum Ertragspotential des Ackerbaus. in: Krausse, D., Beilharz, D. (Eds.), "Fürstensitze" und Zentralorte der frühen Kelten. Forschungen und Berichte zur Vor- und Frühgeschichte in Baden-Württemberg 120/2, Theiss, Stuttgart, pp. 195–265.

Fricke, H.C., O'Neil, J.R., 1996. Inter- and intra-tooth variation in the oxygen isotope composition of mammalian tooth enamel phosphate: implications for palaeoclimatological and palaeobiological research. Paleogeography, Paleoclimatology, Paleoecology 126, 91–99.

Giblin, J.I., 2009. Strontium isotope analysis of Neolithic and Copper Age populations on the Great Hungarian Plain. Journal of Archaeological Science 36, 491–497.

Gillmaier, N., 2009. The Strontium Isotope Project of the International Sachsensymposion. Beiträge zur Archäozoologie und Prähistorischen Anthropologie VII, Beier and Beran, Langenweißbach, 133–142.

Goodfriend, G.A., Hood, D.G., 1983. Carbon isotope analysis of land snail shells: Implications for carbon sources and radiocarbon dating. Radiocarbon 25, 810–830.

Grupe, G., Price, T.D., Schröter, P., Söllner, F., Johnson, C.M., Beard, B.L., 1997. Mobility of Bell Beaker people revealed by strontium isotope ratios of tooth and bone: a study of southern Bavarian skeletal remains. Applied Geochemistry 12, 517–525.

Habermehl, K.H., 1975. Altersbestimmung bei Haus- und Labortieren. 2nd ed. Parey, Hamburg/Berlin.

Hegner, E., Walter, H.J., Satir, M., 1995. Pb-Sr-Nd isotopic compositions and trace element geochemistry of megacrysts and melilitites from the Tertiary Urach volcanic field: source composition of small volume melts under SW Germany. Contributions to Mineralogy and Petrology 122, 322–335.

Heller, J., Magaritz, M., 1983. From where do land snails obtain the chemicals to build their shells? Journal of Molluscan Studies 49, 116–121.

Hillson, S., 1986. Teeth. Cambridge Univ. Press, Cambridge.

Hofmann, A., Köhler, H., 1973. Whole rock Rb-Sr ages of anatectic gneisses from the Schwarzwald, SW Germany. Neues Jahrbuch für Mineralogie, Abhandlungen 119, 163–187.

Hoppe, K.A., Stover, H.M., Pascoe, J.R., Amundson, R., 2004. Tooth enamel biomineralization in extant horses: implications for isotopic microsampling. Palaeogeography, Palaeoclimatology, Palaeoecology 206, 355–365.

Horn, P., Hölzl, S., Fehr, T., 1997. Spurenelemente und Isotopenverhältnisse in fossilen Knochen und Zähnen. in: Wagner, G. A., Beinhauer, K. W. (Eds.), Homo heidelbergensis von Mauer. Das Auftreten des Menschen in Europa. Winter, Heidelberg, pp. 144–166.

Horn, P., Hölzl, S., Storzer, D., 1994. Habitat determination on a fossil stag's mandible from the site of Homo erectus heidelbergensis at Mauer by use of ^{87}Sr, ^{86}Sr. Naturwissenschaften 81, 360–362.

Horn, P., Müller-Sohnius, D., 1999. Comment on "Mobility of Bell Beaker people revealed by strontium isotope ratios of tooth and bone: a study of southern Bavarian skeletal remains" by Grupe, G., Price, T.D., Schröter, P., Söllner, F., Johnson, C.M., Beard, B.L. Applied Geochemistry 14, 263–269.

Kalt, A., Grauert, B., Baumann, A., 1994. Rb-Sr and U-Pb isotope studies on migmatites from the Schwarzwald (Germany): constraints on isotopic resetting during Variscan high-temperature metamorphism. Journal of Metamorphic Geology 12, 667–680.

Knipper, C., 2004. Die Strontiumisotopenanalyse: Eine naturwissenschaftliche Methode zur Erfassung von Mobilität in der Ur- und Frühgeschichte. Jahrbuch Römisch Germanisches Zentralmuseum 51, 589–685.

Knipper, C., 2009. Die räumliche Organisation der Tierhaltung in der Linearbandkeramik: Naturwissenschaftliche und archäologische Untersuchungen. PhD thesis, University Tübingen.

Knipper, C., Paulus, S., Uerpmann, M., Uerpmann, H.-P., 2008. Seasonality and land use in Iron Age Kachetia (Georgia). Oxygen and strontium isotope analyses on horse and cattle teeth. Archäologische Mitteilungen aus Iran und Turan 40, 149–168.

Knipper, C., in press. Strontium-Isotopenanalysen an Pferde- und Schweinezähnen von der Hünenburg bei Watenstedt. Ein Vorbericht. in: K.-H. Willroth (Ed.), Die Bronzezeit im nördlichen Harzvorland. Eine bronze- und früheisenzeitliche Befestigung nördlich des Harzes und ihr Umfeld. Göttinger Forschungen zur Ur- und Frühgeschichte 2. Wachholtz, Neumünster.

Küster, H., 1985. Hochdorf I. Neolithische Pflanzenreste aus Hochdorf, Gemeinde Eberdingen (Kreis Ludwigsburg). in: Körber-Grohne, U. Hochdorf I. Die biologischen Reste aus dem hallstattzeitlichen Fürstengrab von Hochdorf, Gemeinde Eberdingen (Kreis Ludwigsburg). Forschungen und Berichte zur Vor- und Frühgeschichte in Baden-Württemberg 19, Theiss, Stuttgart, pp. 13–83.

Leng, M.J., Heaton, T.H.E., Lamb, H.F., Naggs, F., 1998. Carbon and oxygen isotope variations within the shell of an African land snail (*Limicoloaria kambeul chudeaui* germain): a high-resolution record of climate seasonality. The Holocene 8 (4), 407–412.

McCance, R.A., Ford, E.H.R., Brown, W.A.B., 1961. Severe undernutrition in growing and adult animals. The British Journal of Nutrition 15, 213–224.

McConnaughey, T.A., Gillikin, D.P., 2008. Carbon isotopes in mollusk shell carbonates. Geo-Marine Letters 28, 287–299.

Metref, S., Rousseau, D.-D., Bentaleb, I., Labonne, M., Vianey-Liaud, M., 2003. Study of the diet effect on $\delta^{13}C$ of shell carbonate of the land snail *Helix aspersa* in experimental conditions. Earth and Planetary Science Letters 211, 381–393.

Nehlich, O., Montgomery, J., Evans, J., Schade-Lindig, S., Pichler, S.L., Richards, M.P., Alt, K., 2009. Mobility or migration: a case study from the Neolithic settlement of Nieder-Mörlen (Hessen, Germany). Journal of Archaeological Science 36, 1791–1799.

Niven, L.B., Egeland, C.P., Todd, L.C., 2004. An intersite comparison of enamel hypoplasia in bison: implications for paleoecology and modeling Late Plains Archaic subsistence. Journal of Archaeological Science 31, 1783–1794.

Passey, B.H., Cerling, T.E., 2002. Tooth enamel mineralization in ungulates: Implications for recovering a primary isotopic time-series. Geochimica et Cosmochimica Acta 66, 3225–3234.

Poll, S., Wagenstaller, J., Schweissing, M.M., Driesch, A.v.d., Grupe, G., Peters, J., 2005. Sr isotopes in horn cores provide information on early modern cattle trade. Archaeofauna 14, 243–251.

Price, T.D., Burton, J.H., Bentley, R.A., 2002. The characterization of biologically available strontium isotope ratios for the study of prehistoric migration. Archaeometry 44, 117–135.

Price, T.D., Grupe, G., Schröter, P., 1998. Migration in the Bell Beaker period of central Europe. Antiquity 72, 405–412.

Price, T.D., Knipper, C., Grupe, G., Smrcka, V., 2004. Strontium isotopes and prehistoric human migration: the Bell Beaker period in Central Europe. European Journal of Archaeology 7, 9–40.

Price, T.D., Wahl, J., Bentley, R.A., 2006. Isotopic evidence for mobility and group organization among Neolithic farmers at Talheim, Germany, 5000 BC. European Journal of Archaeology 9, 259–284.

Price, T.D., Wahl, J., Knipper, C., Burger-Heinrich, E., Kurz, G., Bentley, R.A., 2003. Das bandkeramische Gräberfeld vom 'Viesenhäuserhof' bei Stuttgart-Mühlhausen: Neue Untersuchungsergebnisse zum Migrationsverhalten im frühen Neolithikum. Fundberichte aus Baden-Württemberg 27, 23–57.

Probst, A., Gh'Mari, A.E., Aubert, D., Fritz, B., McNutt, R., 2000. Strontium as a tracer of weathering processes in a silicate catchment polluted by acid atmospheric inputs, Strengbach, France. Chemical Geology 170, 203–219.

Regnath, R.J., 2008. Das Schwein im Wald. Vormoderne Schweinehaltung zwischen Herrschaftsstrukturen, ständischer Ordnung und Subsistenzökonomie. Schriften zur Südwestdeutschen Landeskunde 64. Thorbecke, Ostfildern.

Richards, M., Harvati, K., Grimes, V., Smith, C., Smith, T., Hublin, J.-J., Karkanas, P., Panagopoulou, E., 2008. Strontium isotope evidence of Neanderthal mobility at the site of Lakonis, Greece using laser-ablation PIMMS. Journal of Archaeological Science 35, 1251–1256.

Schatz, K., 2009. Die Tierknochenfunde aus der frühlatènezeitlichen Siedlung Eberdingen-Hochdorf "Reps" – Archäozoologische Untersuchungen zur Wirtschaftsweise, Ernährung und Landnutzung der frühen Kelten im mittleren Neckarraum. In: Schatz, K., Stika, H.-P., Hochdorf VII. Archäobiologische Untersuchungen zur frühen Eisenzeit im mittleren Neckarraum. Forschungen und Berichte zur Vor- und Frühgeschichte in Baden-Württemberg 107, Theiss, Stuttgart, pp. 17–123.

Schatz, K., Stephan, E., 2008. Archäozoologie frühkeltischer Faunenfunde – Studien zur Wirtschaftsgeschichte im Umfeld frühkeltischer Fürstensitze. in:

Krausse, D. (Ed.), Frühe Zentralisierungs- und Urbanisierungsprozesse. Zur Genese und Entwicklung frühkeltischer Fürstensitze und ihres territorialen Umlandes. Kolloquium des DFG-Schwerpunktprogramms 1171 in Blaubeuren, 9.–11. Oktober 2006. Forschungen und Berichte zur Vor- und Frühgeschichte in Baden-Württemberg 101, Theiss, Stuttgart, pp. 349–366.

Schweissing, M.M., 2004. Strontium-Isotopenanalyse (^{87}Sr, ^{86}Sr). Eine archäometrische Applikation zur Klärung anthropologischer und archäologischer Fragestellungen in Bezug auf Migration und Handel. Münchner Geologische Hefte, A 31, München.

Schweissing, M.M., Grupe, G., 2003. Tracing migration events in man and cattle by stable strontium isotope analysis of appositionally grown mineralized tissue. International Journal of Osteoarchaeology 13, 96–103.

Silver I.A., 1969. The ageing of domestic animals. in: D.R. Brothwell, E. Higgs (Eds.), Science in Archaeology. Thames and Hudson, London, pp. 283–302.

Stephan, E., 2009. Rekonstruktion eisenzeitlicher Weidewirtschaft anhand archäozoologischer und isotopenchemischer Untersuchungen. in: Benecke, N. (Ed.), Beiträge zur Archäozoologie und Prähistorischen Anthropologie VII, Beier and Beran, Langenweißbach, pp. 65–79.

Stephan, E., Schatz, K., Posluschny, A., 2010. Archäozoologische Untersuchungen und Modellberechnungen zu Viehhaltung, Landnutzung und Ertragspotential im Umkreis der Zentralorte Hohenasperg, Heuneburg und Ipf. in: Krausse, D., Beilharz, D. (Eds.), "Fürstensitze" und Zentralorte der frühen Kelten. Forschungen und Berichte zur Vor- und Frühgeschichte in Baden-Württemberg 120/2, Theiss, Stuttgart, pp. 232–253.

Stika, H.-P., 2009. Stika, Landwirtschaft der späten Hallstatt- und frühen Latènezeit im mittleren Neckarland – Ergebnisse von pflanzlichen Großrestuntersuchungen. In: Schatz, K., Stika, H.-P. Hochdorf VII, Archäobiologische Untersuchungen zur frühen Eisenzeit im mittleren Neckarraum. Forschungen und Berichte zur Vor- und Frühgeschichte in Baden-Württemberg 107, Theiss, Stuttgart, pp. 125–295.

Stott, L.D., 2002. The influence of diet on the δ^{13}C of shell carbon in the pulmonate snail Helix aspersa. Earth and Planetary Science Letters 195, 249–259.

Sykes, N.J., White, J., Hayes, T.E., Palmer, M.R., 2006. Tracking animals using strontium isotopes in teeth: the role of fallow deer (*Dama dama*) in Roman Britain. Antiquity 80, 948–959.

Taylor, S.R., McLennan, S.M., McCulloch, M.T., 1983. Geochemistry of loess, continental crustal composition and crustal model ages. Geochimica et Cosmochimica Acta 47, 1897–1905.

Tütken, T., 2003. Die Bedeutung der Knochenfrühdiagenese für die Erhaltungsfähigkeit in vivo erworbener Element- und Isotopenzusammensetzungen in fossilen Knochen. PhD thesis, University Tübingen. URN: urn:nbn:de:bsz:21-opus-9629; URL:http://w210.ub.uni-tuebingen.de/dbt/volltexte/2003/962/

Ufrecht, W., Hölzl, S., 2006. Salinare Mineral- und Thermalwässer im Oberen Muschelkalk (Trias) im Großraum Stuttgart – Rückschlüsse auf Herkunft und Entstehung mit Hilfe der ^{87}Sr, ^{86}Sr-Strontium-Isotopie. Zeitschrift der deutschen Gesellschaft für Geowissenschaften 157, 299–316.

Veizer, J., Buhl, D., Diener, A., Ebneth, S., Podlaha, O.G., Bruckschen, P., Jasper, T., Korte, C., Schaaf, M., Ala, D., Azmy, K., 1997. Strontium isotope stratigraphy: potential resolution and event correlation. Palaeogeography, Palaeoclimatology, Palaeoecology 132, 65–77.

Viner, S., Evans, J., Albarella, U., Parker Pearson, M., 2010. Cattle mobility in prehistoric Britain: Strontium isotope analysis of cattle teeth from Durrington Walls (Wiltshire, Britain). Journal of Archaeological Science 37, 2812–2080.

Wilson, B., Grigson, C., Payne, S. (Eds.), 1982. Ageing and Sexing Animal Bones from Archaeological Sites. BAR British Series 109, Oxford.

Wolff-Boenisch, B., 1999. Sr-Isotope und Multielement-Analysen zur Herkunftsbestimmung von Wein. PhD thesis University Mainz. Reihe Geowissenschaften 58. Edition Wissenschaft. Marburg.

Yanes, Y., Delgado, A., Castillo, C., Alonso, M.R., Ibanez, M., Nuez, J. de la, Kowalewski, M., 2008. Stable isotope (δ^{18}O, δ^{13}C, and δD) signatures of recent terrestrial communities from a low-latitude, oceanic setting: Endemic land snails, plants, rain, and carbonate sediments from the eastern Canary Islands. Chemical Geology 249, 377–392.

Yates, T.J.S., Spiro, B.F., Vita-Finzi, C., 2002. Stable isotope variability and the selection of terrestrial mollusc shell samples for ^{14}C dating. Quaternary International 87, 87–100.

Corina Knipper[a,] *, Anne-France Maurer[b], Daniel Peters[c], Christian Meyer[a], Michael Brauns[d], Stephen J.G. Galer[e], Uta von Freeden[c], Bernd Schöne[b], Harald Meller[f], Kurt W. Alt[a]

Mobility in Thuringia or mobile Thuringians: A strontium isotope study from early medieval Central Germany

* Corresponding author: knipper@uni-mainz.de
a Institute of Anthropology, Johannes Gutenberg University, Mainz, Germany
b Earth System Science Research Center, Department of Applied and Analytical Paleontology, Institute of Geosciences, University of Mainz, Germany
c Romano-Germanic-Commission, Frankfurt/Main, Germany
d Curt-Engelhorn-Center for Archaeometry, Mannheim, Germany
e Max-Planck-Institute for Chemistry Mainz, Germany
f State Heritage Department and Museum for Prehistory of Saxony-Anhalt, Halle, Germany

Abstract

Residential changes of people during the Migration Period are crucial for archaeological research. Within an extensive study of the migration of the Langobards, strontium isotope analysis was carried out on tooth enamel taken from 48 burials from the Thuringian cemeteries of Rathewitz and Obermöllern (Burgenlandkreis, Sachsen-Anhalt, Germany), which date to the late 5th–mid 6th century. Modern vegetation and water samples provided detailed information about the isotopic composition of the biologically available strontium of geological units in the area. Although the rich furnishing of the burials provides evidence for contacts with many different regions, only one individual (7.1%) in Rathewitz and three (12.5%) in Obermöllern are isotopically nonlocal to the sites. These individuals were buried among the locals and their graves were similarly equipped. In contrast, many nonlocal grave goods were found with isotopically local individuals, often in combination with local items or pieces indicating several different source areas. This suggests the existence of strong interregional ties among the members of the local elites. The cemeteries cannot overall be associated with newly arriving groups; rather, they resulted from a change of funeral customs of the indigenous population from cremation to inhumations or small-scale changes of the burial places. They reflect individual residential changes rather than large-scale movements of groups.

Keywords

Migration Period, Central Germany, Strontium isotopes, mobility, migration

Introduction: the interdisciplinary Langobard project

The migration of the Langobards in the 5/6th century has been studied very intensively by historians and archaeologists. Written sources and grave goods from cemeteries provided the foundation for the development of a detailed picture of Langobardic movements from the lower Elbe region to Moravia, Pannonia, and finally to Italy (Pohl, 2005). An interdisciplinary project, "Isotope analysis and mapping to investigate the origin of nonlocal groups during the early Middle Ages – New approaches to Langobard research" (German title: "Analyse und Kartierung von Isotopen zur Herkunftsbestimmung ortsfremder Personenverbände während des Frühmittelalters – Neue Wege der Langobardenforschung"), designed to test the existing hypotheses, is currently supported by the German Ministry of Education and Research (BMBF).

The three-component project allows researchers to take a new, more detailed and comparative look both at the material culture and its regional ties and at the skeletal remains of the people themselves, with the help of multi-isotope analyses. Strontium and oxygen isotope ratios provide information about human mobility (Ericson, 1985; Schwarcz and Knyf, 1991; Tütken et al., 2008), while carbon and nitrogen isotopes are an archive of dietary information (Ambrose, 1993). Within this project, nine cemeteries in four countries have been chosen as case studies (Fig. 1). Samples have been taken from a total

Fig. 1 | Map of the early medieval cemeteries studied in the Langobards project. This paper focuses on the Central German sites of Obermöllern and Rathewitz

of approximately 480 graves, encompassing all possible individuals with no selection according to grave goods or architecture. Isotope mapping provides a framework of comparative data on locally biologically available isotope ratios. The interdisciplinary analysis of archaeological and isotope geochemical data will reveal which individuals are nonlocal, provide information about their "integration" in the burial communities, and create the basis for a detailed review of the existing hypotheses on the migrations of the Langobards.

This paper focuses on strontium (Sr) isotope analyses for the burials from the central German cemeteries of Rathewitz and Obermöllern, their archaeological interpretation and environmental comparative data from around the sites. Neither cemetery is assigned to the Langobards, instead both have been assigned to the early medieval tribe of the Thuringians[1]. They have been included in the Langobard project in order to test two opposing hypotheses: Do some of the Central German cemeteries represent

[1] All names of historically recognized cultural groups are either used in the same way as by the cited author or as an ordinary description of a region, when comparing the distribution of objects. The interpretation of these terms as ethnic groups is currently debated and will be addressed in forthcoming data analysis and publications (see also Brather 2004). We use these terms for convenience and clarity and do not imply an ethnic interpretation.

archaeological relics of the transition of the Langobards from the lower Elbe River in the 2nd century to the northern Danubian area in the late 5th century, about which historical sources do not provide any details? Or, did the Thuringians take part in the later migrations of the Langobards to Pannonia and finally to Italy, as certain brooch forms suggest (see, e.g., Droberjar 2008; Tejral, 2005; Tejral, 2008; Tejral, 2009).

The cemeteries of Obermöllern and Rathewitz

The cemeteries of Obermöllern and Rathewitz (Burgenlandkreis, southern Saxony-Anhalt) have been chosen to be case studies. The very richly equipped graves there provide an excellent basis for answering the research questions outlined above. The excavations have yielded both local Thuringian objects and finds and features providing evidence of contacts across Europe. Furthermore, they have been only slightly affected by later disturbances, such as grave robbery.

The skeletal remains had been stored in a state museum collection and were sorted well by grave contexts. The generally good state of preservation and the absence of more recently excavated, equally well suited material legitimates the analyses, even though several decades have passed since the excavations took place.

In contrast to the row grave cemeteries of Western and Southern Germany, which often consist of several hundred burials, the Central German sites comprise only a few dozen inhumations. They probably do not represent all of the deceased from a settlement community, but rather a selection that might have been based on social status or kinship. Such cemeteries are typical in the area, which is believed to be Thuringian in the 5/6th century (Theune, 2008).

The cemetery of Obermöllern is the larger of the two sites and consisted of 31 burials (Schmidt, 1975) (Fig. 2). It was excavated between 1925 and 1931 (Grimm, 1953; Holter, 1925) and finally published in the 1970s (Schmidt, 1975). Most of the inhumations are very well equipped. The grave goods found with the greatest frequency are objects of jewellery and weaponry.

Anthropological analysis of the skeletal remains was performed in conjunction with the initial archaeological investigations (Holter, 1925; Müller, 1961; Schott, 1961). Within the current project, a reappraisal of these early studies was conducted using contemporary analytical standards. Additional skeletal remains of children were detected in two graves. Because there were a few graves for which no bones were preserved, a total of 27 human individuals were subject to anthropological investigation. Eight (29.6 %) of them are (probably) female, eight (29.6 %) are (probably) male, one (3.7 %) is an adult whose sex could not be determined, and ten (37.0 %) individuals are children ranging from newborn to fourteen years of age. In contrast to the findings of the first analysis, which suggested that very young and very old individuals were overrepresented in the group, coinciding with ethnographical analogies of an emigration of juvenile and adult community members (Burmeister, 1998), the new investigations show a more equal distribution over age classes.

The somewhat smaller cemetery of Rathewitz (Fig. 3) was excavated between 1955 and 1957 and published by Berthold Schmidt (Schmidt, 1975). It yielded eighteen human burials, from which skeletal remains of sixteen individuals were preserved. In addition, the skeletons of one horse and one dog were unearthed (cf. Blaich, 2009b). Our anthropological analysis identified eight individuals (50 %) as (probably) female, seven (43.8 %) as (probably) male and one (6.3 %) as a child between three and five years of age.

Fig. 2 | Map of the cemetery of Obermöllern indicating the sex of the burials. The mapped local and nonlocal artifacts and features are a selection of a rich assemblage of grave goods

Fig. 3 | Map of the cemetery of Rathewitz indicating the sex of the burials. The mapped local and nonlocal artifacts and features are a selection of a rich assemblage of grave goods

Fig. 4 | Map of the major geological units of the study area (modified from GK1000, BGR Geologie). Quaternary (grey shading/white), Cenozoic (yellow nuances), Mesozoic (purple nuances), Palaeozoic (green nuances), Precambrian (pink nuances), volcanic rocks (red nuances) and plutonic rocks (orange)

Both graveyards were in use for only two to three generations, or for a maximum of 80 years, from the late 5th century to the mid 6th century (cf. Hansen, 2004; Schott, 1961; Theune, 2008). Therefore, if the cemeteries were founded by immigrants, a significant portion of the burials should contain nonlocal individuals.

Geological settings

The study area is located in the southwest of Saxony-Anhalt. It lies on the northeastern edge of the Thuringian basin, formed by Triassic rocks (Buntsandstein, Muschelkalk and Keuper). Toward the east, Pleistocene and Holocene deposits (glacial, periglacial and fluviatile sediments) are dominant. To the north and south, at a distance of about 50 km, the Harz massif and the Thuringian highlands constitute the oldest units of the area (mainly Palaeozoic with a few plutonic and volcanic areas) (Fig. 4).

Despite the occurrence of diverse geological units in the nearer surroundings of the cemeteries (all of those mentioned above, plus a few Oligocene sediments), Pleistocene loess deposits constitute the main substratum within a 2 km radius around the sites. They cover ca. 75 % of the area around Obermöllern and ca. 90 % of that around Rathewitz. Muschelkalk carbonate rocks are also an important component of the landscape in the immediate periphery of Obermöllern (25 %), whereas it is nearly absent from the area of Rathewitz. Buntsandstein occupies only a small area close to the cemeteries (less than 5 %). It is composed of sandstones with intercalated clays (Middle Buntsandstein) and gypsum (Upper Buntsandstein). Except for two small areas of carbonate deposits from the Zechstein (Palaeozoic, Permian), these geological formations prevail within a 40 km radius of the cemeteries.

Material and methods

Information indicating the provenance of an individual is linked to the geological conditions of the area where he or she grew up. Since ^{87}Sr is a radiogenic isotope, ^{87}Sr/^{86}Sr ratios of bedrock vary with Rb content and age (Faure, 1986). After weathering, bedrock strontium is released into soils and groundwater, is absorbed by plants, and passes on through the food chain without any significant fractionation. In mammals, strontium is primarily incorporated into bones and teeth, where it substitutes for calcium. Tooth enamel is a favoured material for provenance studies. It is a very dense material with low organic content that does not remodel in later stages of life and is comparatively resistant against alteration during burial (reviewed in Bentley [2006] and Knipper [2004]). It mineralizes in human permanent teeth between the individual's birth and an age of sixteen or later in some cases, with systematic differences among different teeth (AlQahtani et al., 2010; Schroeder, 1987; Schumacher et al., 1990).

Sampling concentrated on permanent first molars (M1) whenever possible in order to obtain data associated as closely as possible with the birth of the individual: M1 crowns mineralize between birth and approximately the third year of life. Third molars (M3), which mineralize ca. between the ages of seven and fourteen to eighteen (Olze et al., 2003; Schroeder, 1987; Schumacher et al., 1990), were also sampled for older children and adults in order to track possible movements during childhood. Strontium isotope analysis was carried out on a total of 24 individuals from Obermöllern. They include seven adult females and seven adult males, one adult of undetermined sex, and nine children. For ten individuals, tooth pairs of first and third or, in a few cases, second molars from the same individuals were sampled. The Rathewitz samples were taken from fourteen individuals: six adult females and seven adult males, and the child. Tooth pairs were analyzed for nine burials. Details about sample preparation are given in the Appendix.

Characterization of the local biologically available strontium is crucial to identify nonlocal individuals within a burial community. The ideal comparative material would be contemporary to the human remains in question, have a known catchment area and be unaffected by alteration over time. Since there is no material that fulfils all of these requirements, past migration studies and isotope mapping projects have opted for a variety of substitutes whose advantages and disadvantages have been discussed in detail (Price et al., 2002; Evans et al., 2009). These include modern plants, sediment leachates, water, human bones, and archaeological faunal teeth (Chenery et al., 2010; Haak et al., 2008; Bentley and Knipper, 2005; Evans and Tatham, 2004; Schweissing and Grupe, 2003; Chiaradia et al., 2003; Montgomery et al., 2000; Sillen et al., 1998; Grupe et al., 1997).

Within this study a number of different modern and archaeological materials have been analyzed to provide the baseline of the local variation of the biologically available strontium. Among the archaeological materials are bone samples from the femur compacta of seven individuals from Obermöllern and six from Rathewitz. These either integrated dietary strontium during the last years of life or were diagenetically overprinted during burial (Price et al., 2002; Bentley, 2006).

Faunal tooth enamel is more resistant to contamination, but the exchange of single animals with other communities or seasonal mobility of larger herds can cause them to reflect nonlocal values (Knipper, 2009). The grave fillings in both cemeteries occasionally yielded faunal remains, from among which one pig tooth from Obermöllern was included. Because of the lack of contemporary settlement features, three samples from sheep/goat, pig, and cattle from an Iron Age settlement pit (Ha D2; personal comm. Dr. H.-J. Döhle) from Obermöllern were sampled as examples of pre-industrial specimens.

In addition to the archaeological samples, a preliminary examination was conducted on water and plants from the area. These were collected during the spring of 2009. The river samples average the iso-

Fig. 5 | Localities of environmental samples and names of sampled rivers. The coordinates of each location were recorded with GPS and mapped in a geographic information system (GIS). Green: vegetation; blue: water samples (map modified after GK25 4835; 4836; 4837)

tope ratios of the different geological units which they cross. In contrast, plants inform about the isotope ratios of the biologically available strontium for precise localities within a particular geological domain. However, the utilisation of modern river and plant samples for migration studies in the past must be viewed with caution. River water can be prone to seasonal variation (Palmer and Edmond, 1989), and both river and plant samples can be influenced by fertilizers and/or atmospheric inputs (Evans et al., 2010; Green et al., 2004; West et al., 2009; Böhlke and Horan, 2000; Tricca et al., 1999). Our vegetation samples were collected in forests in order to minimize the contribution of fertilizers as much as possible. In addition, a control sample was collected from an agricultural field to allow an estimation of the potential distortion of the natural strontium isotope ratios by fertilizers.

Despite the potential biases, data from river and plant samples are being tested to provide a guide for a first approximation of the modern regional variability, which will be compared to data obtained from archaeological faunal teeth. Twelve water samples from rivers and springs and twenty six plant samples (leaves and grass) have been collected from an area of around 160 square kilometers in the area of the cemeteries. Most of them come from within a 2 km radius around the sites (more than 60% of the samples). Each sampling locality was recorded with a hand-held GPS receiver (Fig. 5). Details about sample preparation are given in the Appendix.

Geological characteristics and biologically available strontium

The water and the vegetation samples from around the cemeteries yielded relatively similar ranges ($^{87}Sr/^{86}Sr$ water: 0.70845–0.71064; $^{87}Sr/^{86}Sr$ vegetation: 0.70776–0.71061, Fig. 6; Table 1). Water samples are therefore good candidates for an initial delimitation of the regional strontium isotopic signature in this geological environment. However, the determination of the strontium isotopic composition of the biosphere within each geological unit is inferred from the data obtained from the modern

Table 1 | Sr isotope ratios of modern environmental samples and archaeological faunal teeth from the study area

	Waypoint	Rivers/springs	Latitude	Longitude	^{87}Sr / ^{86}Sr	± 2 σ
	Water samples					
	53	Unstrut	51,22633	11,67894	0,708450	0,000100
	50	Saale	51,15250	11,76591	0,708870	0,000130
	55	Hasselbach	51,19193	11,73039	0,709130	0,000200
	19	Hasselbach	51,16111	11,64105	0,709190	0,000230
	43	spring	51,12456	11,85215	0,709190	0,000010
	39	Wethau	51,11808	11,85450	0,709600	0,000270
	23	Steinbach	51,19088	11,52330	0,710110	0,000240
	32	Schoppbach	51,12301	11,87309	0,710110	0,000050
	22	Steinbach	51,19057	11,52309	0,710260	0,000170
	44	Nautschke	51,13588	11,86652	0,710400	0,000120
	25	spring	51,19070	11,52306	0,710510	0,000120
	31	spring	51,12005	11,87561	0,710640	0,000170
	Vegetation samples					
*	51	agricultural field	51,16241	11,66505	0,705552	0,000006
	38	forest	51,11224	11,89450	0,707760	0,000040
	4	forest	51,16552	11,66983	0,708190	0,000030
	40	alluvial plain	51,11822	11,85434	0,708200	0,000050
*	36	forest	51,12322	11,86339	0,708250	0,000007
	42	forest	51,12475	11,85100	0,708270	0,000030
	17	quarry Muschelkalk	51,16465	11,66454	0,708400	0,000060
	54	alluvial plain	51,22667	11,67986	0,708420	0,000030
	35	forest	51,12321	11,86382	0,708550	0,000020
	45	forest	51,13501	11,84944	0,708580	0,000010
	7	quarry Muschelkalk	51,16572	11,66749	0,708660	0,000060
	20	forest	51,15637	11,64908	0,708660	0,000020
	8	quarry Muschelkalk	51,16591	11,66681	0,708750	0,000040
	21	forest	51,15689	11,64857	0,708750	0,000020
	57	forest	51,15433	11,72152	0,708870	0,000020
*	11	forest	51,16321	11,66920	0,708933	0,000006
*	37	forest	51,11538	11,87961	0,708998	0,000006
	56	forest	51,15581	11,72055	0,709330	0,000080
	15	forest	51,16371	11,66361	0,709490	0,000040
	47	forest	51,13544	11,84785	0,709500	0,000010
*	14	forest	51,16136	11,66185	0,709517	0,000005
*	58	forest	51,15279	11,72165	0,709605	0,000012
*	48	forest	51,13485	11,84518	0,709663	0,000006
*	33	quarry Loess	51,12470	11,86896	0,709731	0,000007
*	6	quarry Muschelkalk	51,16584	11,66751	0,710178	0,000006
*	24	forest	51,19076	11,52319	0,710614	0,000006
	Faunal samples (tooth enamel) Obermöllern					
	pig	Thuringian	grave 23	M3	0,710460	0,000330
*	pig	Iron Age	pit	M1 upper L	0,708912	0,000005
*	sheep/goat	Iron Age	pit	M3 upper R	0,709693	0,000005
*	cattle	Iron Age	pit	pd4 lower R	0,709594	0,000006

* measured with a TIMS

Fig. 6 | Strontium isotope ratios of the environmental samples, archaeological faunal teeth and human bones from Obermöllern and Rathewitz. The regional variability is given for the water and the vegetation samples. The names of the rivers or the waypoint numbers of the springs are italicized. The isotopic signature of each geological unit (Middle and Upper Buntsandstein, Muschelkalk, Oligocene, loess and riverine sediments) is obtained from the modern vegetation samples

vegetation. Excluding one outlier, the samples collected directly on or close to calcareous Muschelkalk outcrops display a fairly narrow range (0.70819–0.70875). Because of the gypsum-rich nature of the outcrop, one sample from the Upper Buntsandstein lies in the same range with a Sr isotope ratio of 0.70858. The biologically available strontium of the vegetation collected from riverine sediments also indicates the influence of carbonates in the immediate environment, yielding values similar to the samples collected on the Muschelkalk. In contrast, samples on loess soils covering the Upper Buntsandstein displayed higher values (0.70950 to 0.709663). The highest strontium ratio in the area, however, was found on sandstones of the Middle Buntsandstein (0.71061). Together with the samples collected on Muschelkalk outcrops, they constitute the endmembers of the isotopic signature of the biosphere in this area. The samples collected on the loess and on the Oligocene sediments are indistinguishable and yielded intermediate ratios (loess: 0.70893–0.70973; Oligocene: 0.70887–0.70961). One sample from the loess near the cemetery of Rathewitz displayed a very low value (0.70776), indicating a high likelihood of having been influenced by modern fertilizers. Bias toward low values caused by fertilizers is obvious in one vegetation sample from an agricultural field, which yielded an ^{87}Sr/^{86}Sr ratio of 0.70555. These results indicate that even samples collected in forests – especially in small forests surrounded by agricultural fields – can be affected by modern activities. However, when most of the values from one geological unit fall into a fairly narrow range and are comparable with literature data for the same geological units the data are very likely reliable, as was for instance the case for Muschelkalk and loess (Ufrecht and Hölzl, 2006; Stephan, 2009). In summary, for those geological entities for which a minimum of three vegetation samples were collected, the variability of the ratios did not exceed 0.0008.

The archaeological faunal teeth yielded strontium isotope ratios within the range of the regional variability inferred from the modern environmental samples and confirmed the overall spectrum of isotope ratios in the modern samples (Fig. 6 and 7).

Fig. 7 | Comparison of Sr isotope ratios of human tooth enamel from Obermöllern, Rathewitz, environmental samples from the area (excluding two outliers for Muschelkalk and loess) and archaeological faunal teeth. The Sr isotope ratios of the human individuals from both cemeteries are overall very similar with few non-local values. This suggests individual mobility rather than large-scale migrations of extensive groups of people

Strontium isotope ratios in Obermöllern and Rathewitz – Human tooth enamel

Obermöllern

The differentiation of local and nonlocal individuals was based on a combination of the analytical results for modern environmental samples, archaeological faunal enamel, and human bones. For Obermöllern, the mean $^{87}Sr/^{86}Sr$ value ± 2σ (standard deviations) of seven bones ranged from 0.70930 to 0.71023. Either due to diagenetic overprint (Horn and Müller-Sohnius, 1999) or due to adjustment to the local ratios by constant remodelling (Price et al., 2002), bones usually present local Sr isotope values. The range among the bones from Obermöllern falls into the span of Sr isotope ratios determined for all other comparative samples.

The $^{87}Sr/^{86}Sr$ ratios in the human enamel samples varied between 0.70887 and 0.71425 (Fig. 7; Table 2, see appendix). Under a conservative interpretation, values plotting outside the range of the comparative samples are considered nonlocal. Among the 24 analyzed individuals, this approach revealed three migrants, one adult woman (Grave 2), a late-adult man (Grave 12) and the burial in Grave 20 whose sex could not be determined by anthropological techniques, while the grave goods indicate female sex. The male burial from Grave 12 is of special interest. While the Sr isotope ratio of his lower left M1, 0.71425, is indisputably nonlocal, the $^{87}Sr/^{86}Sr$ value of his M3 (0.71050) falls into the local range. This provides evidence of movement between his first years of life and his later childhood/youth. All of the Sr isotope ratios found for subadult individuals overlapped with the environmental values. None of them appeared to be unquestionably nonlocal. According to these data, 20% of the adult individuals from Obermöllern, i.e. 12.5% of the whole burial community, did not grow up close to the site.

Because of the comparatively broad range of environmental Sr isotope data in the geologically variable area and because the $^{87}Sr/^{86}Sr$ ratio range between about 0.7090 and 0.7105 is not unique, but overlaps

Table 2 | Human burials from Obermöllern, with age and sex information, sampled teeth, and ^{87}Sr/^{86}Sr ratios

Sample	HK-Nr	Grave	Sex	Age	Material	Skeletal element	Abrasion	Macroscopic quality	^{87}Sr/^{86}Sr	± 2 σ
OBMÖ 1.1	25;676a	2	female	mature	enamel	lower left M1	medium	very good	0,71410	± 0,00012
OBMÖ 2.1	25;677a	3	female?	adult	enamel	lower left M1	slight to medium	good-very good	0,71035	± 0,00007
OBMÖ 2.2					enamel	lower left M3	slight	very good	0,71071	± 0,00010
OBMÖ 2.3					bone	left femur	mineralization incomplete	good-very good	0,70974	± 0,00017
OBMÖ 3.1	25;678a	4	indet.	inf. I (0.5–1.5)	enamel	lower right dm1	heavy	good	0,71041	± 0,00007
OBMÖ 7.1	25;679a	5	female?	mature	enamel	upper right M1	medium	very good	0,70975	± 0,00010
OBMÖ 7.2					enamel	upper left M2		very good	0,71060	± 0,00008
OBMÖ 7.3					bone	left humerus		very good	0,71004	± 0,00023
OBMÖ 6.1	25;680a	6	female?	mature-senil	enamel	lower right C	medium	good	0,70948	± 0,00008
OBMÖ 9.1	25;682a	9	female	adult	enamel	lower left M1	slight	very good	0,70961	± 0,00020
OBMÖ 9.2					enamel	upper right M3	none	very good	0,70964	± 0,00035
OBMÖ 9.3					bone	left femur		very good	0,70970	± 0,00004
OBMÖ 10.1	25;683a	10	male	mature	enamel	upper right M1	medium to heavy	very good	0,71008	± 0,00008
OBMÖ 11.1	25;684a	11	male	early mature	enamel	lower right M1	slight	very good	0,79920	± 0,00027
OBMÖ 12.1	25;685a	12	male	late mature	enamel	lower left M1	medium	very good	0,71425	± 0,00015
OBMÖ 12.2					enamel	lower left M3	slight	very good	0,71050	± 0,00008
OBMÖ 12.3					bone	right femur		good	0,71004	± 0,00002
OBMÖ 13.1	25;686a	13		inf. II (10–12)	enamel	lower right M1	minimal	very good	0,70887	± 0,00010
OBMÖ 14.1	25;687a	14	male	adult	enamel	lower left M1	heavy to very heavy	good-very good	0,70965	± 0,00015
OBMÖ 14.2					enamel	upper left M3	heavy	good	0,71098	± 0,00013
OBMÖ 14.3					bone	right femur		good	0,70951	± 0,00004
OBMÖ 4.1	25;689a	16	indet.	inf. II (9–11)	enamel	lower right M1	minimal	very good	0,79970	± 0,00009
OBMÖ 5.1	25;689	16	male?	adult	enamel	lower left M1	slight	good	0,79960	± 0,00023
OBMÖ 5.2					enamel	lower left M3	minimal	very good	0,79918	± 0,00028
OBMÖ 15.1	25;690a	17		inf. I (2–4)	enamel	lower right dm2	none	very good	0,71036	± 0,00008
OBMÖ 16.1	25;691a	18		inf. I (2–4)	enamel	lower left dm2	minimal	very good	0,79984	± 0,00024
OBMÖ 17.1	25;692a	19		inf. II (8–14)	enamel	upper right M1	very slight	very good	0,71029	± 0,00005
OBMÖ 17.3					enamel	upper right M3 (?)	mineralization incomplete	good	0,71004	± 0,00019
OBMÖ 18.1	25;693a	20		mature	enamel	lower right M1	medium to heavy	very good	0,71158	± 0,00012
OBMÖ 22.1	25;709a	22	female	late adult	enamel	lower left M1	medium	very good	0,70888	± 0,00006
OBMÖ 22.2					enamel	lower left M3	slight to medium	very good	0,71023	± 0,00020
OBMÖ 22.3					bone	right femur		very good	0,70985	± 0,00012
OBMÖ 20.1	25;710a	23	female	adult	enamel	M3	mineralization incomplete	bad-medium	0,71046	± 0,00033
OBMÖ 23.1	25;711	24	male	early adult	enamel	upper left M1	medium	good-very good	0,70954	± 0,00012
OBMÖ 23.2					enamel	lower left M3	slight	very good	0,70995	± 0,00012
OBMÖ 23.3					bone	left femur		very good	0,70946	± 0,00002
OBMÖ 25.1	31;1348 i	29		inf. I (1.5–2.5)	enamel	upper left M1	mineralization incomplete	medium-good	0,71058	± 0,00005
OBMÖ 26.1	31;1349 l	30		inf. I (0.5–1.5)	enamel	lower left dm2	mineralization incomplete	medium-good	0,71012	± 0,00018
OBMÖ 27.1	31;1350 h	31	male	mature	enamel	upper right M1	slight to medium	very good	0,70965	± 0,00020
OBMÖ 27.2					enamel	lower right M3	slight to medium	very good	0,70898	± 0,00035
OBMÖ 28.1	31;1351 c	32		inf. I (2–4)	enamel	lower left dm2	no	very good	0,71012	± 0,00024

with other localities, the possibility of some number of unrecognized nonlocal burials could not be ruled out. In addition, it is likely that individuals whose $^{87}Sr/^{86}Sr$ ratios vary more than 0.001 between early and late forming teeth experienced some kind of change in the origins of their food sources that may have been related to movement during childhood. This might be the case for the male burial in Grave 14, who was interred separately from all other inhumations of the cemetery, several meters to the east (Fig. 2). In addition, the $^{87}Sr/^{86}Sr$ ratio of the man's M3 fell slightly above the local range, making the inference that he experienced some relocation during childhood even more likely.

The late-adult woman in Grave 22 also exhibited a comparatively large difference between the $^{87}Sr/^{86}Sr$ ratios of the enamel of her M1 and M3 teeth, with a comparatively low value in the M1. Nevertheless, the environmental samples from the study area regularly revealed Sr isotope ratios below 0.70900, especially in association with calcareous soils of the Muschelkalk strata. Therefore, a nonlocal origin or movement of the woman across a larger distance cannot be reliably proven.

Rathewitz

The mean plus and minus two standard deviations of the bone samples from Rathewitz defined a span from 0.7094 to 0.7106, which is considered the narrowest estimate of the local variation of biologically available strontium. Similarly to that for Obermöllern, this range was narrower than the variation of the modern and archaeological comparative samples.

Only Sr isotope ratios that fell outside the isotopic variation of the comparative samples were considered nonlocal. This was the case only for one female individual, whose two tooth samples had $^{87}Sr/^{86}Sr$ ratios of 0.71357 and 0.71322 (Fig. 7; Table 3, see appendix). Overall, this represents a proportion of nonlocal individuals of only 7.1%. None of the male adults nor the child could be assigned as nonlocal. Nevertheless, as is the case for Obermöllern, it is possible that the sample contains a certain number of unrecognized nonlocal individuals.

Comparison of the sites and overall trends

Sr isotope ratios of tooth enamel samples from both sites that were assessed as local, fell into the same range, which is consistent with the $^{87}Sr/^{86}Sr$ ratios of the environmental samples from the area (Fig. 7). Nevertheless, looking at the M1s, which reflect the earliest signals in the lifetime of an individual, some internal trends appeared. Although these tendencies were not statistically significant, in Rathewitz the M1s of the males had somewhat lower values than those of the females, and in Obermöllern the children tended to have more radiogenic (higher) Sr isotope ratios in comparison to the adults.

These trends may point to slightly different patterns of land use and localities of the cultivated plots of land. So far, we know only the positions of the cemeteries: the settlements and agrarian fields have not yet been located. The existing comparative data suggest a concentration of agricultural activities on the fertile loess soils with some addition of Buntsandstein and calcareous soils on the Muschelkalk or in the flood plains. Environmental samples that were collected directly on Muschelkalk exposures have less radiogenic (lower) $^{87}Sr/^{86}Sr$ ratios than the human teeth. This indicates that none of the people who were buried in Obermöllern and Rathewitz lived exclusively from food grown in such localities.

Table 3 | Human burials from Rathewitz, with age and sex information, sampled teeth, and $^{87}Sr/^{86}Sr$ ratios

Probe	HK-Nr	Grave	Sex	Age	Material	Skeletal element	Abrasion	Macroscopic quality	$^{87}Sr/^{86}Sr$	± 2 σ
RATH 1.1	56:270	1	male?	mature	enamel	upper right M1	medium-heavy	medium-good	0,70956	± 0,00018
RATH 1.3					bone	right humerus		very good	0,71004	± 0,00016
RATH 2.1	56:271a	2	male	late mature-senil	enamel	upper right M1	heavy	good	0,70965	± 0,00007
RATH 3.2	56:272a	3	female	mature	enamel	lower right M3	slight-medium	good	0,70965	± 0,00007
RATH 3.3					bone	left tibia		very good	0,71047	± 0,00030
RATH 4.1	56:274a	5	female?	late adult-early mature	enamel	lower left M1	medium	very good	0,71011	± 0,00021
RATH 4.2					enamel	lower left M3	slight	very good	0,70953	± 0,00006
RATH 4.3					bone	left femur		very good	0,70952	± 0,00010
RATH 6.1	56:276a	7	male?	adult-mature	enamel	lower left C	none	very good	0,71023	± 0,00033
RATH 7.1	56:277a	8		inf. I (3–5)	enamel	upper left M1	none	very good	0,71060	± 0,00010
RATH 8.1	56:278a	10	female	adult	enamel	lower left M1	medium	very good	0,71034	± 0,00043
RATH 8.2					enamel	lower left M3	slight	very good	0,70920	± 0,00004
RATH 9.1	56:279a	11	female?	adult	enamel	lower right M1	medium	very good	0,71357	± 0,00014
RATH 9.2					enamel	lower right M3	slight	very good	0,71322	± 0,00011
RATH 9.3					bone	right femur		very good	0,71008	± 0,00033
RATH 10.1	56:280a	12	female	late adult-mature	enamel	upper right M1	partly heavy (oblique)	very good	0,71034	± 0,00010
RATH 10.2					enamel	upper left M2	medium, very oblique	very good	0,70994	± 0,00021
RATH 10.3					bone	right femur		very good	0,71002	± 0,00017
RATH 11.1	56:282a	14	male	early mature	enamel	lower left M1	heavy	very good	0,70930	± 0,00014
RATH 11.2					enamel	lower left M3	slight, uneven	very good	0,70928	± 0,00023
RATH 12.1	56:283a	15	female	early mature	enamel	lower left M1	slight	very good	0,70897	± 0,00015
RATH 12.2					enamel	lower left M3	none	very good	0,71015	± 0,00050
RATH 12.3					bone	left femur		very good	0,71011	± 0,00009
RATH 14.1	57:80a	18	male	adult	enamel	upper right M1	slight	very good	0,70897	± 0,00008
RATH 14.2					enamel	upper right M3	none	very good	0,70975	± 0,00020
RATH 15.1	57:79a	17	male	adult	enamel	upper right M1	medium-heavy	very good	0,70967	± 0,00016
RATH 15.2					enamel	lower right M3	slight	very good	0,70957	± 0,00022
RATH 16.1	60:12a	19	male	adult	enamel	lower right M1	slight-medium	very good	0,70904	± 0,00003
RATH 16.2					enamel	upper right? M3	none	very good	0,70939	± 0,00012

Discussion

At both sites, Obermöllern and Rathewitz, the proportions of nonlocal individuals are low, at 12.5 and 7.1 % respectively. Although it is possible that some of the other individuals were born in areas featuring similar geological conditions, our interpretation of the results so far provides evidence for individual mobility. The few nonlocal individuals might have come to Rathewitz and Obermöllern for personal reasons, such as marriage or to settle there after a comparatively mobile life during which they were involved in trade and exchange. This fits in with hints suggesting that movement occurred at different ages. So far, there is evidence neither for the immigration of larger groups of people who came to Central Germany from a common place of origin, nor for large-scale resettlements from a number of different localities. Either of those would have resulted in higher portions of nonlocal individuals with a range of different Sr isotope ratios.

Although residential changes seem to have played a minor role, the material-culture remains from both sites demonstrate the involvement of both communities in larger trade and exchange systems. A number of apparently local individuals were buried with grave goods and jewellery originating from fairly distant localities, while isotopically nonlocal people showed no clear pattern of association with foreign grave goods.

Local isotope ratios – foreign grave goods

In both cemeteries, "local" and "nonlocal" objects of material culture sometimes occur in the same graves, and oftentimes "nonlocal" forms are associated with isotopically local individuals (Fig. 8). For instance, the adult woman of Grave 10 at Rathewitz, one of the oldest graves at the site (500 AD), contained a miniature sheet brooch with rectangular head plate that has its closest parallels in Gudme (DK) and the Saxon cemetery of Issendorf (Bemmann, 2008). The grave also yielded a brooch with a caliper-shaped head plate (Rathewitz type), an item best known from Thuringian cemeteries, but which also occur in Langobardian contexts in the Danubian region and in Alemannia (south-western Germany) (Bemmann, 2008; Böhme, 1996; Friesinger and Adler, 1979; Koch, 1998).

Large Nordic cross-shaped brooches like those found in Grave 12 at Rathewitz, (phase MD 4; 530–560/70 AD) are usually assigned to the Saxons (Brieske, 2001; Knol, 2009). However, because this piece was deposited later than comparable Saxon and Anglosaxon brooches it is more likely to be a local Thuringian imitation, an heirloom or a hint of some continuation of Nordic influences (cf. Hansen, 2004).

A further example of the complexity of the interpretation of material objects as local or nonlocal is the small brooch of Krefeld/ Weimar type (cf. Schott 1961; Koch, 1998) in Grave 8 at Rathewitz, (infans II; phase MD 4, 530–560/570 AD). This kind of fibulae was primarily distributed in central Germany, while other examples have been found in the Merovingian west (Böhme, 1988; Koch, 1998). They have usually been interpreted as having been brought to the region by Thuringian refugees after the 530s, and then developed further there (Theune, 2008). Although human movement from Merovingia back to central Germany cannot be ruled out, this specific fibula, which was deposited in the grave of a child one generation after the main occurrence of this type, was more likely a present than an item that belonged to the child's costume. A comparable pair of brooches is known from Grave 2 at Obermöllern, where they were indeed deposited with a nonlocal woman.

Fig. 8 | Comparison of the occurrence of local or foreign influenced grave goods to the results of Sr isotope analysis on human tooth enamel. Matches of archaeological local or non-local origin of objects and isotopic signals in tooth enamel are marked with "+". Local objects in graves of non-local individuals or foreign objects in graves of isotopically local burials are marked with "-". For instance, foreign brooches or bracteates in Graves 10 and 12, Rathewitz, and Graves 9, 13, and 6, Obermöllern, were associated with isotopically local people (images from Schmidt 1961; Schmidt 1975; Dräger 2001, not to scale)

The overall shape of the bow fibula of Rositz type in Grave 15 at Rathewitz, (central third of the 6th century) is common in the region and also occurs in Langobardian context, while the specific variant is one most frequently found in southwest Germany (Bemmann, 2008). The grave also yielded keys of a kind well known from Langobardian cemeteries (Bóna and Horváth, 2009).

Furthermore, horse bones indicate a certain degree of mobility. There was a horse found buried close to Grave 14 at Rathewitz, which held the remains of an isotopically local adult male. This pointed to a nonlocal origin of this individual, who was buried with full weaponry equipment, an east Gothic coin (Athalarich, 526–534 AD [Schott, 1961]) and a nonlocal ceramic vessel, probably from the Rhineland.

In summary, all of the objects from Rathewitz that might indicate mobility or even migration were found with isotopically local individuals. In addition to trade, gifts or – in the case of the man from Grave 14 – feuds, raids or participation in wars could be possible explanations for this pattern. The widespread distribution of brooches as elements of female costume very likely gives evidence for regional and supra-regional fashion and trends that were followed by the members of networking social elites.

The situation is very similar in Obermöllern, where the rich graves in particular contained many imports and goods that point to even wider distribution areas. The following discussion will focus on two graves in which women were buried (Graves 5 and 6) who feature artificial skull deformations that have repeatedly been associated with Hunnic influence and viewed as an indicator of nonlocal origin

(see Alt, 2006; Hakenbeck, 2009). So far, both individuals from Obermöllern fail to support this hypothesis, because the Sr isotope ratios of their teeth fall within the range of local isotope variation for the site. It is very likely that the then-inhabitants of what is now Central Germany adopted this custom, making it fashionable in the local communities. This outcome confirms earlier results from Bavaria (Schweissing and Grupe, 2000).

Nevertheless, the rich furnishing of Graves 5 and 6 at Obermöllern do suggest that the women were involved in interregional relationships. The mature woman in Grave 5 has recently been described as a "foreign woman" (Schafberg and Schwarz, 2001) based on archaeological evidence. She wore an S-shaped fibula of the 5th century that has parallels in Liebenau (Saxony) and in the northern Danubian region (Brieske, 2001; Tejral, 2002). A bronze polyhedral pendant dates to the second half of the 5th century and, like the artificial skull deformation, it is considered as showing influence from the east or riding nomads (Brieske, 2001; von Freeden and Lehmann [2005] report the same combination in a 6th-century grave).

The mature to elderly woman in Grave 6 was buried somewhat later, in the 6th century. Her grave furnishing draws a heterogeneous picture of long-distance contacts into different directions (cf. Axboe, 2004; Hansen, 2004; Koch, 1998). A golden bracteate, a single-sided gold medal worn as jewellery, is often assumed to exhibit Nordic-Scandinavian influence (cf. Hansen, 2004; Munksgaard, 1978a; Munksgaard, 1978b; Thews and Behrens, 2009), but its use as a mite (Holter, 1925; Roth, 1978) or grave good is a continental custom which is well known from Pannonia (Pedersen, 2009). Its imprinting does not have any known parallels (Pesch, 2007), which, like some additional single attributes, supports its interpretation as a local work. The Thuringian calliper brooches (Theune, 2008) (for distribution see Bemmann[2008]) are typical regional forms, although they also occur in western Francia (Hansen, 2004; cf. Koch, 1998), like the pair of small brooches.

Finally, attention should be drawn to the Nordic bow brooches (mid 6th century) in the women's Graves 9 (adult) and 13 (juvenile), which at a first glance looked nonlocal or seemed to show nonlocal influence. After looking at individual decoration elements, as like she did for the golden bracteates, Karen Høilund Nielsen argues that both Nordic brooches were local developments (Nielsen, 2009). The associated ceramic vessels have local traditions and the leg bindings and small brooches are widely distributed or in general "Merovingian".

In summary, foreign objects and fashionable goods in Obermöllern also appear predominantly in graves of local individuals. This indicates long-reaching contacts on the part of the upper class, including participation in fashion development and long-distance trade.

Furnishings associated with isotopically nonlocal individuals

The isotopically nonlocal burials, rare in both cemeteries, differ from the well-furnished burials of locals. For instance, the sole nonlocal burial at Rathewitz (Grave 11) was very poorly equipped, with only one knife and eggshells. Eggs are quite common grave goods in Merovingian cemeteries, even though they are considered typical in Thuringia (Blaich, 2009a). The humble furnishing of that grave raises the question of whether it was related to the individual's identity as a foreigner – perhaps a traveler who died unexpectedly while en route? The woman, however, was buried amongst the local members of the small community or burial group. This makes it unlikely that she was a serf or even a slave.

The burials of isotopically nonlocal women from Obermöllern tend to have typical local furnishings. Grave 2 (500 AD) contained a pair of small fibulae (Weimar/Arcy-Sainte-Restitue type) similar to

those from Grave 8 at Rathewitz, and Grave 6 at Obermöllern. Such brooches are well known from Thuringia and western Francia. Their comparatively late deposit (first third of the 6th century) may indicate that they were already heirlooms, or again raise the question of whether people and objects travelled against the flow of a migration as it has been inferred from historical tradition.

The mature woman in Grave 20 was buried one generation later, in the second third of the 6th century (cf. Axboe, 2004). Two bow fibulae with biting heads oriented downwards are typical Thuringian brooches (Bemmann, 2008; Koch, 1977).

Unlike the bracteate from Grave 6 that is interpreted as being a local imitation (Thews and Behrens, 2009), one of the bracteates in Grave 20 is considered to be a true import (Nielsen, 2009; cf. Hansen, 2004; Munksgaard, 1978b). Its motif belongs to a group which is primarily known from Scandinavia (Pesch, 2007). A second golden bracteate shows a Christian cross in an arrangement indicating Byzantine influence (Ellmers 1974; Roth, 1978; see also Dräger, 2001). The occurrence of pagan and Christian motifs in the same grave raises the question of whether the woman was aware of their contrasting iconographic meaning or whether she primarily appreciated the decorative effect of the gold. The different origins of these objects and their possible misunderstanding by their wearer do not support an interpretation of these pieces of jewellery as items of personal property that point to the birth region. Indeed, they may instead be presents from elites from other regions or have been acquired in different ways. Most of the other objects in this woman's grave, such as a pair of small disc brooches with inlays of garnets, represent "international" fashions of the central European social elites. Furthermore, the grave construction is of interest for its interpretation. Elbe Germanic pottery was deposited along with the dead body and the other grave goods in a niche 50 cm above the grave floor. A similar construction has been found in Graves 13 and 16 (Holter, 1925), in which isotopically local people were buried. Along with the presence of the regional brooch type, this indicates the integration of a nonlocal woman into the living and later the burial community (Peters 2007).

In summary, both nonlocal women from Obermöllern are associated with grave constructions and grave goods that represent local traditions and customs. One possible and convincing explanation for the integration of rich nonlocal women into a socially high-standing community is exogamy.

Unlike the case for Rathewitz, nonlocal men were identified in Obermöllern. The clearest example is Grave 12, one of the cemetery's latest graves, which held an individual who was buried, without any weaponry, in the second half of the 6th century. The larger of his ceramic vessels shows Frankish influence, while the smaller one combines both Thuringian and Frankish style. The biconic form is characteristic for Frankish handicraft, while the inlay decoration is typical for Thuringian pottery. This piece could be seen as an attempt to combine foreign form and local decoration.

Only one other male grave (Obermöllern Grave 14) failed to contain weapons among its grave goods. The comparatively large difference between the Sr isotope ratios of the M1 and M3 of that individual, and the fact that the M3 ratio falls slightly above the local range suggest that this man had been abroad temporarily. His grave goods included two small ceramic vessels that seem to be more common in child burials. Furthermore, he had a bucket that, even in its poor and undecorated form, is a rare grave good. In combination with his elevated $\delta^{15}N$ value (Knipper et al., unpublished data), the in part nonlocal Sr isotope ratios and the unusual grave goods may point to a different economic background, which could represent the reason for his higher mobility in later years.

Conclusion and outlook

The combination of Sr isotope analysis for human burials from the Thuringian sites of Rathewitz and Obermöllern and a detailed analysis of their grave goods does not provide any indication of large-scale migrations to central Germany during the early Middle Ages. The three nonlocals among 30 deceased in Obermöllern and 1 nonlocal among 18 deceased in Rathewitz may reflect individual residential changes, but no movement of larger groups of people, or in this specific case, the Langobards who are thought to have migrated through central Germany.

Furthermore, interments of nonlocal individuals occur throughout the period in which the cemeteries were in use, while the isotope ratios for individuals found in the oldest graves, those of the founders, did not differ from the local values. This suggests that the newly founded cemeteries of the 5th century were not initiated by newly arriving groups but result instead from a change of the funeral customs, from cremation to body graves, of an indigenous population.

In both cemeteries, nonlocal people were buried among the locals. Their graves revealed similar grave constructions and were similarly well equipped, with local and foreign objects. Nevertheless, many of the nonlocal grave goods were found with isotopically local individuals, often in combination with local items or pieces that indicated several different source areas. This suggests strong interregional ties involving the exchange of goods among the members of the elites. Therefore some grave goods, especially the brooches, are good indications of interregional relationships among communities, although they do not necessarily reflect the birthplace of an individual.

Acknowledgement

We are very grateful to Prof. Friedrich Lüth (Roman-Germanic Commission, Frankfurt) for his kind contributions to the development of and support for the project and for valuable discussions. We thank the State Heritage Department and Museum for Prehistory of Saxony-Anhalt, especially Dr. Roman Mischker and Dr. Hans-Jürgen Döhle, for providing us access to the human and faunal skeletal remains. Sigrid Klaus and Bernd Höppner (Curt Engelhorn Center for Archaeometry) contributed substantially to the preparation and analysis of the human samples and Dr. Wafa Abouchami, Ingrid Raczek, and Heinz Feldmann (Max Planck Institute for Chemistry, Mainz) provided valuable advice on sample preparation and help with the clean lab procedures for the environmental samples. Lars Heller and Stefanie Thiele (Department of Applied and Analytical Paleontology, Mainz) assisted with the preparation of environmental samples. We are thankful to Dr. Susan Harris (Schleswig), Prof. Lynn Fisher (Springfield), and an anonymous reviewer for helpful comments and language corrections. This research is supported by the Germany Ministry of Education and Science, which is gratefully acknowledged.

Appendix: Sample preparation

Water samples were collected in acid-cleaned Teflon tubes (30 ml), acidified beforehand (100 μl HNO_3 65%) to prevent any action of bacteria, and stored in a cool and dark place. Directly after collection, 2–3 ml of the supernatant, collected after centrifugation, were sampled and dried down.

Fresh leaves and grass were stored in zip-lock bags and cleaned with demineralized water to remove any dust that could bias the strontium isotope ratios of the biosphere. Washed samples were dried in an oven at 50°C, ground manually, and stored. To facilitate the digestion procedure, 1 g of dried plant matter was ashed for 14 hours in acid-washed silica crucibles at 550°C. Then 20 mg of ash were digested with a mixture of ultrapure HNO_3 and H_2O_2 and evaporated to dryness.

After cleaning with de-ionised water in an ultrasonic bath, the surfaces of the human tooth crowns were removed completely with a diamond-coated dental drill bit. Discoloured portions were removed completely, which resulted in varying depth of surface removal. Afterward, samples of core enamel were milled from the preserved crown height. Admixture with the underlying dentin was very carefully avoided. In other cases, sections of the tooth crowns were removed with a dental saw disc. All surfaces of the chips and adhering dentin were removed manually with the dental drill. The pieces were powdered in an agate mortar. In order to dissolve possible secondary carbonates that might have introduced diagenetic strontium, ten to twelve mg of enamel powder were washed with 1.9 ml of de-ionised H_2O, 0.1 molar acetic acid with Ca-acetate buffer (pH 4.5) and rinsed four times with H_2O. During each step samples were shaken with a vortexer, placed in an ultrasonic bath for 10 min at 45°C and centrifuged for 5 min at 10000 rpm. After drying overnight, the samples were ashed at 850°C for 10 hours. The complete pretreatment led to substantial sample loss (enamel mean: 35.7±11.4% [1σ] [RATH]; 34.6±7.1% [OBMÖ]; bone: 46.7±7.9% [RATH], 46.4±9.3% [OBMÖ]). Weak buffered acid was preferred (cf. Tütken et al., 2006; 2007) because using stronger (1 molar) and unbuffered acid on powdered samples (cf. Balasse et al., 2002; Garvie-Lok et al., 2004) leads to even greater sample loss.

Further preparation was done under clean lab conditions at the Curt Engelhorn Center for Archaeometry in Mannheim. Five mg of pretreated enamel or bone powder were digested in 6 N HNO_3 and diluted with H_2O to HNO_3 3 N. Sr separation was carried out in 50 μl Teflon columns with Eichrom Sr-Spec resin. The Sr concentrations of the eluants were determined with a Quadrupole ICP-MS. The solution was diluted to 200 ppb Sr for isotope determination.

The isotope ratios of the teeth, bones, water and most of the plant samples were determined using a magnetic sector field MC-ICP-MS (Multi-Collector Inductively Coupled-Plasma Mass Spectrometer) VG Axiom and corrected according to the exponential mass fractionation law to $^{88}Sr/^{86}Sr = 8.375209$. Blank values were less than 10 pg Sr during the whole clean lab procedure, including digestion, Sr separation and measurement. The Eimer & Amend standard that was run along with the skeletal and environmental samples yielded $^{87}Sr/^{86}Sr$ ratios of 0.70803 ± 0.00009 and 0.70799 ± 0.00006. The long-term mean ± 2σ (Dec. 2009–Aug. 2010; 142 measurements) is 0.70802 ± 0.00007. The interlaboratory mean is 0.708027 ± 0.000035 (1σ, standard deviation) (Müller-Sohnius, 2007). Some analyses of plant samples were performed on a Triton (ThermoFisher) TIMS instrument of the Max Planck Institute for Chemistry in Mainz. After strontium separation, the samples were loaded onto tungsten filaments with Ta-fluoride activator. The difference between both methods was less than 0.00006.

References

AlQahtani, S.J., Hector, M.P., Liversidge, H.M., 2010. Brief communication: The London atlas of human tooth development and eruption. American Journal of Physical Anthropology 142, 481–490.

Alt, K.W., 2006. Die artifizielle Schädeldeformation bei den Westgermanen, in: Artificial deformation of human head in Eurasian past. OPUS: Interdisciplinary investigation in archaeology. RAS Vol. 5. Research Institute for Bioarchaeology, Moscow, pp. 115–126.

Ambrose, S.H., 1993. Diet reconstruction with stable isotopes, in: Standford, M. K. (Ed.), Investigations of Ancient Human Tissue. Chemical Analysis in Anthropology, Gordon and Breach, Langhorn, PA, pp. 59–130.

Axboe, M., 2004. Die Goldbrakteaten der Völkerwanderungszeit – Herstellungsprobleme und Chronologie. de Gruyter, Berlin, New York.

Balasse, M., Ambrose, A. H., Smith, A. B, Price, T. D., 2002. The seasonal mobility model for prehistoric herders in the south-western Cape of South Africa assessed by isotopic analysis of sheep tooth enamel. Journal of Archaeological Science 29 (9), 917–32.

Bemmann, J., 2008. Mitteldeutschland im 5. Jahrhundert – Eine Zwischenstation auf dem Weg der Langobarden in den mittleren Donauraum?, in: Bemmann, J., Schmauder, M. (Eds.), Kulturwandel in Mitteleuropa. Langobarden – Awaren – Slawen. Akten der Internationalen Tagung in Bonn vom 25. bis 28. Februar 2008. RGK. Kolloquien zur Vor- und Frühgeschichte Band 11. Habelt, Bonn, pp. 145–228.

Bentley, R. A., 2006. Strontium isotopes from the earth to the archaeological skeleton: A review. Journal of Archaeological Method and Theory 13, 135–187.

Bentley, R. A., Knipper, C., 2005. Geographical patterns in biologically available strontium, carbon and oxygen isotope signatures in prehistoric SW Germany. Archaeometry 47 (3), 629–644.

Blaich, M.C., 2009a. Bemerkungen zur Speisebeigabe im frühen Mittelalter, in: Heinrich-Tamaska, O., Krohn, N., Ristow, S. (Eds.), Dunkle Jahrhunderte in Mitteleuropa? Tagungsbeiträge der Arbeitsgemeinschaft Spätantike und Frühmittelalter. 1. Rituale und Moden (Xanten, 8. Juni 2006) 2. Möglichkeiten und Probleme archäologisch-naturwissenschaftlicher Zusammenarbeit (Schleswig, 9.–10. Oktober 2007). Studien zu Spätantike und Frühmittelalter 1. Dr. Kovač, Hamburg, pp. 27–44.

Blaich, M.C., 2009b. Bemerkungen zu thüringischen Funden aus frühmittelalterlichen Gräbern im Rhein-Main-Gebiet, in: Castritius, H., Geuenich, D., Werner, M. (Eds.), Die Frühzeit der Thüringer. Archäologie, Sprache, Geschichte. Ergänzungsbände des Reallexikons der Germanischen Altertumskunde 63. de Gruyter, Berlin, New York, pp. 37–62.

Böhme, H.-W., 1988, Les Thuringiens dans le Nord du royaume franc. Revue archéologique de Picardie, 3–4, 57–69.

Böhme, H.-W., 1996. Kontinuität und Traditionen bei Wanderungsbewegungen im frühmittelalterlichen Europa vom 1.–6. Jh. Archäologische Informationen 19, 89–103.

Böhlke, J.K., Horan, M., 2000. Strontium isotope geochemistry of groundwaters and streams affected by agriculture, Locust Grove, MD. Applied Geochemistry 15, 599–609.

Bóna, I., Horváth, J.B., 2009. Langobardische Gräberfelder in West-Ungarn. Magyar Nemzeti Múzeum, Budapest.

Brather, S., 2004, Ethnische Interpretationen in der frühgeschichtlichen Archäologie. Ergänzungsbände des Reallexikons der Germanischen Altertumskunde 42. de Gruyter, Berlin, New York.

Brieske, V., 2001. Schmuck und Trachtbestandteile des Gräberfeldes von Liebenau, Kr. Nienburg/Weser. Vergleichende Studien zur Gesellschaft der frühmittelalterlichen Sachsen im Spannungsfeld zwischen Nord und Süd. Isensee, Oldenburg.

Burmeister, S., 1998. Ursachen und Verlauf von Migrationen – Anregungen für die Untersuchung prähistorischer Wanderungen, in: Häßler, H.-J. (Ed.), 46. Internationales Sachsensymposion "Die Wanderung der Angeln nach England" im Archäologischen Landesmuseum der Christian-Albrecht-Universität Schloß Gottorf, Schleswig, 3. bis 5. September 1995. Studien zur Sachsenforschung 11, pp. 19–41.

Chenery, C., Müldner, G., Evans, J., Eckardt, H., Lewis, M., 2010. Strontium and stable isotope evidence for diet and mobility in Roman Gloucester, UK. Journal of Archaeological Science 37, 150–163.

Chiaradia, M., Gallay, A., Todt, W., 2003. Different contamination styles of prehistoric human teeth at a Swiss necropolis (Sion, Valais) inferred from lead and strontium isotopes. Applied Geochemistry 18, 353–370.

Dräger, U., 2001. Magische Amulette der Germanen. Die Goldbrakteaten aus Aschersleben und Obermöllern, in: Meller, H. (Ed.), Schönheit, Macht und Tod. 120 Funde aus 120 Jahren Landesmuseum für Vorgeschichte Halle. Ausstellungskatalog Halle. Mayr Miesbach, Halle/Saale, pp. 128–129.

Droberjar, E., 2008. Thüringische und langobardische Funde und Befunde in Böhmen, in: Schmauder, M. (Ed.), Kulturwandel in Mitteleuropa. Langobarden – Awaren – Slawen. Akten der Internationalen Tagung in

Bonn vom 25. bis 28. Februar 2008. RGK. Kolloquien zur Vor- und Frühgeschichte Band 11. Habelt, Bonn, pp. 229–248.

Ellmers, D., 1974. Eine byzantinische Mariendarstellung als Vorbild für Goldbrakteaten. Jahrbuch des Römisch-Germanischen Zentralmuseums 18, 233–237.

Ericson, J.E., 1985. Strontium isotope characterization in the study of prehistoric human ecology. Journal of Human Evolution 14, 503–514.

Evans, J.A., Montgomery, J., Wildman, G., 2009. Isotope domain mapping of $^{87}Sr/^{86}Sr$ biosphere variation on the Isle of Skye, Scotland. Journal of the Geological Society 166 (4), 617–31.

Evans, J.A., Montgomery, B.L.J., Wildman, G., Boulton, N., 2010. Spatial variations in biosphere $^{87}Sr/^{86}Sr$ in Britain. Journal of the Geological Society 167, 1–4.

Evans, J.A., Tatham, S., 2004. Defining "local signature" in terms of Sr-isotope composition using a tenth–twelfth century Anglo-Saxon population living on a Jurassic clay-carbonate terrain, Rutland, UK, in: Pye, K., Croft, D. J. (Eds), Forensic Geoscience: principles, techniques and applications. Geological Society of London Special Publication 232, pp. 237–248.

Faure, G., 1986. Principles of Isotope Geology. John Wiley, New York.

Friesinger, H., Adler, H., 1979. Die Zeit der Völkerwanderung in Niederösterreich. Niederösterreichisches Pressehaus, St. Pölten, Wien.

Garvie-Lok, S.J., Varney, T.L., Katzenberg, A.M., 2004. Preparation of bone carbonate for stable isotope analysis: the effects of treatment time and acid concentration. Journal of Archaeological Science 31, 763–76.

Green, G.P., Bestland, E.A., Walker, G.S., 2004. Distinguishing sources of base cations in irrigated and natural soils: evidence from strontium isotopes. Biogeochemistry 68, 199–225.

Grimm, P., 1953. Zur Erkenntnismöglichkeit gesellschaftlicher Schichtungen im Thüringen des 6.–9. Jahrhunderts. Jahresschrift für Mitteldeutsche Vorgeschichte 37, 312–322.

Grupe, G., Price, T.D., Schröter, P., Söllner, F., Johnson, C.M., Beard, B.L., 1997. Mobility of Bell Beaker people revealed by strontium isotope ratios of tooth and bone: a study of southern Bavarian skeletal remains. Applied Geochemistry 12, 517–525.

Haack, W., Brandt, G., N. de Jong, H., Meyer, C., Ganslmeier, R., Heyd, V., Hawkesworth, C., W.G. Pike, A., Meller, H., Alt, K.W., 2008. Ancient DNA, strontium isotopes, and osteological analyses shed light on social and kinship organization of the Later Stone Age. Proceedings of the National Academy of Sciences, 105, 18226–18231.

Hakenbeck, S., 2009. 'Hunnic' modified skulls: physical appearance, identity and the transformative nature of migrations, in: Sayer, D., Williams, H. (Eds.), Mortuary Practices and Social Identities in the Middle Ages. Essays in Burial Archaeology in Honour of Heinrich Härke. University of Exeter Press, Exeter, pp. 64–80.

Hansen, C.M., 2004. Frauengräber im Thüringerreich. Zur Chronologie des 5. und 6. Jahrhunderts n. Chr. Archäologie-Verlag, Basel.

Holter, F., 1925. Das Gräberfeld bei Obermöllern aus der Zeit des alten Thüringen. Jahresschrift für die Vorgeschichte der sächsisch-thüringischen Länder 12.

Horn, P., Müller-Sohnius, D., 1999. Comment on "Mobility of Bell Beaker people revealed by strontium ratios of tooth and bone: a study of southern Bavarian skeletal remains" by Gisela Grupe, T. Douglas Price, Peter Schröter, Frank Söllner, Clark M. Johnson and Brian L. Beard. Applied Geochemistry 14, 263–269.

Knipper, C., 2004. Die Strontiumisotopenanalyse: eine naturwissenschaftliche Methode zur Erfassung von Mobilität in der Ur- und Frühgeschichte. Jahrbuch des Römisch-Germanischen Zentralmuseums Mainz 51, 589–685.

Knipper, C., 2009. Die räumliche Organisation der linearbandkeramischen Rinderhaltung: naturwissenschaftliche und archäologische Untersuchungen. PhD thesis Eberhard-Karls-Universität Tübingen.

Knol, E., 2009. Anglo-Saxon migration reflected in cemeteries in the Northern Netherlands, in: Quast, D. (Ed.), Foreigners in Early Medieval Europe. Thirteen International Studies on Early Medieval Mobility. Monographien des Römisch-Germanischen Zentralmuseums 78. Verlag des Römisch-Germanischen Zentralmuseum, Mainz, pp. 113–129.

Koch, A., 1998. Bügelfibeln der Merowingerzeit im westlichen Frankenreich. Habelt, Bonn.

Koch, U., 1977. Das alamannische Reihengräberfeld von Schretzheim. Gebrüder Mann Verlag, Berlin.

Montgomery, J., Budd, P., Evans, J., 2000. Reconstructing the lifetime movements of ancient people: a Neolithic case study from southern England. European Journal of Archaeology, 3 (3), 370–85.

Müller, C., 1961. Das anthropologische Material zur Bevölkerungsgeschichte von Obermöllern. Prähistorische Zeitschrift 39, 115–142.

Müller-Sohnius, D., 2007. $^{87}Sr/^{86}Sr$ for isotope standards of Eimer and Amend (E&A), modern seawater strontium (MSS), and the Standard Reference Material (SRM) 987: development of interlaboratory mean values, procedures of adjusting, and the comparability of results. Geologica Bavarica 110, 1–56.

Munksgaard, E., 1978a. Brakteaten. Mitteleuropa, Reallexikon der Germanischen Altertumskunde 3. de Gruyter, Berlin, New York, pp. 342–343.

Munksgaard, E., 1978b. Brakteaten. Archäologisches, Reallexikon der Germanischen Altertumskunde 3. de Gruyter, Berlin, New York, pp. 337–341.

Nielsen, K.H., 2009. The real thing or just wannabes? Scandinavian-style brooches in the fifth and sixth Centuries, in: Quast, D. (Ed.), Foreigners in Early Medieval Europe. Thirteen International Studies on Early Medieval Mobility. Monographien des Römisch-Germanischen Zentralmuseums 78. Verlag des Römisch-Germanischen Zentralmuseum, Mainz, pp. 51–111.

Olze, A., Schmeling, A., Rieger, K., Kalb, G., Geserick, G., 2003. Untersuchungen zum zeitlichen Verlauf der Weisheitszahnmineralisation bei einer deutschen Population. Rechtsmedizin 13, 5–10.

Palmer, M.R., Edmond, J.M., 1989. The strontium isotope budget of the modern ocean. Earth and Planetary Science Letters 92, 11–26.

Pedersen, A., 2009. Amulette und Amulettsitten der jüngeren Eisen- und Wikingerzeit in Südskandinavien, in: von Freeden, U., Friesinger, H., Wamser, E. (Eds.), Glaube, Kult und Herrschaft. Phänomene des Religiösen im 1. Jahrtausend n.Chr. in Mittel- und Nordeuropa. Akten des 59. Internationalen Sachsensymposions und der Grundprobleme der frühgeschichtlichen Entwicklung im Mitteldonauraum. Kolloquien zur Vor- und Frühgeschichte 12. Habelt, Bonn, pp. 287–302.

Pesch, A., 2007. Die Goldbrakteaten der Völkerwanderungszeit – Thema und Variation, Ergänzungsbände des Reallexikons der Germanischen Altertumskunde 36. de Gruyter, Berlin, New York.

Pohl, W., 2005. Die Langobarden: Herrschaft und Identität. Verlag der Österreichischen Akademie der Wissenschaften, Wien.

Price, T.D., Burton, J.H., Bentley, R.A., 2002. The characterization of biologically available strontium isotope ratios for the study of prehistoric migration. Archaeometry 44, 117–135.

Roth, H., 1978. Brakteaten. Merowingerzeit, Reallexikon der Germanischen Altertumskunde 3. de Gruyter. Berlin, New York, pp. 344–351.

Schafberg, R., Schwarz, W., 2001. Eine Fremde im Thüringerreich. Eine Frau mit deformiertem Schädel aus Obermöllern, in: Meller, H. (Ed.), Schönheit, Macht und Tod. 120 Funde aus 120 Jahren Landesmuseum für Vorgeschichte Halle. Mayr Miesbach, Halle/Saale, pp. 126–127.

Schmidt, B., 1975. Die späte Völkerwanderungszeit in Mitteldeutschland. Katalog (Nord- und Ostteil). Deutscher Verlag der Wissenschaften, Berlin.

Schott, L., 1961. Deformierte Schädel aus der Merowingerzeit in anthropologischer Sicht, in: Schmidt, B. (Ed.), Die späte Völkerwanderungszeit in Mitteldeutschland. Veröffentlichungen des Landesmuseums für Vorgeschichte in Halle 18. Niemeyer, Berlin, pp. 209–236.

Schroeder, H.E., 1987. Orale Strukturbiologie. Entwicklungsgeschichte, Struktur und Funktion normaler Hart- und Weichgewebe der Mundhöhle und des Kiefergelenkes, 3rd ed. Thieme, Stuttgart, New York.

Schumacher, G.-H., Schmidt, H., Börnig, H., Richter, W., 1990. Anatomie und Biochemie der Zähne. 4th ed. Gustav Fischer, Stuttgart, New York.

Schwarcz, H.P.G., L., Knyf, M., 1991. Oxygen isotope analysis as an indicator of place of origin, in: Pfeiffer, S., Williamson, R. (Eds.), Snake Hill: An Investigation of a Military Cemetery from the War of 1812. Dundurn Press, Toronto. pp. 263–268.

Schweissing, M.M., Grupe, G., 2000. Local or non-local? A research of strontium isotope ratios of teeth and bones on skeletal remains with artificial deformed skulls. Anthropologischer Anzeiger 58, 99–103.

Schweissing, M. M., Grupe, G., 2003. Stable strontium isotopes in human teeth and bone: a key to migration events of the late Roman period in Bavaria. Journal of Archaeological Science 30, 1373–83.

Sillen, A., Hall, G., Richardson, S., Armstrong, R., 1998. $^{87}Sr/^{86}Sr$ ratios in modern and fossil food-webs of the Sterkfontein Valley: implications for early hominid habitat preference. Geochimica et Cosmochimica Acta 62 (14), 2463–73.

Stephan, E., 2009. Rekonstruktion eisenzeitlicher Weidewirtschaft anhand archäozoologischer und isotopenchemischer Untersuchungen. in: Benecke, N. (Ed.), Beiträge zur Archäozoologie und Prähistorischen Anthropologie 7. Beier & Beran, Langenweissbach, pp. 65–79.

Tejral, J., 2002. Beiträge zur Chronologie des langobardischen Fundstoffes nördlich der mittleren Donau, in: Tejral, J. (Ed.), Probleme der frühen Merowingerzeit im Mitteldonauraum.Spisy Archeologický ústavu AV ČR Brno. Brno, pp. 313–358.

Tejral, J., 2005. Zur Unterscheidung des vorlangobardischen und elbgermanisch-langobardischen Nachlasses, in: Pohl, W., Erhart, P. (Eds.), Die Langobarden. Herrschaft und Identität. Österreichische Akademie der Wissenschaften Philosophisch-Historische Klasse, Denkschriften 329 = Forschungen zur Geschichte des Mittelalters 9. Verlag der Österreichischen Akademie der Wissenschaften, Wien, pp. 103–200.

Tejral, J., 2008. Ein Abriss der frühmerowingerzeitlichen Entwicklung im mittleren Donauraum, in: Bemmann, J., Schmauder, M. (Eds.), Kulturwandel in Mitteleuropa. Langobarden – Awaren – Slawen. Akten der Internationalen Tagung in Bonn vom 25. bis

28. Februar 2008. Kolloquien zur Vor- und Frühgeschichte 11. Habelt, Bonn, pp. 249–283.

Tejral, J., 2009. Langobardische Fürstengräber nördlich der mittleren Donau, in: von Freeden, U., Friesinger, H., Wamser, E. (Eds.), Glaube, Kult und Herrschaft. Phänomene des Religiösen im 1. Jahrtausend n. Chr. in Mittel- und Nordeuropa. Akten des 59. Internationalen Sachsensymposions und der Grundprobleme der frühgeschichtlichen Entwicklung im Mitteldonauraum. Kolloquien zur Vor- und Frühgeschichte 12. Habelt, Bonn, pp. 123–162.

Theune, C., 2008. Methodik der ethnischen Deutung. Überlegungen zur Interpretation der Grabfunde aus dem thüringischen Siedlungsgebiet, in: Brather, S. (Ed.), Zwischen Spätantike und Frühmittelalter. Archäologie des 4. bis 7. Jahrhunderts im Westen. Ergänzungsbände des Reallexikons der Germanischen Altertumskunde 57. de Gruyter, Berlin, New York, pp. 211–233.

Thews, S., Behrens, F., 2009. Theorien zu merowingerzeitlichen Runeninschriften: Ritual und Mode, in: Heinrich-Tamaska, O., Krohn, N., Ristow, S. (Eds.), Dunkle Jahrhunderte in Mitteleuropa? Tagungsbeiträge der Arbeitsgemeinschaft Spätantike und Frühmittelalter. 1. Rituale und Moden (Xanten, 8. Juni 2006) 2. Möglichkeiten und Probleme archäologisch-naturwissenschaftlicher Zusammenarbeit (Schleswig, 9.–10. Oktober 2007). Studien zu Spätantike und Frühmittelalter 1. Dr. Kovač, Hamburg, pp. 27–44.

Tricca, A., Stille, P., Steinmann, A., Kiefek, B., Samuel, J., Eikenberg, J., 1999. Rare earth elements and Sr and Nd isotopic compositions of dissolved and suspended loads from small river systems in the Vosges mountains (France), the river Rhine and groundwater. Chemical Geology 160, 139–158.

Tütken, T., Vennemann, T. W., Janz, H., Heizmann, E. P. J., 2006. Palaeoenvironment and palaeoclimate of the Middle Miocene lake in the Steinheim basin, SW Germany: A reconstruction from C, O, and Sr isotopes of fossil remains. Palaeogeography, Palaeoclimatology, Palaeoecology 241 (3–4), 457–491.

Tütken, T., Furrer, H, Vennemann, T. W., 2007. Stable isotope compositions of mammoth teeth from Niederweningen, Switzerland: Implications for the Late Pleistocene climate, environment, and diet. Quaternary International 164–165, 139–150.

Tütken, T., Knipper, C., Alt, K.W., 2008. Mobilität und Migration im archäologischen Kontext: Informationspotential von Multi-Element-Isotopenanalysen (Sr, Pb, O), in: Bemmann, J., Schmauder, M. (Eds.), Langobarden – Awaren – Slawen. Kulturwandel in Mitteleuropa. Akten der Internationalen Tagung in Bonn vom 25. bis 28 Februar 2008. Kolloquien zur Vor- und Frühgeschichte 11. Dr. Rudolf Habelt, Bonn, pp. 13–42.

Ufrecht, W., Hölzl, S., 2006. Salinare Mineral- und Thermalwässer im Oberen Muschelkalk (Trias) im Großraum Stuttgart – Rückschlüsse auf Herkunft und Entstehung mit Hilfe der $^{87}Sr/^{86}Sr$-Strontium-Isotopie. Zeitschrift der deutschen Gesellschaft für Geowissenschaften, 157 (2), 299–316.

von Freeden, U., Lehmann, D., 2005. Das frühmittelalterliche Gräberfeld von Peigen, Gem. Pilsting, Lkr. Dingolfing-Landau. Befunde und Funde sowie Anthropologie und Paläopathologie, Eichendorf, Landau.

West, J.B., Hurley, J.M., Dudas, F.O., Ehleringer, J.R., 2009. The stable isotope ratios of Marijuana. II. Strontium isotopes relate to geographic origin. Journal of Forensic Sciences 54, 1261–1269.

T. Douglas Price[a, *], Karin Margarita Frei[b], Vera Tiesler[c], Hildur Gestsdóttir[d]

Isotopes and mobility: Case studies with large samples

* Corresponding author: tdprice@wisc.edu
a Laboratory for Archaeological Chemistry, University of Wisconsin–Madison, USA, and Department of Archaeology, University of Aberdeen, United Kingdom
b Saxo Institute and Center for Textile Research, Copenhagen University, Denmark
c Universidad Autónoma de Yucatan, Mérida, Yucatan, Mexico
d Institute of Archaeology, Reykjavík, Iceland

Abstract

The use of isotopes in tooth enamel for investigating place of origin for archaeological human remains is becoming common practice. Too often, however, only a few samples are analyzed and little work is done to establish baseline information. An argument for large samples is made in the discussion here, pointing to the presence of substantial variation in human populations due to both migration and dietary differences. The need to determine local isotope ratios is highlighted by the differences that may exist between naturally available isotope ratios in rock, sediments, and surface water and bioavailable isotope ratios found in living and fossil organisms. The use of multi-isotope approaches is also strongly encouraged. Two examples demonstrate the importance of these recommendations. In the first example described in this study, carbon isotopes in both enamel and collagen provide important ancillary information. The arrival of Spanish and African settlers in Campeche, Mexico in the 16th century AD left new isotopic and dietary signals in the cemeteries of the early colonial town. The colonization of Iceland in the 9th century AD brought settlers from northern Europe to the unoccupied islands of the North Atlantic. Dramatic isotopic contrasts in this region enhance our ability to understand population variation. These projects were largely successful because of large sample size, good baseline data, and the use of more than one isotopic system.

Keywords

Strontium, oxygen, carbon, North Atlantic, Colonial Mexico, mobility, provenience, archaeology

Introduction

The subject of this paper is the use of isotopes to distinguish nonlocal individuals in archaeological burial populations. The primary research question involves mobility and migration in the human past. While other isotopic systems may be of utility, most research to date has concentrated on strontium and oxygen. This paper will focus on strontium isotopes. Though such studies have been conducted in the last two decades, it is only recently that they have become more commonplace. Still, such research remains exploratory and problems such as small sample size, a lack of baseline data, and the use of a single isotopic system may limit research goals. This paper argues for the analysis of more samples, the determination of baseline isotopic values, and the use of multiple isotope systems in the study of past human mobility.

This essay is organized as follows. Basic principles of strontium isotope analysis are outlined along with a brief discussion of the methods involved. To document the importance of sample size, baseline data, and the use of multiple isotopes in such studies, two examples are provided. Concluding remarks offer a short synthesis and reaffirmation of the recommendations herein.

Principles and Method

The basic principle for the isotopic proveniencing of human remains involves the comparison of isotope ratios in human tooth enamel with local, or baseline, levels in bone or other materials. Because isotopic ratios vary geographically, values in human teeth (marking place of birth) that differ from the local ratio (place of death) indicate mobility. There are four possible outcomes from the comparison of enamel and

Fig. 3 | Scatter plot of δ¹³C enamel apatite vs. δ¹³C bone apatite. δ¹³C enamel apatite measures childhood diet; δ¹³C bone apatite measures adult diet. Burial number is shown for outliers from the main cluster. Open circles indicate individuals with $^{87}Sr/^{86}Sr$ above 0.7092. n=43

than 0.7092 also had had several teeth modified by filing and chiselling, a practice they probably underwent in their African homelands (Tiesler 2002; Price at al., 2006).

In addition to the local natives and the Africans, there may also be Europeans present in the cemetery. Strontium isotope values in southern Spain, the homeland of most of the early European inhabitants of Mexico and Central America, overlap with the local and nonlocal ranges at Campeche. European burials at Campeche are, therefore, difficult to distinguish by means of strontium isotopes in enamel. Carbon isotopes provide additional perspective and are discussed below.

Interesting relationships are apparent in a plot of carbon isotope ratios in enamel apatite vs. bone apatite (Fig. 3). Enamel apatite records early childhood diet, while bone apatite contains carbon isotopes from the later years of life. A clear cluster of individuals of local origin and similar diets appears in the upper right-hand corner of the graph. Local diets would likely have been dominated by maize and perhaps seafood. Both of these sources produce more positive carbon isotope ratios. Open circles denote nonlocal $^{87}Sr/^{86}Sr$, above 0.7092. The range of values for both bone and enamel apatite for nonlocal individuals is quite broad, reflecting a variety of different childhood and adult diets. West Africa has a variety of staple crops, including several C_4 plants in some regions and C_3 plants in others (Harris 1976).

Four individuals stand out in this graph. Burials 23 and 71 have local isotope signals combined with values pointing to an adult diet very different from that of the other local individuals. The more negative carbon isotope ratios in these two individuals suggest a diet with less maize, fish, or both. The most striking aberrant points in the scatter plot belong to Burials 52 and 128. Both of these individuals exhibit a strontium isotope signal of less than 0.7092, but both are very different from the local cluster in the upper right-hand corner of the graph. δ¹³C values are the most negative of both enamel and bone apatite

in the entire sample, implying a largely terrestrial diet in an absence of C_4 plants. We believe that these two individuals are the best candidates in the burial population for European colonists.

As we have discussed, strontium isotope ratios in southern Spain cover a wide range of values and overlap with the local values in Campeche. The carbon isotope values for these two individuals though are quite different from those of the local population, pointing to a distinctly different diet. Grave location provides an addition clue in the case of Burial 128, one of two individuals found during the excavations inside the church. We believe that the placement within the church points to the special status of this adult male individual and may well relate to his European origins. The similarity of values between Burials 128 and 52 suggest that both came originally from Europe.

The results of our study, combining different isotopic regimes of carbon and strontium, provide a means for distinguishing the place of origin of many of the individuals buried in the Campeche cemetery. Differences in strontium isotopes separated the local and nonlocal individuals while values for carbon isotopes as a proxy for diet helped us to identify the Europeans in the population. Only thanks to the larger sample, good baseline information, and multiple isotope approach were we able to obtain such detailed information.

North Atlantic

Another extraordinary saga unfolded more than 1000 years ago as the people of Scandinavia began an expansion that took them across the North Sea to the British Isles and across the Atlantic to the Faroe Islands by AD 825; Iceland by AD 871; Greenland by AD 895; and the New World (AD 1000), almost 500 years before Columbus and the Spanish. The Viking colonization of a series of remote and uninhabited islands in the North Atlantic is a staggering achievement of ship technology, navigation, and fortitude. The explanations offered for this expansion are numerous and have invoked population growth, political unrest, favourable climatic conditions and other factors.

In this study we focus on the colonization of Iceland. Archaeological evidence supports a late 9th century settlement of the island; however, the homeland of the settlers and the nature of the settlement have long been debated. The Icelandic Sagas report that almost all of the colonists came during the first 60 years of settlement and very few thereafter, and that these individuals came from western Norway (Karlsson, 2001). There is some documentary evidence that people from the Hebrides, Ireland, and the west coast of Scotland settled in Iceland, although they were likely of Norwegian descent (Loyn, 1977). There is also recent evidence from both modern and ancient DNA that the population of northern Britain and Ireland made a substantial contribution to the genetic makeup of Iceland. Analyses of modern mtDNA indicate a contribution from Scandinavia to the population of Iceland of 37.5% (Helgason et al., 2001). Studies of samples of aDNA in 68 early settlers of Iceland indicated they were more closely related to the contemporary inhabitants of Scotland, Ireland, and Scandinavia than to the modern Icelandic population (Helgason et al., 2009).

The Laboratory for Archaeological Chemistry has been involved in the isotopic investigation of the Viking diaspora for more than a decade (Price and Gestsdóttir, 2006). We have measured values in tooth enamel from the early settlers of Iceland to study questions regarding place of birth. As part of this study we determined the local values on Iceland.

Iceland is an exceptional place in many ways. It is one of the youngest landmasses on earth, having been spewed from the Mid-Atlantic Ridge as a large volcanic island over the last 20–25 million years. For

this reason, the strontium isotope ratio observed there is very low and quite distinct from that of many other areas around the rim of the North Atlantic. Numerous studies of strontium isotope ratios in the basalt of Iceland have reported values that average ca. 0.703 for the volcanic rocks that makes up the island (Moorbath and Walker, 1965; Sun and Jahn, 1975; Wood et al., 2004).

In order to determine the baseline bioavailable $^{87}Sr/^{86}Sr$ value on the island, we measured enamel from modern domestic animals, including sheep and cattle, from different parts of Iceland. We were surprised to note that bioavailable strontium isotope ratios were significantly different from that of the basalt rock. Ratios for sheep tooth enamel from four places around Iceland average at 0.706, while two cows from northern Iceland provided values of 0.704. Åberg (1995) describes a value of 0.706 from a transplanted modern reindeer on Iceland as intermediate between grass growing on volcanic soil, with a $^{87}Sr/^{86}Sr$ ratio between 0.703 and 0.704, and the $^{87}Sr/^{86}Sr$ ratio of rainwater of about 0.709.

Sea-spray, rather than rainwater, is likely responsible for the higher than expected bioavailable value witnessed in modern fauna on Iceland. A number of researchers have documented the concentrations and distribution of sea spray in Iceland itself (Kettle and Turner, 2007; Lovett, 1978; Prospero et al., 1995). The $^{87}Sr/^{86}Sr$ of sea spray will be the same as that of seawater, 0.7092, and plants and animals consuming this strontium will exhibit values somewhere intermediate between the basalt rock of Iceland and the sea. This is the pattern we observe in the fauna, flora, and humans on Iceland.

The ancient human samples used in our study come from two time periods in Icelandic archaeology, the pre-Christian Viking Age and the early medieval Christian periods. The pre-Christian period begins with the first settlers around AD 871 and ends ca. AD 1000 with the conversion to Christianity. Pre-Christian graves are usually solitary or form part of small burial clusters; Christian graves are found in cemeteries around churches. Approximately 200 pre-Christian skeletons have been excavated to date in Iceland. Of these, about 30% are well preserved. More than 90% of the burials are adults; approximately 68% are male and 32% are female. We have measured strontium isotopes in 83 pre-Christian individuals from 52 sites from various locations and 33 early medieval Christian burials from two cemeteries (Skeljastadir in Thjórsárdalur, southern Iceland, and Haffjardarey in Haffjördur, western Iceland). The results of this analysis are presented in Figure 4, arranged by time period in ranked order of value.

On the left of this bar graph are the results of baseline measurements of rock, cattle, barley and sheep, which suggest an average bioavailable value for strontium isotope ratio between approximately 0.704 and 0.707. At the same time, there is a smooth continuous range of variation in the human tooth enamel values, from 0.7056 to 0.710. Decisions about where to distinguish local and nonlocal individuals appear difficult.

It is essential to remember that there are two major sources of strontium in the human diet on Iceland: the first is terrestrial (basalt 0.703 + sea spray 0.709 = 0.704–0.707), and the second is marine (0.7092). Thus, values in humans on Iceland might range between these two extremes and this is what we are seeing in the continuous range of values in the data. At the same time, the highest value available to the human population on Iceland is 0.7092; there are no higher sources for $^{87}Sr/^{86}Sr$. Thus any values above seawater must be nonlocal.

Based on this information, we can identify 32 of the 82 pre-Christian individuals in our sample as nonlocal. For the Christian sample, only one individual among 33 samples has a value greater than 0.7092. It is also important to note in our study that the nonlocal $^{87}Sr/^{86}Sr$ values show a broad range with a maximum value of 0.7257. This wide range of values suggests that nonlocal individuals came to Iceland from a number of different places. The high proportion of nonlocal individuals, almost 40%, suggests that the "settlement period" lasted longer than the documentary sources indicate. The pres-

Fig. 4 | Ranked strontium isotope ratios for baseline (left), pre-Christians (centre), and Christian burials from Iceland

ence of a nonlocal in the medieval Christian cemetery, as well as radiocarbon dates on a number of the earlier skeletons, confirming a chronological placement for some nonlocals in the latter half of the pre-Christian period, supports this.

Conclusions

Recent laboratory methods involving isotopes and aDNA are greatly enhancing the study of past human remains and providing a lot of new information about and insight into groups and individuals. In combination with conventional studies of skeletal and archaeological evidence, these methods permit a much richer picture of our human ancestors to be drawn. The number of published studies involving the isotopic provenience assessment of human remains has greatly increased in the last few years. There are studies underway addressing all continents except Antarctica. As isotopic studies of past human provenience become more commonplace, it emerges that larger numbers of samples, definition of baseline local and potential homeland signals, and the use of multiple isotopic analyses will provide a clearer picture of past activity and permit more accurate reconstructions of human movement.

Acknowledgements

These studies are the result of the cooperation and assistance of a number of individuals and institutions. We would especially like to thank James Burton, David Dettman, Robert Frei, Paul Fullager and Stephanie Jung. TDP also gratefully acknowledges the financial support of the US National Science Foundation and the Alexander von Humboldt Foundation. VT is indebted to her colleagues Carlos Vidal, Heber Ojeda, and Carlos Huitz of the INAH Center in Campeche, with whom she directed the rescue excavations in Campeche's old town. HG thanks the Icelandic Centre for Research for financial support.

References

Åberg, G. 1995. The use of natural strontium isotopes as tracers in environmental studies. Water, Air, and Soil Pollution 79, 309–322.

Benson, L.V., Stein, J.R., Taylor, H.E., 2009, Possible sources of archaeological maize found in Chaco Canyon and Aztec Ruin, New Mexico: Journal of Archaeological Science, v. 36, no. 2, 387–407.

Budd, P., Montgomery, J., Barreiro, B., Thomas R.G., 2000. Differential diagenesis of strontium in archaeological human dental tissues. Applied Geochemistry 15, 687–694.

Cárdenas Valencia, F., 1937. Relación historial eclesiástica de la provincia de Yucatán de la Nueva España, escrita el año 1639. Antigua Librería Robredo de José Porrua e Hijos, Mexico City.

DeCorse, C.R., 2001. The Archaeology of Elmina. Smithsonian, Washington DC.

Faure, G., Mensing, T.M., 2005. Isotopes: Principles and Applications. Wiley, New York.

Gerhard, P., 1992. The Southeast Frontier of New Spain. Norman, University of Oklahoma Press, Oklahoma.

Goodman, A., Jones, J., Reid, J., Mack, M., Blakey, M.L., Amarasiriwardena, D., Burton, P., Coleman, D., 2004. Isotopic and elemental chemistry of teeth: Implications for places of birth, forced migration patterns, nutritional status, and pollution, in: Blakey, M.L., Rankin-Hill, L.M. (Eds.), Skeletal Biology Final Report. Vol. I. African Burial Final Reports. Howard University, Washington DC, pp. 216–265

Harris, D.R., 1976. Traditional systems of plant food production and the origins of agriculture in West Africa, in: Harlan, J.R., De Wet, J.M.J., Stemler, A.B.L. (Eds.). Origins of African Plant Domestication. Mouton, The Hague, pp. 311–356.

Helgason, A., Hickey, E., Goodacre, S., Bosnes, V., Stefansson, K., Ward, R., Sykes, B., 2001. mtDNA and the islands of the North Atlantic: Estimating the proportions of Norse and Gaelic ancestry. American Journal of Human Genetics 68, 723–737.

Helgason, A., Lalueza-Fox, C., Ghosh, S., Sigurdardottir, S., Lourdes Sampietro, M., Gigli, E., Baker, A., Bertranpetit, J., Arnadottir, L., Porsteinsdottir, U., Stefinsson, K., 2009. Sequences from first settlers reveal rapid evolution in Icelandic mtDNA pool. PLoS Genetics 5: e1000343

Hillson, S., 2005. Teeth. Cambridge University Press, Cambridge

Hodell, D.A., Quinn, R.L., Brenner, M., Kamenov, G., 2004. Spatial variation of strontium isotopes ($^{87}Sr/^{86}Sr$) in the Maya region: A tool for tracking ancient human migration. Journal of Archaeological Science 31, 585–601.

Karlsson, G., 2001. Iceland's 1100 years: the history of a marginal society. Mál og menning, Reykjavík.

Kettle, A.J., Turner, S.M., 2007. Upper ocean response to a summer gale south of Iceland: Importance of sea spray in the heat and freshwater budgets of storms. Journal of Geophysical Research 112, 1–34.

Lovett, R. F., 1978. Quantitative measurement of airborne sea salt in the North Atlantic. Tellus 30, 358–364.

Loyn, H., 1977. The Vikings in Britain. St. Martins' Press, New York

Moorbath, S., Walker, G.P.L., 1965. Strontium isotope investigation of igneous rocks from Iceland. Nature 207, 837–840.

Müller, W., Fricke, H., Halliday, A.N., McCulloch, M.N., Wartho, J.-A., 2003. Origin and migration of the alpine iceman. Science 302, 862–866.

Price, T.D., Johnson, C., Ezzo, J., Burton, J., Ericson, J., 1994. Residential mobility in the American Southwest: A preliminary study using strontium isotope analysis. Journal of Archaeological Science 21, 315–330.

Price, T.D., Gestsdóttir, H., 2006. The first settlers of Iceland: An isotopic approach to colonization. Antiquity 80: 130–144.

Price, T.D., Burton, J.H., Bentley, R.A., 2002. Characterization of biologically available strontium isotope ratios for the study of prehistoric migration. Archaeometry 44, 117–135.

Price, T.D., Tiesler, V., Burton, J.H., 2006. Early African diaspora in colonial Campeche, Mexico: Strontium isotopic evidence. American Journal of Physical Anthropology 130, 485–490.

Price, T.D., Burton, J.H., Fullagar, P.D., Wright, L.E., Buikstra, J.E., Tiesler, V., 2008. $^{87}Sr/^{86}Sr$ ratios and the study of human mobility in ancient Mesoamerica. Latin American Antiquity 19, 167–180.

Price, T.D., Burton, J.H., Sharer, R., Buikstra, J., Wright, L.E., Moore, K., 2010. Kings and commoners at Copán: Isotopic evidence for origins and movement in the Classic Maya period. Journal of Anthropological Archaeology 29, 15–32.

Price, T.D., Burton, J.H., Tiesler, V., Cucina, A., Zabala, P., Tykot, R., 2011. Isotopic studies of human skeletal remains from a 16th–17th century AD churchyard in Campeche, Mexico: Diet, ethnicity, place of origin, and age. Current Anthropology, in press.

Prospero, J. M., Savoie, D.L., Arimoto, R., Olafsson, H., Hjartarson, H., 1995. Sources of aerosol nitrate and non-sea-salt sulfate in the Iceland region. The Science of the Total Environment 160/161, 181–191.

Schoeninger, M.J., Hallin, K.A., Reeser, H., Valley, J.W., Fournelle, J., 2003. Isotopic alteration of mammalian tooth enamel. International Journal of Osteoarchaeology 13, 11–19.

Sjögren, K.-G., Price, T.D., Ahlström, T. 2009. Megaliths and mobility in south-western Sweden. Investigating relations between a local society and its neighbours using strontium isotopes. Journal of Anthropological Archaeology 28, 85–101.

Sun, S.-S., Jahn, B., 1975. Lead and strontium isotopes in post-glacial basalts from Iceland. Nature 255, 527–528.

Tiesler, V.,. 2002. New cases of an African tooth decoration type from Campeche, Mexico. HOMO, Journal of Comparative Human Biology 52, 277–282.

Tiesler, V., Zabala, P., Cucina, A. (Eds.), 2010. Natives, Europeans, and Africans in Colonial Campeche: History and Archaeology. University Press of Florida, Gainesville.

Wood, D.A., Joron, J.-L., Treuil, M., Norry, M., Tarney J., 2004. Elemental and Sr isotope variations in basic lavas from Iceland and the surrounding ocean floor. Contributions to Mineralogy and Petrology 70, 319–339.

Wright, J.B., Hastings, D.A., Jones, W.B., Williams, H.R., 1985. Geology and Mineral Resources of West Africa. George Allen & Unwin, London.

Gisela Grupe[a,*], Sabine Eickhoff[b], Anja Grothe[b], Bettina Jungklaus[b], Alexander Lutz[a]

Missing in action during the Thirty Years' War: Provenance of soldiers from the Wittstock battlefield, October 4, 1636. An investigation of stable strontium and oxygen isotopes

* Corresponding Author: G.Grupe@lrz.uni-muenchen.de
a Dept. I der Fakultät für Biologie, Bereich Biodiversitätsforschung/Anthropologie, Biozentrum der Ludwig-Maximilians-Universität, Martinsried, Germany
b Brandenburgisches Landesamt für Denkmalpflege und Archäologisches Landesmuseum, Zossen, Ortsteil Wünsdorf, Germany

Abstract

In 2007, a mass burial featuring 88 male skeletons buried *in situ* was recovered at Wittstock in Brandenburg (Germany). Based on the archaeological evidence and historical records, the individuals were identified as victims of the 1636 Battle of Wittstock. To determine whether the victims had belonged to the Swedish troops or the German imperial army, $^{87}Sr/^{86}Sr$ isotope analysis of the enamel of a first permanent molar was performed, combined with $\delta^{18}O$ analysis of the enamel's structural carbonate. While the unusually high level of variability of both isotopic ratios confirmed that the buried soldiers represented a multi-ethnic army, identification of their places of origin was possible for only one-fourth to one-fifth of the individuals, who were determined to have belonged to the Swedish troops. Given the fact that the victims could potentially have originated in any part of Europe, the outcome of this study can be viewed as a success.

The study does demonstrate the limitations of archaeometric provenance studies based on stable isotopes in skeletal remains, as well as their potential however. Since isotopic ratios are redundant by nature and identical ratios can occur in many different places in the world, firm, testable hypotheses concerning possible or probable places of origin that are based on archaeological, historical or anthropological records are an indispensable prerequisite to such studies.

Keywords

Provenance analysis, unknown place of origin, stable isotopes, strontium, oxygen

Introduction

The Battle of Wittstock (Brandenburg, Germany) took place on October 4, 1636, when the Swedish army (aided by Scottish troops and soldiers from other countries) fought against forces of the Imperial army and the Elector of Saxony. The Imperial forces, with about 22,000 soldiers, outnumbered their Swedish counterparts (ca 16,000 soldiers). The battle must have been a particularly bloody one, since about 6,000 casualties were reported. A mass burial, measuring 4.8 m by 3.5 m, was discovered in a sand pit south of Wittstock in 2007. Anthropological investigation revealed that the pit contained 88 human *in situ* skeletons, most belonging to males between 20 and 40 years of age, though several juveniles were also present (Grothe and Jungklaus, 2009). The site had been disturbed in modern times; based on the reconstructed size of the pit, a total about 120 to 130 victims were originally buried there (Eickhoff et al., 2009). The morphological appearance and frequency of unhealed skeletal trauma, including cut marks from sharp-edged weapons and gunshot entrance wounds caused by lead bullets, many of them fatal, quickly led to the conclusion that the skeletons belonged to victims of a battle. In some instances, isolated lead projectiles were also found, either embedded in bone or lying among the skeletons, having once been lodged in long-since-decayed soft tissues. The historical documentation of the battles of the Thirty Years' War ultimately permitted the attribution of the mass burial to the 1636 Battle of Wittstock (Grothe and Jungklaus, 2009). However, no artefacts or remains of uniforms that might have provided evidence as to affiliation with one army or the other were found preserved with the dead. To answer that

question, provenance analysis based on stable isotopic ratios of strontium in the enamel of one first permanent molar sampled from each skeleton was attempted. The results were further supported by analysis of stable oxygen isotopes of the structural carbonate of the enamel. While the isotopic ratio for stable strontium provides clues to the geologically defined place in which an individual spent his or her childhood (see Price et al., this volume), $\delta^{18}O$ is related to meteoric water and hence to the ecologically defined place of childhood (Kohn and Cerling, 2002; Rozanski et al., 1992). $\delta^{18}O$ values of meteoric water are strongly affected by latitude (Kelly et al., 2005): after passing through the cycle of evaporation, condensation and precipitation, groundwater exhibits a systematic geographical isotopic variation. In general, the heavy ^{18}O isotope is concentrated in the liquid phase. Decreasing temperatures lead to a depletion of the heavy isotope (^{18}O) in precipitation, when water vapour from oceans in equatorial regions moves to higher latitudes and altitudes (Craig, 1961). Evaporation, condensation and precipitation events are thus responsible for a continuous depletion of ^{18}O when clouds move inland and gain altitude (Kelly et al., 2005). Consequently, groundwater reflects this isotopic gradient from coastal to inland areas (Dansgaard, 1964).

This study differs, though, from the majority of provenance reconstructions performed for archaeological human skeletons. The methods, as such, are well established, and so is the usual procedure of data interpretation: first, the local $^{87}Sr/^{86}Sr$ isotopic ratio has to be defined either through soil analyses or, preferably, through the analysis of accompanying bone finds of residential animals (see Price et al. [2002] for a definition of the isotopic ratio of local bioavailable strontium). However, in this case, it was safe to assume that very few of the soldiers were of local origin, though it is possible that some additional combatants were recruited 'on the spot'. The next step would have been the definition of a probable or at least hypothetical place of origin for the nonlocal individuals. However, soldiers involved in the Battle of Wittstock could have come from almost anywhere in Europe (see below). Identification of a place of origin on the basis of stable isotope ratios leads to robust results only if several important prerequisites have been met. These include cases where a hypothetical place of origin can be tested, regional isotopic mapping of bioavailable strontium can be established, the isotopic end members are defined, and conventional mixing diagrams provide better resolution of possible mixed isotopic ratios (Grupe et al., 1999; Bentley, 2006). In this study, it was not possible to determine either the local $^{87}Sr/^{86}Sr$ isotopic ratio that had entered the food chain in the 17th century or the local $^{87}Sr/^{86}Sr$ isotopic ratio of possible places of origin. No animal bones were recovered, and since the armies were constantly on the move and food was most probably both acquired on the spot and carried along with the other provisions, faunal remains would not have been helpful in the analysis. Furthermore, as mentioned above, while some of the soldiers may have been of local origin, and would therefore not have served in the army for longer than a few days or weeks, according to the historical records, the majority of the soldiers were definitely not local to the site. While most of the Swedish troops originated from southern Sweden, the army also included around 1,700 Scotsmen, a number of the soldiers came from today's Finland and approximately 6000 soldiers were described as coming 'from other countries'. The German soldiers had been recruited from almost every corner of Germany (East Frisia, northern and southern Germany, Westfalia, Rheinland, Hesse and Bavaria), and there were Spaniards and Saxons fighting in the Imperial Army as well (Eickhoff, pers. comm.) Under these circumstances, determination of a place of origin for every single individual amongst the 88 skeletons was highly unlikely.

Material and methods

First permanent molars from either the upper or lower jaw were available from only 73 skeletons, somewhat reducing the sample size. Since the enamel of the first permanent molar is precipitated in early childhood, its $^{87}Sr/^{86}Sr$ isotopic ratio should be indicative of the geochemistry of the place the individual spent his or her childhood. On the whole, the bones exhibited a poor state of preservation, due to the burial conditions. For that reason, we also measured $\delta^{18}O$ in the enamel structural carbonate. We are acutely aware that the stable oxygen isotopic ratio would be obscured to an unknown degree by a weaning signal (see discussion).

Individual numbers, tooth type, and measurement data are listed in Table 1. For the determination of the $^{87}Sr/^{86}Sr$ isotopic ratio in the enamel, all samples were first subjected to mechanical cleaning under running tap water, followed by ultrasonic cleaning in distilled water (10 minutes). After the sample was heated for one hour at 300°C, a temperature which does not cause isotopic fractionation, which could skew results from the subsequent oxygen isotope analyses, and which does not affect the thermally stable $^{87}Sr/^{86}Sr$ isotopic ratio (Harbeck et al., 2011), tooth enamel was mechanically separated from the dentin.

Before the strontium isotopic analysis was performed, samples were cleaned ultrasonically for 5 minutes in concentrated formic acid, in order to quantitatively remove contaminants from the inner and outer enamel surface (strontium salts are more acid-soluble than calcium salts, Mewis, 2004). After being heated at 500°C for 12 hours to remove all organic residues, the samples were homogenized, and 50 mg of each were wet ashed under pressure for 6 hours at 160°C in 1 mL concentrated HNO_3. Finally, 9 mL H_2O was added to provide 10 mL of stock solution. Before mass spectrometry, samples were passed through cation exchange columns (Dowex AG 50Wx8, 200–400 mesh, 2.5 N HCl) to separate Sr from other elements, including interfering ^{87}Rb. Isotopic ratios were measured with a Finnigan MAT 261 mass spectrometer using the double filament technique. Standards NBS SRM 987 and NBS SRM 1400 served for quality control (mass spectrometry and wet ashing, respectively).

For the measurement of stable oxygen isotopic ratios in the enamel structural carbonate, 100 mg of enamel were incubated into 5 mL 4% NaOCl until effervescence ceased, which took three full days. The solution was changed daily. NaOCl removes all organic molecules by oxidation (Koch et al., 1997; Balasse 2002). After being washed with distilled water, the samples were incubated for half a day in 5 mL of 1 M acetic acid – calcium acetate buffer (pH 4.75) and kept in constant, gently rocking motion. The acidic buffer removes all absorbed carbonates (Koch et al., 1997). Finally, the samples were washed again, lyophylized and kept in a vaccum oven until mass spectrometry. Mass spectrometry was performed using a Gasbench II and Continuous Flow Isotope Gas Mass Spectrometer (CF-IRMS; Thermoquest-Finnigan), where the sample reacts for 1 h with o-phosphoric acid at 72°C, and where resulting CO_2 is transferred, with He as carrier gas, into the mass spectrometer. The δ values are expressed against the PDB standard. Standards NBS 18 and NBS 19 (International Atomic Energy Agency) served for quality control. Measurement error did not exceed 0.1‰.

Table 1 | List of sample number, tooth identification, measurement data and $\delta^{18}O_{carbonate}$ converted into $\delta^{18}O_{water}$ (cf. text)

Sample no.	Tooth	$^{87}Sr/^{86}Sr$	$\delta^{18}O$	$\delta^{18}O_{water}$
Wit 1	26	0.70888	−5.4	−9.6
Wit 2	46	0.71052	−5.3	−9.4
Wit 3	16	0.71077	−4.2	−7.6
Wit 4	26	0.70839	−4.4	−7.9
Wit 5	16	0.71004	−5.9	−10.3
Wit 6	46	0.71131	−3.0	−5.7
Wit 7	46	0.70971	−5.2	−9.2
Wit 8	36	0.71131	−4.8	−8.6
Wit 9	16	0.71816	−5.9	−10.3
Wit 10	26	0.71070	−5.6	−9.9
Wit 11	26	0.70892	−4.7	−8.5
Wit 12	26	0.70918	−5.6	−9.9
Wit 13	16	0.71232	−6.4	−11.2
Wit 14	16	0.71123	−4.6	−8.6
Wit 15	26	0.71145	−5.3	−9.4
Wit 16	46	0.71068	−3.7	−6.9
Wit 17	26	0.71851	−7.6	−13.1
Wit 19	46	0.71859	−8.0	−13.7
Wit 20	26	0.71722	−5.2	−9.2
Wit 21	46	0.71531	−6.2	−10.9
Wit 22	46	0.70803	−5.9	−10.3
Wit 23	46	0.71230	−4.7	−8.5
Wit 25	16	0.71121	−5.4	−9.5
Wit 26	36	0.71232	−4.7	−8.5
Wit 27	16	0.70878	−4.1	−4.6
Wit 28	16	0.70913	−4.9	−8.7
Wit 29	46	0.70913	−4.9	−8.7
Wit 30	46	0.71087	−3.4	−6.4
Wit 31	26	0.70841	−4.1	−7.5
Wit 32	36	0.71021	−4.3	−7.8
Wit 33	36	0.71312	−5.4	−9.6
Wit 35	26	0.71049	−4.9	−8.8
Wit 36	16	0.71702	n.d.	n.d.
Wit 38	36	0.72716	−6.9	−11.9
Wit 40	26	0.71033	−4.7	−8.5
Wit 44	16	0.71168	−3.8	−7.0
Wit 45	46	0.70636	−3.9	−7.2
Wit 46	46	0.70994	−8.0	−13.7
Wit 47	26	0.71167	−4.9	−8.7
Wit 48	46	0.71122	−4.5	−8.2
Wit 49	16	0.70980	−4.0	−7.3
Wit 51	36	0.70989	−6.1	−10.6
Wit 52	16	0.71012	−4.7	−8.5
Wit 54	16	0.70893	−5.7	−10.0

Table 1 | continued

Sample no.	Tooth	$^{87}Sr/^{86}Sr$	$\delta^{18}O$	$\delta^{18}O_{water}$
Wit 56	26	0.70970	−3.7	−6.8
Wit 57	16	0.70954	−6.0	−10.6
Wit 58	46	0.71097	−4.0	−7.3
Wit 59	26	0.71187	−5.2	−9.2
Wit 60	26	0.70849	−4.8	−8.5
Wit 61	26	0.70977	−2.4	−4.8
Wit 62	36	0.71349	−4.8	−8.5
Wit 63	46	0.72053	−4.8	−8.5
Wit 64	46	0.71210	−4.5	−8.1
Wit 65	26	0.71016	−4.7	−8.5
Wit 66	16	0.70863	−6.0	−10.5
Wit 67	16	0.71128	−4.7	−8.4
Wit 68	16	0.71904	−4.0	−7.3
Wit 69	36	0.71833	−5.8	−10.2
Wit 70	46	0.71974	−6.6	−11.4
Wit 71	26	0.71218	−4.3	−7.9
Wit 72	16	0.70914	−4.2	−7.6
Wit 73	26	0.71079	−4.7	−8.5
Wit 74	26	0.70987	−2.6	−5.1
Wit 75	16	0.70851	−5.6	−9.9
Wit 76	16	0.71359	−4.8	−8.6
Wit 77	46	0.70980	−4.2	−7.6
Wit 78	16	0.71834	−3.2	−6.1
Wit 79	36	0.70892	−4.9	−8.8
Wit 81	16	0.70987	−4.4	−7.9
Wit 82	26	0.71000	−4.2	−7.6
Wit 83	16	0.70954	−4.8	−8.6
Wit 84	16	0.70939	−4.9	−8.8
Wit 88	46	0.70899	−3.5	−6.5
	Mean	0.71170	−4.9	
	Minimum	0.70636	−8.0	
	Maximum	0.72716	−2.4	

Results

Enamel $^{87}Sr/^{86}Sr$ isotopic ratios exhibited considerable variability, covering the range between 0.70636 (indicative of young volcanic rock) to 0.72716 (indicative of rather old granites/gneisses; cf. Table 1). However, the ratios do not reflect an even distribution, instead forming four distinct clusters (Table 2, Fig. 1). While the individual with the lowest isotopic signature (Wit 45) is the only one with a ratio around 0.706, the other clusters include a sufficient number of individuals to permit statistical tests. Data are normally distributed within clusters 2–4 (Kolmogorov-Smirnov test), variances are heterogeneous (Levene test), and both a Brown-Forsythe test and a Welch test confirmed a highly significant dif-

Fig. 1 | Total variability of $^{87}Sr/^{86}Sr$ isotopic ratios in the enamel of a first permanent molar of 73 skeletons from the mass burial. Clusters are indicated (cf. text)

ference in mean values among them (Lutz 2010). Therefore, the individuals from the mass burial could be firmly grouped into four clusters based on the geologically-defined stable strontium isotopic ratios of their place of childhood.

Likewise, enamel $\delta^{18}O$ values vary considerably, though much more gradually, between −2.5 and −8.0‰ (Fig. 2). These ratios should be interpreted with caution. As mentioned previously, the enamel of the first permanent molar precipitates during approximately the first three to four years of age, thus preserving the developmental stages of the child when it is still nursing. Mother's milk is enriched with ^{18}O (up to 2.69‰ [Roberts et al., 1988]), therefore, carbonate $\delta^{18}O$ levels may no longer be directly related to drinking water. Also, the 17th century falls within the so-called "Little Ice Age", a time associated with considerably lower mean annual temperatures, and for which meteoric water

Table 2 | $^{87}Sr/^{86}Sr$ isotopic ratio and isotopic ranges of four statistically significant clusters identifiable within the overall variability of isotopic ratios in the enamel samples

Cluster	n	$^{87}Sr/^{86}Sr$
1	1	0.70636
2	29	0.70772–0.71000
3	31	0.71000–0.71500
4	12	0.71500–0.72716

Fig. 2 | Total variability of $\delta^{18}O_{water}$, calculated from $\delta^{18}O_{carbonate}$ of first permanent molars. Error bars indicate possible uncertainties due to weaning signals and the overall climatic conditions during the "Little Ice Age"

Fig. 3 | Weak negative relationship between $^{87}Sr/^{86}Sr$ and $\delta^{18}O_{water}$

lower than the respective ratios encountered in Sweden (see Table 3). Therefore, individuals Wit 78, 68, 23, 62, 76, and possibly also individuals Wit 71, 64, 33, 20, 6, and 9, may also have originated in Scotland. The only skeleton where a remarkably positive ^{87}Sr/^{86}Sr isotopic ratio is combined with a considerable negative $δ^{18}$O is Wit 38 whose values fit the isotopic signature of several parts of Sweden. Wit 17 and Wit 19 may have been Swedes as well, but could also have originated in Finland (Fig. 3). They, then, probably also had their origins in northern Europe (Scandinavia). Wit 70 also fits the Scandinavian isotopic signatures better than the Scottish or German ones. Due to the characterization of the Baltic countries, especially Lithuania, by young moraines and boulder clay, and an estimated $δ^{18}$O in meteoric water between −10 and −11‰ using the OIPC, five to six additional individuals indicated in Figure 3 might have their origins in that region. Wit 19 appears as an outlier in Figure 3 due to its negative $δ^{18}$O. There are several places on the European continent that could account for its stable strontium isotopic ratio; its $δ^{18}$O values might indicate a mountainous area and higher altitudes. Since there is no way to narrow down the range of possible places of origin of this individual, mixed isotopic ratios are hardly identifiable.

In sum, it was possible to determine a probable place of origin for 15 to 20 soldiers out of the total of 73 individuals (20–27 %), representing one-fifth to one-fourth of the total sample. Given the special circumstances of this study though, the outcome is rather successful. Whether or not the victims of the battle were sorted into different mass graves according to their army affiliation when the battlefield was cleared is unknown. If this was the case, then the burials recovered in the sand pit were mostly members of the Swedish army.

Conclusion

This study clearly outlines the potential, but at the same time also the limitations of provenance analyses by stable isotopic ratios in skeletal finds. While combining geologically-defined ratios of this type (^{87}Sr/^{86}Sr) with ratios defined ecologically ($δ^{18}$O) generally reduces the redundancies inherent to provenance studies based on a single isotopic system alone, any assessment of place of origin must still remain hypothetical in the absence of grave goods, historical accounts, or other sources which could better specify, or narrow down, the choice of possible places of origin. Since it will hardly ever be the case that isotopic analyses lead to a precise "hit" for a certain area, the formulation of a firm, testable hypothesis is a necessary prerequisite for any such provenance study, to allow inherent redundancies to be reduced or even excluded. Such a hypothesis must exclude migration from one region dominated by a certain soil/bedrock type to another region characterized by the same soil/bedrock type, because migration of that kind would be difficult to detect on the basis of stable isotopic ratios. Likewise, such a hypothesis must include possible or at least plausible places of origin which can be tested. Other scenarios are plausible: e.g. if migration is accompanied by a change in diet which could be revealed by the analysis of stable isotopes of light elements such as carbon and nitrogen, or if migration occurs in an area where additional isotopic systems may help in eliminating redundancies (e.g. sulfur isotopes: coast/inland migration or *vice versa*, lead isotopes: mountainous areas).

Acknowledgements

We are greatly indebted to Dr. Mike Schweissing, Munich, for the mass spectrometry of $^{87}Sr/^{86}Sr$, and PD Dr. Michael Joachimski, Erlangen, for the mass spectrometry of $\delta^{18}O$. This manuscript was edited by Dr. George McGlynn, Munich.

References

Åberg, G., 1995. The use of natural strontium isotopes as tracers in environmental studies. Water, Air and Soil Pollution 29, 309–332.

Åberg, G., Wickmann, F.E., 1987. Variations of $^{87}Sr/^{86}Sr$ in water from streams discharging into the Bothnian Bay, Baltic Sea. Nordic Hydrology 18, 33–42.

Andersson, P., Torssander, P., Ingri, J., 1992. Sulphur isotope ratios in sulphate and oxygen isotopes in water from a watershed in Central Sweden. Hydrobiologia 235/236, 205–217.

Bain, D.C., Bacon, J.R., 1994. Sr isotopes as indicators of mineral weathering in catchments. Catena 22, 201–214.

Balasse, M., 2002. Reconstructing dietary and environmental history from enamel isotopic analysis: time resolution of intra-tooth sequential sampling. International Journal of Osteoarchaeology 12, 155–165.

Bentley, R.A., 2006. Strontium isotopes from the earth to the archaeological skeleton: A review. Journal of Archaeological Method and Theory 13, 135–187.

Chauvel, C., 1982. Géochimie isotopique (Nd, Sr) et géochimie des éléments traces des basaltes alcalins du Massif Central français: contraintes pétrogénétiques et arguments en faveur du métasomatisme mantellique. Thèse Université de Rennes I.

Craig, H., 1961. Isotopic variations in meteoric waters. Science 133, 1702–1703.

Cruz-San, J., Araguas, L., Rozanski, K., Benavente, J., Cardenal, J., Hidalgo, M.C., Garcia-Lopez, S., Martinez-Garrido, J.C., Moral, F., Olias, M., 1992. Sources of precipitation over South-Eastern Spain and groundwater recharge. An isotopic study. Tellus 44B, 226–236.

Dansgaard, W., 1964. Stable isotopes in precipitation. Tellus XVI, 436–468.

Darling, W.G., Talbot, J.C., 2003. The O & H stable isotopic composition of fresh waters in the British Isles. 1. Rainfall. Hydrology and Earth System Sciences 7, 163–181.

Eickhoff, S., Grothe, A., Jungklaus, B., 2009. Memento Mori – Söldnerbestattungen der Schlacht bei Wittstock 1636. Archäologie in Deutschland 1, 26–29.

Evans, J.A., Montgomery, J., Wildman, G., 2009. Isotope mapping of $^{87}Sr/^{86}Sr$ biosphere variation on the Isle of Skye, Scotland. Journal of the Geological Society, London 166, 617–631.

Evans, J.A., Bullman, R., 2009. $^{87}Sr/^{86}Sr$ fingerprinting of Scottish and Icelandic migratory shorebirds. Applied Geochemistry 24, 1927–1933.

Förstel, H., Boner, M., Zahnen, J., 2008. Projektabschlussbericht. Überprüfung der Herkunftsdeklaration von Holz mittels Isotopenverteilung. Entwicklung der Isotopenmethode zur praxistauglichen Anwendbarkeit für Holz. Projektnummer AZ 23895/31 2. WWF Deutschland, Frankfurt/Main. www.wwf.de/fileadmin.de/fm-wwf.pdf_neu/Abschlussbericht_Internet_Isotopenmethode_final.pdf.

Förstel, H., Henkel, C., 1982. Simulation function of the local climate (Jülich, Federal-Republic-of-Germany) from a 10-year observation period (1972–1981). Landwirtschaftliche Forschung 35, 275–279.

Fortunato, G., Mumic, K., Wunderli, S., Pillonel, L., Bosset, J.O., Gremaud, G., 2003. Application of strontium isotope abundance ratios measured by MC-ICP-MS for food authentication. Journal of Analytical Atomic Spectrometry 19, 227–234.

Gillmaier, N., Kronseder, C., Gruppe, G., von Carnap-Bornheim, C., Söllner, F., Schweissing, M., 2009. The Strontium Isotope Project of the International Sachsensymposion in: Benecke, N. (Ed.), Beiträge zur Archäozoologie und Prähistorischen Anthropologie 7. VML Leidorf, Rahden/Westf., pp. 133–142.

Grothe, A., Jungklaus, B., 2009. In Reih' und Glied – die Söldnerbestattungen von 1636 am Rande des Wittstocker Schlachtfeldes, archäologische und anthropologische Aspekte, in: Meller, H. (Ed.), Schlachtfeldarchäologie. Tagungen des Landesmuseums für Vorgeschichte Halle 2. Landesmuseum, Halle, pp. 163–171.

Grupe, G., Price, T.D., Söllner, F., 1999. Mobility of Bell Beaker people revealed by strontium isotope ratios of tooth and bone: a study of southern Bavarian skeletal remains. Reply to the comment by Peter Horn and Dieter Müller-Sohnius. Applied Geochemistry 14, 271–275.

Harbeck, M., Schleuder, R., Schneider, J., Wiechmann, I., Schmahl, W., Grupe, G., 2011. Research potential and limitations of trace analyses of cremated remains. Forensic Science International 204, 191–200.

Harmon, R.S., Hoefs, J., 1995. Oxygen isotope heterogeneity of the mantle deduced from global ^{18}O systematics of basalts from different geotectonic settings. Contributions to Mineralogy and Petrology 120, 95–114.

Hoefs, J., 2004. Stable isotope geochemistry. 6th ed. Springer, Berlin/Heidelberg.

Hoefs, J., Wedepohl, K.H., 1968. Strontium isotope studies on young volcanic rocks from Germany and Italy. Contributions to Mineralogy and Petrology 19, 328–338.

Iacumin, P., Bocherens, H.G., Mariotti, A., Longinelli, A., 1996. Oxygen isotope analyses of co-existing carbonate and phosphate in biogenic apatite: a way to monitor diagenetic alteration of bone phosphate? Earth and Planetary Science Letters 142, 1–6.

Kelly, S., Heaton, K., Hoogewerff, J., 2005. Tracing the geographical origin of food: The application of multi-element and multi-isotope analysis. Trends in Food Science & Technology 16, 555–567.

Koch, P.L., Tuross, N., Fogel, M.L., 1997. The effects of sample treatment and diagenesis on the isotopic integrity of carbonate in biogenic hydroxylapatite. Journal of Archaeological Science 24, 417–429.

Kohn, M.J., Cerling, T.E., 2002. Stable isotope compositions of biological apatite, in: Kohn, M.J., Rakovan, J., Hughes, J.M. (Eds.), Phosphates. Geochemical, geobiological, and materials importance. Reviews in Mineralogy and Geochemistry 48, Mineralogical Society of America, Washington, pp. 455–488.

Kortelainen, N., 2007. Isotopic fingerprints in superficial waters: Stable isotope methods applied in hydrogeological studies. PhD thesis, Helsinki.

Land, M., Ingri, J., Andersson, P.S., Öhlander, B., 2000. Ba/Sr, Ca/Sr and $^{87}Sr/^{86}Sr$ ratios in soil water and groundwater: implications for relative contributions to stream water discharge. Applied Geochemistry 15, 311–325.

Lécolle, P., 1985. The oxygen isotope composition of land snail shells as a climatic indicator – applications to hydrogeology and palaeoclimatology. Chemical Geology 58, 157–181.

Longinelli, A., 1984. Oxygen isotopes in mammal bone phosphate: A new tool for paleohydrological and paleoclimatological research? Geochimica et Cosmochimica Acta 48, 385–390.

Lutz, A., 2010. Anthropologische Untersuchungen an Massengräbern aus dem Dreißigjährigen Krieg. Diploma thesis, Munich.

Mewis, A., 2004. Strontium-90 in der Umwelt: Migrationsverhalten im Boden, Transfer in die Nahrungskette und Strahlenexposition in der nördlichen Ukraine. PhD thesis, Kiel.

Montgomery, J., Evans, J.A., Wildman, G., 2006. $^{87}Sr/^{86}Sr$ isotope composition of bottled British mineral waters for environmental and forensic purposes. Applied Geochemistry 21, 1626–1634.

Negrel, P., Guerrot, C., Cocherie, A., Azaroual, M., Brach, M., Fouillac, C., 2000. Rare earth elements, neodymium and strontium isotopic systematic in mineral waters: evidence from the Massif Central, France. Applied Geochemistry 15, 1345–1367.

Negrel, P., Deschamps, P., 1996. Natural and anthropogenic budgets of a small watershed in the Massif Central (France): Chemical and strontium isotopic characterization of water and sediments. Aquatic Geochemistry 2, 1–27.

NERC, Natural Environment Research Council, 2009. NERC Isotope Geoscience Laboratory: The application of isotope analysis in tooth enamel to the study of population migration and movement. www.bgs.ac.uk/nigl/SBA_Methodology.htm.

Pin, C., Paquette, J.L., 2002. Le magmatisme basique calcoalcalin d'age dévono-dinantien du nord du Massiv Central, témoin d'une marge active hercynienne: arguments géochimiques et isotopiques Sr/Nd. Geodinamica Acta 15, 63–77.

Poszwa, A., Ferry, B., Dambrine, E., Pollier, B., Wickman, T., Loubet, M., Bishop, K., 2004. Variations of bioavailable Sr concentration and $^{87}Sr/^{86}Sr$ ratio in boreal forest ecosystems. Role of biocycling, mineral weathering and depth of root uptake. Biogeochemistry 67, 1–20.

Powell, J.L., Bell, K., 1970. Strontium isotopic studies of alkali rocks: Localities from Australia, Spain, and the Western United States. Contributions to Mineralogy and Petrology 27, 1–10.

Price, T.D., Burton, J.H., Bentley, R.A., 2002. The characterization of biologically available strontium isotope ratios for the study of prehistoric migration. Archaeometry 44, 117–135.

Price, T.D., Wahl, J., Knipper, C., Burger-Heinrich, E., Kurz, G., Bentley, R.A., 2003. Das bandkeramische Gräberfeld vom "Viesenhäufer Hof" bei Stuttgart-Mühlhausen: Neue Untersuchungsergebnisse zum Migrationsverhalten im frühen Neolithikum. Fundberichte aus Baden-Württemberg 27, 23–57.

Roberts, S.B., Coward, W.A., Ewing, G., Savage, J., Cole, T.J., Lucas, A., 1988. Effect of weaning on accuracy of doubly labelled water method in infants. American Journal of Physiology 254, R623–627.

Rozanski, K., Araguas-Araguas L, Gonfiantini R, 1992. Relation between long-term trends of oxygen-18 isotope composition of precipitate and climate. Science 258, 981–985.

Soler, A., Canals, A., Goldstein, S.L., Otero, N., Antich, N., Spangenberg, J., 2002. Sulfur and strontium isotope composition of the Llobregat river (NE Spain): Tracers of natural and anthropogenic chemicals in stream waters. Water, Air and Soil Pollution 136, 207–224.

Stephan, E., 2009. Rekonstruktion eisenzeitlicher Weidewirtschaft anhand archäozoologischer und isotopenchemischer Untersuchungen, in: Benecke, N. (Ed.), Beiträge zur Archäozoologie und Prähistorischen Anthropologie 7. VML Leidorf, Rahden/Westf., pp. 65–79.

Williams, M., Dunkerley, D., de Decker, P., Kershaw, P., Chappell, J., 1998. Quaternary Environments. Hodder Arnold, New York.

Jason E. Laffoon[a,] *, *Menno L. P. Hoogland*[a]

Migration and mobility in the circum-Caribbean: Integrating archaeology and isotopic analysis

* Corresponding Author: j.e.laffoon@arch.leidenuniv.nl
a Faculty of Archaeology, Leiden University, The Netherlands

Abstract

Strontium (Sr) isotope analysis of human skeletal remains has become a routine method for investigating patterns of mobility and migration from the archaeological record. We present the preliminary Sr isotope results as a component of a large scale research project examining exchange and mobility in the ancient Caribbean. Integrations of isotopic (strontium, carbon, and nitrogen) data and other lines of archaeological evidence (mortuary, osteological, material culture) provide insights into the migratory behaviors and geographic origins of ancient inhabitants of the West Indies. Our initial results indicate several interesting trends including the following: substantial immigration to some sites, often from diverse origins; distinct correlations between geographic origins and dietary practices for certain individuals; and an unexpectedly large local Sr isotope range in one setting, potentially obscuring our ability to identify nonlocals. Drawing on several case studies from the Lesser Antilles, we highlight the possibilities and potential limitations of applying this approach to the circum-Caribbean region and propose avenues for future research.

Keywords

Mobility, migration, strontium isotope, Caribbean origins

Introduction

Migration and mobility have been central concerns of Caribbean archaeology for many years (Rouse, 1986; Rouse, 1989; Siegel, 1991; Keegan, 1995). Available archaeological evidence points to the widespread movement of peoples, goods and ideas throughout the circum-Caribbean region (Hofman et al., 2007; Hofman et al., 2008; Rodríguez Ramos, 2007; Coppa et al., 2008). Yet the nature and dynamics of the social relationships and networks that conditioned and were conditioned by these movements are still poorly understood. In 2008, a NWO-funded research project entitled "Communicating Communities in the Circum-Caribbean", a multidisciplinary and multidimensional approach to exchange and mobility, was initiated under the supervision of Prof. Dr. Corinne Hofman. Conducted by a large international team of Caribbean scholars, the research in the project focuses on the movement and circulation of people, goods, and ideas, through investigations of the social, material and ideological realms of past cultures using approaches from archaeology, archaeometry, ethnohistory, and ethnography.

Considerations of strontium isotope variation in the Caribbean

One aspect of this research involves the application of strontium isotope analyses to several large, well-researched skeletal assemblages from various islands in this region, to explore human migration and mobility at the scale of the individual. The strontium isotope results are interpreted through an integrated contextual approach involving the comparison of mobility patterns with other patterns derived from osteological and isotopic analyses, such as demography and diet. A regional database of strontium isotope variation in the Caribbean is being developed to allow the proper interpretation of the results derived from the isotopic analyses of human remains. This database uses strontium isotope data derived

from comparative environmental reference samples, primarily faunal (modern and archaeological), floral and soil samples. Here, we present the preliminary results of our Sr isotope analyses and initial interpretations of these results. We draw on several case studies to highlight some of the potentials and limitations of applying this approach to insular and coastal contexts.

Available geological evidence suggests that the Caribbean in general and the West Indies in particular represent a highly suitable setting for the application of Sr isotope analyses (Fox and Heezen, 1975; Maurey et al., 1990; Mann et al., 1990). Spatial variation in isotope ratios is a required parameter to effectively address issues of movement and migration with this method. The geological history of the region is such that the underlying bedrock geology varies significantly within and between islands and archipelagos (Maurey et al., 1990). For example, the neighbouring Limestone and Volcanic Caribbees of the Lesser Antillean island chain are expected to have rather distinct and potentially nonoverlapping Sr isotope ranges. In addition, the Greater Antilles can be characterized as complex combinations of igneous, metamorphic and sedimentary (oceanic and continental) deposits (Fox and Heezen, 1975; Mann et al., 1990). As variation in underlying bedrock geology is often considered the primary source of spatial Sr isotope variation (Ericson, 1985; Sealy et al., 1991; Price et al. 1994; Beard and Johnson, 2000; Chiaradia et al., 2003), this suggests that we should expect a fair degree of intra- and interisland isotopic heterogeneity within this region.

However, it is important to remember that geological sources (bedrock and soil minerals) are not the only, nor in certain cases even the primary, contributors of strontium to the total dietary Sr budgets in certain geographic contexts (Bentley 2006). This has been clearly illustrated in various environmental settings (Borg and Banner, 1996; Kennedy and Derry, 1995; Kennedy et al. 1998; Kennedy et al., 2002; Pozwa et al., 2000; Pozwa et al., 2002; Pozwa et al., 2004) and may be especially pertinent to volcanic island settings, where nongeological sources of strontium may be substantial (Kennedy et al., 1998; Price and Gestsdottir, 2006). In coastal and insular settings, atmospheric and/or hydrological sources may dominate, especially where water-soluble strontium sources in soils have been depleted (Kennedy et al. 1998; Chadwick et al., 1999; Vitousek et al., 1999). Marine effects, such as (marine-derived) precipitation, sea-spray (Chadwick et al., 1999; Vitousek et al., 1999; Whipkey et al., 2000) and even the direct consumption of marine resources can all make large and significant contributions to the total Sr intake of organisms subsisting in such environments (Bentley, 2006; Chadwick et al., 1999; Wright, 2005). Atmospheric dryfall may also make substantial contributions under certain conditions (Probst et al., 2000). Thus, while knowledge of underlying bedrock geology may provide helpful starting points for the development of local or regional isoscapes (isotopic landscapes) the application of such isoscapes in the interpretation of Sr isotope data derived from human archaeological materials requires the input of data derived from sources representing the bioavailable strontium for particular ecosystems (Bentley et al., 2004; Price et al., 2002; Schwarcz et al., 2010).

To these ends, we have begun the process of developing an initial Caribbean Strontium Isotope Variation database (Laffoon and Hoogland, 2009; Laffoon et al., 2010). As previously mentioned, this database will primarily be composed of Sr data obtained from biological reference samples collected from various islands and regions and will supplement the available geochemical data available for the greater region, which is primarily based on data derived from whole rocks and rock minerals. To date, we have collected 164 botanical samples and 152 zoological samples from 24 different islands, representing most of the southern, eastern, and central islands of the Caribbean.

Previous isotopic research in the region

Reports on previous applications of strontium isotope analyses to address past human migrations and mobility in the Caribbean are limited to two recent publications. Schroeder et al. (2009) published the results of carbon, nitrogen, and strontium isotope analyses on a burial assemblage of a slave population from the site of Norman Estate, Barbados. They sought to identify African born individuals, to explore the potential natal origins of these slaves and to examine changes in dietary patterns which occurred as part of forced migration processes. Utilizing an integrated approach, they successfully identified a number of nonlocal immigrants deriving from multiple origins within Africa. They were also able to compare these patterns to dietary shifts through serial sampling of different skeletal elements representing different periods of individual life histories.

Booden et al. (2008) presented the results of strontium isotope analyses of archaeological materials from the site of Anse à la Gourde, Grande-Terre, Guadeloupe. This study was the first published archaeological application of this technique to pre-Columbian populations in the Caribbean and successfully highlighted the enormous potential of this approach. The researchers identified a substantial number of nonlocals amongst the burial population. Our research represents an expansion of this pilot project involving the inclusion of more samples, drawn from multiple sites representing different islands/regions and time periods.

Materials and Methods

Our isotopic research into patterns of ancient mobility in the Caribbean is based on several large or otherwise culturally significant skeletal assemblages for which there are sufficient contextual data available to permit synthesized interpretations. To date, these include: Anse à la Gourde, Guadeloupe; Tutu, St. Thomas, USVI; Kelbey's Ridge 2, Saba; El Chorro de Maíta, Cuba; Maisabel, Puerto Rico; Punta Macao & El Cabo, Dominican Republic; Anse Lavoutte & Pointe de Caille, St. Lucia; Argyle & Escape, St. Vincent; Heywoods, Barbados; and Manzanilla, Trinidad. Here we report on the preliminary results and initial interpretations from the first three of these.

Sites and Settings

Anse à la Gourde, Guadeloupe, is a Ceramic Age site located on the eastern peninsula of Grande-Terre (Fig. 1). Most burials are attributed to the main occupation phase of the site, which is assigned to the Troumassoid period, based on ceramic chronology and dated to roughly AD 1000 to 1350 (Hofman et al., 1999; Hofman et al., 2001; Hoogland et al., 2001). The island of Grande-Terre is primarily underlain by deposits of Pleistocene and Quaternary marine carbonate, with expected $^{87}Sr/^{86}Sr$ values similar to modern seawater of ~0.7092 (Booden et al., 2008). The Sr results from the earlier study revealed that all of the soil and faunal samples and the majority of the human samples shared Sr signals similar to this expected value (Booden et al., 2008). Interestingly, these results indicated substantial migration among the burial population, with 14 of 50 (28%) individuals identified as nonlocal to the region. We have expanded on the original sample of 50 human, four rice rat, and four soil samples to include an additional 18 human samples, and we interpret these in comparison with pre-

Fig. 1 | Map of sites included in research project

viously published carbon and nitrogen isotope results from this burial population (Laffoon and de Vos, 2010).

Tutu is a large Ceramic Age Amerindian settlement site located in the eastern interior of St. Thomas, USVI (Fig. 1). The site was excavated by a large team of investigators prior to development of the land for use as a shopping centre in the 1990s (Righter, 2002). These excavations revealed the presence of a large multicomponent village apparently occupied in both the early and late Ceramic Age (Righter, 2002). Nearly 40 burials dating to both time periods were discovered; these been subjected to intensive and extensive archaeological analyses, including osteology, trace elements, and stable isotope analyses amongst others (Farnum, 2002; Larsen et al., 2002; Norr, 2002; Sandford et al., 2002). Associated ceramics and radiocarbon data indicate that some (>9) of the skeletons are associated with a late extension of the Saladoid Cuevas period, dating to roughly AD 500–900, while the remainder (>17) are associated with a later Ostionoid occupation, dating to around AD 1200–1500 (Hofman et al., 2001).

Kelbey's Ridge 2 is a late Ceramic Age site located on the northeastern slope of the island of Saba in the northern Lesser Antilles (Fig. 1). Excavations of this site uncovered the remains of at least eleven individuals in seven separate burials buried in association with several structures (Hofman and Hoogland, 1991; Hoogland and Hofman, 1993). The structures and burials are assigned to the Chican Ostionoid subseries and date to between AD 1200 and 1500 (Norr, 2002; Sandford et al., 2002). Some of the ceramic assemblage has been identified as being of a style similar to that being produced at contemporaneous sites in the eastern Dominican Republic. In addition, a bone snuff inhaler carved into the shape of a fish was also discovered. This evidence led the excavators to propose an interpretation of the site as a 'Taino' outpost or perhaps a (failed) founder's settlement, located at a strategic site to manipulate and/or control trade between the Greater Antilles and northern Lesser Antilles (Hoogland and Hofman, 1993).

Samples and procedures

All human samples reported herein are derived from dental enamel, as we are primarily interested in identifying individuals of foreign origin (those raised in a nonlocal isotopic environment). Most human samples are of premolars (>70%), although we sampled various other teeth when a suitable intact premolar was unavailable. Rice rat and domestic pig samples were also derived from dental enamel, while land snail samples were taken from shell.

All sample processing and analyses were performed under controlled conditions at the Faculty of Earth and Life Sciences, The Free University Amsterdam, The Netherlands, using protocols similar to those published in Booden et al. (2008). Dental samples were mechanically cleaned prior to enamel extraction. For most samples, mechanical cleaning and removal of the outer surface (soil, calculus, staining) and outermost layers of enamel was sufficient to reveal the inner core enamel, from which the enamel was extracted for subsequent analysis. When the selected tooth was particularly soiled, it was sonicated for 1 hour in ultra-pure water before processing began. The cleaning and extraction of the enamel was accomplished by means of a variable speed dental microdrill, specifically, a Minilor Perceuse M1 handheld drill, with a sterilized, tungsten–carbide burr tip.

Approximately 1–5 mg of powdered enamel was transferred to precleaned centrifuge tubes and dissolved in 1 N ultrapure acetic acid for several hours to remove possible diagenic carbonates. Samples were then centrifuged and the leachate removed, after which the precipitate was washed with Milli-Q water, centrifuged and dried down in a sterile laminar flow-hood. Samples were dissolved in ultrapure 3 N HNO_3, transferred to sterilized PFA vials, then dried down and renitrated. Shell samples underwent similar procedures except that they were not pretreated with acetic acid.

Botanical samples were air dried and then ashed in precleaned nickel crucibles in a muffler furnace at 500 °C for 5 hours. Ashed samples were transferred to sterilized PFA vials, and then dissolved in concentrated distilled nitric acid and dried down, then redissolved in concentrated nitric acid and H_2O_2 and dried down again, and finally redissolved in 3 N HNO_3. Sr extraction of all sample types was accomplished through cation exchange chromatography with 3 N HNO_3 as the mobile phase.

All samples were analyzed for strontium isotope composition with a thermal ionization mass spectrometer (TIMS, ThermoFinnigan MAT 262 RPQ plus) at the FALW, Vrije University, Amsterdam, The Netherlands. Samples were loaded onto rhenium filaments, mass fractionation was corrected for using the exponential mass fractionation law with $^{86}Sr/^{88}Sr = 0.1194$. The average $^{87}Sr/^{86}Sr$ of the NBS-987 SRM strontium carbonate standard at the VU over the period of analysis was 0.710230, with a 2SE for most samples of approximately 0.000008–0.000020 over a minimum of 60 cycles of data acquisition.

Results and Discussion

The results of Sr isotope analyses from the site of Anse à la Gourde, Guadeloupe, are displayed in Figure 2. We have analyzed the dental enamel of 68 individuals from this population (Table 1). Based on the local-range estimate of ~0.7090–0.7092 (Booden et al., 2008) we have identified 17 nonlocals, i.e., 25% of the analyzed population. Based on the relative geological homogeneity of this island, we suggest that the spatial extent of this local range is probably the island of Grande-Terre. Therefore, in this geographical context, 'nonlocal' probably indicates childhood origins external to Grande-Terre.

Table 1 | Demographic data and Sr, C & N isotope results for human remains from the sites of Anse à la Gourde, Guadeloupe; Kelbey's Ridge & Spring Bay, Saba; and Tutu, St. Thomas

Burial #	Site	Sex[1]	Age (yrs)[1]	$\delta^{13}C$[2]	$\delta^{15}N$[2]	$^{87}Sr/^{86}Sr$[3]	2SE
050a	Anse à la Gourde	female	46+	−16.69	9.62	0.709171	0.000008
089	Anse à la Gourde	female	26–35	−13.59	12.00	0.709161	0.000007
108a	Anse à la Gourde	male	36–45	−14.38	10.38	0.709172	0.000015
139	Anse à la Gourde	male	46+	−14.64	10.99	0.709034	0.000009
159	Anse à la Gourde	female	18–25	−14.53	10.81	0.709146	0.000009
171a	Anse à la Gourde	male	18–25	−13.81	10.52	0.708636	0.000020
196	Anse à la Gourde	male	18+	−15.11	10.72	0.709038	0.000009
202	Anse à la Gourde	possible female	18+	−13.97	10.42	0.709127	0.000012
206a	Anse à la Gourde	male	18+			0.709127	0.000009
207	Anse à la Gourde	female	36–45	−15.39	9.57	0.709116	0.000013
212	Anse à la Gourde	possible female	18+	−13.74	10.40	0.709083	0.000010
241	Anse à la Gourde	unknown	unknown			0.709058	0.000008
253	Anse à la Gourde	female	18+	−14.92	11.90	0.709162	0.000015
288	Anse à la Gourde	possible female	26–35	−14.61	10.72	0.708646	0.000008
292	Anse à la Gourde	possible male	36–45	−15.07	11.86	0.708755	0.000010
304	Anse à la Gourde	female	26–35	−15.01	9.81	0.709122	0.000040
307	Anse à la Gourde	male	46+	−14.47	11.56	0.709165	0.000008
311	Anse à la Gourde	female	26–35	−14.50	10.40	0.708849	0.000014
332	Anse à la Gourde	female	18–25	−14.85	10.25	0.708278	0.000009
342	Anse à la Gourde	male	26–35	−14.32	10.74	0.709031	0.000007
349c	Anse à la Gourde	female	26–35			0.708590	0.000009
350	Anse à la Gourde	female	36–45	−14.77	10.52	0.709182	0.000010
377	Anse à la Gourde	unknown	1–4			0.709071	0.000027
378	Anse à la Gourde	female	18–25	−15.30	10.66	0.707490	0.000009
430	Anse à la Gourde	female	26–35	−14.78	10.88	0.708794	0.000009
447	Anse à la Gourde	female	18–25	−13.90	11.49	0.709090	0.000011
450	Anse à la Gourde	male	26–35	−14.19	11.50	0.708690	0.000009
451	Anse à la Gourde	female	26–35	−14.28	11.56	0.709113	0.000008
452	Anse à la Gourde	female	26–35	−15.33	11.00	0.709182	0.000006
454	Anse à la Gourde	female	18+			0.709164	0.000009
706	Anse à la Gourde	possible male	26–35	−15.18	11.15	0.709168	0.000018
726	Anse à la Gourde	male	18–25	−15.84	11.92	0.709228	0.000013
953	Anse à la Gourde	female	46+	−15.52	11.07	0.709162	0.000012
1203	Anse à la Gourde	possible male	26–35	−14.66	11.95	0.709131	0.000012
1226	Anse à la Gourde	male	26–35	−14.43	12.06	0.709068	0.000009
1413	Anse à la Gourde	unknown	1–4			0.709193	0.000018
1496a	Anse à la Gourde	male	18–25			0.709158	0.000007
1651	Anse à la Gourde	male	26–35	−14.22	11.95	0.709168	0.000006
2005	Anse à la Gourde	possible female	18–25	−13.68	11.04	0.708475	0.000012
2107	Anse à la Gourde	possible female	10–14	−13.70	10.69	0.709149	0.000008
2211	Anse à la Gourde	unknown	1–4			0.709412	0.000014
2212	Anse à la Gourde	female	36–45	−14.01	10.99	0.709100	0.000008
2214	Anse à la Gourde	unknown	46+	−14.01	11.14	0.709156	0.000012
2215	Anse à la Gourde	female	26–35	−16.80	10.33	0.707747	0.000007

Table 1 | continued

Burial #	Site	Sex[1]	Age (yrs)[1]	$\delta^{13}C$[2]	$\delta^{15}N$[2]	$^{87}Sr/^{86}Sr$[3]	2SE
2216	Anse à la Gourde	male	36–45	−14.96	11.21	0.709165	0.000006
2217	Anse à la Gourde	female	18–25	−13.93	11.34	0.709168	0.000005
T01	Tutu	female	45–55	−15.90	13.40	0.707984	0.000016
T02	Tutu	unknown	Unknown	−15.50	12.60	0.707863	0.000009
T03	Tutu	female	40–50	−14.40	12.90	0.707587	0.000005
T4/7	Tutu	female	18–25	−16.30	10.10	0.706947	0.000005
T05	Tutu	female	40–50	−16.50	12.20	0.708057	0.000009
T06	Tutu	unknown	5.5–7	−15.60	12.90	0.708076	0.000008
T09	Tutu	male	45–55	−15.20	12.10	0.706764	0.000008
T10	Tutu	female	45–55	−15.80	12.70	0.707237	0.000009
T12	Tutu	male	45–55	−14.70	12.90	0.708275	0.000008
T13	Tutu	female	40–55	−15.70	12.80	0.707967	0.000007
T13A	Tutu	female	45–55			0.707877	0.000008
T16	Tutu	female	35–45	−15.20	12.50	0.708047	0.000010
T19	Tutu	female	40–50	−15.80	12.90	0.707793	0.000007
T20	Tutu	unknown	9	−15.60	11.70	0.707789	0.000008
T21	Tutu	male	40+			0.707836	0.000009
T22B	Tutu	unknown	4–5	−15.40	11.40	0.707833	0.000016
T23A	Tutu	unknown	1			0.707538	0.000008
T23B	Tutu	female	35+			0.706280	0.000009
T26	Tutu	female	17–21	−16.80	12.80	0.706991	0.000009
T27	Tutu	unknown	2			0.708256	0.000009
T30	Tutu	male	35–45	−15.60	12.70	0.707875	0.000010
T31	Tutu	female	35–45	−17.30	10.30	0.707094	0.000009
T32A	Tutu	unknown	5			0.707693	0.000008
T33	Tutu	male	35–45	−14.90	11.60	0.707972	0.000010
T36	Tutu	unknown	40–50			0.707778	0.000005
T38	Tutu	male	45–50	−12.90	11.10	0.708708	0.000010
T39	Tutu	unknown	8	−15.30	11.60	0.708010	0.000010
T41	Tutu	unknown	1.5			0.708236	0.000008
68	Kelbey's Ridge 2	male	36–45	−14.91	11.24	0.708789	0.000008
132	Kelbey's Ridge 2	female	46+	−15.43	10.73	0.708848	0.000284
148	Kelbey's Ridge 2	possible female	18+	−16.72	10.21	0.708512	0.000007
166	Kelbey's Ridge 2	unknown	10–12			0.708592	0.000012
313	Kelbey's Ridge 2	unknown	11–13	−15.68	10.11	0.708281	0.000009
337	Kelbey's Ridge 2	unknown	2–3	−15.35	11.41	0.707699	0.000010
1	Spring Bay	unknown	2–4	−15.81	10.87	0.707852	0.000012

* Age & sex estimates are from – Sandford et al. (2002); Weston (2010)
** All C & N isotope data are from bone collagen – Norr (2002); Stokes (1998); de Vos (2010)
*** All Sr isotope data are from dental enamel

Fig. 2 | Graph of strontium isotope results from Anse a la Gourde, Guadeloupe

Anse à la Gourde, Guadeloupe

Comparison of these results with basic demographic data reveals some interesting patterns. Of the 26 individuals analyzed that were identified as adult females or probable females, 10 (28%) are nonlocal, whereas only four (19%) of the 21 individuals analyzed that were identified as adult males or probable males are nonlocal. This may indicate a small but substantial difference in immigration rates for females relative to males. In addition, the Sr isotope results from the adult females display a greater range than those from the adult males. This might reflect more diverse origins for females than for males. On the other hand, this may be an artefact of the differences in sample sizes between these two groups and/or small sample sizes in general.

Comparison of the results of the strontium isotope analyses on this population with those of the carbon and nitrogen isotope analyses (Stokes, 1998) may shed further light on the timing or age of migration and potential changes in dietary practices associated with migration. These comparisons have revealed no significant differences in diet between locals and nonlocals at this site (Laffoon and de Vos, 2010). There are at least two possible ways to interpret this: 1) All of the nonlocals originate from islands/regions with dietary practices similar to those found at Anse à la Gourde, and/or 2) since C & N isotope analyses are conducted on bone while the Sr isotope analyses are conducted on enamel, they reflect different time periods in an individual's life, and because bone remodels throughout life while enamel does not, it is possible that the bone values have equilibrated with the local pattern. Thus the C & N isotope results may indicate that locals and nonlocals shared similar diets or, to put it differently, even if nonlocals and locals ate quite different diets as children (in their various places of origin), they all seem to have adopted a local diet while residing on Grande-Terre.

Fig. 3 | Graph of strontium isotope results from Tutu, St. Thomas, USVI

Given the fact that several of the nonlocal individuals are young adults, if we assume that pre-existing dietary differences between locals and nonlocals were present, this suggests the possibility that some migration may have occurred during childhood or adolescent years, as the turnover rate of bone collagen is rather slow (~1–5% per year) (Stokes, 1998). This is further supported by the identification of three out of seven juveniles as nonlocal, a rather high rate compared to other sites in the Caribbean for which we have similar data. These data, suggesting rather early ages of migration for certain individuals, may have important implications for the testing and formulation of hypotheses concerning issues such as marriage, mobility and post-mortem migration in the pre-Columbian Caribbean (Keegan, 2009; Siegel, 2010).

Tutu, St. Thomas, USVI

The results of Sr isotope analyses for the site of Tutu are displayed in Figure 3. Here, we report on the preliminary results of strontium isotope analyses of 29 individuals from this burial assemblage (Table 1). Unfortunately, data from faunal remains from which the local Sr isotope range could be estimated are not yet available. Nonetheless we deliberately chose to present these data here in order to highlight the possibility that interesting insights can be derived from the structure of the data set itself, independently of the local range determination.

In the absence of comparative bioavailable Sr data for the determination of a local range, we can propose a local-range estimate based on the total range of Sr results from juvenile remains of 0.7074–0.7083. This is based on the assumption that individuals who died at a young age had fewer op-

portunities to migrate within their brief lifetimes. Thus they should, on the whole, be fairly representative of the total Sr range for the local population (Cucina et al., 2005; Haak et al., 2008). This does not mean that all juveniles are locals, for the results from Anse à la Gourde discussed above have revealed the presence of migrating juveniles in a contemporaneous context. We are suggesting only that most juveniles and especially the youngest should possess Sr isotope signals similar to those of the local population.

For Tutu, the local-range estimate also includes most of the adults analyzed to date and overlaps with an estimate, based on the underlying bedrock geology of the island, of 0.7072–0.7080 (Righter, 2002). Thus, the determination of the total number of locals and nonlocals and the specific assignment of the attribute local/nonlocal for many individuals are obviously dependent on which local-range estimate is used. However, several individuals are clearly outliers, regardless of which estimate is used. Four adult females clearly have Sr signals that are much lower than the rest of the sample population; one adult male has a similarly low Sr signature and another male has a Sr signature that is much higher than those of the rest of the population. We have tentatively identified these 6 individuals as nonlocals.

These results are particularly interesting when compared to available data derived from carbon and nitrogen isotope analyses from this same assemblage (Norr, 2002), as well as with respect to the comparison of this data set with carbon and nitrogen ranges for the West Indies as a whole (Stokes, 1998). As is the case for most other sites in the Caribbean for which stable isotope analyses have been performed, C & N results from human bone collagen from the Tutu site display relatively minor intrapopulation variation in dietary patterns (Norr, 2002). Available data for the circum-Caribbean in general reveals significant interpopulation or interregional dietary variation: there is very little overlap of C & N isotope clusters between sites, regions or islands. This has been interpreted as the result primarily of ecological constraints on diet rather than cultural preferences per se (Stokes, 1998).

Interestingly, three of our proposed nonlocals have C & N values which cluster within the local dietary pattern. This can be interpreted in multiple ways: that these three individuals originated from an as-yet unidentified region that has carbon and nitrogen isotope ranges (and hence dietary practices) nearly identical to those of the inhabitants of Tutu and/or that these three individuals resided at Tutu (and thus shared similar dietary habits) long enough for their bone collagen values to equilibrate to the local pattern. Because the turnover rate of human bone collagen is based on a complex combination of factors, we cannot determine accurately how long this would have taken, but we can assume as a very rough estimate a minimum of several years (Hedges et al., 2007).

In addition, one adult male and three of the adult females tentatively identified as nonlocal based on their Sr isotope values also possess C & N isotope values which clearly fall outside of the local dietary cluster. In fact, the three nonlocal females exhibit C & N values which do not cluster clearly with any known site within the West Indies. Instead, the values for each of the three women appear to be intermediate between the local dietary clusters of Tutu and one other location, in one case Puerto Rico, another Haiti, and the third, the Dominican Republic (Stokes, 1998; Norr, 2002). This suggests to us that these three individuals may have originated from those respective locations but had subsisted on local (St. Thomas) resources long enough for their bone collagen to equilibrate partially, but not completely, with the local signal. Thus the integration of multiple isotopic data sets can, under certain circumstances, potentially provide valuable information concerning both the origins of migrants and the timing of (or age at) the migration itself (Wright and Schwarcz, 1999; Knudson and Price, 2006; Schroeder et al., 2009; Somerville et al., 2010).

Fig. 4 | Graph of strontium isotope results from Saba

Kelbey's Ridge 2, Saba

Strontium isotope analysis of six individuals from this assemblage (and one from the neighbouring Spring Bay site; [Table 1]) was conducted to determine if any or all of these individuals were nonlocal to the island of Saba. Data obtained from the human remains were compared to the local strontium isotope range estimation based on Sr analyses of local soils, rocks, and fauna. As Saba is geologically a relatively young volcanic island we expected rather lower (less radiogenic) signals for the island as a whole (White and Patchett, 1984; Van Soest et al., 2002; Roobol and Smith, 2004). Somewhat surprisingly, the results from the human and faunal samples were rather radiogenic (elevated) and the data set as a whole was quite variable. To investigate further the nature and dynamics of the variation in bioavailable strontium in a small, volcanic, insular setting, we have systematically and intensively sampled the island for modern floral and faunal remains (Laffoon and Hoogland, 2009).

All Sr isotope results from Saba are shown in Figure 4. Analyzing the Sr isotope data patterns, we observe a systematic offset between the low Sr values for geological (rocks and bulk soil) samples and the much higher human, floral and faunal samples. In addition, soil samples were subjected to sequential leaching in increasingly acidic HCl solutions and the leachates and precipitates were reanalyzed. These results indicate that the carbonate fractions of the soil samples are somewhat more radiogenic than the bulk soil samples. We conclude from this that the water soluble component of the soil is more reflective of the bioavailable strontium, as different minerals within the soil matrix will possess different concen-

trations and compositions of strontium, some of which will be more or less soluble under natural conditions of mineral weathering (Bentley, 2006).

In addition, we interpret the relatively elevated Sr range for our biological samples as indicating substantial direct and indirect marine influences on the local ecosystem. As the island of Saba is fairly small (~13 km²), most of the island lies within 2 km of the coast and is subjected to sea-spray, from prevailing winds, tropical storms and hurricanes. In fact, the highest peak, Mount Scenery, at an elevation of ~860 masl, is often shrouded in rain clouds and is thus subjected to high levels of orthographic precipitation. An epiphyte (an unidentified moss species) sampled from this peak contained an $^{87}Sr/^{86}Sr$ signal of 0.710201 (±0.000009), well outside of the range of our two end-members, the terrestrial/geological values of ~0.703 and that of the sea ~0.7092. As epiphytes grow entirely on the surfaces of other plants (in this case a tropical hardwood), they have no direct contact with local soil matrices. Thus, any biogenic strontium in their tissues must be derived indirectly from the surface of their substrate or from atmospheric precipitation. A strontium isotope signature which is elevated relative to that of the sea is rather surprising in this geographic context and suggests a third possible source of Sr to the local ecosystem: atmospheric dryfall. It has been reported that large quantities of particulates of Saharan origin ride atmospheric currents across the Atlantic Ocean and are deposited in the Caribbean (Muhs et al., 1990; Goudie and Middleton, 2001).

In summary, the Sr isotope data set from Saba displays a large range and variance disproportionate to the small size of the island. Observations of the Sr results plotted onto a map of the island illustrate that there is only limited spatial patterning of the data (Fig. 5). Therefore we interpret the observed pattern of large range and variance as being primarily due to substantial contributions on the part of non-geological sources, specifically marine and atmospheric sources, to the total Sr budget of this island, owing to a combination of its size, topography, and geographical setting. For the purposes of our research questions concerning past human mobility, all human Sr signals fall within this large local Sr isotope range. Thus, all of the sampled individuals are isotopically local, but their Sr values also correspond to expected and measured Sr values from the hypothesized place of origin, eastern Hispaniola. It should also be noted that the Saban Sr range is so large that it is likely to mask or conceal the identification of nonlocal migrants from most other Caribbean regions as well. We must conclude then that Sr isotope analysis in isolation is not a very effective tool for identifying nonlocals in this particular environmental setting. We are currently exploring the utility of applying other complementary biogeochemical techniques, including analyses of trace element concentrations and lead isotopes, to address these issues.

Conclusions

Our preliminary results show that strontium isotope analyses can be successfully applied to human skeletal materials from the Caribbean region to shed light on questions about mobility and migration, although the method seems to be more effective in some geographic settings than in others. In particular, the Sr results from Saba are highly variable relative to the size of the island and the estimates of bioavailable strontium isotope ranges are quite distinct from those of the underlying bedrock and bulk soils. This pattern may also prevail on other small oceanic islands where large Sr isotope ranges exist owing to large differences in the isotopic signatures of the various strontium sources (end-members) contributing to the total strontium budget of the local ecosystem. This may also be expected in other similar set-

Fig. 5 | Map of strontium isotope results from Saba

tings where these conditions occur and thus may reduce the efficacy of utilizing these methods under certain circumstances, especially for the windward coasts of volcanic islands.

Nonetheless, data obtained to date from other sites indicate that there was substantial immigration to some sites/islands in the pre-Columbian Lesser Antilles, particularly when one considers that this particular method provides only minimal estimates of the number of nonlocals. At the site of Anse à la Gourde, Guadeloupe, and to a lesser extent at Tutu, St. Thomas, there are clear differences between females and males, not only with respect to the relative proportions of nonlocals versus locals but also with respect to the origins of these individuals, with females seemingly deriving from more diverse (isotopic) origins (Laffoon and de Vos, 2010).

The integration of data sets from multiple isotopes has allowed us to further investigate relationships between migratory behaviour and dietary practices. Carbon and nitrogen isotope results have

shown that in the case of most individuals at these sites there are no observable differences in diet between locals and nonlocals (identified as such on the basis of their Sr isotope values). This could be interpreted as an indication that nonlocals were originating from regions where ecological conditions (and associated subsistence patterns) were similar to the local conditions and patterns, although available evidence indicates distinct spatial clustering of C & N isotope values in the West Indies (Stokes, 1998). Therefore we interpret these isotopic correlations as resulting from the integration of nonlocals or 'exotic' individuals into local dietary custom, resulting in the equilibration of foreign bone C & N values with local ones over time. If so, we can use estimates of bone collagen turnover rates in conjunction with age-at-death estimates to begin to assess issues concerning age at migration and their consequent implications for past social processes, for example the structure of migratory groups.

Isotopic values from three nonlocal individuals from the site of Tutu, St. Thomas, fall outside the main local dietary cluster and can be compared with known regional variations in dietary isotope arrays to narrow down possible natal origins. We tentatively propose possible origins from Puerto Rico and/or Hispaniola and suggest that these individuals resided at Tutu, or at least on St. Thomas, for some time prior to their deaths, but not long enough for the isotope signals characteristic of their natal bone collagen to become completely eradicated via the consumption of local food resources.

In order to further explore these topics, including the relationships between mobility, demography, diet, and origins, we have begun a pilot project to analyze C & N isotopes in human dentine and strontium isotopes in human dental calculus. In addition, we are continuously expanding our database of biologically available strontium isotopic variation in the Caribbean, based on human, faunal, and floral samples. In the future, we will also explore the possibility of incorporating other isotopic systems, such as lead and oxygen, as well trace element analyses, to assist in the identification of nonlocals or migrants and the search for their geographic origins.

Acknowledgements

This research was financially supported by the Nederlandse Organisatie voor Wetenschappelijk Onderzoek, through the NWO-funded research project "Communicating Communities in the Circum-Caribbean" (NWO grant #016084621) under the supervision of Prof. Dr. Corinne Hofman. We wish to thank Prof. Dr. Gareth Davies of the Vrije Universiteit, Amsterdam for the supervision of the strontium isotope analyses. We also take this opportunity to thank Bart de Vos and Laura Font for their assistance and helpful input. We are especially grateful to everyone who provided us with samples and/or assisted in the sample collection process, including Elizabeth Righter, Ryan Espersen and Yann Hoogland.

References

Beard, B.L., Johnson, C.M., 2000. Strontium isotope composition of skeletal material can determine the birth place and geographic mobility of humans and animals. Journal of Forensic Sciences 45, 1049–1061.

Bentley, R.A., 2006. Strontium isotopes from the earth to the archaeological skeleton: A review. Journal of Archaeological Method and Theory 13, 135–187.

Bentley, R.A., Price, T.D., Stephan, E., 2004. Determining the "local" $^{87}Sr/^{86}Sr$ range for archaeological skeletons: A case study from Neolithic Europe. Journal of Archaeological Science 31, 365–375.

Booden, M.A., Panhuysen, R.G.A.M., Hoogland, M.L.P., de Jong, H.N., Davies, G., Hofman, C.L., 2008. Tracing human mobility with $^{87}Sr/^{86}Sr$ at Anse à la

Gourde, Guadeloupe, in: Hofman, C., Hoogland, M.L.P., Van Gijn, A.L. (Eds.), Crossing the Borders: New Methods and Techniques in the Study of Archaeological Materials from the Caribbean. University of Alabama Press, Tuscaloosa, pp. 214–225.

Borg, L.E., Banner, J.L., 1996. Neodymium and strontium isotopic constraints on soil sources in Barbados, West Indies. Geochimica et Cosmochimica Acta 60, 4193–4206.

Chadwick, O.A., Derry, L.A., Vitousek, P.M., Huebert, B.J., Hedin, L.O., 1999. Changing sources of nutrients during four million years of ecosystem development. Nature 397, 491–497.

Chiaradia, M., Gallay, A., Todt, W., 2003. Different contamination styles of prehistoric human teeth at a Swiss necropolis (Sion, Valais) inferred from lead and strontium isotopes. Applied Geochemistry 18, 353–370.

Coppa, A., Cucina, A., Hoogland, M.L.P., Lucci, M., Luna Calderón, F., Panhuysen, R.G.A.M., Tavarez María, G., Valcárcel Rojas, R., Vargiu, R., 2008. New evidence of two different migratory waves in the circum-Caribbean area during the Pre-columbian Period from the analysis of dental morphological traits, in: Hofman, C., Hoogland, M.L.P., Van Gijn, A.L. (Eds.), Crossing the Borders: New Methods and Techniques in the Study of Archaeological Materials from the Caribbean. University of Alabama Press, Tuscaloosa, pp. 195–213.

Cucina, A., Neff, H., Tiesler Blos, V, 2005. Detecting provenance of African-origin individuals in the Colonial Cemetery of Campeche, Yucatán: A new approach using trace elements and LA-ICP-MS, in: Speakman, R.J., Neff H. (Eds.), Laser Ablation ICP-MS in Archaeological Research. University of New Mexico Press, Albuquerque, pp. 187–197.

Ericson, J.E., 1985. Strontium isotope characterization in the study of prehistoric human ecology. Journal of Human Evolution 14, 503–514.

Farnum, J.F., 2002. Trace element analyses of skeletal remains and associated soils from the Tutu site, in: Righter, E. (Ed.), The Tutu Archaeological Village Site: A Multidisciplinary Case Study in Human Adaptation, Routledge, London, pp. 250–262.

Fox, P.J., Heezen, B.C., 1975. Geology of the Caribbean Crust, in: Nairn, A.E.M., Stehli, F.G. (Eds.), The Ocean Basins and Margins. Volume 3. The Gulf of Mexico and the Caribbean. New York, pp. 444–451.

Goudie, A.S., Middleton, N.J., 2001. Saharan dust storms: nature and consequences. Earth Science Reviews 56, 179–204.

Haak, W., Brandt, G., De Jong, H.N., Meyer, C., Ganslmeier, R., Heyd, V., Hawkesworth, C., Pike, A.W.G., Meller, H., Alt, K.W., 2008. Ancient DNA, strontium isotopes, and osteological analyses shed light on social and kinship organization of the Later Stone Age. Proceedings of the National Academy of Sciences USA 105, 18226–18231.

Hedges, R.E.M., Clement, J.G., Thomas, C.D.L., O'Connell, T.C., 2007. Collagen turnover in the adult femoral mid-shaft: Modeled from anthropogenic radiocarbon tracer measurements. American Journal of Physical Anthropology 133, 808–816.

Hofman, C.L., Hoogland, M.L.P., 1989. The later prehistory of Saba, N. Antilles. The settlement site of Kelby's Ridge, 1300-1450. Proceedings of the 13th Congress of the International Association for Caribbean Archaeology, Curacao 1989, pp. 477–492.

Hofman, C.L., Bright, A.J., Boomert, A., Knippenberg, S., 2007. Island rhythms: The web of social relationships and interaction networks in the Lesser Antillean Archipelago between 400 B.C. and A.D. 1492. Latin American Antiquity 18, 243–268.

Hofman, C.L., Bright, A.J., Hoogland, M.L.P., Keegan, W.F., 2008. Attractive ideas, desirable goods: Examining the Late Ceramic Age relationships between Greater and Lesser Antillean aocieties. Journal of Island and Coastal Archaeology 3, 17–34.

Hofman, C.L., Delpuech, A., Hoogland, M.L.P., 1999. Excavations at the Site of Anse à la Gourde, Guadeloupe: Stratigraphy, ceramic chronolology and structures, in: Proceedings of the 18th Congress of the International Association for Caribbean Archaeology, Grenada, pp. 162–172.

Hofman, C., Hoogland, M., Delpuech, A., 2001. Spatial organisation at a Troumassoid settlement: The case of Anse La Gourde, Guadeloupe, in: Proceedings of the 19th Congress of the International Association for Caribbean Archaeology, Aruba, pp. 162–172.

Hoogland, M.L.P., Hofman, C.L., 1993. Kelby's Ridge 2, a 14th century Taino settlement on Saba, Netherlands Antilles. Analecta Praehistorical Leidensia 26, 163–181.

Hoogland, M.L.P., Romon, T., Brasselet, P., 2001. Excavations at the Site of Anse à la Gourde: Troumassoid burial practices, in: Proceedings of the 18th Congress of the International Association for Caribbean Archaeology, Grenada, pp. 173–178.

Keegan, W.F., 1995. Modeling dispersal in the prehistoric West Indies. World Archaeology 26, 400–420.

Keegan, W.F., 2009. Central Plaza Burials in Saladoid Puerto Rico: An Alternative Perspective. Latin American Antiquity 20(2), 375–385.

Kennedy, M.J., Derry, L.A., 1995. Lack of importance of bedrock weathering in supplying base cations to unpolluted forests: Evidence from Sr isotopes. Geological Society of America Abstracts 27, A235.

Kennedy, M.J., Hedin, L.O., Derry, L.A., 2002. Decoupling of unpolluted temperate forests from rock nutrient sources revealed by natural $^{87}Sr/^{86}Sr$ and ^{84}Sr tracer addition. Proceedings of the National Academy of Sciences USA 99, 9639–9644.

Kennedy, M.J., Chadwick, O.A., Vitousek, P.M., Derry, L.A., Hendricks, D.M., 1998. Changing sources of base cations during ecosystem development. Hawaiian Islands Geology 26, 1015–1018.

Knudson, K.J., Price, T.D., 2007. Utility of multiple chemical techniques in archaeological residential mobility studies: Case studies from Tiwanaku and Chiribaya affiliated sites in the Andes. American Journal of Physical Anthropology 132, 25–39.

Laffoon, J.E., Hoogland, M.L.P., 2009. An application of strontium isotope analysis to Caribbean contexts: promises and problems. 23rd Congress of the International Association for Caribbean Archaeology, Antigua & Barbuda.

Laffoon, J., de Vos, B., 2010. Diverse origins, similar diets: An integrated isotopic perspective from Anse à la Gourde, Guadeloupe. Leiden in the Caribbean IV: From Prehistory to Ethnography in the Circum-Caribbean. Leiden, The Netherlands.

Laffoon, J.E., Hoogland, M.L.P., Valcárcel Rojas, R., 2010. Exploring mobility and origins in Caribbean contexts: An integrated isotopic perspective. Paper presented at the Annual Meeting of the Society for American Archaeology, St. Louis, Missouri.

Larsen, C.S., Teaford, M.F., Sandford, M.K., 2002. The Tutu teeth: Assessing prehistoric health and lifeway from St Thomas, in: Righter, E. (Ed.), The Tutu Archaeological Village Site: A Multidisciplinary Case Study in Human Adaptation. Routledge, London, pp. 230–249.

Mann, P., Schubert, C., Burke, K., 1990. Review of Caribbean neotectonics, in: Dengo, G., Case, J.E. (Eds.), The Caribbean Region. Geological Society of America, Boulder, pp. 307–338.

Maurey, R.C., Westbrook, G.K., Baker, P.E., Bouysse, P., Westercamp, D., 1990. Geology of the Lesser Antilles, in: Dengo, G., Case, J.E. (Eds.), The Caribbean Region. The Geological Society of America, Boulder, pp. 141–166.

Muhs, D.R., Bush, C.A., Stewart, K.C., Rowland, T.R., Crittenden, R.C., 1990. Geochemical evidence of Saharan dust parent material for soils developed on quaternary limestones of Caribbean and Western Atlantic islands. Quaternary Research 33, 157–177.

Norr, L., 2002. Bone isotopic analysis and prehistoric diet at the Tutu site, in: Righter, E. (Ed.), The Tutu Archaeological Village Site: A Multidisciplinary Case Study in Human Adaptation. Routledge, London, 2002, pp. 263–273.

Pozwa, A., Dambrine, E., Pollier, B., Atteia, O., 2000. A comparison between Ca and Sr cycling in forest ecosystems. Plant and Soil 225, 299–310.

Pozwa, A., Dambrine, E., Ferry, B., Pollier, G., Loubet, M., 2002. Do deep tree roots provide nutrients to the tropical rainforest? Biochemistry 60, 97–118.

Pozwa, A., Ferry, B., Dambrine, E., Pollier, G., Wickman, T., Loubet, M., Bishop, K., 2004. Variations of bioavailable Sr concentration $^{87}Sr/^{86}Sr$ ratio in boreal forest ecosystems: Role of biocycling, mineral weathering and depth of root uptake. Biochemistry 67, 1–20.

Price, T.D., Grupe, G., Schroter, P., 1994. Reconstruction of migration patterns in the Bell Beaker period by stable strontium isotope analysis. Applied Geochemistry 9, 413–417.

Price, T.D., Gestsdottir, H., 2006. The first settlers of Iceland: an isotopic approach to colonisation. Antiquity 80, 130–144.

Price, T.D., Burton, J.H., Bentley, R.A., 2002. The characterization of biologically available strontium isotope ratios for the study of prehistoric migration. Archaeometry 44, 117–136.

Probst, A., El Gh'mari, A., Aubert, D., Fritz, B., McNutt, R., 2000. Strontium as a tracer of weathering processes in a silicate catchment polluted by acid atmospheric inputs (Strengbach, France). Chemical Geology 170, 203–219.

Righter, E., 2002. The Tutu archaeological village site: A multidisciplinary case study in human adaptation. Routledge, London.

Rodríguez Ramos, R., 2007. Puerto Rican Precolonial History Etched In Stone, Department of Anthropology. University of Florida, Gainesville.

Roobol, M.J., Smith, A.L., 2004. Volcanology of Saba and St. Eustatius, Northern Lesser Antilles. Royal Netherlands Academy of Arts and Sciences, Amsterdam.

Rouse, I., 1986. Migrations in Prehistory: Inferring Population Movement from Cultural Remains. Yale University Press, New Haven.

Rouse, I., 1989. Peopling and repeopling of the West Indies, in: Woods, C.A. (Ed.), Biogeography of the West Indies: Past, Present, and Future. Sandhill Crane Press, Gainesville, pp. 119–136.

Sandford, M.K., Bogdan, G., Kissling, G.E., 2002. Biological adaptation in the prehistoric Caribbean: Osteology and bioarchaeology of the Tutu site, in: Righter, E. (Ed.), The Tutu Archaeological Village Site: A Multidisciplinary Case Study in Human Adaptation. Routledge, London, pp. 209–229.

Schroeder, H., O'Connell, T.C., Evans, J.A., Shuler, K.A., Hedges, R.E.M., 2009. Trans-Atlantic slavery: Isotopic evidence for forced migration to Barbados. American Journal of Physical Anthropology 139, 547–557.

Schwarcz, H.P., White, C.D., Longstaffe, F.J., 2010. Stable and radiogenic isotopes in biological archaeology: Some applications, in: West, J.B., Bowen, G.J., Dawson, T.E., Tu, K.P. (Eds.), Isoscapes: Understanding Movement, Pattern, and Process on Earth through Isotope Mapping. New York, Springer.

Sealy, J.C., van der Merwe, N.J., Sillen, A., Kruger, F.J., Krueger, H.W., 1991. $^{87}Sr/^{86}Sr$ as a dietary indicator in modern and archaeological bone. Journal of Archaeological Science 18, 399–416.

Siegel, P.E., 1991. Migration research in Saladoid Archaeology: A review. Florida Anthropologist 44, 79–91.

Siegel, P.E., 2010. Continuity and change in the evolution of religion and political organization on pre-Columbian Puerto Rico. Journal of Anthropological Archaeology 29, 302–326.

Somerville, A.D., Nelson, B.A., Knudson, K.J., 2010. Isotopic investigation of pre-Hispanic macaw breeding in Northwest Mexico. Journal of Anthropological Archaeology 29, 125–135.

Stokes, A.V., 1998. A biogeographic survey of prehistoric human diet in the West Indies using stable isotopes. PhD thesis. Department of Anthropology, University of Florida, Gainesville.

Van Soest, M.C., Hilton, D.R., Macpherson, C.G., Mattey, D.P., 2002. Resolving sediment subduction and crustal contamination in the Lesser Antilles Island Arc: A combined He–O–Sr isotope approach. Journal of Petrology 43, 143–170.

Vitousek, P.M., Kennedy, M.J., Derry, L.A., Chadwick, O.A., 1999. Weathering versus atmospheric sources of strontium in ecosystems on young volcanic soils. Oecologia 121, 255–259.

de Vos, B., 2010. United by diet: Stable carbon and nitrogen isotope analysis on bone collagen for diet reconstruction on Anse à la Gourde, Guadeloupe. Faculty of Archaeology, Leiden University, Leiden.

Weston, D., 2010. Human Skeletal report: Kelbey's Ridge 2 and Spring Bay 1c, Saba. Barge's Antropologica. Leiden University, Leiden.

White, W., Patchett, J, 1984. Hf-Nd-Sr isotopes and incompatible element abundances in island arcs: implications for magma origins and crust-mantle evolution. Earth and Planetary Science Letters 67, 167–185.

Whipkey, C.E., Capo, R.C., Chadwick, O.A., Stewart, B.W., 2000. The importance of sea spray to the cation budget of a coastal Hawaiian soil: A strontium isotope approach. Chemical Geology 168, 37–48.

Wright, L.E., 2005. Identifying immigrants to Tikal, Guatemala: Defining local variability in strontium isotope ratios of human tooth enamel. Journal of Archaeological Science 32, 555–566.

Wright, L.E., Schwarcz, H.P., 1999. Correspondence between stable carbon, oxygen and nitrogen isotopes in human tooth enamel and dentine: Infant diets at Kaminaljuyu. Journal of Archaeological Science 26, 1159–1170.